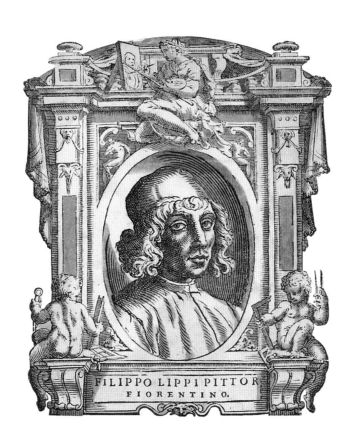

FILIPPO LIPPI PITTOR
FIORENTINO.

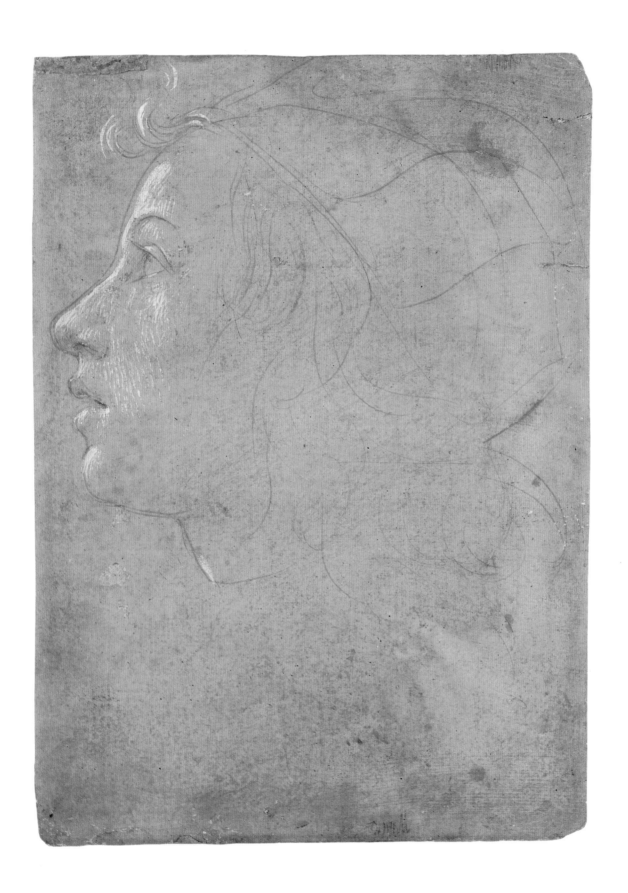

The Drawings of Filippino Lippi and His Circle

GEORGE R. GOLDNER

CARMEN C. BAMBACH

ALESSANDRO CECCHI

WILLIAM M. GRISWOLD

JONATHAN NELSON

INNIS HOWE SHOEMAKER

ELIZABETH E. BARKER

THE METROPOLITAN MUSEUM OF ART, NEW YORK

Distributed by Harry N. Abrams Inc., New York

This publication is issued in conjunction with the exhibition
"The Drawings of Filippino Lippi and His Circle," organized by
The Metropolitan Museum of Art, New York, and held there
from October 28, 1997, to January 11, 1998.

This publication is made possible, in part, by The Drue E. Heinz
Fund.

Published by The Metropolitan Museum of Art, New York

John P. O'Neill, Editor in Chief
Carol Fuerstein, Editor
Malcolm Grear Designers, Inc., Designer
Katherine van Kessel, Christopher Zichello, Production

New photography at the Gabinetto Disegni e Stampe degli
Uffizi, Florence, and the Istituto Nazionale per la Grafica, Rome,
by Katherine Dahab and Eileen Travell, the Photograph Studio,
The Metropolitan Museum of Art, New York

Set in Bembo
Printed on Aberdeen Silk
Separations by Arnoldo Mondadori, S.p.A., Verona, Italy
Printed and bound by Arnoldo Mondadori, S.p.A., Verona, Italy

Translations from the Italian of the essay and entries by
Alessandro Cecchi by Carmen C. Bambach and Marguerite Shore

Jacket illustrations: front, *Head of a Young Woman,* cat. no. 8; back,
*Winged Monster with its Paws on a Helmet, with Part of an Oval Frame
with a Winged Putto,* cat. no. 103
Half-title page illustration: Presumably Giorgio Vasari. *Portrait of
Filippo Lippi.* Woodcut with hand-applied brown wash. Detail, p. 299
Frontispiece: *Head of a Young Boy Facing Left,* cat. no. 73

Library of Congress Cataloging-in-Publication Data
Lippi, Filippino, d. 1504.
 The drawings of Filippino Lippi and his circle / George R.
 Goldner, Carmen C. Bambach; [with] Alessandro Cecchi . . . [et al.].
 p. cm.
 Catalog of an exhibition to be held Oct. 28, 1997, to Jan. 11, 1998,
at the Metropolitan Museum of Art.
 Includes bibliographical references and index.
 ISBN 0-87099-828-5 (hc: alk. paper).—ISBN 0-8109-6509-7
(Abrams)
 1. Lippi, Filippino, d. 1504—Exhibitions. 2. Lippi, Filippino,
d. 1504—Influence—Exhibitions. 3. Drawing—15th century—
Italy—Exhibitions. I. Goldner, George R., 1943- . II. Bambach,
Carmen C. III. Cecchi, Alessandro. IV. Metropolitan Museum
of Art (New York, N.Y.). V. Title.
NC257.L56A4 1997
741.945—dc21 97-28294
 CIP

Contents

Lenders to the Exhibition

Director's Foreword

Filippino Lippi was among the most original and accomplished draftsmen of the Renaissance. His mastery of metalpoint drawing on prepared paper and his freedom of execution with both stylus and pen have been admired from his lifetime to our era. The greatest modern connoisseur of Italian Renaissance art, Bernard Berenson, was a harsh critic of Filippino as a painter, but even he wrote with enthusiasm about his draftsmanship. Thus it is surprising that no major exhibition has ever been devoted to Filippino. Given the dazzling variety and the beauty of surviving sheets from his hand, he seemed the perfect subject for a show at the Metropolitan Museum.

No exhibition of Filippino's drawings would be possible without the collaboration of the Uffizi, Florence, which appropriately enough houses the largest and best group of his works. We are, therefore, deeply grateful to Annamaria Petrioli Tofani, Direttore degli Uffizi, for supporting the undertaking from the outset and for making possible the loan of virtually all of the major sheets by Filippino in the Uffizi. We are also indebted to the many other lenders who have granted our requests with remarkable generosity. As a result, visitors to the show can see sheets related to the same project side by side and, for the first time in centuries, the three intact pages with Filippino's drawings from Vasari's *Libro de' disegni* reunited. In addition, it is possible to study a small predella panel, borrowed from the National Gallery of Art in Washington, D.C., together with its preparatory cartoon, now in the Allen Memorial Art Museum in Oberlin. Our profound gratitude goes as well to Drue Heinz, as it is the generous support of The Drue E. Heinz Fund that has made this publication possible.

It is our goal that this presentation should foster not only an appreciation of the drawings of Filippino and his circle but also of the wider range of drawings from the fifteenth century, a period of draftsmanship not well represented in American collections and rarely the subject of exhibitions here or in Europe.

The exhibition was organized by George R. Goldner, Drue Heinz Chairman of the Department of Drawings and Prints, together with Carmen C. Bambach, Associate Curator of Drawings and Prints. Their principal collaborator at the Uffizi has been Alessandro Cecchi, Direttore del Dipartimento della Pittura dal Medioevo al Primo Rinascimento.

PHILIPPE DE MONTEBELLO
Director
The Metropolitan Museum of Art

Acknowledgments

To the many individuals who have in one way or another played a role in the making of this exhibition and of its catalogue I would like to offer my gratitude.

First in line outside The Metropolitan Museum of Art is Annamaria Petrioli Tofani, Direttore degli Uffizi, Florence, who encouraged me in this undertaking and who laid its foundation stone by agreeing to lend a large number of the Uffizi's great treasures by Filippino and his circle. Without her generosity, there would have been no exhibition. At the same time I extend my thanks to her colleague Alessandro Cecchi, Direttore del Dipartimento della Pittura dal Medioevo al Primo Rinascimento degli Uffizi, for his helpfulness at every stage of the project, as well as for his important contributions to this publication.

Other lenders were equally generous, turning down not a single Filippino loan request. I am grateful to all of them, not only for this but also for their assistance and advice in response to many individual queries and requests. With apologies for any inadvertent omissions, I also acknowledge: the Acadia Summer Art Program, for support of Innis Howe Shoemaker's essay, Giovanni Agosti, Christina Åhlander, Sophie Allgårdh, Robert Anderson, Renata Antoniou, Stephen Astley, Jean Aubert, Rita Parma Baudille, Herbert Beck, Mària van Berge-Gerbaud, Robert P. Bergman, the staff at the Biblioteca Berenson and Fototeca Berenson of Villa I Tatti, the Harvard Center for Italian Renaissance Studies, Florence, Veronika Birke, Per Bjurström, Maurizio Boni, Giorgio Bonsanti, Eve Borsook, Edgar Peters Bowron, Dominique Brachlianoff, Arnauld Brejon de Lavergnée, Barbara Brejon de Lavergnée, David Alan Brown, Emmanuelle Brujerolles, Ulf Cederlöf, Maria Luisa Cerrón Puga, Hugo Chapman, Martin Clayton, Robert Randolf Coleman, Michele Cordaro, Dominique Cordellier, James Cuno, Peter Day, Diane DeGrazia, Jeroen A. De Scheemaker, Christian Dittrich, Helen Dorey, Barbara Dossi, Dominique Dumas, Philippe Durey, Electa, Milan, Charles Ellis, Ruppert Featherstone, Nelda Ferace, Chris Fischer, Shelley Fletcher, Carter Foster, Maria Clelia Galassi, Dennis Geronimus, Giovanna Giusti, Catherine Monbeig Goguel, Hilliard Goldfarb, Margaret Morgan Grasselli, Anthony V. Griffiths, Herwig Guratzsch, Colin Harrison, Anne Hawley, Rudolf von Hiller, Wolfgang Holler, Peter Humfrey, Annie Jacques, Walter Kaiser, Petra Kuhlmann-Hodick, Laurence Llinaresa, Jiří Machalický, Karl-Heinz Mehnert, Lucia Monaci Moran, Ilaria della Monica, Anne F. Moore,

Theresa-Mary Morton, Paolo Nannoni, Antonio Natali, Konrad Oberhuber, Sheila O'Connell, Nicolò Orsi Battaglini, Giovanni Pagliarulo, Serenita Papaldo, Allegra Pesenti, Charles E. Pierce Jr., Michiel C. Plomp, Earl A. Powell III, Antonio Quattrone, Margaret Richardson, Jane Roberts, William W. Robinson, Andrew Robison, Anna Rollová, Pierre Rosenberg, Martin Royalton-Kisch, Patricia Rubin, Richard Rutherford, Laurent Salomé, Sabine Sameith, Werner Schmidt, Ruth Schmutzer, Hein-Th. Schulze Altcappenberg, Jutta Schütt, Maurizio Seracini, Arlette Serullaz, Miriam Stewart, Andreas Stolzenberg, Kathleen Stuart, Margaret Stuffmann, Fiorella Superbi Gioffredo, Edoardo Testori, Elisabeth Thobois, Peter Thornton, Silvia Meloni Trkulja, Nicholas Turner, Lisa Venturini, Françoise Viatte, Alena Volrábová-Vlasáková, Elizabeth Walmsley, John Walsh, Catherine Whistler, Lucy Whitaker, Christopher White, Marjorie E. Wieseman, and Martin Zlatohlávek.

For sharing with us their knowledge of Filippino's career and his work as a painter, we are deeply indebted to Jonathan Nelson and to Patrizia Zambrano. We are equally grateful for our discussions of the drawings with Innis Howe Shoemaker. William M. Griswold took part in the planning of the exhibition when he worked at the Metropolitan Museum, playing a significant role in determining its composition. After departing the Museum for his current post at The Pierpont Morgan Library, New York, he continued to contribute to the undertaking.

Within the Metropolitan Museum, I first thank Philippe de Montebello, our Director, for his unstinting support of this project. Mahrukh Tarapor, our Associate Director for Exhibitions, and her staff were helpful throughout, as was Linda M. Sylling, our Associate Manager for Operations and Special Exhibitions. Carmen C. Bambach took over for William M. Griswold and has been an outstanding collaborator and coauthor. She has brought to the exhibition and the publication her great knowledge, precision, and unswerving insistence on excellence. We have discussed every issue of attribution and chronology, over time arriving at agreement on all major questions. We have both benefited enormously from the assistance of Elizabeth E. Barker, a student at the Institute of Fine Arts, New York University, who has played a major role in almost every aspect of the exhibition since the selection process was completed two years ago. So significant has her part been in matters both scholarly and practical that we have come to view her more as a junior

partner than as an assistant. Three other students at the Institute of Fine Arts, Anne Leader, Jeanette Sisk, and Lisa A. Banner, were very helpful in the preparation of the bibliographical material.

At all points Everett Fahy gave us useful advice, putting his knowledge of late-fifteenth-century paintings at our disposal. Marjorie Shelley conserved the drawings lent by the Christ Church Picture Gallery, Oxford, and generously shared her technical expertise. Maryan W. Ainsworth assisted us by conducting infrared reflectography examinations of paintings by Filippino and Raffaellino del Garbo in the Metropolitan Museum collection. We appreciate the efforts of the Editorial Department, led by John P. O'Neill, to make this a successful publication. In particular, Carol Fuerstein, our editor, has worked with tireless dedication and good sense, much improving the contents of the catalogue. The book's present form also reflects the vigilant efforts of Jean Wagner, Bibliographic Editor, Katherine van Kessel, Production Manager, Malcolm Grear Designers, Inc., as well as Barbara Cavaliere, Production Editor, and Robert Weisberg, Computer Specialist. Pamela T. Barr edited the exhibition labels, Daniel Kershaw designed the installation, and Barbara Weiss designed the graphics. Our gratitude is also owed to the Photograph Studio, headed by Barbara Bridgers, and, in particular, to Katherine Dahab and Eileen Travell, who photographed drawings in Italian collections. Thanks are due as well to registrars Herbert M. Moskowitz and Nina S. Maruca and to Kenneth Soehner and the staff of the Thomas J. Watson Library. Finally, David Del Gaizo brought his great skills to the installation of the exhibition.

GEORGE R. GOLDNER
Drue Heinz Chairman
Department of Drawings and Prints

Notes to the Reader

Works illustrated are by Filippino Lippi unless otherwise stated. Drawings in the exhibition are reproduced at actual size whenever possible, with areas of loss or damage toned to a lighter hue than that of the original sheet. Colorplates representing Filippino's most important paintings immediately precede the catalogue section.

The catalogue entries are arranged by artist in the following order: Fra Filippo Lippi, Sandro Botticelli, Filippino Lippi, Raffaellino del Garbo, Piero di Cosimo, Tommaso, and Raphael. Filippino's drawings are presented generally following the chronology proposed here. Drawings from the page of Giorgio Vasari's *Libro de' disegni* in the National Gallery of Art, Washington, D.C., are catalogued individually by artist.

Dimensions are given with height preceding width. Metalpoint signifies lead, silver, gold, tin, copper, or other metal alloys; paper is white unless otherwise indicated. All inscriptions and annotations on the drawings are transcribed, as are those of historical importance on the mounts.

The literature section of each entry is as complete as possible and includes exhibition catalogues. Attributions made by previous scholars, listed in brackets, are given only if they differ from those of the present authors. Citations are abbreviated throughout the catalogue; full references are provided in the bibliography, which also includes material not cited in the text.

Contributors to the Catalogue

EEB ELIZABETH E. BARKER
Exhibition Assistant
The Metropolitan Museum of Art, New York

CCB CARMEN C. BAMBACH
Associate Curator, Drawings and Prints
The Metropolitan Museum of Art, New York

AC ALESSANDRO CECCHI
Direttore, Dipartimento della Pittura dal Medioevo al Primo Rinascimento
Galleria degli Uffizi, Florence

GRG GEORGE R. GOLDNER
Drue Heinz Chairman, Department of Drawings and Prints
The Metropolitan Museum of Art, New York

WMG WILLIAM M. GRISWOLD
Charles W. Engelhard Curator, Department of Drawings and Prints
The Pierpont Morgan Library, New York

JONATHAN NELSON
Assistant Professor of Art History
Syracuse University in Florence

INNIS HOWE SHOEMAKER
Senior Curator of Prints, Drawings, and Photographs
Philadelphia Museum of Art

Chronology
The Life of Filippino Lippi

ELIZABETH E. BARKER

Dates are New Style

1456

May 1 The Feast of the Girdle of Our Lady. On this day Lucrezia Buti (1433/35–after 1504), a nun in the convent of Santa Margherita, Prato, elopes with Fra Filippo Lippi (ca. 1406–1469), the Florentine painter and Carmelite friar serving as chaplain to the convent (as recorded by the sixteenth-century artist and art historian Giorgio Vasari).

1457/58

Presumably during this winter Filippino Lippi is born in Prato to Lucrezia Buti and Fra Filippo Lippi.

1459

December 23 Lucrezia Buti, her sister Spinetta, and three companions renew their vows at Santa Margherita in the presence of an episcopal vicar. Lucrezia will eventually leave the convent permanently (perhaps before the birth of Filippino's sister, Alessandra, in 1465), since she is referred to as "monna" (lady or mistress) in Filippino's will of 1488.

1461

May 8 An anonymous denunciation (*tamburazione*) of Fra Filippo Lippi and the notary Ser Piero d'Antonio is filed with the Committee of Public Morals (Ufficiali di Notte e Monasterii). The document charges that Fra Filippo has fathered the child of a nun at Santa Margherita, identified as Spinetta Buti (although Filippino's will of 1488 refers to Lucrezia Buti as his mother). The denunciation gives "Filippino" as the name of the child and describes him as "big" (grande) and living with Fra Filippo.

1467

At the beginning of the year Filippino and his father move to Spoleto, where Fra Filippo has been com-missioned to paint the fresco cycle in the apse of the city's cathedral, then called Santa Maria Maggiore. The account book of the cathedral's board of works (Libro dell'Opera) records payments made to Fra Filippo for Filippino; the first, dated May 13, 1467, is for "a pair of stockings for his [son] Filippino" (uno paro di calze per Filippino suo).

1469

October 10 Fra Filippo Lippi dies in Spoleto, as recorded in the account book of the cathedral's board of works.

1472

June The ledger (Libro Rosso) of the Lay Brotherhood of Saint Luke (Compagnia di San Luca), the craft association of painters, in Florence records Filippino's placement in the workshop of Sandro Botticelli (1445–1510), who had probably trained with Fra Filippo Lippi in the 1460s: "Filippo [son] of Filippo of Prato painter with Sandro Botticello" (Filippo di Filippo da Prato dipintore chon Sandro Botticello). Filippino certainly leaves Botticelli's studio before October 1481, as he does not accompany Botticelli to Rome at that time to paint in the Sistine Chapel.

1480

May 1 Filippino signs a three-year lease for a house on the via Palazzuolo, Florence, owned by the convent of San Donato in Polverosa. He remains in this house until April 1488.

According to his tax declaration (*portata al catasto*) for 1495 (filed in 1498), Filippino is "away from Florence" (fuori di Firenze) during this year.

CA. 1480–83

The date proposed in this publication for Filippino's work in the Brancacci Chapel, Santa Maria del Carmine, Florence, where he completes the frescoes left unfinished by Masaccio and Masolino in the 1420s.

August 18 Filippino enrolls in the Confraternity of Saint Paul (Confraternita di San Paolo), Florence, a lay brotherhood of flagellants whose members include the statesman Lorenzo de' Medici, il Magnifico (1449–1492); the painters Domenico and David Ghirlandaio (1449–1494; 1452–1525); and the humanist scholar and poet Angelo Poliziano (1454–1494).

1482

March Filippino probably paints *Saints Roch, Sebastian, Jerome, and Helen* for San Michele in Foro, Lucca.

June 23 The date of a payment to Filippino for the design of a wall hanging depicting a foliate motif ("uno disegno d'una spalliera a verdura fittoci"), recorded in the account books of the Florentine banker and businessman Filippo di Matteo Strozzi (1428–1491).

September 29 Filippino signs the contract to paint an altarpiece for Nicola di Stefano Bernardi for San Ponziano, Lucca. (The altarpiece has not been preserved in its original state: the *Annunciation* is lost; *Saints Benedict and Apollonia* and *Saints Paul and Fredianus* are in the Norton Simon Art Foundation, Pasadena; and the statue of Saint Anthony Abbot remains in the church.) Filippino receives the final payment for this work on September 23, 1483.

December 31 Filippino receives the commission to paint the north wall of the Sala dei Gigli, Palazzo della Signoria, Florence, replacing Biagio Tucci (1446–1515) and Pietro Perugino (ca. 1450–1523) in the original contract. Filippino is absent from Florence for the signing of the document. The decorative scheme for this room is eventually reduced; Filippino's projected frescoes are never painted.

1483

February 8 The town priors of San Gimignano appoint two members to a subcommittee formed to commission an Annunciation in two tondi for the Audientia (audience hall) of the Palazzo Comunale, San Gimignano. Funds for this project were first set aside on April 1, 1482; the panels are presumably completed by May 19, 1484, when the priors arrange for their hanging. Although the town records (*deliberazioni e provvisioni del comune*) do not name the artist, the commission they cite can reasonably be identified with Filippino's *Annunciation* tondi (Museo Civico, San Gimignano).

1485

December 16 Filippino buys a cottage (*casolare*) on the via delle Tre Gore in Prato; the cottage is attached to a little house (*casetta*), which he may have inherited from his father and where his mother resides.

February 20 Filippino signs the *Virgin and Child with Saints John the Baptist, Victor, Bernard, and Zenobius* (Uffizi, Florence), known as the *Pala degli Otto di Practica,* painted for the Sala del Consiglio (council room), Palazzo della Signoria, Florence. The record books of the works department of the Florentine government (*deliberazioni e stanziamenti degli Operai del Palazzo*) state that this commission was awarded to Filippino on September 27, 1485, and that the price for the painting, determined by Lorenzo de' Medici himself, was announced on April 7, 1486.

By this year Filippino's *Vision of Saint Bernard* (church of the Badia, Florence) is installed in the chapel of the Florentine cloth merchant Piero di Francesco del Pugliese (1430–1498) in Santa Maria in Campora, near Florence, as indicated by a manuscript inventory compiled in 1488, listing Del Pugliese's expenditures in the chapel.

1487

April 21 Filippino signs the contract to paint the chapel of Filippo Strozzi in Santa Maria Novella, Florence.

1488

January 5 Filippino purchases a house on the via degli Angioli (now via degli Alfani), near the monastery of San Michele Visdomini, Florence, as documented in his tax declaration for 1495. Although Filippino's will of September 21, 1488, describes the house as empty ("Domum emptarum per dictum Filippum a monasterio de Angelis de Florentia"), by the time of his death the house serves as his residence and is the site of his workshop. (Filippino had already purchased two small adjoining houses on the same street from the monastery during the previous year; the monastery did not receive papal approval of the sale, however, and these houses do not appear in Filippino's tax declaration for 1495.)

August 26 Filippino arrives in Rome, where he signs the contract to paint the chapel of Cardinal Oliviero Carafa (1430–1511) in Santa Maria sopra Minerva, Rome; the commission had been awarded to him on the recommendation of Lorenzo de' Medici.

September 3 Filippino leaves Rome for a brief trip to Florence to put his affairs in order.

September 21 Filippino signs his first will in Florence. It lists three houses: one in Florence, near Santa Maria degli Angioli, which he bequeaths to his mother, Lucrezia Buti, and two in Prato, which he bequeaths to his sister, Alessandra Ciardi. He leaves additional property to the hospital of Santa Maria Nuova, Florence, which in the event of his death is required to supply oil, wood, and salt meat to his mother for the remainder of her life. The will records Filippino's request that

Francesco di Filippo del Pugliese (1458–1519), the nephew of Piero di Francesco del Pugliese, collect the outstanding fee for two panel paintings from Matthias Corvinus (1433–1490), king of Hungary.

1488 or 1489

Filippino travels to Rome by way of Spoleto, where he designs a memorial to his father, which is placed before the central door of the city's cathedral and later relocated within the edifice. Lorenzo de' Medici pays for the red and white marble tomb, and Angelo Poliziano composes the epitaph.

In Rome Filippino enlists in the brotherhood of resident Florentines.

1489

June–October Filippino begins to fresco the Strozzi Chapel. After this campaign, work in the chapel is suspended.

Autumn or winter Filippino may travel to Venice, as stipulated in the contract for the Strozzi Chapel, presumably to purchase pigments.

1490–91

The presumed date of Filippino's frescoes (destroyed) in the Spedaletto, a villa in Volterra owned by Lorenzo de' Medici.

1491

January 5 The date of a meeting sponsored by the building committee of the cathedral of Florence (Opera del Duomo) to address the competition for the design of the cathedral's facade; ten entries had been submitted, including one by Filippino, who is absent from the meeting. At the recommendation of Lorenzo de' Medici, a final decision is postponed; the award of the project remains unresolved at the time of Lorenzo's death in April 1492. (The cathedral's present facade dates from the nineteenth century.)

May 14 Filippo Strozzi dies; as Strozzi had requested in his will, his heirs will continue to support Filippino's work in the family chapel.

1493

Spring By this time Filippino completes the frescoes in the Carafa Chapel, where Pope Alexander VI celebrates the Feast of the Annunciation on March 21; the event is documented in a diary entry of March 25 by Johannes Burchard, master of ceremonies for the pope. A marble tablet, dated June 14, 1493, on the right wall of the chapel is inscribed with a papal bull granting indulgences to worshipers (issued by Alexander on May 19, 1493).

Summer or autumn The presumed date of Filippino's unfinished and much-damaged *Sacrifice of Laocoön*, painted on the front loggia of the villa built for Lorenzo de' Medici at Poggio a Caiano.

1494

March 21 and July 23 Filippino purchases a lot on the via Ventura, Florence.

April Raffaellino del Garbo probably paints the small mortuary chapel adjoining the Carafa Chapel to Filippino's designs.

Summer Filippino again takes up work in the Strozzi Chapel, where he is employed by Filippo Strozzi's son, Alfonso di Filippo Strozzi (b. 1467).

November 17 As part of the festivities honoring the triumphal entry of King Charles VIII of France into Florence, a float designed by Filippino representing the Triumph of Peace is displayed in the Piazza della Signoria. The float is a large wagon constructed of wood and canvas, covered with cloth of gold; its decorations include a large golden lily and a silver crown of palms and olive branches. Women dressed as nymphs in golden yellow and eighteen musicians and singers dressed in red-and-white taffeta ride on it.

1495

March 7 Filippino signs a contract with the monks of the Certosa (Carthusian monastery) of Pavia to paint an altarpiece depicting a Pietà with Saints. The work remains unfinished; in 1511 the commission is transferred to Mariotto Albertinelli (1474–1515).

March 13 Filippino sells the lot on the via Ventura, Florence, that he had bought the previous year.

March 27 Benedetto da Maiano (1442–1497) receives the final payment for his sculpture on the altar wall of the Strozzi Chapel; with Benedetto's work completed, Filippino can begin the frescoes on this wall.

1496

March 6 The date of Filippino's second will. In addition to provisions for his mother and sister, this specifies bequests to Filippino's wife, Maddalena, daughter of Pietro Paolo Michele de' Monti, whom he evidently had married in 1494, as suggested by tax records. The couple would have three sons: Ruberto (1500–1574), who became a friend of the engraver Cristofano Robetta (1462–after 1522); Giovanni Francesco (b. 1501), who became a goldsmith and a friend of Benvenuto Cellini (1500–1571); and Aloysio (b. 1504), whose name was changed to Filippino after his father's death.

March 29 The date inscribed on the back of Filippino's altarpiece the *Adoration of the Magi* (Uffizi, Florence), painted for the monastery of San Donato a Scopeto, near Florence. Leonardo da Vinci (1452–1519) had been awarded the commission for the work in 1481 but had executed only a monochrome underpainting (Uffizi, Florence) when he left Florence in 1482 or

1483 to work in Milan; the commission was probably transferred to Filippino in 1495.

Filippino slows work on the Strozzi Chapel, complaining of the cost of pigments.

1497

January 19 A committee made up of Cosimo Rosselli (1439–1504), Benozzo Gozzoli (1420–1497), Pietro Perugino, and Filippino Lippi files a report assessing the value of the frescoes by Alesso Baldovinetti (1425?–1499) in the Gianfigliazzi Chapel, Santa Trinita, Florence.

April Filippino institutes legal action against the Strozzi heirs, claiming that he has received insufficient payment for his work in the Strozzi Chapel and cannot afford the pigments required to complete it. The case is tried before the guild of physicians and apothecaries (Arte dei Medici e Speziali), which includes painters. The Strozzi heirs hire a stonemason, Simone di Tommaso, to represent them; they maintain that Filippino "has not worked since the death of Filippo Strozzi and has left the chapel incomplete" (*dopo la morte del nostro Filippo, lui non vi lavorava e lasciava la imperfetta*). Filippino wins the case and is awarded the sum of 100 large florins in addition to the 250 large florins stipulated in the original contract (although he absorbs legal expenses totaling just over 8 florins). In return for the additional payment, he agrees to complete the frescoes.

The date inscribed on Filippino's *Meeting of Joachim and Anna* (Statens Museum for Kunst, Copenhagen).

1498

May 28 Filippino receives the commission for the altarpiece for the Sala del Gran Consiglio, Palazzo della Signoria, Florence, before this date. The work is never painted; on November 26, 1510, the commission is transferred to Fra Bartolommeo (1472–1517), whose *Saint Anne* altarpiece (Museo di San Marco, Florence) remains unfinished. The postmortem inventory of Filippino's possessions records several carved, gessoed pieces of ornament, probably parts of the frame intended for his altarpiece; in Vasari's day the pieces of ornament belonged to Maestro Baccio Baldini, a Florentine physician.

June 26 Filippino attends a meeting sponsored by the building committee of the cathedral of Florence to address the repair of the cathedral's lantern, which had been struck by lightning on May 19, 1492.

July 27 The Florentine merchant, civil servant, and diplomat Tanai de' Nerli (b. 1427) dies; the date provides the terminus ad quem for Filippino's commission to work in the Nerli Chapel, Santo Spirito, Florence, where he designs the stained-glass window and paints the altarpiece the *Virgin and Child with the Infant Saint John the Baptist and Saints Martin of Tours and Catherine of Alexandria and Donors*.

July 28 Filippino is paid for estimating the value of the gilding on two candlesticks for the altar of the cathedral of Prato.

The date inscribed on Filippino's frescoed street tabernacle the *Virgin and Child with Saints Stephen, Catherine of Alexandria, Anthony Abbot, and Margaret* (originally on the canto al Mercatale, Prato, now Museo Civico, Prato), painted near the house of Antonio di Antonio Tieri (b. 1440).

1499

September 13 Filippino purchases a small lot of farmland in Settignano.

1500

June 17 Filippino is paid for two designs for silver candlesticks for the main altar of the cathedral of Florence.

1501

The date inscribed on the *Mystic Marriage of Saint Catherine* (Isolani Chapel, San Domenico, Bologna), painted for a member of the Casali family of Bologna.

1502

January 26 Filippino is commissioned to paint an altarpiece in the form of a tondo depicting the Virgin with Saints Stephen and Leonard for the Udienza dei Priori (council hall) of the Palazzo del Comune, Prato. On February 13 Filippino is instructed to replace Saint Leonard with Saint John the Baptist and to change the format from a round panel to an arched one.

The date inscribed on the *Raising of Drusiana* (Strozzi Chapel).

1503

April 23 Filippino's name is stricken from the membership rolls of the Confraternity of Saint Paul (perhaps because he did not attend its meetings regularly or because he had enrolled in another confraternity).

September 15 Filippino is awarded the commission for the high altarpiece of Santissima Annunziata, Florence, which is to consist of eight paintings: two large compositions for the front and back to depict the Deposition and an undetermined subject, and six smaller panels, to be placed elsewhere, each to represent a full-length saint. He completes only the upper part of the *Deposition* (Uffizi, Florence); on August 5, 1505, the commission is transferred to Pietro Perugino, who receives the final payment for his work on January 9, 1506.

September 23 Francesco Malatesta, an agent of Isabella d'Este (1474–1539), writes to the marchese that Filippino is too busy with other work to paint something for her *studiolo* for at least six months.

December 15 Filippino lends 2 florins to the Brotherhood of Saint Luke, Florence, "for the wall" (per la muraglia), presumably for construction work.

The date inscribed on the *Virgin and Child with Saints John the Baptist and Stephen* (Museo Civico, Prato).

The date inscribed on the altarpiece *Saint Sebastian between Saints John the Baptist and Francis* for San Teodoro, Genoa. (The main section of the altarpiece remains in the church; the lunette is the *Virgin and Child with Two Angels,* now in the Palazzo Bianco, Genoa.)

1504

January 7 Filippino is listed among the twenty-eight artists who represent the Brotherhood of Saint Luke in negotiations with Santa Maria Nuova, Florence, for the rental of a meeting room.

January 25 A thirty-member committee formed by the Florentine wool guild (Arte della Lana) meets to discuss the location of Michelangelo's *David*; among the artists on the committee are Filippino, Botticelli, Leonardo, Perugino, Andrea della Robbia (1435–1525), and Piero di Cosimo (1462–1521). Filippino's opinion, that the committee should defer to Michelangelo's own wishes regarding the placement of his sculpture, is recorded in the minutes of the meeting.

April 18 or 20 Filippino dies and is buried in his parish church, San Michele Visdomini, Florence. The Libro Rosso of the Accademia del Disegno records the date as April 18; the death registry (*registro di morti*) of the guild of physicians and apothecaries gives the date as April 20.

May 16 An inventory of Filippino's house and work- shop is carried out.

SOURCES

Vasari 1906; Halm [1931]; Neilson 1934; Scharf 1935; Wilde 1944; Ragghianti 1960; Borsook 1961; Fahy 1965; Borgo 1966; Borsook 1970; Friedman 1970; Levine 1974; Borsook 1975; Parks 1975; Lightbown 1978; Sale 1979; Borsook 1980; Foster 1981; Fischer 1986b; Geiger 1986; Carl 1987; Bridgeman 1988; Fischer 1990; Nelson 1991; Nelson 1992a; Nelson 1992b; Ruda 1993; Cecchi 1994a; Cecchi 1994b; Krohn 1994; Nelson 1994; Nelson 1995; Hegarty 1996; Nelson 1996; Nelson 1997.

An Introduction to the Life and Styles of Filippino Lippi

JONATHAN NELSON

In a poem about Florentine artists, completed before 1491, Ugolino Verino paid tribute to Botticelli and Leonardo but heralded Filippino Lippi (1457/58–1504) as "worthy to hold the first place."[1] By 1488 Filippino's works had earned the praise of Alessandro Braccesi in Florence and Giovanni Santi in Urbino, and two altarpieces and a *Last Supper* from his hand, all now lost, had entered the collection of King Matthias Corvinus of Hungary. A memorandum on four painters living in Florence in 1493, the only contemporary example of comparative stylistic analysis, helps clarify the reasons for Filippino's success. From it we learn that Botticelli's (recent) works have a "virile air," "virile" being an adjective that Giorgio Vasari, in 1550 and 1568, associated with grave, severe, and mature.[2] Botticelli's paintings exhibit "the greatest judgment and perfect proportion" and thus more "art" than Filippino's. Lippi is "the best disciple of the aforesaid, and son of the most singular master of his time." His works, and Perugino's as well, have a "sweeter air," a phrase Vasari often used in conjunction with "soft," "graceful," "delicate," and "pleasing." Finally, Domenico Ghirlandaio's have a "good air." This information was sent to the duke of Milan, who recommended Filippino and Perugino, not Botticelli, for work in Pavia (see cat. nos. 86–88).[3] Sweetness had triumphed.

According to Raffaello Borghini in 1584, Filippino learned this "sweet manner" from his father, Fra Filippo, and then improved upon it.[4] Most Renaissance writers on Filippino mention Filippo, albeit for different reasons. Vasari took pleasure in recounting how the lustful friar became enamored of a nun in Prato. During a religious procession, he claimed, Filippo stole Lucrezia Buti away from her convent; Filippino was born in 1457 or 1458. Vasari described the scandal as a "stain," which the son "blotted out" with both his exemplary behavior and the excellence of his art.[5] Filippino certainly enjoyed a quieter life than his father. In 1481 he joined the Confraternity of Saint Paul, one of the strictest brotherhoods in Florence, and through 1489 he attended an average of thirteen of its meetings a year. A prayer written on the back of a drawing (cat. no. 96) indicates that he later joined the Confraternity of Saint Job. Fra Filippo never abandoned his religious vows for Lucrezia, but Filippino evidently married Maddalena Monti in 1494, and thus their three sons were legitimate. The eldest, Ruberto (1500–1574), also became a painter. He probably

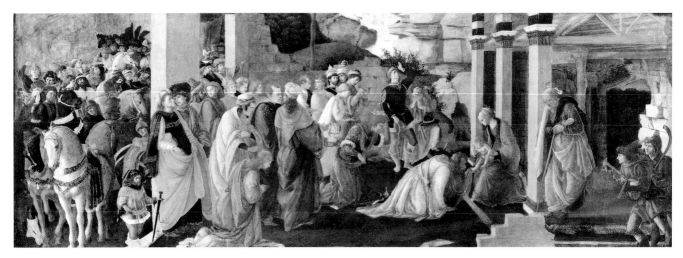

FIG. I Filippino Lippi and Sandro Botticelli. *Adoration of the Magi.* Tempera on panel, 50 x 136 cm. National Gallery, London 592

inherited his father's drawings and provided his colleague Vasari with information used in the extremely accurate *Life* of Filippino.[6]

As Vasari observed, Filippino used his skill to elevate his family status. He even invented a Lippi coat of arms for the marble tomb of his father, which he designed for the Spoleto cathedral about 1489. This work also contains a bust of Filippo, based on the self-portrait the friar painted in the same church. During the period in which Filippo executed the mural cycle that includes this portrait, between 1467 and his death in 1469, he surely gave instruction to his young son. According to Vasari, Filippo entrusted Filippino to the care of his assistant, Fra Diamante, who proceeded to keep most of the funds received for the mural cycle in Spoleto. Filippino's age, illegitimacy, and status as a friar's son complicated his legal rights, but in 1478 he successfully resisted Diamante's attempts to dispossess him of a home in Florence. Both Filippino and Diamante played a role in the continuation of Filippo's workshop in the early 1470s: the two painters collaborated on a predella (Museo Civico, Prato), and Filippino used a composition (or an unfinished panel) by Filippo for his *Entombment* (Musée Thomas Henry, Cherbourg).[7]

A ledger of the Florentine painters' brotherhood records that Filippino had to pay membership fees in June 1472 and registers the receipt of moneys beginning in September 1473.[8] The first entry lists him as a painter with Sandro Botticelli, which suggests that at fifteen Filippino worked as an apprentice to his father's foremost student. The payment and the listing itself indicate some professional activity by Filippino, who in 1478 completed an independent commission for an altarpiece in Pistoia, now lost.[9] Through the early 1480s, however, he worked closely with Botticelli. Both painted sections in an *Adoration of the Magi* now in London (fig. I). Botticelli seems to have created the figural compositions used in Filippino's *Story of Virginia* (pl. 6) and *Story of Lucretia* (Galleria Palatina, Florence); he also may have collaborated on the cycle of Esther stories (Musée Condé, Chantilly [pl. 4]; Museo Horne, Florence; National Gallery, Ottawa; Musée du Louvre, Paris). The sweet manner of many Filippino paintings appears so similar to that of the *early* Botticelli that Berenson once ascribed them to an "Amico di Sandro."[10]

The linear and delicate style, also used in an altarpiece for San Michele in Foro in Lucca, about 1482 (pl. 10), and two Tobias paintings (Galleria Sabauda, Turin; National Gallery of Art, Washington, D.C. [pl. 5]), was not Filippino's only form of expression. His second Lucchese altarpiece, documented 1482–83 (pls. 11, 12), and the *Annunciation* tondi for San Gimignano, documented 1483–84 (pls. 13, 14),[11] show affinities with Flemish painting. The Corsini Tondo, about 1483 (pl. 15), is among the rare reflections in a Florentine work of Leonardo's otherworldly landscapes.[12] Two paintings now in the Uffizi establish further links between Filippino and Leonardo. A generally reliable Renaissance source states that Filippino's altarpiece for the Palazzo Vecchio, dated 1486, was begun by Leonardo and finished on his designs.[13] And the composition of Lippi's *Adoration of the Magi* for San Donato a Scopeto, dated 1496 (pl. 35), derives from da Vinci's unfinished work for the same convent. In about 1483, however, when Filippino completed the *Raising of Theophilus's Son* in the Brancacci Chapel, Santa Maria del Carmine, Florence (pl. 8), he adapted Masaccio's composition and style. Lippi's own artistic objectives appear more clearly in the frescoes he designed there *ex novo*: the *Judgment and Crucifixion of Saint Peter* (pl. 9), for example, shows his attention to the mechanics of execution and to emotions. These same interests reappear in his *Martyrdom of Saint Philip*, about 1494–95, and *Martyrdom of Saint John*, about 1498–1500, both in the Strozzi Chapel, Santa Maria Novella, Florence (pls. 27, 25).

Filippino coordinated several pictorial devices and artistic precedents in his *Vision of Saint Bernard* (pl. 18). For the inscriptions he used four types of lettering, a subtlety that humanists would not have missed.[14] In rendering the main figures, he distinguished between the ethereal profile of Mary, the intense gaze of Bernard, and the highly particularized features of the donor, Piero del Pugliese. The placid Virgin and inspired saint testify to Filippino's careful study of Botticelli's Madonna paintings and *Saint Augustine* in the church of the Ognissanti, Florence. The detailed treatment of the portrait and setting recalls northern paintings, but Filippino's use of a rocky outcropping displays his highly personal approach to compositions. Landscape takes on even greater importance in the *Virgin and Child with Saints Jerome and Dominic*, about 1487, in London (pl. 20), where the unprecedented outdoor setting emphasizes the humility of the nursing Madonna.

The reputation Filippino earned with his paintings from the mid-1480s won him four prestigious fresco commissions. In the early 1490s he painted a mythological story, perhaps *Prometheus Stealing the Celestial Fire* (see cat. no. 68), at the villa of Lorenzo il Magnifico at Spedaletto. In about 1493 Filippino began his fresco the *Death of Laocoön* at the Medici villa at Poggio a Caiano.[15] In 1487 he signed a contract for the decoration of the chapel of a wealthy Florentine banker, Filippo Strozzi, in Santa Maria Novella in Florence. Lippi was to complete the project in three years, but he executed the vault in 1489 and the walls between 1494 and 1502 (pls. 23–28). A more lucrative commission contributed to the delay: between 1488 and 1493 Filippino frescoed the chapel of Cardinal Oliviero Carafa in Santa Maria sopra Minerva in Rome (pls. 29–33).

Filippino probably worked out the organization for the two chapel decorations in the same period. He transformed both spaces by integrating the framing elements

of walls and vaults into his frescoes. In the Carafa Chapel we look through two sets of arches with similar architecture—one marble, one fictive—to witness the *Assumption* (pl. 30). The *Annunciation*, a frescoed altarpiece set off by a marble frame and a fictive painted banner, seems much closer to us. For the *Triumph of Saint Thomas Aquinas* (pl. 33), depicted on the side wall, Filippino planned a fictive balustrade, to continue the marble one delineating the chapel, and fictive stairs leading to the pavement (cat. no. 55). This daring solution was evidently rejected by Cardinal Carafa.

In his Santa Maria Novella frescoes Filippino presumably had more freedom than Carafa allowed, especially after Filippo Strozzi's death in 1491. Figures stand in front of the pilasters, thus entering our realm, in the lower side frescoes, the *Saint Philip Banishing the Dragon*, about 1495–96 (pl. 28), and the *Raising of Drusiana*, dated 1502 (pl. 26). Instead of dividing the altar wall into separate units, as in Domenico Ghirlandaio's adjacent Tornabuoni Chapel, Filippino created a complicated architectural fantasy in a unified space, embellished with birds, angels, ribbons, simulated statues, and mosaics. Similar thinking underlies the Sistine Ceiling, leading to the conclusion that Michelangelo studied Filippino's work. Raphael certainly did, as his drawings testify (cat. no. 125). Indeed, the Vatican frescoes by both artists show their debt to the sophisticated conceptual unity in the Carafa and Strozzi chapels.

After his arrival in Rome in 1488, Filippino had begun adorning works with ancient motifs. These frequently appear in unexpected places, such as the decorations on the sarcophagus and fictive architecture in the Carafa Chapel and the analogous details on the throne and piers in the Nerli Altarpiece in Santo Spirito, Florence (pl. 22).[16] Most often Filippino transformed decorative elements found in grotesques, the recently excavated ancient paintings. In addition, he turned to Roman sculpture for poses, as seen in the drawings of Laocoön and Meleager. He was evidently fascinated by ancient reliefs depicting gods and heroes in tightly packed groups against stylized backgrounds. Lippi's mature works often include figures limited to a narrow foreground space. In the *Assumption* and *Triumph* at the Carafa Chapel, for example, they stand in two crowds on the left and right, while in the *Drusiana*, dated 1502, they are aligned in a single frieze. In the *Adoration of the Magi*, dated 1496 (pl. 35), and the *Deposition*, begun in 1503 for Santissima Annunziata (Galleria dell'Accademia, Florence), they are arranged along the surface extended in height, not depth. And in the *Meeting of Joachim and Anna* (pl. 36), dated 1497, and the *Holy Family* tondo, mid-1490s (pl. 34), they occupy nearly all the available space. These works later presented Rosso and Pontormo with attractive and authoritative alternatives to the perspectival compositions so popular in Renaissance Florence.

Motifs and compositions derived from antiquity play a major role in Filippino's highly ornate works after 1487. He included ancient details in nearly all the later paintings already mentioned and in all other dated works: the *Virgin and Child with Four Saints*, 1498, in the Museo Civico, Prato, the *Mystic Marriage of Saint Catherine*, 1501 (pl. 44), and the *Saint Sebastian between Saints John the Baptist and Francis*, 1503 (pl. 45). The disconcerting illusionism in the Strozzi Chapel and the illogical arrangement of the altar wall probably reflect Filippino's reaction to the confusing

spatial effects in many ancient murals; these qualities establish a visual parallel to the enigmatic inscriptions he executed in the chapel. But Filippino did not always use this ornate mode in his later works.

Order and clarity reign in the composition and framing elements of the Carafa Chapel, which celebrates orthodox dogma and chastity. And several of Lippi's late altarpieces were executed in an austere mode that incorporates no references to antiquity. The painter might have considered such elements inconsistent with, for example, the deliberately archaic iconography of the *Double Intercession* in the Alte Pinakothek, Munich, or the pathos of the *Saint Jerome* (pl. 21), both from the mid-1490s. Filippino also gave this more "virile" air to his decorations of about 1498–1500 for the chapel in San Procolo of Francesco Valori, a leading supporter of Girolamo Savonarola's. The artist probably recognized that any unnecessary ornamentation would have been at odds with the preacher's cries for simplicity in all aspects of life.[17]

This selective use of decorative motifs and illusionism helps illustrate the range in Filippino's formal vocabulary. His works exhibit greater stylistic variety than those of any other central Italian painter in the 1400s. Several paintings executed during the same period, such as the works for the Strozzi and Valori chapels, show startling differences; yet some long considered to be contemporaneous, including the Strozzi vault and the *Meeting of Joachim and Anna*, or the *Drusiana* and *Laocoön* frescoes, were carried out several years apart. The fixed points in the chronology of Lippi's work do not allow us to plot a smooth development in a single direction for his later paintings.

At times we can postulate a connection between aspects of Filippino's works and the interests of his patrons. In the Valori *Crucifixion*, formerly in the Kaiser Friedrich Museum, Berlin, he showed the Virgin calm and composed, just as she is described in a sermon by Savonarola. In the Santissima Annunziata *Deposition* Filippino followed traditional iconography in depicting Mary collapsed at the foot of the cross, a detail surely appreciated by the Servite friars, who commissioned the painting and particularly venerated her suffering.[18] Nevertheless, we have no reason to assume that the original owners of Lippi's paintings always determined his artistic decisions. In the *Deposition* the attention to the process of lowering a corpse seems more closely related to Filippino's earlier depictions of executions than to the Servites' devotional practices. In other works Lippi's variations seem to reflect his interest in experimenting with different modes of expression.

By the time of his death in 1504, Filippino had become one of the most respected painters in Italy. Leading citizens in Florence, Rome, Bologna, Genoa, and Mantua vied for his services. In the mid-1500s two qualities in Filippino's paintings took on particular importance. Vasari lauded Lippi for introducing grotesques and for showing younger artists how to embellish figures with ancient attire. Moreover, his works exhibit "abundant . . . invention" and "bizarre" details.[19] The emphasis on what Vasari termed "strange fancies"—notably absent in many austere paintings by Filippino but characteristic of others and of Mannerist works by Vasari—has been adopted by most modern critics. Some find this a reason to dismiss Lippi; Berenson gave "scant admiration to the first adept of anarchy in art."[20] But many today share the view of his rival Longhi, who clearly esteemed "the most restless and lawless Florentine in the last decades of the 1400s."[21]

NOTES

1 Verino's volume of epigrams, finished by 1485, is known from a revised version, copied in 1491; see the forthcoming critical edition by Francesco Bausi, who kindly allowed me to consult the galleys. For references to Verino, and to all documents relating to Filippino mentioned in the present essay, see Nelson 1991 unless otherwise stated.

2 For the Italian text, see Horne 1980, p. 353. I discuss the date and significance of the memo in the second volume (on the later works) of a forthcoming monograph on Filippino; the first volume (on the early works) is by Patrizia Zambrano.

3 Ghirlandaio died in January 1494.

4 Borghini 1584, p. 359.

5 Vasari 1996, vol. 1, p. 570; for another Renaissance reference to Filippino's scandalous birth, see Bandello 1928, vol. 2, p. 288.

6 Davis 1995, pp. 132–33. For an attempt to identify the paintings of Ruberto, see Natali 1995.

7 For these works, with slightly different datings, see Zambrano 1995 and Zambrano 1996.

8 Horne 1980, p. 31.

9 Pons 1996, p. 50.

10 For the *Lucretia* and *Virginia*, see Nelson 1996, p. 242; for a recent opinion on the controversial *Esther* panels, see Fahy 1993a, pp. 354–55; for the *Adoration* and other early works ascribed to the Amico di Sandro, see Zambrano 1996, pp. 321, 324. She includes the Hyde *Annunciation*, although most authors note the dependence of the Virgin's pose on Botticelli's *Annunciation* (1489–90).

11 Krohn 1994.

12 Nelson in Gregori, Paolucci, and Acidini Luchinat 1992, p. 240.

13 See Marani 1989, pp. 125–27, where the Leonardesque quality of Filippino's angels is noted.

14 Covi 1963, p. 17.

15 Nelson 1994.

16 Nelson 1995, p. 72.

17 Nelson in Cecchi and Natali 1996, p. 84.

18 Nelson 1997.

19 Vasari 1996, vol. 1, p. 565. In the 1540s the author of the Codex Magliabechiano praised the "bellissimi adornamenti et varie bizarrie et fantasche" in the Carafa Chapel (Frey 1892, p. 128).

20 Berenson 1903, vol. 1, p. 78.

21 Longhi 1956, p. 60.

Filippino as a Draftsman

GEORGE R. GOLDNER

Morto e il disegno or che Filippo parte" (Drawing is dead now that Filippo is gone). So began Filippino's lost epitaph, formerly in San Michele Visdomini, Florence. Filippino has been admired for his draftsmanship since the time of his death in 1504. Cellini, for example, appreciatively studied his drawings in the albums retained by his son Giovanni Francesco Lippi, a goldsmith. And Vasari owned a significant group of Filippino drawings of every type and period, including three surviving full pages from his *Libro* primarily or exclusively made up of his work (pp. 99, 111, 298).

In modern times Filippino has been studied mainly as a painter. The principal work accomplished on his drawings appeared in Berenson's *Drawings of the Florentine Painters* (1903, 1938, 1961) and Scharf's monograph on the artist (1935). In concert Berenson and Scharf formulated most of the modern corpus of Filippino drawings, although neither investigated the development of his draftsmanship or his methods in drawing. The most complete and accurate study of his drawings and the most perceptive analyses of their uses and evolution were carried out by Shoemaker, whose dissertation (1975) is fundamental for the subject. Her corpus of authentic sheets is somewhat overrestrictive, but this is true for the most part in only two areas: the Amico di Sandro group and the later pen drawings. There are in addition the few but excellent contributions made by Byam Shaw, especially in supporting the attribution of a number of rejected but fully authentic drawings. Lastly, Shoemaker deserves further credit for successfully placing Filippino's drawings in a positive context of their own, rather than treating them merely as a foil or support to his work as a painter.

Fortunately, nearly 150 authentic drawings by Filippino survive—indeed, in this respect only Leonardo of all fifteenth-century artists is better represented. Furthermore, sheets remain in every medium Filippino presumably employed, and from each period of his life, so that a clear picture of his use of drawings and his stylistic evolution unfolds.

Filippino's early work is predictably dominated by the example of his father, Fra Filippo, and by Botticelli. A precious few drawings by Filippo are known, but they present a varied and impressive indication of his draftsmanship. Richly colored

grounds, subtle effects of tone, and painterly, broad application of white gouache are all evident in his metalpoint studies. These are characteristics taken up by his son, although even the earliest metalpoint studies by Filippino that survive (cat. nos. 8, 9, 11, 12) suggest a stronger influence from Botticelli. The physiognomic types, with broad, planar faces and firm outlines, indicate the impact of Botticelli, while the soft textures call to mind the work of Filippo.

The earliest pen drawing by Filippino, from the mid-1470s, is entirely Botticellian in form and expressive character (cat. no. 10)—so much so that it was once assigned to the fictitious Amico di Sandro. The sure outlines, physical types, and drapery forms are all redolent of Botticelli's influence. It is among the anomalies of Filippino's surviving corpus that no further pen drawings by him are datable to the period before the late 1480s. There are, however, considerable numbers of metalpoint studies from the years between the late 1470s and 1488, when he departed Florence for Rome. The majority of examples from the earlier part of this period (cat. nos. 12–16) are drawn in a relatively tidy manner, with firm, continuous Botticellian outlines, finely modeled shaded areas, and lively white gouache heightening. They reveal a tendency to cover the figure in elaborate draperies, perhaps in part to mask an unsure anatomical understanding. However, in the studies on a Vasari page at Christ Church, Oxford (cat. nos. 11A, B), Filippino overcame some of these limitations, rendering animated figures with an intense appreciation of the nude in motion and a spirited use of media, the former probably inspired by Antonio Pollaiuolo and Andrea Verrocchio.

The early 1480s mark an important phase in Filippino's development as a draftsman. He began to regularly draw more than one figure on a study page and to show a markedly superior grasp of the human figure clothed or nude (cat. nos. 21–28). During these years there also emerged the first drawings related to existing paintings by Filippino and his immediate followers (cat. nos. 22, 25, 29 recto). The *garzone* studies of this period were drawn in the tradition of model-book types, to be used several times in various ways for figures in paintings. Among them are several sheets showing pairs of apparently interrelated figures (cat. nos. 24–28) that probably were once part of a sketchbook. There are considerable variations within this group, but in some pairs Filippino has clearly attempted to suggest communication by gesture and pose (cat. nos. 24, 26, 28). This development Shoemaker has intelligently viewed against the background of Verrocchio's contemporary work in Florence, specifically the *Doubting of Thomas* installed at Orsanmichele, and Leonardo's efforts to depict vitally animated and interrelated figure groups. The metalpoint drawings of this type and others of the period about 1482 to 1484 show a greater sharpness and flexibility of line, with the introduction of freer cross-hatching, and a more marked spontaneity of handling than in the sheets that preceded them. Moreover, draperies have become more complex and take on notable richness of pattern and movement.

These metalpoint studies and others of a slightly later date show wide variation in inspiration and range from models posed to represent a fixed iconography to genre studies drawn from life that reflect the influence of Maso Finiguerra's work of several decades earlier (cat. nos. 30, 35). Surprisingly, no more than a small number

of surviving drawings from the time before his Roman trip can be connected to paintings, and only one is linked with certainty to a picture by Filippino himself (cat. no. 34). Its more concentrated and specific expressive nature and lighter, more economical touch distinguish it from the *garzone* studies of the same period. Shoemaker has shown that another drawing by Filippino (cat. no. 22) was used by two artists in his circle, but merely as a model for certain aspects of their painted images. All this strongly suggests that the principal purpose of the metalpoint drawings Filippino made before his visit to Rome was instructional and that they only on rare occasions served as studies for paintings.

The 1480s also saw Filippino's growing interest in naturalistic portraiture, undoubtedly encouraged by the commission to complete the frescoes in the Brancacci Chapel at Santa Maria del Carmine, Florence, which he undertook at the beginning of the decade.[1] This project called for a degree of naturalistic observation of physiognomy not required by his earlier pictures. The results are clear in two splendid drawings (cat. nos. 19, 20) that demonstrate an almost Netherlandish precision and an extreme subtlety of expressive characterization. This enhanced naturalism in portrait heads is paralleled by a closer and more effective rendering of the nude. Sometimes drawn from life, these nude studies show a much-developed ease of pose, gesture, and, most important, movement (cat. nos. 29, 36, 37). Similarly, Filippino began to look creatively at the antique, employing classical postures for posed models (cat. nos. 43, 46, 48). This more integrated type of figural study took him away from the practice of model-book drawing and toward a more modern conception of the development of forms. In addition, throughout the decade his metalpoint technique became increasingly varied and textural, producing effects closer to those of pen-and-ink drawing.

During the first fifteen years of his career Filippino must have made many pen drawings, as his natural spontaneity would always have attracted him to this medium, but only one that is certainly of this period seems to have survived (cat. no. 10). From the Roman years onward, however, they took a prominent place among his drawings. The studies after the antique that were executed in Rome are of special importance and show a freedom of handling and a spiritedness that are essential for his creative interpretation of ancient sources (cat. nos. 60, 63). In this period there appeared the first figural pen drawings made with bold and varied hatching, long parallel lines for modeling, and short, quick notational strokes for outline, informed by a sense of almost unequaled energy (cat. no. 49). This style carried over immediately into his metalpoint drawings, as a comparison of two sheets for the Carafa Chapel in Santa Maria sopra Minerva (cat. nos. 49, 50) reveals. The pen style represented by these studies is the one Filippino took back to Florence and used for many drawings, including some that have wrongly been ascribed to Raffaellino del Garbo (cat. nos. 82, 84, 85).

Alongside these free pen sketches there also emerged by the late 1480s new types of compositional drawing by Filippino, made in pen and ink and in some instances with subtly graduated washes (cat. nos. 45, 55, 56, 69, 70). In those with relatively large figures (cat. nos. 45, 69, 70) he employed a rather short, sometimes broken pen stroke for outlines and the rendering of detail, while developing a highly

sophisticated tonal system that lends a suffused light and shadow and augments the illusion of spatial recession. Some of these (cat. nos. 69, 70) are quite fully elaborated and have the character of presentation drawings for a patron. In other studies, which represent an earlier, exploratory stage of evolution, line is freer and less precise—as is the use of wash—and figures are depicted with correspondingly more energetic, expressive character (cat. nos. 90, 91, 96). Yet other sheets display more complicated compositions with smaller figures drawn in a still more notational manner, with abstracted heads and only rudimentary detailing (cat. nos. 55, 56). The figures are jotted down with amazing spontaneity, even in a large design for a fresco that was probably made to show the patron (cat. no. 55). Again, wash is applied in a novel manner, to aid in the rendering of atmospheric space.

The emergence of this remarkably varied, lively, and original pen style may have been influenced to some extent by the work of Leonardo. However, it should be noted that this phase of Filippino's development did not occur until several years after Leonardo departed Florence for Milan in 1482. Shoemaker has correctly pointed out some specific similarities between the quick pen sketches of the two artists, but the impact of Leonardo's drawings was secondary and provided a stimulant for only one aspect of Filippino's draftsmanship in pen.[2] Alongside it, one should recognize the importance of Fra Filippo's lively pen drawings (cat. nos. 1, 3), in which broken, short lines, complex tonal effects, and animated, expressive small figures all anticipate the work his son produced three decades later. The larger and broader figural drawings in pen seem to be related specifically to the artist's Roman visit, perhaps inspired by his effort to copy three-dimensional models (cat. no. 46), for which his bold manner, featuring parallel and sometimes crosshatched lines, would have been appropriate.

Continued change and inventive variation marked the decade. His metalpoint drawings from the end of the 1480s and thereafter show an astonishingly broad and painterly handling of white gouache (cat. nos. 63–65, 68, 72), while the metalpoint strokes are thinner, sparser, and finer than those in the preceding sheets. Portraiture and head studies from models reveal a newly acquired ability to capture the principal features and expressive character of his subjects in fewer and more finely wrought metalpoint lines and in brilliant, increasingly linear and economical white heightening (cat. nos. 63, 73–76). The figure studies of 1500 to 1504 are marked by metalpoint strokes of a reasserted forcefulness, but made with an even lighter and freer touch than the lines of a decade earlier (cat. nos. 100, 101, 105–7). The sheets also evidence a freedom of movement and gesture, in which the character of expression and action effectively suggests structure without describing it. Shoemaker has perceptively compared the most vigorous of these drawings to Antonio Pollaiuolo's work of several decades earlier.[3]

The later pen drawings are more varied in nature. Those made in the mid- to later 1490s reflect an evolution to a more complex and richer modeling (cat. nos. 83–88) and then to an increasingly angular, almost spidery line that well serves a tendency toward expressive exaggeration. Some sheets from the last few years are executed in a fully synthesized and highly refined manner (cat. nos. 81, 83), while others have passages that are somewhat lacking in control or consistency, although the

overall expressive result is so powerful that it overcomes the inattention to detail (cat. nos. 86, 91). The very late drawings also reveal Filippino's nearly complete ability to alternate media with breathtaking skill. A large composition executed in animated, notational pen lines describing a multitude of small figures, for example, was followed immediately on the verso of its sheet by a study of one of the principal figures carried out in black chalk on a larger scale but in a style fully compatible with the initial sketch (cat. no. 99). It is appropriate, if no doubt accidental, that Filippino's most fully elaborated surviving drawing made in a mixture of media dates from these last years (cat. no. 110).

The chronological development of Filippino's draftsmanship is complex because it does not follow a direct, linear path. In the 1480s and early part of the next decade he broadened his uses, media, and techniques of drawing, reaching a point at which very different types of drawings and styles coexist. Throughout he was furiously inventive as a draftsman, probing the boundaries. He tested the limits of metalpoint, sometimes using it like a pen. He sometimes applied white gouache as interwoven line and on other occasions almost as if it were paint on a panel. His pen work has a freedom equaled in his time only by that of Pollaiuolo and Leonardo, and its tendency toward abstraction and mannerism of line is entirely his own. The resultant forms are always above all about movement, expressed in the gestures and poses of his figures and in the rapid strokes that define them. Chalk, with its broad, atmospheric effects, predictably, was not for him and rarely appears among his media. Like other artists of his time, he made studies from life and from the antique, but, tellingly, even the copying of archaeological material became a spirited adventure of creative spontaneity. Although surpassed by his greater contemporary Leonardo, Filippino remains after him the most varied, original, and creative draftsman of his time.

NOTES

1 Following the clear statements of Vasari, I believe that Filippino's contribution to the Brancacci frescoes should be situated chronologically at a relatively early point in his career—that is, just after 1480.

2 Shoemaker 1994, pp. 260–61.

3 Shoemaker 1975, pp. 126–27; Shoemaker 1994, pp. 261–62.

Technique and Workshop Practice in Filippino's Drawings

CARMEN C. BAMBACH

Typical of the medieval and Renaissance system of apprenticeship, Filippino's training under his father, Fra Filippo Lippi, and later under Sandro Botticelli formed his drawing techniques and design practices. The media he favored for drawing were common for the second half of the quattrocento: metalpoint with lead white highlights on prepared paper for figure studies and pen and ink with wash on buff unprepared paper for composition drawings. Although the function of his drawings frequently determined his choice of materials, there were enough exceptions, especially at the height of his career, to suggest that Filippino sometimes used drawing media interchangeably and in a boldly experimental fashion. For example, a dramatic pen-and-ink drawing highlighted with white gouache, the *Woman Seen Half-Length and Holding a Shield* (cat. no. 65), is executed on paper with a dark bluish gray preparation made of soot, commonly employed for metalpoint drawing.

Filippino carried out his composition sketches in pen and ink, usually modeled with wash, over preliminary underdrawings in leadpoint or black chalk—as in the *Triumph of Saint Thomas Aquinas* (cat. no. 55). This is a technique that he often also applied in his drawings after the antique (cat. no. 60). X-ray fluorescence of Filippino's two sketches of angels (cat. nos. 107, 108) confirms that the type of ink he frequently used is the somewhat corrosive iron gall.[1] In adopting pen and ink for his initial drawings, Filippino was following traditional practice: since the writing of Cennino Cennini's *Libro dell'arte* in about 1400, the medium had been regarded as ideally suited for the rapid, extemporaneous sketch.[2] And by the late 1490s such vigorously reinforced compositions as the *Meeting of Christ and John the Baptist* (cat. no. 92) and the *Pietà* drawings probably intended for the Pavia altarpiece (cat. nos. 86–88) demonstrate the creative flux Leonardo advocated for drawings: "the sketching of compositions should be quick, and the working out of the limbs should not be too finished, but limited to their positioning."[3] By 1500 Filippino's small composition sketches achieved an airiness of line, light, and space (cat. nos. 93–96). In these he rapidly summed up his figures in angular, flickering outlines and usually modeled shadows delicately with two tones of brown wash, one of a cool cast, the other warm, to suggest subtly translucent effects of light. Often he enhanced the coloristic effect by rubbing the buff color of the paper with an atmospheric tint of reddish chalk, as in the Berlin study for the allegory of Music in the Strozzi Chapel (cat. no. 96).

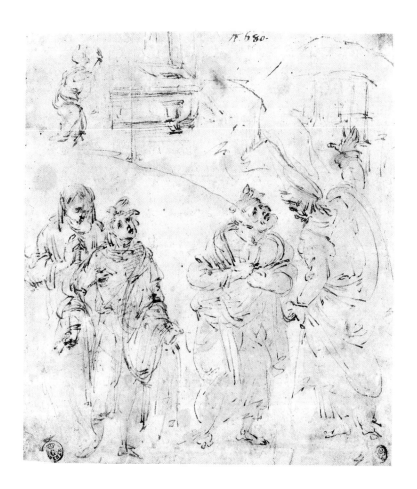

FIG.2 *Study for the Assumption of the Virgin in the Carafa Chapel.* Pen and brown ink and brown wash over black chalk or leadpoint, 168 x 145 mm. Gabinetto Disegni e Stampe degli Uffizi, Florence 183 s

Filippino also used pen and ink with wash for contractual drawings for patrons, but with a precisely descriptive handling. Examples of this type are the studies for the *Volto Santo* (cat. no. 69) and the stained-glass window depicting Saint Martin for the Nerli Chapel at Santo Spirito, Florence (cat. no. 70), which detail the framing elements for the compositions. In such works he traced contours clearly, with emphatic single strokes devoid of pentimenti and with little underdrawing. This manner of execution sharply contrasts with, for example, that of the purely exploratory composition sketch for the *Assumption of the Virgin* in the Carafa Chapel (fig. 2), which exhibits reinforced contours full of movement.

A number of pen-and-ink drawings by Filippino and his workshop reveal the use of *spolvero* (pouncing), a technique of design transfer applied with varying degrees of complexity by artists of the period (cat. nos. 45, 91, 94B, 98, 107, 108, 110). According to this procedure, the artist placed the original sheet on top of another support, pricked the outlines of the design, and then rubbed through the perforations with powdered black chalk or charcoal to produce a dotted chalk outline on the new working surface. The *spolvero* technique was commonly used to transfer cartoons or full-scale final drawings. The few extant cartoons by Filippino and his workshop, which are drawn in pen and ink with wash, still exhibit the remains of smudged black chalk pouncing dust extending over nearly their entire surfaces, much beyond their pricked outlines. Draftsmen also relied on the *spolvero* technique to transfer preliminary drawings from one sheet of paper to another, to obtain a clean draft. A transfer of this type accounts for the laborious pricking on the intricate

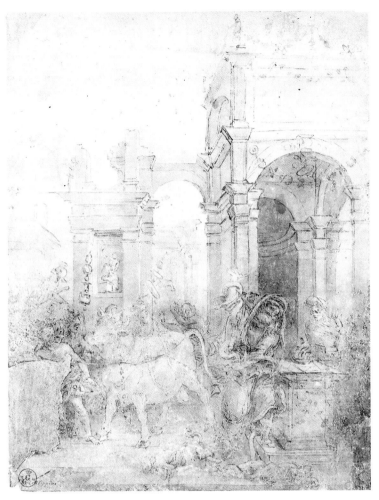

FIG. 3 *Sacrifice of Laocoön.* Pen and brown ink and brown wash with pricked outlines on brown-tinted paper rubbed with pouncing dust, 324 x 251 mm. Gabinetto Disegni e Stampe degli Uffizi, Florence 169 F

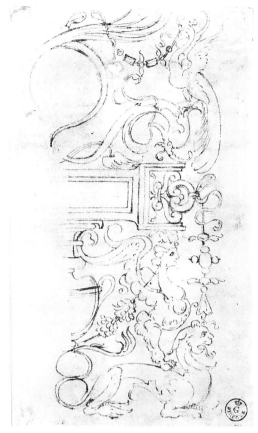

FIG. 4 *Designs for Ornament.* Pen and brown ink over *spolvero* underdrawing, 230 x 135 mm. Gabinetto Disegni e Stampe degli Uffizi, Florence 176 Orn.

foreground design in the composition draft for the *Sacrifice of Laocoön* (fig. 3), which is also rubbed with pouncing dust and whose background is left entirely untouched. In addition, Filippino used the technique as a shortcut in developing a vocabulary of antique-style ornament, as a sheet in the Uffizi (fig. 4) vividly reveals. Here, by connecting the dots obtained from a pricked earlier design, he outlined a pattern of antique-inspired ornament that recalls the tightly knit grotesque motifs decorating the fictive marble architecture of the Carafa and Strozzi chapels.

The materials and techniques of metalpoint drawing described by Cennino remained largely unchanged into the late quattrocento.[4] The ground applied to the paper of these drawings traditionally consisted of a mixture of finely pulverized bone, color, lead white, and glue. On some of Filippino's sheets (cat. nos. 17, 19, 21, 27, 30, 52, 53, 73) this preparation is relatively thick and stiff, brushed on seamlessly, and burnished to a slight shimmer. Filippino also experimented with thinner, more rapidly made grounds, together with a quicker handling of the metalpoint medium (cat. nos. 13, 22, 31, 37, 43, 50, 59); such grounds are frequently of nearly washlike transparency, applied against the grain of the laid lines of the paper with a thick brush (about ten millimeters wide) in sweeping, curving strokes that have left unevenly built-up pigment. Sometimes the rectos and versos of his sheets are of different colors, and not infrequently only one side of the paper is prepared. He

obtained the hues for his ground preparations mostly by mixing colors from mineral sources: lead white, ocher, sinoper, hematite, vermilion, green earth (*terra verde*), azurite, lapis lazuli, and soot. It is possible that he bought the quires he used for sketching with the paper already commercially prepared, for these may have been available in the shops of stationers by the late quattrocento.

Filippino followed Cennino, who recommends the use of various metal styli, either "of silver, or brass, or anything else, provided the ends be of silver, fairly slender, smooth, and handsome," as well as of leadpoint "made of two parts lead and one part tin, well beaten with a hammer." The softness and gentle gray color of leadpoint are especially suited for underdrawing, as demonstrated by the unfinished outline sketch of a classical female nude (cat. no. 77 verso). The appearance of some of Filippino's sheets suggests that he began the drawings in leadpoint and later reworked the figures, probably with silverpoint (cat. nos. 28, 36). The preference for silver for refined types of drawing is clearly stated in both Cennino's *Libro* and the nearly contemporary manuscript treatise of 1398 by Johannes Alcherius (an important fact in light of modern doubts regarding the extent of its use). X-ray fluorescence spectroscopy of Filippino's studies on the Vasari page in Washington reveals deposits of silver and scattered minute residues of its alloy tin, confirming that silverpoint was used here. The lines from a silverpoint stylus, which would have had the cool gray hue of modern graphite when freshly applied to the prepared paper, have oxidized to a warm, slightly golden brown color, which shows delicately shimmering particles under magnification. This shiny brown hue characterizes numerous other metalpoint drawings by Filippino, but firm conclusions about the specific medium used in them are not possible until further scientific examination is conducted. Often the white highlights, which according to the *Libro* can be made from "a little white lead well worked up with gum arabic" dissolved in water, have changed color: in many drawings of the period, Filippino's included, the lead white has oxidized to dark gray.

Filippino exploited the inherently linear, incisive qualities of the difficult medium of metalpoint with a bravura and range of handling that remain singular in the history of the technique. Cennino's treatise counsels a cautious approach, whereby the artist begins drawing very lightly with the metal stylus, gradually reinforcing strokes to build up density of tone, because mistakes or unwanted lines cannot easily be erased. By contrast, Filippino captured the spontaneity of his models' poses with only quick staccato outlines and sweeping strokes of parallel and crosshatching. In comparison with Filippino's, the metalpoint drawings by even as gifted a draftsman as Domenico Ghirlandaio are tightly drawn and restrained in their highlighting. Many of Filippino's highly modeled life studies in the medium exhibit very fine, wiry preliminary underdrawn lines, which helped him articulate the limbs and the main axes of his figures. His late drawings, however, are more freely improvised, with rapidly reinforced lines of equal weight, in keeping with his now more pictorial use of color grounds and loose, nearly transparent white highlights.

Filippino also pushed the medium of metalpoint to its limits to obtain nuanced effects of tone, at times taking drawings that had been done with a fine instrument and reworking them with a broad, rounded stylus to achieve softly graded shadows

(cat. nos. 15, 38, 40, 43, 50, 52, 53). He explored ways to unify tones, which in metalpoint can be only partially blended by stumping with the edge of a cloth or the tip of a finger. His increasingly tonal handling of the medium culminated between 1488 and 1493. In a number of delicately rendered studies of this time he used a nearly translucent layer of brown wash to unify the intermediate ranges of shadow (cat. nos. 38, 58). During this period he often varied the range of intermediate lead white highlights by hatching in stippled or parallel strokes with a partly dry brush in some areas, but building up the brightest highlights thickly and in more liquid form, making them shine like shot silk, especially along the ridges of drapery folds. The highlights in a few studies from the late 1480s to the early 1490s (cat. nos. 29 verso, 42, 44) were applied more freely and in rounded clumps, with a quick, upright motion of the brush. Throughout the 1490s Filippino also experimented with sharply contrasting painterly effects of chiaroscuro in metalpoint drawings on dark grounds, where stark liquid highlights flicker against deep shadows.

Probably because they were parts of sketchbooks, and therefore protected, figure studies are by far the most common type of drawing by Filippino that survives. At least four of his sketchbooks can be hypothetically reconstructed: a small one with a pale blue ground from his early, Botticellian period (see cat. no. 15), two large ones with a bluish gray ground from the first half of the 1480s (see cat. nos. 24–26, 31–33), and yet another small one, with a saturated orange ground, probably from the time of the Carafa Chapel murals (see cat. nos. 52, 53). The codicological evidence of binding, such as holes or creases in the paper, no longer exists because the sheets have been cropped, but consistency in the dimensions of pages, scale of figures, drawing technique, and colors and types of paper preparation offers fairly concrete proof that the works were once gathered into sketchbooks.

By the late quattrocento the use of sketchbooks for drawing after life, as one of the most significant exploratory tools for naturalistic representation, had evolved from the medieval tradition of model books. About 1490–92 Leonardo urged artists to fill small sketchbooks with shorthand design notations for nearly journalistic observation of the human figure in various attitudes (*atti*). The artist should record with "slight strokes" in a book with prepared paper that he carried with him at all times. He must not erase and must refer to his sketches as his "guides and masters."[5] Leonardo further advised the draftsman to cull the best limbs and bodies from his nude studies for use in his practice and for commitment to memory. The elements of life drawing operative in Filippino's numerous figure studies can be reconstructed from these remarks and also from Leonardo's memorandums and notes, which refer to the use of workshop assistants as dressed and nude models. Leonardo's writings, like Filippino's studies, devote considerable attention to the human figure both in motion and in repose, recognizing an extraordinary range of nuance. In particular, he urged that artists "select someone who is well grown and who has not been brought up in doublets, and so may not be of stiff carriage, and make him go through a number of agile and graceful actions"—a point of view evidently shared by Filippino.

Filippino continued to rely on the traditional medium of metalpoint in the late 1490s and after, even as the practice of drawing figure studies in chalk was becoming

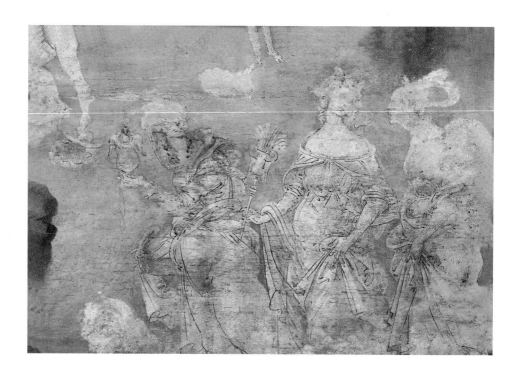

FIG.5 Detail, *Birth of Venus*. Oil on panel, 68 x 77 cm. Christ Church Picture Gallery, Oxford JBS 41 verso

FIG.6 Infrared reflectogram, detail, underdrawing and underpainting of drapery, Nerli Altarpiece, pl. 22

increasingly popular. A sheet that exhibits red chalk in the underdrawing and reworking of the design (cat. no. 81) may be his sole venture into that medium. He adopted black chalk quite late in his career, perhaps not coincidentally after Leonardo's return to Florence in 1500, and then only rarely, for example in the bold, monumental outline sketch of the reclining figure of Drusiana (cat. no. 99 verso) and in the *Pietà* (cat. no. 109). Although there is no firm evidence that he used charcoal for drawings on paper, this was almost certainly the medium in which he executed the first layer of underdrawing on panels and the *arriccio* (base plaster) of murals, as it could easily be erased when the ensuing layers of aqueous pigment were applied.

For Filippino the process of developing preliminary drawings on paper remained closely tied to the preparation of underdrawings on the surfaces that were to be painted—surfaces on which he often significantly adjusted and refined his original designs. Extensive modifications were carried out especially in the architectural settings for his compositions. The murals in the Carafa Chapel, in the portico of the Villa Medici at Poggio a Caiano, and, above all, in the Strozzi Chapel display complex, measured constructions incised or ruled by means of compass marks, snapped cords, and straightedges. However, hardly any extant drawings on paper attest to Filippino's dazzling mastery of intricate effects of architectural illusionism. The studies for the *Triumph of Saint Thomas Aquinas* (cat. nos. 54, 55) and the *Sacrifice of Laocoön* (fig. 3) offer rare portrayals of architectural space but present only relatively schematic, intuitive renderings.

Examination of panel and mural paintings by Filippino suggests that he may often have omitted cartoons, in which case he perhaps worked from smaller-scale studies, according to the earlier practice of his father and Botticelli.[6] In the Strozzi Chapel frescoes scattered *spolvero* dots from cartoons can be seen in minor figures and ornamental motifs.[7] But freehand underdrawings are detectable in certain of his

panels: the *Tobias and the Three Angels* (Galleria Sabauda, Turin), the Strozzi Madonna (pl. 17), and the unfinished verso of the *Centaur in a Landscape* (fig. 5).[8] Filippino brushed the aqueous medium of his underdrawings with fluid outlines, modeling forms only sparsely with wash and scattered passages of hatching—the handling is similar to that of some of his small-scale composition drawings in pen on paper (cat. nos. 55, 61, 62, 95, 96). The underdrawing in his monumental altarpiece for the Nerli family chapel is unusually elaborate—a virtual cartoon, but drawn on panel rather than paper.[9] Drapery passages are often deeply modeled with the brush with bold but orderly hatching and unified with thin washes (fig. 6). The density of tone is carefully crafted from underdrawing to underpainting, in superimposed layers of

FIG. 7 Infrared reflectogram, detail, underdrawing and underpainting, *Adoration of the Magi*, pl. 35

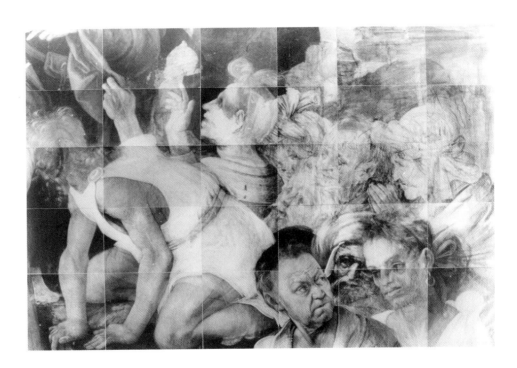

FIG. 8 Infrared reflectogram, detail, underdrawing and underpainting, Leonardo da Vinci. *Adoration of the Magi.* Oil on panel. Galleria degli Uffizi, Florence 1594

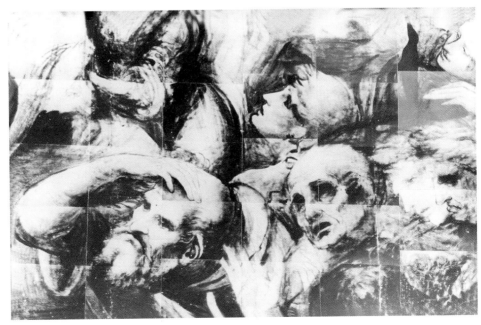

design, and outlines are frequently reinforced. The deeply tonal underdrawing and underpainting of the *Adoration of the Magi* of 1496 (pl. 35) strikingly evoke the creative flux of the methods Leonardo recommended in their dynamic freehand brushing of forms and their numerous pentimenti (figs. 7, 8).[10] Although executed in pen and ink with wash, Filippino's small compositional cartoon in Oberlin (cat. no. 110) is highly rendered in the tradition of the monumental cartoons that became increasingly common by the late quattrocento and early cinquecento. Not surprisingly, the underdrawing on the corresponding oil panel (National Gallery of Art, Washington, D.C.), which probably dates from shortly after 1500, is sparse and schematic, consisting primarily of long, fluent outlines, with scattered passages of parallel hatching over broad areas of wash modeling.[11]

Filippino's distinctly practical approach to the problems of designing on paper and painting surfaces probably freed him to work with great speed and on several paintings at the same time. Indeed, the inventory of his possessions at the time of his death lists eighteen unfinished panel paintings, carefully distinguishing among their various stages of completion.[12] Thirteen panels had not progressed much further than their ground preparation, and two were at the stage of underdrawing, testifying to what must have been a free, efficient, and rapid working process.

NOTES

1 Examination report by Shelley Fletcher, Head of Paper Conservation, National Gallery of Art, Washington, D.C., January 10, 1994.

2 Cennini 1991, p. 27; Cennini 1933, p. 8 (English translation).

3 Richter 1970, vol. 1, p. 340, no. 579; and Pedretti 1977, vol. 1, p. 343.

4 On the techniques of metalpoint drawing and ground preparations, see Cennini 1991, pp. 26–33, 40; and Cennini 1933, pp. 5–12, 18 (English translation).

5 The discussion here and below is based on the following passages in Leonardo's notes: Richter 1970, vol. 1, pp. 264, 308–10, 314–15, 338, nos. 368, 497, 502, 503, 513–15, 571; Pedretti 1977, vol. 1, pp. 274–75, 328–32, 340–41; McMahon 1956, nos. 361, 373, 374.

6 See further Bertelli 1965b; Borsook 1980, pp. 122–27; Acidini Luchinat 1986; Galassi 1988–89, pp. 165–76; Casazza 1990; Dunkerton and Roy 1996, pp. 21–31; and Galassi 1997.

7 On the evidence of *spolvero*, see Borsook 1980, pp. 124–26; and Acidini Luchinat 1986, p. 15.

8 On the underdrawing of the *Tobias*, see Galassi 1988–89, pp. 165–66. Infrared reflectography examination of the Strozzi Madonna by Maryan Ainsworth, Senior Research Fellow, Sherman Fairchild Paintings Conservation Center, Metropolitan Museum, August 21, 1996. Data on the Christ Church panel are based on an infrared photograph and a conservation report made by David Bull and Robert Shepherd on February 23, 1976.

9 Infrared reflectography examination by Maurizio Seracini (EDITECH) in April–May 1987; see, for example, Galassi 1988–89, pp. 168–70.

10 Cf. ibid., pp. 170–74. Infrared reflectography examination by Maurizio Seracini in February 1988.

11 Infrared reflectography examination by Elizabeth Walmsley, Paintings Conservator, National Gallery of Art, Washington, D.C., August 1996.

12 See Carl 1987. The panels were found in a ground-floor room and in the workshop below the house on the via degli Angioli occupied by Filippino and his family.

Filippino and His Antique Sources

INNIS HOWE SHOEMAKER

When Filippino Lippi arrived in Rome in 1488, the impact of classical antiquity upon his art was immediate and profound. Its influence first became evident as a fully developed phenomenon in the decorative framework and the landscape and architectural backgrounds of his frescoes for the Carafa Chapel in Santa Maria sopra Minerva and in his design of an imitation-antique vault in stucco and fresco for the small chamber adjacent to the chapel.[1] In proportion to the plethora of antiquities that fill many of the paintings Filippino made after his Roman trip, not much evidence remains of what must have been a great many drawings after ancient monuments and decorations. The surviving drawings of this kind consist of a very few true copies and a greater number of fanciful adaptations of antique ornamental motifs.

Filippino's drawn copies of ancient works of art fall into two categories: rough sketches, presumably made on the spot, in pen and ink or metalpoint; and finished ones in pen and ink, sometimes touched with wash. An example of the first type is his drawing after figures in a scene for the *Departure of Hippolytus for the Hunt*, with two other motifs (cat. no. 65 verso), copied from the Golden House of Nero, handled in a loose, sketchy style with each element kept separate from the other.[2] A copy of the more finished sort is *Herm Pointing at a Man in Combat with a Centaur* (fig. 9), an ink-and-wash drawing after a sarcophagus that is now in the Vatican Museum.[3] Here he used wiry, unbroken outlines for the figures, which he carefully shaded with parallel hatchings and modeled with wash. This drawing is so highly finished as to suggest that it may have been preceded by a freer sketch on the order of the *Hippolytus*, which he probably made directly from the sarcophagus. The existence of the two stylistically distinct classes of copies after antique sources must indicate that Filippino worked up some of his sketches into finished drawings that could be used as models by members of his workshop; this, presumably, was also the practice of his contemporary Domenico Ghirlandaio, who is thought to have made drawings that a follower copied for the Codex Escurialensis.[4] Indeed, Filippino's use of the method is documented by three workshop copies after his drawings, now in Christ Church, Oxford (cat. nos. 94C, D, E), one depicting a pair of Tritons with a lamp, which is a copy of one of his works in the Uffizi (cat. no. 62).[5] These copies show that Filippino's followers imitated closely the precise yet spirited style of his highly finished drawings after ancient motifs.

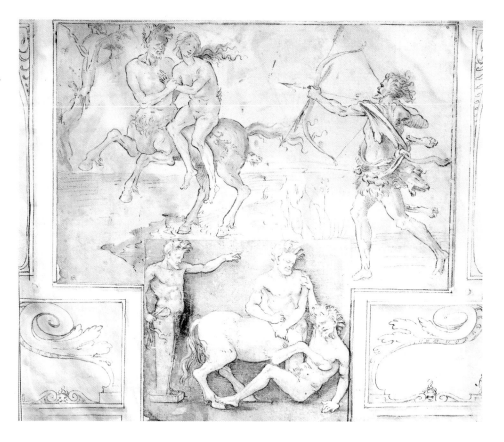

FIG.9 *Herm Pointing at a Man in Combat with a Centaur*, mounted on page from Vasari's *Libro de' disegni*. Pen and brown ink and wash, heightened with white gouache, on brown paper, 283 x 280 mm, maximum. Nationalmuseum, Stockholm 2/1863

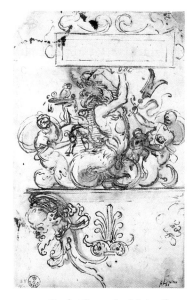

FIG.10 *Bracket Supporting Marine Creatures Sustaining a Tablet*. Black chalk, pen and brown ink, and brown wash, 191 x 120 mm. Gabinetto Disegni e Stampe degli Uffizi, Florence 1633 E

It has long been recognized that Filippino's paintings and the majority of his surviving drawings after antique sources suggest that his preferred practice was to create his own fantastic variations and embellishments of these models rather than to copy them closely. Although he sometimes simply reinterpreted an ancient form to suit a particular decorative program—as he did in the Carafa Chapel, where he translated a Roman relief showing pagan sacrificial vessels into a frieze of Christian liturgical implements[6]—he more frequently altered an antique prototype almost beyond recognition. Two of Filippino's drawings derived from antique compositions depicting Tritons and Nereids with tumbling putti, for example, show the extent to which he transformed stock motifs from Neptune sarcophagi; in both, the figures are so changed that the models cannot be precisely identified.[7] In one a Nereid with a circling tail is grasped by a faun and reaches upward to clutch a tumbling putto to whom she offers her breast (cat. no. 63); in the other a Triton with a swirling tail and a griffin's head, accompanied by smaller sea creatures, raises its arms to sustain a decorative plaque (fig. 10). In each drawing Filippino imitated the poses and the chaotic energy of the figures in Neptune sarcophagus compositions, but he freely varied the traditional attributes of these ancient sea creatures by adding a faun's or a griffin's head or by transforming a Nereid into a suckling woman reminiscent of a Christian representation of Charity. These drawings may have had some connection to the frescoes of the Carafa Chapel, where the program includes marine imagery, but their loose, experimental handling suggests that they were probably free and independent inventions rather than preparatory sketches.

FIG. 11 *Ornamental Studies for Carafa Chapel Frescoes*. Pen and brown ink and brown wash over traces of black-chalk underdrawing, 52 x 112 mm and 87 x 58 mm. Gabinetto Disegni e Stampe degli Uffizi, Florence 185 Orn.

FIG. 12 Detail, *Assumption of the Virgin*, pl. 30

There has until now been no evidence of preparatory drawings for the decorative portions of Filippino's fresco cycles. Two fragmentary drawings mounted on a single sheet in the Uffizi (fig. 11) thus have special significance, for they have recently been identified by the present author as studies for ornamental sections of the Carafa Chapel frescoes: the vertical fragment, showing two horn-blowing creatures arranged back-to-back on either side of a central axis and supported by two bearded masks, corresponds to the uppermost motif on the pilasters that flank the Carafa *Assumption of the Virgin* (fig. 12); the horizontal fragment, depicting a fantastic beast and a winged figure holding reins, is probably related to some part of the decoration of the incomplete grisaille dado beneath the *Triumph of Saint Thomas Aquinas*, in which a similar winged figure holds the reins of a mythical creature.[8] Executed with sure strokes of the pen, without pentimenti, and lightly touched with wash, the motifs in these sketches recall the figures in Filippino's finished type of ornament drawings, such as the pair of Tritons holding a lamp in the work at the Uffizi discussed above. As might be expected, the motifs in the two Carafa Chapel drawings do not have identifiable antique sources, but their derivation is clearly from ancient models. What is most interesting about them, beyond their connection to the Carafa Chapel, is how different they are from the frescoes: the thick, painterly brushstrokes and chiaroscuro modeling of the frescoes endow their decorative forms with a scale, depth, and three-dimensionality that the drawings lack entirely. Although it is not possible to determine exactly how the drawings functioned in the process of the design and execution of the final works, the correspondence between the details of

the vertical fragment and those of the painted pilaster suggests that the sketch served as a reference during the making of the fresco. Whatever the precise purpose of these drawings, however, it is certain that they offer the first evidence that detailed, if somewhat schematic, preparations for the decorative portions of the Carafa Chapel were initially made on paper.

Filippino's drawings after antique ornament clearly provided him with an endless resource for motifs, which he varied and embellished for the remainder of his career; it is not surprising, moreover, to find that antique figural compositions also enriched his repertory of expressive poses for the figures in his drawings and paintings. A few of Filippino's drawings show that he used a novel method of arranging live models in the attitudes of figures in ancient sculptures and narrative reliefs, from which he evolved certain poses in his paintings. Like the sketches after antique decorative motifs, his drawings of posed figures reveal how he freely varied the ancient proto-types, often modifying them to the extent that they become nearly unidentifiable in the finished paintings.

The practice of copying the attitudes of figures from antique sources was not a new one for Renaissance artists; nor was the posing of studio models in imitation of ancient sculptures unprecedented, for there are several examples of figures positioned like classical Thorn Pullers and Bound Captives among quattrocento Florentine studies that have been variously attributed to David Ghirlandaio and the School of Filippino.[9] Filippino's method is exceptional in that he used antique poses only as a point of departure for working out solutions for his own figures. The few surviving examples of Filippino's exercise of this practice date from the 1490s, after his return to Florence, at about the time he was preparing the frescoes for the Strozzi Chapel in Santa Maria Novella. It was then that he also developed an inter-est in portraying muscular figures in motion, which he drew from nude or nearly nude models and transformed into draped figures in the finished paintings.[10]

The best-known example of Filippino's use of an antique sculptural prototype for a study from the model is the Louvre drawing for the expiring hero in a *Death of Meleager* (cat. no. 46), in which he arranged his model in a pose that combines the head and upper torso of Cupid with the legs of Psyche from the famous relief known in the Renaissance as the "Bed of Polykleitos" (see fig. 13).[11] He made a few minor adjustments in the pose of the figure to enhance its dramatic character, and, as is typical of his studies of the nude from the end of the century, he emphasized the muscles of the arms, legs, and chest with shading effected through swiftly exe-cuted parallel hatched lines and brilliant strokes of white highlighting. The two sur-viving compositional drawings for the *Death of Meleager* add more information about Filippino's development of the figure from the antique relief. The lively pre-liminary study for the composition in the Ashmolean Museum, Oxford (cat. no. 45), which surely precedes the Louvre drawing, shows how Filippino first copied only the upper torso of Cupid from the ancient prototype. His subsequent decision to incorporate the legs of Psyche in the Louvre model study greatly increased the drama of the pose, which he further intensified in the more finished compositional

FIG.13 "Bed of Polykleitos," 16th-century copy after Roman model with Hellenistic figure types. Marble. Location unknown (formerly J. Hewitt)

drawing in the British Museum (cat. no. 47) by reversing the figure and dropping its left shoulder to reveal more prominently Meleager's anguished facial expression.

Quite a number of quotations from the poses of figures in ancient works of art appear in the Strozzi Chapel decorations: the pair of Muses on the lower right side of the altar wall, for example, was copied with very few changes from two Muses on a sarcophagus with the Muses, Minerva, and Apollo that was once in Santa Maria Maggiore, Rome.[12] However, Filippino developed the Jacob and Noah on the vault of the chapel (pl. 23) through a complex process of elaborating the pose of an ancient river-god, as a drawing of models for the patriarchs (cat. no. 41) indicates. The river-god in Filippino's drawing was the ultimate source for his experimentation with four different poses for the patriarchs, which he eventually resolved as reversed variations of one another. The frescoes of Jacob and Noah fill sections of the vault across from each other on opposite sides of the chapel, so that the figures face in opposite directions: thus Filippino used reversal here to achieve compositional harmony. The pose of the figure in the lower left of the drawing is closest to that of the traditional ancient river-god, but Filippino turned the model's head back over his shoulder and made small changes in the position of his legs and arms. This study and the one in the center of the sheet, in which the direction of the figure's head and legs is altered but the arms remain basically the same, are preparatory for the Jacob. The two other studies on the sheet, which are less finished, are preparatory for the head and upper body of the Noah. In the frescoes Filippino returned to a much closer imitation of the left arm and outstretched legs of the ancient river-god for Jacob, and he added the cornucopia over Noah's arm almost as if it were a footnote to document the source. The original prototype for the patriarchs' poses could have been any of the several river-god statues that were known to Renaissance

artists, for example the colossal pair representing the Tiber and the Nile (fig. 14), then on Monte Cavallo, whose poses, when viewed in profile, are the reverse of each other.[13]

Once Filippino's method is recognized, other figure studies for the Strozzi Chapel frescoes can be identified as examples of his unusual practice. The braced figures of Meleager and hunters in his entourage attacking the boar with spears in sarcophagus reliefs showing the Calydonian Boar Hunt, for instance, appear to be the ultimate source for Filippino's model study for the man who prods the base of the cross with a log in the *Martyrdom of Saint John* (cat. no. 44). Figures on a sarcophagus relief portraying that hunt, now in Woburn Abbey (fig. 15), which was available to quattrocento artists,[14] provide particularly close parallels with Filippino's drawing of the man with a log; the pose of this figure especially resembles that of the man in a tunic, with arms and legs facing to the right, who stands next to Meleager. Filippino gave the man in his drawing a greater sense of three-dimensionality than the hunter in the ancient relief possesses, but considerably diminished the solidity of the corresponding figure in his fresco.

The ultimate inspiration for Filippino's brilliant action study for the litter bearers in the *Raising of Drusiana* (cat. no. 101) may have been another variant of the Calydonian Boar Hunt composition, in which Meleager and a nude opponent confront each other on either side of the boar. Although Filippino's specific antique source for the figures is difficult to pinpoint, it may well have been the sarcophagus with this composition in the Camposanto, Pisa (fig. 16); this example seems to have been known to him, for a figure from its relief was the probable source for the pose of the patriarch Adam on the Strozzi Chapel vault (pl. 23).[15] Clearly there are some differences between details of the poses of the litter bearers in the drawing and of the figures in the sarcophagus relief, but the dynamic pairing of their front and back views and their rhythmic back-and-forth motion on either side of a central motif are exceedingly similar.[16]

Why did Filippino pose live models in the attitudes of antique figures? A clue to the answer seems to lie in the fact that he began to follow this practice at exactly the same moment he became preoccupied with exploring figural movement and its

FIG. 15 *Calydonian Boar Hunt*, Roman, late 3rd century A.D.
Marble. Woburn Abbey, Bedfordshire

expression through anatomy in his model studies. In the ancient figural composi-
tions Filippino must have seen potential prototypes for the dynamic movement and
the expressive poses and gestures that fill the Strozzi Chapel frescoes and the sur-
viving drawings for them. The subjects of the antique compositions evidently were
of little interest to him, as his choice of a source for his *Death of Meleager* clearly
shows: the Cupid and Psyche in the "Bed of Polykleitos" apparently provided a
more vivid and dramatic pose for the expiring Meleager than did the ancient rep-
resentations of the subject that Filippino surely knew;[17] however, the striking poses
of figures in Meleager sarcophagi conveyed the kind of energy he sought for figures
in the narrative scenes of the Strozzi Chapel.[18]

Considered in light of Filippino's training, which involved preparatory drawings
that consisted chiefly of variations upon preexisting figure types, his use of antique
sources as the starting point for his studies of nudes in dynamic motion is not sur-
prising. Moreover, his tendency to select isolated ancient motifs as the models for
figural poses is equally in keeping with traditional quattrocento practice. Filippino's
paintings reveal the evidence of a piecemeal method of preparation in their obsessive
animation and abundant detail, but his drawings foreshadow more advanced har-
monies. His complex method of developing poses through studies of nude models

FIG. 16 *Calydonian Boar Hunt*. Carl
Robert. Line engraving after Roman
sarcophagus. Camposanto, Pisa, from
Die Antiken Sarkophag-Reliefs, vol. 3,
Berlin, 1904

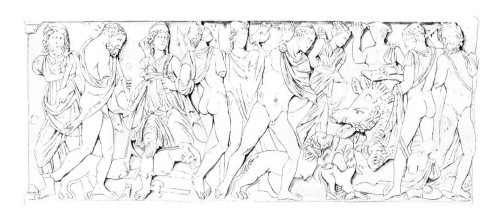

for clothed figures in paintings and his free, experimental style of sketching would become integral parts of the next generation's practice. Filippino's drawings after antique figural and decorative motifs show that the experience of ancient art was an important force in liberating him from the old pattern-book traditions and stylized methods of drawing.

NOTES

1 Bertelli 1963 reports the rediscovery of the small vaulted burial chamber and confirms that it was executed by Filippino's assistant, Raffaellino del Garbo. However, a similarly structured vault appears in the background of the altarpiece Filippino painted for the chapel, which suggests that the vault in the small chamber was designed by Filippino.

2 See Shoemaker 1978. The source of the motifs in this drawing is here identified as the Domus Aurea, or Golden House, of Nero. The Hippolytus scene was in the Volta Dorata, and the two other subjects were in the Cryptoporticus.

3 Shoemaker 1975, p. 289. The sarcophagus is published in Lippold 1936, p. 29, no. 513.

4 Egger 1906, vol. 1, pp. 7–53.

5 Shoemaker 1975, p. 263.

6 Halm [1931], pp. 409–10.

7 Bober and Rubinstein 1986, pp. 131–33. Their no. 99, Nereids and Tritons: the Triumph of Neptune and Amphitrite?, shows certain similarities to Filippino's drawing with a Nereid, and their no. 100.ii, Nereids and Tritons with the Triumph of Neptune, has features that correspond with motifs in his drawing with a Triton.

8 Attributed on mount to Benedetto da Rovezzano. Both Giuliano da Sangallo's Taccuino Senese and the Codex Escurialensis show putti with reins similar to those of the winged figure in Filippino's dado. Egger cites as possible sources for the putti in the Codex Escurialensis a painting in the Baths of Titus as well as a sarcophagus. See Falb 1899, p. 37, pl. 17; Egger 1906, p. 142, fol. 58.

9 See Ragghianti and Dalli Regoli 1975 nos. 71, 204, pls. 80, 283 (for the Spinario), nos. 23, 33, pls. 45, 47, 50 (for the Bound Captives).

10 Shoemaker 1994, pp. 261–63. Here it is proposed that Filippino's practice of making drawings for clothed figures from nude models was introduced when the Strozzi Chapel frescoes were designed.

11 Parker 1956, no. 21, identifies the "Bed of Polykleitos" as Filippino's source. His drawings for the Death of Meleager are discussed individually and as a group in Shoemaker 1975, pp. 378–93.

12 Bober and Rubinstein 1986, p. 79, no. 38. This correspondence was first noted in Winternitz 1965, pp. 263–80, who first identified this connection.

13 Halm [1931], pp. 419–21, discusses the influence of antique sources on Filippino's art, pointing out the stylistic differences between his preparatory drawings and his paintings. Halm maintains that Filippino did not include quotations from antique decorative motifs in his drawings but added them in his paintings, resulting in stylistic changes. But in Shoemaker 1978, pp. 39–40, I suggest that Filippino did make drawings in which he included the antique trappings that appear in his paintings.

14 Bober and Rubinstein 1986, pp. 144–45, no. 113.

15 Robert 1969, vol. 2, p. 318, nos. 250–250b, pl. 85. The connection between the patriarch Adam and the figure on the Pisa sarcophagus was made in Sale 1979, pp. 196, 220, n. 90.

16 Antonio Pollaiuolo's engraving the Battle of the Nudes could also have inspired the contrapuntal arrangement of Filippino's litter bearers; certainly Pollaiuolo's work was important in encouraging Filippino's interest in anatomy during the 1490s. Nevertheless, Filippino's figures seem even closer to those in the Meleager sarcophagi than to Pollaiuolo's nudes.

17 Bober and Rubinstein 1986, pp. 145–46, nos. 114–16. The authors cite several sarcophagi representing the Death of Meleager that were known to Renaissance artists. Only a few years before Filippino made his drawings for the Strozzi Chapel decorations, a Death of Meleager relief (ibid., no. 114) had served as the source for the frieze on the tomb of Francesco Sassetti in Santa Trinita, Florence.

18 Yet another study by Filippino from a live model that is probably based upon the pose of an antique figure is in the Musée du Louvre, Paris, and shows a reclining youth (cat. no. 48) that derives from the pose of a sleeping Endymion from a relief on a sarcophagus now known only through drawings but believed to have been in Rome about 1500. See especially ibid., pp. 68–69, no. 26b.

Filippino and His Circle, Designers for the Decorative Arts

ALESSANDRO CECCHI

Vasari, describing Filippino's artistic personality, dwells upon his pleasure in "strange fancies," in caprices of the imagination, that found their ideal area of application in decorative schemes. He adds, however, almost as if to give an air of high-mindedness to those often irreverent eccentricities, that "he never executed a single work in which he did not avail himself with great diligence of Roman antiquities, such as vases, buskins, trophies, banners, helmet-crests, adornments of temples, ornamental head-dresses, strange kinds of draperies, armour, scimitars, swords, togas, mantles, and such a variety of other beautiful things."[1] Two revolutionary painting cycles, in the Carafa Chapel at Santa Maria sopra Minerva in Rome and the Strozzi Chapel at Santa Maria Novella in Florence, bear witness to his boundless repertory, teeming with fantastic painted candelabra and other ornament that saturate every space not taken up by the figural narrative.

Filippino's exceptional facility of invention also found expression in the numerous drawings he provided to woodworkers, master glassworkers, sculptors, and tapestry weavers.[2] Among the objects produced in wood, the frame for the so-called *Pala degli Otto*, dated 1486 (pl. 19), carved by Chimenti di Domenico del Tasso and clearly based on a drawing by Filippino, has been lost. However, a richly carved ceiling is preserved in the Sala degli Otto (fig. 17) in the Palazzo Vecchio, Florence. This coffered ceiling, which is undocumented, shows particularly fine craftsmanship; the degree of detail in the ornament differentiates it from the more monumental and sculptural ceilings of the Sala dell'Udienza, the Sala dei Gigli, and the Sala de' Dugento, executed by various woodworkers associated with the Da Maiano brothers, the first artisans entrusted with the project in the Palazzo Vecchio.[3] The Sala degli Otto ceiling, which relies on a decorative vocabulary more painterly than sculptural in conception, is carved with openwork palmettes, scrolls, rosettes, and volutes, as well as rose shapes and cherubs' heads surmounted by fleurs-de-lis at the back of the coffers. It seems slightly later than the ceilings by the Da Maiano and was probably completed by 1486, when the *Pala degli Otto* was executed.[4] Thus we may wonder whether this ceiling, a work so markedly similar in some respects to that of the Sala dell'Udienza and which has been placed within the Del Tasso circle, might, like the *Pala degli Otto* frame, have been carved by Chimenti on the basis of drawings by Filippino. In fact, Filippino and Chimenti are frequently linked in payment

FIG. 17 Detail, carved ceiling, Sala degli Otto di Practica. Wood, gesso, gold leaf, and tempera. Palazzo Vecchio, Florence

records. Moreover, the carved ceiling recalls the gilded openwork set against a blue background in the frame of Filippino's Nerli Altarpiece in Santo Spirito, Florence, which is now considered to be by Chimenti.

Apart from these clear connections to Chimenti, additional evidence would seem to establish close links between Filippino and other members of the numerous Del Tasso family of woodworkers. In this regard significant inferences can be drawn from the correspondences between Filippino's frescoed column decorations in the Carafa Chapel and the designs carved on the fascia of the engaged pilasters articulating the wood paneling and benches on the walls of the sacristy in Santa Croce, Florence; this paneling was attributed by Middeldorf to Domenico di Francesco del Tasso as well as to his sons Marco and Francesco.[5] Similarly, Filippinesque traces are found in a series of *spalliere* (wainscoting) of inlaid wood that Middeldorf attributed to the same workshop. Now in San Niccolò Oltrarno, Florence, these were originally located elsewhere, as indicated by the presence on one capital of the coat of arms of the Ridolfi, a family that was never a patron of this church.[6] Above the finely carved capitals, which, unfortunately, are in poor condition, an inlay frieze (fig. 18) depicts a procession of male figures with a pilgrim's staff; the figures face a sacrificial altar and alternate with plant volutes and fantastic birds, a vocabulary that, in its originality and eccentricity, specifically brings to mind a sheet of ornamental studies by Filippino in the Uffizi (inv. no. 1632 E).[7]

The connections that can be established between Filippino and the Del Tasso family also include the design of their family tomb in Sant'Ambrogio, Florence, carried out by Francesco di Domenico del Tasso in 1470. The niche with the wooden

FIG.18 Detail, inlay frieze. Wood. San Niccolò Oltrarno, Florence

FIG.19 Leonardo di Chimenti and collaborators. Detail, tomb of Del Tasso family. Sant' Ambrogio, Florence

FIG.20 Piero di Cosimo. *Ornamental Study of Two Columns*. Pen and brown ink over traces of black chalk, 144 x 81 mm. Gabinetto Disegni e Stampe degli Uffizi, Florence 286 E

statue of Saint Sebastian (fig. 19) was executed by a nephew, Leonardo di Chimenti, prior to 1500. The two columns flanking the arched niche are carved with decorative candelabrum motifs, the spandrels on the top contain two painted angels, and the zone of the predella displays a small tondo with the Annunciation—all strongly evocative of Filippino's painting style.[8] However, the mediocre quality of the ensemble encourages an attribution of the paintings not to Filippino but to one of his collaborators.[9]

Among the artists who were influenced by Filippino, Piero di Cosimo constitutes a case unto himself. Although at first, during the 1480s, he closely followed Filippino's style, he soon took a path completely his own, where his reworking of antique myths allowed him to give free rein to his inventive imagination. Piero's interest in ornament, however, seems to have been superficial, as indicated by the somewhat formulaic decorative candelabra of his Del Pugliese Altarpiece in Saint Louis and the pilasters in the background of his *Sacra Conversazione* in Sarasota. The only known ornamental study by Piero (fig. 20), executed on the back of a drawing in the Uffizi and connected to his Capponi *Visitation*, formerly in Santo Spirito and now in Washington, D.C. (fig. 60), seems atypical and without connection to Filippino. It depicts two painted columns, one barely indicated, the other better defined, and most likely was related to the lost frame of the altarpiece, which was carved by Chimenti del Tasso and completed sometime prior to October 13, 1489.

Raffaellino del Garbo presents another case altogether. Trained in Filippino's workshop, he suffered undeservedly from Vasari's negative judgment, according to which he was victim to a lifelong regression, after exhibiting "extraordinary beginnings"

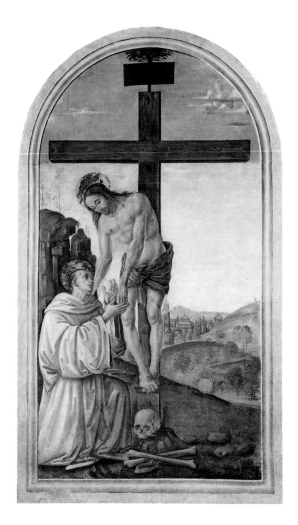

FIG.21 Here attributed to Raffaellino del Garbo. *Crucified Christ with Saint Bernard*. Detached fresco from chapter house, Santa Maria Maddalena dei Pazzi, Florence

in his youth.[10] In fact, Vasari does not seem to have been well informed about Raffaellino, and he was mistaken even about the year of the artist's death: "Wherefore, being overtaken by infirmities and impoverished, he finished his life in misery at the age of fifty-eight, and was buried in S. Simone, at Florence, by the Company of the Misericordia, in the year 1524."[11] In reality, the painter was still alive in April 1527, when a census listing all men available to bear arms was taken throughout the four *quartieri* of the city. The census results, recorded in a ledger in the Biblioteca Nazionale in Florence, cite a certain "Raffaellino, painter, who has one son, one helper, and one worker" in the via del Garbo.[12] This must be our Raffaellino, who was known by the name of the street where he had, since 1499, maintained his workshop, which he rented from the monks of the Badia in Florence. The date of Raffaellino's death remains unknown, and the most likely hypothesis regarding its cause is that he succumbed to a new outbreak of an exceptionally virulent plague that afflicted Florence between 1527 and 1528.

Throughout his career Raffaellino paid moving homage to Filippino's style but "gave much more delicacy to that manner in the draperies, and greater softness to hair and to the expressions of the heads,"[13] modifications that show the additional influence of Perugino and Pinturicchio. The mingling of elements borrowed from Filippino and Perugino, fundamental to the four altarpieces Raffaellino executed between 1501 and 1505 for chapels in Santo Spirito,[14] can be seen as well in the *Crucified Christ with Saint Bernard* (fig. 21), a fresco detached, along with its sinopia

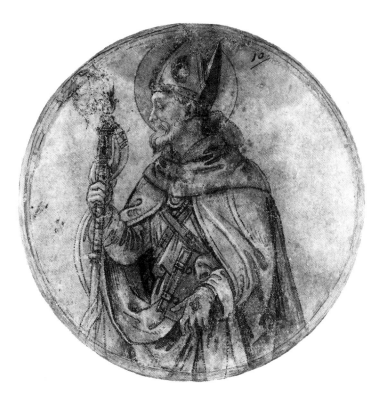

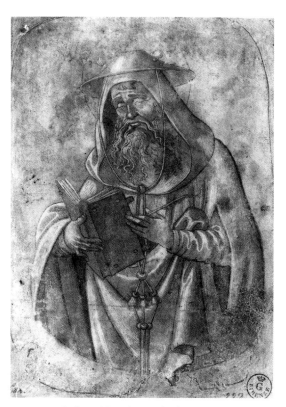

FIG.22 Raffaellino del Garbo. *Study of Saint Augustine*. Black chalk, pen and brown ink, and brown wash on paper partially rubbed with reddish chalk, d. 147 mm. Gabinetto Disegni e Stampe degli Uffizi, Florence 223 F

FIG.23 Raffaellino del Garbo. *Study of Saint Jerome*. Pen and brown ink and brown wash, heightened with white gouache, 182 x 133 mm, maximum. Gabinetto Disegni e Stampe degli Uffizi, Florence 222 F

underdrawing, from a wall in the chapter house at Santa Maria Maddalena dei Pazzi, Florence.[15] This fresco is among the most typical of the artist's paintings from the end of the first decade of the cinquecento, when he was completing his work at that convent.[16]

Like Filippino before him, Raffaellino did not consider himself above providing drawings for various decorative enterprises. He also must have devoted some time to painting miniatures on parchment, if, as this author believes, the *Pietà with the Virgin and Saint John*, enclosed in a pax of gilded silver and translucent enamel, is from his hand. This work, now in San Salvi, was originally in the Vallombrosan convent of San Giovanni Evangelista, which stood outside the Porta a Faenza until the monastery was destroyed in the siege of 1529–30.[17]

However, the activity that brought Raffaellino renown was the furnishing of drawings for embroidery work, a pursuit with an illustrious tradition and one to which Vasari devotes ample space in the conclusion of his *Life* of the artist.[18] The most ambitious such commission was the sumptuous Passerini vestments, now in the Museo Diocesano, Cortona.[19] These embroideries are partly based on four drawings in the Uffizi. Two tondi depict Saint John the Baptist (inv. no. 196 E) and the Virgin and Child (inv. no. 345 E) and were used for the back of the chasuble stole. Two others, hitherto overlooked, show Saint Augustine (fig. 22) and Saint Jerome (fig. 23) and were models for the front of the vestment and for the stole of the cope, respectively.[20]

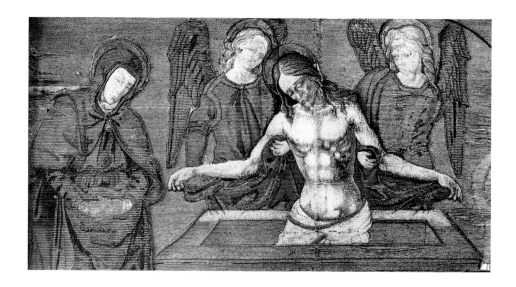

Fifteen or so additional embroideries can be linked stylistically to Raffaellino. These are the tondi with the Virgin and Child, God the Father, Christ in the pose of the Pietà, and saints carried out on the chasuble and cope, and Saints Margaret and Anthony Abbot on the altar frontal. Only six, by contrast, appear to be related to designs by Andrea del Sarto: the Resurrection on the cope, the Virgin and Child and the four Evangelists on the altar frontal.[21] This disparity would seem to indicate that it must have been Raffaellino who was first commissioned to make the drawings for the vestments, which were most likely executed between 1521, the year Cardinal Silvio Passerini was appointed bishop of Cortona, his native city, and 1526, when Passerini's mother, Margherita, willed them to the cathedral.

If the death date Vasari gave Raffaellino is moved forward at least three years, the possibility, previously hypothesized, that Andrea replaced Raffaellino after 1524 to complete the project is eliminated. Indeed, it is more probable that Raffaellino obtained the commission after 1521 and had time to finish it, calling on Andrea del Sarto from the very beginning to provide certain drawings.

Along with the Passerini vestments, which engaged Raffaellino and the major Florentine embroiderers for some time,[22] there remain fragmentary traces of other commissions of this kind based on his work. These include some of the embroideries for a vestment in the collegiate church of San Martino in Pietrasanta, which can be attributed in its entirety to Raffaellino and should be dated no later than the first decade of the cinquecento.[23] Another, completed by the end of the same decade, is a small embroidery fragment depicting a Pietà with Virgin and Angels, in the Palazzo Vecchio, Florence, a piece that still shows the influence of Filippino (fig. 24).[24]

In addition to creating drawings for embroideries, following the example of his masters Filippino and Perugino, and according to custom, Raffaellino must have supplied designs for stained-glass windows. He can be linked to windows in the chapels in Santo Spirito, where he had painted altarpieces, and to others in that church as well.[25]

Berenson was aware of the existence of a round window with Saint Mary Magdalen (fig. 25) in the church of Santa Maria Assunta in Staggia, based on a drawing

FIG.25 After Raffaellino del Garbo. *Saint Mary Magdalen.* Stained glass. Santa Maria Assunta, Staggia

FIG.26 After Raffaellino del Garbo. *Saint John the Baptist.* Stained glass. Santa Maria Assunta, Staggia

by the artist, but he did not notice the window depicting Saint John the Baptist (fig. 26), also connected to Raffaellino's designs, in the chapel opposite.[26] The window with the Magdalen, which decorates the chapel that housed Piero Pollaiuolo's *Communion of the Magdalen*,[27] is not a youthful work, as Berenson maintained, but should be dated within the third decade of the cinquecento, on the evidence of its mannered eclecticism and significant similarities to the Passerini drawings and embroideries. The window with the Baptist also relates to the Passerini project; it would seem, therefore, that for this window Raffaellino reused the Uffizi drawing for the embroidered tondo showing Saint John in the Passerini vestment.

NOTES

1 Vasari 1996, vol. 1, p. 565.

2 See Cecchi 1994a.

3 For quattrocento ceilings in the Palazzo Vecchio, see Cecchi 1994b.

4 Cecchi 1996.

5 Middeldorf 1928.

6 Moretti 1973, pp. 61–62; Liscia Bemporad in San Niccolò Oltrarno 1982, pp. 85–86, no. 28.

7 Cecchi 1994a, fig. 16.

8 Scharf 1935, pp. 68, 104, no. 5, pl. 86, figs. 123, 124; Neilson 1938, pp. 150–51.

9 The hand may be that of a woodworker who was also a painter, an artisan linked since the early 1900s to a drawing for a tomb in the Louvre that exhibits certain similarities to Filippino's late manner. Gamba 1909, pp. 37–38, figs. 2, 3.

10 Vasari 1996, vol. 1, p. 687.

11 Ibid., p. 691.

12 Biblioteca Nazionale Centrale di Firenze (B.N.C.F., Nuovi Acquisti 987, c. 86r).

13 Vasari 1996, vol. 1, p. 688.

14 Carpaneto 1970, pp. 14–16, figs. 16, 17; Carpaneto 1971, pp. 3–4, 6–9, figs. 28, 33; Capretti in Santo Spirito 1996, pp. 284–85.

15 Dal Poggetto in Metropolitan Museum 1968, pp. 186–89, nos. 50, 51; Luchs 1977, pp. 111–12, fresco 3, fig. 82.

16 In this context we should consider whether the two windows from the chapter house of the Cestello, now in the National Gallery of Art, Washington, D.C., might have been executed after Raffaellino's designs, a derivation that would explain their Florentine, Peruginesque style (Luchs 1977, pp. 117–18, figs. 88a,b).

17 Liscia Bemporad in Rolfi, Sebregondi, and Viti 1992, p. 193, no. 8.19.

18 Vasari 1906, vol. 4, pp. 239–41; Garzelli 1973; Pons 1992, nos. 10.1–10.14.

19 For more on this vestment, see Devoti in Collareta and Devoti 1987, pp. 56–59, nos. 6–16, figs. 60–83.

20 See Petrioli Tofani 1991, pp. 99 (Saint Augustine), 98–99 (Saint Jerome).

21 For more about Andrea del Sarto's drawings of Saint Mark the Evangelist and Saint John the Evangelist for the vestments, see Petrioli Tofani in Palazzo Pitti 1986, pp. 246–47, nos. 39, 40.

22 The April 1527 census of men available to bear arms provides interesting data about embroiderers then living in the city. The famous Galieno, mentioned by Vasari, lived in the Santa Maria Novella quarter, at via Porta Rossa, near the Bartolini palace, along with Ser Bartolomeo. Nearby there was a certain "Girolamo, embroiderer"; and "Tommaso di Francesco, embroiderer" resided in the Santa Croce quarter, at via degli Sbanditi, near via de' Pilastri (B.N.C.F., Nuovi Acquisti 987).

23 Digilio in Baracchini and Russo 1995, pp. 91–92, 97–98.

24 This embroidery is part of the right portion of the composition, where the figure of Saint John the Evangelist most likely appeared, accompanying the surviving image of the Virgin. See Lunardi 1982, pp. 51, 54–55.

25 Here the question is whether the window with the Vision of Saint Bernard, attributed to Pinturicchio, and the damaged window with Saint Peter in the Dei Chapel should be linked to Raffaellino and dated after 1506, when they would have been executed in accordance with the last will and testament of Rinieri di Bernardo Dei. Raffaellino seems to have furnished other cartoons for windows in this same church, including the *Doubting of Thomas* in the Antinori Chapel, the figures of which are very similar to those in the *Miracle of the Loaves and Fishes* of 1503, the detached fresco formerly in Cestello. For more on the Santo Spirito windows, see Capretti in Santo Spirito 1996, pp. 357–61.

26 Berenson 1963, vol. 1, p. 188.

27 Brogi 1897, p. 419. For more about this work, see Ettlinger 1978, pp. 138–39, n. 4; and Pons 1994, p. 94, n. 2.

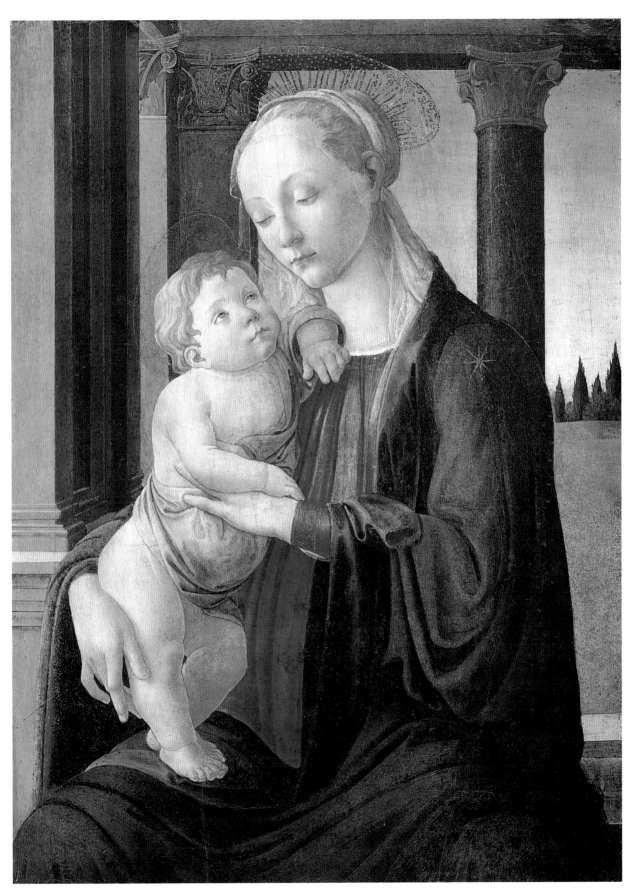

PL. I *Virgin Adoring the Christ Child* (Corsini Madonna). Tempera and oil on panel, 76 x 55.5 cm.
National Gallery of Art, Washington, D.C., Andrew W. Mellon Collection 1937.1.21

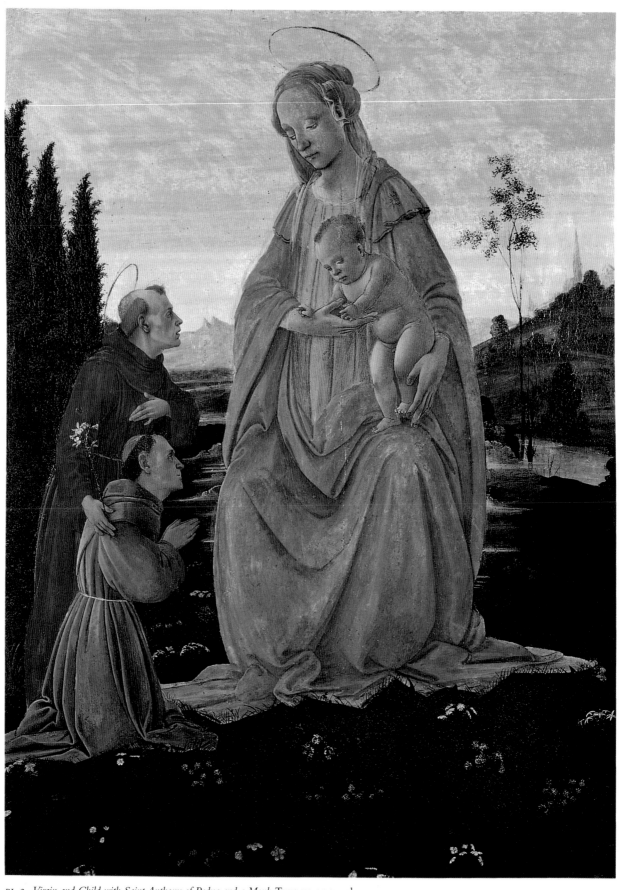

PL.2 *Virgin and Child with Saint Anthony of Padua and a Monk.* Tempera on panel,
56 x 42 cm. Szépmüvészeti Múzeum, Budapest 1140

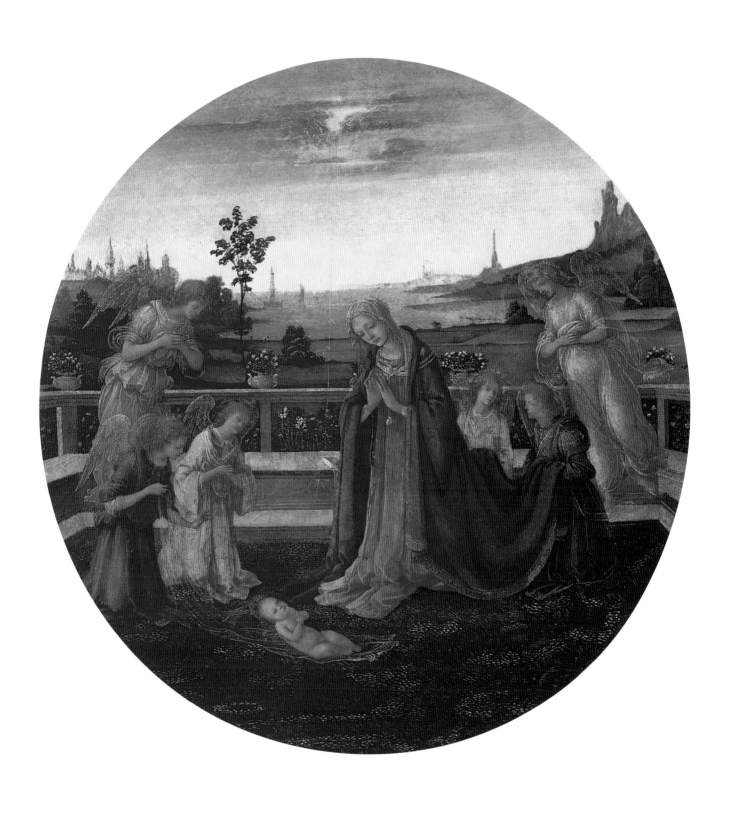

PL. 3 *Adoration of the Christ Child.* Oil and tempera on copper, d. 53 cm.
The State Hermitage Museum, Saint Petersburg

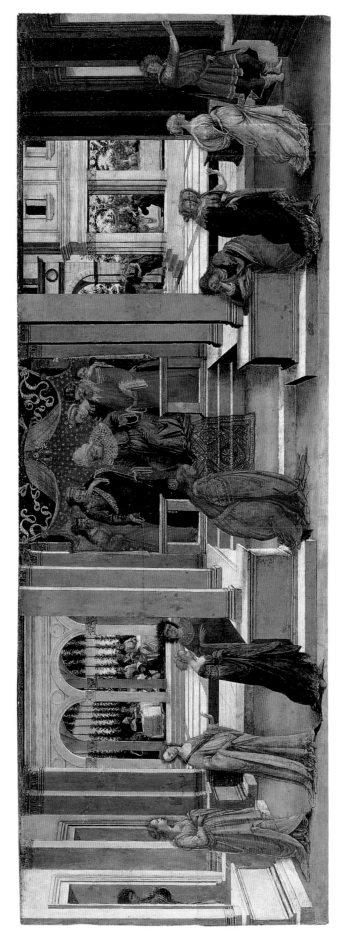

PL. 4 *Presentation of the Virgin (Esther?) to Ahasuerus.* Tempera on panel,
47 × 138 cm. Musée Condé, Chantilly 19

48

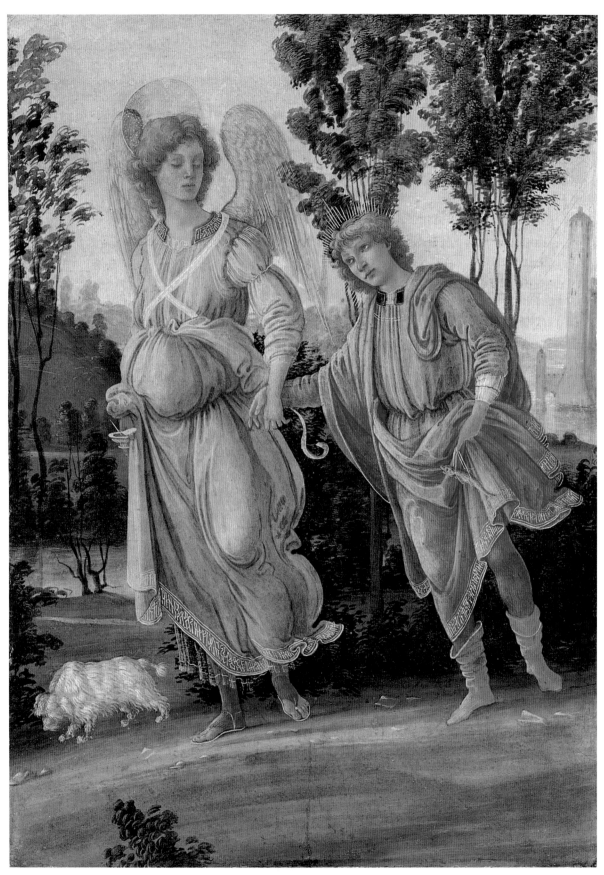

PL.5 *Tobias and the Angel.* Tempera on panel, 32.5 x 23.5 cm. National Gallery of Art, Washington, D.C., Samuel H. Kress Collection 1939.1.229

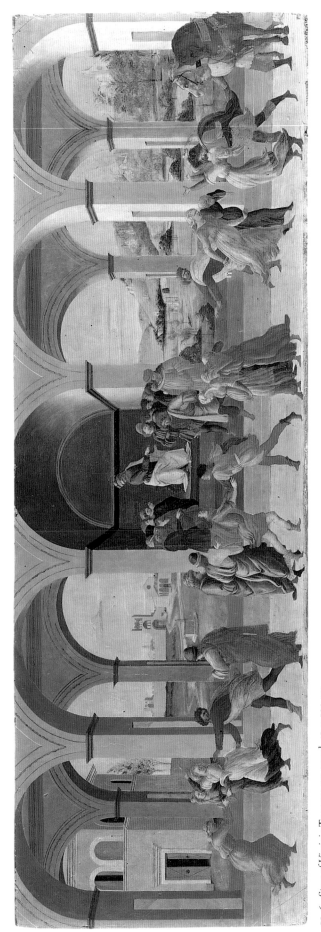

PL. 6 *Story of Virginia*. Tempera on panel, 41 x 125 cm.
Musée du Louvre, Paris 1662 A

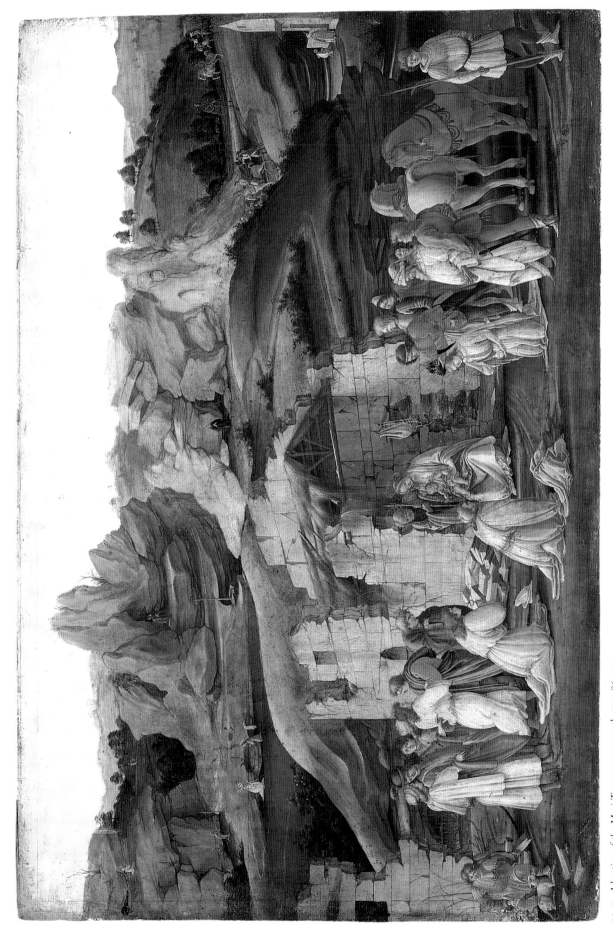

PL. 7 *Adoration of the Magi*. Tempera on panel, 57 x 86 cm.
National Gallery, London 1124

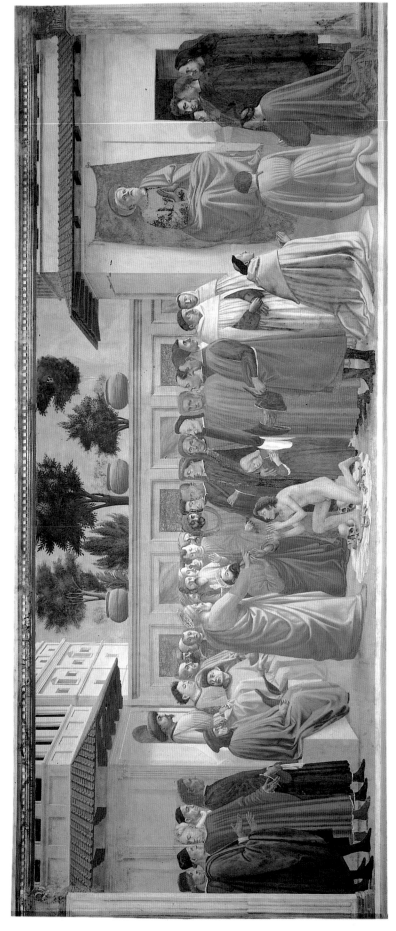

PL. 8 Masaccio and Filippino Lippi. *Raising of Theophilus's Son.* Fresco.
South wall, Brancacci Chapel, Santa Maria del Carmine, Florence

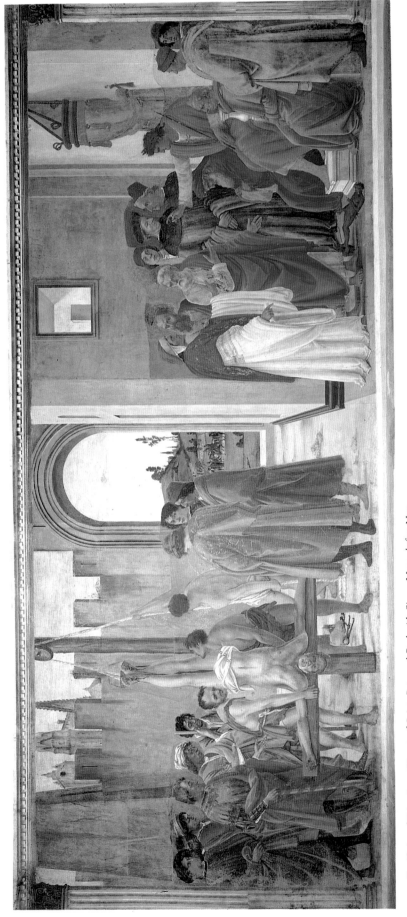

PL. 9 *Crucifixion of Saint Peter; Dispute of Saints Peter and Paul with Simon Magus before Nero.*
Fresco. North wall, Brancacci Chapel, Santa Maria del Carmine, Florence

53

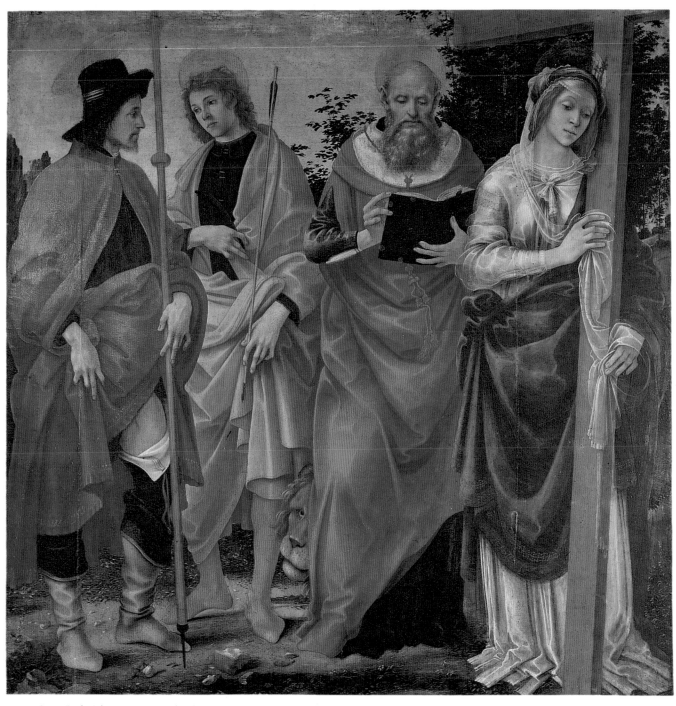

PL.10 *Saints Roch, Sebastian, Jerome, and Helen* (Magrini Altarpiece). Tempera on panel,
145 x 155 cm. San Michele in Foro, Lucca

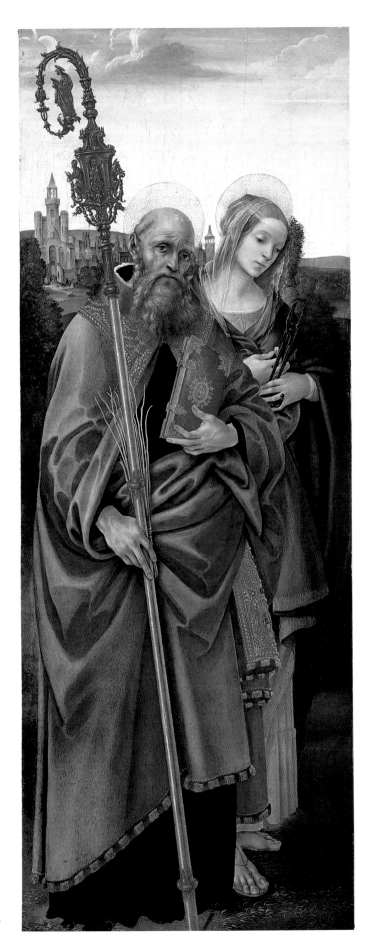

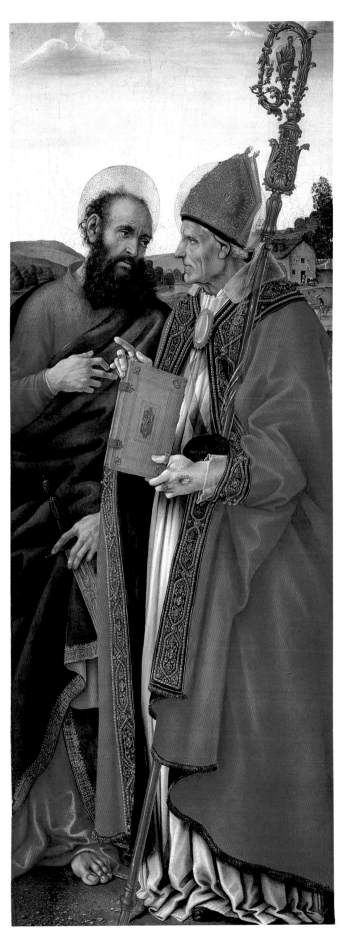

PL.11 *Saints Benedict and Apollonia* (from the San Ponziano
Altarpiece). Tempera and oil on panel, 156 x 59 cm.
Norton Simon Art Foundation, Pasadena

PL.12 *Saints Paul and Fredianus* (from the San Ponziano
Altarpiece). Tempera and oil on panel, 156 x 59 cm.
Norton Simon Art Foundation, Pasadena

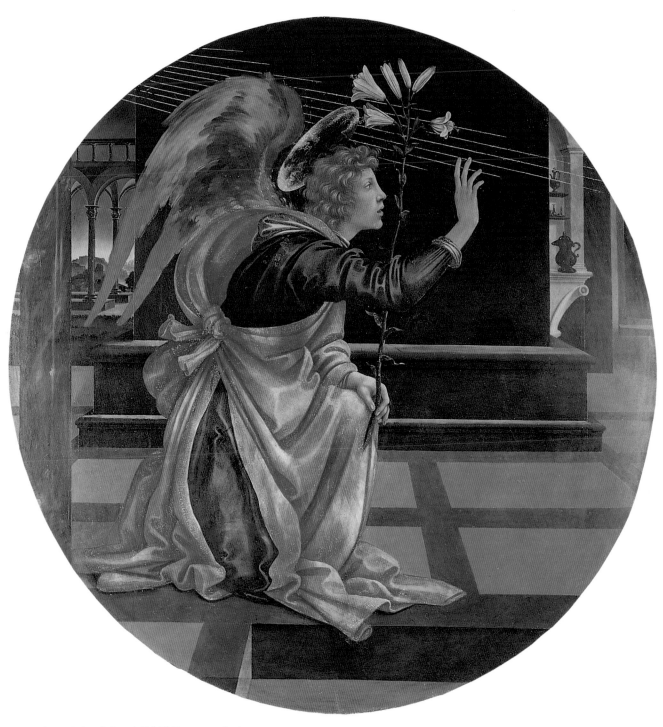

PL.13 *Annunciation: Archangel Gabriel.* Tempera and oil on panel,
d. 110 cm. Museo Civico, San Gimignano

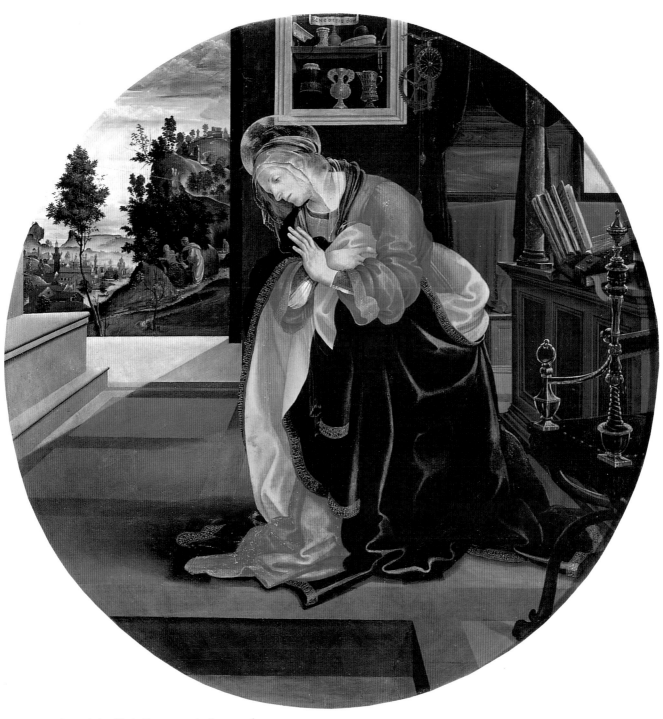

PL.14 *Annunciation: Virgin.* Tempera and oil on panel,
d. 110 cm. Museo Civico, San Gimignano

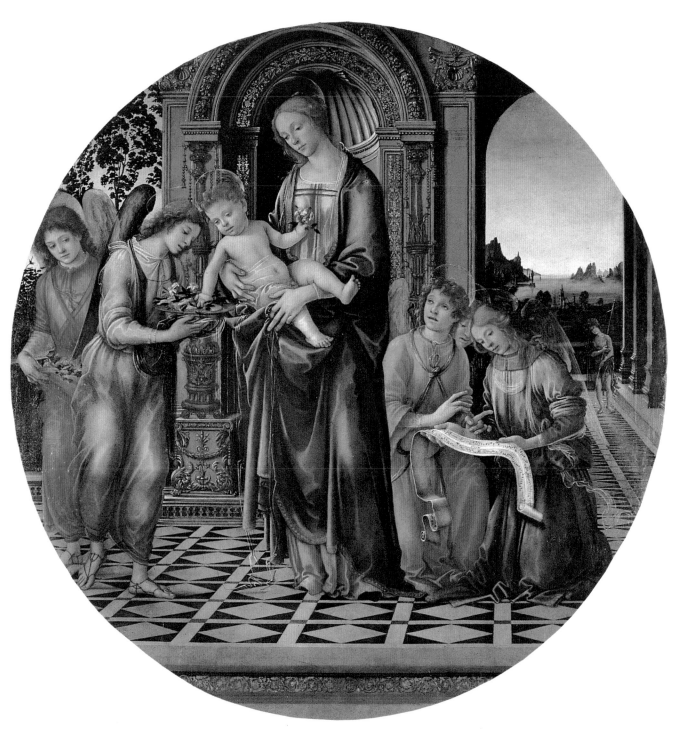

PL.15 *Virgin and Child with Saint John the Baptist and Angels* (Corsini Tondo).
Tempera on panel, d. 173 cm. Cassa di Risparmio, Florence

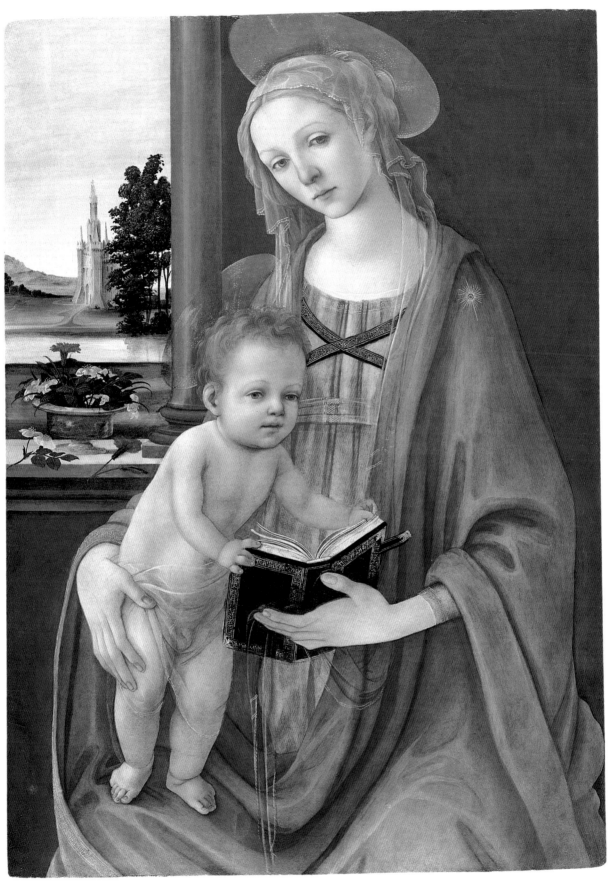

PL.16 *Virgin and Child*. Tempera on panel, 77 x 51 cm. Gemäldegalerie,
Staatliche Museen, Berlin 82

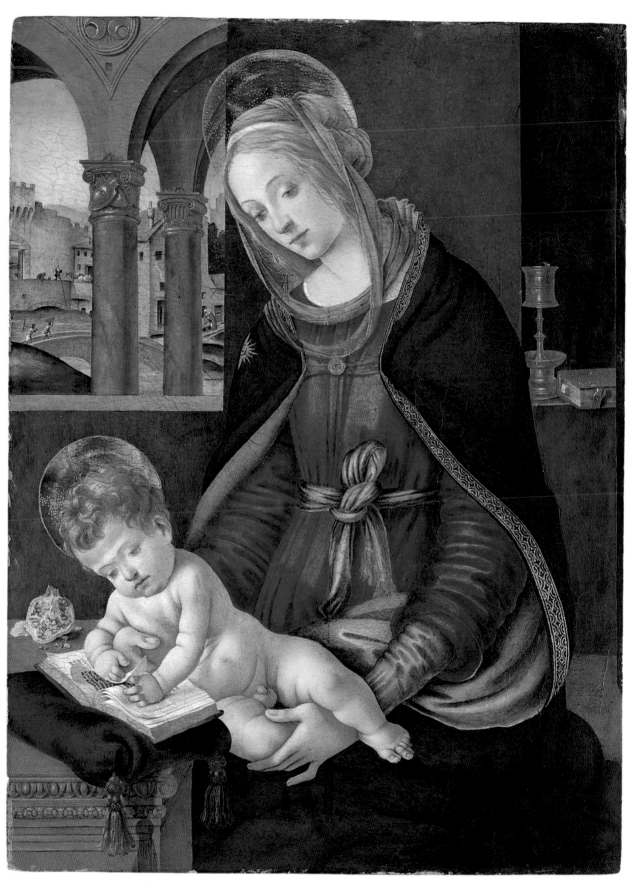

PL.17 *Virgin and Child* (Strozzi or Bache Madonna). Tempera and oil on panel, 83 x 62 cm.
The Metropolitan Museum of Art, New York, The Jules Bache Collection, 1949 49.7.10

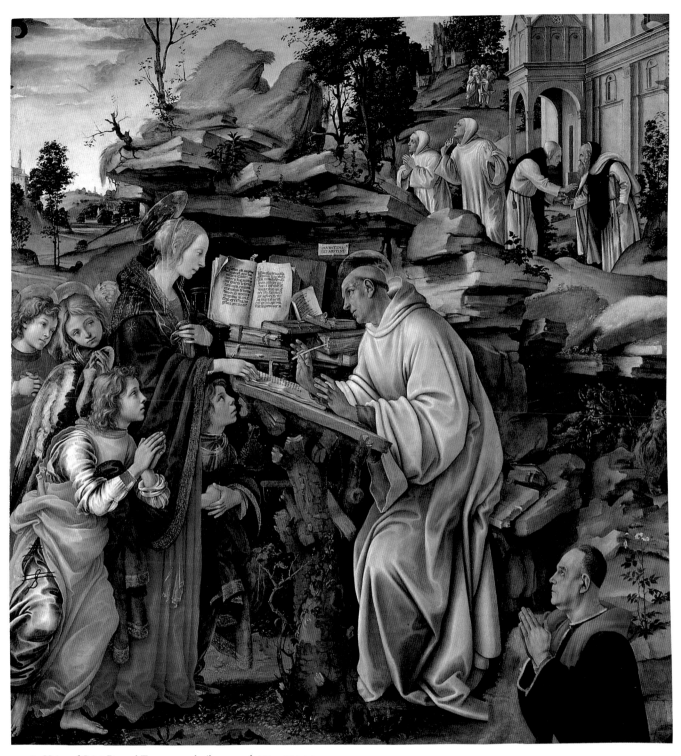

PL.18 *Vision of Saint Bernard.* Tempera and oil on panel, 210 x 195 cm.
Church of the Badia, Florence

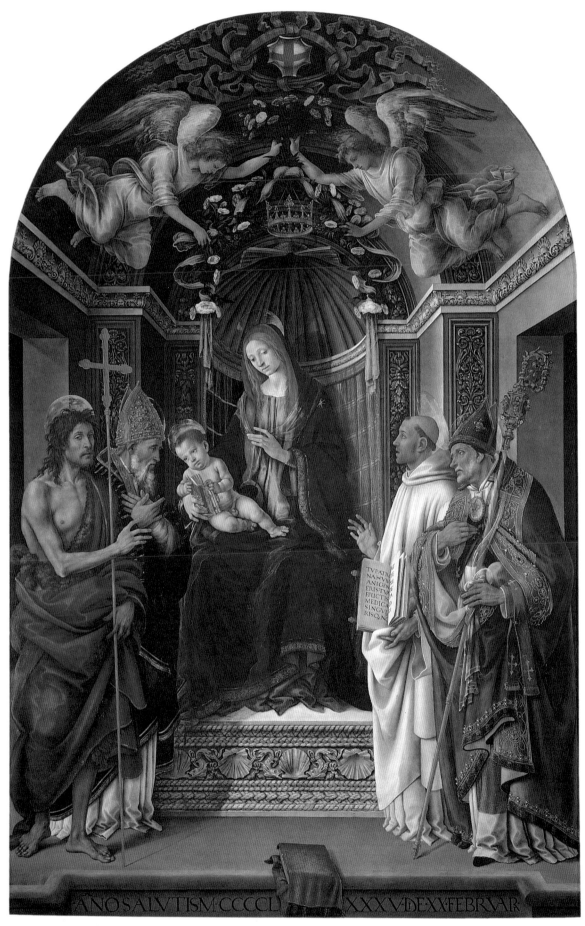

PL.19 *Virgin and Child with Saints John the Baptist, Victor, Bernard, and Zenobius (Pala degli Otto di Practica or Pala della Signoria)*. Tempera on panel, 355 x 225 cm. Galleria degli Uffizi, Florence 1568

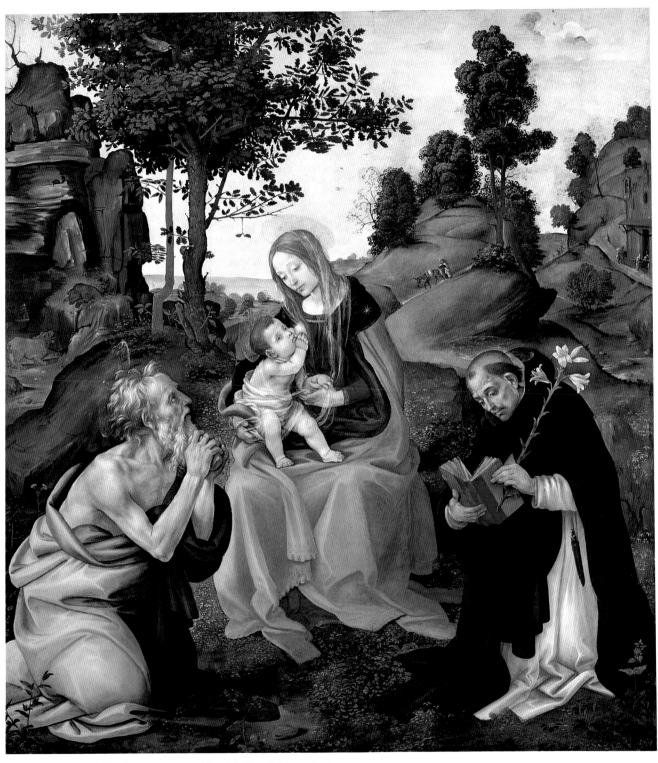

PL.20 *Virgin and Child with Saints Jerome and Dominic* (Rucellai Altarpiece).
Tempera on panel, 203 x 186 cm. National Gallery, London 293

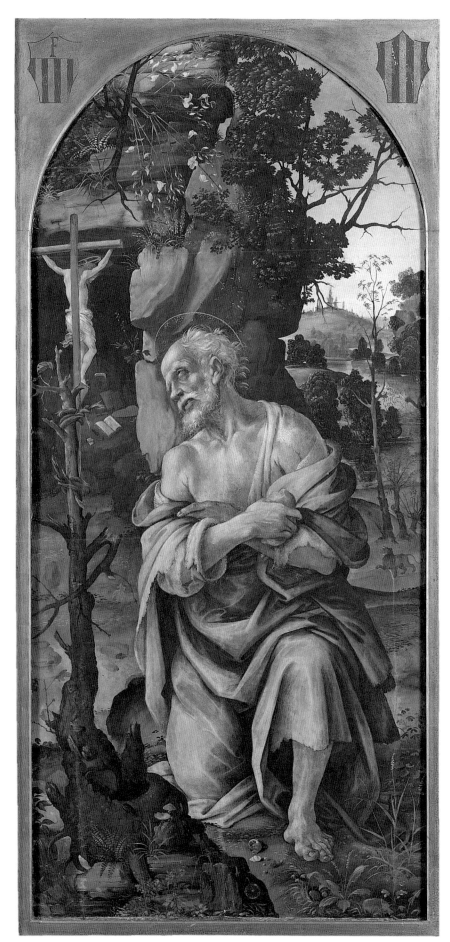

PL.21 *Saint Jerome*. Tempera and oil on panel, 136 x 71 cm.
Galleria degli Uffizi, Florence 8652

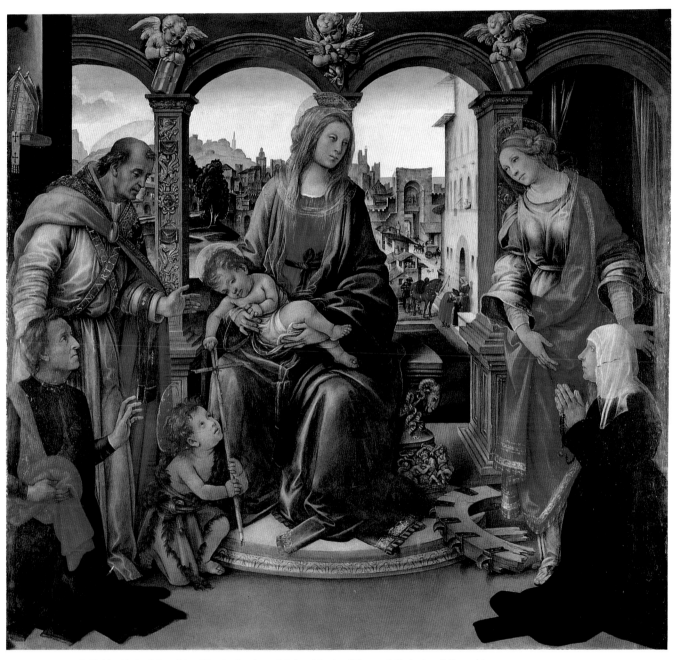

PL.22 *Virgin and Child with the Infant Saint John the Baptist and Saints Martin of Tours and Catherine of Alexandria and Donors* (Nerli Altarpiece). Tempera and oil on panel, 160 x 180 cm. Nerli Chapel, Santo Spirito, Florence

PL.23 *Patriarchs Adam, Noah, Abraham, and Jacob.* Fresco. Vault,
Strozzi Chapel, Santa Maria Novella, Florence

PL.24 Altar wall, Strozzi Chapel, Santa Maria Novella, Florence

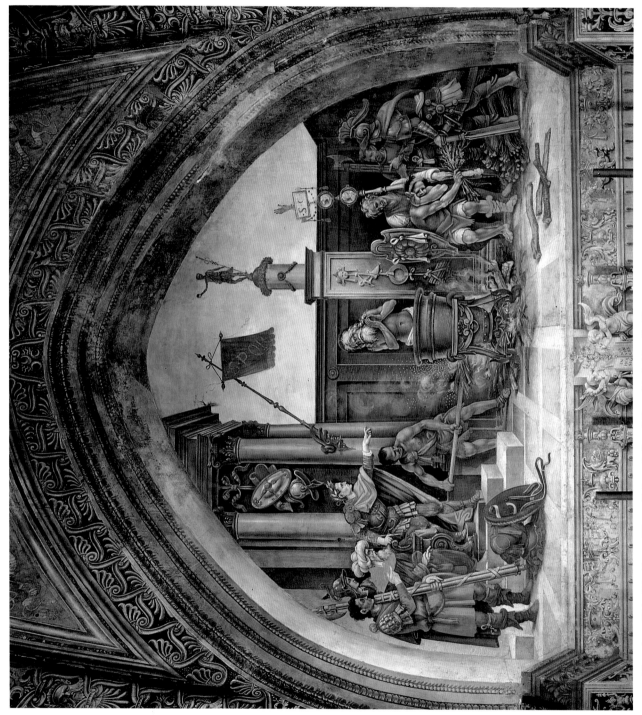

PL.25 *Martyrdom of Saint John.* Fresco. West wall, Strozzi Chapel, Santa Maria Novella, Florence

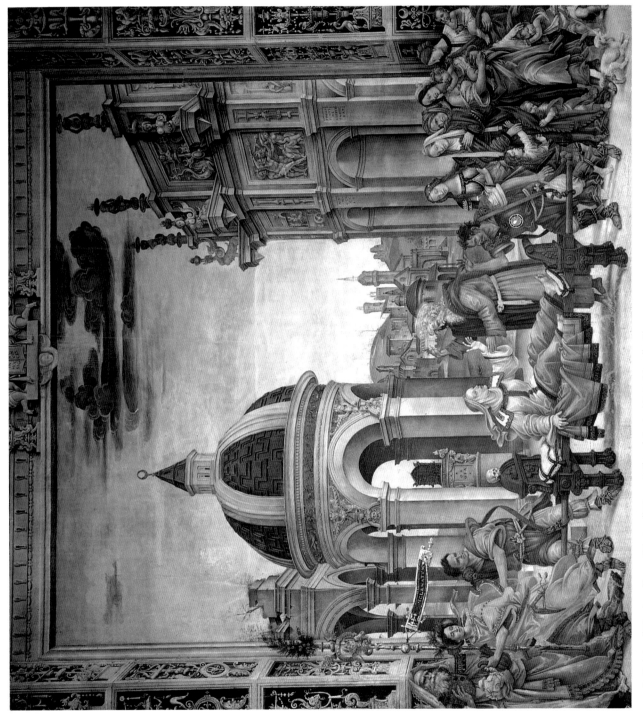

PL. 26 *Raising of Drusiana*. Fresco. West wall. Strozzi Chapel, Santa Maria Novella, Florence

69

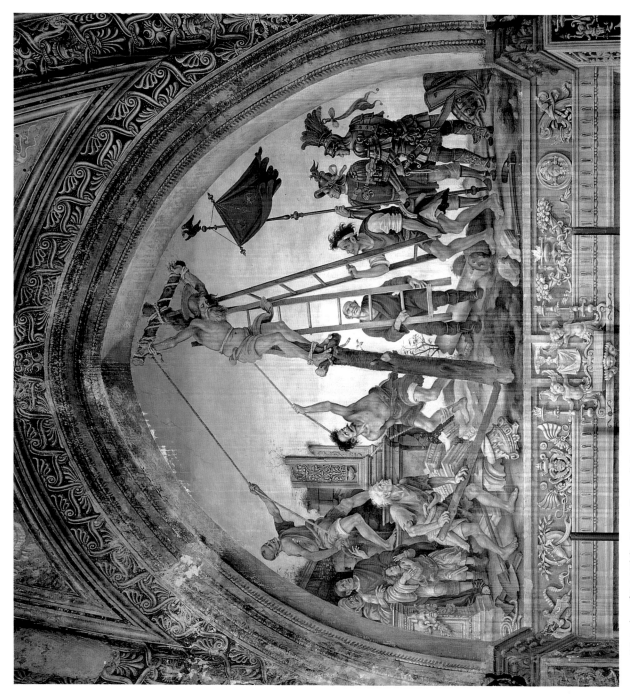

70

PL. 27 *Martyrdom of Saint Philip.* Fresco. East wall, Strozzi Chapel, Santa Maria Novella, Florence

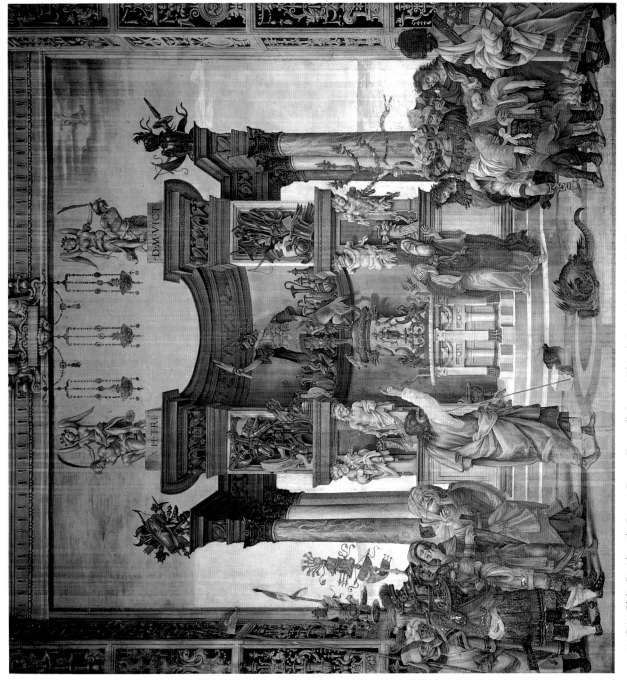

PL. 28 *Saint Philip Banishing the Dragon*. Fresco. East wall, Strozzi Chapel, Santa Maria Novella, Florence

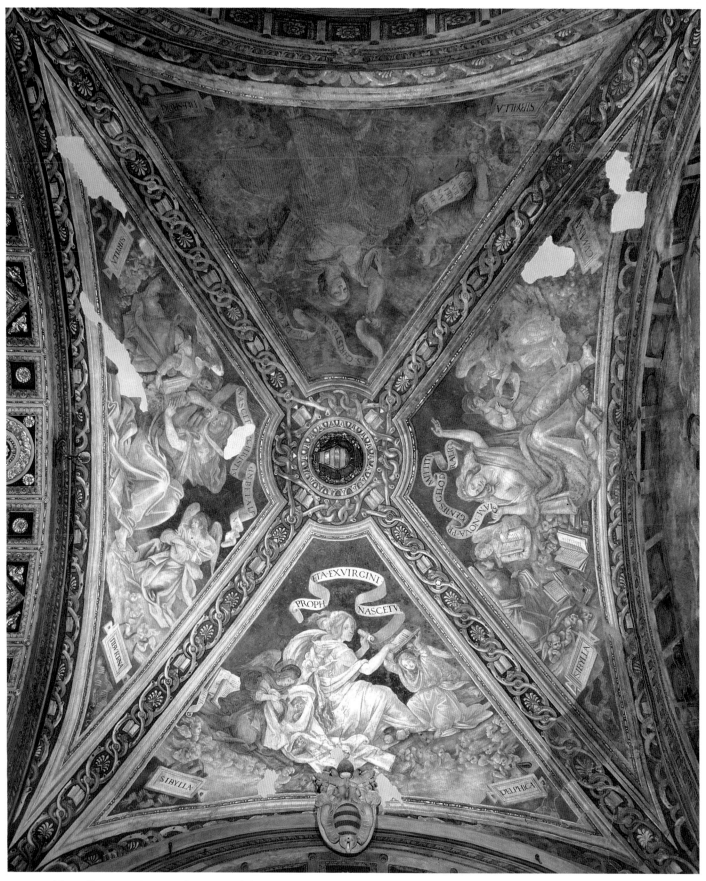

PL.29 *Delphic, Hellespontine, Tiburtine, and Cumaean Sibyls*. Fresco.
Vault, Carafa Chapel, Santa Maria sopra Minerva, Rome

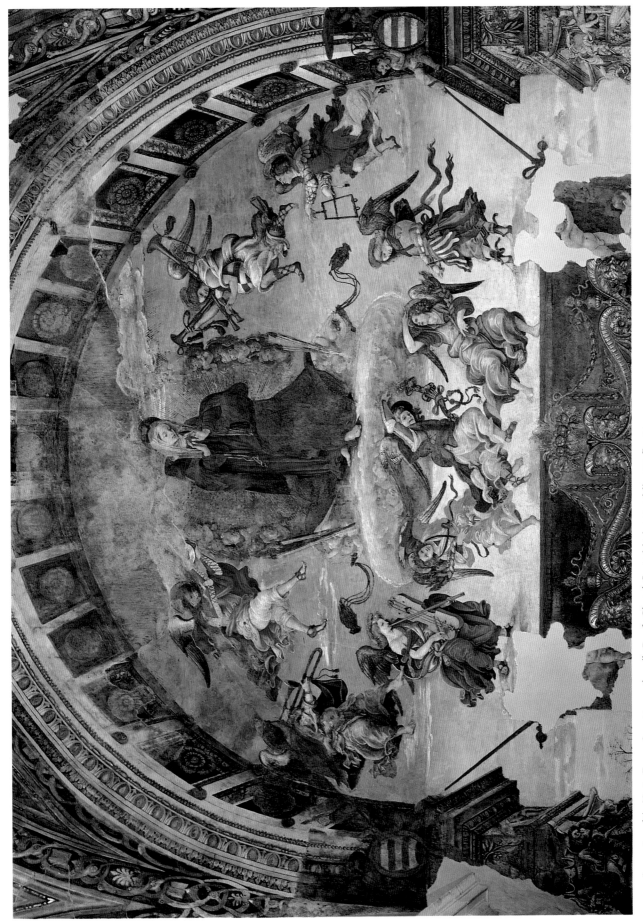

PL. 30 *Assumption of the Virgin*. Fresco. Lunette, south wall, Carafa Chapel, Santa Maria sopra Minerva, Rome

73

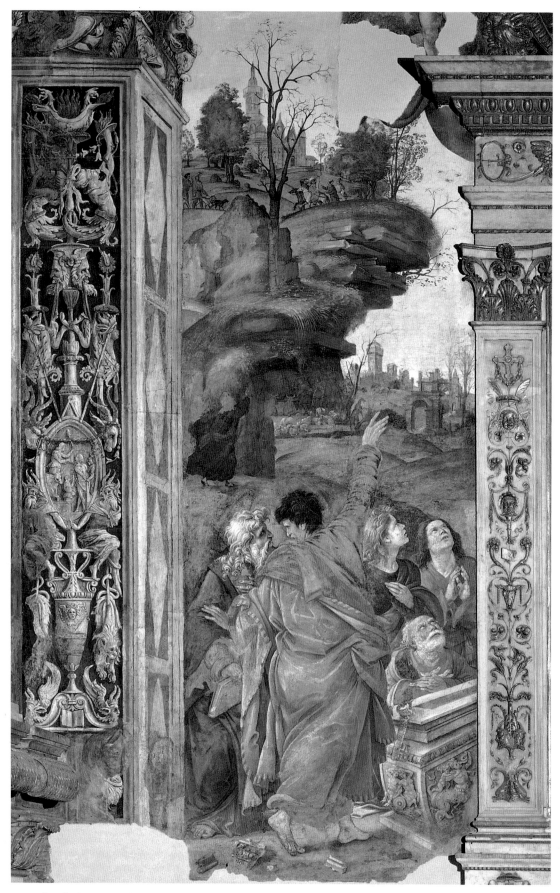

PL.31 Detail, *Assumption of the Virgin*. Fresco. Lower left section, south wall,
Carafa Chapel, Santa Maria sopra Minerva, Rome

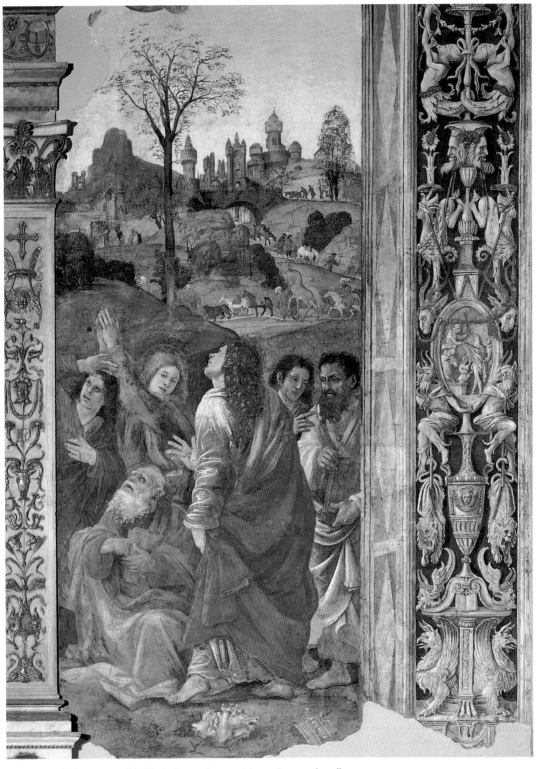

PL. 32 Detail, *Assumption of the Virgin*. Fresco. Lower right section, south wall,
Carafa Chapel, Santa Maria sopra Minerva, Rome

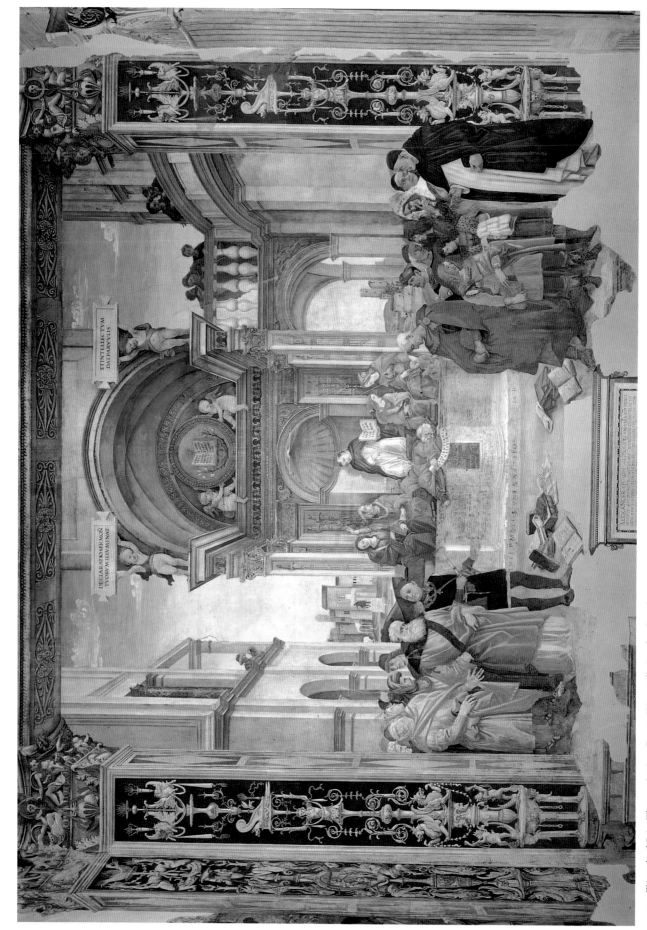

PL. 33 *Triumph of Saint Thomas Aquinas.* Fresco. West wall, Carafa Chapel, Santa Maria sopra Minerva, Rome

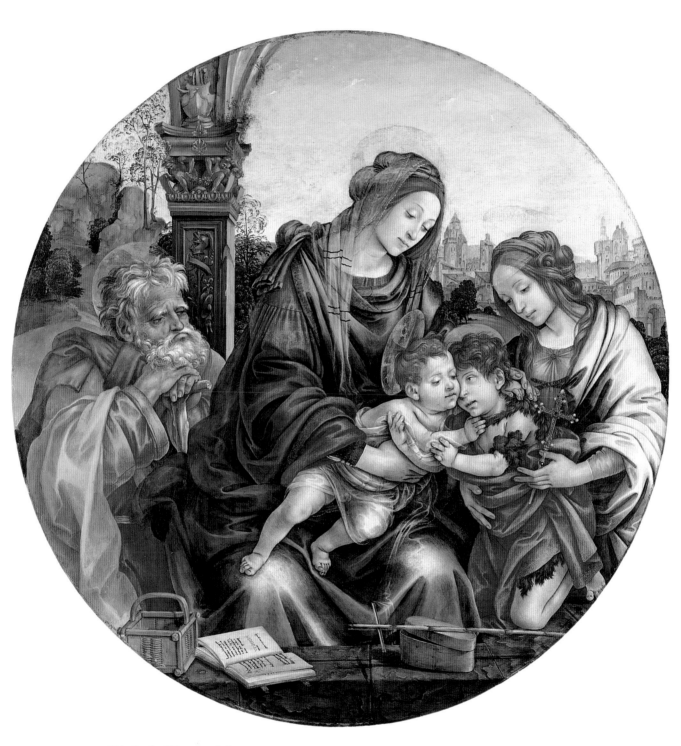

PL. 34 *Holy Family*. Oil on panel, d. 155 cm.
The Cleveland Museum of Art 32.227

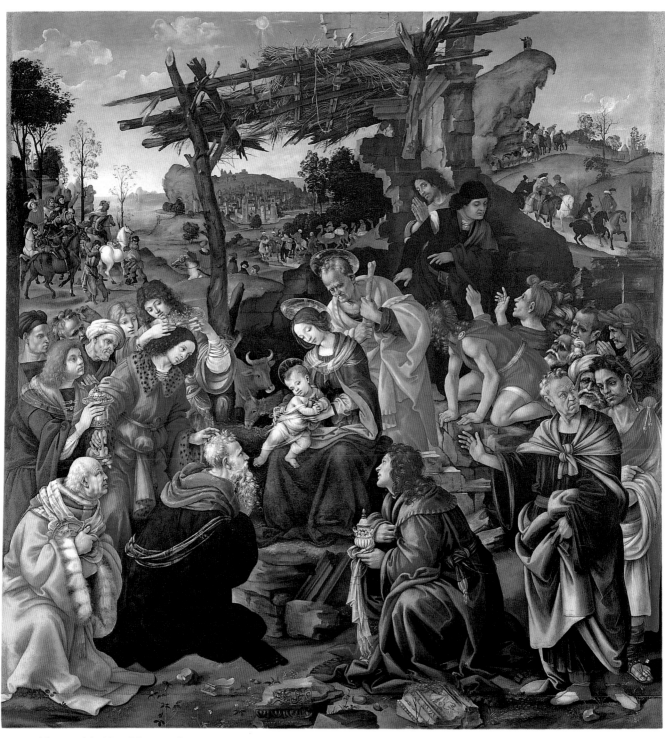

PL.35 *Adoration of the Magi*. Oil on panel, 258 x 243 cm.
Galleria degli Uffizi, Florence 1566

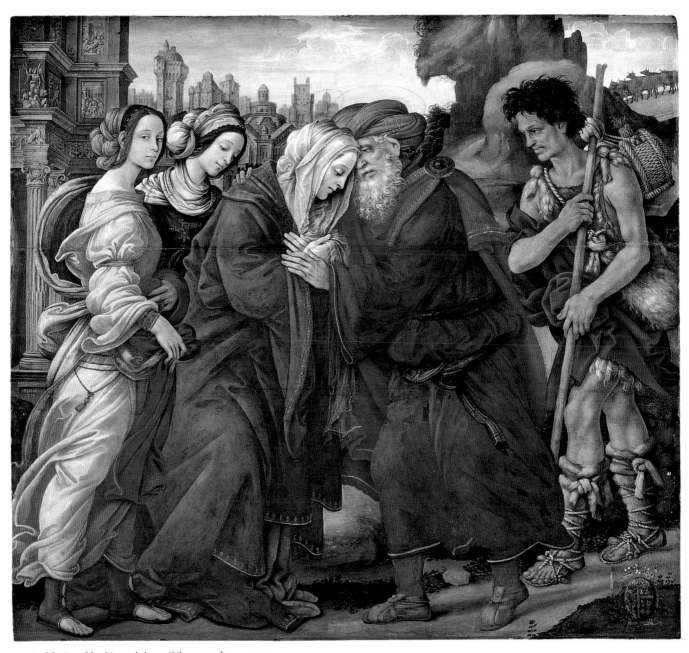

PL.36 *Meeting of Joachim and Anna*. Oil on panel, 111 x 122 cm.
Statens Museum for Kunst, Copenhagen 184

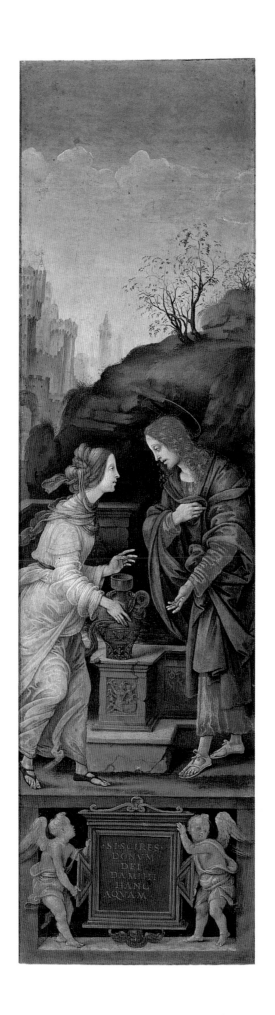

PL. 37 *Christ and the Woman of Samaria
at the Well.* Oil on panel. Pinacoteca
Manfrediniana e Raccolte del
Seminario Patriarcale, Venice 15

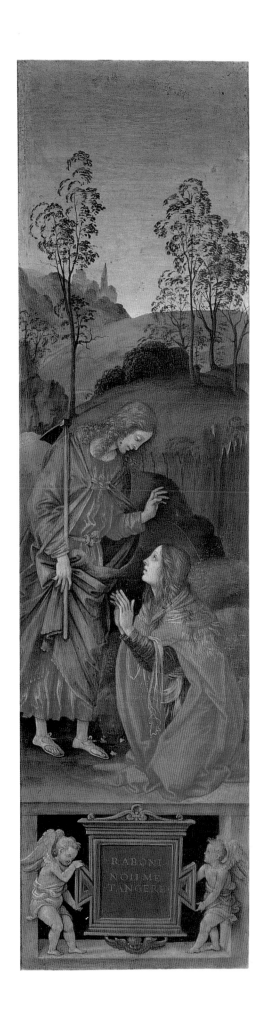

PL. 38 *Noli Me Tangere*. Oil on panel.
Pinacoteca Manfrediniana e Raccolte
del Seminario Patriarcale, Venice 17

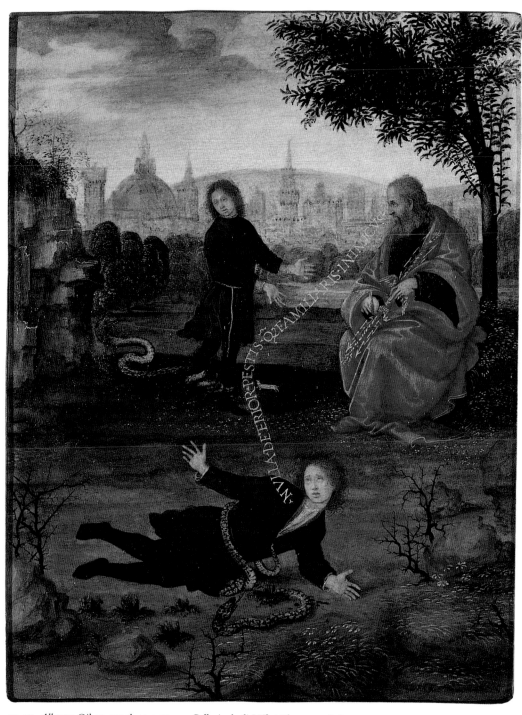

PL.39 *Allegory*. Oil on panel, 29 x 22 cm. Galleria degli Uffizi, Florence 3878

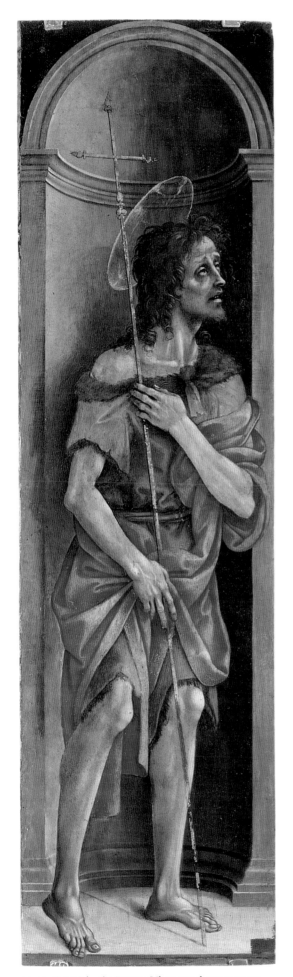

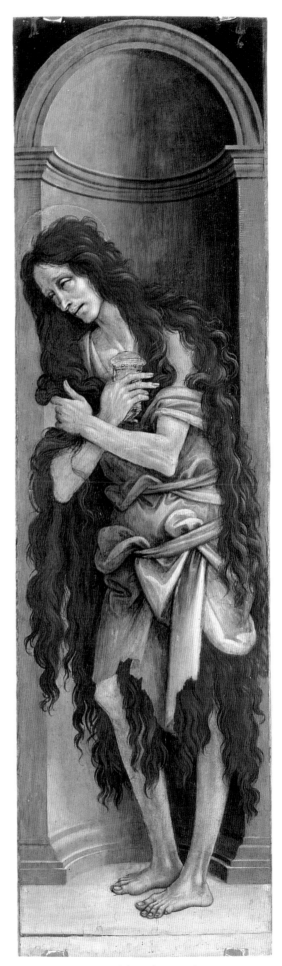

PL.40 *Saint John the Baptist*. Oil on panel, 132 x 55 cm.
Galleria dell' Accademia, Florence 8651

PL.41 *Saint Mary Magdalen*. Oil on panel, 132 x 55 cm.
Galleria dell' Accademia, Florence 8653

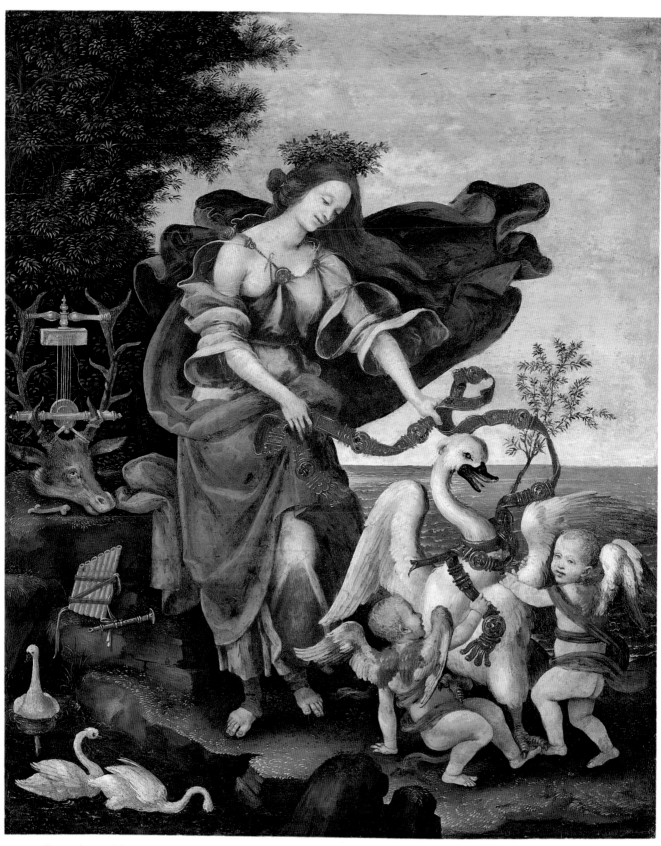

PL.42 *Allegory of Music (The Muse Erato?)*. Tempera on panel, 61 x 51 cm.
Gemäldegalerie, Staatliche Museen, Berlin 78 A

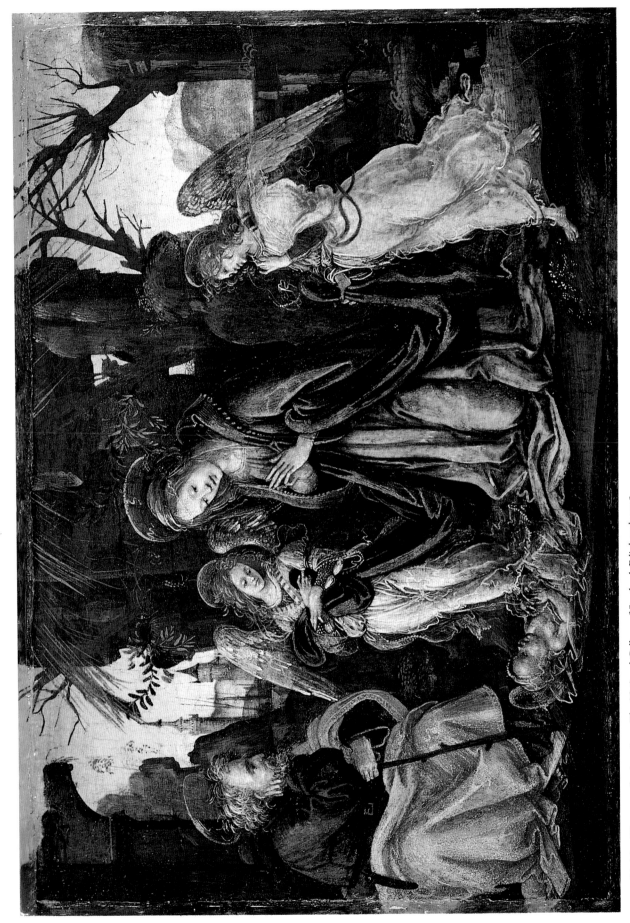

PL.43 *Nativity.* Oil on panel, 26 x 38 cm. The National Gallery of Scotland, Edinburgh 1758

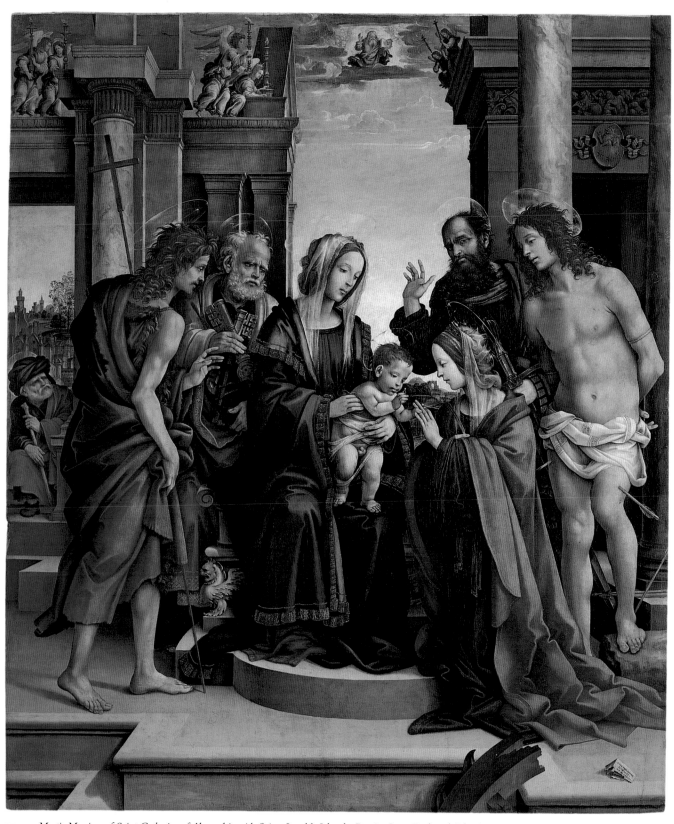

PL.44 *Mystic Marriage of Saint Catherine of Alexandria with Saints Joseph?, John the Baptist, Peter, Paul, and Sebastian.*
Oil on panel, 202 x 172 cm. Isolani Chapel, San Domenico, Bologna

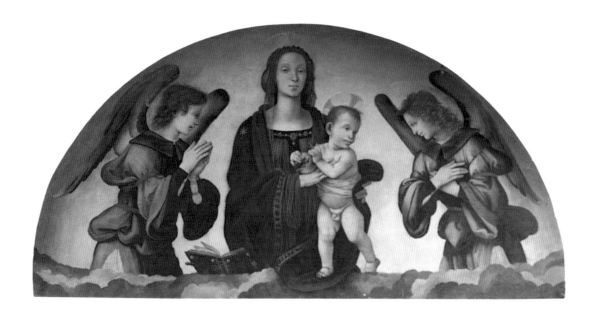

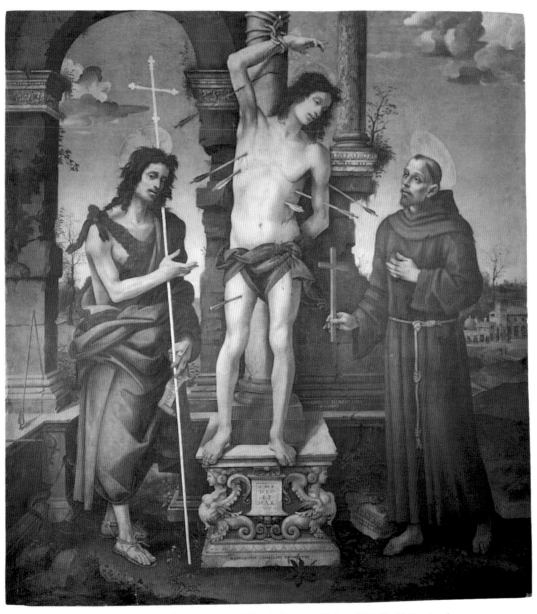

PL.45 *Saint Sebastian between Saints John the Baptist and Francis*; lunette, *Virgin and Child with Two Angels*.
Oil on panel, 301 x 182 cm. Palazzo Bianco, Genoa 12

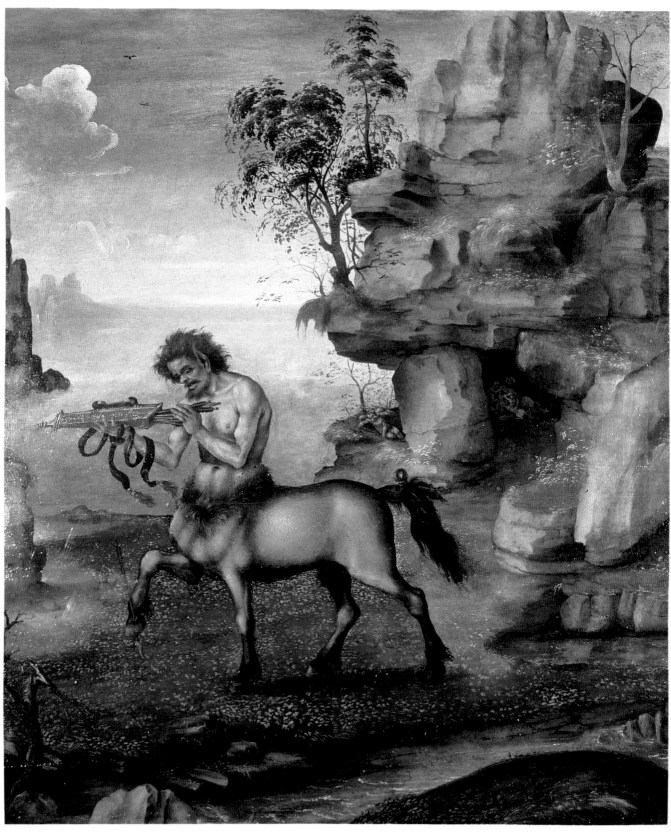

PL.46 *Centaur in a Landscape*. Oil on panel, 77 x 68 cm.
Christ Church Picture Gallery, Oxford JBS 41 recto

FRA FILIPPO LIPPI (CA. 1406–1469)

I *Crucifixion*

Pen and brown ink over traces of leadpoint on paper tinted with orange-red chalk or wash, 133 x 123 mm (5¼ x 4⅞ in.)

Inscribed on recto of mount by nineteenth-century hand: *Gio. Stefano Marceselli*; on verso of mount: *Di mano di Gio. Stefano Marceselli. Il dipinto a fresco è in Pisa sopra la porta del Parlatorio delle convertite esposa al Pubblico.*

British Museum, London 1936-10-10-9

PROVENANCE: Charles Rogers, London (Lugt 625); sale, Thomas Philipe, London, April 18, 1799, lot 408; Hodges (listed on verso of mount); Wadmore; William Bateson, London; his sale, Sotheby's, London, April 23, 1929, lot 44; Henry Oppenheimer, London; his sale, Christie's, London, July 10, 1936, lot 115.

LITERATURE: Berenson 1932b, p. 16, pl. 21; Oppenheimer sale 1936, p. 59, lot 115, pl. 27; Popham 1937a, pp. 127–28, pl. 36; Berenson 1938, vol. 2, no. 1387A, vol. 3, fig. 167; Oertel 1942, no. 5, fig. 5; Pittaluga 1949, pp. 206–7, fig. 144; Popham and Pouncey 1950, no. 149, pl. 140; Berenson 1961, vol. 2, no. 1387A, vol. 3, fig. 168; Degenhart and Schmitt 1968, no. 355, pl. 301a; Marchini 1975, no. F, fig. 180; Ruda 1982, pp. 140–42, fig. 71; Ruda 1993, p. 327, no. D3, pls. 185, 386.

The figures below the cross likely represent, from the left: Saints John the Baptist, Francis, Mary Magdalen (at the foot of the cross), Jerome, and John the Evangelist, with the Virgin and the Holy Women in the foreground. Ruda (1993) has identified the person at the extreme right as a woman, but there is little doubt that he is wrong and the probable candidate is John

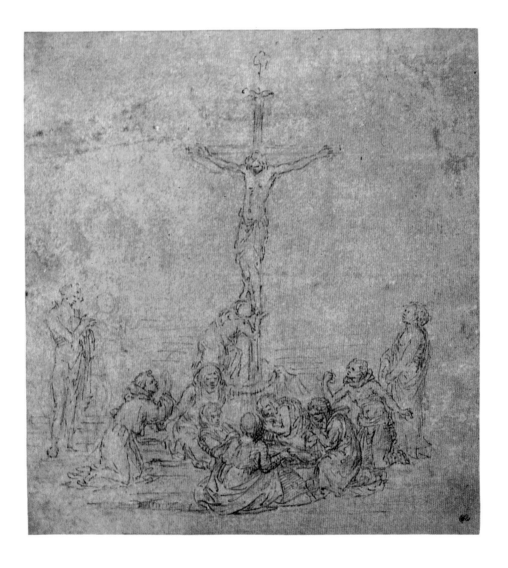

the Evangelist. Fra Filippo indicated an additional standing figure in leadpoint to the right of the Baptist but never completed it in pen and ink.

The attribution of this remarkable drawing to Fra Filippo was first made by Berenson and has been universally accepted.[1] The sheet may have some connection to a painting of the Crucifixion with Saint Jerome that, according to Richa's guidebook of 1754–62 to the churches of Florence, was in the Ginori Chapel in San Lorenzo.[2] Berenson suggested that the compositional format indicates that the drawing is preparatory for a tondo; this possibility cannot be discounted, but the arrangement of figures does not offer strong support to the proposal.

The drawing is admirable in a variety of respects. The elaborate yet firmly unified composition is achieved with great sophistication. Moreover, the short, animated pen strokes lend the forms a dynamism that is unsurpassed in drawings of the first half of the fifteenth century. Here the origin of Filippino's spontaneous use of pen and ink is apparent.

This is one of a handful of surviving pen-and-ink drawings by Fra Filippo Lippi. These few examples— among them a slight, somewhat more atmospheric sketch datable to 1457 in the Archivio di Stato, Florence, and the much more highly worked compositional drawing in Cleveland (cat. no. 3)—provide little basis for dating the *Crucifixion*. It probably can be dated about 1450, however, based on analogies with Fra Filippo's painted work of the period.

GRG

1 The nineteenth-century inscription on the mount attributing the sheet to Giovanni Stefano Marucelli (1586–1646) and claiming that it was made in preparation for a fresco in Pisa has no evidentiary value.

2 Oertel 1942 tentatively identified the drawing with the altarpiece depicting Christ Crucified with Saint Jerome mentioned in Richa 1754–62, vol. 5 (1757), p. 27.

2 *Standing Female Saint Facing Right,* recto
Standing Man Turned to the Left, verso

Metalpoint and brown wash over black chalk, heightened
with white gouache, on salmon pink prepared paper, recto;
metalpoint, heightened with white gouache, on ocher
prepared paper, verso, 308 x 166 mm (12⅛ x 6½ in.)

British Museum, London 1895-9-15-442

PROVENANCE: Jonathan Richardson Sr., London (Lugt 2184);
Benjamin West, London (Lugt 419); Sir Thomas Lawrence,
London (Lugt 2445); Sir John Charles Robinson, London
(Lugt 1433); John Malcolm, Poltalloch and London.

LITERATURE: Robinson 1869, no. 6 (recto only) [ascribed to
Filippo Lippi]; École des Beaux-Arts 1879, no. 13 [attributed to
Filippo Lippi]; Morelli 1892, col. 443, no. 13 [forged]; Ulmann
1894a, p. 322; Berenson 1903, recto: vol. 1, p. 53, pl. XXXV, vol.
2, no. 1387, verso: vol. 1, p. 53 [Fra Diamante]; Ede 1926, p. 17
(recto only); Berenson 1938, recto: vol. 1, p. 82, vol. 2, no.
1387, vol. 3, fig. 169, verso: vol. 1, p. 85, vol. 2, no. 747, vol. 3, fig.
174 [Fra Diamante]; Tolnay 1943a, no. 48, fig. 48 (recto only);
Pittaluga 1949, p. 207, fig. 145 (recto only); Chastel 1950, pl. 36
(recto only); Popham and Pouncey 1950, no. 150, pls. 138, 139;
Grassi 1956, p. 63, fig. 11 (recto only); Dalli Regoli 1960,
pp. 200–202, figs. 25, 27 [attributed to Filippo Lippi]; Royal
Academy 1960, no. 511; Berenson 1961, recto: vol. 1, p. 130, pl.
XXVII, vol. 2, no. 1387, verso: vol. 1, p. 133, vol. 2, no. 747 [Fra
Diamante]; Ames 1962, no. 115 (recto only); Ames 1963, p. 41,
pl. 10 (recto only); Degenhart and Schmitt 1968, no. 360, pl. 303;
Marchini 1975, no. M, figs. 187, 188; Ruda 1982, pp. 143–45,
figs. 73, 74; Ruda 1993, recto: p. 331, no. D8, pls. 188, 393, verso:
p. 331, no. D2, pls. 189, 392.

The figure on the recto of this sheet is usually—and
probably accurately—identified as the Virgin in a
Crucifixion scene. The woman is rendered with a
monumentality of form and grandiloquence of
gesture and facial expression that mark her as one
of the most moving images in Florentine drawing of
the quattrocento. Technically, the sheet documents
the special place Fra Filippo occupies in the devel-
opment of Florentine draftsmanship. Here a complex
combination of media allowed him to create a figure
with spontaneity of line, Masaccesque volume, and
subtle gradations of tone.

 The recto is generally dated toward the end of
Fra Filippo's career, although it cannot be connected
to any known painting. The figure type and expres-
sive character support this opinion, however, as does
the technical richness, which is comparable to that
of the study in the Uffizi for the so-called major-
domo in the Prato frescoes (inv. no. 673 E verso). The
verso is simpler in form and technique. Its figure is
less rounded, and white highlights are applied in a
manner that is not as fully integrated. Some scholars
have therefore separated verso from recto in terms
of hand or date. While there seems to be no reason
to deny Fra Filippo's authorship of the verso, the
style of its figure and drapery is closer than that of the
recto to painted images such as the Saint Jerome in
the right panel of a dismembered altarpiece now in the
Accademia Albertina, Turin (inv. no. 140). This altar-
piece seems to date from about 1440, suggesting that
the verso of the present sheet may precede the recto.

 GRG

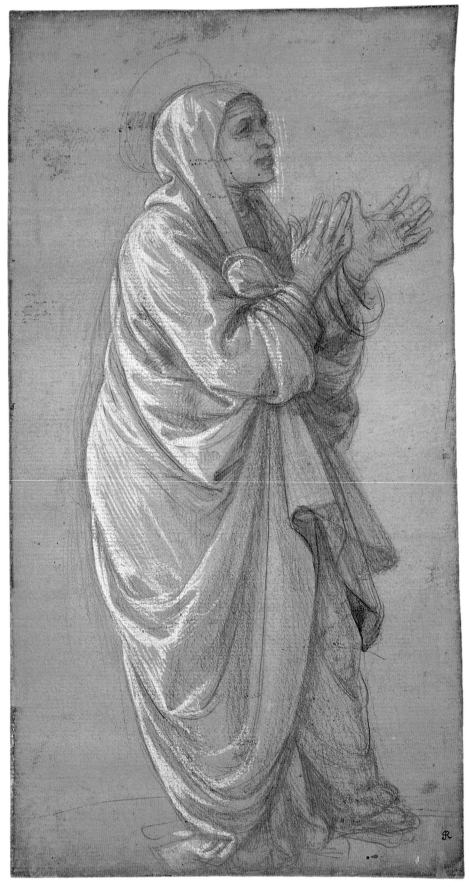

2 RECTO

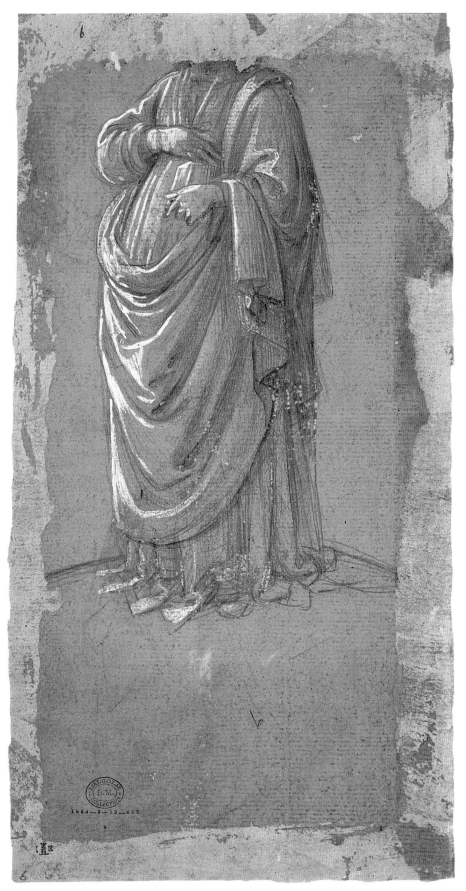

2 VERSO

3 *Funeral of Saint Stephen* or *Celebration of the Relics of Saint Stephen*

Pen and brown ink and brown wash over underdrawing with traces of stylus and leadpoint or black chalk, 250 x 193 mm (9¹³⁄₁₆ x 7⁹⁄₁₆ in.), maximum

Inscribed in brown ink on verso of mount: *Pordonone fece*

The Cleveland Museum of Art, John L. Severance Fund 1947.70

PROVENANCE: Possibly Giorgio Vasari, Arezzo; Ludwig Rosenthal, Bern and Munich; Dr. F. A. Drey, Munich, ca. 1936; Norman Colville, London; Paul Oswald, Locarno; Carl O. Schniewind, Zurich and Chicago; Dr. August Maria Klipstein, Bern; Richard H. Zinser, Long Island, New York; purchased, John L. Severance Fund, 1947.

LITERATURE: Francis 1948, pp. 15–18, cover illus. [Domenico Ghirlandaio?]; Popham and Pouncey 1950, p. 90; Ames et al. 1959, no. 3, pl. 4; Berenson 1961, vol. 2, no. 1387E-2 [School of Fra Filippo Lippi]; Pouncey 1964, p. 287, pl. 35; Degenhart and Schmitt 1968, no. 357, fig. 301b; Pillsbury 1971, no. 51, fig. 51 [ascribed to Fra Filippo Lippi]; Ragghianti Collobi 1971, fig. 4 [Filippo Lippi?]; Borsook 1975, p. 23, fig. 31; Marchini 1975, no. K, fig. 185; Ruda 1982, pp. 152–54, fig. 81 [late fifteenth century, close to Ghirlandaio]; Cadogan 1983, p. 277, n. 20; White 1987, p. 186, n. 18, pl. 47a; Ruda 1993, pp. 342–43, no. DR2, pls. 193, 399 [Domenico Ghirlandaio or follower]; Di Giampaolo 1994, p. 283, fig. 9; Dunbar and Olszewski 1996, no. 4, fig. 4 [Domenico Ghirlandaio].

As Pouncey noted when he attributed the sheet to Fra Filippo Lippi, this is among the most significant composition studies from the quattrocento, breathtaking in the monumentality of its figures and light-filled space. The mourners in the foreground are directly indebted to Masaccio's lost *Sagra* and Brancacci Chapel frescoes. The figural types and airy manner of pen drawing recall Fra Filippo's small composition sketch for a *Crucifixion* in the British Museum (cat. no. 1), while the vigorous, slightly curving parallel hatching evokes the technique in

his more finished metalpoint study in the Uffizi showing Saint Jerome praying (inv. no. 184E verso). The composition is related to the left section of the mural on the bottom tier of the left wall in the cathedral of Prato (fig. 27), part of a cycle Fra Filippo painted between 1452 and 1465. Most scholars believe that the sheet is autograph and a preliminary study for Prato; dissenters consider it a copy after the mural by a contemporary follower of Fra Filippo's or an artist from the succeeding generation—either Domenico Ghirlandaio or someone close to him.

Arguing for the creative, exploratory function of the drawing are significant variations of design with respect to the mural: in the detailing of the church interior, the differences in positioning of individual figures and groups of figures within the composition, and the evocations of figural arrangements not used in the *Funeral of Saint Stephen* mural but present in other frescoes in the cycle. The five figures on the left of the sheet recall the group around the bishop in the *Ordination of Saint Stephen*, painted earlier than the funeral scene. The quickly sketched man on the far right of the drawing, omitted in the mural, captures the type of pose assumed by the young woman at the far right in the later *Feast of Herod*. Furthermore, the drawing's relatively shallow, compartmentalized space is closer to the schemes of Fra Filippo's earlier paintings, such as the Pitti Tondo, about 1452–55 (Galleria Palatina, Florence), than to the unified, plunging recession of the *Funeral of Saint Stephen*. The perspective projection of the church interior in the drawing is intuitive and imprecise, with multiple, nonconvergent orthogonals, whereas in the mural the one-point projection is nearly iconic in its frontality. Comparison of the sheet with Ghirlandaio's composition study for the *Granting of the Franciscan Rule* in the Kupferstichkabinett, Berlin (inv. no. KDZ 4519), clearly reveals new features that mark Ghirlandaio's drawing as a work from a generation later: precisely measured perspective projection, thoroughly constructed with ruled and compass-work underdrawing, and tactile geometric underpinning of figures.

As Borsook has pointed out, this sheet shows that Fra Filippo originally planned to portray a funeral mass as a secondary ceremony unfolding at the altar. By eliminating that detail from the mural, the artist focused attention on the foreground, where he showed the veneration of the body of the dead saint taking place in the nave of the church.[1] Ragghianti Collobi suggested that the sheet may have been included in Vasari's *Libro de' disegni*, based on Vasari's statement in his *Life* of Fra Filippo that drawings of "the chapel in Prato" are in "our book of drawings."[2]

CCB

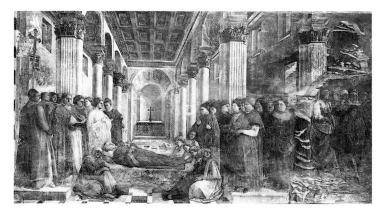

FIG. 27 Fra Filippo Lippi. Detail, *Funeral of Saint Stephen*. Fresco. Choir Chapel, Cathedral, Prato

1 Borsook 1975, p. 23, n. 63.
2 Vasari 1996, vol. 1, p. 443.

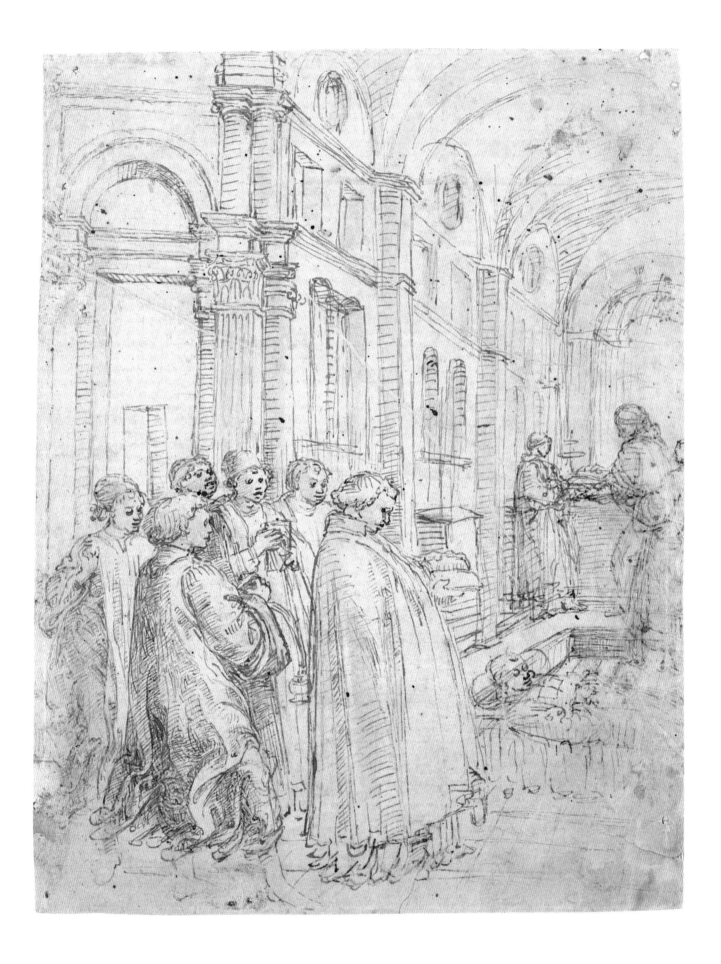

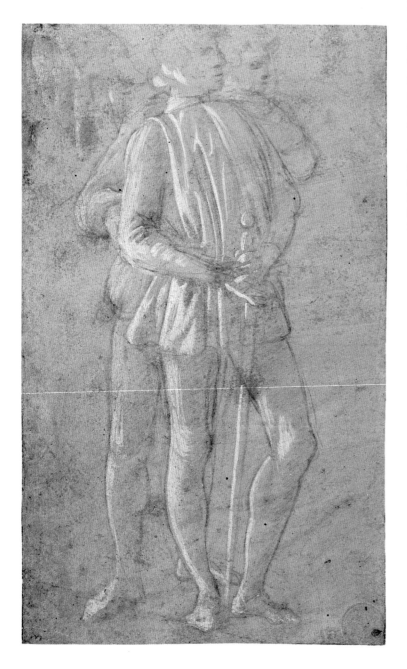

SANDRO BOTTICELLI (1445–1510)

4 *Two Standing Men and Study of a Hand*

Metalpoint, heightened with white gouache, on mauve prepared paper, 165 x 100 mm (6½ x 3¹⁵⁄₁₆ in.)

Inscribed in ink at lower right: *Pl.77*

Palais des Beaux-Arts, Lille Pl.77

PROVENANCE: Jean-Baptiste-Joseph Wicar, Lille (Lugt 2568); acquired 1834.

LITERATURE: Benvignat 1856, no. 398 [Masaccio]; Gonse 1877, no. 398; Pluchart 1889, no. 77; Berenson 1903, vol. 2, no. 838 [David Ghirlandaio, copy after Botticelli]; Berenson 1938, vol. 2, no. 838 [David Ghirlandaio, copy after Botticelli]; Berenson 1961, vol. 2, no. 838 [David Ghirlandaio, copy after Botticelli]; Viatte 1963, no. 57 [School of Filippino Lippi]; Châtelet and Scheller 1968, no. 57, pl. 6 [School of Filippino Lippi]; Châtelet 1970, no. 56 [Filippino Lippi]; Ragghianti and Dalli Regoli 1975, no. 37, pl. 24; Brejon de Lavergnée 1989, no. 4, illus. [Filippino Lippi]; Caneva in Petrioli Tofani 1992, no. 14.2, illus.

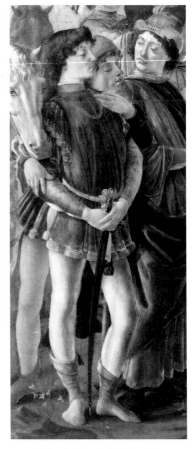

FIG.28 Sandro Botticelli. Detail, *Adoration of the Magi* (Del Lama *Adoration*). Tempera on panel. Galleria degli Uffizi, Florence 882

More than a century ago Gonse recognized that this was a study for the two figures—probably representing Giuliano de' Medici and Angelo Poliziano—at the left of the Del Lama *Adoration* in the Uffizi (fig. 28). Although the connection Gonse made to the painted figures cannot be questioned, his attribution of the drawing to Botticelli was not taken up again until Ragghianti and Dalli Regoli convincingly reasserted it. These authors argue that a number of characteristics mark the sheet as a preparatory study rather than a copy after the painting: the spontaneity of execution, the absence of detail, and the variations between drawing and painting in terms of pose and placement of hands and the expressive nature of pose and gesture.

Two further points in favor of the attribution to Botticelli can be made. There is a sketch of a right hand, barely mentioned in the literature, at the upper left of the sheet. It is, in fact, a study for the right hand of the presumed Poliziano, which appears just below the horse's mouth at the extreme left of the painting. Its presence clearly indicates that Botticelli reconsidered the positioning of the right arm and hand of the figure in the principal drawing, whose somewhat awkward effect he must have recognized. In the painting he altered the composition of the two figures by bringing the right arm of Poliziano around so that his hand rests on the right arm of Giuliano de' Medici. This entailed making a study of the hand, which is precisely what he did in the small sketch above the figures. In addition, the clearly defined outlines—evident even in this quite free and spontaneous study—and the broad application of white highlights correspond closely to features in Botticelli's drawing in Rennes (cat. no. 5). Each sheet is a rare and important example of Botticelli's use of preparatory studies during his early maturity. The relationship to the Del Lama *Adoration* situates the present drawing in 1475.

GRG

5 Head of an Angel

Metalpoint, heightened with white gouache, on gray prepared paper, 205 x 179 mm (8⅛ x 7 in.)

Inscribed in brown ink at upper left: *185*; at lower left: *n°6*; at lower right: *Pollajolo de Florence*

Musée des Beaux-Arts de Rennes 794-1-2504

PROVENANCE: Pierre Crozat, Paris; his sale, Paris, April 10–May 13, 1741; Christophe-Paul de Robien, Rennes; his son, Paul-Christophe de Robien; acquired 1805.

LITERATURE: Berenson 1938, vol. 2, no. 998D [Francesco Granacci, Ghirlandajesque]; Ragghianti 1939, p. XXVI, fig. 3; Bertini 1953, p. 9, pl. 1; Ragghianti 1954, p. 329, n. 5; Laclotte 1956, no. 135, pl. 57.2; Salvini 1958, vol. 1, p. 69, pl. 136; Berenson 1961, vol. 2, no. 998D [Francesco Granacci, Ghirlandajesque]; Bergot 1972, no. 4, pl. 4; Ragghianti and Dalli Regoli 1975, pp. 1, 28, 42, 128, 140, fig. 10; Ramade 1988, pp. 38, 45; Ramade 1990, no. 6, illus.; Caneva in Petrioli Tofani 1992, no. 14.4, illus.

Berenson believed that this drawing was a "Ghirlandajesque" sheet by Granacci. The attribution to Botticelli was made by Ragghianti (1939) and has been maintained by the majority of scholars, although the sheet is occasionally omitted from the literature on the artist. The clarity of form and firmness of line are characteristic of Botticelli's style, as is the sensitive rendering of the facial planes. White highlights are applied with appropriate variation of technique, exemplified in the broad strokes in the hair and the finer modulations of gouache on the face. The metalpoint passages show similar range, from the clear outline along the right side of the face to the quickly sketched thinner lines in the hair.

The sheet has suffered considerably and has been cut down. Nevertheless, it still shows a boldness and plasticity that would account for the early attribution to Pollaiuolo indicated by the inscription at the lower right. The drawing dates from about 1475–80, retaining an evident admiration for the sculptural force of Pollaiuolo and Verrocchio. Ragghianti proposed that it was made as a preparatory study for the angel to the immediate left of the Virgin in the Raczynski Tondo in Berlin (fig. 29). Despite differences in lighting, the two heads are closely similar, indicating that at the very least they were based on the same model and executed within a relatively short span of time. This connection sustains the proposed dating of the drawing.

GRG

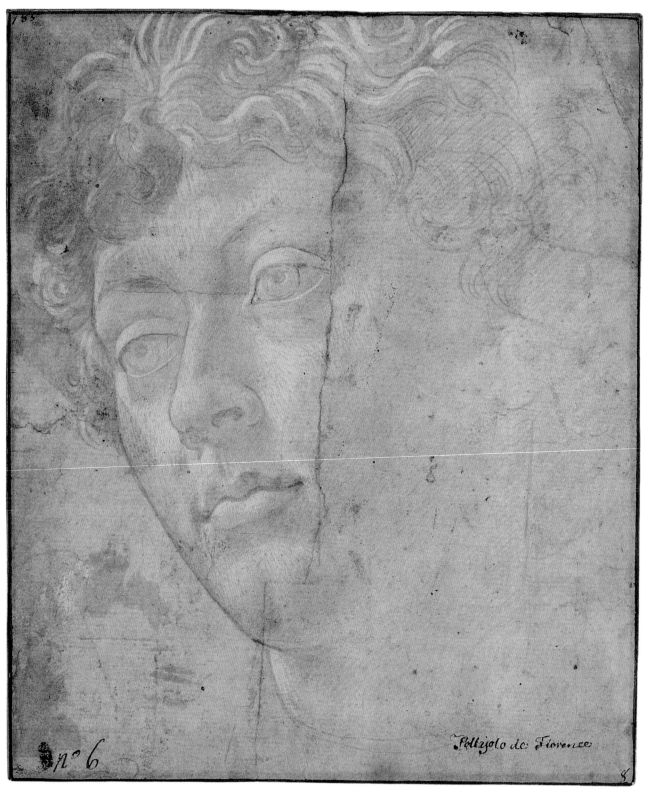

Page from the Libro de' disegni

Framing and decoration by Vasari of ten drawings by Filippino Lippi and attributed to Sandro Botticelli and Raffaellino del Garbo (cat. nos. 6, 51, 64, 66, 79, 80, 84, 107, 108, 117)

Framing and decoration, pen and brown ink and brown and gray wash on light buff paper, 567 x 457 mm (22�5⁄16 x 18 in.)

Inscribed in brown ink on recto and verso in cartouches at lower center of each: *Filippo Lippi Pitt: Fior:*

National Gallery of Art, Washington, Woodner Family Collection, Patrons' Permanent Fund 1991.190.1.a–j

PROVENANCE: Giorgio Vasari, Arezzo; purchased by Niccolò Gaddi, Florence, 1574; possibly Thomas Howard, earl of Arundel and Surrey, England; probably William Cavendish, second duke of Devonshire, Chatsworth; by descent, dukes of Devonshire; sale, Christie's, London, July 3, 1984, lot 46; Ian Woodner, New York; by descent, his daughters, Andrea and Dian Woodner, New York, 1990; purchased 1991.

Vasari approached the design of both the recto and verso of this sheet as if he were an architect and decorator creating grand architectural facades. The recto is thinly framed with a broad, altarlike structure emerging from the flat wall of the page. The supporting consoles at the sides rest on steps and are set between decorative swags of fruit. A cartouche with an inscribed attribution sits on the lower step, and the most important drawing on this side of the page appears to be embedded in the lower section of the structure. That Vasari intended the viewer to understand the white of the sheet as a lighted wall illuminated by a source at the left is suggested by the shadow on the inside of the console at the left. The upper part of the page is dominated by the large drawing resting on the lower entablature, flanked by smaller studies in octagons, all of which are set forward illusionistically from the page. The interplay of "real" drawings and drawn architecture calls to mind elaborate Mannerist wall decorations.

The design of the verso is equally elaborate; less rationally ordered, it is more original than that on the recto. It is dominated by the colored drawing of three saints at the bottom, which is set within a marble frame that is extended by the addition of a pediment. Emerging from behind the pediment is a superstructure framing the drawing with a dancing putto. On either side of the mini-altarpiece showing the saints are niches that contain figure drawings, and all around it is broadly washed shadow. Two fragments depicting torch-bearing angels occupy the upper lateral spaces; lightly sketched clouds suggest that they are set in limitless heavenly space.

GRG

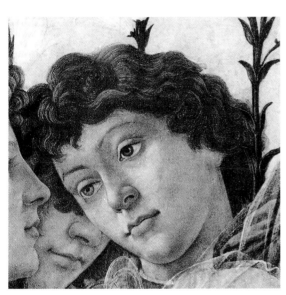

FIG.29 Sandro Botticelli. Detail, *Virgin and Child with Eight Angels* (Raczynski Tondo). Tempera on panel. Gemäldegalerie, Staatliche Museen, Berlin 102 A

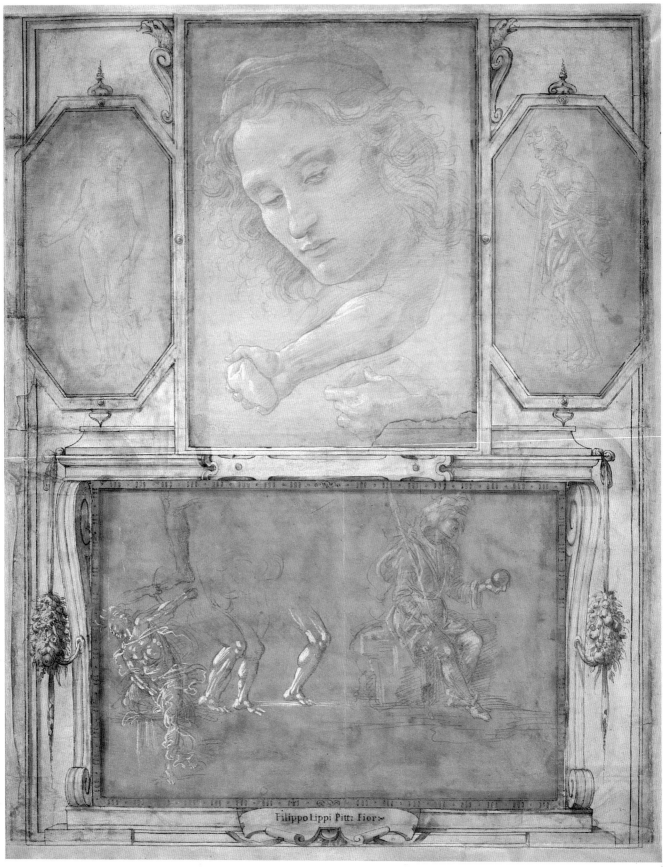

Filippo Lippi Pitt: Fior~

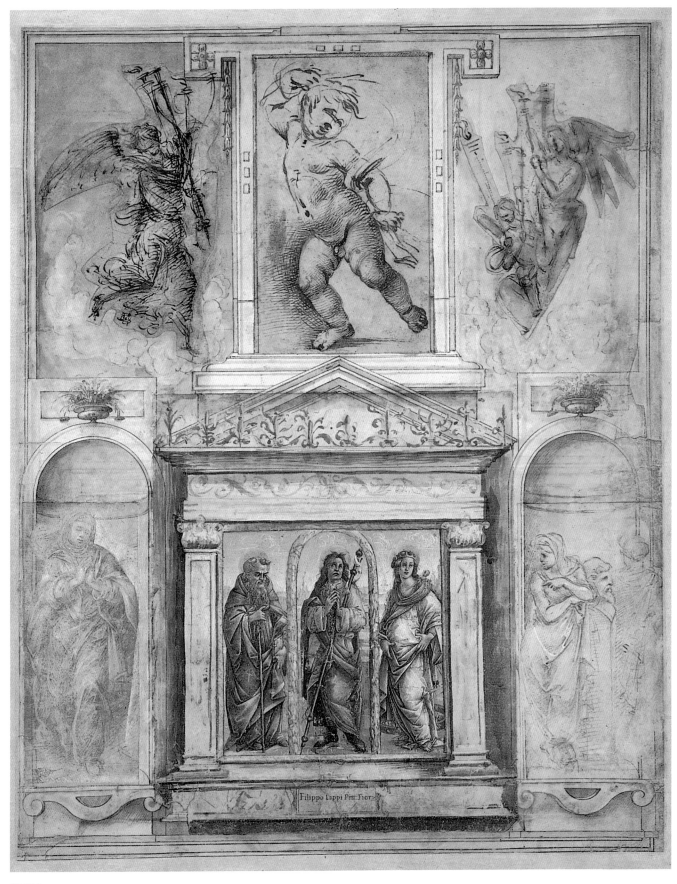

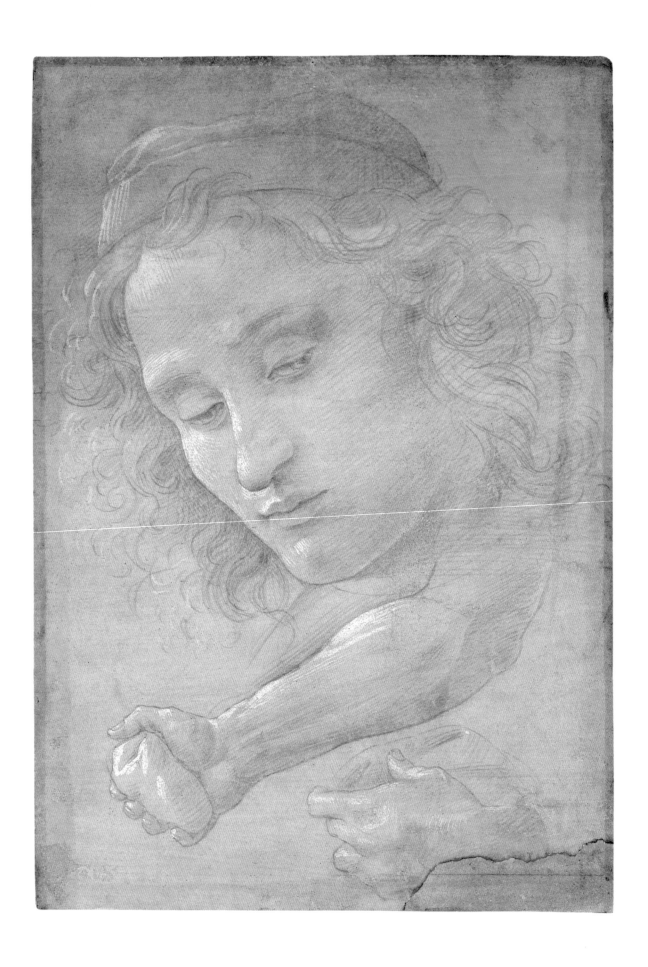

6 *Head of a Youth Wearing a Cap and Studies of a Right Forearm with the Hand Clutching a Stone and a Left Hand Holding a Drapery*, upper center of recto of *Page from the Libro de' disegni*, see p. 99

Metalpoint, heightened with white gouache, on mauve prepared paper, 288 x 201 mm (11⅜ x 7⁹⁄₁₆ in.); lower right corner made up

National Gallery of Art, Washington, Woodner Family Collection, Patrons' Permanent Fund 1991.190.1.a

PROVENANCE: see p. 99.

LITERATURE: Strong 1902, no. 14 [Filippino Lippi]; Berenson 1903, vol. 2, no. 760 [Raffaellino del Garbo]; Vasari Society 1920–35, no. 4 [Filippino Lippi]; Popham 1931, no. 50.2 [Raffaellino del Garbo]; Scharf 1935, no. 292 [Filippino Lippi]; Kurz 1937, p. 14 [Filippino Lippi]; Berenson 1938, vol. 2, no. 760 [Raffaellino del Garbo]; Popham 1949, no. 10 [Raffaellino del Garbo]; Berenson 1961, vol. 2, no. 760 [Raffaellino del Garbo]; Popham 1962, no. 36 [Raffaellino del Garbo]; Popham 1969, no. 36 [Raffaellino del Garbo]; Popham 1973, no. 36 [Raffaellino del Garbo]; Ragghianti Collobi 1974, p. 85, pl. 234 [Raffaellino del Garbo]; Shoemaker 1975, no. 113 [Raffaellino del Garbo]; Bayser 1984, pp. 73–76 [Filippino Lippi]; Miller in Woodner collection 1986a, 1986b, 1986c, no. 24 recto A, illus. [Filippino Lippi]; Wohl 1986, no. 26 recto A [Raffaellino del Garbo or Filippino Lippi]; Melikian 1987, p. 86 [Filippino Lippi]; Turner in Woodner collection 1987, no. 22A, illus. [Filippino Lippi]; Miller (Turner) in Woodner collection 1990, no. 29A, illus. [Filippino Lippi]; National Gallery of Art 1992, pp. 312, 313 [Filippino Lippi]; Gahtan and Jacks 1994, pp. 12, 41, 42, no. 52 [Filippino Lippi]; Jaffé 1994, vol. 1, no. 36 [Filippino Lippi]; Goldner in Woodner collection 1995, no. 9A, illus. [Filippino Lippi].

Over the last decades opinion has been divided concerning whether this study should be attributed to Filippino or Raffaellino. The argument in favor of Filippino rests mainly on analogies with similar heads in his paintings, such as the *Tobias and the Three Angels* in the Galleria Sabauda, Turin. In addition, the quality of the drawing is notably higher—with more refined technique and less prosaic expressive character—than that of any of Raffaellino's known sheets, even the grand design for a Resurrection in the British Museum (cat. no. 112). Yet some well-founded hesitation has been expressed about the attribution to Filippino. The rather firm and hard outline of the face is atypical for him, and the use of metalpoint differs from that found in his many surviving sheets in that medium, including the various head studies of the 1470s and 1480s (cat. nos. 8, 9, 18–20; Musée Condé, Chantilly, inv. no. 23).

A more probable candidate is Botticelli. The strong outlining of the face, the highly refined application of white gouache on the cheeks and forehead, and the

light metalpoint strokes used for modeling and creating areas of shadow visible here all occur as well in the drawing from Rennes that is indisputably by Botticelli (cat. no. 5). Further parallels can be seen in the splendid head of an angel in Botticelli's *Virgin and Child with an Angel*, early 1470s, in Boston (fig. 30): the overall character of the faces, as well as specific details—such as the way the eyes, eyebrows, and sockets are formed—is closely similar in both works. All these analogies argue for an attribution to Botticelli and a date of about 1470, a few years earlier than the somewhat more sophisticated drawing in Rennes.

It should be noted that the hand studies on the lower part of the page may well be less pleasing than the head as a result of the later retouching of the white gouache, which creates a rather crude impression.[1]

GRG

1 The presence of two applications of white highlights in this area was revealed and kindly communicated to me by Shelley Fletcher, Head of Paper Conservation, National Gallery of Art, Washington, D.C.

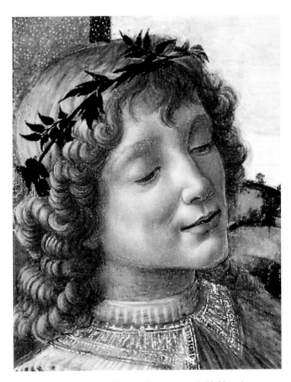

FIG. 30 Sandro Botticelli. Detail, *Virgin and Child with an Angel (Madonna of the Eucharist)*. Tempera on panel, Isabella Stewart Gardner Museum, Boston

7 *Saint John the Baptist Turned toward the Left*

Pen and brown ink and brown wash, heightened with white gouache, over traces of leadpoint or black chalk, with traces of pen-and-brown-ink framing outlines, on paper rubbed with reddish chalk around main figure, 358 x 157 mm (14¹⁄₁₆ x 6³⁄₁₆ in.), maximum; scattered losses along borders and corners

Inscribed in brown ink on scroll by the artist: *ECE AGNUS . . .* ; at lower left, probably by Filippo Baldinucci: *[san]dro [D? or B?] Botticello*

Gabinetto Disegni e Stampe degli Uffizi, Florence 188 E

PROVENANCE: Houses of Medici and Lorraine (manuscript inventory written by Giuseppe Pelli Bencivenni before 1793); museum stamp (Lugt 930).

LITERATURE: Ferri 1890, p. 34, no. 188; Schönbrunner and Meder 1896–1908, p. 262; Van Marle 1923–38, vol. 12 (1931), pp. 198–99, fig. 118; Berenson 1938, vol. 1, pp. 94–95, vol. 2, no. 563, vol. 3, fig. 196; Salvini 1958, p. 44, pl. 23; Berenson 1961, vol. 1, p. 144, vol. 2, no. 563, vol. 3, fig. 189; Grassi 1961, p. 181, fig. 58; Bertini 1968, p. 3, pl. 2; Lightbown 1978, vol. 1, p. 151, vol. 2, no. D4, fig. D4; Petrioli Tofani 1986, no. 188 E; Caneva in Petrioli Tofani 1992, no. 14.6, illus.

Baldinucci's early attribution of this sheet (indicated by his inscription) has been widely accepted. On the basis of style, the drawing is often dated between 1483 and 1490; it seems most appropriate to place it in the mid-1480s, at the moment of the Bardi Altarpiece (Gemäldegalerie, Berlin), which was painted in 1484. The sinewy protagonist of the drawing finds parallels with the depiction of Saint John in three of Botticelli's altarpieces, although none of these paintings offers a precise correspondence of design: the Bardi Altarpiece, the San Barnaba Altarpiece, 1480–90 (Uffizi, Florence), and the *Trinity and Saints*, about 1490–95 (Courtauld Institute Galleries, London). In fact, the differences between the highly finished drawing, which exhibits no visible pentimenti, and these paintings are sufficiently significant to suggest that the sheet was probably not preparatory for any of them. It is more likely, however, that the drawing served as an attractive *ricordo* or exemplum to be copied and adapted for use in the workshop, for figures of Saint John the Baptist were commonly included in altarpieces by Botticelli and his circle. Such a function would explain the treatment of the saint as an isolated figure devoid of background context and the careful drawing technique, which integrates exquisitely pictorial calibrations of drawing media and ground with disciplined use of hatching for shadows and white highlights. It would also account for the generic nature of the gesture of John's empty hand, which holds neither scroll nor draperies nor attributes. Filippino characteristically used figure drawings as exempla, and throughout his career he included remarkably Botticellian Saint John types in his altarpieces.

CCB

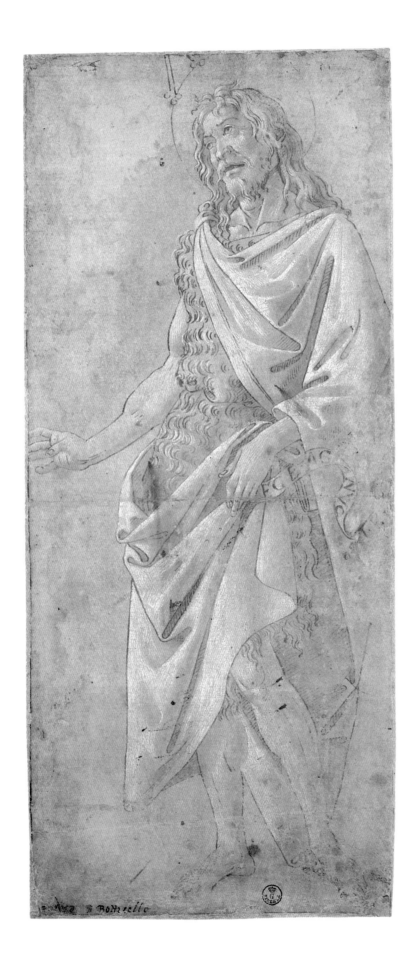

8 *Head of a Young Woman*

Metalpoint, heightened with white gouache, on paper rubbed lightly with reddish chalk, 214 x 173 mm (8⅜ x 6¹³⁄₁₆ in.), maximum; corners cropped

Inscribed in black ink on recto at lower left: *17.*; in graphite on verso toward top: *1156E / Botticelli*

Gabinetto Disegni e Stampe degli Uffizi, Florence 1156 E

PROVENANCE: Houses of Medici and Lorraine (manuscript inventory written by Giuseppe Pelli Bencivenni before 1793); museum stamp (Lugt 930).

LITERATURE: Ferri 1890, p. 36, no. 1156 [Sandro Botticelli]; Ulmann [1893], p. 88, n. 1 [Sandro Botticelli]; Schönbrunner and Meder 1896–1908, vol. 3, no. 248 [Sandro Botticelli]; Berenson 1903, vol. 1, p. 70, vol. 2, no. 48 [Amico di Sandro]; Scharf 1935, p. 78; Berenson 1938, vol. 1, p. 336, vol. 2, no. 1313B, vol. 3, fig. 233; Fossi [Todorow] 1955, no. 2; Berenson 1961, vol. 2, no. 1313B, vol. 3, fig. 211; Shoemaker 1975, no. 1; Petrioli Tofani 1987, no. 1156 E.

9 *Head of a Young Woman in a Cap with Downcast Eyes*

Metalpoint, heightened with white gouache, on paper rubbed lightly with reddish chalk, 245 x 184 mm (9¹¹⁄₁₆ x 7¼ in.), maximum; corners cropped

Inscribed in graphite on recto at lower left: *17.*; on verso along top: *N 53 esp / Botticelli*

Gabinetto Disegni e Stampe degli Uffizi, Florence 1153 E

PROVENANCE: Houses of Medici and Lorraine (manuscript inventory written by Giuseppe Pelli Bencivenni before 1793); museum stamp (Lugt 930).

LITERATURE: Ferri 1890, p. 36, no. 1153 [Sandro Botticelli]; Ulmann [1893], p. 88, n. 1 [Sandro Botticelli]; Schönbrunner and Meder 1896–1908, vol. 3, no. 254 [Sandro Botticelli]; Berenson 1903, vol. 1, p. 70, vol. 2, no. 47 [Amico di Sandro]; Scharf 1935, p. 78 [discusses without attribution]; Berenson 1938, vol. 1, p. 336, vol. 2, no. 1313A, vol. 3, fig. 232; Fossi [Todorow] 1955, no. 1; Berenson 1961, vol. 2, no. 1313A, vol. 3, fig. 212; Grassi 1961, p. 185, fig. 63; Spencer 1966, pp. 27–28, fig. 3; Shoemaker 1975, no. 2; Petrioli Tofani 1987, no. 1153 E; Dalli Regoli 1992, p. 69, fig. 10 [Sandro Botticelli?].

Executed in the identical technique and of comparable dimensions, these large-scale studies of heads

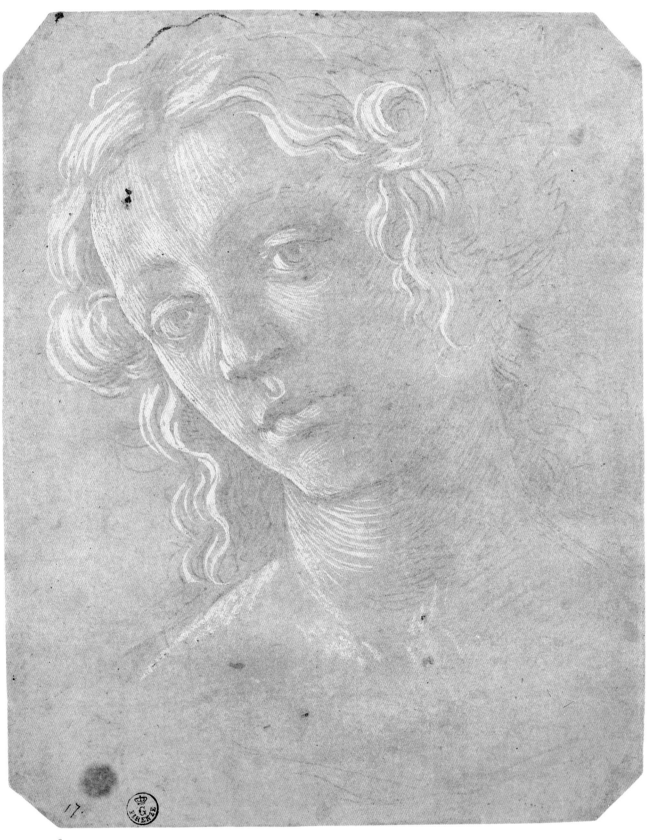

Executed in the identical technique and of comparable dimensions, these large-scale studies of heads must originally have formed part of the same sketchbook or model book. They constitute the core of a group of drawings first attributed by Berenson (1903) to the fictitious master Amico di Sandro, who was later recognized by Scharf and Berenson himself (1938) to be the young Filippino Lippi. The Uffizi heads must be among Filippino's earliest extant drawings, as they reflect the styles of both Fra Filippo Lippi and Sandro Botticelli in the late 1460s. These stylistic precedents point to an earlier dating for the two drawings than is usual in the literature: about, or before, June 1472, when the young artist was recorded as an assistant in the workshop of Botticelli in the Libro Rosso of the Lay Brotherhood of Saint Luke. Probably preparatory for a figure of the Virgin, the *Young Woman in a Cap* especially recalls the head types of Fra Filippo's late Virgins, but in reverse, notably the Virgin and Child panels in the Museo di Palazzo Medici, Florence, and the Alte Pinakothek, Munich, as well as the *Coronation of the Virgin* fresco in the apse of the cathedral of Santa Maria dell'Assunta, Spoleto. This head type also recurs in Botticelli's early Virgins, for example the panels probably from about 1467–70 in the Museo e Galleria Nazionale di Capodimonte, Naples, and the Uffizi, Florence, as well as the Del Lama *Adoration* of about 1475 in the Uffizi. As Ulmann first pointed out, the head in the other sheet recalls the head of Venus in Botticelli's *Primavera*, about 1478 (Uffizi, Florence).

With their clear description of form on a large scale, the present drawings probably offered useful models for private devotional paintings of the Virgin and Child, which must have constituted the young Filippino's bread and butter as he began his career as an independent painter. The facial type of the woman in a cap is, in fact, close to Filippino's Virgin and Child panels in the Museo Bandini, Fiesole; National Gallery, London; and Szépmüvészeti Múzeum, Budapest (pl. 2), while that of the other sheet recalls paintings in the Musée Jacquemart-André, Paris (fig. 31), and Gemäldegalerie, Berlin.[1] All of these panels are datable to the second half of the 1470s; however, the broad execution of the drawings, as well as their somewhat stunted treatment of the head as fragments, seems the work of an artist younger than the one responsible for the delicate, refined form and more fluent figural vocabulary in the paintings.

CCB

FIG.31 Here attributed to Filippino Lippi. *Virgin and Child.* Tempera on panel. Musée Jacquemart-André, Paris

1 The attribution of the Fiesole (inv. no. 1914 II, 15) and Paris panels to the young Filippino is unpublished. For the other examples, see Scharf 1935, pp. 106, 108–9, nos. 18, 32, 36, 39; and Neilson 1938, pp. 26–27.

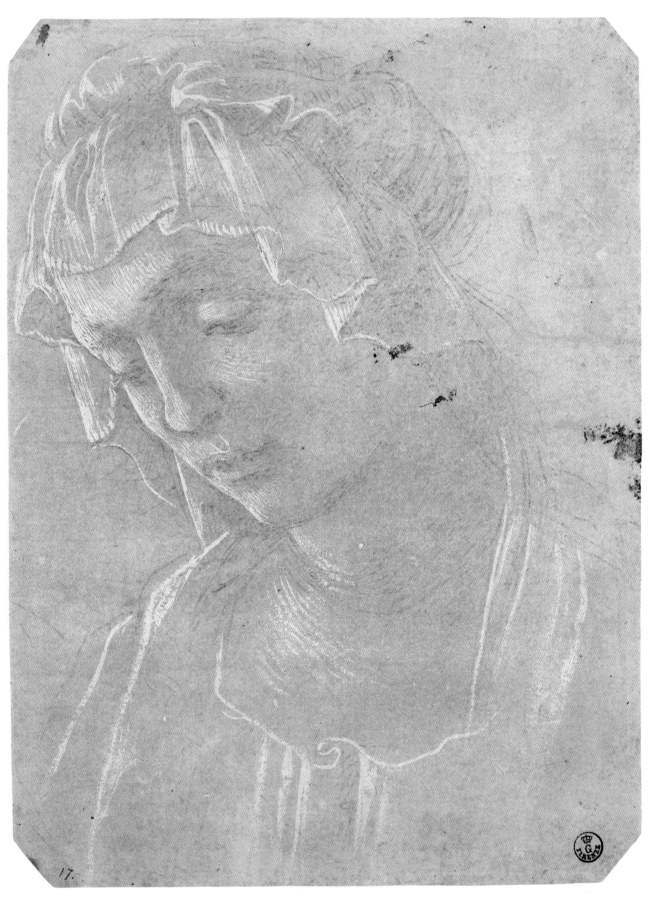

17.

9

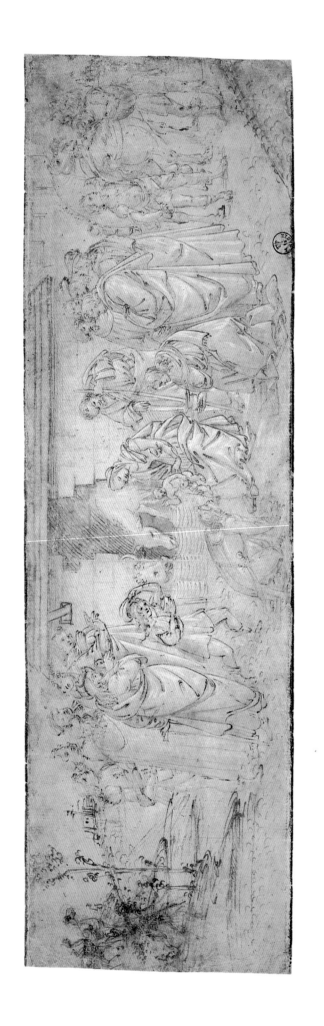

10 *Adoration of the Magi*

Pen and brown ink and brown wash over traces of black chalk on yellow-tinted paper, 107 x 355 mm (4¼ x 14 in.)

Inscribed in brown ink on verso by early, probably sixteenth-century, hand: *Sandro.BL.*

Gabinetto Disegni e Stampe degli Uffizi, Florence 210 E

PROVENANCE: Museum stamp (Lugt 930).

LITERATURE: Ferri 1890, p. 35, no. 210 [Sandro Botticelli]; Berenson 1903, vol. 1, p. 71, vol. 2, no. 45 [Amico di Sandro]; Van Marle 1923–38, vol. 12 (1931), p. 262, fig. 166 [Amico di Sandro]; Scharf 1935, no. 179, fig. 143; Berenson 1938, vol. 1, p. 336, vol. 2, no. 1303A, vol. 3, fig. 239; Fossi [Todorow] 1955, no. 3; Berenson 1961, vol. 1, pp. 158–59, vol. 2, no. 1303A, vol. 3, fig. 216; Grassi 1961, p. 186, nos. 66, 67; Shoemaker 1975, no. R.2; Petrioli Tofani 1986, no. 210 E; Cecchi in Petrioli Tofani 1992, no. 7.17, illus.

The drawing has long been attributed to Botticelli, as the inscription on the verso attests, and is catalogued as such by Ferri. In the first edition of his catalogue Berenson proposed that an imaginary Amico di Sandro was the author of this sheet and other drawings in the same Botticellian style, a judgment shared by Van Marle. Berenson, however, later recognized the hand of the young Filippino Lippi, active in Botticelli's workshop and therefore influenced by him, but possessing his own humorous and charming sensibility—particularly noticeable in the paintings, and quite different from his master's more controlled feeling. Since then the attribution to Filippino has been accepted generally, meeting with the approval of Scharf and Fossi, among others.

In recent years only Shoemaker has thought that the hand of an unknown follower of Botticelli's could be discerned in the present drawing. Her suggestion is not convincing, for, in fact, Filippino, the talented young follower of Sandro, was at work here, still operating within the same Botticellian system visible in many paintings of his youthful period—such as the *Adoration of the Magi* in the National Gallery, London (pl. 7), with its space inhabited by bizarre and expressive small figures. Nevertheless, Filippino used precise and agitated contours, accompanied by rapid, summary touches of white gouache, to define the facial features and draperies that already show a subtle eccentricity, which would become more marked in his mature career.

The present sheet should be placed within the years 1475 to 1480, the period of the stylistically similar London *Adoration* and the five *Story of Esther* paintings—panels now in Florence, Vaduz, Paris, and Chantilly (pl. 4)—which are also among the youthful works once attributed to the Amico di Sandro.

AC

Page from the Libro de' disegni

Framing in passe-partout by Vasari of two drawings by Filippino Lippi (cat. nos. 11A, B)

Framing, pen and brown ink and brown and gray wash, 565 x 450 mm (22¼ x 17¹¹⁄₁₆ in.)

Inscribed in brown ink on recto at lower center by Vasari: *Filippo Lippi Pittor' Fior:* ; on verso at lower center by Vasari: *Filippo Lippi P:*

Christ Church Picture Gallery, Oxford JBS 33

PROVENANCE: Giorgio Vasari, Arezzo; probably Niccolò Gaddi, Florence, 1574; probably Salomon Gautier, Amsterdam and Paris; General John Guise, London; his bequest, 1765.

LITERATURE: Colvin 1907, pls. 6, 7; Bell 1914, p. 63; Berenson 1938, vol. 2, nos. 1355B (recto), 853A (verso [David Ghirlandaio]); Berenson 1961, vol. 2, nos. 1355B (recto), 853A (verso [David Ghirlandaio]); Byam Shaw 1972, no. 39, illus.; Ragghianti Collobi 1974, p. 85, figs. 235, 236; Shoemaker 1975, nos. R.14A, B [workshop of Filippino Lippi]; Byam Shaw 1976, no. 33, pls. 35, 36; Ames-Lewis and Wright 1983, no. 38, pl. 12.

Vasari was the earliest systematic collector who considered issues of quality and historical significance in amassing holdings that spanned the development of Italian draftsmanship from Cimabue to his own time. His drawings were concrete companions to his written *Lives*, exemplifying the work of his predecessors and contemporaries while at the same time providing a sample of their creative activity.

The drawings Vasari collected were mounted on large pages, with frames and other decorations that he drew himself, as well as cartouches with his own attributions at their bottoms. Here he created double-sided mounts framing two sheets by Filippino. The framing ornament on the recto is the more elaborate one, including a richly varied scrollwork pattern. Wash is added in numerous places to suggest shadow and the three-dimensional actuality of the frame. Byam Shaw (1976) has plausibly suggested that the falcons at the upper corners may refer to the device of the collector Niccolò Gaddi, who very probably inherited the *Libro*. Vasari's design for the illusionistic frame of the verso has relatively few ornamental details.

GRG

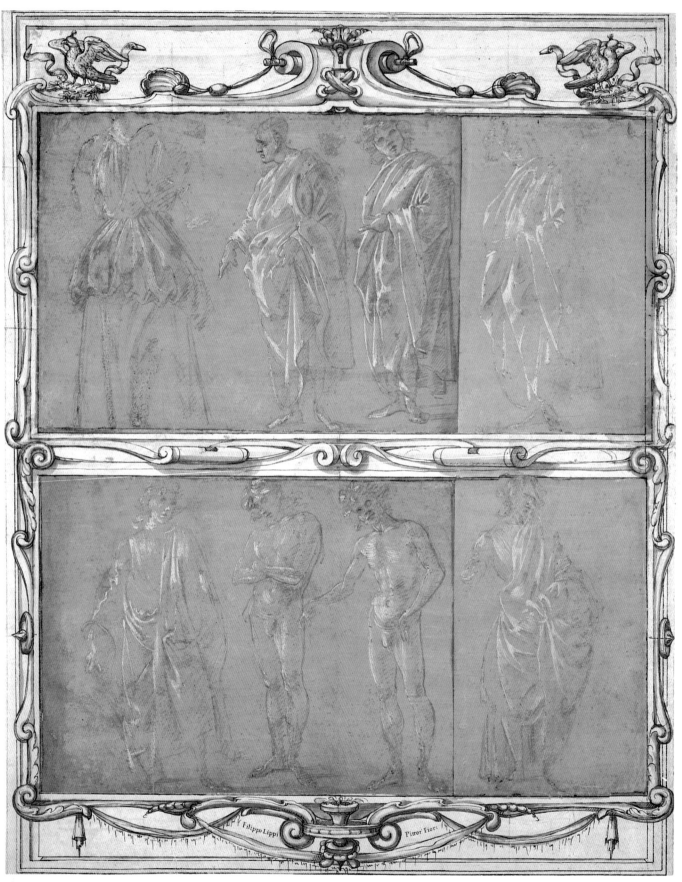

RECTO

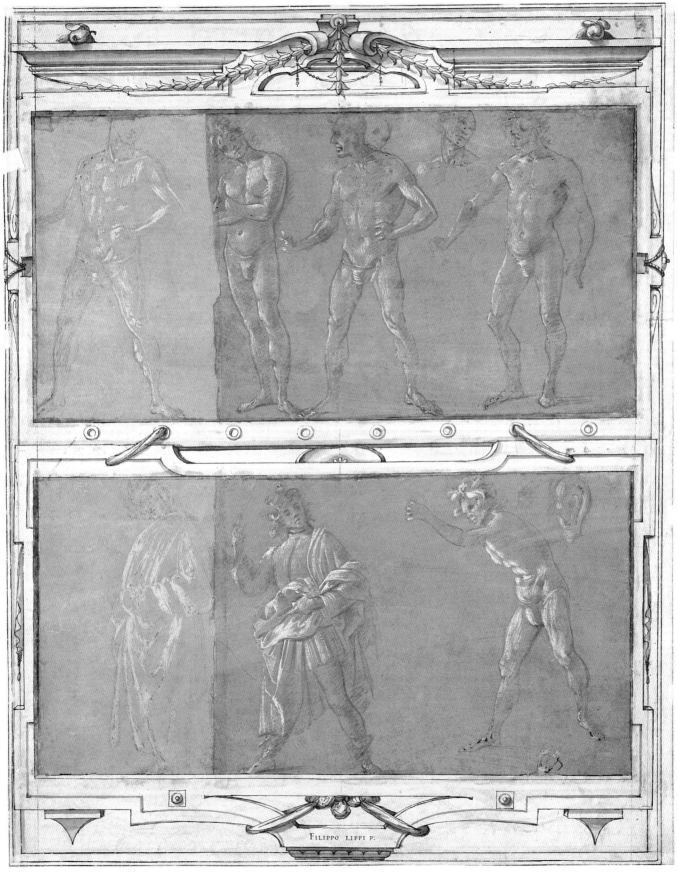

FILIPPO LIPPI P:

Two double-sided sheets in Vasari's passe-partout
(described on p. 111)

11A *Drapery Study, Elderly Standing Man
Facing Left, and Two Studies of a Standing
Man* (the last on a separate piece of paper), recto

*Standing Male Nude with His Head Turned
to the Right, Standing Male Nude, Elderly
Standing Male Nude Turned to the Left
(with a Pentimento of His Head), and
Standing Male Nude Turned to the Left*
(the first on a separate piece of paper), verso

Metalpoint, heightened with white gouache, on slate blue
prepared paper, sheet extended at right (recto) with lighter
tone of same color, 207 x 415 mm (8⅛ x 16⁵⁄₁₆ in.)

11B *Standing Man, Two Standing Male Nudes,
and Standing Man* (the last on a separate piece
of paper), recto

*Two Standing Men, Male Nude Facing Left,
and Study of an Ear* (the first on a separate piece
of paper), verso

Metalpoint, heightened with white gouache, on slate blue
prepared paper, sheet extended at right (recto) with lighter
tone of same color, 207 x 408 mm (8⅛ x 16 in.)

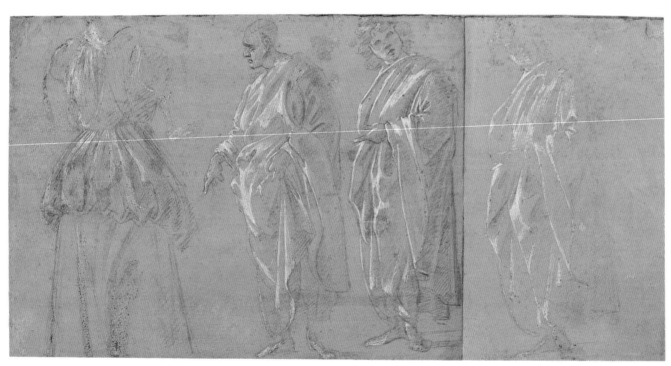

11A RECTO

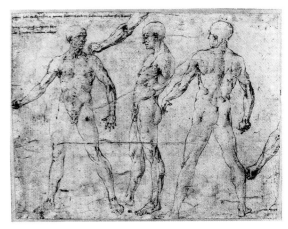

FIG. 32 Antonio Pollaiuolo. *Nude Seen from the Front, Side, and Back*. Pen and brown ink with traces of brown wash and stylus incisions, 264 x 351 mm. Département des Arts Graphiques du Musée du Louvre, Paris 1486

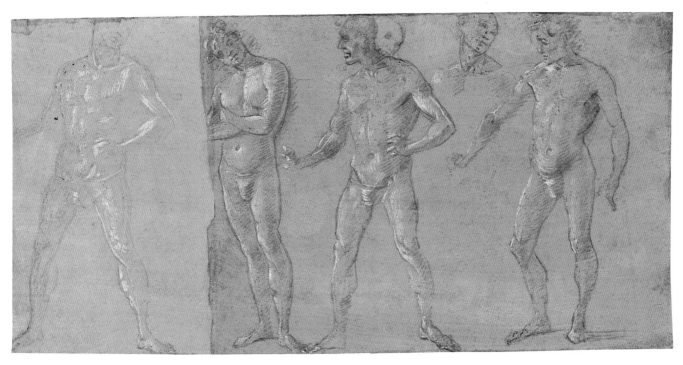

IIA VERSO

The principal sections of drawings A and B were prepared in the same color; given this and their similarities of scale and format, it is very likely that they were originally part of one sheet. By the same token, the smaller sections added to A and B display drawings executed on an identical but lighter ground in a closely similar manner, suggesting that they formed part of a second original sheet made at the same time as the first.

The various studies on this page have had a curiously negative critical history. Vasari's attribution to Filippino was rejected or ignored by most specialists, while Berenson idiosyncratically gave both rectos to Filippino and both versos to David Ghirlandaio. It was Byam Shaw (1972) who restored them to their rightful place as early works by Filippino. He noted that Lord Crawford suggested a relationship between the figure at the left of B verso and the standing man

at the right of Botticelli's Del Lama *Adoration* of about 1475. Whether directly related or not, the figures are close enough to support the placement of these sketches in Filippino's most Botticellian phase. By contrast, the more robust nude studies recall the explorations of this genre pursued by Pollaiuolo and Verrocchio, for example the former's sheet of anatomical studies in the Louvre (fig. 32). The figure at the right of B verso is somewhat akin to the striding young men at the left and center of Filippino's *Story of Virginia* panel in the Louvre (pl. 6), a work that seems to belong to the mid- to late 1470s.

The manner of composing these studies with firm, continuous outlines again shows the strongly Botticellian origins of Filippino's early draftsmanship, whereas the rapidly sketched white highlights are early indications of his tendency toward spontaneous handling of media.

GRG

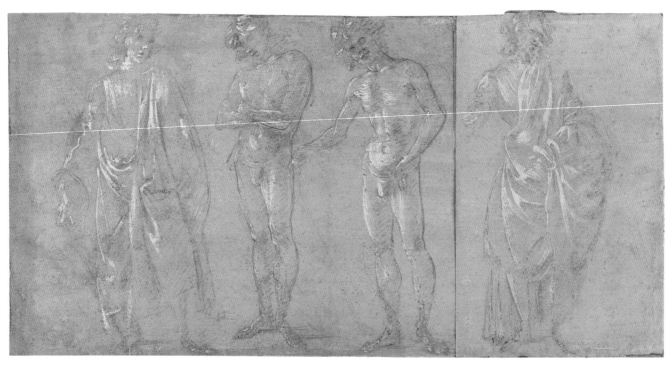

11B RECTO

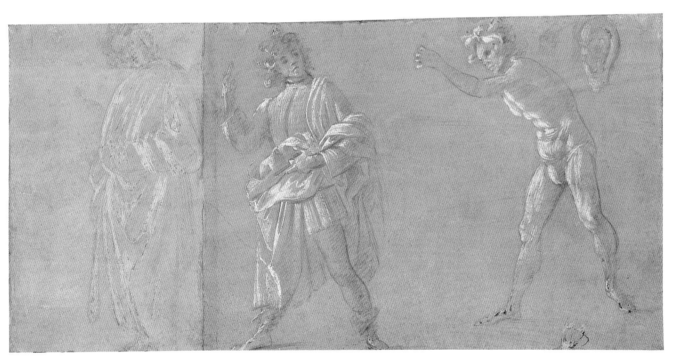

IIB VERSO

12 *Standing Young Man with His Hands Folded in His Sleeves*

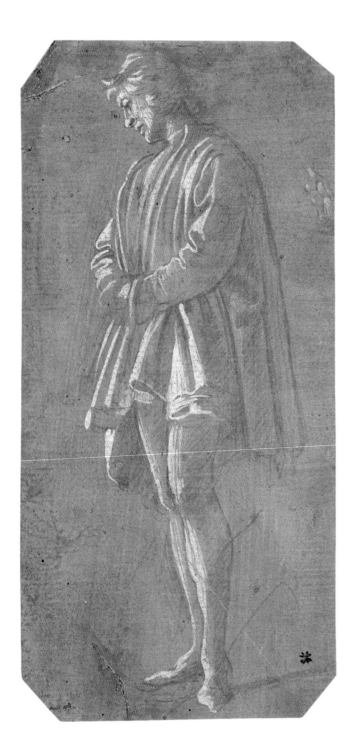

Metalpoint, heightened with white gouache, on purple-pink prepared paper, 182 x 87 mm (7⅛ x 3⅜ in.); corners chamfered, mounted in full

Duke of Devonshire and the Chatsworth Settlement Trustees, Chatsworth 886 A

PROVENANCE: Nicholas Lanier, London (Lugt 2886); dukes of Devonshire, Chatsworth.

LITERATURE: Thompson 1929, no. 886a [David Ghirlandaio];[1] Byam Shaw 1969, no. 33A, illus. [Filippino Lippi or Raffaellino del Garbo]; Ragghianti and Dalli Regoli 1975, p. 74, no. 2, pl. 16; Shoemaker 1975, no. R.12 [workshop of Filippino Lippi]; Ames-Lewis and Wright 1983, no. 30A, pl. 11; Jaffé 1994, p. 72, no. 37, illus.

The fingers of an outstretched hand just visible on the right edge of the sheet suggest that this drawing may once have contained a second figure, presumably lost when the page was trimmed to its current dimensions (sometime before the seventeenth-century collector Nicholas Lanier placed his stamp in the lower right corner).

Filippino's early, cautious manipulation of the metalpoint stylus is in evidence here. The elegant features and sweet, melancholy air of the young figure testify to his experience in Botticelli's workshop, suggesting a date of the mid- to late 1470s. Already in this youthful work, Filippino's own interests are apparent. The hesitant passages of metalpoint record an exploration of volumetric form, while the more fluid application of the white heightening—indicating contours rather than atmospheric effects—reveals the young artist's concern with its calligraphic potential. The present drawing's strong correspondences to other early figure studies by the artist (such as cat. no. 13) and its unusually high quality confirm the attribution to Filippino.

EEB

1 In a note entered in Thompson's typescript catalogue in 1943, Popham attributed the drawing to David Ghirlandaio.

13 *Seated Man with Clasped Hands,* recto
 Seated Man Holding a Staff, verso

Metalpoint, heightened with white gouache, on gray prepared
paper; verso retouched with pen and brown ink, 188 x 132 mm
(7⅜ x 5¼ in.)

Inscribed in black chalk on verso at lower right corner: *19*

The Pierpont Morgan Library, New York II, 72–73

PROVENANCE: Duke of Cambridge, England; Charles Fairfax
Murray, London and Paris.

LITERATURE: Fairfax Murray 1905–12, vol. 2, nos. 72, 73;
Buffalo 1935, no. 17, illus. (recto); Scharf 1935, nos. 270, 271;
Berenson 1938, vol. 2, no. 1353D; Pierpont Morgan Library
1939, p. 20, no. 66; D'Otrange-Mastai 1955, p. 140, fig. 5
(recto); Berenson 1961, vol. 2, no. 1353D; Ames 1962, no. 121,
illus. (recto); Shoemaker 1975, no. 12.

Bright, densely packed strokes of white gouache stand
out against the heavy metalpoint lines and soft gray
ground preparation of the drawing on the recto of
this sheet. Such areas of striking contrast and hard
articulation yield to subtler passages, where the metal-
point has lightly traced more delicate forms in
glittering, gold-colored lines. The refined handling
of the metalpoint and the elegant facial features of
the figure recall the style of Sandro Botticelli, in
whose workshop Filippino was employed in 1472.

Although the seated man's contemplative,
Botticellian countenance is particularly compelling
for modern viewers, the thick masses of drapery
that engulf him were the principal subject of the
study. His cloak is modeled in strong chiaroscuro yet
appears strangely flat and insubstantial, the effect
of an unsettling double vantage point. Whereas the
model's head and torso are depicted straight on,
the lower body is drawn as if viewed from above.
The resulting low, elongated lap is characteristic of
Filippino's drawn and painted figures of the mid- to
late 1470s, such as the figure of the Virgin in the *Virgin
and Child with Saint Anthony of Padua and a Monk*
in Budapest (pl. 2). The Virgin in the Budapest panel,
dated to about 1475, is similarly engulfed in long
draperies that fall from the knee in a few simple folds.

The verso of the sheet is more freely sketched than
the recto. The expansive pose of the seated figure, which
reaches beyond the limits of the page, conveys a
sense of monumentality, while the spontaneous
metalpoint technique energizes the image. Despite its
abbreviated handling, the drawing on the verso shares
significant technical and stylistic characteristics with
the more finished study on the recto. Specifically, the
thin application of ground color, which allows the
grain of the paper to remain visible; the careful
articulation of youthful facial features; and the uncer-
tain conception of volume on both sides of the sheet
record Filippino's practices in the period immediately
following his work in the studio of Botticelli.

EEB

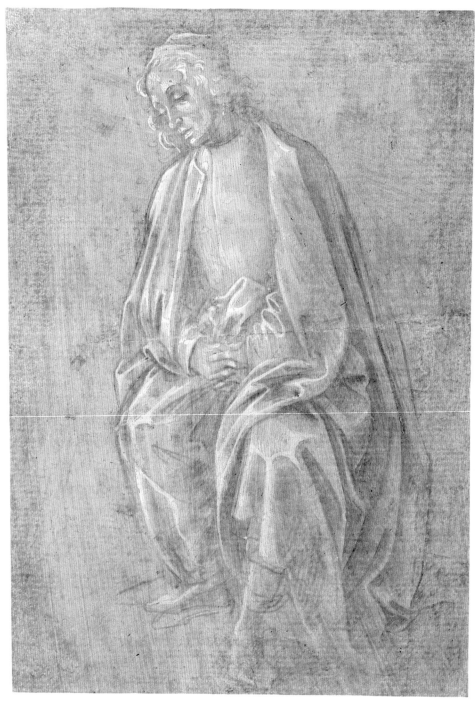

13 RECTO

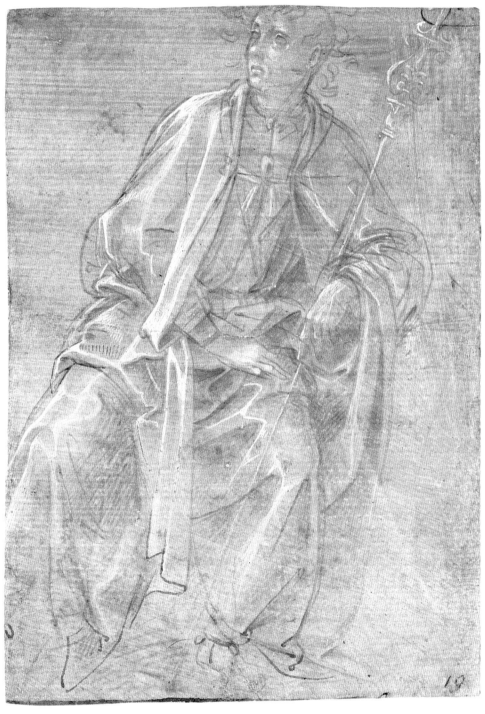

13 VERSO

14 *Seated Man Turned to the Right*, recto
Standing Man with His Foot on a Ledge, verso

Metalpoint and pen and brown ink, heightened with white gouache, on gray prepared paper, 200 x 110 mm (7⅞ x 4⁵⁄₁₆ in.)

Département des Arts Graphiques du Musée du Louvre, Paris
RF 432

PROVENANCE: Aimé-Charles-Horace His de La Salle, Paris (Lugt 1333); his gift, 1878.

LITERATURE: Ulmann 1894c, p. 113 [Raffaellino del Garbo]; Berenson 1903, vol. 2, no. 1362; Scharf 1935, p. 127, no. 274; Berenson 1938, vol. 2, no. 1362; Berenson 1961, vol. 2, no. 1362, vol. 3, fig. 220 (recto); Shoemaker 1975, no. 11.

The figure on the recto was composed with firm outlines and varied metalpoint shading that lend a textural quality less evident in the slightly earlier studies of seated men in the Morgan Library (cat. no. 13). The application of white heightening follows the contours of the drapery with considerable animation but, like the metalpoint strokes, is carried out with restraint. Filippino integrated the pose of the figure in space and foreshortened the legs with greater success than in the Morgan Library sheet but revealed little of the structure of the form beneath the elaborate drapery. There are notable pentimenti in both feet, showing the artist wrestling with the problem of the figure's spatial placement.

The verso is drawn in a very similar manner, with a comparable tendency to mask the form of the figure beneath a complex and full drapery pattern. The pose is rather ambitious and looks forward to that of the seated soldier at the right of *Saint Peter Liberated from Prison* of about 1480–83 (fig. 33) in the Brancacci Chapel. The drawing is less advanced than the frescoed figure, suggesting that the former should be dated to the late 1470s.

GRG

FIG. 33 Detail, *Saint Peter Liberated from Prison*. Fresco. North wall, Brancacci Chapel, Santa Maria del Carmine, Florence

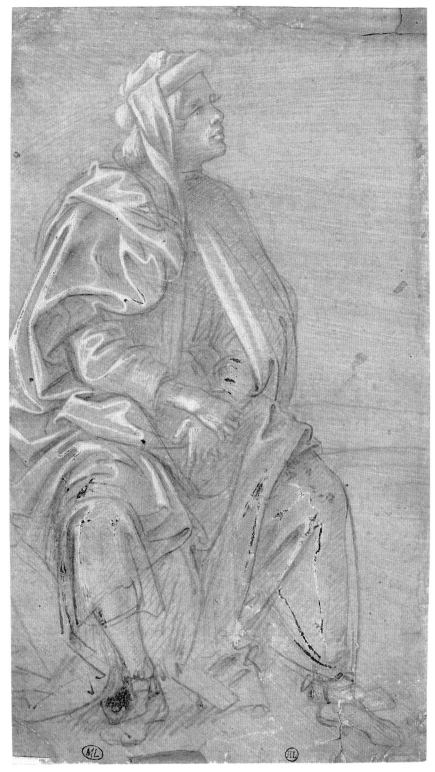

14 RECTO

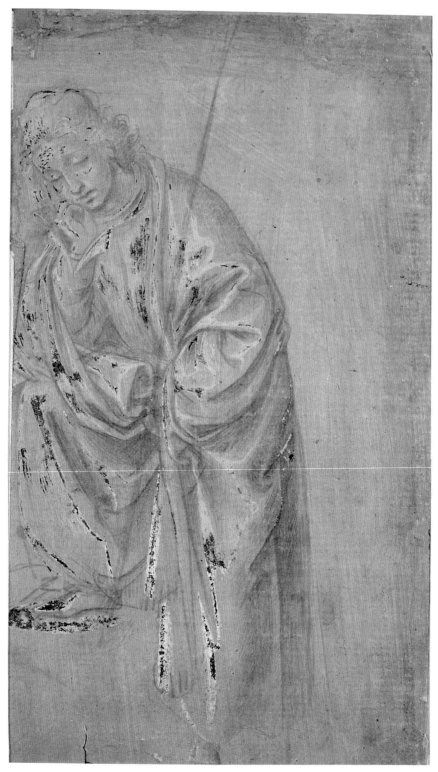

14 VERSO

15 *Seated Man Holding a Sword or Staff*

Metalpoint, heightened with white gouache, on blue-gray prepared paper, 196 x 106 mm (7¹¹⁄₁₆ x 4³⁄₁₆ in.), maximum

Inscribed in gray ink at lower left, probably by Filippo Baldinucci: *Filippino*

Gabinetto Disegni e Stampe degli Uffizi, Florence 204 E

PROVENANCE: Houses of Medici and Lorraine (manuscript inventory written by Giuseppe Pelli Bencivenni before 1793); museum stamp (Lugt 930).

LITERATURE: Ferri 1890, p. 91, no. 204; Berenson 1903, vol. 2, no. 1301; Scharf 1935, no. 260; Berenson 1938, vol. 2, no. 1301; Fossi [Todorow] 1955, no. 8; Berenson 1961, vol. 2, no. 1301; Shoemaker 1975, no. 48; Petrioli Tofani 1986, no. 204 E.

The present condition of this early Botticellian draw-
ing compromises a judgment of its quality: the scat-
tered reapplication by restorers of the blue-gray
preparation on the paper and the extensive oxida-
tion of the brushed white gouache highlights distort
the original tonal scale. Nevertheless, since Berenson
assigned the sheet to Filippino in 1903, it has been
accepted as autograph. All the hallmarks of Filippino's
style are indeed present: the expressive, deep-set eyes
of the seated man, the mannered tilt of his head, the
scribbled treatment of his hair and legs, and the
zigzag strokes of the modeling, carried out with a
rounded, soft metalpoint. Moreover, the pose and
proportions of the figure, marked by a low center of
gravity and gawky articulation of limbs, evoke those
of the enthroned Appius in the *Story of Virginia* (pl. 6),
a panel attributed to Filippino by Scharf in 1935; they
are also part of a vocabulary that carries over to
Filippino's portrayal of the seated Nero in his fresco the
Crucifixion of Saint Peter in the Brancacci Chapel (pl. 9).
The present sheet is identical in style, technique,
and dimensions to another study of a heavily draped
seated young man in the Uffizi (inv. no. 206 E), this one
shown turned to the left in a three-quarter view, sug-
gesting that both were pages in the same sketchbook.

 CCB

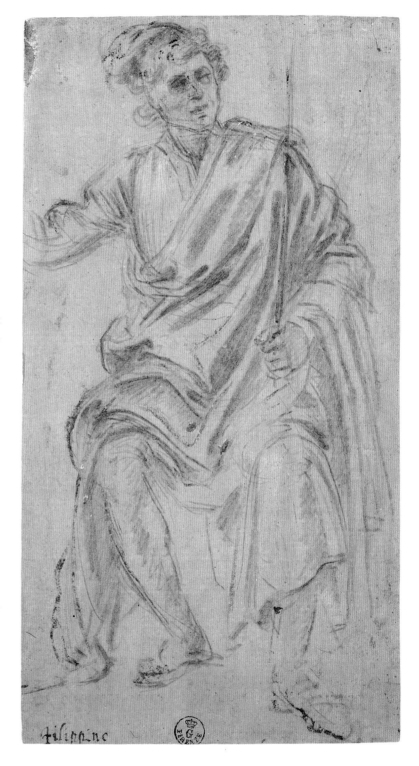

16 *Two Standing Men Turned to the Left*

Metalpoint, heightened with white gouache, on salmon pink prepared paper, 197 x 174 mm (7¾ x 6⅞ in.)

Duke of Devonshire and the Chatsworth Settlement Trustees, Chatsworth 886 B

PROVENANCE: Dukes of Devonshire, Chatsworth.

LITERATURE: Thompson 1929, no. 886B; Scharf 1935, no. 217; Byam Shaw 1969, no. 33B, illus.; Shoemaker 1975, no. 26; Ames-Lewis and Wright 1983, pp. 164–65, no. 30B, illus.; Jaffé 1994, no. 38, illus.

Thompson was the first to attribute this fine sheet to Filippino. It was considered "somewhat Botticellian" by Byam Shaw, who dated it about 1480, whereas Shoemaker placed it five years later. The evidence on balance favors the earlier date. The tendency toward highly complex drapery forms that mask the figure in drawings of the later 1470s is still present here. The firm, rather Botticellian outline has become more varied but persists to some degree, and the white highlights are applied in a broadened version of the technique of that early phase. Lastly, the metalpoint is employed with more diverse and livelier strokes. All these factors point to a dating of about 1480, as does the similarity of the head of the turbaned figure to that of the seated man in the *Dispute of Saints Peter and Paul with Simon Magus before Nero* in the Brancacci Chapel (fig. 34), a work of the early 1480s.

GRG

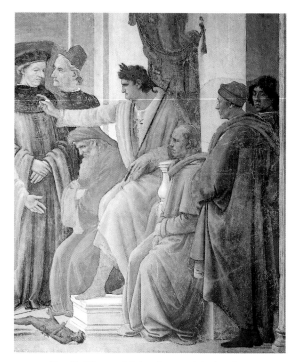

FIG. 34 Detail, *Dispute of Saints Peter and Paul with Simon Magus before Nero*, pl. 9

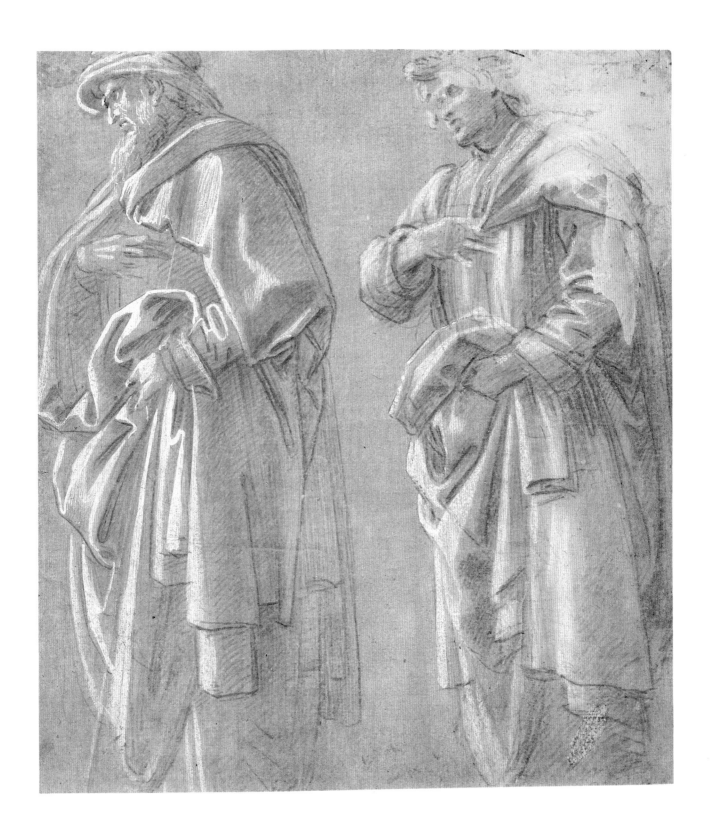

17 *Standing Male Nude with His Hands behind His Back and Seated Man Reading,* recto

Studies of Hands, verso

Metalpoint, heightened with white gouache, on pale pink prepared paper, 246 x 216 mm (9¹¹⁄₁₆ x 8½ in.)

Watermark: Briquet no. 11662

The Metropolitan Museum of Art, New York; Harris Brisbane Dick Fund, 1936 36.101.1

PROVENANCE: Sir Algernon Sidney, baron de L'Isle and Dudley, Penshurst, Kent; John Postle Heseltine, London; Henry Oppenheimer, London; sale, Christie's, London, July 10–14, 1936, lot 112.

LITERATURE: Ulmann 1894b, p. 244 [Raffaellino del Garbo after Pollaiuolo]; Ulmann 1894c, p. 113 [Raffaellino del Garbo after Pollaiuolo]; Berenson 1903, vol. 2, no. 1349; Heseltine 1913, no. 22, illus. [Domenico Ghirlandaio]; Van Marle 1923–38, vol. 12 (1931), pp. 360–61, n. 2; Popham 1931, p. 14, no. 46, pl. 40; Scharf 1935, p. 82, no. 229, fig. 148; Oppenheimer sale 1936, p. 57, lot 112, pl. 25; Degenhart 1937, pp. 333–36, no. 213a, fig. 331; Metropolitan Museum 1937, illus.; Berenson 1938, vol. 2, no. 1353B; Metropolitan Museum 1942, pl. 5; Holme 1943, pl. 21; Metropolitan Museum 1943, p. 149, fig. 2; Tolnay 1943a, p. 112, no. 47, fig. 17; Tietze 1947, no. 16, illus.; Fogg Art Museum 1948, no. 10; Mongan 1949, p. 24, illus.; Chastel 1950, pl. 46; Philadelphia Museum of Art 1950, no. 18, illus.; Metropolitan Museum 1952, no. 58, illus.; Berenson 1961, vol. 2, no. 1353B; Bean [1964], no. 6, illus.; Bean and Stampfle 1965, p. 30, no. 22, illus.; Shoemaker 1975, no. 30; Bean and Turčić 1982, no. 117, illus.

This relatively finished sheet of figure studies reflecting the anatomical types of Verrocchio and Botticelli can be dated to the late 1470s or early 1480s. It vividly illustrates the range of the young Filippino's virtuosity as a draftsman. The handling of the metalpoint remains delicate and precisely descriptive, with a shallow, relieflike rendering of chiaroscuro, as in the portrait drawing in Leipzig (cat. no. 19). Yet the anatomical conception of the subjects is more ambitious here than in the earlier sheets in the Morgan Library (cat. no. 13) and the Louvre (cat. no. 14); signs attesting to Filippino's explorations of anatomical structure are especially evident in the nude male figure on the left, where there are multiple pentimenti and reinforcements of outline that he attempted to disguise as background shading. The pose of this figure, which was most likely a preparatory study for a Saint Sebastian, or perhaps for a Christ in a Flagellation scene, recalls Botticelli's early *Saint Sebastian* in Berlin; that panel can be dated to January 1474 and thus was probably painted during Filippino's apprenticeship in Botticelli's workshop. Filippino's lean, muscular nude is much more naturalistic than Botticelli's figure, however,

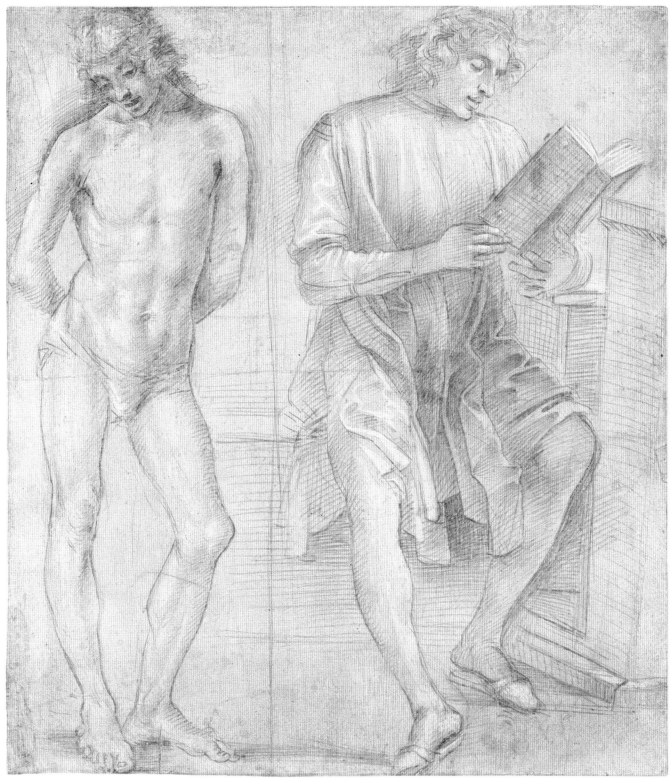

17 RECTO

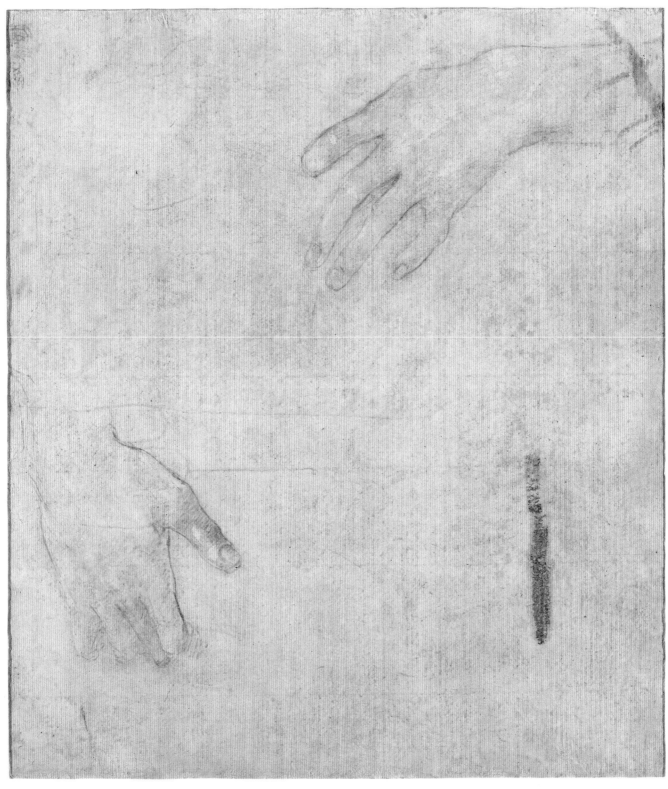

17 VERSO

and closely emulates the Christ in the *Baptism of Christ* (Uffizi, Florence) painted by Verrocchio and Leonardo for the monks at San Salvi, probably about 1476.

The two faded studies of hands on the verso are of weaker execution than the figures on the recto. Extremely rare in Filippino's oeuvre for their large scale, they are in a style that dates no later than his Lucchese period, 1482–83, as exemplified by his Magrini Altarpiece in Lucca (pl. 10). At an early point in the history of the drawing, a fragile mount was glued to the verso, partly covering the two hand studies; a fragment of this mount is preserved in the archives of the Metropolitan Museum's Department of Drawings and Prints. This remnant displays framing elements of circles, rectangles, and small grotesque masks in an antique style that are closely similar to the ornamental motifs on the mounts of Vasari's *Libro de' disegni* (pp. 99, 111, 298). On the lower rectangle of the partial mount a faded and abraded offset of a drawing in pen and brown ink and brown wash of a Christ Child is visible with ultraviolet light (fig. 35). The figural type is closely related to those of Fra Filippo Lippi and Botticelli and recalls infants in panels from the 1470s attributable to the young Filippino in the Galleria dell'Accademia, Florence, and the Museo Bandini, Fiesole.

CCB

FIG. 35 Ultraviolet photograph, *Christ Child*. Pen and brown ink and brown wash on fragment of Vasari? mount, 153 x 116 mm (6 x 4⅝ in.)

18 *Head of a Young Man Turned to the Left and Looking Down*, recto

Two Cows Grazing in a Landscape, verso

Metalpoint, heightened with white gouache, on red-tinted paper, recto; on gray prepared paper, verso, 188 x 122 mm (7⅜ x 4¹³⁄₁₆ in.), maximum; losses on upper left recto

Kupferstichkabinett, Staatliche Museen, Berlin KDZ 5174

PROVENANCE: Meyer Guggenheim, Venice; Adolf von Beckerath, Berlin (Lugt 1612, 2504); acquired 1902.

LITERATURE: Berenson 1903, vol. 1, p. 71, vol. 2, no. 44 (recto) [Amico di Sandro]; Beckerath 1904, p. 239, no. 3, fig. 3 (recto); Beckerath 1905, pp. 123–24; Lippmann 1910, p. ix, no. 18, pl. 18 (recto); Scharf 1935, no. 289; Berenson 1938, vol. 1, p. 337, vol. 2, no. 1271B; Berenson 1961, vol. 1, p. 159, vol. 2, no. 1271B; Shoemaker 1975, no. 15; Schulze Altcappenberg 1995, pp. 217–18.

The study of a youth's head on the recto is among the drawings attributed by Berenson to the Amico di Sandro, later identified as the young Filippino Lippi. It is often compared to the head of the boy Tobias in the center of Filippino's panel *Tobias and the Three Angels* (Galleria Sabauda, Turin), as well as to that of Sebastian in the Magrini Altarpiece at San Michele in Foro, Lucca (pl. 10), and thus should be dated about 1480–83. Although the present sketch is characterized by a Botticellian delicacy that calls to mind the sheet of figure studies at the Metropolitan Museum (cat. no. 17), the handling of the metalpoint in the description of volumes is more emphatic here than in the drawing in New York. The attitude of the youth's head evokes the head of the attendant who stands seventh from the right in Filippino's *Adoration of the Magi* (pl. 7), usually dated in the late 1470s or at the latest 1480.

The fragile study of cows grazing in a landscape on the verso is unexpectedly pastoral in its subject and mood, and follows from a rich tradition of such drawings in Florentine model books of the early quattrocento. The great naturalism in the description of both beasts is in contrast to approximately contemporary studies of cows or oxen by Lorenzo di Credi and Piero di Cosimo, in which the animals appear self-consciously posed on the page, usually without a landscape setting.[1]

CCB

1 See especially Royal Library, Windsor, inv. no. 12365 (Lorenzo di Credi), inv. no. 12796 (Piero di Cosimo); and Boijmans Van Beuningen Museum, Rotterdam, inv. no. I. 242 (Piero di Cosimo).

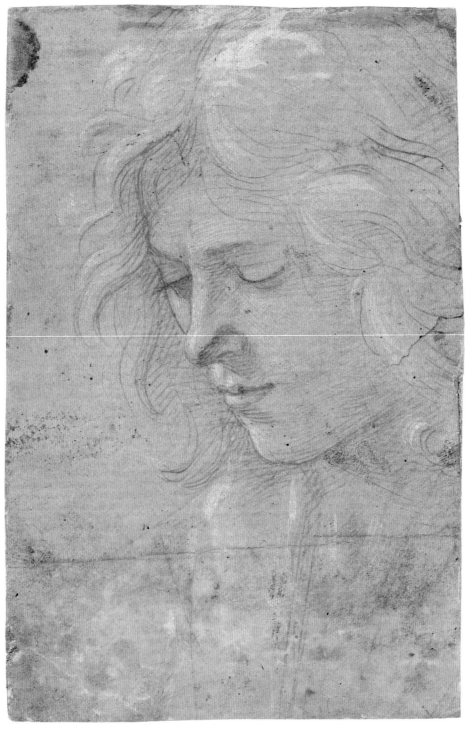

18 RECTO

18 VERSO

19 *Head of an Elderly Man Turned to the Right with Downcast Eyes*

Metalpoint, heightened with white gouache, on pale pink prepared paper, compass arc at bottom, 150 x 113 mm (5⅞ x 4⁷⁄₁₆ in.), sight; glued to window of mat

Inscribed in black ink at lower right: *l.d. vinci*

Museum der Bildenden Künste, Leipzig NI.246

PROVENANCE: Johann August Otto Gehler, Leipzig; Emilie Dörrien bequest, 1859 (Lugt 1669).

LITERATURE: Voss 1913, p. 227, fig. 16; Scharf 1935, no. 362; Berenson 1938, vol. 2, no. 1341K, vol. 3, fig. 235; Berenson 1961, vol. 2, no. 1341A-1; Shoemaker 1975, no. 92; Nelson 1992b, p. 171, n. 93.

Drawn after life, this sensitive portrait may have been intended for a tondo, as suggested by the compass arc, thrown from a point on the corner of the figure's left eyebrow and still evident on the lower portion of the sheet. The naturalistic rendering of the face approaches Leonardo's and Lorenzo di Credi's delicacy of tone and is accomplished through a varied but highly controlled use of the metalpoint medium, with a translucent, painterly application of white highlights. Although showing a less chiseled handling of the face, this portrait is comparable in technique and style to Filippino's drawing of Mino da Fiesole

(cat. no. 20) and, like it, can be dated to about the time of the Brancacci Chapel frescoes, that is, about 1480–83.

The question of the sitter's identity is not easily resolved. Although the man traditionally has been identified as Piero di Francesco del Pugliese (1428–1498), he may well be another member of the Del Pugliese family.[1] The sitter's head—with its broad forehead, large detached earlobe, and lean, rugged features set within a square, jowly face—conforms to a type that appears in a number of works by Filippino. Closest in age and features is the patrician man standing third from the left in the *Raising of Theophilus's Son* in the Brancacci Chapel (fig. 36), where Vasari noted a portrait of a "Piero del Pugliese."[2] The only likeness of Piero di Francesco del Pugliese that can be firmly documented shows him at about fifty years of age, as the praying donor figure on the right in Filippino's altarpiece in the church of the Badia, Florence (pl. 18), which he commissioned.[3] But the man in the present drawing looks about a decade older and has facial features that may be sufficiently different to mark him as another person. The man with his head turned to the upper right, standing among the crowd of barbarian onlookers on the right in the Uffizi *Adoration*, dated 1496 (pl. 35), is also often identified as Piero di Francesco del Pugliese. However, his facial features are similar but by no means identical to those of the present sitter, as he seems younger and fleshier and has bushier hair.[4]

Recently Nelson has cast doubt on the theory that the disputed likenesses represent any member of the Del Pugliese family, suggesting that the sitter in the present drawing may instead be Domenico Bonsi (1430–1501), the Florentine lawyer prominent in both Medicean and Republican governments. No documented portrait of Bonsi appears to survive, and thus this hypothesis remains unverifiable.

CCB

1 See Carl 1987, pp. 374–75.

2 Vasari 1906, vol. 3, pp. 462–63.

3 Piero di Francesco del Pugliese's nephew, Francesco di Filippo del Pugliese (1461–1519/20), was also a patron of the decoration of the family chapel. Francesco was in addition an executor of Filippino's will, a guarantor of his loans for purchasing real estate, and a patron of other paintings by Filippino. See Scharf 1935, p. 87, doc. VII (for the *ricordi* about the patronage of the altarpiece).

4 A highly finished drawing in the Pinacoteca Ambrosiana, Milan (inv. no. 12775), closely reflects the design of the head in the Uffizi *Adoration*. Finally, the same elderly man with lean, rugged features and distinctive fleshy earlobe who appears in the present drawing seems to be portrayed in profile in a much-abraded workshop drawing in the Kupferstichkabinett, Berlin (inv. no. KdZ 616).

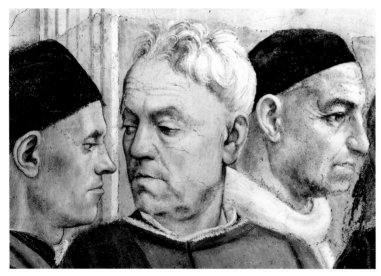

FIG. 36 Detail, *Raising of Theophilus's Son*, pl. 8

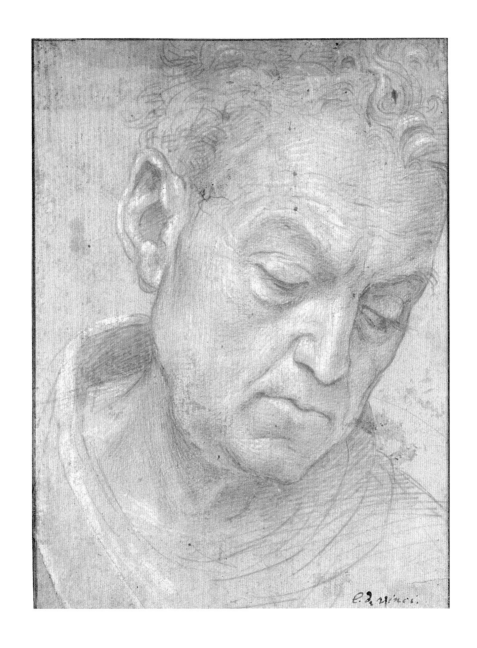

20 *Portrait of a Man Looking Down
(Mino da Fiesole)*

Metalpoint, heightened with white gouache, on blue-gray prepared paper, 190 x 140 mm (7½ x 5½ in.); sheet cut down to an oval

Duke of Devonshire and the Chatsworth Settlement Trustees, Chatsworth 705

PROVENANCE: Giorgio Vasari, Arezzo; purchased by Niccolò Gaddi, Florence, 1574; Thomas Howard, earl of Arundel and Surrey, England; Nicholaes Anthoni Flinck, Rotterdam (Lugt 959); presumably William Cavendish, second duke of Devonshire, Chatsworth, 1723; by descent, dukes of Devonshire.

LITERATURE: Morelli 1900, p. 91, n. 1 [Lorenzo di Credi]; Strong 1902, p. 5, colorpl. 29 [Lorenzo di Credi]; Berenson 1903, vol. 2, no. 671 [Lorenzo di Credi]; Thompson 1929, no. 705 [Lorenzo di Credi]; Popham 1931, no. 58, pl. 47b [Lorenzo di Credi]; Scharf 1935, no. 292; Berenson 1938, vol. 2, no. 1274B, vol. 3, fig. 238; Berenson 1961, vol. 2, no. 1274B, vol. 3, fig. 238; Ames 1962, no. 127, illus.; Ragghianti Collobi 1974, vol. 1, pp. 69, 86, vol. 2, fig. 190; Shoemaker 1975, no. R.41 [not Filippino Lippi]; Ames-Lewis and Wright 1983, no. 66, colorpl. 20; Caneva in Petrioli Tofani 1992, no. 4.10, illus.; Jaffé 1994, no. 34, illus.

Morelli first noticed the clear similarity between the sitter in this drawing and the head in the portrait of Mino da Fiesole (1431–1484) used to illustrate Vasari's *Life* of Mino. Furthermore, Vasari states, "Il ritratto di Mino è nel nostro Libro de'disegni, non so di cui mano; perché a me fu dato con alcuni disegni fatti col piombo dallo stesso Mino, che sono assai belli" (The portrait of Mino is in our book of drawings, but I do not know by whose hand; it was given to me together with some drawings made with blacklead by Mino himself, which have no little beauty).[1] Given this evidence, it is very probable that the subject of the drawing is Mino, that the sheet once belonged to Vasari, and that it was used in the making of the woodcut illustration of Mino's portrait in the *Lives*.

The drawing was attributed to Credi by Morelli, but the correct ascription to Filippino has generally been followed since it was put forward by Scharf. The varied use of metalpoint and white heightening to create subtle gradations of tone and the expressive naturalism of the image point toward a date for the work in the early to mid-1480s, which would coincide with the last year or so of Mino's life. It would also seem appropriate in view of the strong current of naturalistic portraiture that emerged in Filippino's work at the Brancacci Chapel in the early 1480s.

GRG

1 Vasari 1996, vol. 1, p. 480.

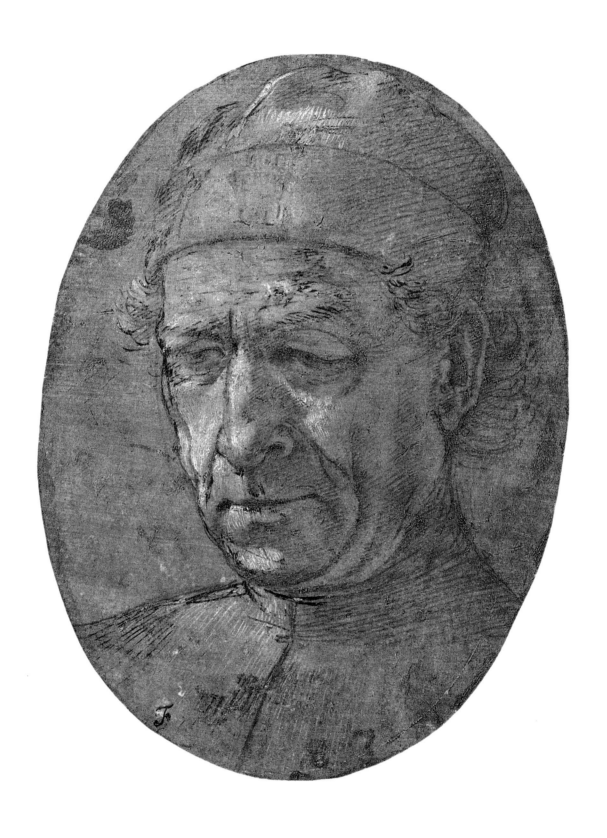

21 *Seated Young Man Turned to the Left and Facing Front,* recto

Standing Male Nude Facing Left and Leaning on a Staff, verso

Metalpoint, heightened with white gouache, on gray prepared paper, 272 x 84 mm (10¹¹⁄₁₆ x 3⁵⁄₁₆ in.), as mounted

Kupferstich-Kabinett, Staatliche Kunstsammlungen Dresden C.21

PROVENANCE: Sir Thomas Lawrence (Lugt 2445), London; Samuel Woodburn, London; his estate sale, Christie's, London, June 4–8, 1860.

LITERATURE: Ulmann 1894c, p. 112 [Raffaellino del Garbo]; Woermann 1896, vol. 1, nos. 29, 30, pl. 21 [Raffaellino del Garbo]; Berenson 1903, vol. 2, no. 1279; Van Marle 1923–38, vol. 12 (1931), pp. 367–68, fig. 243; Scharf 1935, no. 257; Berenson 1938, vol. 1, p. 106, vol. 2, no. 1279; Berenson 1961, vol. 2, no. 1279; Shoemaker 1975, no. 28.

This sheet can be dated to the late 1470s or early 1480s. Its clearly defined chiaroscuro, strong, rhythmic outlines, and expressive highlights are all characteristics of Filippino's style of the period immediately before he produced the drawings of the presumed sketchbook (see cat. nos. 24–26). The face of the pensive youth on the recto, with its direct, portraitlike gaze, recalls the sitter in Filippino's *Portrait of a Young Man* (National Gallery of Art, Washington, D.C.). The softly slouching gait and protruding stomach of the nude on the verso recall earlier types from the 1470s by both Verrocchio and Botticelli; the figure was adapted by Cristofano Robetta for the neophyte shown standing on the left in his engraving the *Baptism of Christ* (Hind D.II.12), there seen in reverse. As Hind has pointed out, Filippino's drawings appear to have been one of Robetta's main sources of inspiration. The engraver may have gained access to them through Filippino's son Ruberto (1500–1574); the two were friends and belonged to the same social club, the Compagnia del Paiuolo.[1]

CCB

1 Vasari 1906, vol. 6, p. 609. The Compagnia del Paiuolo was led by the sculptor Giovan Francesco Rustici, who was Ruberto's master (Colnaghi 1986, p. 238).

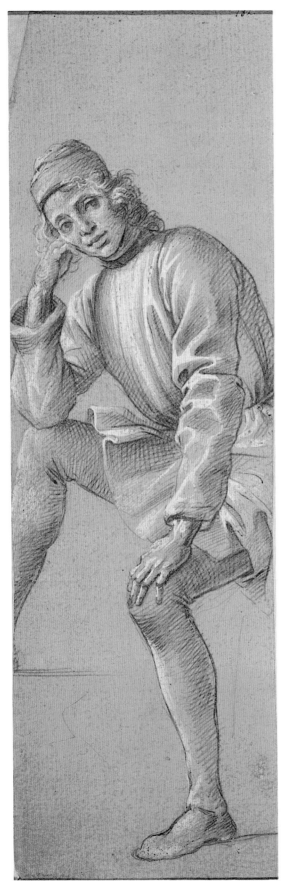

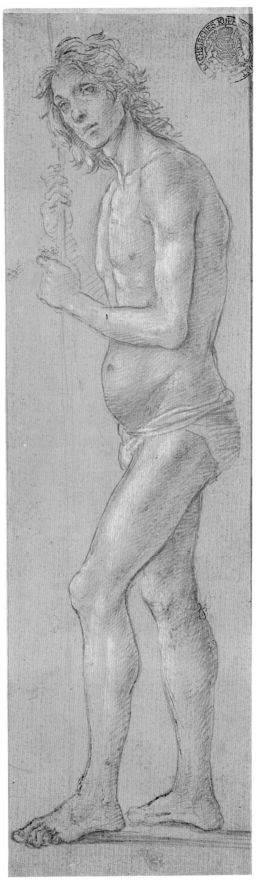

21 RECTO

21 VERSO

22 *Standing Man Facing Right and Holding a Quill or Palm,* recto

Seated Male Nude Holding a Sling, Noose, or Whip, verso

Metalpoint, heightened with white gouache, on blue-gray prepared paper, recto; on gray-purple prepared paper, verso, 257 x 116 mm (10⅛ x 4⁹⁄₁₆ in.); losses along all borders

Inscribed in brown ink on verso at upper right: *H.I.Ii.*

Kupferstichkabinett, Staatliche Museen, Berlin ᴋᴅᴢ 5150

ᴘʀᴏᴠᴇɴᴀɴᴄᴇ: Possibly Pope Paul IV, Rome; Adolf von Beckerath (Lugt 1612, 2504), Berlin; acquired 1902.

ʟɪᴛᴇʀᴀᴛᴜʀᴇ: Ulmann 1894c, p. 112 [Raffaellino del Garbo]; Mackowsky 1898, no. 144; Berenson 1903, vol. 1, pp. 78–79, 81, vol. 2, no. 1270; Lippmann 1910, p. ix, nos. 17a,b, illus.; Scharf 1935, no. 240; Berenson 1938, vol. 1, p. 106, vol. 2, no. 1270; Berenson 1961, vol. 2, no. 1270; Levenson, Oberhuber, and Sheehan 1973, p. 300, n. 6, no. 120; Shoemaker 1975, no. 16; Shoemaker 1994, pp. 255–57, fig. 1; Schulze Altcappenberg 1995, pp. 161–63.

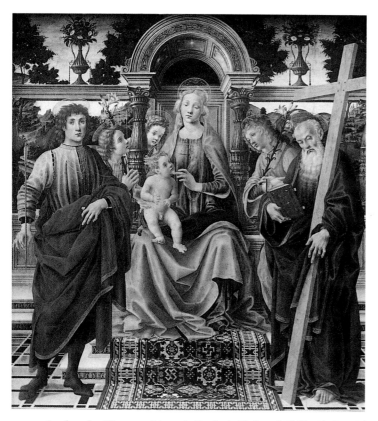

ꜰɪɢ. 37 Attributed to Vincenzo d'Antonio Frediani. *Virgin and Child with Saint John the Baptist and Saints Sebastian and Andrew.* Tempera and oil on panel, 154 x 137 cm. Destroyed (formerly Kaiser Friedrich Museum, Berlin 87)

Filippino still attained color effects of a Botticellian subtlety against delicately contrasting hues of ground preparation in this sheet, although in medium and handling it anticipates a large group of figure drawings produced throughout the 1480s. The flickering white highlights that constitute intermediate values are especially descriptive and finely stippled, and the gray-purple of the ground preparation of the verso recalls the color of the early Morgan Library sheet (cat. no. 13).

Although the hand of Filippino is clearly discernible in the Berlin sheet, the pose of the standing man shown on the recto is comparable to that of the Saint Sebastian in the lost *Sacra Conversazione* formerly in the Kaiser Friedrich Museum, Berlin (fig. 37). Morelli believed Raffaellino was the author of the Berlin panel, and on the basis of that opinion Ulmann attributed the present drawing as well to Raffaellino;[1] however, the painting has been convincingly attributed by Fahy to Vincenzo d'Antonio Frediani (fl. 1481–1505), one of Filippino's Lucchese followers. The precise configuration of the drapery folds on the recto is repeated on the figure of Saint John the Baptist on the left wing of a triptych attributed to Frediani and dated 1487 (Museo Villa Guinigi, Lucca). However, in all other respects the design of the Saint John differs from that of the subject of Filippino's drawing, demonstrating the extent to which the members of his workshop modified his figure studies for use as exempla in their paintings.[2] The resemblance of the seated nude man on the verso to the central figure in Cristofano Robetta's signed engraving the *Allegory of Carnal Love* seems less precise than is often suggested.[3] The rather brutal facial expression of Filippino's nude indicates that the figure may be a study for an executioner in a scene of martyrdom.

ᴄᴄʙ

1 Morelli 1893; Ulmann 1894c, p. 102.

2 Shoemaker 1994, pp. 256–57.

3 Walker 1933, pp. 33–36; Levenson in Levenson, Oberhuber, and Sheehan 1973, p. 300, n. 6; Shoemaker 1975, p. 156.

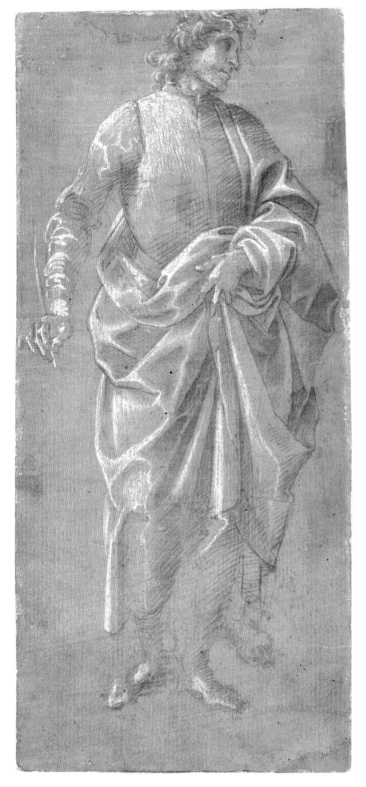

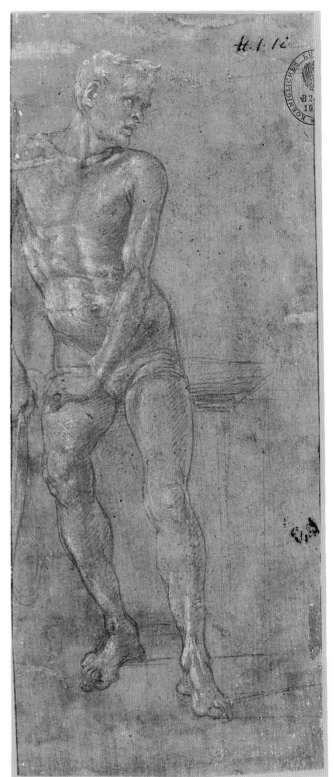

22 RECTO

22 VERSO

23 *Seated Man with His Head in His Hand,* recto

Seated Man Turned to the Left with His Right Arm Extended, verso

Metalpoint, heightened with white gouache, on gray prepared paper, 185 x 127 mm (7¼ x 5 in.)

Département des Arts Graphiques du Musée du Louvre, Paris 1253

PROVENANCE: Everhard Jabach, Paris (Lugt 2959); purchased for French royal collection, 1671; Antoine Coypel, Paris (Lugt 478).

LITERATURE: Reiset 1866, p. 74, no. 230 [Fra Filippo Lippi]; Berenson 1903, vol. 2, no. 1356A; Rouchès 1931, p. 20, no. 16; Scharf 1935, p. 127, no. 272; Berenson 1938, vol. 2, no. 1356A; Louvre 1952, p. 10, no. 30; Berenson 1961, vol. 2, no. 1356A; Bacou and Viatte 1968, no. 15, illus.; Shoemaker 1975, no. 24.

In style and technique the recto of this sheet is close to several other drawings of the early 1480s (cat. nos. 24, 31). The rather neat use of metalpoint and the firm, continuous outlining are points they have in common and argue for a date in the early 1480s. The characterization of the seated man is compared by Shoemaker to that of a seated figure in the *Liberation of Saint Peter* (fig. 33) in the Brancacci Chapel. The comparison is apt and reinforces the date suggested here.

By contrast, the verso is drawn more freely and expressively: the metalpoint strokes, especially along the right arm, and the white heightening are achieved with greater spontaneity and considerably less precision than the strokes and highlights on the recto. The figure on the verso has consistently been identified as a study for the archangel in an Annunciation. The *Annunciation* in San Gimignano is the painting closest in date to the drawing and shares with it the richly elaborate and fluid drapery patterns typical of Filippino's work of the early 1480s. However, the pose of the figure on the present sheet has nothing in common with the representation of Gabriel in that panel.

GRG

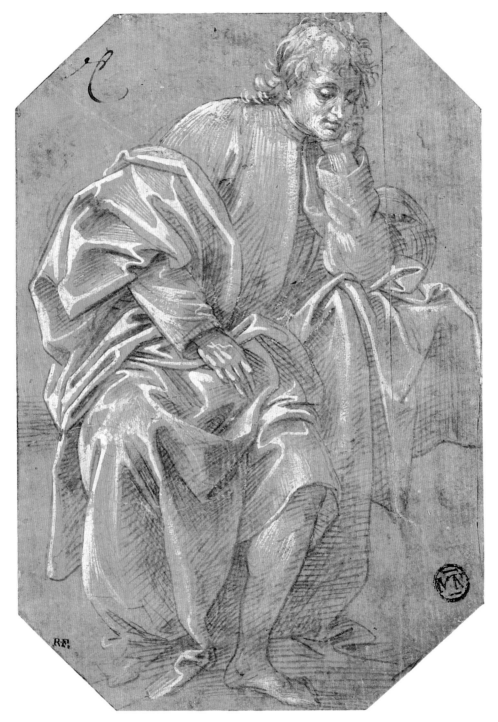

23 RECTO

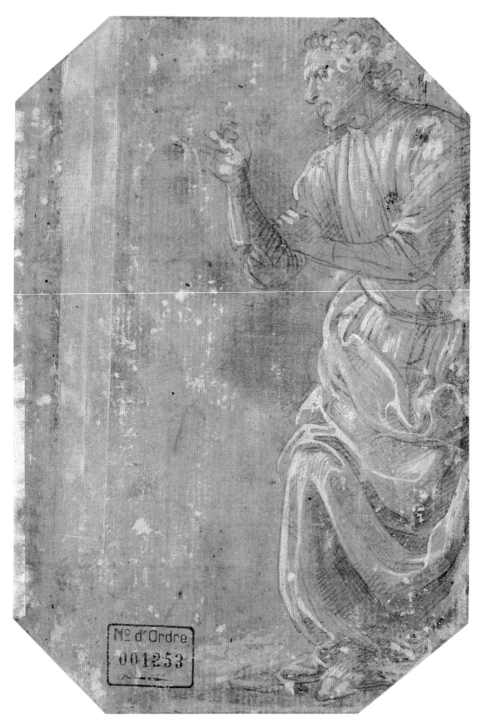

23 VERSO

24 *Seated Man Looking Up and Standing Man Turned to the Left*, recto

Seated Man Looking Down and Standing Man Turned to the Left, Both Holding Books, verso

Metalpoint, heightened with white gouache, on gray prepared paper, 260 x 208 mm (10¼ x 8³⁄₁₆ in.)

École Nationale Supérieure des Beaux-Arts, Paris 187

PROVENANCE: Aimé-Charles-Horace His de La Salle, Paris; his gift.

LITERATURE: Robinson 1869, with no. 18; École des Beaux-Arts 1879, with no. 46; Müntz 1889, pl. opp. p. 206 (verso); Müntz 1890, p. 292, n. 2; Berenson 1903, vol. 2, no. 1363; Lavallée 1917, p. 267, n. 1; Lavallée 1935, no. 59; Scharf 1935, p. 82, no. 231, pl. 151 (recto); Berenson 1938, vol. 2, no. 1363; Chastel 1950, pl. 43; École des Beaux-Arts 1953, no. 143; Berenson 1961, vol. 2, no. 1363; Shoemaker 1975, no. 33.

The attribution to Filippino was first made by Robinson, who suggested that this sheet and several others by the artist were once grouped in a sketchbook with metalpoint figure studies. Although scholars have disagreed to some degree regarding the components of this supposed sketchbook, the hypothesis that it existed has regularly and reasonably been maintained.

The four sheets that most clearly belong together in the presumed sketchbook are this one, one formerly in the Koenigs collection, Rotterdam,[1] a third in Dresden (cat. no. 25), and another in the British Museum (cat. no. 26). They are all double-sided, drawn on gray prepared ground in a lively metalpoint technique with white heightening, and of closely similar size. Perhaps most important, all show pairs of animated clothed male figures, sometimes gesturing or apparently conversing. Displayed in all is Filippino's great skill in the use of metalpoint, with a dazzling variety of parallel and crosshatched strokes that accentuate the expressive spontaneity of pose and gesture. Shoemaker has aptly identified the *Doubting of Thomas* that Verrocchio executed for Orsanmichele, Florence, and the contemporaneous work of Leonardo as stimulants in the development of Filippino's more dynamic interrelationships among figures.[2]

Related to these four sheets are a single-sided drawing in Berlin (cat. no. 27) and another double-sided one in the Morgan Library (cat. no. 28).[3] However, the former stands apart not only in the use of the recto alone but also because Filippino kept the figures somewhat more separate and employed less varied metalpoint lines. And the Morgan Library example is unique among the works in question in that the recto shows a complete composition, a Noli Me Tangere, and is partially executed in leadpoint. Nevertheless, all six drawings are very similar in figure types, technique, and scale.

The purpose of the drawings that formed this "sketchbook" has been well elucidated, especially by Shoemaker. Ranging from a narrative composition (cat. no. 28) to somewhat miscellaneous figure pairs (cat. no. 25), they were drawn in the studio and provided Filippino as well as the members of his shop with exemplars to be used with variations in paintings; they also offered study material for young assistants. Finally, the more animated and interrelated pairs were a testing ground for Filippino as he developed an increasingly advanced gestural communication between figures in his paintings.

These drawings have been given dates that range from the mid-1480s through the early part of the following decade. The weight of evidence clearly favors a still earlier date of about 1482–83 for them all. The paintings that can be broadly connected to some of the drawings are of that period. And drawings closely similar to the pages of the "sketchbook," such as the recto of the sheet in Malibu (cat. no. 29), show figures analogous to painted figures of the early 1480s. Furthermore, as Shoemaker has noted, in the panels he painted for San Ponziano, Lucca, in 1483 (pls. 11, 12) Filippino was moving toward the representation of interacting paired figures, which are altogether absent from his altarpiece for San Michele in Foro, Lucca, of the preceding year (pl. 10). Lastly, the "sketchbook" sheets are far closer in style and technique to the *garzone* studies of the period about 1480–81 than to the drawings made in Rome about 1489–90 (for example, cat. no. 50).

Within this group the present sheet appears to be relatively early. The rather self-contained and precise rendering of form places it not much later than the study of a seated young man in Dresden (cat. no. 21). Moreover, it shows less dynamic poses and is smaller than several of the associated drawings (for example, cat. nos. 26, 28).

GRG

1 Koenigs collection 1995, no. 98, illus.

2 Shoemaker 1975, pp. 113–16.

3 Uffizi inv. no. 1253 E, often considered to belong to this series, is in a later, somewhat different style and is not part of the "sketchbook."

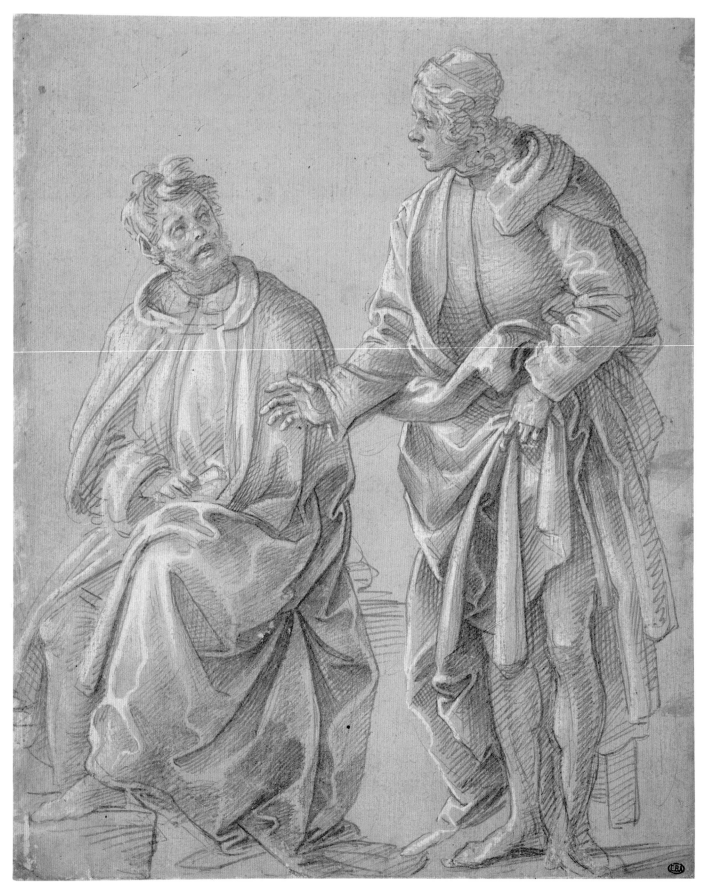

24 RECTO

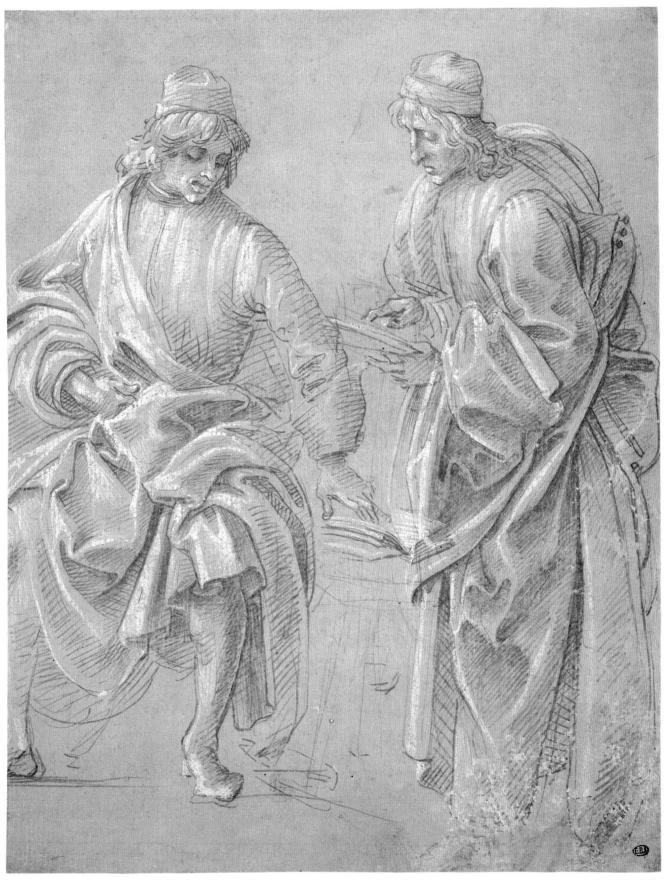

24 VERSO

25 *Seated Man Facing Right and Leaning against a Ledge and Standing Elderly Man Holding a Staff and Reading,* recto

Seated Man Facing Right, Holding a Staff and Sleeping, and Standing Man in Hungarian Costume Holding a Mace, verso

Metalpoint, heightened with white gouache, on gray prepared paper, 281 x 203 mm (11 1/16 x 8 in.), sight; glued to window of secondary paper support

Kupferstich-Kabinett, Staatliche Kunstsammlungen Dresden C.39

PROVENANCE: Acquired before Seven Years War, 1756–63.

LITERATURE: Gruner 1862, p. 27, no. 13; Morelli 1880, p. 255; Morelli 1892–93, col. 54, no. 32; Ulmann 1894c, pp. 111–12 [Raffaellino del Garbo]; Woermann 1896, vol. 1, nos. 27, 28, pls. 19, 20 [Raffaellino del Garbo]; Berenson 1903, vol. 2, no. 1278; Scharf 1931, p. 216, fig. 13; Scharf 1935, p. 82, nos. 257 (recto), 218, fig. 150 (verso); Berenson 1938, vol. 1, pp. 106, 108, vol. 2, no. 1278; Berenson 1961, vol. 2, no. 1278, vol. 3, fig. 219 (recto); Shoemaker 1975, no. 35; Schmidt et al. 1978, p. 27, no. 4; Shoemaker 1994, pp. 255–57, fig. 2 (recto).

Recognized in 1880 by Morelli as a work by Filippino, this little-known sheet was part of the artist's presumed sketchbook of metalpoint drawings, here dated to the early 1480s. The verso drawings were revealed during restoration in 1890. The discontinuities of background elements in the left and right halves of the recto and the disjunctive groundlines behind the seated man and the standing man on the verso suggest that the figures were meant to function as independent exempla.

With his intent gaze and distinctive protruding chin, the model for the study on the left of the recto was probably the same man who posed for the figure on the left of a drawing of two male nudes in London (cat. no. 36). The bearded old man on the right of the recto of the present sheet is only slightly less unified in conception than the figures of Saints Benedict and Fredianus in Filippino's panels for San Ponziano, Lucca (pls. 11, 12), commissioned in 1482 and completed the following year. Ulmann first noted the close relationship of the heavily draped old man in the drawing to the Saint Andrew on the far right in the lost *Sacra Conversazione* formerly in the Kaiser Friedrich Museum, Berlin (fig. 37). The painting is now considered to be by one of Filippino's Lucchese followers, possibly Vincenzo d'Antonio Frediani (fl. 1481–1505).[1] In addition to the old man in the present sheet, another preparatory figure study by Filippino, now in the Kupferstichkabinett, Berlin (cat. no. 22), was adapted for use in the *Sacra Conversazione.*

Filippino's study of a man in Hungarian costume on the verso of the present sheet may be related to his lost paintings for Matthias Corvinus, king of Hungary.[2] Filippino would also depict figures in Hungarian costume among the crowd of exotic soldiers in the left and right foreground of the fresco *Saint Philip Banishing the Dragon* in the Strozzi Chapel (pl. 28).

CCB

1 Suggestion by Everett Fahy (in conversation, May 1996). Fahy also points out that the Saint Andrew figure type is repeated in reverse on the left of the *Annunciation* attributed to Tommaso di Stefano Lunetti in Fucecchio.

2 Scharf 1935, pp. 89–90, 92, docs. X, XIII; Vasari 1906, vol. 3, p. 467.

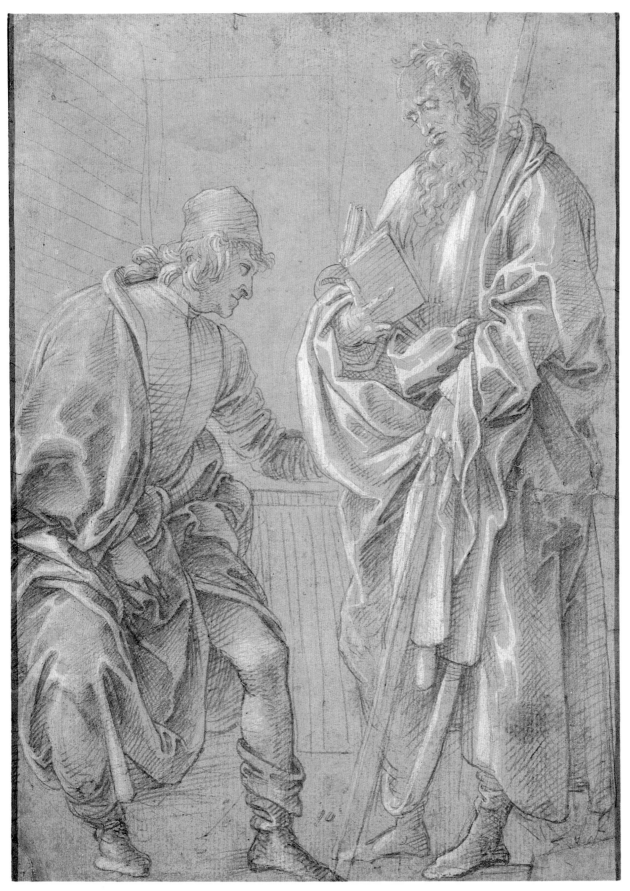

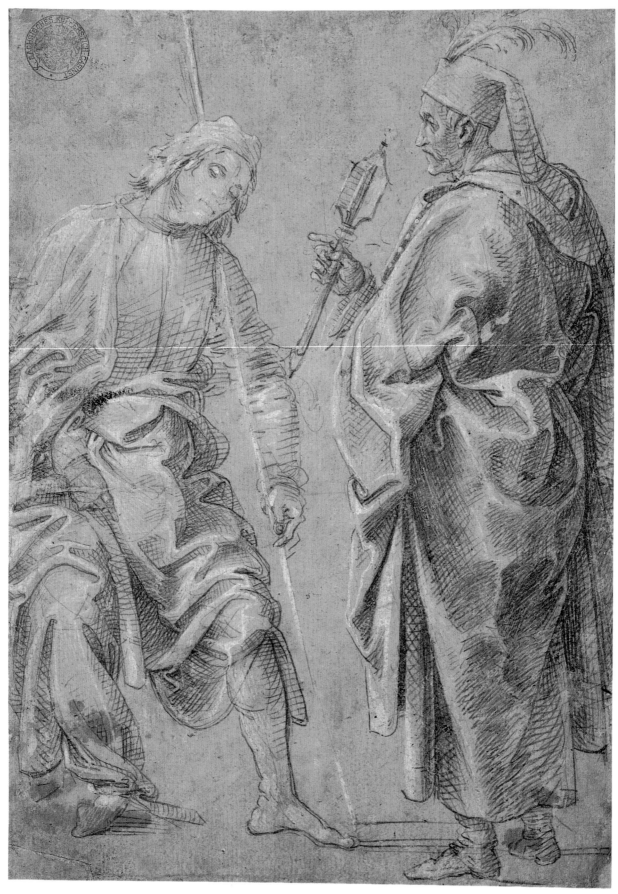

25 VERSO

26 *Seated Man Turned to the Right and Standing Man Seen from the Back*, recto

Standing Man Turned to the Left and Holding a Staff and Standing Man Facing Left and Holding a Book, verso

Metalpoint, heightened with white gouache, on gray prepared paper, 274 x 195 mm (10¹³⁄₁₆ x 7¹¹⁄₁₆ in.)

British Museum, London 1895-9-15-454

PROVENANCE: Sir Thomas Lawrence, London (Lugt 2445); Sir John Charles Robinson, London (Lugt 1433); John Malcolm, Poltalloch and London (Lugt 1489).

LITERATURE: Robinson 1869, no. 18; École des Beaux-Arts 1879, no. 46; Ulmann 1894c, p. 112 [Raffaellino del Garbo]; Colvin 1895, p. 11, no. 24; Loeser 1897, p. 344; Berenson 1903, vol. 2, no. 1347; Scharf 1935, p. 82, no. 227; Berenson 1938, vol. 2, no. 1347; Chastel 1950, pl. 44 (recto); Popham and Pouncey 1950, no. 136, pls. 124, 125; Scharf 1950, p. 47, figs. 39, 40; Fossi [Todorow] 1955, no. 13; Berenson 1961, vol. 2, no. 1347; Grassi 1961, no. 64, illus. (verso); Shoemaker 1975, no. 32; Shoemaker 1994, pp. 258, 260, n. 9, fig. 7.

Among the most beautifully preserved drawings by Filippino, this sheet is clearly part of the presumed sketchbook dating from about 1482–83. The draftsmanship is lively and varied, yielding a brilliance of abstract movement across the page. The recto shows the most vivid interaction between figures in the drawings of this group, anticipating later work for the Carafa Chapel. However, in technique it is very different from the drawings related to that project and must, therefore, date from an earlier moment.

The bald man on the recto made an earlier appearance as the standing figure shown second from the left in the top register of the recto of a drawing of the mid- to late 1470s at Christ Church (cat. no. 11A). This *zuccone*-like head exemplifies Filippino's striving for the heightened expressive naturalism of Donatello.

GRG

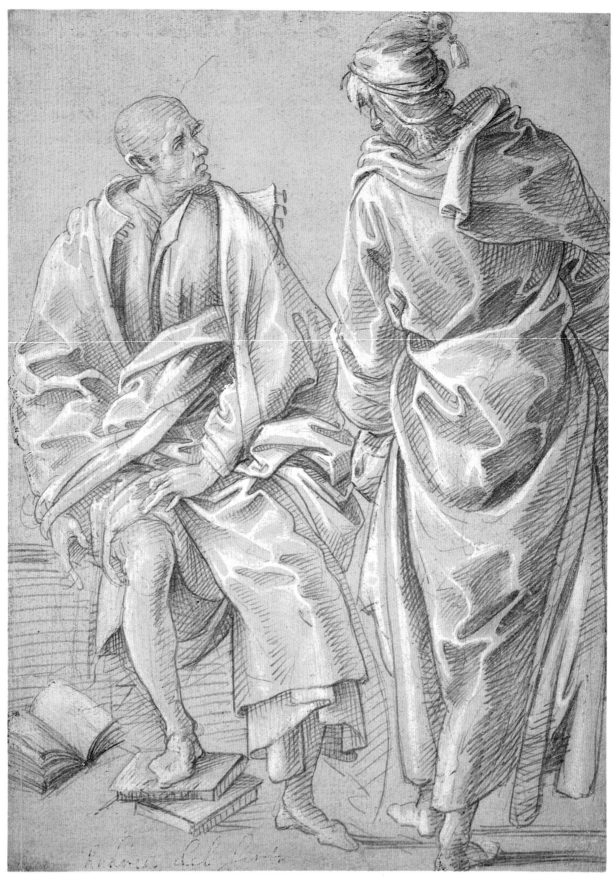

26 RECTO

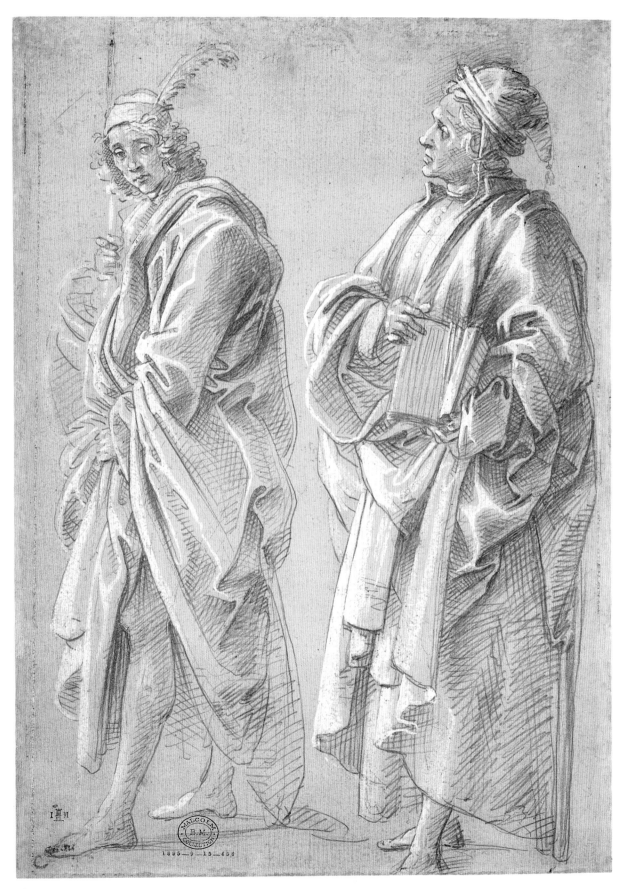

26 VERSO

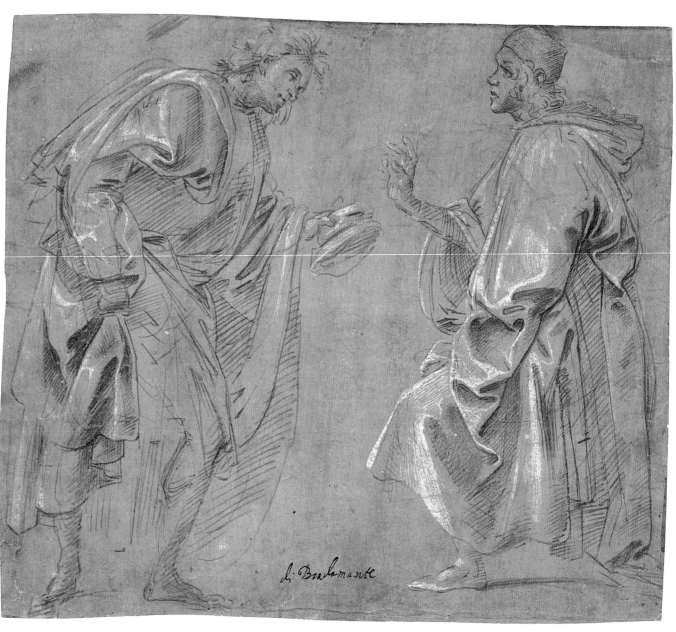

d. Bralomante

27

27 *Man Bowing to the Right and Man Genuflecting to the Left*

Metalpoint, heightened with white gouache, on blue-gray prepared paper; two brushstrokes of blue-gray color at right on unprepared verso, 214 x 244 mm (8⅜ x 9⁵⁄₁₆ in.), maximum; losses on top, unevenly cropped borders

Inscribed in black ink on recto at lower center by sixteenth- or seventeenth-century hand: *di Bradamante*

Kupferstichkabinett, Staatliche Museen, Berlin ᴋᴅᴢ 5043

ᴘʀᴏᴠᴇɴᴀɴᴄᴇ: Adolf von Beckerath (Lugt 1612, 2504), Berlin; acquired 1902.

ʟɪᴛᴇʀᴀᴛᴜʀᴇ: Mackowsky 1898, no. 143; Berenson 1903, vol. 2, no. 1271; Lippmann 1910, p. ix, no. 16, illus.; Meder 1923, p. 10, pl. 38; Van Marle 1923–38, vol. 12 (1931), p. 360, n. 2; Popham 1931, no. 48, pl. 41; Scharf 1935, no. 216, fig. 147; Berenson 1938, vol. 2, no. 1271; Arnolds 1949, pp. 18–19, fig. 9; Berenson 1961, vol. 2, no. 1271; Shoemaker 1975, no. 45; Dreyer 1979, no. 9; Schulze Altcappenberg 1995, pp. 164–65, 219, illus.

Whether this sheet was part of Filippino's supposed sketchbook is not entirely clear, as the handling of the metalpoint is looser and the drapery more voluminous than in the drawings that more certainly belong in the group. The models, probably intended for supporting figures in an Adoration of the Magi, reveal in their animation, rather than design, awareness of Leonardo's *Adoration* (Uffizi, Florence)—a panel commissioned in 1481 and left unfinished in 1482–83, when the artist left Florence for Milan. It does not seem possible that the figure at the left, studied from a *garzone* posed in the workshop, was preparatory for an angel in an Annunciation, as is sometimes suggested: this hypothesis presumes that such celestial beings wore hats or caps that they took off when greeting the Virgin. The same *garzone* shown in the study on the right appears to have modeled for the standing figure on the recto of the "sketchbook" sheet in the École des Beaux-Arts, Paris (cat. no. 24). The treatment and proportions of its figures place the present sheet somewhere between the documented works painted in Lucca in 1482–83—the Magrini Altarpiece (pl. 10) and the panels for San Ponziano (pls. 11, 12)—and the Virgin and Child with Saints commissioned for the Sala del Consiglio of the Palazzo della Signoria, Florence (pl. 19), which is dated 1486.

ᴄᴄʙ

28 *Kneeling Saint Mary Magdalen and Standing Christ for a Noli Me Tangere Composition*, recto

Standing Man Holding a Sword and Kneeling Man Holding a Staff, verso

Leadpoint, heightened with white gouache, on gray prepared paper; verso reworked in silverpoint over leadpoint underdrawing, 271 x 201 mm (10¹¹⁄₁₆ x 7⅞ in.)

The Pierpont Morgan Library, New York; Purchased with the assistance of the Fellows 1951.1

ᴘʀᴏᴠᴇɴᴀɴᴄᴇ: Stefan von Licht, Vienna; E. Czeczowiczka, Vienna; his sale, C. G. Boerner and Paul Graupe, Berlin, May 12, 1930, lot 98; Mark Oliver; Geoffrey Agnew, London; Dr. Carl Robert Rudolf, London (Lugt suppl. 2811b); his sale, P. and D. Colnaghi, London, 1951, lot 1.

ʟɪᴛᴇʀᴀᴛᴜʀᴇ: Fairfax Murray n.d., vol. 1, no. 4e; Van Marle 1923–38, vol. 12 (1931), p. 361; Scharf 1935, no. 228, fig. 154 (recto); Berenson 1938, vol. 2, no. 1348A, vol. 3, fig. 253 (verso); Colnaghi & Co. 1951, no. 1, frontis. (verso); Adams 1952, pp. 59–62, illus. (recto and verso); D'Otrange-Mastai 1955, pp. 137–39, figs. 3, 4; Pierpont Morgan Library 1957, no. 82, pl. 50 (verso); Berenson 1961, vol. 2, no. 1353ꜰ; Wildenstein 1961, no. 59, illus. (verso); Bean and Stampfle 1965, no. 21, illus. (recto and verso); Shoemaker 1975, no. 36; Meder and Ames 1978, vol. 1, pp. 162–63, 177, 326, 328, vol. 2, p. 36, pl. 39.

Figure studies for a Noli Me Tangere appear on the recto of this brilliant sheet, which may have formed part of Filippino's presumed sketchbook. They are shown in a spatially discontinuous arrangement, with the Magdalen kneeling on a rocky ledge that is much higher than the groundline on which Christ stands. To judge from the rugged facial features, the Magdalen's bony, agitated figure appears to have been studied from a *garzone*. Although it is often compared with this drawing, the tall, unevenly executed Noli Me Tangere panel from about 1500 (pl. 38) is almost two decades later in date and offers a significantly different composition. The alert pose of the heavily cloaked standing man with a sword on the left of the verso evokes the monumentality of expression in Donatello's marble *Saint George* (Museo Nazionale del Bargello, Florence). The kneeling youth on the right is frequently related to the seminude figure crouching on a ledge in Filippino's *Adoration of the Magi* dated 1496 (pl. 35). More closely comparable, however, in terms of pose, but without a direct correspondence of design, is the young executioner pulling a rope at the right of the crucified Saint Peter in the earlier fresco cycle in the Brancacci Chapel (pl. 9).

The leadpoint underdrawing (now a gray color) of the standing figure on the verso has been heavily reworked in silverpoint (now a golden hue).

ᴄᴄʙ

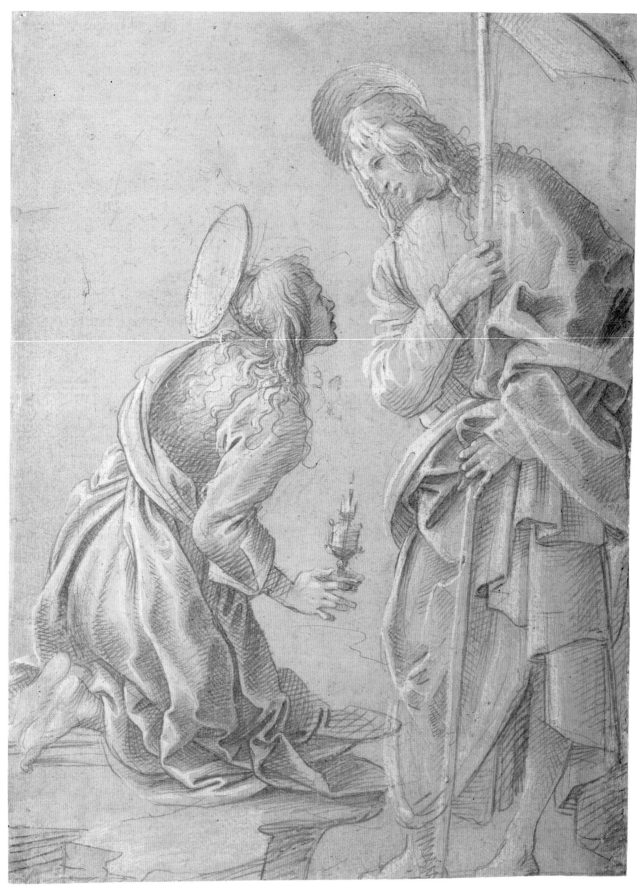

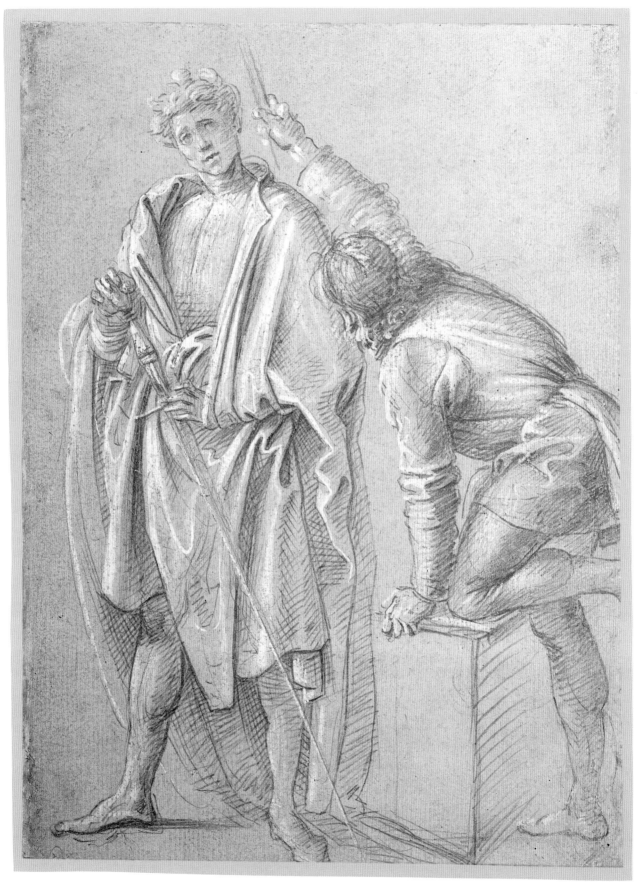

29 *Standing Male Saint*, recto

*Male Nude Seen from the Back and Turned
to the Left, Christ at the Column, Saint John
the Baptist, Bust of a Male Saint Looking
Up, and Turbaned Man Looking Down*, verso

Metalpoint, heightened with white gouache, on gray prepared
paper, 271 x 174 mm (10¹¹⁄₁₆ x 6⅞ in.)

Inscribed in brown ink on recto at lower right: *S. V. n 44*

Collection of The J. Paul Getty Museum, Malibu, California
91.GG.33

PROVENANCE: Sagredo family, Venice.

LITERATURE: Goldner 1993, no. 68, pl. 4.

This sheet was recently discovered in an album of
drawings that is now dismembered and probably
once belonged to the Sagredo family in Venice. As the
inscription at the lower right of the recto indicates,
a member of the family considered the drawing
Venetian (*S. V.* is the abbreviation for *scuola
veneta*), but the authorship of Filippino is manifest.

The recto shows a standing saint with a staff or
stick in his hand. The figure is quite similar in terms
of facial type and the rendering of the lower drapery
to the Saint Sebastian in Filippino's altarpiece with
Saints Roch, Sebastian, Jerome, and Helen in San
Michele in Foro, Lucca (pl. 10), which was painted
in 1482. The treatment in evidence in this drawing
exemplifies the increasingly lively use of metalpoint
and white heightening and the highly complex
drapery forms that are hallmarks of his figure studies
of the early 1480s.

The verso, with two large studies fully worked
up in metalpoint with white heightening added and
several subsidiary sketches in metalpoint alone, is a
rare example of a composite study page in Filippino's
work of this period. Unusually for his metalpoint
drawings, perspective lines for an entire composition
are indicated. The figure representing Christ at the
Column shows considerable command of the nude

and reflects a familiarity with the work of Verrocchio,
Pollaiuolo, and other sculptors of the period. The
large, indelicately gesturing man shown next to
Christ probably has no narrative relationship to him.
The character of his gesture suggests that he is sim-
ply a studio model who posed for the figure of Christ
and then turned around so that Filippino could cap-
ture his back view. The marginal Saint John the
Baptist on the left also lacks connection to Christ in
a narrative sense. He may be related to a small image
of the Baptist that appears on the left of the Corsini
Tondo (pl. 15), although the poses of the two figures
are quite different. No figures that seem comparable
to those in the sketches on the right of the sheet can
be found in paintings, however.

In style the verso looks forward to such works of
the end of the 1480s as the Uffizi study for the Strozzi
Chapel frescoes (cat. no. 44), with which it shares
potent musculature and broadly applied white high-
lights. Moreover, the Christ is notably later and more
evolved than the Saint Sebastian in the Metropolitan
Museum study sheet from the beginning of the decade
(cat. no. 17). And the execution of the marginal metal-
point sketches anticipates the manner of the draw-
ings Filippino made in the period after his move
to Rome in 1488. All of these observations suggest
that there was an interval of perhaps five or six years
between the creation of the recto and the verso.

GRG

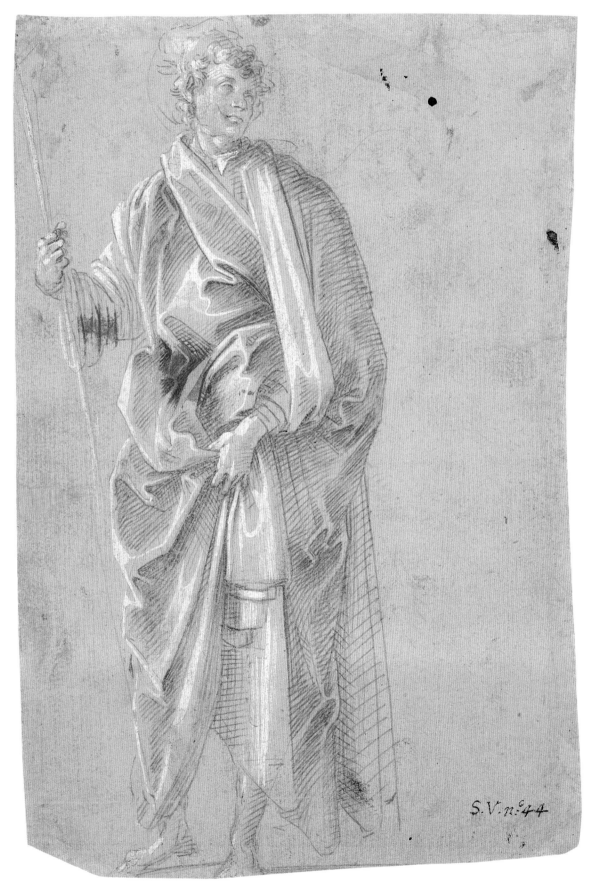

29 RECTO

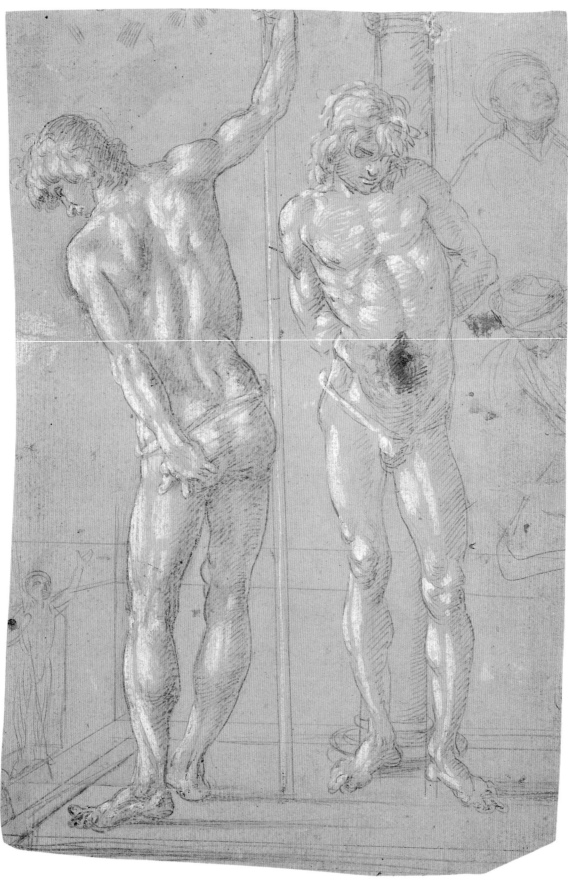

30 *Young Saint John the Baptist in Contemplation, Seated beneath a Tree,* recto

Nude Man Pulling the Tail of a Cow, Bull, or Ox and Nude Youth Seen from the Back Holding a Standard, verso

Metalpoint, heightened with white gouache, on gray prepared paper; recto with branch and leaves redrawn in graphite, 260 x 186 mm (10¼ x 7⁵⁄₁₆ in.), maximum as restored; gouache partly oxidized, losses along upper, right, and lower borders of sheet made up

Inscribed in brown ink on verso at upper left: *148*; in black ink along lower left: *Antonio Pollajolo*; in brown ink at lower right made-up corner: *47*

Nationalmuseum, Stockholm 74.76/1863

PROVENANCE: Pierre Crozat, Paris; his sale, Paris, April 10–May 13, 1741, lot 1, 2, or 3 (as annotated by Carl Gustaf Tessin in his copy of the sale catalogue); Comte Carl Gustaf Tessin, Stockholm (manuscript inventory, 1749, p. 17, no. 3, as Pollaiolo [*sic*]); sold to Swedish royal family, 1750s; Kungliga Museum, Stockholm, 1792 (Lugt 1638); incorporated into Nationalmuseum, 1866.

LITERATURE: Schönbrunner and Meder 1896–1908, vol. 8, no. 868 (recto), vol. 10, no. 1188 (verso); Sirén 1902, p. 123, nos. 40, 41 [Raffaellino del Garbo]; Sirén 1917, nos. 41, 42; Sirén 1933, p. 62, pls. 37, 38; Scharf 1935, no. 191; Berenson 1938, vol. 2, no. 1366B, vol. 3, fig. 256 (recto); Berenson 1961, vol. 2, no. 1366C; Reutersvärd 1966, pp. 79–100, fig. 1; Bjurström 1969, p. 17, no. 7, illus. (recto); Shoemaker 1975, no. 29.

A date of about 1483–88 can be proposed for this sheet, based on the incisive metalpoint technique and the figural type of the adolescent Saint John the Baptist on the recto, which still depends on Botticelli's and Pollaiuolo's work of the late 1470s to early 1480s. The saint recalls the seated boy in the left foreground of Filippino's *Adoration of the Magi* (pl. 7). His pose also evokes the young soldier shown sleeping in Filippino's fresco *Saint Peter Liberated from Prison* (fig. 33) in the Brancacci Chapel. The execution is closely related to that of the pages of the presumed sketchbook (cat. nos. 24–26), sharing with them a descriptive use of metalpoint, thickly applied white highlights, and thin ground preparation.

John holds his traditional attributes, the reed cross and scroll, and a small dish, probably alluding to the baptismal water he used, rests on a rocky ledge on the left. On the right are enigmatic secondary attributes of the saint, which follow an iconographic tradition that was fairly unusual in the Florence of the trecento and quattrocento.[1] One of these is a sleeping bear cub or, less likely, a dog or a wolf. A bear cub may signify the Baptist's early life as a hermit, surrounded by animals in the wilderness. The bear cub would have additional meaning for Saint John: according to Pliny's *Natural History* (8:126) and medieval bestiaries, formless newborn bear cubs are licked alive and into shape by their mothers, an act interpreted by the Church as comparable to the conversion of heathens to Christianity by baptism.[2] However, the dog is sometimes seen as an attribute of Melancholy, which the pensive saint may here evoke.[3] The motif of the ax embedded in the tree stump is of Byzantine origin[4] and symbolizes phrases associated with the Baptist in the Gospels of Matthew (3:10) and Luke (3:9).

The handling of the metalpoint on the verso shows extraordinary vigor, despite the abraded condition of the sheet. The mysterious subject here may be loosely based on an episode in the myth of Hercules and the giant Cacus. The key element of the story for a reading of Filippino's composition can be pieced together from Virgil's *Aeneid* (8:200–208) and Ovid's *Fasti* (1:543–85). These tell that Cacus stole some of the cattle Hercules captured from Geryon when the hero lay down to sleep; the giant did this by silently dragging them backward into his cave. It may well be, then, that the figure pulling an animal by the tail represents Cacus. Although the group evokes the monumentality of ancient Roman relief sculpture, it appears to have been studied from life: clearly the youth on the right was drawn after a *garzone* posing in his breeches in the artist's workshop.

CCB

1 The Florentine iconography of Saint John the Baptist is discussed in Lavin 1955; Lavin 1961; and Dalli Regoli 1994a.

2 Wehrhahn–Stauch 1968, cols. 242–43.

3 Ibid., vol. 2, pp. 334–35.

4 This motif accompanies the young Baptist in the left foreground of Fra Filippo Lippi's *Adoration of the Christ Child*, about 1463–65 (Gemäldegalerie, Berlin). It appears also in a panel by Filippino's workshop, *Saint John the Baptist* (Szépművészeti Múzeum, Budapest). The subject shown on the recto is depicted in a similar composition in a painting in the Fogg Art Museum, Harvard University Art Museums, Cambridge, Massachusetts, attributed to the Pseudo-Granacci, which may, however, be by one of Filippino's distant followers. Panels attributed to Jacopo del Sellaio also exemplify this iconography (Dalli Regoli 1994a).

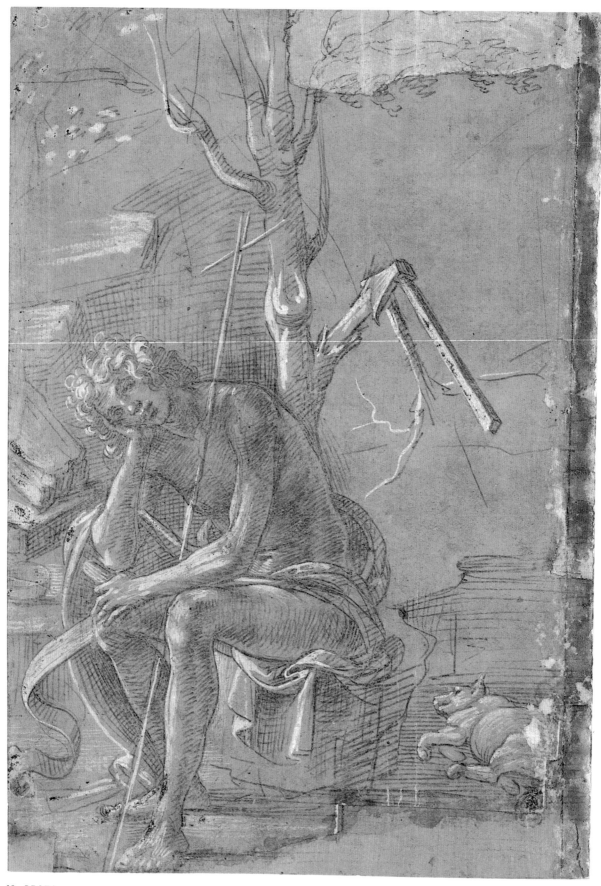

30 RECTO

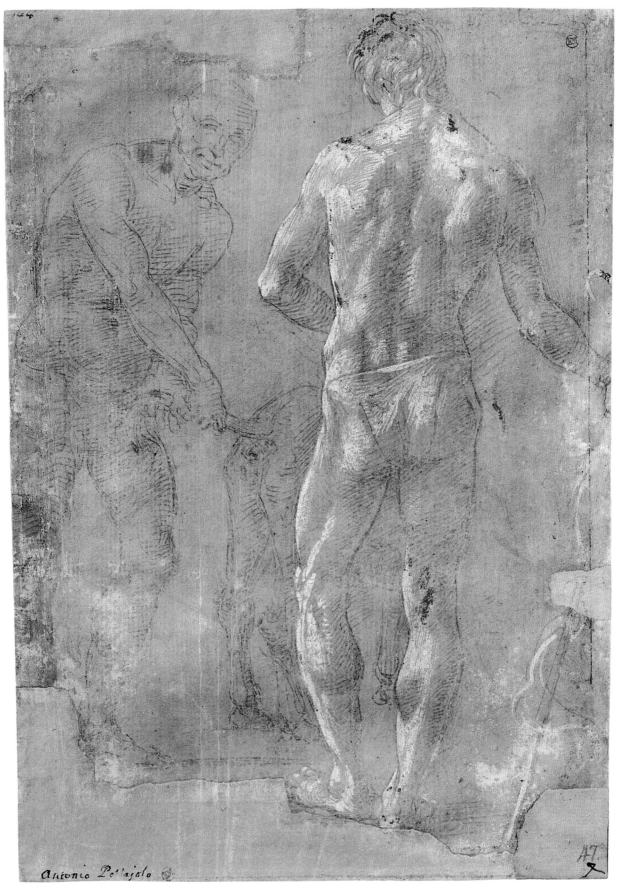

Antonio Pollajolo

31 *Three Standing Men, One Facing Right, One Seen from the Back Stepping on a Stool, and One Seen from the Back Holding a Stool*, recto

Seated Youth Holding a Staff and Seated Man Sleeping against a Bench, verso

Metalpoint, heightened with white gouache, on gray prepared paper; verso with ground preparation reapplied toward center, stylus-incised outlines around figures, 196 x 278 mm (7¹¹⁄₁₆ x 10¹⁵⁄₁₆ in.)

Inscribed in brown ink on verso along lower right border by sixteenth- or seventeenth-century hand: *ridolfo d[e]l ghirlandaio*

Gabinetto Disegni e Stampe degli Uffizi, Florence 141 E

PROVENANCE: Houses of Medici and Lorraine (manuscript inventory written by Giuseppe Pelli Bencivenni before 1793); museum stamp (Lugt 930).

LITERATURE: Ferri 1890, p. 90, no. 141; Ulmann 1894c, p. 113 [Raffaellino del Garbo]; Berenson 1903, vol. 2, no. 1286; Loeser 1916, no. 19 [Ridolfo del Ghirlandaio]; Scharf 1935, no. 212; Berenson 1938, vol. 2, no. 1286; Fossi [Todorow] 1955, no. 6; Berenson 1961, vol. 2, no. 1286; Ragghianti and Dalli Regoli 1975, pp. 75–76, no. 8, figs. 31, 32; Shoemaker 1975, no. 40; Petrioli Tofani 1986, no. 141 E; Berti and Baldini 1991, p. 284, illus.

As Fossi has recognized, this sheet, which was probably produced immediately after the pages from the supposed sketchbook (cat. nos. 24–26), and two other sheets in the Uffizi (cat. nos. 32, 33) are closely linked in style and technique. In fact, the model shown sleeping on the right of the verso here posed for the study on the right of the verso of one of the related Uffizi drawings (cat. no. 33). Now widely recognized as a work by Filippino, the present sheet was first attributed to him by Ferri in his inventories of 1879–81.[1] Berenson remarked on its close stylistic affinity with *garzone* studies that he gave to David Ghirlandaio but considered Filippino's sheet to be more animated. Indeed, he believed this drawing was among his finest examples of the genre, possibly related to the Strozzi Chapel frescoes, for example, the *Raising of Drusiana* (pl. 26), a connection less precise than he hypothesized. Shoemaker's proposed date of about 1485, which in the end is fully convincing, takes into account the sheet's stylistic variations. In her view the sketchy, painterly treatment of the two figures on the right of the recto typifies Filippino's style of the 1490s, while the greater degree of plasticity and finish with hatching of the other figure on the recto and the two men shown on the verso are characteristic of his manner of the early 1480s. Yet these variations in handling, which seem less pronounced than Shoemaker has suggested, do not arise because the drawings were made at different times; rather, they relate to the function and type of drawing in question.[2]

CCB

1 In 1778 Stefano Mulinari had engraved it as a Francesco Pesellino, probably based on a cataloguing error that originated in the time of Filippo Baldinucci. The stylus incisions around the figures in Filippino's sheet may relate to Mulinari's endeavor.

2 As Ragghianti and Dalli Regoli have pointed out, the two figures on the right of the recto are awkwardly reprised without context or vivacity on the recto and verso of an anonymous pen-and-ink drawing in the Kupferstich-Kabinett Dresden (inv. no. C.18).

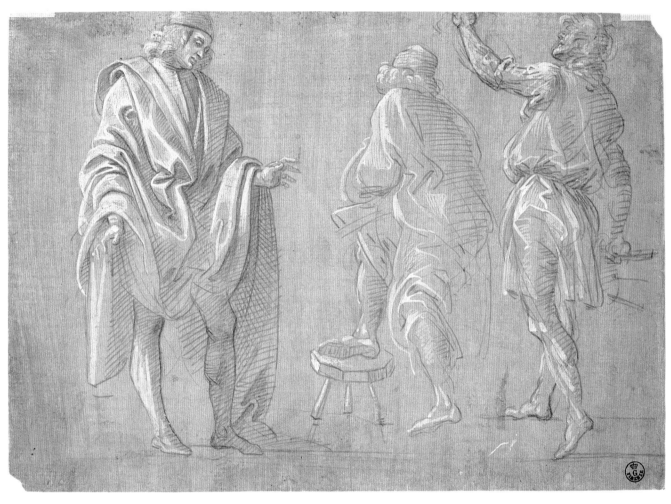

31 RECTO

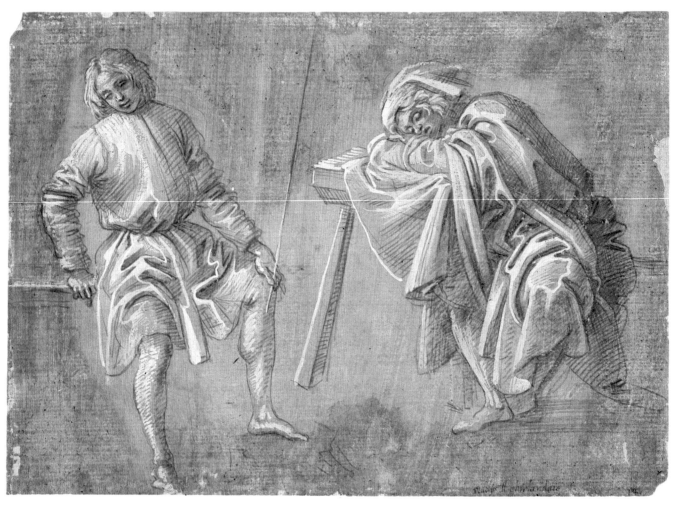

31 VERSO

32 *Three Men, One Standing and Turned to the Right, One Kneeling, and One Seen from the Back and Standing,* recto

Three Standing Men, One Turned to the Right and Two to the Left, verso

Metalpoint, heightened with white gouache, on gray prepared paper, cut into two parts and hinged separately, 248 x 172 mm (9¾ x 6¾ in.); left, 246 x 131 mm (9¹¹⁄₁₆ x 5⅛ in.); right, 248 x 305 mm (9¾ x 12 in.), maximum as restored and mounted

Gabinetto Disegni e Stampe degli Uffizi, Florence 172 E

PROVENANCE: Houses of Medici and Lorraine (manuscript inventory written by Giuseppe Pelli Bencivenni before 1793); museum stamp (Lugt 930).

LITERATURE: Ferri 1890, p. 89, no. 172 [Fra Filippo Lippi]; Ulmann 1894c, p. 113, R.71, Nr.172 [Raffaellino del Garbo]; Morelli 1900, p. 116; Berenson 1903, vol. 2, no. 1296; Scharf 1935, no. 213; Berenson 1938, vol. 2, no. 1296, vol. 3, fig. 245; Fossi [Todorow] 1955, no. 4; Berenson 1961, vol. 2, no. 1296; Shoemaker 1975, no. 39; Petrioli Tofani 1986, no. 172 E.

This sheet is related to two others in the Uffizi (cat. nos. 31, 33) and is among the rare *garzone* studies by Filippino with a recognizable narrative. The arrangement of the figures on the recto resembles that of *Saint Roch Blessing or Healing an Ecclesiastic* (fig. 38), part of a predella panel that is probably from the Magrini Altarpiece Filippino executed for San Michele in Foro, Lucca, in 1482 (pl. 10). The composition also recalls Pietro Perugino's *Christ's Charge to Saint Peter* fresco of 1481–83 on the right wall of the Sistine Chapel, which Filippino may have known indirectly before he arrived in Rome in 1488 to work on the Carafa Chapel. Neither Scharf's identification of the present sheet as a study for a lost Noli Me Tangere nor Shoemaker's more tentative proposal of its iconographic link to the *Raising of Theophilus's Son* in the Brancacci Chapel (pl. 8) is clearly demonstrable. The elegant and complex treatment of the draperies on both recto and verso occurs also in the work Filippino produced in Lucca and San Gimignano from 1482 to 1484 and, despite its more restrained graphic marks, evokes as well the pages from the supposed sketchbook; those parallels suggest a date about 1483–85 for the sheet.

CCB

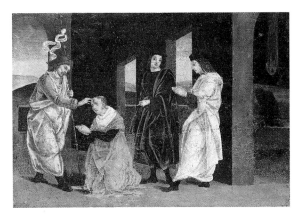

FIG. 38 *Saint Roch Blessing or Healing an Ecclesiastic.* Tempera on panel, 23 x 33 cm. Location unknown (formerly with dealer Bellini, Florence)

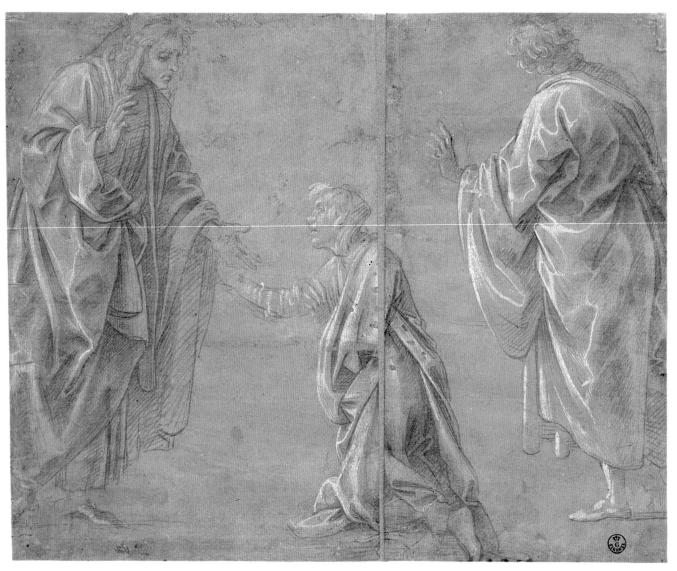

32 RECTO

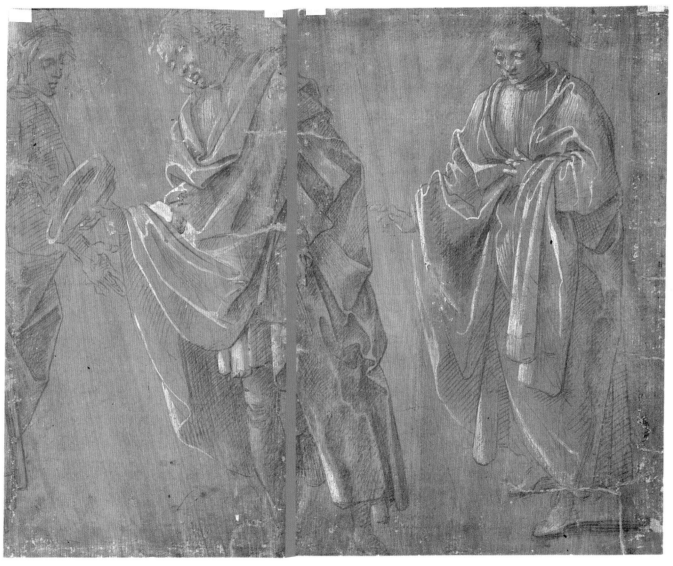

32 VERSO

33 *Kneeling Male Saint Facing Left and Holding a Crozier and Standing Turbaned Man Turned to the Right*, recto

Two Seated Men, One Turned to the Right and One to the Left, verso

Metalpoint, heightened with white gouache, on gray prepared paper, cut into two vertical parts and reglued with 8–10 mm overlap, 239 x 248 mm (9⅜ x 9¾ in.) with overlap, ca. 239 x 258 mm (9⅜ x 10³⁄₁₆ in.) without overlap

Gabinetto Disegni e Stampe degli Uffizi, Florence 171 E

PROVENANCE: Houses of Medici and Lorraine (manuscript inventory written by Giuseppe Pelli Bencivenni before 1793); museum stamp (Lugt 930).

LITERATURE: Ferri 1881, p. 13 [Fra Filippo Lippi]; Ferri 1890, p. 89, no. 171 [Fra Filippo Lippi]; Ulmann 1894c, p. 113, R.72, Nr.171 [Raffaellino del Garbo]; Morelli 1900, p. 116; Berenson 1903, vol. 2, no. 1295; Van Marle 1923–38, vol. 12 (1931), p. 367, fig. 239; Scharf 1935, no. 222; Berenson 1938, vol. 2, no. 1295; Fossi [Todorow] 1955, no. 5; Berenson 1961, vol. 2, no. 1295; Shoemaker 1975, no. 38; Petrioli Tofani 1986, no. 171 E.

Attributed to Fra Filippo Lippi by Ferri in his inventories of 1879–81, as well as by other early critics, this sheet was restored to Filippino by Morelli in 1881.[1] It was convincingly dated about 1483–85 by Shoemaker. The drawing and another in the Uffizi (cat. no. 32) may have been pages in the same sketchbook, although their present dimensions cannot be used to support this hypothesis: both have been cut and reassembled by old restorers. Ulmann, who gave the present sheet to Raffaellino, noticed that the pose and gesture, but not the physical type, of the kneeling saint on the recto recall the figure of Saint Peter Martyr in the right foreground of the lost *Enthroned Virgin and Child with Saints* (formerly Kaiser Friedrich Museum, Berlin) by a follower of Filippino. And, as Fossi observed, Filippino's spirited, sculptural treatment of the draperies on both recto and verso evokes Donatello's prophets carved for the campanile of the cathedral of Florence and Verrocchio's *Doubting of Thomas* at Orsanmichele, Florence.

Although they are by no means of uniform quality, the drawings on both recto and verso of this sheet all appear to be by the same hand; their variations illustrate the range of execution that must have characterized life drawings in late-quattrocento sketchbooks. The kneeling saint on the recto is noticeably larger than the turbaned youth on the right. The youth in turn exhibits a finer handling of the metalpoint, with more meticulous hatching but heavier application of white highlights than the saint. The execution of the studies on the verso is considerably coarser than that of either figure on the recto.

CCB

1 Ferri 1881, p. 13, with annotation regarding Morelli's attribution to Filippino.

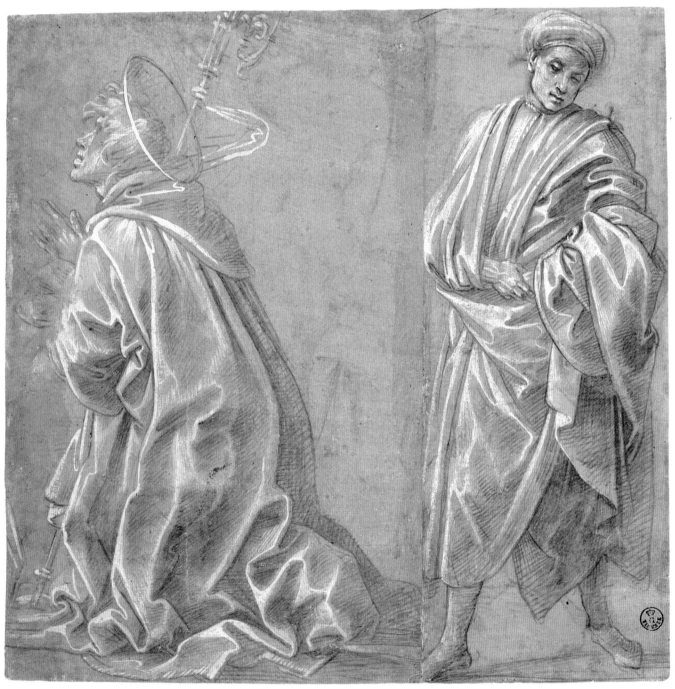

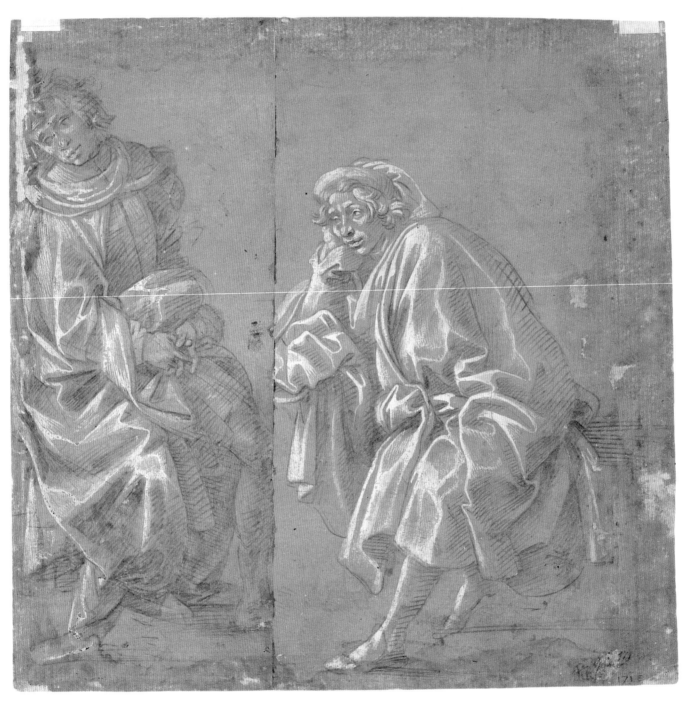

33 VERSO

34 *Saint Bernard*

Metalpoint, heightened with white gouache, on peach-color prepared paper, 212 x 131 mm (8¼ x 5⅛ in.); upper corners cropped

Gabinetto Disegni e Stampe degli Uffizi, Florence 129 E

PROVENANCE: Houses of Medici and Lorraine (manuscript inventory written by Giuseppe Pelli Bencivenni before 1793); museum stamp (Lugt 930).

LITERATURE: Ferri 1890, p. 89, no. 129; Ulmann 1894c, p. 111, n. 28; Berenson 1903, vol. 1, p. 76, vol. 2, no. 1282; Van Marle 1923–38, vol. 12 (1931), p. 361; Scharf 1935, p. 79, no. 258, fig. 145; Berenson 1938, vol. 1, p. 104, n. 1, vol. 2, no. 1282, vol. 3, fig. 223; Scharf 1950, p. 54, no. 49; Fossi [Todorow] 1955, no. 17; Berenson 1961, vol. 1, pl. XXXIV, vol. 2, no. 1282; Spencer 1966, p. 30, fig. 5; Shoemaker 1975, no. 43; Petrioli Tofani 1986, no. 129 E.

This is among the most important surviving figure drawings by Filippino, since it can be regarded with certainty as his study for the figure of Saint Bernard in the *Vision of Saint Bernard* (pl. 18) in the Florentine Badia, painted for the monastery of the Campora at Marignolle on the commission of Piero di Francesco del Pugliese. The altarpiece has been variously dated between the early 1480s and a year or two before the artist's departure for Rome in 1488. On balance the stylistic and documentary evidence favors a date of about 1485–86.

The saint in the drawing differs from the painted figure in a number of respects. The figure in the study is less attenuated and expressively more immediate and direct, as well as younger, than the one in the painting. In addition, the drapery patterns of the painting are somewhat simplified. It is probable that the drawing was composed from a model in the studio and that the final, painted version was altered to make a more ethereal image.

The draftsmanship here is rapid and subtle, with short, parallel metalpoint strokes used economically to model the form within a quickly executed outline. White highlights are applied with an eye toward the naturalistic representation of light rather than the manneristic love of elaboration evident in some of the *garzone* studies of the period that were not intended for specific use in pictures.

GRG

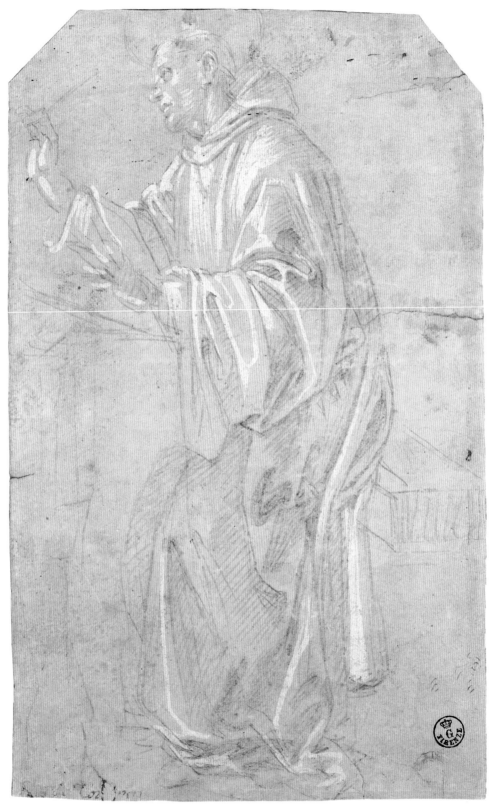

34

35 *Two Seated Men, the One at Right Playing the Mandolin,* recto

A Cobbler at Work, verso

Metalpoint, heightened with white gouache, on gray prepared paper, 196 x 185 mm (7¹¹⁄₁₆ x 7¼ in.); lower left corner and part of lower right corner made up

Département des Arts Graphiques du Musée du Louvre, Paris 1255

PROVENANCE: Filippo Baldinucci, Florence; acquired 1806.

LITERATURE: Berenson 1903, vol. 2, no. 859C [David Ghirlandaio]; Rouchès 1931, p. 20, no. 17; Scharf 1935, p. 124, no. 232; Berenson 1938, vol. 2, no. 1358; Bacou and Bean 1958, pp. 17–18, no. 8; Berenson 1961, vol. 2, no. 1358; Degenhart and Schmitt 1968, vol. 2, p. 649; Shoemaker 1975, no. 14.

The attribution to Filippino goes back at least to Baldinucci and has been maintained by most scholars. The recto is drawn with light, relatively short metalpoint strokes that point to a date in the late 1480s. As in the British Museum drawing of nudes of the mid- to late 1480s (cat. no. 36), there is a clear effort to use metalpoint to model the forms with subtle tonal gradations, although that feature is less well developed in this sheet. At the same time, the facial type and rendering of eyes look forward to the more delicate portrayal of a reclining youth now in the Louvre (cat. no. 48). A similar sitter is depicted in a considerably earlier study by Maso Finiguerra in the Uffizi (inv. no. 91 E).

The genre study on the verso is also comparable in subject to earlier drawings by Finiguerra (fig. 39, for example). Shoemaker has noted that the verso is inferior to the other side of the sheet and suggested that it was executed by a studio assistant. More probably it is Filippino's work but slightly earlier than the recto; it is related in manner to drawings such as the sheet in the Uffizi from about 1483–85 showing a kneeling saint, a turbaned man, and two seated men (cat. no. 33).

GRG

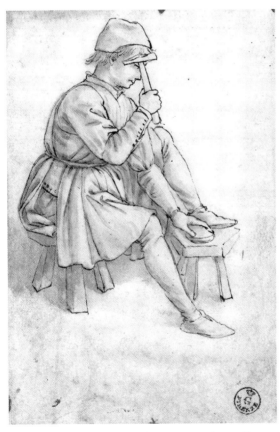

FIG. 39 Maso Finiguerra. *Seated Young Man Making a Shoe.* Pen and brown ink and brown wash with traces of black chalk, 191 x 128 mm. Gabinetto Disegni e Stampe degli Uffizi, Florence 70 F

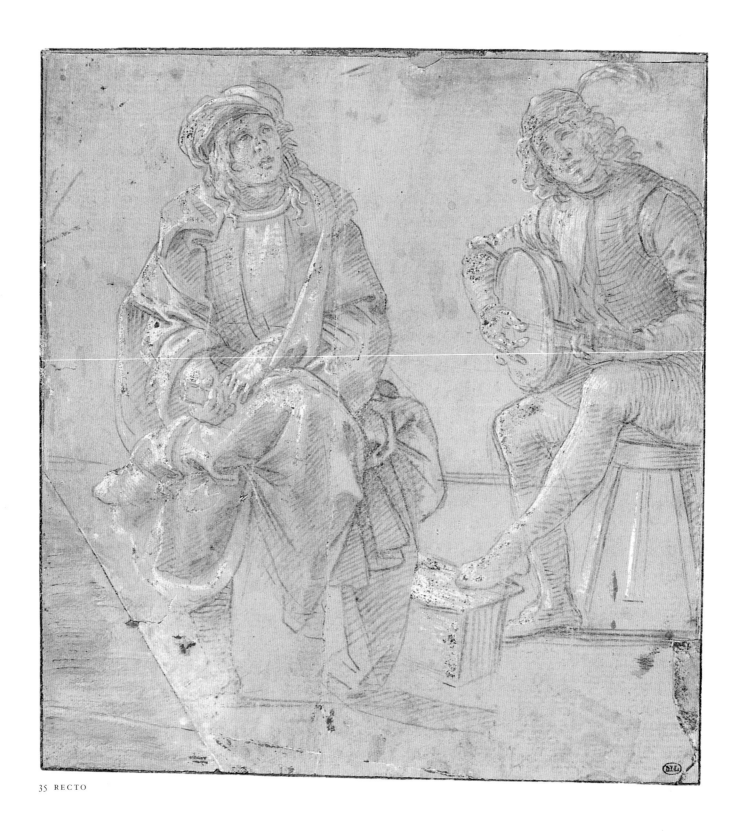

35 RECTO

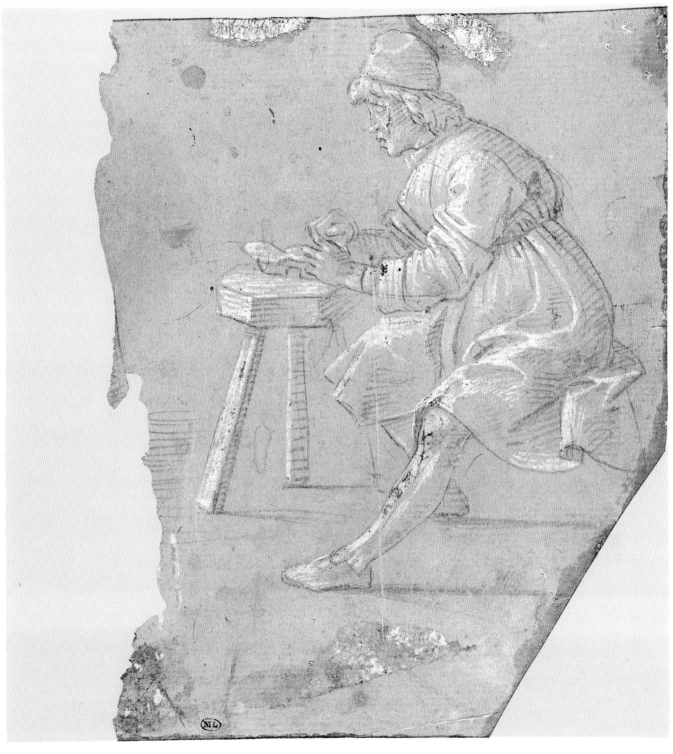

35 VERSO

36 *Seated Male Nude Facing Left and Standing Male Nude Facing Left*

Metalpoint, heightened with white gouache, on gray prepared paper, 260 x 186 mm (10¼ x 7⁵⁄₁₆ in.); upper right and left and lower left corners made up

British Museum, London 1858-7-24-4

PROVENANCE: Comte Nils Barck, Paris and Madrid (Lugt 1959); Tiffin, London.

LITERATURE: Colvin 1895, p. 10, no. 22; British Museum 1896, p. 252, no. 22; Berenson 1903, vol. 2, no. 1345; Scharf 1935, p. 82, no. 311, fig. 149; Berenson 1938, vol. 2, no. 1345; Popham and Pouncey 1950, no. 134, pl. 122; Berenson 1961, vol. 2, no. 1345; Shoemaker 1975, no. 31.

This is a relatively rare example of nude *garzone* studies by Filippino. The man at the left is carried out in a brownish metalpoint, while the one at the right is grayer. The figures are comparable to the clothed pairs of models shown in the pages of the presumed sketchbook (cat. nos. 24–26). Although considered part of the "sketchbook" by Scharf, this drawing belongs to a slightly later phase of Filippino's development than the sheets in that group. Here metalpoint strokes are blended rather than remaining stridently independent of one another as in the "sketchbook" pages. The resultant forms are more naturalistically and tonally modeled; in addition, there is a greater economy of execution. These qualities suggest a date in the mid- to late 1480s, before the artist departed Florence for Rome in 1488.

GRG

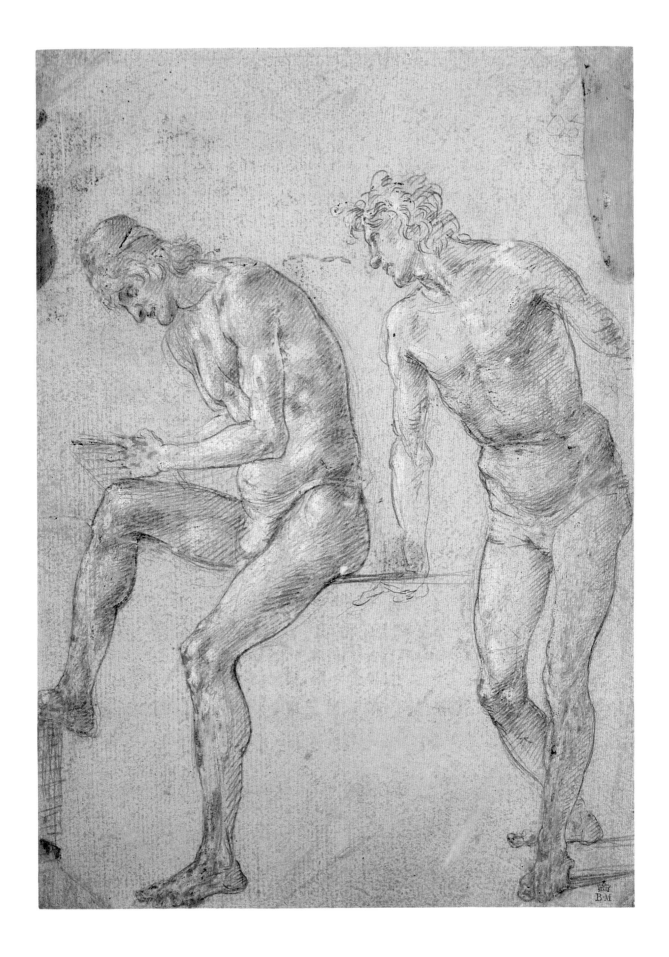

37 *Male Nude Leaning to the Left*

Metalpoint, heightened with white gouache, on mauve-gray prepared paper, 236 x 177 mm (9⅜ x 6¹⁵⁄₁₆ in.); upper corners cropped

Inscribed in brown ink at lower right: *Masaccio 1436*

British Museum, London 1860-6-16-64

PROVENANCE: Sale, Thomas Philipe, London, April 24, 1801, lot 114; Sir Thomas Lawrence, London (Lugt 2445); Samuel Woodburn, London; his estate sale, Christie's, London, June 6, 1860, lot 560.

LITERATURE: Ulmann 1894c, p. 111, n. 28; Colvin 1895, p. 11, no. 23; British Museum 1896, p. 252, no. 23; Berenson 1903, vol. 2, no. 1346; Scharf 1935, pp. 83, 130, no. 312, fig. 179; Berenson 1938, vol. 2, no. 1346; Chastel 1950, pl. 47; Popham and Pouncey 1950, p. 83, no. 135, pl. 123; Berenson 1961, vol. 2, no. 1346; Shoemaker 1975, no. 111; Shoemaker 1994, pp. 261–62, fig. 14.

Since the late nineteenth century this study of a man lurching forward with a ribbon or piece of rope in his left hand has been accepted as the work of Filippino. Shoemaker (1994) has recently noted its relationship to earlier drawings by Antonio Pollaiuolo in which an effort is made to articulate musculature and render animated movement. These concerns had been evident in Filippino's work since the mid-1470s, when the artist addressed them in one of his earliest surviving groups of studies (cat. nos. 11A, B)—which includes a figure in a similar, but much more tentative, pose.

Here Filippino appears to have begun with the right side of the back somewhat lower and to have reworked it to show a broader expanse across the shoulder. The right arm was adjusted, although a bit awkwardly, and, like the left hand, was quickly sketched in. By contrast, the rest of the figure was worked up in varied and integrated metalpoint strokes and white heightening to give continuity and tonal subtlety to the form. The expressive vitality of the face is enhanced by the free calligraphy of the hair.

This is generally considered a late drawing by the artist; Shoemaker compares it to his studies for the Strozzi Chapel. It is closely analogous in all respects to the nude study for the *Martyrdom of Saint John* in the Strozzi Chapel (cat. no. 44) and also to the slightly earlier verso of a sheet of studies in Malibu (cat. no. 29). In addition, the model is certainly the same man who posed for the nude at the right in another sheet at the British Museum (cat. no. 36). These parallels argue for a date in the mid- to late 1480s, as do the significant differences between this group and such later studies as the drawings for the litter bearers at Christ Church and in the Uffizi (cat. nos. 100, 101).

GRG

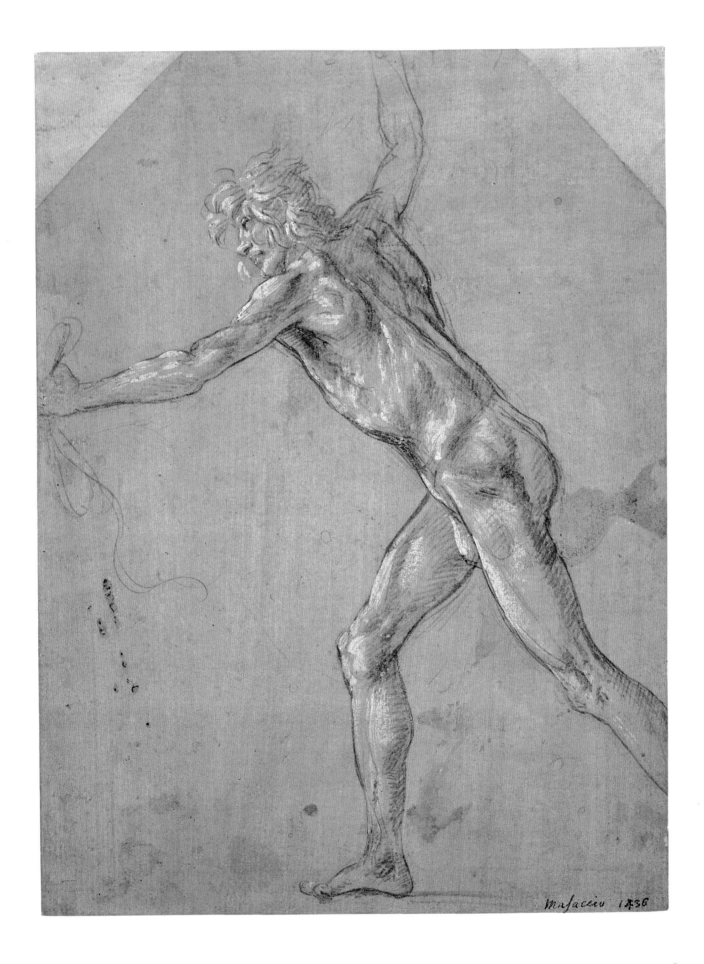

38 *Seated Man Turned to the Left with an Animal at His Side and Study of a Left Hand*

Metalpoint and brown-gray wash, heightened with white gouache, and pen-and-black-ink framing outlines on pink-brown prepared paper, 173 x 105 mm (6¹³⁄₁₆ x 4⅛ in.)

Graphische Sammlung im Städelschen Kunstinstitut, Frankfurt am Main 418

PROVENANCE: Jean David Passavant, Frankfurt am Main; acquired before 1862 (Lugt 2357).

LITERATURE: Berenson 1903, vol. 2, no. 38 [Alunno di Domenico]; Scharf 1935, no. 355 [in the manner of Filippino]; Berenson 1938, vol. 2, no. 1341A; Berenson 1961, vol. 2, no. 1341A; Ragghianti and Dalli Regoli 1975, no. 129, pl. 166; Shoemaker 1975, no. R39 [not Filippino]; Malke 1980, no. 47, fig. 47 [circle of Filippino]; Dalli Regoli 1994, p. 79, fig. 12; Knoch in Bauereisen and Stuffman 1994, p. 44, no. Z3, illus. p. 46 [circle of Filippino].

An attribution of this life study to Filippino himself, rather than his circle, can be advanced on the basis of its parallels with the autograph panel showing Saint Jerome in the Uffizi (pl. 21), dated variously between 1485 and 1496. The similarities are of style rather than of design or figural type. In both works the effects of flickering light on monumental draperies with chiseled folds emphasize the compact proportions of the figures, as well as their low laps, features also present in the study of a seated man in Lille (cat. no. 39). Rotated in slight *sotto in sù* foreshortening, the heads of the figures in the Frankfurt drawing and in the painting are somewhat harshly lit from the upper left, and in each the localized light picks out the wild stringiness of the hair and the strained, upward gaze. A degree of caution should be maintained regarding the attribution of the present drawing, as it offers a refinement of surface similar to that seen in Raffaellino del Garbo's sheet of metalpoint studies of arms and hands in the Albertina (cat. no. 113), whose ground, moreover, is nearly identical in color. Yet the structural knowledge of the figure displayed in the present drawing seems beyond the grasp of Raffaellino: with an extraordinary vivacity of pose, the seated young man turns to an unseen interlocutor, his limbs engaged in a complex rhythm of contrapposto, exemplifying Leonardo's recommendations of about 1490–92: "Never make the head turn the same way as the torso, nor the arm and leg move together on the same side. And if the face is turned to the right shoulder, make all the parts lower on the left side than on the right."[1] Similar types of subtly agitated contrapposto poses are assumed by the seated patriarchs Adam and Abraham on the vault of the Strozzi Chapel.

In the drawing a unified treatment of light plays up the monumentality of the draperies gathered on the lap of the *garzone*, casting a range of secondary shadows; all of these features again reveal awareness of Leonardo's practice. With delicate control, the artist pushed the medium of metalpoint to its limits to create nuanced effects of chiaroscuro, defining the rich tonal range of intermediate shadows mostly with densely spaced parallel hatching and unifying shadows by brushing on a nearly transparent brown-gray wash. He created the highlights with broad areas of white, rather than with individual hatched strokes, and with a subtlety that is now somewhat obscured by surface abrasion. The drawing can thus be dated about 1488–90.

CCB

1 Richter 1970, vol. 1, p. 346, no. 596.

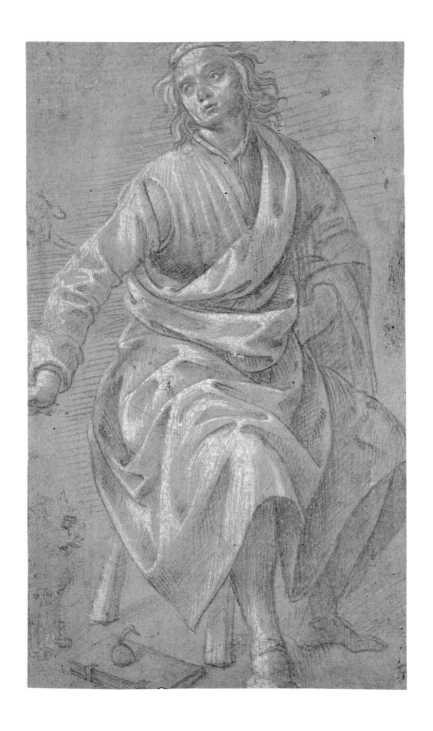

39 Seated Man Turned to the Left with His Right Arm Extended

Metalpoint, heightened with white gouache, on pink prepared paper, 170 x 99 mm (6 11⁄₁₆ x 3 7⁄₈ in.)

Palais des Beaux-Arts, Lille Pl.232

PROVENANCE: Jean-Baptiste-Joseph Wicar, Lille (Lugt 2568); acquired 1834.

LITERATURE: Benvignat 1856, no. 247 [Florentine School]; Gonse 1877, p. 396, no. 247 [Fra Filippo Lippi]; Pluchart 1889, no. 232 [attributed to Finiguerra]; Morelli 1892, col. 443, no. 135 [Florentine artist]; Berenson 1903, vol. 2, no. 842 [David Ghirlandaio]; Berenson 1938, vol. 2, no. 842 [David Ghirlandaio]; Laclotte 1956, p. 102, no. 142, pl. 59; Berenson 1961, vol. 2, no. 842 [David Ghirlandaio]; Viatte 1963, no. 53; Châtelet and Scheller 1968, pp. 25–26, no. 53, pl. 5; Châtelet 1970, p. 46, no. 52, fig. 43; Ragghianti and Dalli Regoli 1975, pp. 60, 117, no. 130, fig. 167; Shoemaker 1975, no. 52; Brejon de Lavergnée 1989, pp. 25–27, no. 6, illus.; Brejon de Lavergnée 1990, p. 41, fig. 3.

Gonse attributed this drawing to Fra Filippo Lippi, noting that others had considered it to be by Filippino. Popham reintroduced the attribution to Filippino, which has since been universally accepted.[1]

In the earlier literature it is sometimes related to drawings from the presumed sketchbook, which also are studies of *garzoni* in animated poses made in the studio. However, Shoemaker has correctly pointed out that this sheet is somewhat later than the "sketchbook" group, looking forward in many respects to the metalpoint studies for the Carafa Chapel, and should be dated in the second half of the 1480s. The broader and more tonal use of metalpoint, the freely sketched hair and right forearm, and the quick parallel strokes modeling the left shoulder are all features that suggest this slightly later stage in Filippino's draftsmanship. There is also a greater understanding here of the relationship among pose, underlying figure, and drapery. These characteristics are evident as well in a stylistically related *garzone* study in Frankfurt (cat. no. 38).

GRG

1 Popham's opinion, received in an oral communication, was published in Laclotte 1956, p. 102, no. 142.

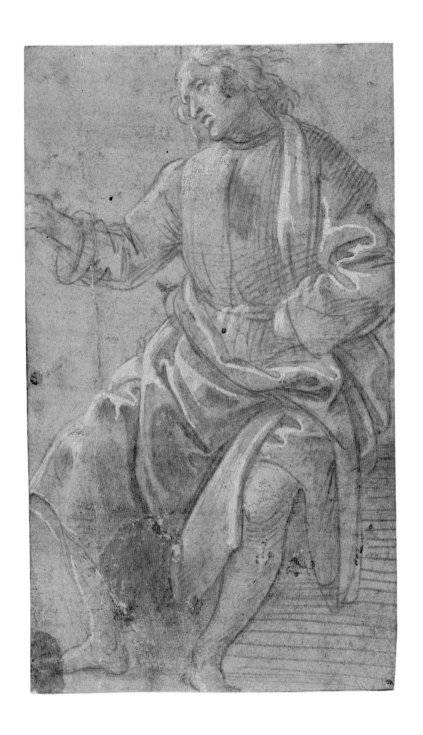

40 *Three Seated Men Wearing Heavy Mantles*

Metalpoint, heightened with white gouache, on pale beige
prepared paper, 256 x 359 mm (10⅛ x 14⅛ in.), maximum;
upper corners cropped

Gabinetto Disegni e Stampe degli Uffizi, Florence 134 E

PROVENANCE: Museum stamp (Lugt 930).

LITERATURE: Ulmann 1894c, p. 111, no. 28; Berenson 1903,
vol. 2, no. 1284; Halm [1931], p. 420; Scharf 1935, no. 211;
Berenson 1938, vol. 2, no. 1284; Fossi [Todorow] 1955, no. 12;
Berenson 1961, vol. 2, no. 1284; Shoemaker 1975, no. 13; Sale
1979, pp. 169, 211, n. 14, fig. 59; Petrioli Tofani 1986, no. 134 E;
Sisi in Petrioli Tofani 1992, no. 2.12, illus.

Much debate has surrounded the dating of this
sheet, long recognized as autograph and unusually
large for Filippino's figure studies in metalpoint.
Proposals range from 1480 to 1493 and depend on
whether or not the seated figures are considered
to be related to the patriarchs on the vault of the
Strozzi Chapel. A date in the late 1480s, immediately
before the Carafa Chapel murals were painted, seems
probable on the basis of both figural typology and
masterly control of the metalpoint medium. Here
Filippino achieved a refined description of tone
despite the evident rapidity with which he executed
the drawing. He first sketched the forms of the
figures with a fine stylus, turning to a broad, softer
point to create unified shadows, and finally built up
highlights in thin layers to obtain delicately luminous
effects. The compact monumentality of form, rela-
tively precise anatomical proportions, and rather
unified treatment of light seem well beyond the grasp
of the young Filippino of the early 1480s; instead
they respond to the work Leonardo produced from
about 1480 to 1482–83, before he left Florence for Milan.

The seated figures more closely evoke the poses of
the Strozzi Chapel patriarchs (pl. 23), especially Jacob
and Noah, than do those in the sheet of studies in
Lille (cat. no. 41) that also is related to the Strozzi
vault. Both sheets may have been prompted by the
task of designing the Strozzi Chapel vault, even though
they are not highly similar—indeed, Filippino seems
to have made diverse designs for the same project
frequently. A contract dated April 1489 and payments
made in August and September 1489 establish that
Filippino did some work for the Strozzi Chapel,
presumably the vault, before he began the Carafa
murals in Rome; the present sheet may well date from
this early phase.

CCB

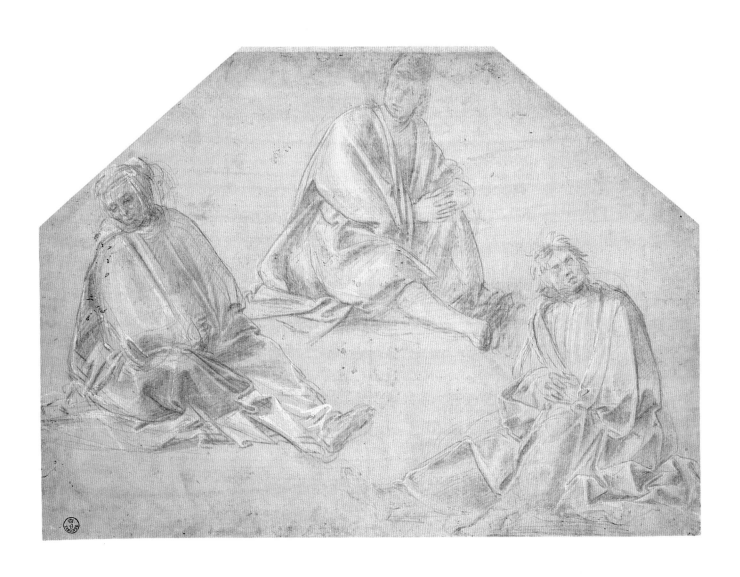

41 *Four Seated Male Nudes*

Metalpoint, heightened with white gouache, on gray prepared paper, 200 x 279 mm (7⅞ x 11 in.)

Palais des Beaux-Arts, Lille Pl. 290

PROVENANCE: Jean-Baptiste-Joseph Wicar, Lille (Lugt 2568); acquired 1834.

LITERATURE: Gonse 1877, p. 396, no. 1086 [Florentine School]; Pluchart 1889, no. 290 [Filippino Lippi]; Morelli 1892, col. 376, no. 9; Berenson 1903, vol. 1, pp. 78–79, vol. 2, no. 1343; Halm [1931], p. 420, fig. 16; Van Marle 1923–38, vol. 12 (1931), pp. 367–68, fig. 241; Scharf 1935, pp. 83, 130, no. 310; Berenson 1938, vol. 1, p. 106, n. 2, vol. 2, no. 1343; Fossi [Todorow] 1955, pp. 6–7, with no. 12; Laclotte 1956, no. 140, pl. 58; Bacou 1957, p. 28; Berenson 1961, vol. 1, p. 163, n. 1, vol. 2, no. 1343; Viatte 1963, p. 26, no. 55; Châtelet and Scheller 1968, no. 55; Châtelet 1970, no. 54, fig. 45; Shoemaker 1975, no. 108.

Pluchart hesitantly proposed the attribution to Filippino, which was affirmed by Morelli and then Berenson and is now universally accepted. Berenson suggested that the four studies were made in preparation for the vault of the Strozzi Chapel, a hypothesis that has also met with general agreement.

The connection between these studies drawn from life and the vault frescoes is not a close one. Halm showed that the frescoed figure of Noah (pl. 23) is informed by Filippino's knowledge of antique river-gods that he would have seen in Rome. Shoemaker has pointed out that the figure in the lower left is closest to the antique prototypes and that it and the study at the center were made in preparation for the frescoed Jacob (pl. 23), whereas the two other sketches were preparatory to Noah. Therefore, the final design was determined by both antique sources and life studies, here symbiotically at work on one sheet.

The technique employed for this sheet is remarkable in its freedom. The ground preparation was quickly applied, as were the minimal metalpoint lines throughout. The major portion of the drawing was executed in broadly brushed white gouache, achieving an unprecedented painterly effect. In style and technique it is somewhat related to the other early Strozzi Chapel studies (cat. nos. 42, 44). Shoemaker correctly notes the similarity to the splendid Meleager study in the Louvre (cat. no. 46). These parallels point to a date of about 1489, just after Filippino's return to Florence from Rome, as does the evolution of the Strozzi Chapel project.

GRG

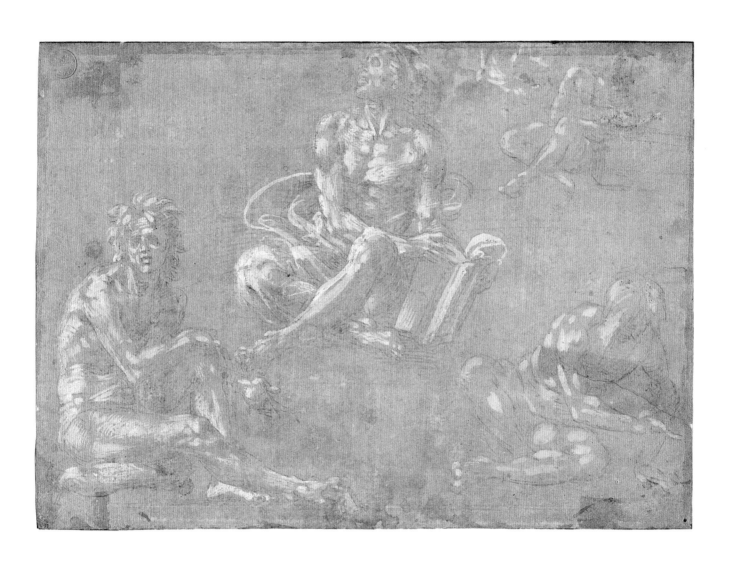

42 *Man Turned to the Right and Holding a Staff (Martial Exercise)*

Metalpoint, heightened with white gouache, on pale pink prepared paper, 181 x 119 mm (7⅛ x 4¹¹⁄₁₆ in.)

Gabinetto Disegni e Stampe degli Uffizi, Florence 303 E

PROVENANCE: Museum stamp (Lugt 930).

LITERATURE: Ferri 1890, p. 91, no. 303; Berenson 1903, vol. 2, no. 1311; Scharf 1935, no. 245; Berenson 1938, vol. 2, no. 1311; Fossi [Todorow] 1955, no. 43; Berenson 1961, vol. 2, no. 1311; Ames 1963, pl. 22; Shoemaker 1975, no. 110; Petrioli Tofani 1986, no. 303 E.

Although the authorship of this vigorously drawn figure study is evident—its attribution to Filippino has not been doubted—the subject is less clearly discernible. The figure is apparently shown in the act of performing a martial exercise. The man has just parried the thrust of an unseen opponent's staff with a horizontal motion of his right hand, causing the weapon to pass by the left side of his body; he is beginning to sweep his left arm up, creating a lever effect that will force the far end of the staff up and out of his enemy's hands.[1] Such bare-handed techniques, with which an unarmed man could defend himself against an armed assailant, were described in most manuals on fencing and dueling that were written in the fifteenth and sixteenth centuries.[2]

The figure in the present drawing generally recalls the design of the executioner who helps raise the cross with a log in the *Martyrdom of Saint Philip* in the Strozzi Chapel (pl. 27). By contrast, however, the athletic young man in the drawing is described with greater anatomical precision, with feet solidly planted on the ground and a more convincing distribution of weight. A figure study on brown-gray prepared paper (cat. no. 44), which was persuasively identified by Berenson as preparatory for the executioner brandishing a stick at the left in the *Martyrdom of Saint John* (pl. 25)—the pendant lunette fresco on the wall opposite the *Saint Philip* in the chapel—is closely related to this sheet in style and technique. Although Filippino appears to have carried out the *Saint Philip* about 1494–95 and the *Saint John* about 1498–1502, he probably made at least some of the preparatory drawings for the upper parts of the chapel walls between the time the Strozzi decorations were commissioned, in April 1487, and his departure for Rome to sign the contract for the Carafa Chapel frescoes, in August 1488. A date of 1487–88, in this early period of preparatory work, rather than in the 1490s, for the Uffizi fencer also accords with the stylistic evidence of a sheet in Malibu (cat. no. 29).

CCB

1 The illustrations to Albrecht Dürer's manuscript treatise on wrestling and fencing from 1512 (Stadtbibliothek Cod. 1246, Breslau) clarify the context of the present drawing. Donald J. LaRocca, Associate Curator, Department of Arms and Armor, The Metropolitan Museum of Art, kindly identified the pose in the drawing and offered assistance with this research (letter, October 7, 1996).

2 Anglo 1989.

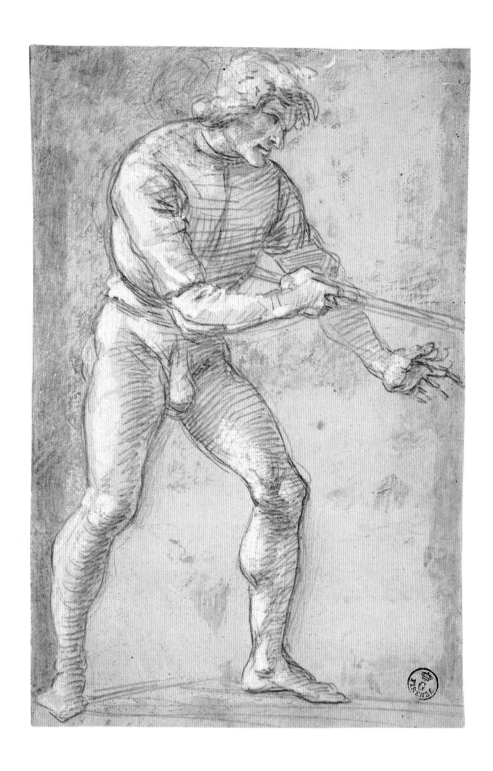

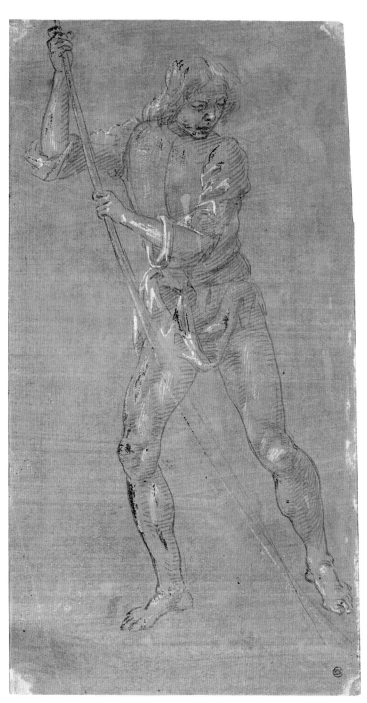

43 RECTO

43 *Standing Half-Dressed Youth Straddling and Holding a Long Staff*, recto

Standing Male Nude Turned to the Right, verso

Metalpoint, heightened with white gouache, on mauve-gray prepared paper, 279 x 156 mm (11 x 6⅛ in.), maximum

Inscribed in brown ink on recto at lower left of center: *Masaccio*; at lower right: *43./4* [canceled]

Nationalmuseum, Stockholm 67/1863 (recto), 68/1863 (verso)

PROVENANCE: Pierre Crozat, Paris; his sale, Paris, April 10–May 13, 1741, lot 1, 2, or 3 (as annotated by Carl Gustaf Tessin in his copy of the sale catalogue); Comte Carl Gustaf Tessin, Stockholm (manuscript inventory, 1749, p. 17, no. 3, as Massaccio [*sic*]); sold to Swedish royal family, 1750s; Kungliga Museum, Stockholm, 1792 (Lugt 1638); incorporated into Nationalmuseum, 1866.

LITERATURE: Schönbrunner and Meder 1896–1908, vol. 8, no. 877 (verso), vol. 10, no. 1171 (recto) [School of Filippino Lippi]; Sirén 1902, p. 123, nos. 38, 39 [Raffaellino del Garbo]; Scharf 1935, no. 314; Berenson 1938, vol. 2, no. 1366A; Berenson 1961, vol. 2, no. 1366B; Bjurström 1970, p. 5, no. 4, illus. (recto); Shoemaker 1975, no. 10.

With his bent knees and staff, the graceful half-dressed youth on the recto evokes a boatman with a pole, and the nude male figure on the abraded verso exhibits a classical monumentality. To judge from the partially erased pentimento outlines on the right of the nude, that figure's contrapposto stance presented a considerable challenge. It apparently follows in reverse the pose of a Roman sculpture of the Antinoüs type from the second century A.D., which was derived from the famous *Doryphoros* bronze by Polykleitos.[1] The handling of both studies, with short, straight, incisive strokes and thin but emphatic outlines, seems very close to the technique in evidence on the verso of another drawing in Stockholm (cat. no. 30), for which a date of about 1483–88 is proposed; however, the use of an antique prototype for the pose of the figure on the verso of the present sheet may suggest a date of about 1488–89, soon after Filippino arrived in Rome.

CCB

1 On the sculpture types, compare further Haskell and Penny 1981, pp. 141–46, nos. 4–7; and Bober and Rubinstein 1986, p. 163, no. 128.

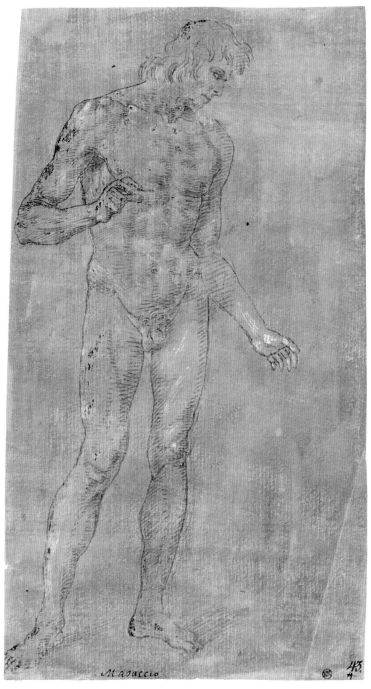

Masaccio

43 VERSO

44 *Standing Male Nude Prodding with a Long Staff*

Metalpoint, heightened with white gouache, on brown-gray prepared paper, 209 x 128 mm (8⅛ x 5 in.)

Inscribed in graphite on verso at upper center by Pasquale Nerino Ferri: *195 esp./Botticelli*

Gabinetto Disegni e Stampe degli Uffizi, Florence 195 E

PROVENANCE: Houses of Medici and Lorraine (manuscript inventory written by Giuseppe Pelli Bencivenni before 1793); museum stamp (Lugt 930).

LITERATURE: Ferri 1890, p. 35, no. 195 [Sandro Botticelli]; Morelli 1892–93, col. 87, no. 129; Berenson 1903, vol. 2, no. 1299; Scharf 1935, no. 306, fig. 177; Berenson 1938, vol. 1, pp. 105–6, vol. 2, no. 1299; Fossi [Todorow] 1955, no. 42, fig. 8; Berenson 1961, vol. 1, pp. 162, 165, vol. 2, no. 1299; Shoemaker 1975, no. 109; Petrioli Tofani 1986, no. 195 E; Shoemaker 1994, p. 262, fig. 16.

Morelli first recognized Filippino's hand in this vigorous nude study from the living model, drawn with awesome rapidity and mastery of anatomical foreshortening. The pose of the model apparently imitates that of a figure in a Roman sarcophagus relief that portrays the Calydonian Boar Hunt.[1] As Scharf and Berenson noted, Filippino's sheet relates to the figure of an executioner who stokes the fire under the cauldron in the *Martyrdom of Saint John* (pl. 25), frescoed on the lunette portion of the west wall in the Strozzi Chapel. Yet the two figures exhibit wholly different facial types, and the executioner has lost much of the nude's emotive force and immediacy of movement. Berenson and Shoemaker (1975) have proposed the dates 1502 and 1495–1500, respectively, for the sheet. However, the study, as well as two others displaying closely comparable technique (cat. nos. 42, 43)—with rather incisive metalpoint hatching and small, rounded clumps of white highlights—may well date from about 1487–90. The broad tonal calibration of the present drawing is somewhat compromised by the small patches of oxidation on the white gouache highlights.

CCB

1 See Shoemaker's essay, "Filippino and His Antique Sources," in this catalogue, p. 34.

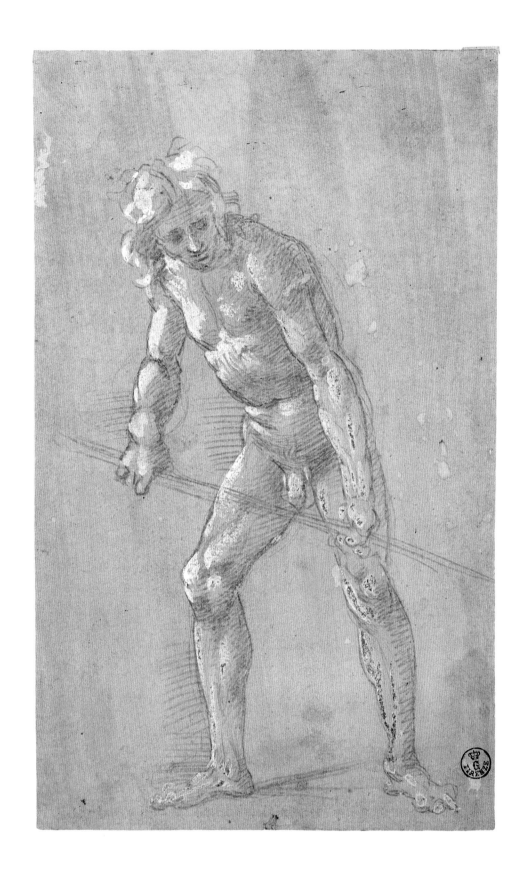

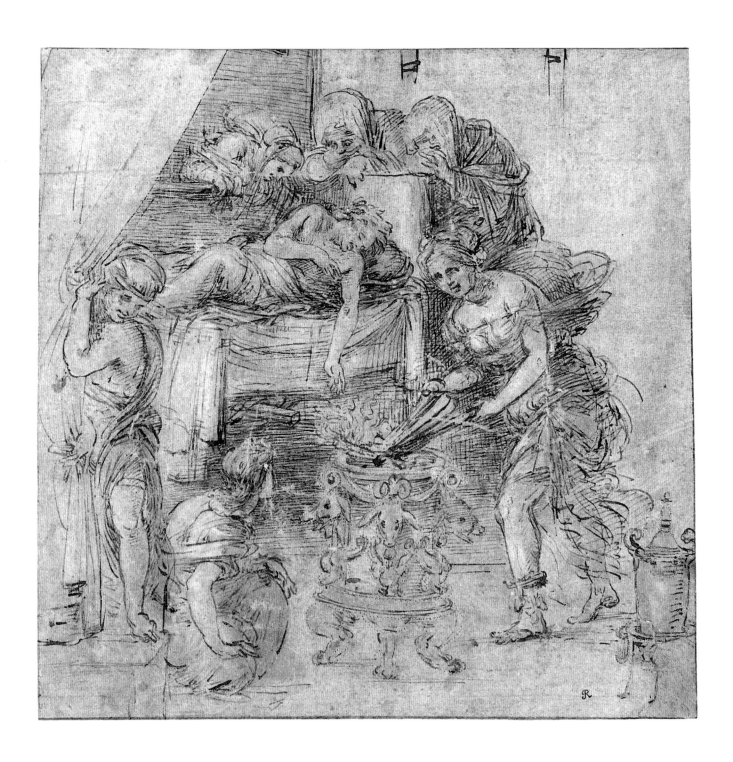

45 *Death of Meleager*

Pen and brown ink over stylus sketch, heightened with white gouache, partially pricked, 226 x 230 mm (8⅞ x 9¹⁄₁₆ in.)

The Visitors of the Ashmolean Museum, Oxford 21

PROVENANCE: Jonathan Richardson Sr., London (Lugt 2184); purchased 1951.

LITERATURE: Ashmolean Museum 1951, p. 64, pl. 14; Parker 1956, no. 21, pl. 8; Royal Academy 1960, no. 509; Berenson 1961, vol. 1, pp. 163–64, vol. 2, no. 1353 I; Pouncey 1964, p. 286; Wildenstein 1970, no. 7, illus.; Ragghianti and Dalli Regoli 1975, p. 90; Shoemaker 1975, no. 116; Ames-Lewis 1981b, p. 137, fig. 123; Ames-Lewis and Wright 1983, no. 55; Bambach Cappel 1988, no. 154; Nelson 1992a, with no. 31, fig. 64; Nelson 1992b, pp. 104–11; Nelson 1994, pp. 170–74, fig. 12; Ames-Lewis 1995, pp. 54–56, fig. 7.

This is the earliest of three surviving drawings by Filippino that presumably relate to a projected painting of the Death of Meleager. The subject is taken from Ovid (*Metamorphoses*, book 8), who tells that Meleager killed the Calydonian boar and then murdered the two brothers of his mother, Althaea. Earlier the Fates had decreed that Meleager would die when a certain log was burned; angered by the murder of her brothers, Althaea cast the log into the fire, causing her son's death. In this drawing two parts of the story are presented in a single space. A female attendant in the left foreground draws back a curtain to reveal, just beyond, a kneeling observer and Althaea, thrusting the log into a brazier, and, immediately behind them, the expiring Meleager and his three mourning sisters. Palpable dramatic resonance is achieved through gesture, facial expression, and concentrated theatrical focus. The pen lines are generally very free and animated, with short, quick strokes except for certain of the outlines. Some wash and white gouache heighten tonal contrast. The spirited draftsmanship is not very far removed from that of the study of a sibyl in Lille (cat. no. 49), suggesting a date for the present drawing of about 1489. Shoemaker has pointed out that the positions of the head and arms of the figure of Meleager are derived from those of Amor in the so-called Bed of Polykleitos relief once in Ghiberti's collection (fig. 13).

The brazier was pricked for transfer, although, as Bambach Cappel notes, the pricking and drawing do not align precisely. The brazier is repeated in exactly this form in a sheet in the Uffizi by another hand (fig. 40); that artist may have transferred it from the present sheet (see also cat. no. 47).

GRG

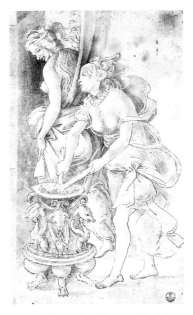

FIG. 40 Copy after Filippino Lippi. *Two Witches Tending a Fire in a Tripod.* Pen and brown ink and brown and gray wash, heightened with white gouache, 256 x 155 mm. Gabinetto Disegni e Stampe degli Uffizi, Florence 203 E

46 *Male Nude Reclining on a Bed*

Metalpoint, heightened with white gouache, on green
prepared paper, 125 x 180 mm (4⅞ x 7⅛ in.)

Département des Arts Graphiques du Musée du Louvre, Paris
9862

PROVENANCE: French royal collection.

LITERATURE: Berenson 1933a, p. 33, pl. 37 [David Ghirlandaio,
copy after Filippino Lippi]; Popham 1935, p. 6, with no. 1
[David Ghirlandaio]; Scharf 1935, with no. 202 [David
Ghirlandaio]; Berenson 1938, vol. 1, p. 339, vol. 2, no. 855D
[David Ghirlandaio]; Popham and Pouncey 1950, p. 82, with
no. 133 [David Ghirlandaio]; Ashmolean Museum 1951, p. 64
[David Ghirlandaio]; Bacou 1952, p. 10, no. 29; Parker 1956,
p. 15, with no. 21 [David Ghirlandaio]; Berenson 1961, vol. 2,
no. 855D [David Ghirlandaio]; Ragghianti and Dalli Regoli
1975, pp. 54, 82, 87, 89–90, no. 42, with nos. 20, 35, fig. 51;
Shoemaker 1975, no. 119; Ames-Lewis and Wright 1983, p. 256,
with no. 55, fig. 55C [Filippino Lippi?]; Nelson 1992b, p. 106,
n. 127; Nelson 1994, pp. 172–73, n. 37, fig. 14 [Workshop of
Filippino Lippi]; Ames-Lewis 1995, p. 55, fig. 9 [Filippino Lippi?].

Berenson was the first to recognize that this splendid
drawing is directly related to the compositional study
of the Death of Meleager in the British Museum
(cat. no. 47). He believed, however, that it was probably
a copy after Filippino, a view followed by the majority
of scholars.

Parker pointed out that the figure is based on
elements of a relief showing Amor and Psyche
(fig. 13)—known in the Renaissance as the "Bed of
Polykleitos"—that was once in Ghiberti's possession.
The head and arms are positioned like those of Amor,
whereas the legs derive, with some minor adjustments,
from Psyche's. The lifelike character of the nude sug-
gests that Filippino also had recourse to a life model,
as a sketch on a sheet in the Louvre (cat. no. 48)
perhaps indicates as well. The figure here is shown in
the same direction as Amor in the "Bed of Polykleitos"
and as the Meleager in the Ashmolean Museum
drawing of the Death of Meleager (cat. no. 45). The
Meleager in the study for this project in the British
Museum is executed in reverse, suggesting that it
came last in the sequence.

The negative reception this drawing has received
from connoisseurs is not easily understood in light of
its exceptional quality. The metalpoint drawing is lively
and highly accomplished, while the varied and bril-
liant use of white gouache exemplifies Filippino's
command of this medium. Shoemaker's comparison of
this sheet to the drawing at Lille for the Strozzi Chapel
vault (cat. no. 41) is apt, although here Filippino's use
of white gouache is broader and more developed.
A date for the sheet shortly after the artist's return to
Florence from Rome in 1489 is supported by the
evidence of style and also by its relationship to the
Ashmolean drawing.

GRG

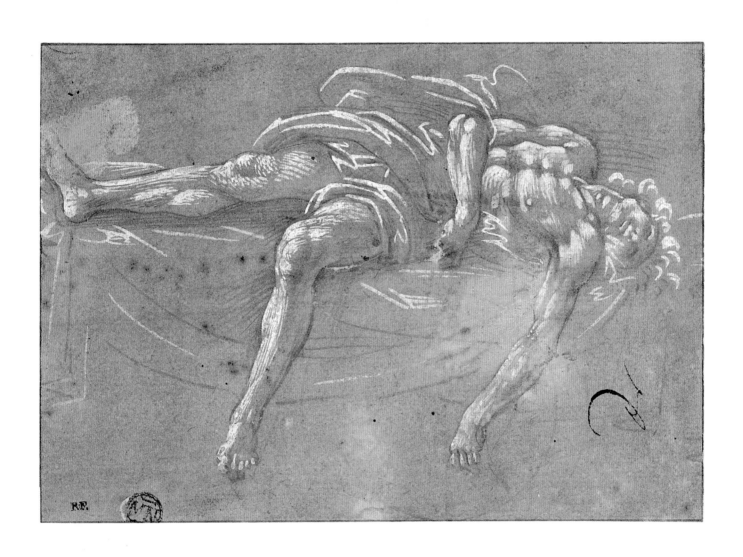

47 *Death of Meleager*

Pen and brown ink and brown wash, heightened with white gouache, 297 x 284 mm (11 11/16 x 11 3/16 in.)

British Museum, London 1946-7-13-6

PROVENANCE: Sir Thomas Lawrence, London (Lugt 2445); Samuel Woodburn, London; his estate sale, Christie's, London, June 4, 1860, lot 6; Sir Thomas Phillipps, Cheltenham and London; his grandson, Thomas Fitzroy Phillipps Fenwick, Cheltenham.

LITERATURE: Berenson 1933a, pp. 32–33, pl. 35; Popham 1935, p. 6, no. 1, pl. 8; Scharf 1935, pp. 71, 82, 122, no. 202, fig. 197 [copy after Filippino Lippi]; Berenson 1938, vol. 2, no. 1277C, vol. 3, fig. 242; Neilson 1938, p. 101, n. 13 [Assistant of Filippino Lippi]; Popham and Pouncey 1950, pp. 81–82, no. 133, pl. 121; Scharf 1950, pp. 40, 46, fig. 136; Ashmolean Museum 1951, p. 64; Degenhart 1955, p. 225, n. 263 [copy after Filippino Lippi]; Parker 1956, p. 15, with no. 21; Berenson 1961, vol. 1, pp. 163–64, vol. 2, no. 1347C, vol. 3, fig. 243; Shoemaker 1975, no. 117 [early-16th-century copy after Filippino Lippi]; Nelson 1992a, with no. 31, fig. 65 [Filippino Lippi and workshop]; Ames-Lewis 1995, p. 55, fig. 8.

First published by Berenson as an autograph work by Filippino, this sheet represents a more advanced stage in the evolution of the Death of Meleager composition than the related Ashmolean drawing (cat. no. 45). The figure of Meleager is reversed, the brazier and Althaea are moved to the left of center, and the servant pulling back the curtain stands next to Althaea rather than opposite her. An early-sixteenth-century copy of another drawing by Filippino in the Uffizi (fig. 40) shows Althaea and the servant girl almost exactly as in this one but presented in reverse, indicating that Filippino developed his design for at least this part of the composition with these two figures and the brazier on the right. In addition, as Popham and Pouncey noted, Ovid describes Althaea as holding the log with her right hand, whereas here she grasps it with her left, again suggesting a reversal of orientation from a quite fully evolved design. The Uffizi copy is significant in documenting the intermediate stage of the process, since the brazier it shows is taken directly from the Ashmolean study, while the figures anticipate the present sheet in all but minor details.

The scene as depicted here is highly dramatic and displays a more fully integrated spatial and narrative structure than the earlier design. Notwithstanding its uneven state of preservation, it retains an affecting theatrical approach to lighting, most readily noticeable in the contrast between the brightly illuminated figures and curtain at the left and the half-lit group emerging from darkness at the right. The effect fully justifies the great praise Berenson accorded the composition.

Berenson noted that this scene would have been highly appropriate for the decoration of a villa, such as the Medici residence at Poggio a Caiano, whose entrance portico still contains a fragmentary, unfinished fresco by Filippino portraying the Death of Laocoön. Berenson proposed that the Meleager drawings might represent an early idea for the Poggio a Caiano commission that was rejected and replaced by the Death of Laocoön. Elaborating on this hint, Nelson has hypothesized instead that the Meleager fresco was not rejected but was to be painted on the western wall of the portico, across from the Laocoön, observing that the two compositions are lit from opposite directions and share a number of generic features as well as compatible subjects. These points are all valid, but it should be recognized that no concrete evidence sustains this hypothesis and that the settings and compositions of the two projects are in no way either similar or complementary.

The present drawing has been attributed to Filippino by the majority of scholars, but it has occasionally been judged a workshop copy, reworked in part by Filippino, or an autograph sheet retouched by a later hand. In large part the doubts that have arisen have focused on the work's supposed inferiority to the Ashmolean study. To be sure, the drawing has suffered greatly and therefore gives a less pleasing effect than it might, yet it retains an enormous expressive impact that is difficult to imagine in a copy. The quick, short pen lines seen throughout are entirely Filippino's own, as is the refined white gouache modeling. No workshop assistant could conceivably have been responsible for the hair of Althaea and her servant or for the torch, the boar's head, or the numerous other spirited passages of the design.

GRG

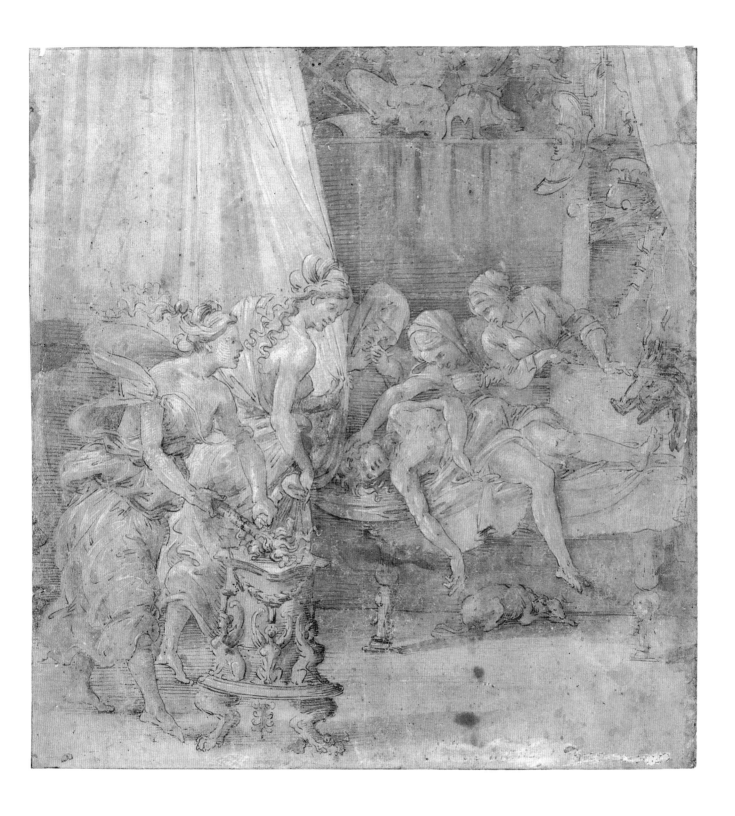

48 *Young Man Reclining on His Left Arm
and Young Man Lying on His Back*, recto

Two Horses, verso

Metalpoint, heightened with white gouache, on gray prepared
paper, 205 x 170 mm (8⅟₁₆ x 6⅝ in.)

Département des Arts Graphiques du Musée du Louvre, Paris
1254

PROVENANCE: Filippo Baldinucci, Florence; acquired 1806.

LITERATURE: Reiset 1866, p. 74, no. 231 [attributed to Fra
Filippo Lippi]; Berenson 1903, vol. 2, no. 859B [David
Ghirlandaio]; Scharf 1935, p. 127, no. 273; Berenson 1938, vol. 2,
no. 1357; Bacou and Bean 1958, p. 17, no. 7; Bacou and Bean
1959, pp. 37–38, no. 9, illus.; Berenson 1961, vol. 2, no. 1357;
Degenhart and Schmitt 1968, vol. 2, p. 649; Shoemaker 1975,
no. 9.

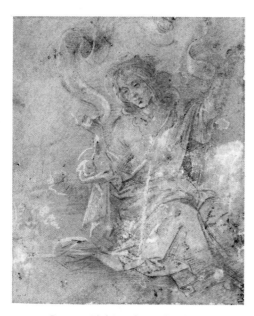

FIG. 41 *Cumaean Sibyl*. Metalpoint, heightened with
white gouache, on brown prepared paper, 129 x
110 mm. British Museum, London 1946-7-13-215

FIG. 42 Detail, *Battle of Romans and Gauls*, Roman, 1st century A.D.
Marble. Palazzo Ducale, Mantua 167

The attribution to Filippino was made by Baldinucci
in his inventory but was revived only in modern
times by Scharf, who has been followed by all subsequent scholars. Generally regarded as a mature work
by the artist, it is dated by Shoemaker about 1480
based on parallels with a study of a standing male
figure by Filippino in the Louvre (inv. no. 1257 verso).
The style of the drawing argues for a later date,
however, for it shows a highly developed metalpoint
technique, with blended strokes yielding subtle
tonal gradations. In these respects the sheet is comparable to the British Museum's beautiful but damaged study for the Cumaean Sibyl for the Carafa
Chapel (fig. 41). Additionally, the facial type of the
principal figure on the present sheet appears in a
drawing of the later 1480s in the Louvre (cat. no. 35).

This young man resting on his arm descends from
a classical type of fallen warrior, used with some frequency as a prototype by Florentine artists after the
middle of the fifteenth century.[1] Although clearly
drawn from a studio model and not from a secondary
source, Filippino's study is informed by his knowledge
of this antique pose, acquired directly or indirectly
through one of his contemporaries.

The slight metalpoint sketch at the top of the recto
can be related in a general way to a different antique
fallen soldier (fig. 42). This figure too must have
been drawn from a model in the studio; it is once
again a direct study from life informed by Filippino's
familiarity with the antique. Here an analogue in
painting exists—albeit a projected but evidently
unexecuted one: in this instance the comparisons can
be made with preparatory studies for a painting of
Meleager shown in the scene of his death (cat. nos.
45–47). The preparatory studies differ in significant
details from this sketch of a boy lying on his back;
however, the pose is highly unusual and Filippino
made several variant studies of it, indicating that the
Louvre example may represent an early stage in the
conception of Meleager.

It is probable that the Death of Meleager drawings were made in 1489–90. A similar date for the
Louvre drawing is supported by the stylistic evidence,
especially the British Museum's study for the
Cumaean Sibyl.

The two horses on the verso cannot be related to
any picture by Filippino. They are sensitively observed
both individually and as a pair and perhaps suggest a
knowledge of Leonardo's horse studies.

GRG

1 Warburg 1905.

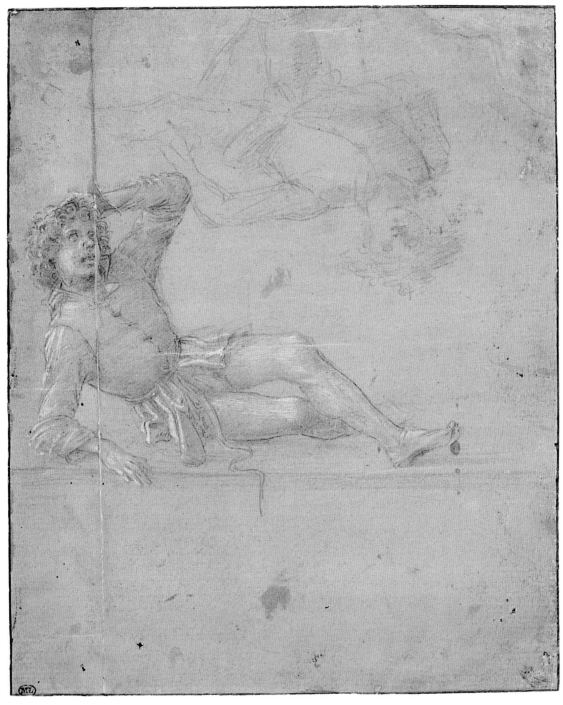

48 RECTO

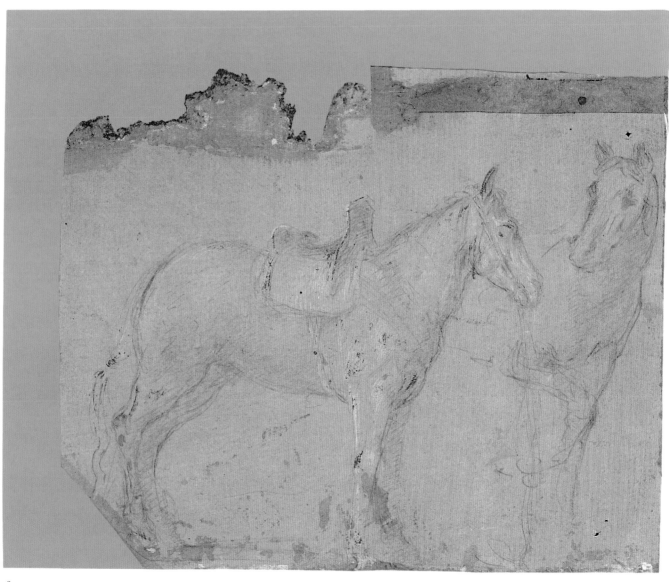

48 VERSO

49 *Sibyl Attended by Two Angels Holding Books*

Pen and brown ink, 81 x 144 mm (3³⁄₁₆ x 5⅝ in.)

Inscribed on recto at lower left corner: *Pl. 633*; on verso in brown ink: *Albert Badi . . . Fra Filippi*

Palais des Beaux-Arts, Lille Pl. 633

PROVENANCE: Jean-Baptiste-Joseph Wicar, Lille (Lugt 2568); acquired 1834.

LITERATURE: Benvignat 1856, p. 268, no. 1153 [unknown master]; Gonse 1877, p. 396, no. 1153 [probably Filippino Lippi]; Pluchart 1889, no. 633 [Italian School]; Berenson 1961, vol. 2, no. 1343A; Viatte 1963, no. 54; Pouncey 1964, p. 286, pl. 30b; Châtelet and Scheller 1968, p. 26, no. 54; Châtelet 1970, p. 46, no. 53, fig. 44; Shoemaker 1975, no. 54; Sale 1979, p. 152, fig. 47; Geiger 1986, pp. 65–66, n. 28, pl. 26; Norman 1987, p. 534; Brejon de Lavergnée 1989, p. 27, no. 7, illus.; Brejon de Lavergnée 1990, p. 41, fig. 4; Brejon de Lavergnée et al. 1990, no. 10, illus.; Metropolitan Museum 1992, no. 47, illus.

The attribution of this drawing to Filippino was first advanced by Pouncey, who suggested that it was a study for the Cumaean Sibyl on the vault of the Carafa Chapel, Santa Maria sopra Minerva, Rome (pl. 29).[1] The frescoes in the chapel were commissioned by Cardinal Oliviero Carafa in 1488, and work on them was completed in 1493. The vault figures must have been carried out before the wall compositions, suggesting a date of 1488–89 for this sheet.

Although Pouncey's attribution of the drawing to Filippino has met with universal acceptance, his identification of the subject has not. Geiger, Norman, and Griswold (in Metropolitan Museum 1992) consider the figure preparatory to the Hellespontine Sibyl, whereas Shoemaker believes that it cannot be specifically connected with any of the four sibyls on the vault but is a study for the series in general. The presence of two rather than four angels and the placement of the figure in the study argue for the identification as the Hellespontine Sibyl—who in the fresco is shown with two angels (the Cumaean Sibyl is accompanied by four) and faces the visitor to the chapel, as she is represented in the sheet. However, one should not be overly dogmatic on this point, given the fact that the drawn figure also emerges from the variously studied poses of the patriarchs in the Strozzi Chapel vault and is clearly an early, rapidly achieved effort by Filippino to formulate his ideas.

The pose of the figure reflects the continuing influence of the work of Antonio Pollaiuolo on the tomb of Sixtus IV and of Roman sculpture, although the expressionistic character of the image is Filippino's alone. This is an important drawing in terms of Filippino's development. It is the earliest firmly datable surviving pen-and-ink study, formed mainly with parallel strokes of a broad pen, made largely with highly charged sweeping lines that lend animation to the entire composition. The angel at the left, more summarily sketched than the two other figures, is composed of only a few broken lines, a technique frequently employed by Filippino in the last fifteen years of his life.

GRG

1 Pouncey's attribution was acknowledged in Berenson 1961, vol. 2, no. 1343A; and Viatte 1963, no. 54; and published in Pouncey 1964, p. 286.

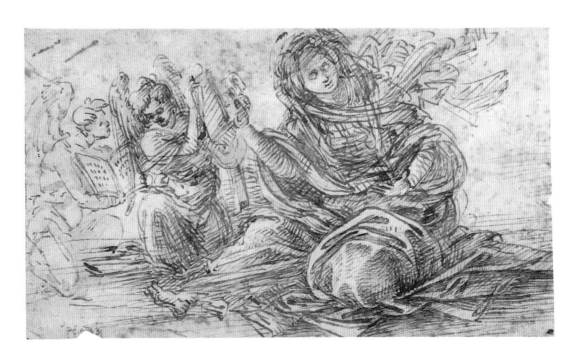

50 *Young Boy or Woman Seen Three-Quarter Length and Seated Figure Turned to the Left with Arms Extended*

Metalpoint, heightened with white gouache, over traces of black chalk on blue-gray prepared paper, 139 x 166 mm (5 7/16 x 6 1/2 in.)

Inscribed in black chalk at lower left: *19*; in brown ink at bottom center, apparently by Filippo Baldinucci: *filippino* [*filippo* with *ino* added and original *o* overwritten] *Lippi*

Gabinetto Disegni e Stampe degli Uffizi, Florence 1164 E

FIG.43 Detail, *Assumption of the Virgin*, pl. 30

PROVENANCE: Houses of Medici and Lorraine (manuscript inventory written by Giuseppe Pelli Bencivenni before 1793); museum stamp (Lugt 930).

LITERATURE: Ferri 1890, p. 91, no. 1164; Berenson 1903, vol. 2, no. 1314; Scharf 1935, no. 224, fig. 192; Berenson 1938, vol. 2, no. 1314; Fossi [Todorow] 1955, no. 36; Berenson 1961, vol. 2, no. 1314; Bertelli 1963, pp. 64–65; Shoemaker 1975, no. 55; Petrioli Tofani 1987, no. 1164E; Shoemaker 1994, pp. 260–61, fig. 11.

Filippino's authorship of this sheet of studies has not been questioned since it was identified in the seventeenth century. The annotation at the bottom center is apparently by Filippo Baldinucci, who in 1687 compiled an inventory of Leopoldo de' Medici's collection of drawings in which twenty-three sheets were listed under Filippino's name. Bertelli first recognized that the study on the left is preparatory for a cloud-bearing angel on the far left below the Virgin in Filippino's *Assumption* fresco on the lunette part of the altar wall in the Carafa Chapel (fig. 43). Bertelli also reasonably proposed that the study on the right may represent an early idea for the lost Hellespontine Sibyl on the vault of the same chapel, which was repainted in the seventeenth century. Although more spirited, this drawing is related in technique and style to the fragile preliminary study in metalpoint for the Cumaean Sibyl on that vault (fig. 41). No less important, the seated pose of the figure in the present drawing mirrors that of the Delphic Sibyl across the groin vault from the Hellespontine Sibyl. This sheet of studies offers the basis of style and technique for the drawings of Filippino's close associate in the Carafa commission, Raffaellino del Garbo, as is made especially clear in Raffaellino's study for the figure of Christ in the Resurrection (cat. no. 112). In the present sheet the soft tonal handling of the metalpoint in the impish face of the angel presents a graphic equivalent to Leonardo's sfumato, all the more impressive because it is created with a medium that is inherently linear; at the same time the dazzling spontaneity of outline and of parallel hatching used for the monumental seated figure communicates an equally compelling Leonardesque quality of exploration and movement.[1]

CCB

1 A large, possibly full-scale copy of the angel's head and shoulders in pen and brown ink, which is either after the fresco or a more finished lost drawing by Filippino, is in the Uffizi (inv. no. 1165 E).

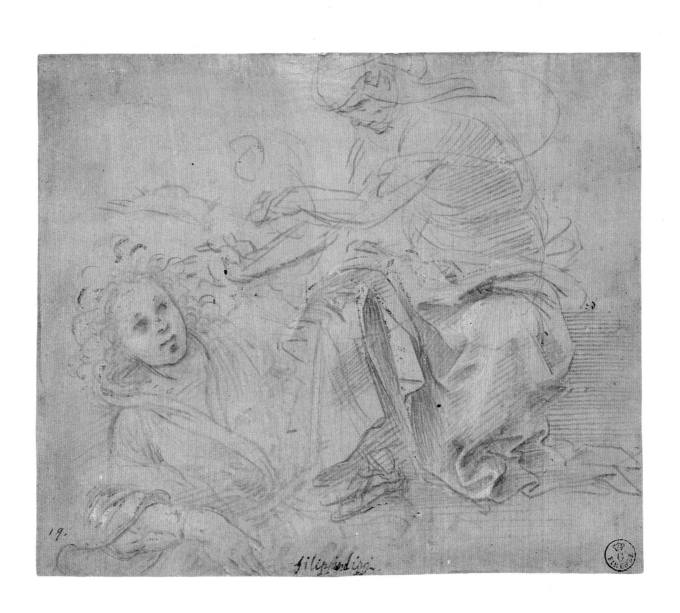

filippino lippi.

51 *Standing Woman with Her Hands Clasped in Prayer,* lower left of verso of *Page from the Libro de' disegni,* see p. 99

Metalpoint and pen and brown ink, heightened with white gouache, on gray prepared paper, 194 x 80 mm (7⅝ x 3⅛ in.)

National Gallery of Art, Washington, Woodner Family Collection, Patrons' Permanent Fund 1991.190.1.i

PROVENANCE: see p. 99.

LITERATURE: Berenson 1903, vol. 2, no. 1275; Berenson 1938, vol. 2, no. 1275; Berenson 1961, vol. 2, no. 1275; Popham 1962, no. 36; Popham 1969, no. 36; Popham 1973, no. 36; Ragghianti Collobi 1974, p. 85, pl. 233; Shoemaker 1975, no. 113 [Florentine]; Miller in Woodner collection 1986a, 1986b, 1986c, no. 24 verso E, illus.; Wohl 1986, no. 26 verso D [possibly Filippino Lippi]; Turner in Woodner collection 1987, no. 22 I, illus.; Cummings 1988 [Florentine, possibly Raffaellino del Garbo]; Miller (Turner) in Woodner collection 1990, no. 29 I, illus.; National Gallery of Art 1992, pp. 312, 313, illus.; Gahtan and Jacks 1994, pp. 12, 41, 42, no. 52, illus.; Jaffé 1994, vol. 1, no. 36; Goldner in Woodner collection 1995, no. 9 I, illus.

Miller has proposed that this may be a study for the Virgin in the *Assumption* fresco painted above the altar in the Carafa Chapel (pl. 30). The poses of the two figures are similar, but not so much as to make the association definitive. The poor state of the drawing, with considerable additions of white heightening by Vasari not only adjacent to but also on the figure, makes it difficult to judge. Nevertheless, the visible metalpoint strokes are of sufficiently high quality to justify the attribution to Filippino. Whether or not it is preparatory for the Carafa Chapel *Assumption,* the drawing is imbued with a heightened classicism that clearly situates it within Filippino's Roman years.

GRG

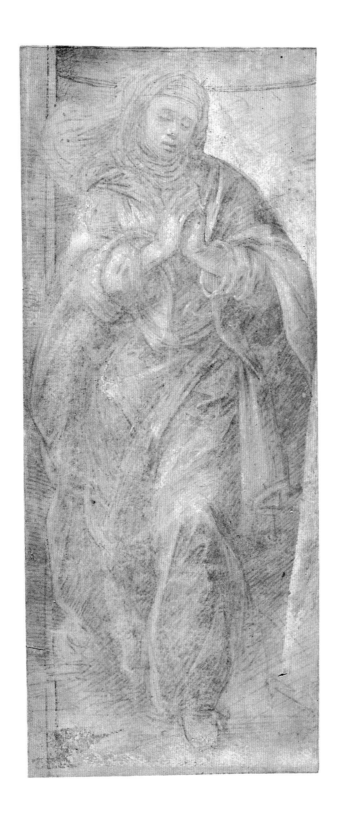

52 *Seated Man Turned to the Right with His Right Hand Extended*

Metalpoint, heightened with white gouache, on orange prepared paper, 185 x 113 mm (7¼ x 4⁷⁄₁₆ in.)

Inscribed in black ink at upper left corner, probably by sixteenth-century hand: *piero di Cosimo*

Gabinetto Disegni e Stampe degli Uffizi, Florence 299 E

PROVENANCE: Houses of Medici and Lorraine (manuscript inventory written by Giuseppe Pelli Bencivenni before 1793); museum stamp (Lugt 930).

LITERATURE: Berenson 1903, vol. 2, no. 1307; Scharf 1935, no. 263; Berenson 1938, vol. 2, no. 1307; Fossi [Todorow] 1955, no. 13; Berenson 1961, vol. 2, no. 1307; Shoemaker 1975, no. 18; Petrioli Tofani 1986, no. 299 E.

53 *Seated Man Turned to the Left with His Head Leaning on His Right Hand*

Metalpoint, heightened with white gouache, on orange prepared paper, 180 x 110 mm (7⅛ x 4⁵⁄₁₆ in.)

Gabinetto Disegni e Stampe degli Uffizi, Florence 302 E

PROVENANCE: Houses of Medici and Lorraine (manuscript inventory written by Giuseppe Pelli Bencivenni before 1793); museum stamp (Lugt 930).

LITERATURE: Berenson 1903, vol. 2, no. 1310; Scharf 1935, no. 266; Berenson 1938, vol. 2, no. 1310; Fossi [Todorow] 1955, no. 14; Berenson 1961, vol. 2, no. 1310; Ragghianti and Dalli Regoli 1975, p. 119, with no. 140, fig. 67; Shoemaker 1975, no. 21; Petrioli Tofani 1986, no. 302 E.

As Fossi first recognized, these two figure studies, as well as two others in the Uffizi that are more faded and abraded and of slightly weaker execution (figs. 44, 45), are apparently pages from the same small sketchbook. The distinctive orange grounds, drawing technique, dimensions of the sheets, and scale of the seated male subjects are nearly identical (the disposition of the figures on the pages suggests that all four sheets were trimmed along their borders). Berenson and Scharf independently attributed the group to Filippino. The drawings can be dated to about 1488–93, as they are similar in technique and style to a figure study for Saint Thomas Aquinas on the right wall of the Carafa Chapel (cat. no. 54 verso). The extensive use of translucent washes and the bold handling of the metalpoint—often with long parallel strokes—find direct analogies in studies of ornamental monsters in the Uffizi (cat. nos. 102, 103). And the poses of the four seated men are directly comparable to the poses of the four seated females at the right of the enthroned saint in the Aquinas fresco, as well as in the composition study for that work (cat. no. 55).

The four studies of men offer a repertory of poses for seated secondary figures in narrative compositions—where they function as members of audiences and display emotive responses, by means of the nuances of their gestures, to unportrayed actions or interlocutors. The man with thinning hair in one drawing (cat. no. 52) turns, either about to speak or after having spoken, with his right hand extended in a rhetorical gesture, as he leans his left hand on his knee. By contrast, the youth in the other study (cat. no. 53) listens intently, leaning his head on his right hand, bent arm on his knee and right foot perched on a block or rock, as he gathers his monumental cloak with his left hand. In a note from about 1490–92 Leonardo admonished artists to employ just such devices to intensify dramatic narrative.[1]

CCB

1 Richter 1970, vol. 1, p. 345, no. 594.

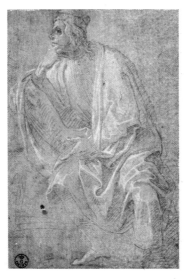

FIG. 44 *Seated Man Turned to the Right.* Metalpoint heightened with white gouache, on orange prepared paper, 157 x 106 mm. Gabinetto Disegni e Stampe degli Uffizi, Florence 300 E

FIG. 45 *Seated Man Holding His Chin in His Hand.* Metalpoint, heightened with white gouache, on orange prepared paper, 157 x 106 mm. Gabinetto Disegni e Stampe degli Uffizi, Florence 301 E

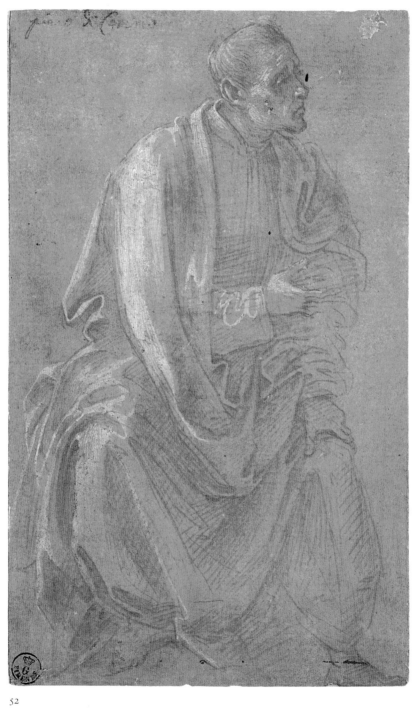

52

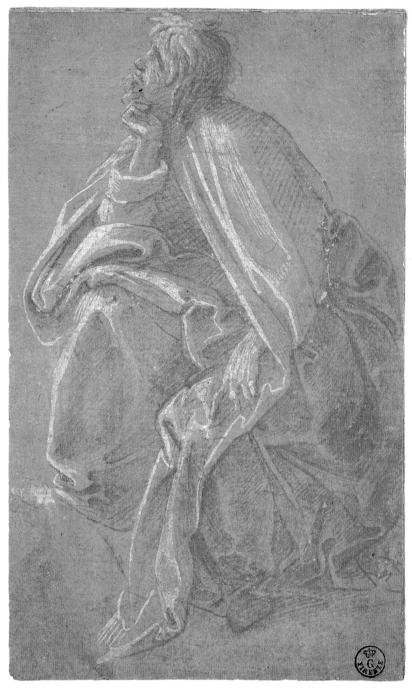

53

54 *Kneeling King for an Adoration of the Magi, Holding a Censer and Blessing,* recto

Study for the Seated Saint Thomas Aquinas in the Carafa Chapel, verso

Metalpoint, heightened with white gouache, reinforced with pen and brown ink and brown wash on pale beige prepared paper, recto; metalpoint, heightened with white gouache, framing outlines in pen and brown ink on green-gray prepared paper, verso, 162 x 124 mm (6⅜ x 4⅞ in.)

Inscribed in graphite on recto at lower right: *128 esp./Lippi Filippino*

Gabinetto Disegni e Stampe degli Uffizi, Florence 128 E

PROVENANCE: Houses of Medici and Lorraine (manuscript inventory written by Giuseppe Pelli Bencivenni before 1793); museum stamp (Lugt 930).

LITERATURE: Ferri 1890, p. 89; Berenson 1903, vol. 2, no. 1281 (recto); Giglioli 1926–27, p. 777, fig. 781 (verso); Brandi 1935, p. 35; Scharf 1935, p. 80, no. 279 (recto), no. 268, fig. 169 (verso); Berenson 1938, vol. 1, p. 104, n. 4, vol. 2, no. 1281; Fossi [Todorow] 1955, no. 20, fig. 7; Berenson 1961, vol. 2, no. 1281, vol. 3, figs. 225, 232; Bertelli 1965b, p. 160; Below 1971, p. 74; Shoemaker 1975, no. 61; Petrioli Tofani 1986, no. 128 E; Nelson 1992b, pp. 169–70.

More rapidly sketched than is usual for Filippino's drawings of this type, the fragile figure study on the verso was preparatory for the *Triumph of Saint Thomas Aquinas* on the west wall of the Carafa Chapel (pl. 33). The study of a king on the recto, which is in excellent condition, is significantly more finished. Nevertheless, it was probably produced about the same time as the drawing on the verso, that is, between 1488 and 1493, when the chapel was frescoed, rather than a few years later, as has often been proposed. This is indicated by the descriptive handling of the metalpoint, which is carefully reinforced with pen and ink and unified tonally with wash. Arguments for a later dating rest on the presumed link of the figure to the kneeling king portrayed slightly to the right of center in Filippino's *Adoration of the Magi* altarpiece in the Uffizi, which is signed and dated 1496 (pl. 35). However, the agitated figural type in the drawing shows little resemblance to the king in the panel, who is characterized by a classical restraint of pose and monumentality of form and is, moreover, youthful and beardless. Rather than bearing a relationship to the Uffizi panel, then, the study was most likely preparatory for a lost painting.

In the sequence of preliminary designs for the Thomas Aquinas fresco, the study on the verso followed the composition draft in the British Museum (cat. no. 55), in which the seated saint holds a scroll, rather than an open book, as in the Carafa Chapel

mural and in the present study. The vertical pen-and-ink lines flanking the saint in the present work, almost certainly drawn by Filippino, offer another point of correspondence with the mural, for they indicate the fasciae of the apse within which Thomas sits. The stance of the figure in the study, however, is still iconic compared with that in the mural and closer to traditional Dominican imagery as exemplified in the *Triumph of Saint Thomas* frescoed by Andrea di Bonaiuti in the Spanish Chapel at Santa Maria Novella, Florence. Moreover, in the drawing the saint supports his book with his right hand, whereas in Filippino's fresco he points with that hand to the lower right.[1]

To judge from the different hues of the oxidized metalpoints in the study, the figure of Saint Thomas was probably begun with broad strokes of leadpoint (now nearly black) and then reworked with fine silverpoint (now warm brown). The layer of white highlights has become nearly transparent.

CCB

1 A later copy of the central portion of Filippino's composition, with Thomas pointing as in the mural but with only minimal indications of the apse and variations in details of the seated figures surrounding the saint, may record a lost drawing at a more advanced stage of design than this study. See Christie's, London, sale cat., December 5, 1989, lot 1; and Nelson 1992b, p. 300, n. 17.

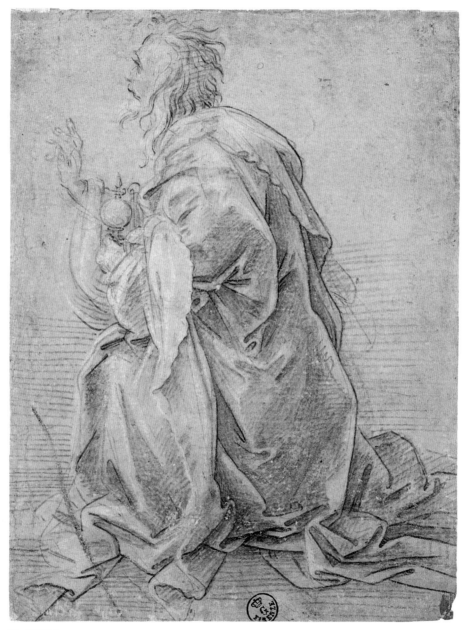

54 RECTO

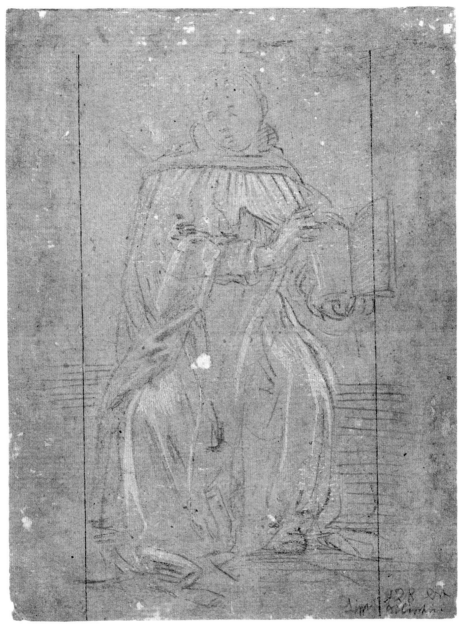

54 VERSO

55 *Triumph of Saint Thomas Aquinas*

Pen and brown ink and brown wash, 291 x 239 mm (11⁷⁄₁₆ x 9⅜ in.); small strip added at top

Inscribed in brown ink at lower right: *Pietro Perugino*

British Museum, London 1860-6-16-75

PROVENANCE: Possibly Giorgio Vasari, Arezzo; Pierre Jean Mariette, Paris (Lugt 2097); his sale, Paris, November 15, 1775, lot 582; Jean-Baptiste-Florentin-Gabriel de Meryan, marquis de Lagoy, Aix-en-Provence (Lugt 1710); Thomas Dimsdale, London (Lugt 2426); Sir Thomas Lawrence, London (Lugt 2445); Samuel Woodburn, London; his estate sale, Christie's, London, June 6, 1860, lot 599.

LITERATURE: Wickhoff 1899, pp. 211–12, n. 1; Berenson 1903, vol. 2, no. 1344; Frizzoni 1905, pp. 243–44, fig. 3; Halm [1931], p. 408, fig. 6; Van Marle 1923–38, vol. 12 (1931), p. 365; Brandi 1935, p. 35; Scharf 1935, pp. 41–42, 121, no. 195, fig. 159; Kurz 1937, p. 14; Berenson 1938, vol. 1, p. 104, vol. 2, no. 1344, vol. 3, fig. 224; Neilson 1938, p. 92, fig. 41; Tolnay 1943a, p. 20; Popham and Pouncey 1950, pp. 78–80, no. 131, pl. 120; Scharf 1950, p. 27; Berenson 1961, vol. 2, no. 1344, vol. 3, fig. 226; Bertelli 1963, pp. 57–58; Sandström 1963, pp. 78–79, fig. 33; Bertelli 1965a, p. 119; Bertelli 1965b, p. 162, n. 14; Golzio and Zander 1968, p. 424, pl. 175; Ragghianti Collobi 1974, p. 85, fig. 238; Shoemaker 1975, no. 60; Ames-Lewis 1981b, pp. 47–48, 137, fig. 24; Hall and Uhr 1985, p. 594, fig. 28; Geiger 1986, pp. 106–8, pl. 61; Nelson 1994, p. 162, fig. 5; Shoemaker 1994, p. 260, n. 12.

Wickhoff was the first to point out that this is Filippino's compositional study for the fresco on the west wall of the Carafa Chapel (pl. 33), painted between 1488 and 1493. This study may well have belonged to Vasari, for he owned a drawing fitting its description.

Saint Thomas is shown enthroned, triumphant over the heretics depicted below him to the right. He is about to be crowned by angels flying above and is attended by the Arts, Philosophy, and Theology. At the left a retinue that includes a prominently placed cardinal (presumably Carafa) observes the scene, which is also witnessed by various casual onlookers in the balconies in the background. The composition is remarkable in a number of respects. The cavernous, almost Bramantesque architectural setting lends grandeur to the scheme, providing an appropriately complex and unified stage for the elaborate figure groupings. The impact of Roman architecture on the Florentine Filippino could hardly be more evident. To its model he added his own creative ingenuity by introducing a fictive balustrade to match the one at the entrance to the Carafa Chapel and a grand set of steps that carry the viewer to center stage.

As Geiger has suggested, the composition also owes a debt to Ghiberti's *Solomon and the Queen of Sheba* relief on the Florentine baptistery's doors in its manipulation of large, diverse figure groups within a great architectural setting; Filippino, however, more fully integrated his figures within receding spaces than Ghiberti did. He also employed broad and varied washes to accentuate spatial recession and to help distinguish parts of the composition. And, finally, he held the many disparate elements of the scene together by means of a relatively straightforward triangular geometric scheme that looks forward to High Renaissance formulations.

Within this framework individual figures are rendered on a very small scale with rapid, small pen strokes that have a notational quality. The speed of execution contributes to the sense of vivid animation in the figural groups. Shoemaker has discerned the impact of Leonardo's style in this sheet and has deduced that drawings in this manner must have been made in the years prior to Filippino's departure from Florence for Rome in 1488. Both she (1975) and Sandström have also pointed out various precedents in Ghirlandaio's works of the mid-1480s that may well have influenced Filippino. Such debts notwithstanding, there is great innovation here—in elements ranging from the conception of architecture to the use of wash—innovation that makes this one of Filippino's most ambitious and successful achievements in drawing.

The related fresco differs from this study in various respects. The balustrade and steps have been done away with and the architecture has been simplified and made more compact. The figures have been reduced in number, and they have become correspondingly larger. In addition, the iconography is altered so that the group with the cardinal has been eliminated in favor of another band of heretics. Berenson was correct in recognizing the greater freshness and overall superiority of the drawing.

GRG

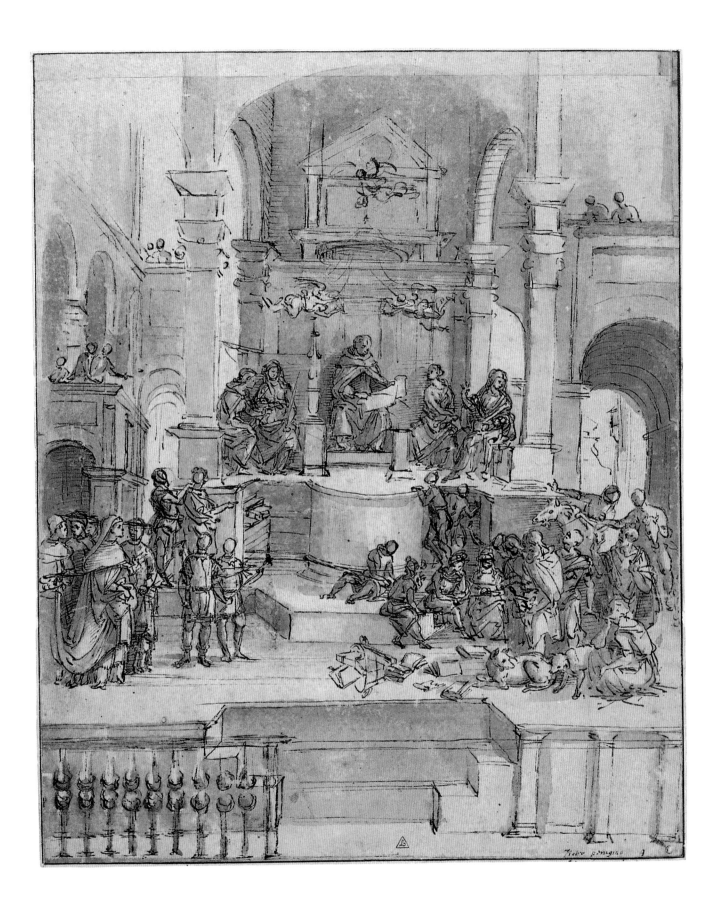

56 *Design for a Triumphal Car*

Pen and brown ink and brown wash over black chalk on vellum, 194 x 206 mm (7⅝ x 8⅛ in.)

Inscribed in brown ink on side of triumphal car: *istoria di venere di marmo o dipinte*; on verso: *rafaello de urbi*; in graphite on verso by modern hand: *Filippino Lippi*

The Visitors of the Ashmolean Museum, Oxford m1-1

PROVENANCE: S. Scharf; A. Burgh; G. Weiler bequest, 1995.

A recent gift to the Ashmolean, this drawing has never before been published. It carried an attribution to Piero di Cosimo, which Griswold correctly rejected; indeed, the anonymous inscription on the verso giving it to Filippino seems surely to be accurate. The animated little figures are formed with the same shorthand abbreviations employed for the small figures looking down at the central scene in the British Museum's grand compositional study for the *Triumph of Saint Thomas Aquinas* (cat. no. 55). The simple geometry and the short broken lines that describe the figures and the freely applied brown wash that suggests shadows are closely similar in the two drawings. The abbreviated treatment of the array of books and other matter in the London study finds parallels in this sheet, and the spontaneous movement of the angels flying above Saint Thomas is echoed by the figures here. Finally, wash is applied in precisely the same manner on the architecture in the London study and on the rocky formation and the base of the car in the present drawing. It should be added that although Filippino's metalpoint drawings were highly influential in his circle of followers, there are no pen-and-ink-and-wash studies of this type known by any other artist. Therefore, the attribution to him, along with a date of about 1490, appears quite certain.

The drawing shows men making armor in the mouth of a cave, surrounded by several putti and reclining figures, while, above, Venus? sits triumphantly in a tree with nudes and putti below her. The precise purpose of the sheet is elusive; it must have been made for some special occasion, perhaps a marriage, since the inscription refers to scenes involving Venus, which would have been most appropriate for that context. The marble or painted reliefs mentioned in the inscription may be illusionistic renderings, as it is highly unlikely that real marble reliefs would have been carved to decorate a ceremonial chariot.

GRG

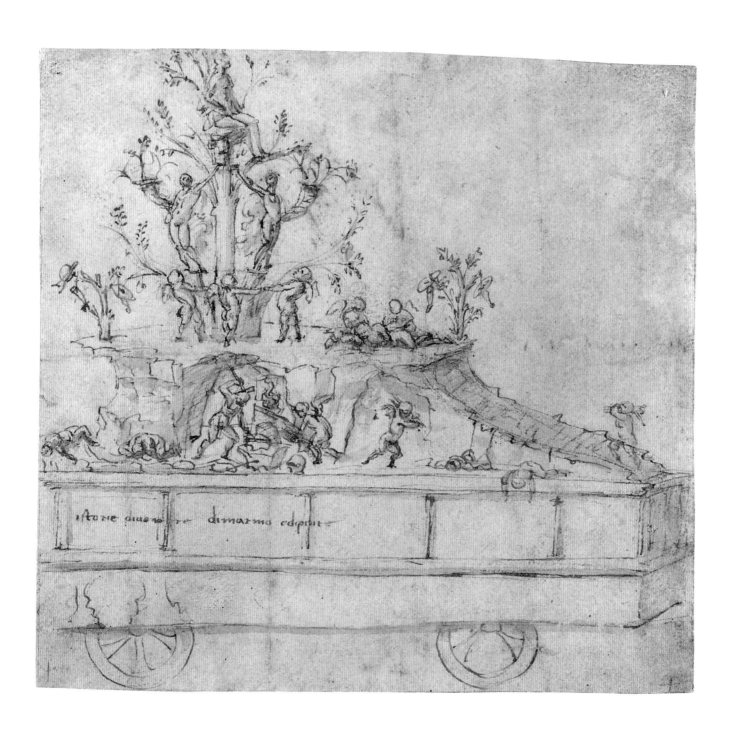

istorie diuerse dimarmo edipute

57 *Bishop Saint in a Niche beneath David in a Roundel; Saint Bernard? in a Niche beneath Moses in a Roundel*

Pen and brown ink and brown wash, each 330 x 65 mm (13 x 2⁹⁄₁₆ in.)

Sir John Soane's Museum, London; Margaret Chinnery Album, f. 19, nos. 20, 21

PROVENANCE: Margaret Chinnery.

LITERATURE: Berenson 1961, vol. 2, no. 1347G; Pouncey 1964, p. 286, pl. 34; Shoemaker 1975, no. 87.

Pouncey first recognized this pair of drawings as the work of Filippino, and their attribution to him has never been contested.[1] The sheets are among the most finished of his pen-and-ink-and-wash studies, suggesting that they are *modelli* intended for an unidentified project. Their subjects would have been entirely suitable for the wings of an altarpiece; generically similar niche figures of saints (now in the Galleria dell'Accademia, Florence) once flanked the lost central panel of the Valori Altarpiece. Shoemaker has pointed out that the studies recall the half-length prophet and sibyl that appear above the principal figures in the *Annunciation* in San Francesco, Fiesole, painted by Raffaellino del Garbo. She also notes the more provocative parallels between Filippino's drawings and the pair of niche figures surmounted by half-length figures in roundels in the marble altarpieces by Antonio Rossellino and Benedetto da Maiano in Santa Anna dei Lombardi, Naples. The similarities of detail between the sculpted figures and those in the drawings are not strong enough to indicate that they are directly connected; in any case, such a relationship would be unlikely, as there is no evidence that Filippino ever visited Naples.

Shoemaker compares these drawings to the study for the window of the Nerli Chapel (cat. no. 70); especially close to the approach here is the handling of the two decorative centaurs in the lower part of the Nerli design. Useful analogies can also be discerned between the present studies and the figures in the lower left section of the composition drawing for the *Triumph of Saint Thomas Aquinas* (cat. no. 55). The style of the pair thus argues for a date of about 1490.

GRG

1 Berenson (1961) acknowledged Pouncey's attribution, brought to his attention by Scharf.

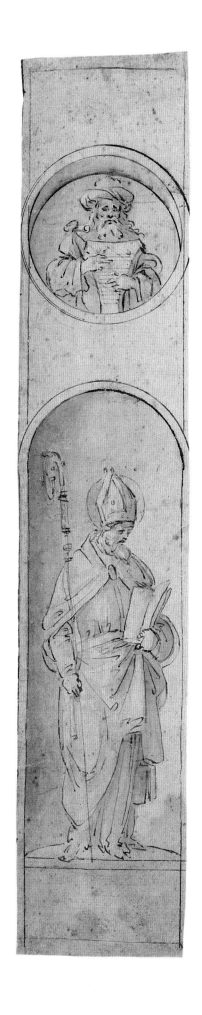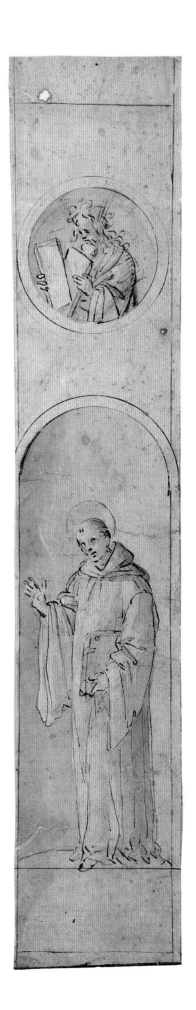

221

58 *Sleeping Figure with Arm and Head Resting on a Stool*

Metalpoint and brown-gray wash, heightened with white gouache, on pink-brown prepared paper, recto; black chalk-based wash with black chalk doodles on pink-brown prepared paper, verso, 133 x 144 mm (5¼ x 5¹¹⁄₁₆ in.)

Inscribed in brown ink on verso at lower right: *Fra Filippino. 3*; on mount along lower edge: *fra filippo Lippi • nato in firenze l'anno 1381 • padre di filippo Lippi 50*

Nationalmuseum, Stockholm 50/1863

PROVENANCE: Pierre Crozat, Paris; his sale, Paris, April 10–May 13, 1741, lot 1, 2, or 3 (as annotated by Carl Gustaf Tessin in his copy of the sale catalogue); Comte Carl Gustaf Tessin, Stockholm (manuscript inventory, 1749, p. 18, no. 3 as Filippo Lippi); sold to Swedish royal family, 1750s; Kungliga Museum, Stockholm, 1792 (Lugt 1638); incorporated into Nationalmuseum, 1866.

LITERATURE: Sirén 1902, p. 122, no. 33; Scharf 1935, no. 276; Berenson 1938, vol. 2, no. 1366D; Berenson 1961, vol. 2, no. 1366E; Shoemaker 1975, no. 42.

This exquisitely observed study after life probably dates from the time of the Carafa Chapel murals (1488–93) rather than from the mid-1480s, as has previously been proposed; in fact, it may well have been inspired by the design of the figures of the sibyls on the chapel's vault. Filippino achieved tonal effects of extraordinary subtlety here, using the soft gray of the metalpoint, the smoky brown of the prepared paper, and the cool white of the heightening applied with nearly imperceptible diagonal and parallel hatching. He further softened the image by unifying the gradations of tone in the metalpoint drawing with a nearly translucent gray wash. This technique is directly comparable to that of the fragile preliminary study in metalpoint for the Cumaean Sibyl in the Carafa Chapel, now in the British Museum (fig. 41), and the graceful arrangement of the draperies on the subject's lap and on the ground recalls the bolder figure study on the right of a sheet in the Uffizi (cat. no. 50) that is also connected with the Carafa Chapel. Both the sfumato manner of drawing and the monumentality of the draperies find parallels in the larger-scale studies of draperies arranged on clay figures that were produced in Verrocchio's workshop by Lorenzo di Credi and Leonardo in the 1470s and early 1480s. Filippino studied the figure from life, probably from a *garzone* posed in the studio. In its intimate, genrelike portrayal the present sheet is reminiscent of a drawing in the Uffizi that shows a woman engaged in a domestic task (cat. no. 59).

CCB

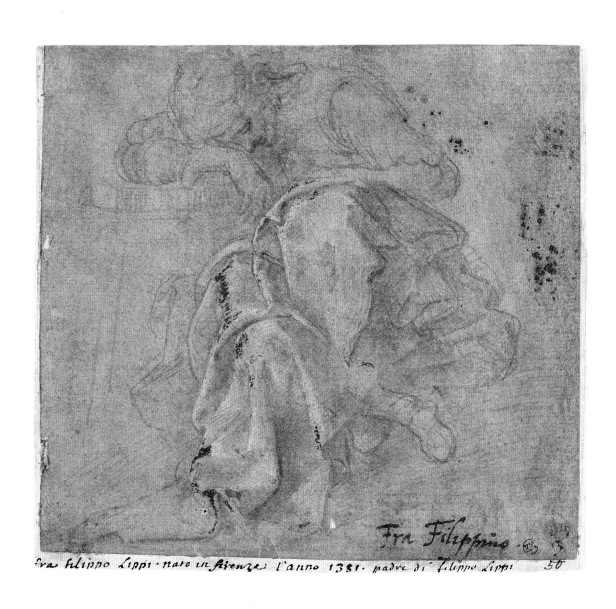

Fra Filippino

Fra filippo Lippi · nato in firenze · l'anno 1381 · padre di filippo Lippi 50

223

59 *Young Woman Seen Bust-Length, Looking Down and Perhaps Sewing*

Metalpoint, heightened with white gouache, on gray prepared paper, 80 x 128 mm (3³⁄₁₆ x 5¹⁄₁₆ in.), maximum; borders irregular

Inscribed in graphite on recto at lower left: *19*; in brown ink along lower border: *444*

Gabinetto Disegni e Stampe degli Uffizi, Florence 1256 E

PROVENANCE: Houses of Medici and Lorraine (manuscript inventory written by Giuseppe Pelli Bencivenni before 1793); museum stamp (Lugt 930).

LITERATURE: Ferri 1890, p. 92, no. 1256; Berenson 1903, vol. 2, no. 1320; Scharf 1935, no. 282, fig. 194; Berenson 1938, vol. 2, no. 1320; Fossi [Todorow] 1955, no. 37, fig. 12; Berenson 1961, vol. 2, no. 1320; Shoemaker 1975, no. 77; Petrioli Tofani 1987, no. 1256 E; Monbeig Goguel 1994, pp. 113–14, n. 12, fig. 6.

With a spontaneity of line fully suggestive of action captured at a glance, this small life study portrays a woman unselfconsciously engaged in domestic work. Characterized by naturalism of both form and mood, Filippino's sheet is a rare extant example of a drawing type that must have become common in late-quattrocento Florence—where its popularity was stimulated by a growing preoccupation with genre, as well as by the study and collecting of northern paintings and prints. The sheet is closely linked in style and technique to preliminary studies for the early murals of the Carafa Chapel: the fragile Cumaean Sibyl in the British Museum (fig. 41) and the figure on the left in a drawing in the Uffizi (cat. no. 50). Therefore, it may be dated about 1488–93. Its genre qualities and the soft sketchiness of metalpoint also recall other small but thematically unrelated studies that, in all probability, date from this period as well: the sheets showing a sleeping *garzone* in Stockholm (cat. no. 58) and fragments of figures in the British Museum (inv. nos. 5212-18, 1946-7-13-214). In view of this stylistic evidence, the recent attribution of the present sheet to Piero di Cosimo or the Master of Santo Spirito seems unconvincing, particularly because it is not easily accommodated into the known oeuvre of either artist.[1]

CCB

1 For the attribution of the sheet to Piero di Cosimo or the Master of Santo Spirito, see Monbeig Goguel 1994, pp. 113–14, n. 12. The drawing is not included among Piero di Cosimo's work in Griswold 1988.

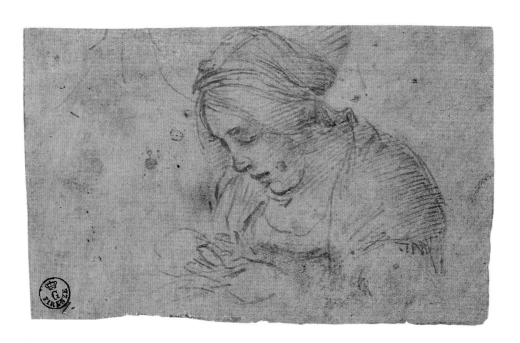

60 *Decorative Frieze, Volute Motif, Vase, and Candelabrum*, recto

FILIPPINO LIPPI

Motifs from the Domus Aurea, verso

Pen and brown ink, 255 x 193 mm (10 x 7⅝ in.)

Inscribed in graphite on recto at lower left by nineteenth-century hand: *205*; at lower right: *26*

Gabinetto Disegni e Stampe degli Uffizi, Florence 1637 E

PROVENANCE: Museum stamp (Lugt 930).

LITERATURE: Ferri 1890, p. 92, no. 1637; Berenson 1903, vol. 2, no. 1333; Halm [1931], pp. 406, n. 3, 407; Scharf 1935, p. 83, no. 324; Berenson 1938, vol. 2, no. 1326c; Marcucci 1951, no. 60; Fossi [Todorow] 1955, no. 29; Berenson 1961, vol. 2, no. 1326c; Dacos 1969, pp. 69, n. 4, 70, fig. 103; Shoemaker 1975, no. 74; Shoemaker 1978, p. 36, pl. 29; Petrioli Tofani 1987, no. 1637 E; Natali in Petrioli Tofani 1992, no. 1.6, illus.

Although both sides of this sheet have traditionally been attributed to Filippino, they present notable differences in style that cannot be considered the result of inspiration by different antique models—sculptural for the recto and pictorial, from the Domus Aurea, for the verso. Indeed, numerous scholars have noted this stylistic disparity; Fossi, for example, has written: "On the verso there are other ornamental motifs, drawn with greater liveliness and freedom, while the recto is one of the least quick and brilliant drawings in the entire series." And more recently Natali expressed doubts about the authorship of the recto. In any case, the dry and calligraphic pen handling that characterizes the frieze, volutes, and other classicizing elements on the recto has little in common with the freedom and freshness of pen strokes that delineate the grotesques on the verso, which are typical of Filippino's graphic style.

It is quite possible that, during the sketching expeditions artists undertook together amid the ancient ruins of Rome, the sheet passed from Filippino's hand to a less gifted colleague, who copied the antiquities on the recto. The models are difficult to identify; Scharf's contention that they relate to decoration in the fresco with Saint Philip Banishing the Dragon in the Strozzi Chapel is unfounded. However, various decorative elements on the verso are clearly reworkings of the grotesques from the Golden House of Nero, despite statements by Dacos to the contrary. Actually, faithful renditions of antique paintings also appear in another sheet by Filippino (cat. no. 65 verso), which shows the Departure of Hippolytus

for the Hunt, copied from the gilded vault of the Domus Aurea, and other decorative motifs, taken from that building's Cryptoporticus.[1] In the present drawing the derivations are from the Cryptoporticus: the small winged sphinx at the lower left and the winged figure that holds a plate, presented horizontally, are taken from the frieze below the second composition on the west portion[2] and from the area beneath the fifth composition. (The last is among the most frequently copied of prototypes, as attested by the Codex Escurialensis and the so-called Taccuino Senese of Giuliano da Sangallo.) The frieze beneath the fifth composition also seems to have inspired the winged horse, from whose head spring spindles with animals and urns with flowers, the fruit of Filippino's own imagination. Similarly, certain candelabra, like the ones between the two winged horses in the same zone of the Cryptoporticus,[3] were elaborated by Filippino, who added the two putti above a portrait in a medallion, swans, and a scroll, none of which derive from the original.

Shoemaker suggests dating the sheet to Filippino's Roman period, 1488 to 1493, when he decorated the Carafa Chapel. This author believes that a dating in the 1490s is most probable, based on the developed style, which presages studies for decorations Filippino undertook on his return to Florence.

AC

1 Natali in Petrioli Tofani 1992, pp. 30–31, no. 1.5.
2 Ibid., figs. 30, 31.
3 Ibid., figs. 34, 35.

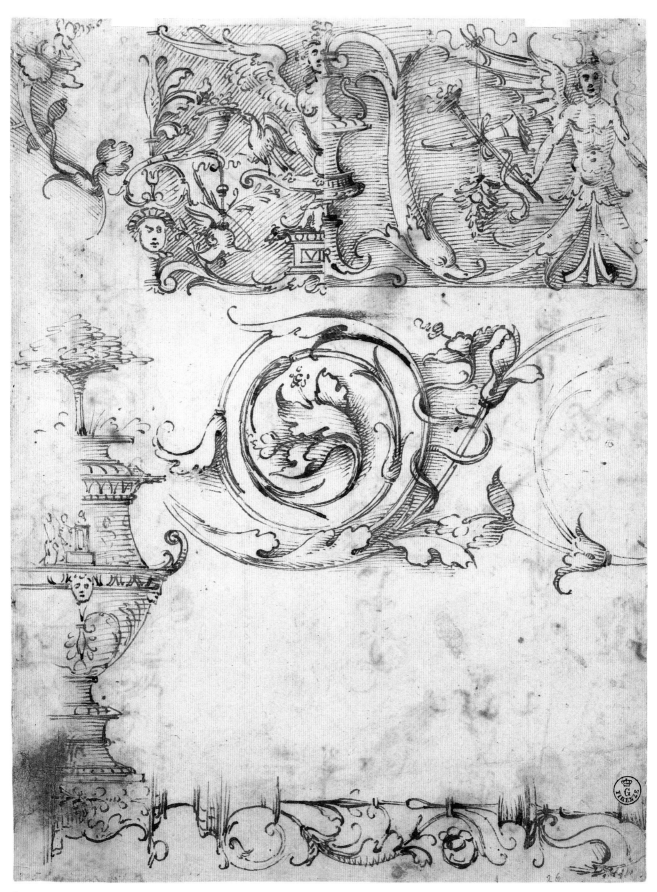

60 RECTO

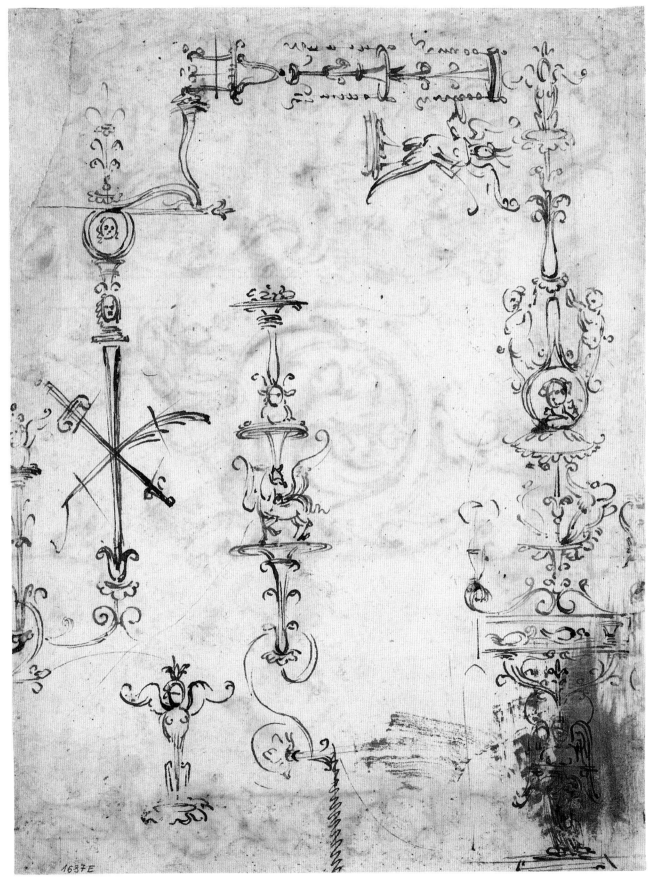

1637E

61 *Two Sea Creatures Holding an Urn*

Pen and brown ink and brown wash over traces of black chalk, d. 96 mm (3¾ in.); glued to secondary paper support

Inscribed in black chalk at lower right: *26*

Gabinetto Disegni e Stampe degli Uffizi, Florence 1630 E

PROVENANCE: Museum stamp (Lugt 930).

LITERATURE: Ferri 1890, p. 92, no. 1630; Berenson 1903, vol. 2, no. 1322; Halm [1931], pp. 406, n. 3, 407; Scharf 1935, p. 83, no. 317, fig. 158; Berenson 1938, vol. 2, no. 1322, vol. 3, fig. 237; Marcucci 1951, no. 58; Fossi [Todorow] 1955, no. 24; Berenson 1961, vol. 2, no. 1322; Dacos 1969, p. 69, n. 4; Shoemaker 1975, no. 67; Shoemaker 1978, p. 39, pl. 33a; Petrioli Tofani 1987, no. 1630 E; Cecchi in Petrioli Tofani 1992, no. 12.12, illus.

The cropping of the legs of the figures along the sides of this small drawing indicates that the sheet was originally rectangular and was later cut down to its circular format. Part of an exceptionally important group of eight decorative drawings now in the Uffizi, it was, as Shoemaker has noted, inspired by antique sources—freely interpreted and not merely copied, as Berenson maintained—during Filippino's stay in Rome from 1488 to 1493. Along with the antique-inspired painted candelabra of the Carafa Chapel and the whimsical, visionary decoration in the Strozzi Chapel, the sheets in the series bear witness to Filippino's powers of invention in the design of ornament.

These beings, like the Tritons in a second sheet in the Uffizi series (cat. no. 62), the figures in the sketch at the top of a page from Vasari's *Libro de' disegni* in Oxford (cat. no. 94D), and those flanking the coat of arms in the study for the stained-glass window in the Nerli Chapel (cat. no. 70), as well as the creatures (which include a monster) in three drawings on another sheet in the Uffizi (inv. no. 1633 E), demonstrate Filippino's taste for marine decorative subjects. This is a predilection displayed in particular—and most appropriately in light of the subject depicted—in the background architecture of his fresco the *Death of Laocoön* at Poggio a Caiano.

The rapid, concise outlines articulated with succinct broken lines and a mottled, impressionistic use of wash in this small drawing suggest a date in the early 1490s—that is, during the late phase of the decoration of the Carafa Chapel, if not at the beginning of the fresco decoration in Poggio a Caiano, which Nelson convincingly places in 1493.[1]

AC

1 Nelson 1994, pp. 161–65.

62 *Two Tritons Holding a Lamp*

Pen and brown ink and brown wash over traces of leadpoint, d. 92 mm (3⅝ in.); glued to secondary paper support

Inscribed in graphite at lower right: *26*

Gabinetto Disegni e Stampe degli Uffizi, Florence 1631 E

PROVENANCE: Museum stamp (Lugt 930).

LITERATURE: Ferri 1890, p. 92, no. 1631; Berenson 1903, vol. 2, no. 1323; Halm [1931], pp. 406, n. 3, 407; Scharf 1935, p. 83, no. 318; Berenson 1938, vol. 2, no. 1323; Fossi [Todorow] 1955, no. 25; Berenson 1961, vol. 2, no. 1323; Dacos 1969, pp. 69–70, fig. 102; Shoemaker 1975, no. 68; Petrioli Tofani 1987, no. 1631 E; Cecchi in Petrioli Tofani 1992, no. 12.11, illus.

The traditional attribution of this small drawing to Filippino, like that of the preceding sheet (cat. no. 61), has never been debated. Its circular format, again like that of the previous work, was probably a collector's doing—in this instance the truncation of the curious marine trumpets held by the Tritons suggests that a rectangular support was cut down. An idea of the sheet's original appearance is afforded by a variation of its design in the drawing at the top of the page of Vasari's *Libro de' disegni* in Oxford (cat. no. 94E), where the Tritons hold military trophies. With an extremely light application of wash, the present drawing is characterized by vibrant and concise outlines that succinctly define the two figures with entangled tails, engrossed in holding up a lamp with three spouts.

This drawing belongs to a group of decorative studies in the Uffizi that are freely inspired by antique sources; like the others in this important series, it should be dated to the early 1490s, when Filippino, intent upon reworking his earlier studies of antiquities and grotesques from the Domus Aurea, frescoed the walls of the Carafa Chapel with monochrome candelabra. His repertory there, carried out with concise brushstrokes and imbued with light, seems to come to life and revive the spirit of the antique. The marine subject matter encountered in the present drawing and the preceding one appears as well in Filippino's *Death of Laocoön* fresco, where it is extraordinarily well suited to the theme. The little that remains of that fresco in the portico of the Medici villa at Poggio a Caiano reveals, in the ancient architecture depicted in the background, sea creatures related to Neptune, the god who meted out cruel punishment to Laocoön and his sons, causing them to be strangled by serpents.

AC

63 Nereid with Two Putti and a Faun

Pen and brown ink over black chalk, 142 x 130 mm (5⅝ x 5⅛ in.); triangular section at left repaired (see below)

Département des Arts Graphiques du Musée du Louvre, Paris 9876

PROVENANCE: Everhard Jabach, Paris (Lugt 2959); purchased for French royal collection, 1671.

LITERATURE: Berenson 1903, vol. 2, no. 1361; Scharf 1935, p. 134, no. 366 [copy after Filippino Lippi]; Berenson 1938, vol. 2, no. 1361; Berenson 1961, vol. 2, no. 1361; Shoemaker 1975, no. 66.

Berenson was the first to ascribe this drawing to Filippino, and although his view was rejected by Scharf, it was sustained by Shoemaker. The handling of the pen, with relatively broad parallel strokes cutting across forms with great vibrancy of touch, is characteristic of a technique that first emerged in Filippino's study of a sibyl in Lille (cat. no. 49). It is seen in more fully developed form here and subsequently in several other examples dating from the last fifteen years of his career (cat. nos. 67, 82, 84, 85). All of these drawings depict energetic figures shown with anatomical details that are sometimes crudely notational.

This drawing was certainly made during Filippino's Roman period, and Shoemaker has reasonably suggested that it may well depend on an antique source, such as a Neptune sarcophagus. A date in the early 1490s would appear appropriate, given that it was made in Rome and in view of its evident stylistic relationship to the Lille study, which is very probably from the late 1480s.

A triangular section of the sheet at the left margin is either a torn part of the original drawing or a replacement that has been inexpertly reset into the paper. Even if it is a replacement, it is certainly by Filippino himself.

GRG

64 *Man Turned to the Left and Gesticulating, Study of His Left Arm, Man Leaning Forward, Studies of His Left Leg and Another Leg, Seated Man Turned to the Right and Holding an Orb and a Staff,* bottom of recto of *Page from the Libro de' disegni,* see p. 99

Metalpoint, heightened with white gouache, on ocher prepared paper, 220 x 329 mm (8¹¹⁄₁₆ x 13 in.); borders drawn in pen and brown ink by Vasari

National Gallery of Art, Washington, Woodner Family Collection, Patrons' Permanent Fund 1991.190.1.d

PROVENANCE: see p. 99.

LITERATURE: Berenson 1903, vol. 2, no. 1276; Popham 1931, no. 50.4; Scharf 1935, no. 207; Kurz 1937, p. 14; Berenson 1938, vol. 2, no. 1276; Popham 1949, no. 10; Berenson 1961, vol. 2, no. 1276; Popham 1962, no. 36 [probably Filippino Lippi]; Popham 1969, no. 36 [probably Filippino Lippi]; Popham 1973, no. 36 [probably Filippino Lippi]; Ragghianti Collobi 1974, p. 85, pl. 234; Shoemaker 1975, no. 113; Bayser 1984, pp. 73–76; Miller in Woodner collection 1986a, 1986b, 1986c, no. 24 recto D, illus.; Wohl 1986, no. 26 recto C; Melikian 1987, p. 86; Turner in Woodner collection 1987, no. 22D, illus.; Miller (Turner) in Woodner collection 1990, no. 29D, illus.; Ames-Lewis 1992, pp. 4–5, fig. 2; National Gallery of Art 1992, pp. 312, 313; Gahtan and Jacks 1994, pp. 12, 41, 42, no. 52; Jaffé 1994, vol. 1, no. 36; Goldner in Woodner collection 1995, no. 9D, illus.

Filippino's style shortly after his return to Florence from Rome in 1493 is typified in this lively series of studies. The free calligraphy of the figure at the left is comparable to that employed for at least one study made in Rome (cat. no. 65 recto). The correspondence is most obvious in the freely handled white heightening, which is spontaneously and liberally applied. This dynamic figure cannot be related to a painting by Filippino but is analogous in its complex pose and extravagant expression to the artist's renderings of Laocoön (fig. 3). The handling of the enigmatic seated man lightly sketched in metalpoint and white heightening at the right is close to that in the study of Prometheus in the Uffizi (cat. no. 68). Zeri has compared this figure to a similarly posed man in a painting in the Cini collection, Venice;[1] the connection is generic, however, and may reflect a common Botticellian source.

GRG

1 Zeri, Natale, and Mottola Molfino 1984, p. 28.

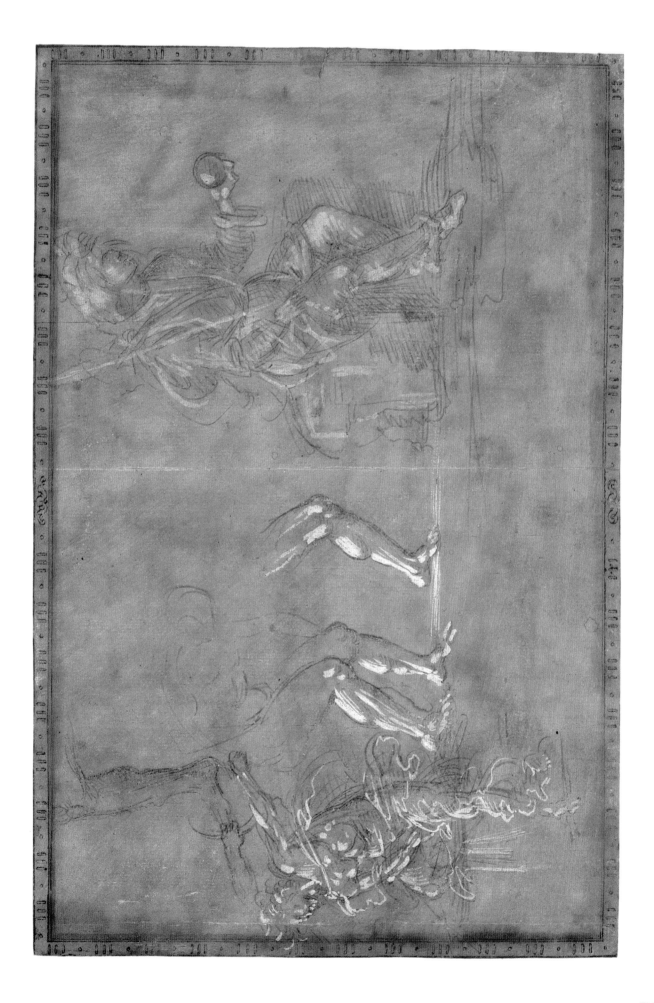

233

65 *Woman Seen Half-Length and Holding a Shield (Portrait of a Woman in the Guise of Minerva?)*, recto

Departure of Hippolytus for the Hunt, a Harpy, and a Decorative Frieze from the Domus Aurea, verso

Pen and brown ink, heightened with white gouache, on blue-gray washed paper, recto; leadpoint, with glued strip of paper at center of sheet, verso, 252 x 204 mm (9¹⁵⁄₁₆ x 8¹⁄₁₆ in.), maximum

Inscribed in graphite on glued strip: *Filippino*; at bottom left: *1255 E*; in brown ink at bottom left: *Filippino [di fra . . . ? (cropped)]*

Gabinetto Disegni e Stampe degli Uffizi, Florence 1255 E

PROVENANCE: Houses of Medici and Lorraine (manuscript inventory written by Giuseppe Pelli Bencivenni before 1793); museum stamp (Lugt 930).

LITERATURE: Ferri 1881, p. 66; Ferri 1890, p. 92; Berenson 1903, vol. 2, no. 1319; Brandi 1935, p. 35, n. 5; Scharf 1935, no. 281; Berenson 1938, vol. 2, no. 1319; Berenson 1954, no. 19, fig. 9; Fossi [Todorow] 1955, no. 44, fig. 9; Berenson 1961, vol. 2, no. 1319; Shoemaker 1975, no. 64; Shoemaker 1978, p. 36, pl. 28; Petrioli Tofani 1987, no. 1255 E; Gasparri 1990, pp. 339, 342, n. 24; Natali in Petrioli Tofani 1992, no. 1.5, illus. (verso).

The attribution of this magnificent sheet of studies has not been questioned since its correct identification in Pelli's inventory. The ornamental flickering of outlines, heightened by stark chiaroscuro, repeats the rhythm of the decorative knot work on the woman's costume and is typical of Filippino's rapid drawing style of the 1490s. Both the dramatic Leonardesque chiaroscuro and the half-length, portraitlike image are echoed in Piero di Cosimo's panel *Saint Mary Magdalen*, dated 1495 (Galleria Nazionale d'Arte Antica, Palazzo Barberini, Rome). A portrait drawing by Piero (Staatliche Graphische Sammlung, Munich, inv. no. 13072), less finished than the study by Filippino but closely related to it in technique and pose, also reveals the common ground shared by the two artists.

Representations of female sitters as famous women from the Bible or antiquity were common in the late quattrocento and early cinquecento. This fact, the likelihood that Filippino's figure is shown in the guise of Minerva, and the similarity of her pose to that of women in painted portraits from the 1490s suggest that the drawing may have been envisioned as a portrait.[1] It would be an unusual surviving example of this genre in Filippino's work.

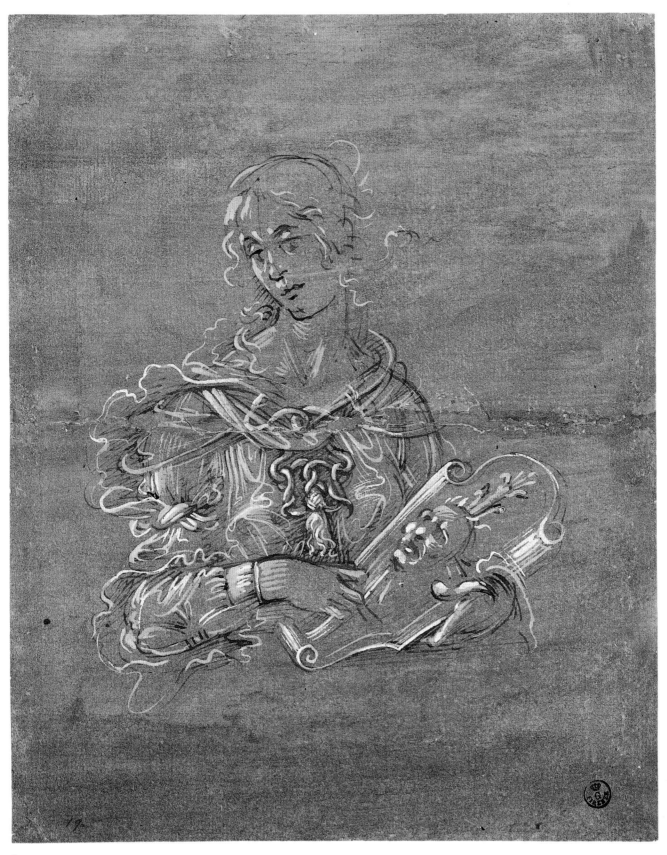

65 RECTO

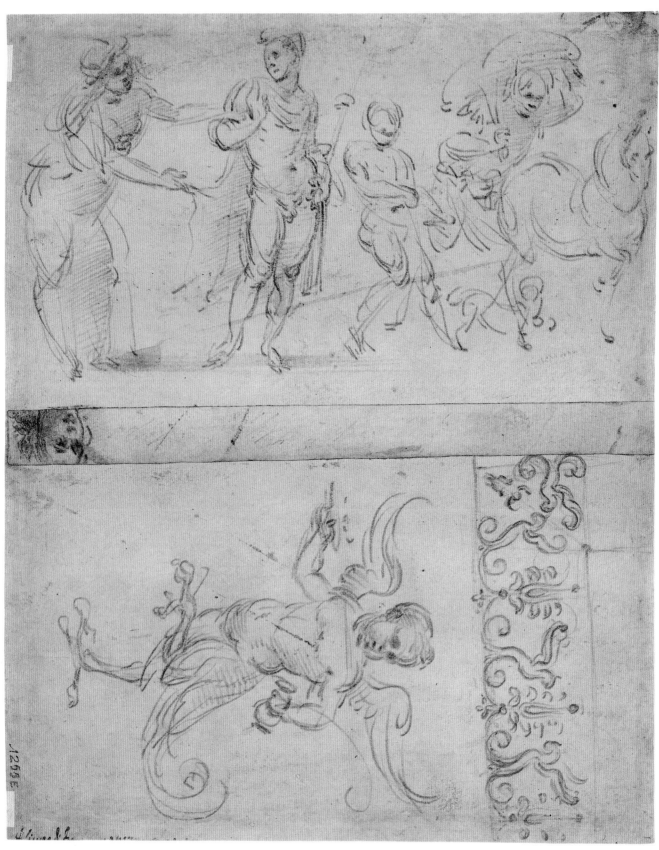

65 VERSO

The Hippolytus scene, Harpy, and ornamental border on the verso are among the rare motifs Filippino copied precisely from antique sources. They derive from the now nearly effaced decorations of the Domus Aurea, or Golden House of Nero, from the first century A.D., in Rome—the first from the Volta Dorata, the others from the Cryptoporticus of that monument. Based on these connections, as well as on the analogy of the recto with Piero di Cosimo's panel, the sheet must date from Filippino's Roman period, probably in the early 1490s. The Harpy motif was adapted for a putto in the fictive frieze of *grotteschi* frescoed in the Strozzi Chapel (fig. 46), below the *Martyrdom of Saint Philip*. The tiny head study on the strip glued to the center of the sheet recalls the style of drawing in two other sheets in the Uffizi (cat. nos. 50, 59).

CCB

1 For instance, the panel attributed to Lorenzo di Credi in the Pinacoteca Civica, Forlì (Dalli Regoli 1966, no. 59). As Berenson observed, the woman's figure seems to have inspired similar types by Raffaellino del Garbo, among them the Saint Catherine seen on the right in his tondo drawing at Christ Church (cat. no. 115).

FIG. 46 Detail, fresco. East wall, Strozzi Chapel, pl. 27

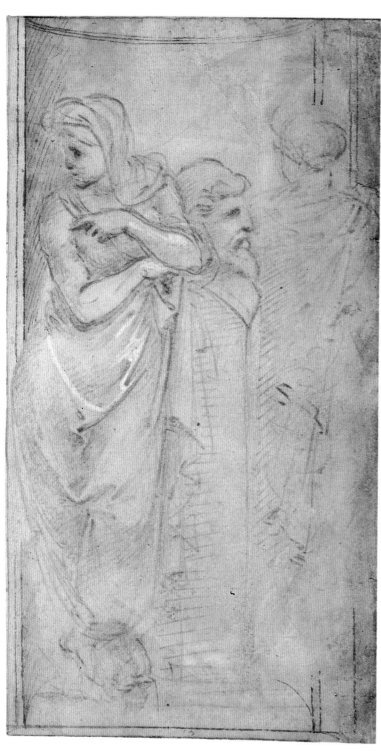

66 *Two Standing Women on Either Side of a Herm,* lower right of verso of *Page from the Libro de' disegni,* see p. 99

Metalpoint and pen and brown ink, heightened with white gouache, on light green prepared paper, 190 x 102 mm (7½ x 4 in.)

National Gallery of Art, Washington, Woodner Family Collection, Patrons' Permanent Fund 1991.190.1.j

PROVENANCE: see p. 99.

LITERATURE: Berenson 1938, vol. 2, no. 1275; Berenson 1961, vol. 2, no. 1275; Popham 1962, no. 36; Popham 1969, no. 36; Popham 1973, no. 36; Ragghianti Collobi 1974, p. 85, pl. 233; Shoemaker 1975, no. 113 [Florentine]; Miller in Woodner collection 1986a, 1986b, 1986c, no. 24 verso F, illus.; Wohl 1986, no. 26 verso D [possibly Filippino Lippi]; Turner in Woodner collection 1987, no. 22J, illus.; Cummings 1988 [Florentine, possibly Raffaellino del Garbo]; Miller (Turner) in Woodner collection 1990, no. 29J, illus.; National Gallery of Art 1992, pp. 312, 313, illus.; Gahtan and Jacks 1994, pp. 12, 41, 42, no. 52, illus.; Jaffé 1994, vol. 1, no. 36; Goldner in Woodner collection 1995, no. 9J, illus.

As Miller first noticed, the woman at the left is based on a figure or figures on the Sarcophagus of the Muses now in the Kunsthistorisches Museum, Vienna.[1] Not unexpectedly, Filippino created his own image out of the first and perhaps the third Muse on the sarcophagus, and he added the herm and the woman shown from the back from other sources. This kind of free interpretation of Roman models is seen also in a similar metalpoint drawing in the Uffizi, made after a scene in the Domus Aurea (cat. no. 65 verso). Both drawings were executed during Filippino's stay in Rome from 1488 to 1493.

GRG

1 Bober and Rubinstein 1986, no. 38. Evidently Filippino used the same source for other works, making it likely that the sarcophagus itself, rather than an intermediary, was the model for this drawing.

67 *Crowned Man Holding a Torch and Basket*, recto

Two Animal Skulls and a Skeletal Right Hand, verso

Metalpoint, heightened with white gouache, on pale pink prepared paper, recto; pen and brown ink and brown wash over traces of black chalk, verso, 130 x 180 mm (5⅛ x 7⁷⁄₁₆ in.)

Gabinetto Disegni e Stampe degli Uffizi, Florence 154 E

PROVENANCE: Houses of Medici and Lorraine (manuscript inventory written by Giuseppe Pelli Bencivenni before 1793); museum stamp (Lugt 930).

LITERATURE: Ferri 1881, p. 12; Ferri 1890, p. 90, no. 154; Berenson 1903, vol. 2, no. 1291 (recto only); Halm [1931], pp. 400–401; Scharf 1935, p. 83, no. 206, fig. 191 (recto); Berenson 1938, vol. 2, no. 1291; Fossi [Todorow] 1955, no. 30; Berenson 1961, vol. 2, no. 1291; Shoemaker 1975, no. 103; Petrioli Tofani 1986, no. 154 E; Tongiorgi Tomasi in Petrioli Tofani 1992, no. 9.14, illus.

Although the attribution to Filippino is clearly correct—it has not been doubted since Ferri proposed it in his inventories of 1879–81—the dating of the sheet is somewhat problematic. The abbreviated lower limbs of the male figure on the recto seem analogous to the quickly sketched legs on two other sheets in the Uffizi: a drawing that shows Hippolytus (cat. no. 65 verso) and one of Prometheus Stealing the Celestial Fire (cat. no. 68), datable to not later than 1493. However, the manner of highlighting with white and the layering of long, parallel hatching to create depth of tone here look forward to studies associated with the *Mystic Marriage of Saint Catherine* of 1501 in San Domenico, Bologna (cat. nos. 105–8), and the *Raising of Drusiana* fresco, dated 1502 (cat. nos. 100, 101). Yet in comparison with those three later works, the study on the recto of the present sheet exhibits a more exquisite control of the metalpoint medium, with finer lines, more precisely calibrated contrasts of tone, and hatched application of white highlights, probably suggesting a date in the second half of the 1490s.

Scharf identified the enigmatic figure portrayed here as Prometheus; be that as it may, this study was perhaps preparatory for the fictive *grotteschi* decoration of a fresco cycle in the style of the ornamental portions of the Strozzi Chapel murals.

The verso of Filippino's sheet may date slightly later than the recto. It offers a rare, important document of the tradition of anatomical drawing in the late quattrocento, which, in contrast to Leonardo's more famous, roughly contemporary scientific illustrations, explores anatomy for entirely creative purposes. The two studies of a skull are based on an actual goat's skull, rather than a carved marble ornament on a Roman monument; this is confirmed by the embedded teeth and jagged bottom outline of the upper jaw in the small-scale profile view, as well as by the delicate asymmetries of outline and topography of surface in the monumental frontal one. Filippino and his contemporaries closely studied the decorations of antique monuments with bucrania, but the descriptive power of the present studies far exceeds that of motifs copied for use in a classical vocabulary of form. The rendering of the goat's skull from different viewpoints in this sheet, for example, parallels Leonardo's method in his portrayal of the human skull in a series of drawings of 1489 and after (Royal Library, Windsor, inv. nos. 19057–59). Filippino's studies of goat skulls seem to have been preparatory for the heads of two such animals that appear in the Strozzi Chapel, placed symmetrically at either side of the lancet window on the altar wall, as fictive monochrome marble decoration on the intrados of the arch. This preparatory function accounts for the relatively large scale of the drawings.

CCB

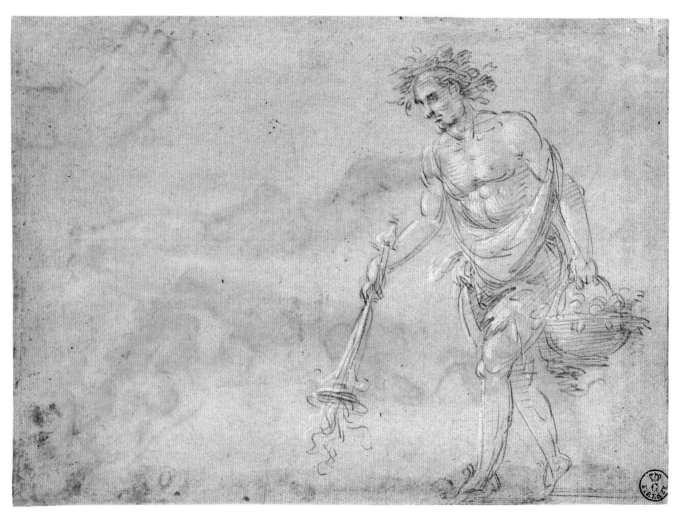

67 RECTO

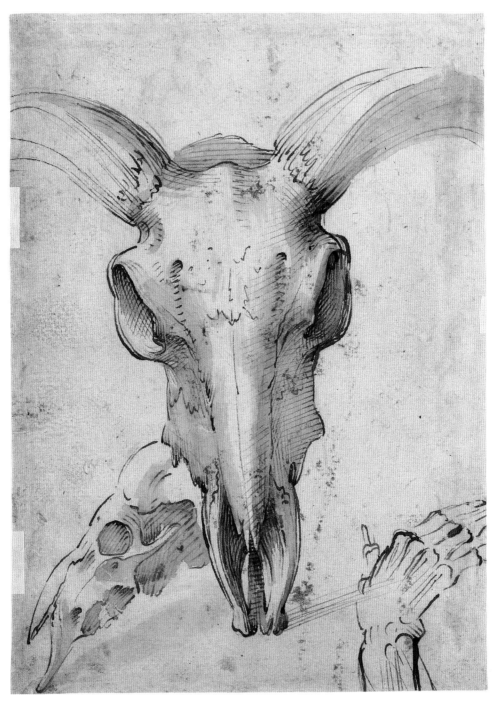

67 VERSO

68 *Prometheus Stealing the Celestial Fire*

Metalpoint, heightened with white gouache, on pink prepared paper, 165 x 164 mm (6½ x 6½ in.)

Inscribed in black chalk at lower left by nineteenth-century hand: *19*

Gabinetto Disegni e Stampe degli Uffizi, Florence 1170 E

PROVENANCE: Blind stamp erroneously identified as that of Cardinal Leopoldo de' Medici (Lugt 2712); museum stamp (Lugt 930).

LITERATURE: Ferri 1890, p. 92, no. 1170; Berenson 1903, vol. 2, no. 1317; Loeser 1916, no. 14; Halm [1931], pp. 400–401; Scharf 1935, no. 205, fig. 189; Berenson 1938, vol. 2, no. 1317; Fossi [Todorow] 1955, no. 45; Berenson 1961, vol. 2, no. 1317; Shoemaker 1975, no. 104; Petrioli Tofani 1987, no. 1170 E; Berti and Baldini 1991, p. 285, illus.

This sheet has always been attributed to Filippino and undoubtedly belongs to his late period, as suggested by the great freedom and agitation of line, the rapid execution, and the impressionistic white gouache highlighting. Shoemaker's proposed dating of the drawing between 1495 and 1500 seems entirely convincing, as are the parallels she finds with contemporaneous drawings in the Uffizi, such as the study for the litter bearers in the *Raising of Drusiana* (cat. no. 101) and the man carrying a torch and basket (cat. no. 67 recto).

The subject, mistaken for the Chariot of Phaëthon by Berenson, who described the sheet as a "dainty and charming drawing," was correctly identified by Scharf as Prometheus Stealing the Celestial Fire—a myth that was extremely popular in Ficino's circle.[1] The circumstances of the commission to which the drawing relates and whether the project was ever executed by Filippino are unknown. Inspired by classical mythology, the subject may have been suggested by a Florentine humanist of the late quattrocento. Such myths were the source of the *Death of Laocoön*, frescoed at Poggio a Caiano, and the work that Nelson suggests may be its pendant, the *Death of Meleager*[2]—the latter a composition recorded in various drawings by Filippino and his circle. The refined intellectual climate that engendered the *Laocoön* and the *Meleager* provided an alternative to Savonarola's intransigent religiosity. It gave expression as well to the erudite antique-inspired allegories in the Strozzi Chapel frescoes, the *Allegory of Music* drawing in Berlin (cat. no. 96 recto), and Filippino's panel painting of the wounded centaur Chiron in Christ Church, Oxford (pl. 46).

The myth of Prometheus makes an appearance not only in the present sheet but also in an extremely original painting now in the Musée des Beaux-Arts, Strasbourg (inv. no. 225), by Piero di Cosimo, who must have seen Filippino's late mythological studies.

AC

1 Chastel 1954, pp. 174–75.
2 Nelson 1994, pp. 170–74.

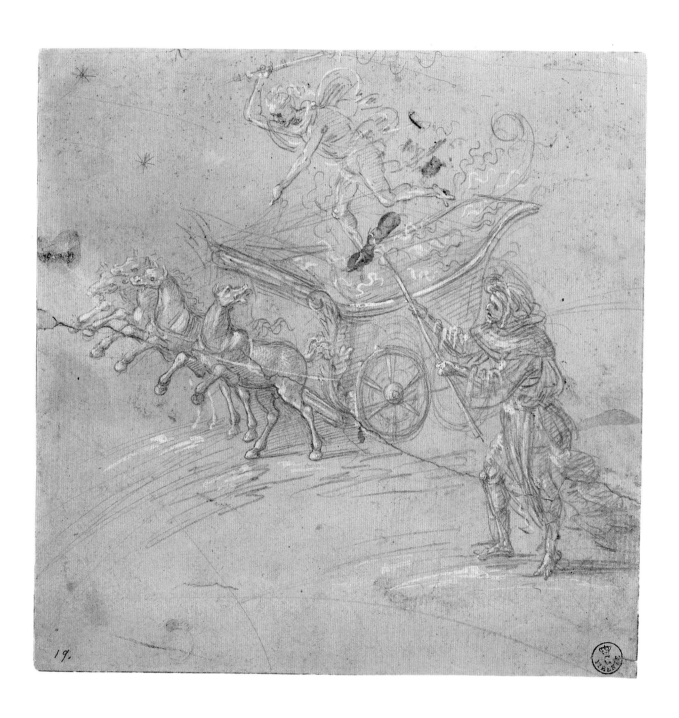

69 *The Volto Santo of Lucca Supported by Two Angels, with Saint John the Baptist and Saint Mark?, within a Frame*

Pen and brown ink and brown wash over traces of black chalk, 201 x 229 mm (7⅞ x 9 in.)

Inscribed in brown ink on recto at lower left by seventeenth-century hand: *Piero di Cosimo*; near lower center by seventeenth-century hand: *Biagio Bolognese* [canceled]; by sixteenth-century hand: *Filippino Lippi* [canceled]; in ink on verso of secondary support by nineteenth-century hand: *Il Quadro è a Londra di Cosimo Rosselli*

WATERMARK: Similar to Briquet no. 11668

Gabinetto Disegni e Stampe degli Uffizi, Florence 227 E

PROVENANCE: Museum stamp (Lugt 930).

LITERATURE: Ferri 1890, p. 104 [Piero di Cosimo]; Morelli 1892–93, col. 8, no. 213; Berenson 1903, vol. 2, no. 1305; Scharf 1935, p. 82, no. 182, fig. 198; Berenson 1938, vol. 1, p. 120, vol. 2, no. 1305; Neilson 1938, p. 40, n. 48; Fossi [Todorow] 1955, no. 33; National Gallery of Art 1960, no. 15; Berenson 1961, vol. 1, p. 178, vol. 2, no. 1305; Shoemaker 1975, no. 88; Petrioli Tofani 1986, no. 227 E; Cecchi in Petrioli Tofani 1992, no. 7.16, illus.; Caroselli 1994, p. 73, n. 50, fig. 51.

Although Ferri ascribed this drawing to Piero di Cosimo on the basis of the old inscription at the bottom of the sheet, Morelli's attribution to Filippino has met with unanimous agreement from scholars. While conceding the accuracy of this attribution, Berenson (1903) remarked on the affinities the sheet shares with works by Raffaellino del Garbo.

The drawing uniquely represents not only the composition for an altarpiece but also a design for its frame. Surprisingly for an artist of Filippino's imaginative gifts, the carved decoration of this frame, characterized by fluted pilasters, composite capitals, and a barely delineated entablature, is quite traditional. It is, in fact, typical of Florentine workshops of the second half of the quattrocento, such as that of Giuliano da Maiano, who produced the frame for the altarpiece that the Pollaiuolo brothers painted for the chapel of the cardinal of Portugal at San Miniato al Monte (now Uffizi, Florence). In the present drawing the *Volto Santo* of Lucca is depicted, supported by two angels and flanked by John the Baptist and an evangelist saint who, lacking specific attributes, is difficult to identify (he may well be Mark).

The mystical representation of the *Volto Santo*, particularly venerated in Lucca (where the original relic is housed in San Martino), led Berenson and Scharf to maintain that the drawing might be related to one of the works that Vasari says Filippino produced in Lucca.[1] As Shoemaker has noted, whether or not this hypothesis is accepted, it is important to recall that there was no dearth of representations of this subject throughout Florence and Tuscany: a notable example is Piero di Cosimo's *Volto Santo*, in the Szépmüvészeti Múzeum, Budapest (inv. no. 1100).[2]

The inscription on the verso of the sheet led to the assumption that the drawing is related to a painting of the *Volto Santo* executed for the Confraternity of Weavers and once believed to be by Cosimo Rosselli but now attributed to the Master of the Epiphany in San Francesco, Fiesole.[3] Now in the Los Angeles County Museum of Art (inv. no. M. 91.242), this *Volto Santo* panel originally came from the convent church of San Marco, Florence. There is, however, no stylistic link between the drawing and the painting, and it is only in terms of iconography that the two works are connected.

Natali has recently noted the close compositional similarities between the drawing and a *Volto Santo between Saint John the Baptist and Saint Mark* in San Salvatore al Monte, Florence, which he correctly attributes to the enigmatic Master of Serumido.[4] The drawing might be preparatory to the altarpiece of the Confraternity of Weavers in San Marco, a commission received by Filippino but executed by another artist at the end of the quattrocento; furthermore, it is possible that the drawing was reused by the Master of Serumido for his own *Volto Santo*. Presumably that artist was not unfamiliar with undertakings of this nature, particularly if, as Natali astutely suggests, he can be identified with Filippino's painter son, Ruberto.[5]

AC

1 Vasari 1996, vol. 1, p. 566.
2 Bacci 1966, pp. 96–97, no. 42, fig. 42.
3 Padoa Rizzo 1989, pp. 19–20.
4 Natali 1995, pp. 138–41.
5 Ibid., pp. 146–47.

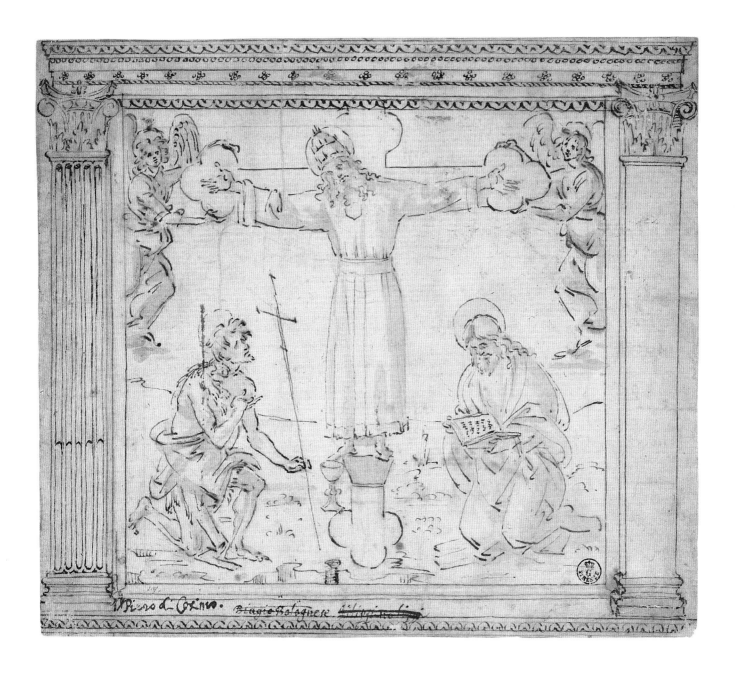

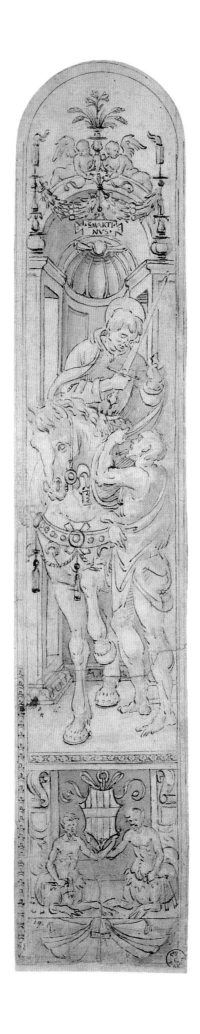

70 *Niche with Saint Martin Sharing His Cloak and Two Centaurs Holding the Coat of Arms of Tanai de' Nerli*

Pen and brown ink and brown wash over traces of black chalk, 383 x 76 mm (15⅛ x 3 in.)

Inscribed in brown ink on recto at upper center by the artist: *S. MARTI / NUS*; in black ink at lower left corner by nineteenth-century hand: *19*; in black chalk: *Filippino* [partly canceled]

Gabinetto Disegni e Stampe degli Uffizi, Florence 1169 E

PROVENANCE: Houses of Medici and Lorraine (manuscript inventory written by Giuseppe Pelli Bencivenni before 1793); museum stamp (Lugt 930).

LITERATURE: Ferri 1890, p. 92, no. 1169; Morelli 1893, p. 16, n. 1 [Raffaellino del Garbo]; Berenson 1903, vol. 2, no. 1316; Loeser 1916, no. 13; Scharf 1935, p. 80, no. 193, fig. 165; Berenson 1938, vol. 2, no. 1316; Kennedy 1938, pp. 42–43; Neilson 1938, p. 70; Straelen 1938, pp. 112–13; Wackernagel 1938, pp. 128–29; Marcucci 1951, no. 57; Fossi [Todorow] 1955, no. 32; Berenson 1961, vol. 2, no. 1316, vol. 3, fig. 230; Shoemaker 1975, no. 83; Shoemaker 1978, p. 39, pl. 34; Petrioli Tofani 1987, no. 1169 E; Bridgeman 1988; Berti and Baldini 1991, p. 286; Cecchi in Petrioli Tofani 1992, no. 12.17; Nelson 1992b, pp. 134–39; Cecchi 1994a, p. 57.

Ferri was the first to recognize Filippino's authorship of this drawing, which had previously been attributed to Piero Pollaiuolo—by Pelli, for example, who catalogued it under his name in the eighteenth century. The attribution to Filippino has not been debated, except by Morelli, whose assertion that he detected the hand of Raffaellino del Garbo justly found no support. Berenson connected the drawing to Filippino's lost stained-glass window for the Nerli Chapel in Santo Spirito, which, together with the altarpiece, is recorded in the *Libro di Antonio Billi*.[1] He was led to this conclusion by the presence in the drawing's lower register of the Nerli coat of arms, held up by two Tritons; this emblem appears above the window of the chapel and, twice, supported by small angels in the altarpiece itself, and again, in miniature, in the left portion of the predella of the altarpiece. The purpose of the drawing is further confirmed by the appearance in the sheet of Saint Martin on horseback sharing his cloak with a pauper, for the Nerli Chapel was dedicated to this saint.

The date of the altarpiece and therefore of the window is still the subject of debate. Most scholars, including Scharf, Neilson, and Berti, propose a dating prior to 1488, when Filippino went to Rome to paint the frescoes in the Carafa Chapel—a hypothesis supported by the fact that many of the Santo Spirito chapels were donated between 1482 and 1485. Berenson (1961), however, places the altarpiece in 1493, when Filippino returned permanently to Florence, while Fossi suggests a date of 1486 for the altarpiece and a more open dating between 1493 and 1503 for the window. This writer initially supported an early chronology but has changed his view in light of Nelson's new documentary findings[2] and on the basis of similarities between the altarpiece and the Carafa Chapel frescoes, noted by Shoemaker, and the patriarchs on the Strozzi Chapel vault, heretofore unremarked. He now thinks that Filippino could have painted the panel and provided the drawing for the window during his Florentine sojourn of June 24, 1489, to January 1490, which took place during an interruption of his work in Rome. The undeniable influence of antique sources in the pilaster strips and throne of the altarpiece clearly implies a Roman experience. Placing the altarpiece and the study for the window in 1489 seems consistent with the style of the sheet, which resembles that of the drawings for the Carafa Chapel and does not yet show the great expressive and decorative freedom of the late 1490s and the early years of the cinquecento. That late manner is documented in studies for frescoes for the Strozzi Chapel, whose large window is still embellished with precious stained glass based on a drawing by Filippino, which, like the lost window of Santo Spirito, was perhaps executed by Ingesuati monks.

AC

1 Billi 1892, p. 50.
2 Nelson 1991, pp. 39–44.

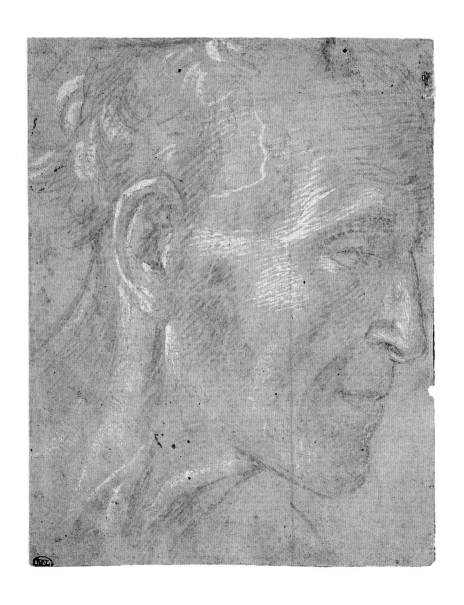

248

71 *Head of a Man Facing Right (Tanai de' Nerli)*

Metalpoint, heightened with white gouache, on pink prepared paper, 138 x 109 mm (5⁵⁄₁₆ x 4⁵⁄₁₆ in.)

Département des Arts Graphiques du Musée du Louvre, Paris 2690

PROVENANCE: Filippo Baldinucci, Florence; acquired 1806.

LITERATURE: Reiset 1866, p. 137, no. 427 [Italian School]; Berenson 1938, vol. 2, no. 1359B; Berenson 1961, vol. 2, no. 1359B, vol. 3, fig. 229; Degenhart and Schmitt 1968, p. 647; Shoemaker 1975, no. 84; Nelson 1992b, p. 135, n. 36.

This drawing was first ascribed to Filippino by Berenson, who identified the subject as Tanai de' Nerli and proposed that it was made in preparation for the altarpiece Nerli commissioned for Santo Spirito, Florence (pl. 22). Berenson suggested that Filippino may have been planning a Nativity when he executed the study, since the figure in it is looking down, unlike the man in the altarpiece, who gazes up at the enthroned Virgin and Child. There is no evidence to corroborate this hypothesis, however, and it is likely that the artist did not mean this rapid life study to capture the precise attitude of his sitter's head in the final painted image.

In any event this is a drawing at a very high level of accomplishment. The early attribution to Donatello advanced by Baldinucci in his inventory calls attention to the great expressive power of this small study, which is reminiscent of the carved prophets for the Florentine campanile. Technically, it shows a subtle and restrained use of metalpoint, animated and enhanced in its tonal range by the varied handling of white gouache, which is applied in short lines as well as painterly dabs. The Santo Spirito altarpiece appears to date from 1489–90, providing a basis for situating this drawing.

GRG

72 *Kneeling Man Turned to the Right*

Metalpoint, heightened with white gouache, on orange prepared paper, 176 x 151 mm (6⅞ x 6 in.)

Inscribed in brown ink at upper left corner by early hand: *Fra Filippo Lippi*; at lower left by another early hand, perhaps that of Filippo Baldinucci: *Pisello*

Gabinetto Disegni e Stampe degli Uffizi, Florence 145 E

PROVENANCE: Houses of Medici and Lorraine (manuscript inventory written by Giuseppe Pelli Bencivenni before 1793); museum stamp (Lugt 930).

LITERATURE: Ferri 1890, p. 90, no. 145; Berenson 1938, vol. 2, no. 1288A; Fossi [Todorow] 1955, no. 34; Berenson 1961, vol. 2, no. 1288A; Below 1971, p. 75; Shoemaker 1975, no. 96; Petrioli Tofani 1986, no. 145 E.

Francesco Pesellino was once thought to be the author of this drawing, as indicated by an old inscription that may be by Baldinucci. Ferri, however, recognized it as a work by Filippino, and his attribution has gained acceptance. Berenson related the study to the *Adoration of the Magi* for San Donato a Scopeto and now in the Uffizi (pl. 35). Fossi linked it to the same painting, specifically to the figure of the king kneeling at the extreme left and shown in profile, holding an astrolabe. The connection to this aged man, identified by Vasari as Pierfrancesco di Lorenzo de' Medici,[1] is not certain but appears likely. To be sure, the poses of the two kneeling figures are not identical: the man in the drawing crosses his hands over his chest and he rests on his right knee, whereas the king in the painting kneels on his left knee. In addition, the costume of the drawn figure lacks the large sleeves trimmed in fur that appear in the altarpiece. Nevertheless, the relationships proposed by Below and supported by Shoemaker are hardly convincing. In Below's view the present figure is a study for an angel in a lost *Annunciation* executed by Filippino in the mid-1490s, a hypothesis based on supposed affinities with the angel in the Carafa Chapel *Annunciation* and with another in a painting of the same subject in Saint Petersburg, datable about 1495.[2] While it is true that the Carafa Chapel angel has his hands folded across his chest, he is shown standing and in the act of climbing a staircase, and the figure in the Saint Petersburg painting, although kneeling, is depicted in stricter profile than the man in the present sheet. Moreover, the pose of the subject in the drawing is more appropriate to a Magus than to the archangel Gabriel.

It may be that this kneeling man, surely drawn from a draped model posing in the studio, represents an early idea for a different version of the *Adoration*, which Filippino abandoned for the final painting, now in the Uffizi.

AC

1 Vasari 1906, vol. 3, p. 473.
2 Scharf 1935, pl. 61.

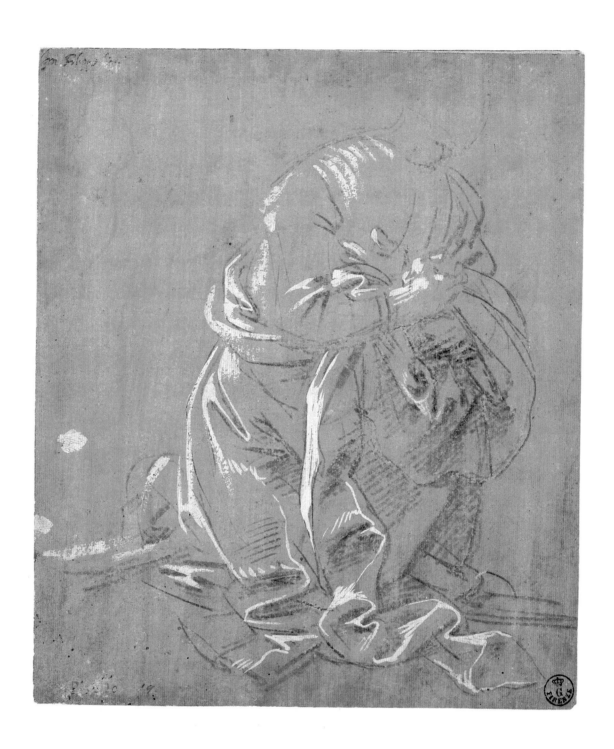

73 *Head of a Boy Facing Left*

Metalpoint, heightened with white gouache, on green prepared paper, 208 x 149 mm (8³⁄₁₆ x 5⅞ in.), maximum; losses on lower left and right corners

Istituto Nazionale per la Grafica, Rome 130455

PROVENANCE: Reale Accademia dei Lincei (Lugt 1683, 2187); Reale Gabinetto delle Stampe (Lugt 1183).

LITERATURE: Berenson 1903, vol. 2, no. 770 [Raffaellino del Garbo]; Scharf 1935, p. 83, no. 303, fig. 182; Berenson 1938, vol. 2, no. 770, vol. 3, fig. 264 [Raffaellino del Garbo]; Berenson 1961, vol. 2, no. 770 [Raffaellino del Garbo]; Ragghianti and Dalli Regoli 1975, pp. 28, n. 2, 93, with no. 52, fig. 49 [Botticelli]; Shoemaker 1975, no. 7; Beltrame Quattrocchi 1979, pp. 31–32, no. 13, illus.; Beltrame Quattrocchi in Catelli Isola et al. 1980, no. 10, illus.; Prosperi Valenti Rodinò 1993, pp. 28–29, no. 6.

A precise dating of Filippino's detailed head studies is difficult: there are not enough extant drawings of the kind to allow the necessary comparisons, and many of the idealized Botticellian facial types they show recur in paintings executed throughout his career. Based on both style and technique, however, it may be possible to date this exquisitely drawn boy's head to 1490–96, rather than 1481–82, as has previously been proposed. Typical of Filippino's drawings of the 1490s is the use of a thick, dark, slightly burnished ground to achieve a great range of tone. The strong highlights here are finely executed with short dashes of the brush tip, which build in intensity and density to a point just short of the delicately drawn outlines of the profile. The approach is reminiscent of the treatment in head studies in the Uffizi (cat. no. 74) and Windsor (cat. no. 75) that are associated with the *Adoration of the Magi* that Filippino painted for San Donato a Scopeto, which is dated 1496 (pl. 35). Although the verso of the Rome sheet displays no drawings (only two small paraphs in fine metalpoint appear), it also recalls those studies, as all three are prepared with a similar blue ground color. An angel's head in a pose similar to that of the head of the boy in the present study appears on the right in the stained-glass window on the altar wall of the Strozzi Chapel (for which there are records of payments made between 1492 and 1503).[1] Filippino's choice of a saturated green color for the paper preparation of his drawing may have been inspired by the challenge of designing stained glass.

CCB

1 Transcribed in Borsook 1970a, pp. 800–801.

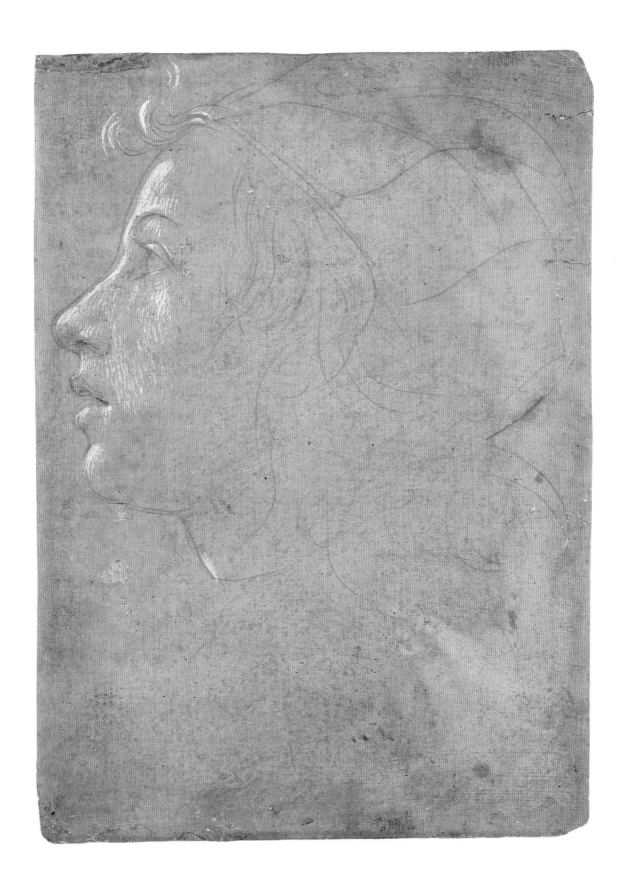

74 *Head of a Young Man in Lost Profile Facing Left*

Metalpoint, heightened with white gouache, on blue-gray prepared paper, d. 112 mm (4⅜ in.)

Gabinetto Disegni e Stampe degli Uffizi, Florence 1151 E

PROVENANCE: Houses of Medici and Lorraine (manuscript inventory written by Giuseppe Pelli Bencivenni before 1793); museum stamp (Lugt 930).

LITERATURE: Berenson 1903, vol. 2, no. 1313; Scharf 1931, pp. 206–8, fig. 5; Scharf 1935, p. 81, no. 298, fig. 169; Berenson 1938, vol. 2, no. 1313; Neilson 1938, pp. 112–14, n. 37; Scharf 1950, no. 89; Fossi [Todorow] 1955, no. 35, fig. 13; Gamba 1958, fig. 22; Berenson 1961, vol. 2, no. 1313; Below 1971, pp. 74–75, n. 59; Shoemaker 1975, no. 56; Geiger 1986, pp. 156–58, pl. 100; Petrioli Tofani 1987, no. 1151 E.

Breathtaking in its economy of stroke and tectonic nuance, this small study from life was preparatory for the head of the king kneeling in the right foreground of the *Adoration of the Magi*, dated 1496 (pl. 35). Filippino painted the *Adoration* altarpiece for the monks of San Donato a Scopeto to replace Leonardo's panel portraying the same subject (Uffizi, Florence), left unfinished when Leonardo departed Florence for Milan in 1482–83. Berenson first recognized Filippino's authorship of the Uffizi sheet but maintained that its subject was linked to the upturned head of a much-repainted apostle in the center foreground of the right portion of the *Assumption of the Virgin* in the Carafa Chapel (pl. 32); only in 1938 did he hesitantly acknowledge a connection to the Uffizi *Adoration*. The view that this connection does indeed exist has, with reason, gained acceptance in the literature.

CCB

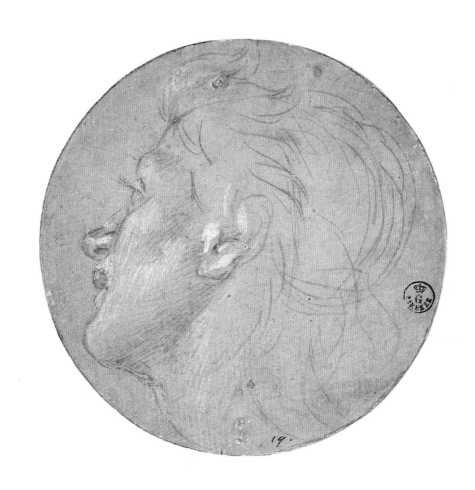

255

75 *Head of a Man Looking Down to the Left*, recto

Study of Praying Hands, verso

Metalpoint, heightened with white gouache, on blue-gray
prepared paper, 241 x 185 mm (9½ x 7¼ in.)

H.M. Queen Elizabeth II, Royal Library, Windsor Castle
12822

PROVENANCE: Royal Collection, Windsor.

LITERATURE: Ulmann 1894c, p. 111, n. 28; Berenson 1903, vol.
2, no. 1369; Scharf 1935, p. 130, no. 305, fig. 152; Berenson 1938,
vol. 2, no. 1369; Popham and Wilde 1949, p. 173, no. 13, fig. 5
(verso), pl. 7 (recto); Berenson 1961, vol. 2, no. 1369, vol. 3, fig.
242; Buckingham Palace 1972, no. 12; Shoemaker 1975, no. 95;
Ames-Lewis and Wright 1983, p. 296, no. 67, illus.; Clayton
1993, no. 7, fig. 17.

Ulmann first attributed the sheet to Filippino, and
Shoemaker was the first to notice that both recto and
verso were made as preparatory studies for a shep-
herd in the *Adoration of the Magi* (pl. 35; fig. 47) that
Filippino painted for San Donato a Scopeto in 1496.
The model is obviously studied from life, and his head
is drawn at the same angle it assumes in the painting.

The technique is highly sophisticated. First,
Filippino quickly sketched the principal outlines in
thin metalpoint strokes, adding a few details and
some shadow in this medium. With equal speed he
then more broadly applied highlights of white
gouache, which he also used to draw parts of the
hair. The effect is one of great economy of means
and spontaneity. The hands on the verso are similarly
achieved and in execution are extremely close to
Filippino's portrait head in Frankfurt (cat. no. 76).
Given the date of the altarpiece, the drawing can be
placed with assurance in 1496.

GRG

FIG. 47 Detail, *Adoration of the Magi*, pl. 35

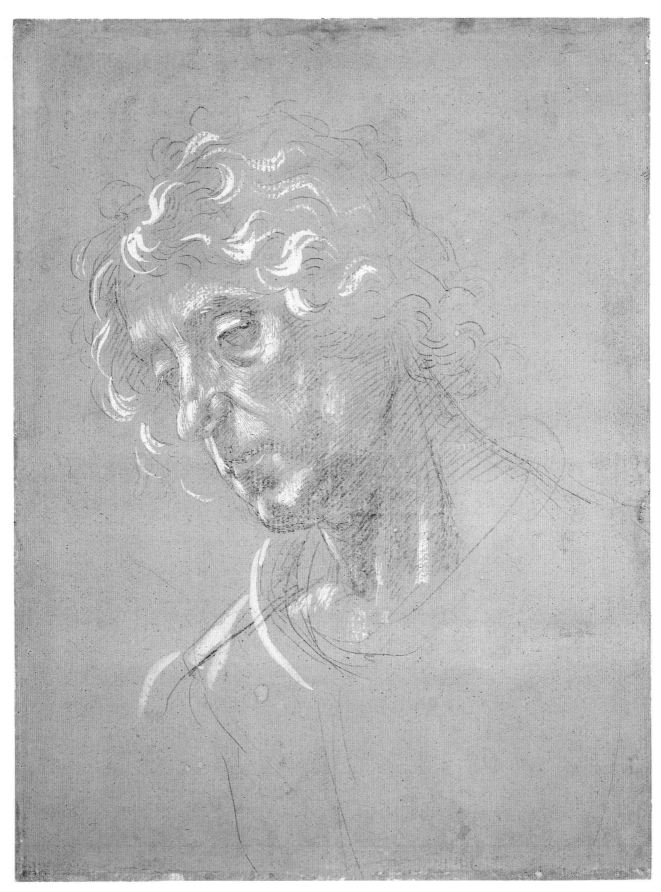

75 RECTO

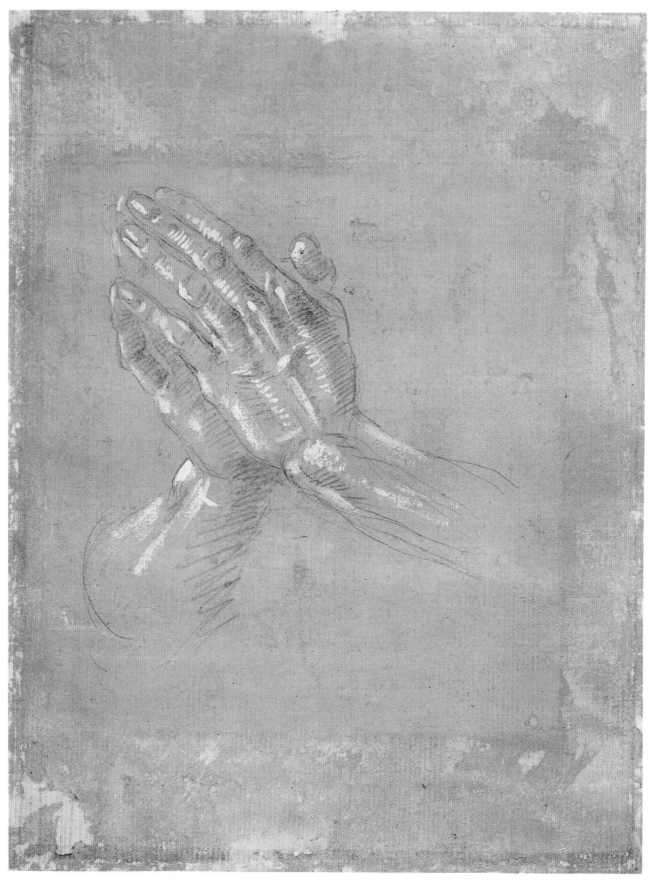

75 VERSO

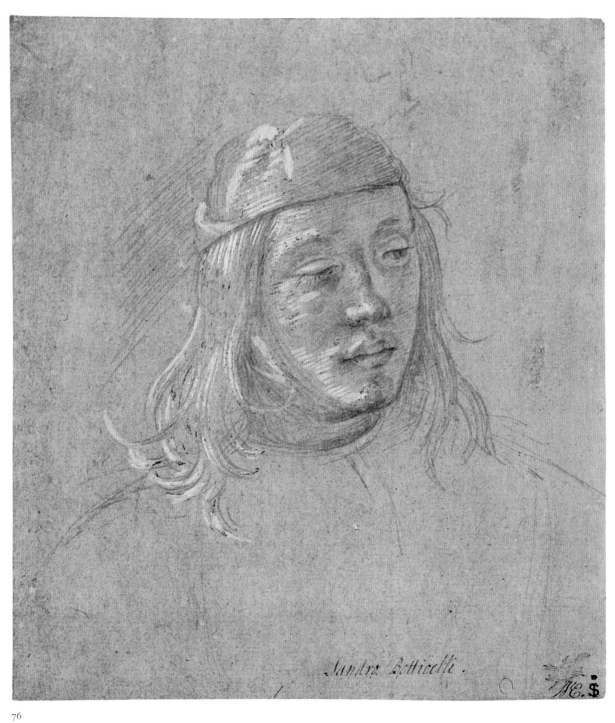

76

76 *Bust of a Youth Turned to the Right*

Metalpoint, heightened with white gouache, on gray-brown prepared paper, 182 x 164 mm (7⅛ x 6⅞₆ in.)

Inscribed in brown ink at lower center: *Sandro Botticelli*

Graphische Sammlung im Städelschen Kunstinstitut, Frankfurt am Main 6950

PROVENANCE: Jonathan Richardson Sr., London (Lugt 2183); Earl Spencer, Althorp (Lugt 1532); William Esdaile, London (Lugt 2617); Comte Nils Barck, Paris and Madrid (Lugt 1959); Alphonse Wyatt Thibaudeau, Paris and London (Lugt 2473); William Mitchell, Australia, London, and Eastbourne; his sale, F. A. C. Prestel, Frankfurt, May 7, 1890, lot 9.

LITERATURE: Berenson 1903, vol. 2, no. 51 [Amico di Sandro]; Scharf 1935, no. 355 [in the manner of Filippino]; Berenson 1938, vol. 2, no. 1341B, vol. 3, fig. 248; Berenson 1961, vol. 2, no. 1341B; Ames 1962, no. 120, illus.; Ragghianti and Dalli Regoli 1975, p. 112, fig. 63; Shoemaker 1975, no. R8; Malke 1980, no. 48.

The youth in this drawing is rendered with an immediacy of expression and economy of means that is in marked contrast to the descriptive, portraitlike drawings of *garzoni* done a decade earlier by Lorenzo di Credi and the Ghirlandaio workshop. Emanating from a source in the upper left, the strong light falling in patches on the boy's features suggests candlelight—calling to mind Leonardo's manuscript notes from about 1490–95 that discuss several artistic and scientific experiments based on candlelight. Filippino's bold treatment of the highlights against the dark color of the ground is characteristic of a number of his drawings that can be dated with certainty in the first half of the 1490s on the basis of external evidence: the *Woman Seen Half-Length and Holding a Shield*, from about 1490–93 (cat. no. 65), and the studies of a head and hands in prayer in Windsor (cat. no. 75), which is related to the Uffizi *Adoration of the Magi*, a signed panel dated 1496 (pl. 35).

CCB

77 *The Virgin Supported by Another Woman,* recto
Reclining Nude Female Torso with Draped Left Arm, verso

Metalpoint, heightened with white gouache, on gray prepared paper, recto; leadpoint on off-white paper, verso, 207 x 138 mm (8³⁄₁₆ x 5⁷⁄₁₆ in.)

Inscribed in graphite on recto at lower left: *61;* on verso near lower border by Pasquale Nerino Ferri: *1840 – Filippino/61*

Gabinetto Disegni e Stampe degli Uffizi, Florence 167 F

PROVENANCE: Houses of Medici and Lorraine (manuscript inventory written by Giuseppe Pelli Bencivenni before 1793); museum stamp (Lugt 930).

LITERATURE: Berenson 1903, vol. 2, no. 1328; Scharf 1935, no. 221; Berenson 1938, vol. 2, no. 1328; Fossi [Todorow] 1955, no. 63 [School of Filippino]; Berenson 1961, vol. 2, no. 1328; Shoemaker 1975, no. R16; Petrioli Tofani 1991, no. 167 F [School of Filippino].

The attribution of this sheet to Filippino has met with some resistance among modern critics. The highly economical manner of drawing on the recto—with long vertical, reinforced strokes and thin, broad highlights applied with a single brush-stroke—suggests a date in the mid- to late 1490s. The study on the recto may have been preparatory for a group of mourning women: the Virgin and attendants in a Crucifixion, Deposition, or Lamentation. In figural type the woman dressed in a nun's habit resembles the Virgin and saints on the left in the main panel and predella of the altarpiece the *Double Intercession,* usually dated about 1495–98, now in the Alte Pinakothek, Munich. Two additional sheets of studies in the Uffizi—one showing two kneeling nuns facing left (inv. no. 166 F), the other portraying a standing woman wearing a heavy mantle (inv. no. 168 F)—are closely related to the present drawing in style and technique and may have been intended for the same project.

The quick, brilliantly suggestive outline study of the torso of a reclining nude woman on the verso of the sheet anticipates the work of Pontormo and other Florentine Mannerist draftsmen of the generation after Filippino. A sculpture of identical design appears in the lower center of Lorenzo Lotto's *Portrait of Andrea Odoni,* dated 1527 (fig. 48). The pose of the torso appears to be based on a reclining Venus, either a Roman sculpture or a Renaissance cast after the antique. Indeed, this figure and the other sculptures depicted in Lotto's portrait were called "antique marble fragments"—a phrase that could also have been applied to Renaissance pseudo-antiques—by Marcantonio Michiel when he described

the painting.[1] Apparently Filippino's drawing is the earliest extant visual record of the sculpture, which remains to be identified.

Filippino probably mined and reconstructed his sketches after the antique for the decorative parts of his paintings: a reclining nude goddess is portrayed on the classical building at the upper left of the *Meeting of Joachim and Anna,* an altarpiece dated 1497 (pl. 36).

CCB

1 "Recorded by Marcantonio Michiel, 1532, in Andrea Odoni's house in Venice" (Shearman 1983, p. 144, no. 143). Michiel saw the painting in Odoni's bedroom during a visit in 1532. Odoni (1488–1545), a noted collector of Roman antiquities, may have owned the torso.

FIG. 48 Lorenzo Lotto. Detail, *Portrait of Andrea Odoni.* Oil on canvas. Royal Collection, Hampton Court 143

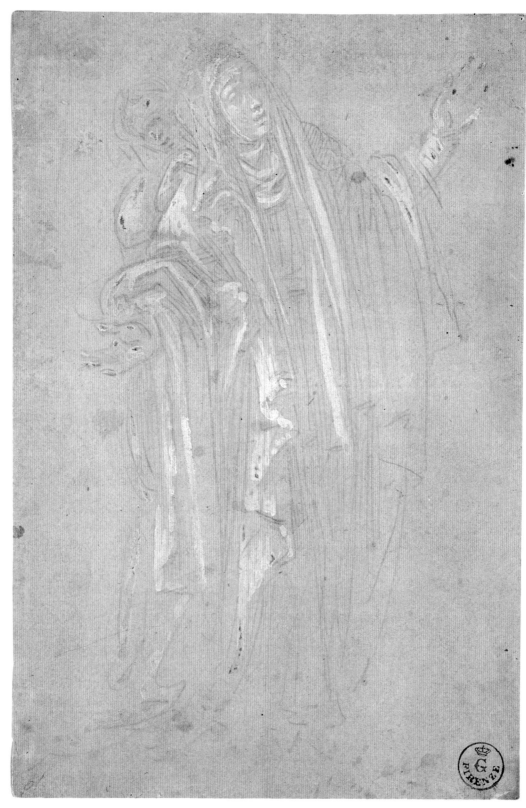

77 RECTO

77 VERSO

78 *Saint Francis Giving the Rule of the Tertiary Order to Saint Louis as Represented by King Louis IX of France and Saint Elizabeth of Thuringia or Hungary?; Saint Elizabeth*, recto

Head of a Woman Turned to the Right, Study of Draperies, and Sketch after Nude Antique Sculpture, verso

Metalpoint, heightened with white gouache, and traces of pen-and-brown-ink framing outlines on mustard-color prepared paper, recto; pen and brown ink and black chalk on unprepared paper, verso, 259 x 186 mm (10³⁄₁₆ x 7⁵⁄₁₆ in.), maximum

Istituto Nazionale per la Grafica, Rome 130452

PROVENANCE: Reale Accademia dei Lincei (Lugt 1683, 2187); Reale Gabinetto delle Stampe (Lugt 1183).

LITERATURE: Fleres 1896, p. 146, n. 2; Berenson 1903, vol. 2, no. 1365; Colasanti 1903, p. 303, illus.; Rusconi 1907, p. 273; Van Marle 1923–38, vol. 12 (1931), p. 373, n. 1; Scharf 1935, no. 190, figs. 166, 167; Berenson 1938, vol. 2, no. 1365; Scharf 1950, pp. 42–43, 58, fig. 140; Berti and Baldini 1957, p. 56, fig. 42; Gamba 1958, pp. 83–84, 93, fig. 29 (recto); Berenson 1961, vol. 2, no. 1365; Ames 1962, vol. 1, no. 126, illus. (recto); Shoemaker 1975, no. 100; Beltrame Quattrocchi 1979, pp. 32–34, no. 14, illus.; Catelli Isola et al. 1980, no. 11 (verso); Prosperi Valenti Rodinò 1993, pp. 30–31, no. 7.

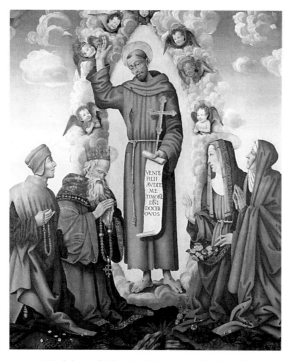

FIG. 49 Workshop of Filippino Lippi. *Saint Francis in Glory.* Tempera on panel, 179.1 x 148.6 cm. Memphis Brooks Museum of Art, Tennessee, Gift of the Samuel H. Kress Foundation 61.190

This drawing probably dates from Filippino's Roman period, specifically in the early 1490s. The recto portrays a compositional idea for an altarpiece. A number of its formal and iconographic elements are reprised in the *Saint Francis in Glory* (fig. 49), a tempera panel that is likely a workshop replica after a lost original by Filippino. It is far from clear whether Filippino's drawing is a preparatory *primo pensiero* for that project or whether the original painting is the work that Vasari records as a panel commissioned from Filippino by Tanai de' Nerli for the church of "San Salvadore fuor di Fiorenza."[1] The extant painting, unlike the drawing, shows Saint Francis in the act of blessing and incorporates four figures of Tertiaries. In composition the drawing also resembles a roughly contemporary majolica tabernacle by the Della Robbia workshop, now in the Misericordia Chapel in the atrium of San Girolamo, Volterra.

The studies of a woman's head and drapery on the verso recall both the Virgin in the Uffizi *Adoration of the Magi*, dated 1496 (pl. 35), and the female saint on the right in the *Holy Family* tondo in Cleveland (pl. 34). The nude figure is quickly drawn in black chalk after an antique source, but less fluently than the nude woman's torso on the verso of the sheet in the Uffizi (cat. no. 77). The figure in the present sheet, whose headdress corresponds to that of a Venus, seems to be female—rather than male, as has often been suggested. It may represent a partially reconstructed antique Venus of the Cnidian type, which was portrayed with and without a head in an Umbrian sketchbook from about 1500.[2]

CCB

1 Vasari 1906, vol. 3, p. 467.
2 See Schmitt 1970, figs. 9–11, 19; and Bober and Rubinstein 1986, p. 61, with nos. 14, 15.

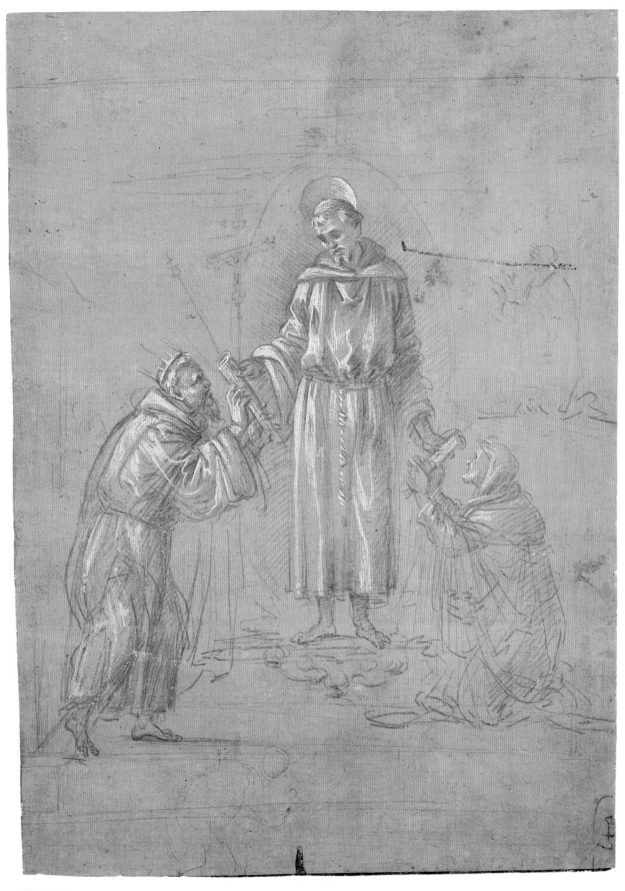

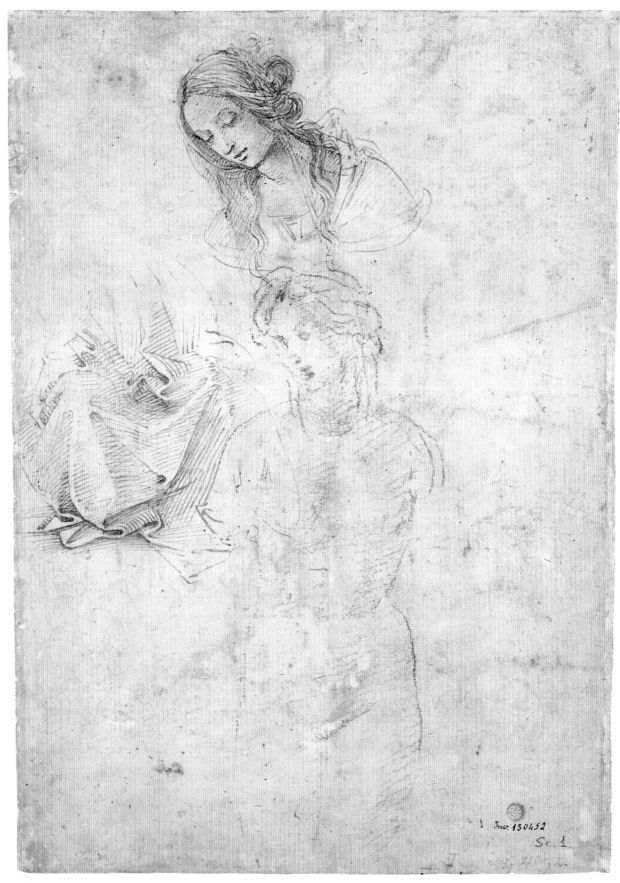

78 VERSO

79 *Standing Nude Youth,* upper left of recto of
Page from the Libro de' disegni, see p. 99

Metalpoint, heightened with white gouache, on gray prepared
paper, 195 x 104 mm (7¹¹⁄₁₆ x 4⅛ in.); corners cropped

National Gallery of Art, Washington, Woodner Family
Collection, Patrons' Permanent Fund 1991.190.1.b

PROVENANCE: see p. 99.

LITERATURE: Strong 1902, no. 34; Popham 1931, no. 50.1
[Florentine]; Kurz 1937, p. 14; Berenson 1938, vol. 2, no. 1276A;
Popham 1949, no. 10 [perhaps Filippino Lippi]; Berenson
1961, vol. 2, no. 1276A; Popham 1962, no. 36 [probably Filippino
Lippi]; Popham 1969, no. 36 [probably Filippino Lippi];
Popham 1973, no. 36 [probably Filippino Lippi]; Ragghianti
Collobi 1974, p. 85, pl. 234; Shoemaker 1975, no. 113 [follower
of Filippino Lippi]; Bayser 1984, pp. 73–76; Miller in Woodner
collection 1986a, 1986b, 1986c, no. 24 recto B; Wohl 1986, no.
26 recto B [possibly Filippino Lippi]; Melikian 1987, p. 86;
Turner in Woodner collection 1987, no. 22B, illus.; Miller
(Turner) in Woodner collection 1990, no. 29B, illus.; National
Gallery of Art 1992, pp. 312, 313; Gahtan and Jacks 1994, pp. 12,
41, 42, no. 52; Jaffé 1994, vol. 1, no. 36; Goldner in Woodner
collection 1995, no. 9B, illus.

80 *Man with a Stick,* upper right of recto of
Page from the Libro de' disegni, see p. 99

Metalpoint, heightened with white gouache, on gray prepared
paper, 196 x 107 mm (7¹¹⁄₁₆ x 4⅛ in.); corners cropped

National Gallery of Art, Washington, Woodner Family
Collection, Patrons' Permanent Fund 1991.190.1.c

PROVENANCE: see p. 99.

LITERATURE: Strong 1902, no. 34; Popham 1931, no. 50.3
[Florentine]; Kurz 1937, p. 14; Berenson 1938, vol. 2, no. 1276B;
Popham 1949, no. 10 [perhaps by Filippino Lippi]; Berenson
1961, vol. 2, no. 1276B; Popham 1962, no. 36 [probably Filippino
Lippi]; Popham 1969, no. 36 [probably Filippino Lippi]; Popham
1973, no. 36 [probably Filippino Lippi]; Ragghianti Collobi
1974, p. 85, pl. 234; Shoemaker 1975, no. 113 [follower of
Filippino Lippi]; Bayser 1984, pp. 73–76; Miller in Woodner
collection 1986a, 1986b, 1986c, no. 24 recto C; Wohl 1986, no. 26
recto B [possibly Filippino Lippi]; Melikian 1987, p. 86; Turner
in Woodner collection 1987, no. 22C, illus.; Miller (Turner) in
Woodner collection 1990, no. 29C, illus.; National Gallery of
Art 1992, pp. 312, 313; Gahtan and Jacks 1994, pp. 12, 41, 42,
no. 52; Jaffé 1994, vol. 1, no. 36; Goldner in Woodner collection
1995, no. 9C, illus.

The attribution of the rather pale nude study from
a studio model to Filippino is correct, despite the
hesitation about it that understandably recurs in
the scholarly literature. Miller has attempted to link
the figure with a standing man at the left side of the
early *Adoration of the Magi* in London (pl. 7). It is,
however, much closer to the portrayal of a standing
older man gesturing toward the Virgin and Child at
the right side of the *Adoration of the Magi,* dated
1496, in the Uffizi (pl. 35). Only the tilt of the head
is different in the two figures. Furthermore, given
the stylistic and historical connection of the drawing
to the *Man with a Stick,* a date of about 1496 is
appropriate.

The *Man with a Stick* has had the same critical his-
tory as the *Standing Nude Youth* and is certainly by the
same hand. It is the more clearly linked of the two to
Filippino's work—as Miller has suggested, there are
connections to a figure of a cowherd in the *Meeting
of Joachim and Anna,* 1497 (pl. 36), and the *Saint John
the Baptist,* of similar date (pl. 40). A still closer version
of the same figure type appears in miniature in the
Visitation scene in the background of the Morgan
Library drawing that shows Job with three friends in
its foreground (cat. no. 95), another late work. These
relationships suggest a date in the late 1490s or early
1500s for the drawing, as does the link to the *Standing
Nude Youth.*

GRG

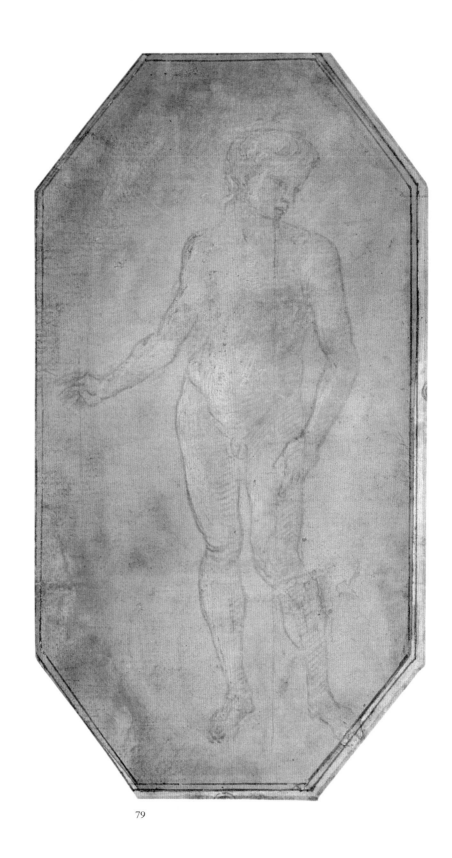

79

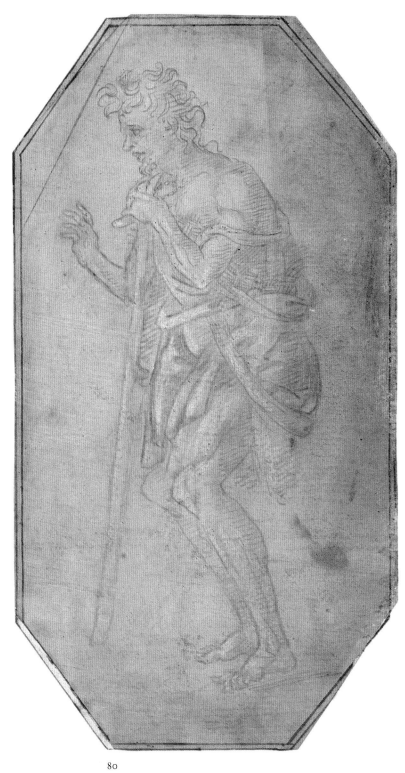

80

81 *Young Woman Moving to the Left*, recto

Standing Young Woman with Her Right Arm Extended, verso

Pen and brown ink and brown wash over red chalk with stylus underdrawing, recto; pen and brown ink and brown wash, verso, 178 x 104 mm (7 x 4⅛ in.)

Inscribed in brown ink on recto at lower left: *F Filip^ino*; at lower right: *g.15* (Resta/Somers number); on verso: *fra filippino*; *g.14*; according to Byam Shaw, in brown ink on old mat at bottom by Jonathan Richardson Sr.: *Filippo del Carmine*; *B.55* (Richardson's shelf number) was cut from verso of old mat

Collection Frits Lugt, Institut Néerlandais, Paris 4984

PROVENANCE: Padre Sebastiano Resta, Milan (Lugt 2992, 2992a); Monsignor Giovanni Matteo Marchetti, bishop of Arezzo (Lugt 2911); his nephew, Cavaliere Marchetti da Pistoia; purchased, probably through John Talman, by John, Lord Somers, London, 1710 (Lugt 2981); his sale, Motteux, Covent Garden, London, May 16, 1717; Jonathan Richardson Sr., London (Lugt 2984, 2995); Hugh Howard, London (Lugt 2957); by descent, Ralph Howard, first earl of Wicklow; Hugh Melville Howard, Delgamy, Wicklow, son of the sixth earl of Wicklow (Lugt 1280b); his sale, Sotheby's, London, February 19, 1936, from lot 61 (album); bought at sale by James Rimell and Son, London; Frits Lugt, Maartensdijk (Lugt 1028); acquired February 20, 1936.

LITERATURE: Berenson 1938, vol. 2, no. 1341I; Berenson 1961, vol. 2, no. 1363B; Shoemaker 1975, no. R31 [imitator of Botticelli]; Byam Shaw 1983, no. 9, pls. 10, 11.

Berenson recognized the drawing as the work of Filippino, but his attribution was either ignored or rejected until Byam Shaw supported it. Byam Shaw not only maintained Filippino's authorship but also noted the similarity between the elegant figure on the recto and the three women advancing to greet Venus in the artist's unfinished *Birth of Venus* on the back of the panel bearing his *Centaur in a Landscape* (pl. 46). Whether made in preparation for the *Birth of Venus* or not, the drawing has much in common with the figures in the painting: both share classical grace and ease of movement as well as general characterization. Moreover, the fine, thin lines that describe the painted figures find further analogy in the unrelated drawing of a woman on the verso of the sheet. That drawing was probably made as a study for a painting of the Annunciation—as Berenson first suggested—although no related work by Filippino exists.

The graphic style of the recto is a sophisticated variant of Filippino's characteristic late manner in pen and ink. The profile of the head finds parallels in two of the studies of the Virgin in the late drawing in the British Museum (cat. no. 82), where a similar, albeit more pervasive, use of broad pen strokes is also in evidence along some outlines. The present sheet is executed with great restraint and precision and is more carefully worked up than the majority of Filippino's late pen drawings. It is nevertheless certainly by his hand and comparable in form and spirit not only to the unfinished *Birth of Venus* but also to several of the allegorical figures in the Strozzi Chapel, as Berenson noted. These analogies suggest a date of about 1495 for the drawing.

GRG

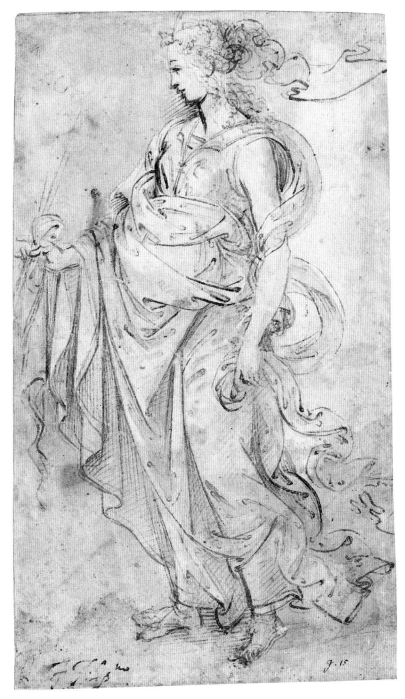

81 RECTO

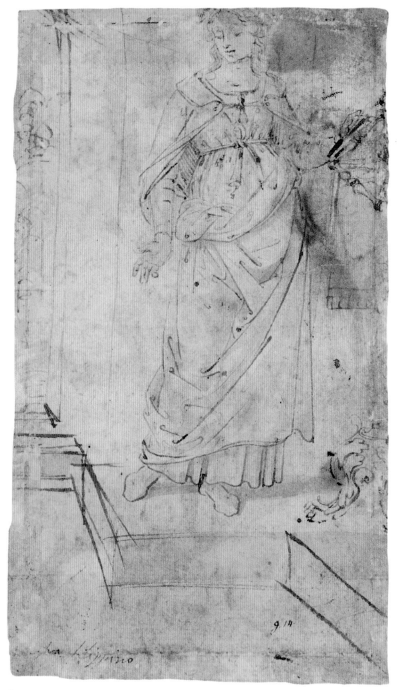

81 VERSO

82 *Three Studies of the Virgin and Child,* recto
Four Studies of the Virgin and Child, verso

Pen and brown ink and brown wash, heightened with white
gouache; figures on verso completed in graphite by much later
hand, 157 x 246 mm (6³⁄₁₆ x 9¹¹⁄₁₆ in.); verso abraded along left
side and bottom

British Museum, London 1946-7-13-4

PROVENANCE: Samuel Woodburn, London; his estate sale,
Christie's, London, June 12, 1860, lot 1086; Sir Thomas Phillipps,
Cheltenham and London; his grandson, Thomas Fitzroy
Phillipps Fenwick, Cheltenham.

LITERATURE: Popham 1935, p. 5, no. 1, pl. 7 [Raffaellino del
Garbo]; Berenson 1938, vol. 2, no. 1849D [Piero di Cosimo];
Popham and Pouncey 1950, no. 63, pl. 63 [Raffaellino del
Garbo]; Berenson 1961, vol. 2, no. 1859D-1, vol. 3, figs. 341, 347
[Piero di Cosimo]; Ames-Lewis 1981b, pp. 119–21, fig. 107
(verso) [perhaps Raffaellino del Garbo]; Byam Shaw 1984,
pp. 411–12.

Berenson attributed this spirited study page to Piero
di Cosimo. However, most scholars have followed
the initially tentative ascription to Raffaellino del
Garbo made by Popham, who compared it to a pen-
and-ink drawing of similar subject indisputably by
Raffaellino at Christ Church (cat. no. 115). This view
was contested by Byam Shaw, who alone maintained
that this and related sheets are by Filippino.

The evidence in favor of Byam Shaw's opinion is
overwhelming. The present drawing bears nothing
but the most generic resemblance to the one at Christ
Church, which, as Byam Shaw points out, is relatively
timid. Moreover, it fits comfortably within a group
of late pen-and-ink studies by Filippino (cat. nos. 84,
85), all of which show a vibrant, if somewhat crude,
line and a similar notational rendering of detail. It is
especially pertinent to compare the verso of this
sheet with the Pietà study in the Louvre (cat. no. 88),
whose attribution to Filippino cannot be sensibly
contested, given its place in the sequence of pre-
paratory drawings for the Pietà altarpiece for the
Certosa of Pavia commissioned from him in 1495.
The similarities in the handling of the pen, in the
short, sometimes broken, rapid lines, and in numerous
morphological details are clear enough to make the
attribution of the present drawing to Filippino a
certainty. Filippino executed a number of paintings
of the Virgin and Child during the 1490s, but none
can be firmly connected to this sheet. Nevertheless,
it can surely be dated to the mid- to late part of the
decade on the basis of its relationship to the Pietà
study in Paris.

GRG

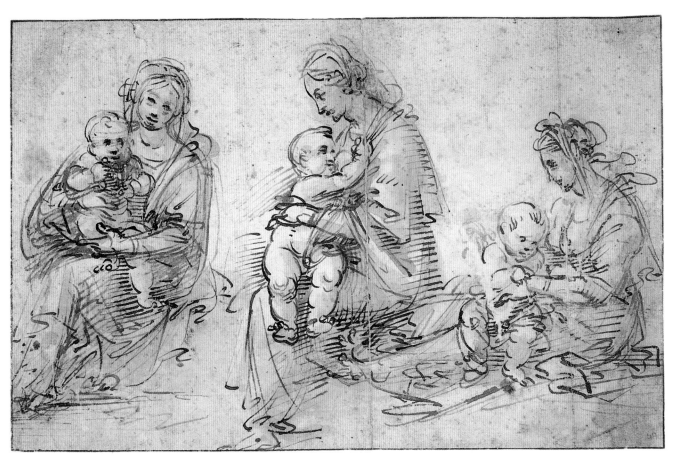

82 RECTO

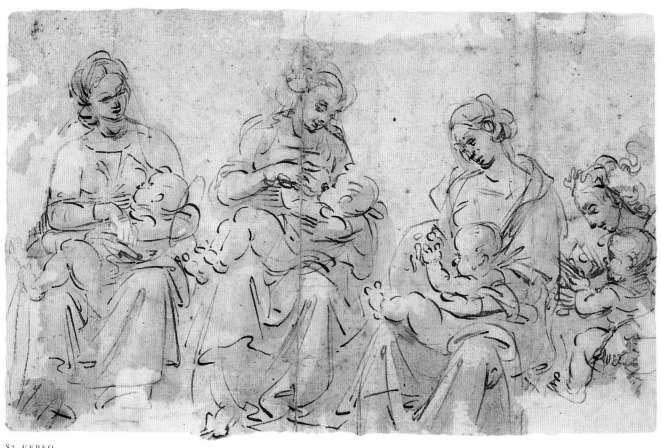

82 VERSO

83 *Virgin and Child with an Angel and Two Other Figures, One Playing the Lute*

Pen and brown ink, heightened with white gouache, over stylus underdrawing, 145 x 187 mm (5 ¹¹⁄₁₆ x 7⅜ in.); gouache heavily oxidized

Inscribed in brown ink at upper right by early hand: *Filippo*

H. M. Queen Elizabeth II, Royal Library, Windsor Castle 12821

PROVENANCE: Royal Collection, Windsor.

LITERATURE: Berenson 1903, vol. 2, no. 1368; Scharf 1935, p. 121, no. 189; Berenson 1938, vol. 2, no. 1368, vol. 3, fig. 257; Popham and Wilde 1949, no. 12, fig. 4; Grassi 1956, p. 64, fig. 13; Berenson 1961, vol. 2, no. 1368; Grassi 1961, p. 185, fig. 65; Ames 1962, no. 117; Buckingham Palace 1972, no. 5; Shoemaker 1975, no. 78; De Marchi in Petrioli Tofani 1992, no. 7.6.

Berenson first advanced the attribution of this fine sheet to Filippino, and his view has not been questioned. Popham and Wilde regarded it as a very late drawing by the artist, whereas Shoemaker and De Marchi have argued for placing it in the early 1490s.

This is certainly the most Leonardesque of all Filippino's pen-and-ink drawings. The organically unified composition, fully integrating individual gestures and movement, and the remarkable subtlety of tonal range (visible despite oxidation of the heightening) are qualities never found to this degree in Filippino's earlier work and are hallmarks of Leonardo's draftsmanship. Furthermore, it recalls the drawings of the Virgin and Saint Anne that Leonardo made once he returned to Florence from Milan soon after 1500, although it does not precisely reflect any of the surviving individual designs. These include several pen-and-ink sketches in which Leonardo rapidly set out the design of the composition in a manner that Filippino clearly emulated here.[1] Moreover, the gesture of Filippino's Virgin has much in common with that shown in Andrea del Brescianino's presumed copy after Leonardo's lost cartoon of 1501 for Santissima Annunziata in Florence[2] and in Leonardo's later autograph painting the *Virgin and Child with Saint Anne* in the Louvre (inv. no. 1598). These parallels can hardly all be coincidental. It should also be noted that efforts to understand the Leonardesque quality of the present drawing as a reflection of the early work Leonardo executed in Florence are inadequate, since none of his designs from that phase have any bearing on its composition and handling. Lastly, if the present sheet were from the early 1490s, it would be a uniquely Leonardesque study made, surprisingly, a decade after Leonardo left Florence.

Within Filippino's own development, the drawing marks not only a strongly Leonardesque moment but also a time of enriched interest in tonal effects, which are deployed in a different way in his late studies of the Pietà (cat. nos. 86–88). The careful interweaving of pen strokes evolved from drawings such as the *Dancing Putto* on the Vasari page in Washington, D.C. (cat. no. 84), while the detail at the lower right is typical of his late sketches. On the other hand, it is not comparable to pen drawings of the early 1490s, for example, the Lille study of the Cumaean Sibyl (cat. no. 49), which are relatively overwrought. A date of about 1500 or slightly later is indicated by all of the evidence.

GRG

1 Popham 1946, nos. 174A,B, 175.
2 Leonardo's cartoon was displayed to the public at Santissima Annunziata in 1501. For a discussion and reproduction of Brescianino's copy, *Saint Anne*, formerly in Berlin, see Freedberg 1961, pp. 40–41, pl. 23.

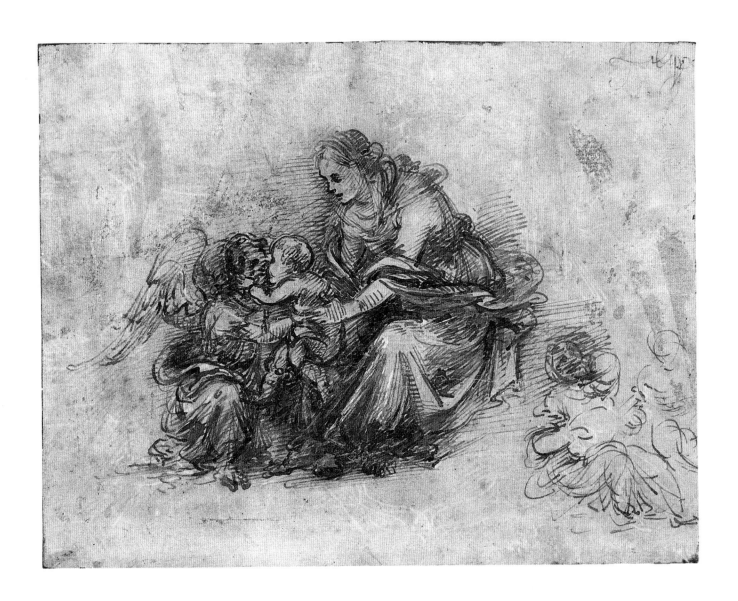

84 *Dancing Putto Holding a Drapery,*
upper center of verso of *Page from the Libro de' disegni,* see p. 99

see p. 99

Pen and brown ink on dark buff paper, 203 x 128 mm (8 x 5 in.)

National Gallery of Art, Washington, Woodner Family Collection, Patrons' Permanent Fund 1991.190.1.e

PROVENANCE: see p. 99.

PROVENANCE: see p. 99.

LITERATURE: Berenson 1938, vol. 2, no. 1275; Berenson 1961, vol. 2, no. 1275; Popham 1962, no. 36; Popham 1969, no. 36; Popham 1973, no. 36; Ragghianti Collobi 1974, p. 85, pl. 233; Shoemaker 1975, no. 113 [Raffaellino del Garbo]; Bayser 1984, pp. 73–76 [not Filippino Lippi]; Miller in Woodner collection 1986a, 1986b, 1986c, no. 24 verso A, illus.; Wohl 1986, no. 26 verso A [Raffaellino del Garbo]; Turner in Woodner collection 1987, no. 22E, illus.; Cummings 1988 [Florentine, possibly Raffaellino del Garbo]; Miller (Turner) in Woodner collection 1990, no. 29E, illus.; National Gallery of Art 1992, pp. 312, 313, illus.; Gahtan and Jacks 1994, pp. 12, 41, 42, no. 52, illus.; Jaffé 1994, vol. 1, no. 36; Goldner in Woodner collection 1995, no. 9E, illus.

Although this spirited study has been attributed to Raffaellino as well as to Filippino, there is clear evidence supporting Filippino's authorship. The highly charged manner of drawing and free modeling are found in the ornamental drawings of his Roman years, 1488 to 1493, specifically two splendid sheets in the Uffizi (inv. nos. 1633 E, 1634 E). In addition, the bisection of the front of the face that is seen here appears as well in pen-and-ink sketches of this kind by Filippino such as the *Angel Carrying a Torch* also on the Washington Vasari page (cat. no. 107) and the *Virgin and Child with Angels* in the Metropolitan Museum (cat. no. 85). The confusion concerning the attribution of this study stems in part from the mistaken idea that the Metropolitan Museum drawing is by Raffaellino, together with the clear stylistic association of the two.[1] In fact, both are certainly by Filippino and date from the period well after his return to Florence from Rome in 1493; not only do both show strong connections to other drawings by Filippino, but they also reveal no relationship of consequence to any surviving work by Raffaellino.

Lewis noticed a resemblance between the lower portion of the putto and that of a terracotta from the orbit of Verrocchio in the National Gallery of Art, Washington, D.C.,[2] a connection that suggests the drawing was likely inspired by this or some similar sculptural prototype.

GRG

1 The relationship was first noted in Colnaghi & Co. 1969, no. 2.

2 Douglas Lewis, National Gallery of Art, typescript note dated September 19, 1994, in the files of the Department of Drawings and Prints, Metropolitan Museum.

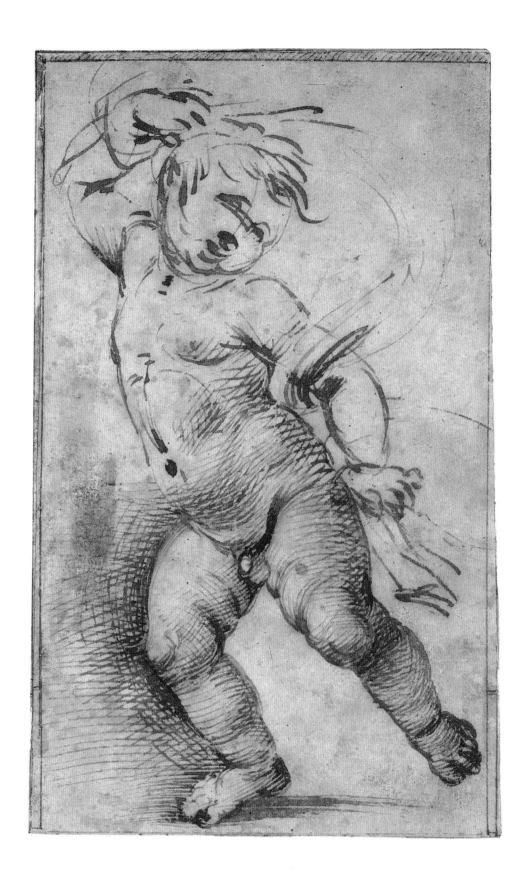

279

85 *Virgin and Child with Angels*

Pen and brown ink and brown wash, heightened with white
gouache, 175 x 222 mm (6⅞ x 8¾ in.); corners cropped

Inscribed in brown ink on verso at lower left: *Bramantino da
milano 1458*

The Metropolitan Museum of Art, New York; Rogers Fund,
1968 68.204

PROVENANCE: Jan Pietersz. Zomer (his handwriting on verso
identified by Michiel C. Plomp); Sir Fairfax Cartwright,
Aynhoe, Oxfordshire; sale, Christie's, London, June 25, 1968,
lot 62, repr.; purchased in London, 1968.

LITERATURE: Popham and Pouncey 1950, with no. 63; Vertova
1968, p. 62, fig. 1 [Raffaellino del Garbo]; Bean 1969, pp. 65–67
illus. [Raffaellino del Garbo]; Colnaghi & Co. 1969, no. 2,
frontis. [Raffaellino del Garbo]; Metropolitan Museum 1975,
p. 59, illus. [Raffaellino del Garbo]; Bean and Turčić 1982, p. 102,
no. 93 [Raffaellino del Garbo]; Byam Shaw 1984, pp. 411–12;
Woodner collection 1987, with no. 22E.

The attribution of this drawing to Raffaellino was
first made by Pouncey, whose view was followed by
Bean. Some hesitation about this opinion was cor-
rectly expressed in an unsigned Colnaghi catalogue
entry, where the style was compared with that of the
Dancing Putto on the Vasari page now in Washington,
D.C. (cat. no. 84). The attribution to Filippino was
first proposed by Byam Shaw, who noted its similar-
ity to the double-sided sheet of studies of the Virgin
and Child in the British Museum (cat. no. 82). He
distinguished both this sheet and the British Museum
studies from the circular drawing of the Virgin and
Child at Christ Church (cat. no. 115), which is certainly
by Raffaellino—a fine sheet drawn in an altogether
less energetic and very different manner.

This sheet belongs to a sequence of late pen-and-
ink drawings that are datable to the last fifteen years
of Filippino's life. The earliest securely dated example
is the study in Lille made for a sibyl on the vault of
the Carafa Chapel (cat. no. 49). Others produced
during the ensuing years include the *Dancing Putto*
and the British Museum studies of the Virgin and
Child, as well as the various drawings for the Pavia
Pietà and the Washington, D.C., study of an angel for
the altarpiece of 1501 in Bologna (cat. nos. 86–88,
107). All share with the present work broad pen lines,
animated short, often parallel strokes, notational and
sometimes eccentric detailing of hands and feet, and
broad use of wash; several also display abstract divisions
of faces like those that mark the two angels here. It
should be noted that none of these elements of style
or draftsmanship occurs in any known drawing by
Raffaellino.

The present drawing can be dated sometime
shortly before Filippino died in 1504, in any case not
earlier than 1500, given its similarity to the angel
study of 1501 on the Washington Vasari sheet. Its
precise purpose is unknown, although it would have
been a suitable design for a scene such as that shown
in the lunette of the altarpiece of 1503 in the Palazzo
Bianco, Genoa (pl. 45).

GRG

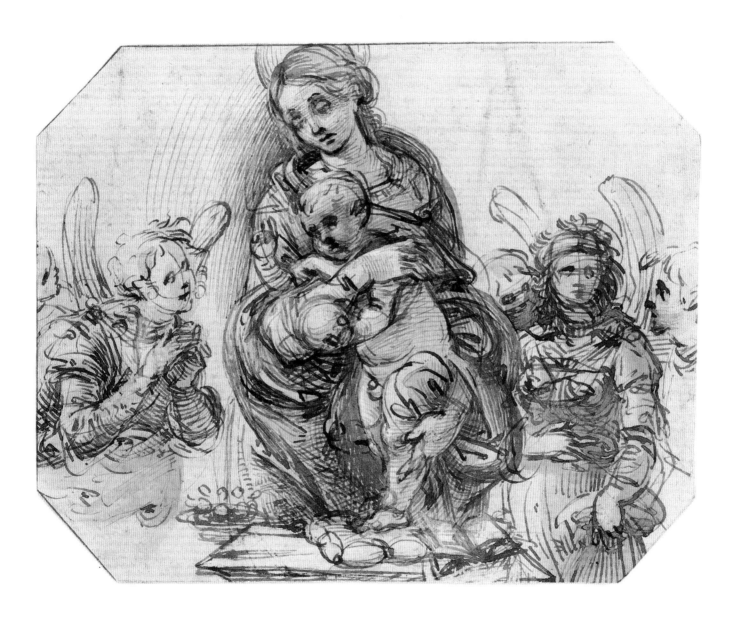

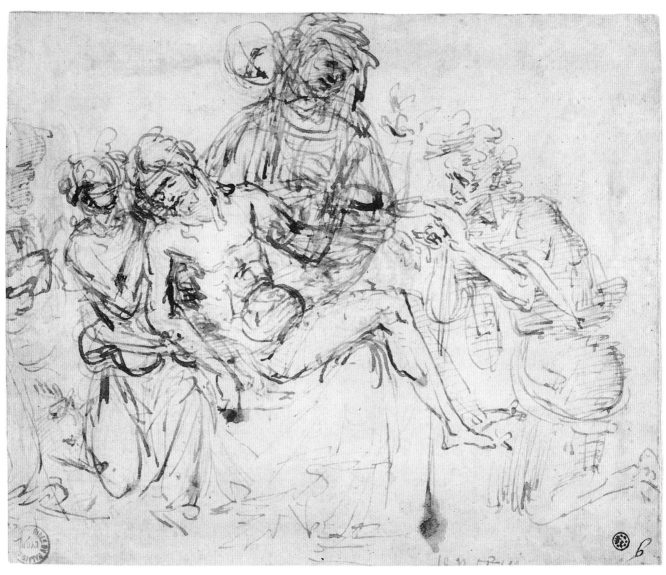

86

86 *Pietà with Saints Anthony Abbot and Paul the Hermit and an Angel*

Pen and brown ink, 150 x 184 mm (5⅞ x 7¼ in.)

Musée des Beaux-Arts, Lyons 1966375

PROVENANCE: Placed on deposit by Bibliothèque Municipale de Lyon, 1966.

LITERATURE: Viatte in Bacou and Séguy 1977, p. 53, with no. 7; Fischer 1990, p. 263, fig. 169; Fischer 1994, no. 70, illus.

87 *Pietà with Saints Anthony Abbot and Paul the Hermit and Angels*, recto
Pietà with Saints Paul the Hermit and Anthony Abbot and Angels, verso

Pen and brown ink over black chalk, recto; pen and brown ink and brown wash over black chalk, verso, 251 x 182 mm (9⅞ x 8³⁄₁₆ in.)

Fogg Art Museum, Harvard University Art Museums, Cambridge, Massachusetts, Bequest of Charles A. Loeser 1932.129

PROVENANCE: Charles A. Loeser bequest, 1932.

LITERATURE: Meder 1919, p. 36, fig. 11; Leporini 1928, p. 174, fig. 73; Van Marle 1923–38, vol. 12 (1931), p. 365, figs. 236, 237; Scharf 1931, pp. 211–13, figs. 8, 9; Walker 1933, pp. 23–24; Scharf 1935, pp. 48–49, 81, 120, no. 185, figs. 172, 173; Berenson 1938, vol. 2, no. 1271H; Neilson 1938, pp. 107–8, figs. 46, 47; Mongan and Sachs 1940, p. 17, no. 22, figs. 21, 22; Tolnay 1943b, vol. 1, p. 149; Tietze 1947, no. 17, pl. 17 (recto); Scharf 1950, pp. 30–31, 46, fig. 101; Berenson 1961, vol. 2, no. 1271H; Ames 1962, no. 116, illus. (verso); Borgo 1966, p. 464, n. 9; Weinberger 1967, vol. 1, pp. 73–74, pls. 21.2, 21.3; Shoemaker 1975, no. 128; Oberhuber 1979, no. 8, illus. (recto); Fischer 1986b, p. 61, figs. 22, 23; Fischer 1990, p. 263, figs. 169, 170; Fischer 1994, p. 112, with no. 71, figs. 28, 29; Nelson 1994, p. 172, n. 36, fig. 13 (recto).

88 *Pietà with Saints Paul the Hermit and Anthony Abbot*

Pen and brown ink and brown wash over black chalk, 140 x 170 mm (5½ x 6¹¹⁄₁₆ in.)

Département des Arts Graphiques du Musée du Louvre, Paris 2697

PROVENANCE: Everhard Jabach, Paris (Lugt 2959); purchased for French royal collection, 1671.

LITERATURE: Berenson 1903, vol. 2, no. 1360; Scharf 1931, pp. 211–12, fig. 10; Scharf 1935, pp. 48–49, 81, no. 186, fig. 174; Berenson 1938, vol. 2, no. 1360; Neilson 1938, p. 107; Mongan and Sachs 1940, p. 17, with no. 22; Tolnay 1943b, vol. 1, p. 149; Chastel 1950, pl. 63; Scharf 1950, pp. 30–31, 46; Berenson 1961, vol. 2, no. 1360; Weinberger 1967, vol. 1, pp. 73–74, pl. 21.1; Shoemaker 1975, no. 129; Fischer 1990, pp. 262–65, fig. 168; Zambrano 1990, pp. 56–57, pl. 48; Fischer 1994, p. 112, no. 71.

The drawing in Lyons, first published by Viatte in 1977, and the sheets in Cambridge and Paris were made in preparation for the commission that Filippino received on March 7, 1495, to paint the altarpiece for the high altar of the Certosa of Pavia. The panel was to depict the Pietà with Saint Anthony Abbot (on the right), Saint Paul the Hermit (at the left), and other, unspecified figures. A complaining letter of May 1, 1499, written by Lodovico Sforza, makes clear that the painting was not far advanced, or perhaps not even begun, by that date. It remained largely unfinished when Filippino died in 1504, and the commission passed to Mariotto Albertinelli in 1511. At that time Albertinelli was given Filippino's unfinished panel, which is now lost. The altarpiece appears finally to have been painted by Albertinelli's partner, Fra Bartolommeo, although it too is lost. A drawing in the École des Beaux-Arts, Paris (inv. no. 40), has been identified by Fischer as very likely a copy after Fra Bartolommeo's work.

Although Filippino's panel itself does not survive, the four extant drawings for it on the present three sheets provide considerable information about the evolution and appearance of the composition.[1] The one in Lyons is the earliest of the group. It is a highly exploratory sketch, in which the principal figures are set out in rough form. The position of the Virgin's head is adjusted twice, and the placement of Christ's left arm is not easily understood and remains unresolved. The pen strokes are rapid, searching, and relatively crude, and the overall effect is one of great creative energy.

The second in the sequence is the recto of the well-known sheet in Cambridge. As in the previous study, Filippino placed Anthony Abbot at the left and Paul the Hermit at the right, both kneeling and separated from the central figures by angels. Here too Filippino tried variant positions for the Virgin's head. However, this sheet differs from the first in the inclusion of a complex architectural setting, broadly reminiscent of his work at the Carafa Chapel. The characterization of expression is gentler, and the pen lines are lighter and more even. The figures are adjusted to interact spatially and emotionally within a logical narrative. The drawing is clearly an elaboration and refinement of the ideas inherent in the Lyons composition.

It is very probable that Filippino turned next to the verso of the Cambridge sheet, making further and quite significant changes in his scheme and figures. He reversed the placement of the two saints, situating Anthony Abbot on the right and Paul on the left, apparently in accordance with the requirements of the now-lost contract, and showing them standing.

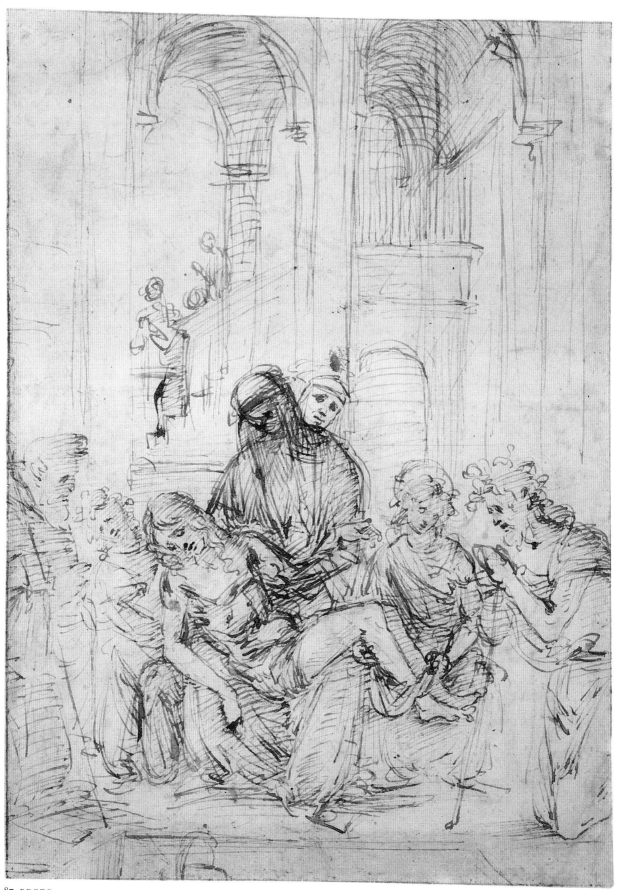

87 RECTO

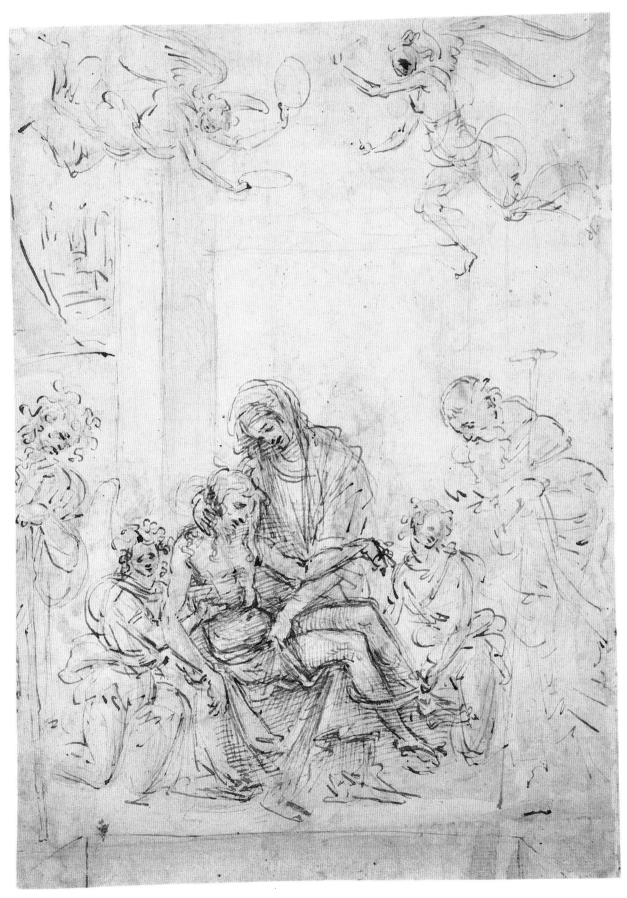

87 VERSO

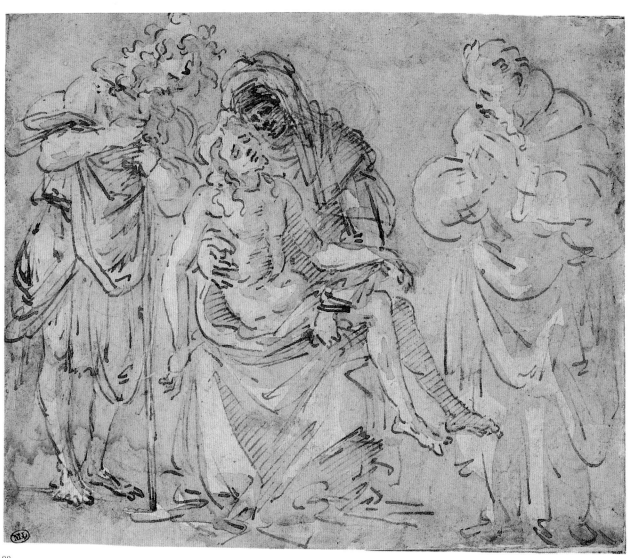

88

The interrelationship of Christ and the Virgin is closer, physically by virtue of the higher placement of his head and emotionally through the gesture of her right hand and her vivid facial expression. Architecture is reduced and simplified, and two angels flying above the scene are introduced. The draftsmanship is somewhat altered as well. There is much more economy of line and a greater sense of certainty in the articulation of forms, although the character of the drawing remains exploratory, with several notable pentimenti involving elements such as the positioning of the Virgin's right hand. In addition, wash has been applied throughout to create shadow and help formulate spatial relationships. Filippino typically used wash for these purposes in his more complete compositional drawings—for example, the *Volto Santo modello* in the Uffizi (cat. no. 69)—and its presence here is further evidence that this study is later than that on the recto and on the Lyons sheet, where it does not appear.

The fourth and last of the series of preparatory studies is the drawing in Paris. The saints, like those on the verso of the Cambridge sheet, are shown standing, although with somewhat altered gestures. The wild calligraphy of Paul the Hermit's hair is retained, as is his stance, in which he leans on his staff. More important, the kneeling angels have been eliminated, bringing the principal actors closer together to lend much greater concentration to the scene. Christ now appears higher on his mother's lap, and she leans down to press her face against his. Scharf (1931) was the first to note the similarity between these drawings and Michelangelo's *Pietà* in Saint Peter's— a suggestion treated hesitantly in the literature. His point is clearly valid, although the connection is present only in this study and is most obvious in the placement of Christ's legs and right arm and in the concentrated sculptural impact of the figure group. Michelangelo completed his *Pietà* in 1499, whereas Filippino had not made much progress on his own by that date and managed to produce only an unfinished panel by the time of his death. This means that he had more than adequate time to take an unrecorded late trip to Rome and see Michelangelo's sculpture or to see drawings of it before carrying out the Paris study. The technique of this drawing is economical in its short, rapid pen lines and richly orchestrated in its tonal use of wash throughout the sheet, against which the reserve of the white paper creates brilliant highlights. It is certainly among the most expressive and dramatic of Filippino's late drawings. Given its relationship to Michelangelo's *Pietà*, it appears to date from 1500 or slightly later. The Lyons and Cambridge sheets, although somewhat earlier, fall within the same period, perhaps just after Lodovico Sforza wrote his letter of 1499.

GRG

1 There have been a number of efforts to establish the order in which these studies were made, many offered before the discovery of the Lyons sheet and its publication in 1977. Of these the best is the most recent, by Fischer (1994).

89 *Two Women with a Child and a Boy Leaning on a Chair with an Open Book*

Pen and brown ink over traces of black chalk, 86 x 124 mm
(3⅜ x 4⅞ in.), maximum; losses along right border made up,
glued to secondary support

Inscribed in brown ink at lower left, possibly by Filippo
Baldinucci: *Filippo Lippi*; in graphite at lower left below first
inscription: *19*.

Gabinetto Disegni e Stampe degli Uffizi, Florence 147 E

PROVENANCE: Houses of Medici and Lorraine (manuscript
inventory written by Giuseppe Pelli Bencivenni before 1793);
museum stamp (Lugt 930).

LITERATURE: Ferri 1890, p. 90, no. 147; Berenson 1903, vol. 2,
no. 1290; Loeser 1916, no. 12, illus.; Scharf 1935, no. 178;
Degenhart 1937, pp. 232, 236, fig. 153; Berenson 1938, vol. 2,
no. 1290; Fossi [Todorow] 1955, no. 31; Berenson 1961, vol. 2,
no. 1290; Shoemaker 1975, no. 79; Petrioli Tofani 1986, no. 147 E.

The subject of this small, genrelike composition,
minutely drawn with a fine pen, is far from clear.
Evocative of Leonardo's compositions from the late
1490s and early 1500s, the group of two female figures
and a baby probably represents the Virgin and Saint
Anne with the infant Christ, although the women
may be the Virgin and Saint Catherine. The boy on
the left is often identified as the young John the
Baptist, but he lacks that saint's usual attributes. The
sketchy staccato outlines of the woman on the far
right are typical of Filippino's late, loose pen style, in
use from the late 1490s, and are, for example, compa-
rable to those in the Gardner Museum *Meeting of
Christ and John the Baptist* (cat. no. 92). Both the sub-
ject matter and precise hatching techniques may
have been inspired by study of northern prints, par-
ticularly those of Martin Schongauer, whose work
was known and copied in Italy by the 1490s, or per-
haps of Master ES and Israhel van Meckenem, as
Shoemaker has noted. Filippino first drew much of
the design in black chalk, probably erasing the under-
drawing as he went over it with pen and ink, and
then reworked the sketchy ink drawing of the infant
with a black chalk with a fine point. The surface of
the sheet is slightly abraded throughout, and only a
few traces remain of the underdrawing and of the
reworking in black chalk that convey the drawing's
original exploratory function.

CCB

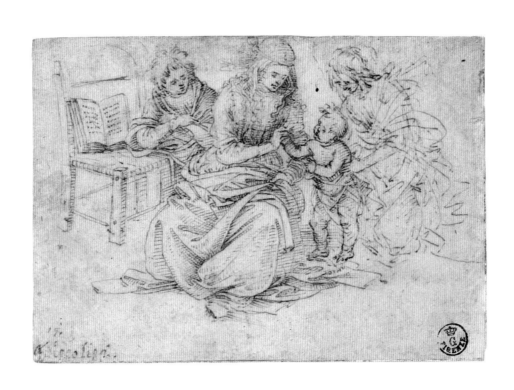

90 *Christ among the Doctors, Study for Two Standing Figures (the Virgin and Saint Joseph?), and Study for Four Standing Figures*

Pen and brown ink and brown wash over traces of black chalk or leadpoint, main drawing and two fragments glued to larger sheet, 116 x 262 mm (4⅝ x 10⅜ in.)

Inscribed in brown ink on verso by sixteenth-century hand: *Fi.po di Frà Filippo*

Gabinetto Disegni e Stampe degli Uffizi, Florence 144 E

PROVENANCE: Houses of Medici and Lorraine (manuscript inventory written by Giuseppe Pelli Bencivenni before 1793); museum stamp (Lugt 930).

LITERATURE: Ferri 1890, p. 90, no. 144; Berenson 1903, vol. 2, no. 1288; Loeser 1916, no. 18, illus.; Scharf 1935, p. 82, no. 181; Berenson 1938, vol. 1, p. 107, vol. 2, no. 1288; Sinibaldi 1954, no. 1; Fossi [Todorow] 1955, no. 39, fig. 10; Berenson 1961, vol. 2, no. 1288; Shoemaker 1975, no. 89; Petrioli Tofani 1986, no. 144 E; Berti and Baldini 1991, p. 288, illus.

This sheet has belonged to the Uffizi *ab antiquo*, as suggested by the early handwriting on the verso. In the late eighteenth century Pelli Bencivenni identified the subject of the main composition. The drawing is now part of a page assembled by Pelli Bencivenni, with two small fragments showing rapidly sketched figures that also relate to the subject of the Dispute with the Doctors. As Shoemaker has suggested, the upper fragment may represent the Virgin and Saint Joseph, the latter portrayed leaning on a stick. That would be appropriate to the Dispute theme: according to the Gospel of Luke (2:42–50), Mary and Joseph unwittingly left the young Christ behind after visiting the temple in Jerusalem and upon their return found him there, engrossed in discussion with the elders. The lower fragment shows two pairs of figures, one behind the other, which seem to be different solutions for a single composition. Presumably they relate to the two men at the extreme left of the largest section of the drawing, one of whom looks at an open book that the other holds and about which they are engaged in animated discussion.

There is no mention in the documents of a painting by Filippino on the subject, which was not common in quattrocento Florentine art. It is possible, therefore, that the drawings might be related to a commission that was never executed or, given the oblong format of the larger work, to a lost predella

panel. The large composition may have some connection to the recto of a sheet in the National Gallery in Prague (cat. no. 91).

The present sheet was assigned by Scharf to the years between 1495 and 1499 and by Berenson and Fossi to Filippino's late period. Shoemaker, however, dates it earlier, locating it in the first half of the 1490s, because of its affinities with Filippino's drawing for the Carafa Chapel in the British Museum (cat. no. 55), his sketches for the *Laocoön*, and his drawing for the stained-glass window for the Nerli Chapel (cat. no. 70). To these comparable sheets other examples can be added: the Louvre *Young Man Hanged by the Foot* (cat. no. 98), a drawing of a young girl in the Uffizi (inv. no. 173 F), and the draped figures in another sheet in the latter collection (inv. no. 183 s), which is perhaps a study for a Calling of Saint Matthew.

As for the parallels Loeser found with Leonardo's unfinished *Adoration of the Magi* for San Donato a Scopeto, there seems to be only the barest echo here of the arrangement of the spectators around the Virgin and Child in that large panel. Leonardo's painting certainly was not a definitive source and, in any case, its model was profoundly transformed by Filippino's fertile imagination.

AC

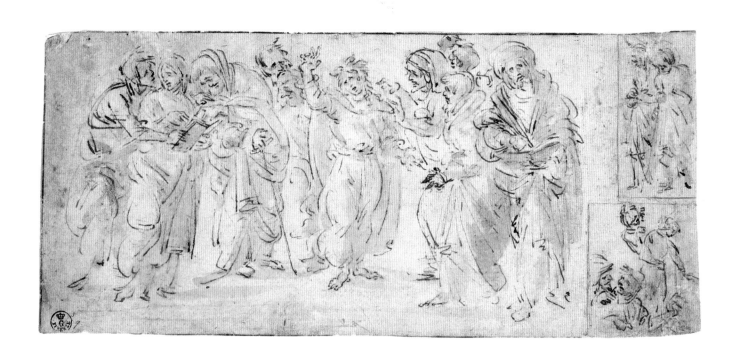

91 *Trial of the Young Moses?*, recto

FOLLOWER OF FILIPPINO LIPPI

Moses Striking Water from the Rock, verso

Pen and brown ink and brown wash over black chalk on paper rubbed with black-chalk pouncing dust at left side, recto; pen and brown ink over traces of black chalk, outlines pricked, on paper rubbed with black-chalk pouncing dust, verso, 165 x 340 mm (6½ x 13⅜ in.), maximum; two halves of sheet glued together

Inscribed in brown ink at lower left of center: *Dom.co Ghirlandaïo*

National Gallery in Prague к 9407

PROVENANCE: Stamp G.S.P. (not in Lugt); E. Desperet, Paris (Lugt 721); Edward Habich, Boston and Kassel (Lugt 862); his sale, H. G. Gutekunst, Stuttgart, April 27–29, 1899, lot 418; Dr. František Machácek bequest.

LITERATURE: Habich sale 1899, p. 48, lot 418; Cagnola 1906, pp. 41–42, illus.; Scharf 1935, p. 82, no. 172, fig. 187; Berenson 1938, vol. 2, no. 1272A; Kurz 1947, p. 147; Davies 1951, p. 225, with no. 4904; Berenson 1961, vol. 2, no. 1272A; Shoemaker 1975, no. 126; Zlatohlávek 1991, pp. 121–23, illus.; Nelson 1992b, pp. 260–61, figs. 100, 101.

The composition sketch on the recto of this sheet is executed with the rapidly reinforced contours of the pen and luminous transparent washes typical of drawings from the last years of Filippino's life. Its abbreviated, elongated figural types relate to drawings in Stockholm, Oxford, and Berlin (cat. nos. 93, 94A, 96), the more securely datable composition sketches for the *Raising of Drusiana* in the Strozzi Chapel (cat. no. 99 recto) and the *Pietà* for the Certosa of Pavia (cat. nos. 86–88). There is some agreement in the literature that Filippino's composition may represent an apocryphal episode from the youth of Moses. Kurz identified the scene as Moses before the Pharaoh and the High Priest at Heliopolis. It appears more probable, however, that Filippino's subject is the Trial of the Young Moses, based on the drawing's iconographic and compositional similarities with Giorgione's panel from about 1505 on that theme (Uffizi, Florence). The crucial figures toward the center of the composition seem recognizable: the bearded high priest in a turban, the crowned Pharaoh seated on a throne, the boy Moses standing on the right of the throne, and the crowned daughter of the Pharaoh. Although Zlatohlávek has recently suggested that the left and right portions of the sheet are parts of two unrelated compositions joined by a restorer, the scene reads as a unified whole. Despite the vertical join of the paper in the center, with losses on the original sheet made up, there are continuities in passages of pen-and-ink drawing from the left to right portions that seem to have been made

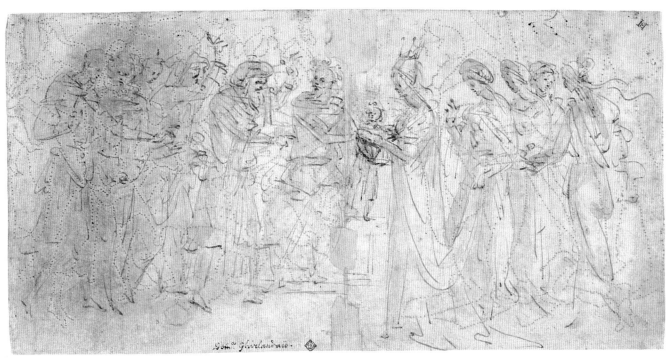

91 RECTO

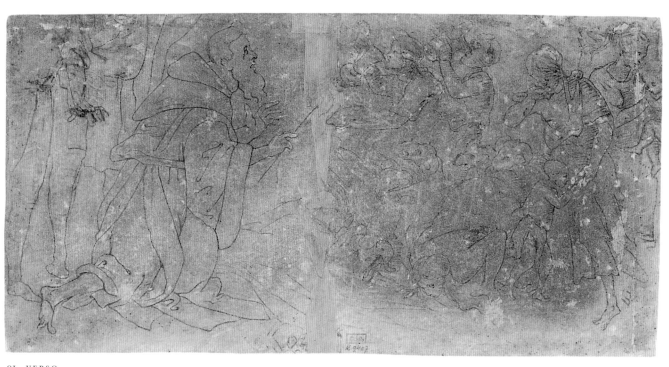

91 VERSO

by Filippino, for instance in the contours of the Pharaoh's arm and in some of the horizontal lines of the molding on his throne. The presence of inks of different colors should not be taken as evidence of retouching, for the colors of Filippino's inks often vary stroke to stroke within the same drawing.

As Cagnola and Kurz suggested, this drawing may have been preparatory for a series on the Life of Moses that also included two long panels executed in Filippino's workshop: *Moses Striking Water from the Rock* (fig. 50) and the *Worship of the Egyptian Bull-God Apis* in the National Gallery, London. The coarse outline cartoon of *Moses Striking Water from the Rock* on the verso of the present sheet offers a fairly close variation on the design of the London panel; it differs from the final work mainly in bringing the kneeling Moses and the group of thirsty Israelites closer together, as well as in details of the figure immediately to the left of Moses and the representation of the two women and the child on the extreme right. The cartoon apparently was drawn by connecting, hole by hole, pricked outlines on the sheet that were based on a tracing or substitute cartoon; the resulting design must have then been reused, as it is heavily rubbed with pouncing dust for transfer. Fahy has suggested that the author of the London panels may be

the Niccolò Zoccolo mentioned by Vasari, a pupil of Filippino's who was nicknamed Niccolò Cartoni, presumably because of his pedestrian specialty, the use and abuse of cartoons.[1] The cartoon may be by this artist as well—the treatment of the figures is strikingly comparable to that in the London panels—and was probably mechanically traced from an original cartoon by Filippino.[2]

CCB

1 Fahy in conversation; Vasari 1906, vol. 3, pp. 476–77.

2 It is possible that a highly finished drawing of the *Moses Striking Water from the Rock* composition, now in Christ Church, Oxford (inv. no. JBS 37), is a full-scale copy after Filippino's cartoon, for the figures in it are more precisely individualized in Filippino's style than those in the Prague cartoon. The sixteenth-century inscription on the upper left of the Christ Church drawing, *filippo lipi fu frate del carmine*, may offer partial confirmation of this hypothesis. The Christ Church copy reveals that very little of the original composition in the present sheet was lost in the cropping and rejoining of the paper along the center. The popularity of Filippino's invention is suggested not only by the London pictures but also by Bacchiacca's panel *Moses Striking Water from the Rock*, about 1530 (formerly Palazzo Giovanelli, Venice), which it evidently inspired as well. On the drawing, see further Byam Shaw 1976, vol. 1, p. 43, no. 37.

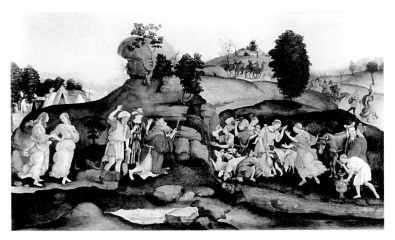

FIG. 50 Workshop of Filippino Lippi. *Moses Striking Water from the Rock.* Tempera and oil on panel, 78 x 137 cm. National Gallery, London 4904

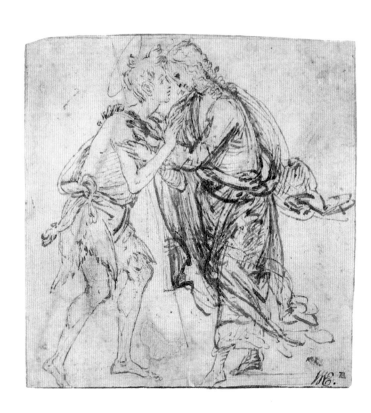

92 *Meeting of Christ and John the Baptist*

Pen and brown ink over black chalk, 93 x 90 mm (3⅝ x 3⁹⁄₁₆ in.)

Inscribed in brown ink on verso along bottom edge by William Esdaile: *1816 Roscoe's coll. P63-N207 Vide Lanzi 1-62*

Isabella Stewart Gardner Museum, Boston 1.1.0/6

PROVENANCE: Jonathan Richardson Jr., London (Lugt 2170); William Roscoe, Liverpool (according to inscription on verso of drawing); his sale, Winstanley, Liverpool, September 23–28, 1816; William Esdaile, London (Lugt 2617); his sale, Christie's, London, June 18–25, 1840; William Russell, London (Lugt 2648); Sir John Charles Robinson, London; his sale, Christie's, London, May 13, 1902, lot 191; Isabella Stewart Gardner, Boston.

LITERATURE: Berenson 1903, vol. 2, no. 1271A; Hendy 1931, p. 200; Scharf 1935, no. 180, fig. 160; Berenson 1938, vol. 2, no. 1271E; Lavin 1955, pp. 98–99, n. 81; Berenson 1961, vol. 2, no. 1271E; Hadley 1968, no. 1, fig. 1; Shoemaker 1975, no. 127.

Since the Robinson sale catalogue of 1902 the attribution of this drawing to Filippino has been maintained without question. Its subject is put in context by Lavin, who points out that a number of Tuscan paintings of the period show the Meeting of Christ and the Baptist in the Desert, a theme derived from the *Vita di San Giovanni Battista* by Domenico Cavalca.

There are no known or documented paintings by Filippino of this theme, although the expressive typology of the paired figures in this sheet is comparable to that of the principals in his *Meeting of Joachim and Anna* of 1497 (pl. 36), as Hadley observes. They also show analogies with the protagonists of *Christ and the Woman of Samaria at the Well* in Venice (pl. 37) and with the saints in the lateral panels of the dismantled Valori Altarpiece (pls. 40, 41), all from the last few years of the fifteenth century. The representations of Christ here and in the painting in Venice are especially close, both in facial and expressive type and in the somewhat overwrought drapery, which is also present in the Valori altarpiece.

Among Filippino's drawings the nearest in style is the sheet with two female figures in Stockholm (cat. no. 93): the proportions of both figures here are comparable, as is the character of the pen strokes that describe Christ, although the Baptist is composed in an alternate, somewhat finer manner. All these comparisons clearly point to a date at the very end of the fifteenth century for the present drawing.

GRG

93 *Two Standing Women Conversing*

Pen and brown ink and brown wash over traces of leadpoint or black chalk on paper rubbed lightly with reddish chalk, figures silhouetted, 115 x 65 mm (4⁹⁄₁₆ x 2⁹⁄₁₆ in.), maximum

Inscribed in brown ink at upper left corner: *206*; in brown and black ink at lower right corner: *65. / 3* [canceled]; in brown ink on mount at bottom center: *girlandaio*

Nationalmuseum, Stockholm 96/1863

PROVENANCE: Pierre Crozat, Paris; his sale, Paris, April 10–May 13, 1741, lot 1, 2, or 3 (as annotated by Carl Gustaf Tessin in his copy of the sale catalogue); Comte Carl Gustaf Tessin, Stockholm (manuscript inventory, 1749, p. 17, no. 3, as Ghirlandaio); sold to Swedish royal family, 1750s; Kungliga Museum, Stockholm, 1792 (Lugt 1638); incorporated into Nationalmuseum, 1866.

LITERATURE: Schönbrunner and Meder 1896–1908, vol. 8, no. 893; Sirén 1933, p. 62, pl. 39; Scharf 1935, no. 234, fig. 180; Berenson 1938, vol. 2, no. 1366G; Berenson 1961, vol. 2, no. 1366H; Shoemaker 1975, no. 125.

Dazzling for its movement, quality of light, and bravura line, this small, rapid sketch is connected in style and technique to Filippino's ambitious composition sketch for the *Raising of Drusiana* in the Strozzi Chapel (cat. no. 99 recto). That preliminary drawing was probably made a few years earlier than the *Drusiana* fresco, which is dated 1502. The arrangement and exotic dress of the women in the present sheet recall the two attendants on the left in Filippino's painting the *Meeting of Joachim and Anna* of 1497 (pl. 36). A more detailed portrayal of the elaborate headdresses worn by the women in this drawing is seen in a metalpoint study in the Uffizi (inv. no. 151 F), which may also have been intended for the Strozzi project.

In his introduction to his biography of Filippino, Vasari singled out the artist's use of exotic costumes as a measure of his great powers of innovation and invention.[1]

CCB

1 Vasari 1906, vol. 3, p. 461.

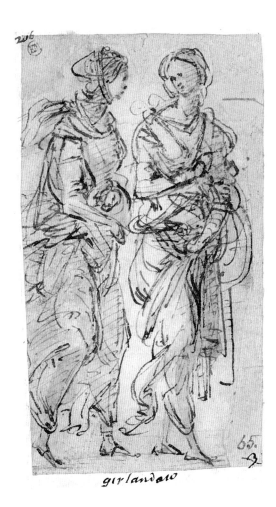

GIORGIO VASARI

Page from the Libro de' disegni

Framing and decoration by Vasari of five drawings by Filippino Lippi and Workshop of Filippino Lippi (cat. nos. 94 A–E) and woodcut portrait of Filippino presumably by Vasari

Framing and decoration, pen and brown ink and brown wash, 597 x 465 mm (23½ x 18⁵⁄₁₆ in.)

Christ Church Picture Gallery, Oxford JBS 36

PROVENANCE: Giorgio Vasari, Arezzo; probably Salomon Gautier, Amsterdam and Paris; General John Guise, London; his bequest, 1765.

On the recto of this page are five drawings and a woodcut portrait of Filippino, all set within an elaborate Mannerist frame. The effect is of a marble architectural system in which the drawings and woodcut are placed as if they were paintings or low-relief sculptures. On the verso, which is not illustrated here, is a single drawing in a highly decorative frame showing the Virgin and Child Enthroned with Saints. This was attributed by Vasari to Altura Mantovano, presumably on the basis of an inscription on the sheet. He is not known through any painting or documentary reference, but the style of the drawing suggests that it is of northern Italian origin and dates from about 1520. In any case, it is entirely unrelated to Filippino's work.

GRG

FILIPPO LIPPI PITTOR
FIORENTINO.

94A *Virgin and Child with Saint Nicholas of Bari, a Male Saint, and an Angel at Left, Two Female Saints at Right, and Studies of Two Children, a Pair of Angels, and a Leg,* lower left of recto

Pen and brown ink and brown wash over black chalk, 286 x 198 mm (11¼ x 7³⁄₁₆ in.)

LITERATURE: Colvin 1907, pl. 8; Bell 1914, p. 63, pl. 63; Van Marle 1923–38, vol. 12 (1931), p. 365, fig. 238; Popham 1931, p. 14, no. 45, pl. 39; Scharf 1935, p. 80, no. 175, illus.; Kurz 1937, pp. 14–15, pl. 7; Berenson 1938, vol. 2, no. 1355A; Neilson 1938, pp. 142–44, fig. 68; Scharf 1950, no. 102; Fossi [Todorow] 1955, p. 14; Matthiesen Gallery 1960, no. 44, pl. 18; Berenson 1961, vol. 2, no. 1355A; Walker Art Gallery 1964, no. 27; Byam Shaw 1972, no. 40, illus.; Ragghianti Collobi 1974, pp. 85–86, fig. 240; Shoemaker 1975, no. 123; Byam Shaw 1976, no. 36, pl. 41; Wohl 1986, no. 29 recto D; Cecchi in Petrioli Tofani 1992, no. 6.8.

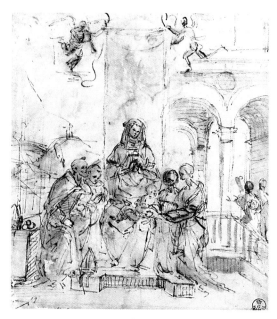

FIG. 51 *Virgin and Child Enthroned with Saints Nicholas, Peter Martyr, and Two Female Saints.* Pen and brown ink with traces of black chalk, 179 x 163 mm. Gabinetto Disegni e Stampe degli Uffizi, Florence 142 E recto

The attribution of this important drawing to Filippino has not been questioned, nor has Scharf's association of it with a related study in the Uffizi (fig. 51). On account of its less complete state, the present study has usually been judged the earlier of the two, but Shoemaker has perceptively pointed out that it is more forward looking than the Uffizi sheet and more akin to Filippino's altarpiece of 1501 in Bologna (pl. 44). The setting of the Uffizi drawing is similar in several respects to those seen on the double-sided sheet with studies of the Pietà in the Fogg (cat. no. 87). The loggia housing a staircase with figures occurs on the recto of that work, while a comparable spontaneously sketched landscape study appears on the verso. The Uffizi drawing is carried out in a lively, somewhat scratchy series of pen strokes, with little effort to precisely elaborate spatial relationships, tone, or the expressive qualities of individual figures. In addition, the principal figure group is rigidly balanced. By contrast, the Christ Church sheet shows a somewhat asymmetrical and dynamic balance of figures around the Virgin and Child, whose poses, in turn, are directed to the right. The sense of diagonal movement that results is enhanced by the placement of figures at various levels of the steps and further accentuated by the open archway at the extreme right. The individual figures are far more developed here in terms of detail and tonal range and in their expressions as well. They are comparable to the more fully described figures in the compositional study for the *Triumph of Saint Thomas Aquinas* (cat. no. 55), suggesting that Filippino had come much closer to a final resolution of his project here than in the Uffizi study, just as Shoemaker proposed.

There is no evidence that ties these drawings to any known project. Neilson suggested that they may have been made in preparation for a work commissioned from Filippino in 1498 for the Sala del Gran Consiglio in the Palazzo Vecchio, Florence, a painting that was never completed. Plausible as this proposal may be, it represents no more than a hypothetical possibility. What is certain, however, is that the drawings date from the turn of the fifteenth century. This is most clearly indicated for the Uffizi example, whose handling finds its closest parallels in the Fogg Pietà studies and other late pen-and-ink drawings, such as the roundel with Job in the Morgan Library (cat. no. 95) and the *Raising of Drusiana* in the Uffizi (cat. no. 99 recto), and whose figural type is comparable to that of the Lille metalpoint drawing of the Virgin and Child (cat. no. 106). Analogies between the composition of the present sheet and the Bologna altarpiece reinforce this date.

GRG

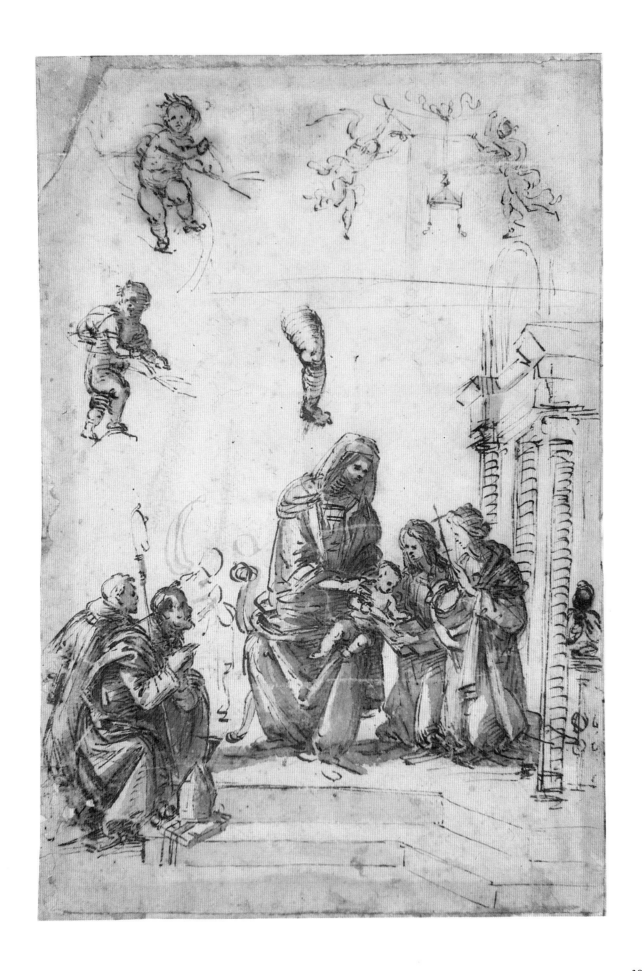

94B *Job with His Wife and Servant and Job Plagued by a Devil*, lower right of recto

Pen and brown ink, main composition and devil at upper right corrected with white gouache and pricked, 291 x 206 mm (11½ x 8⅛ in.); gouache oxidized

Inscribed in brown ink at lower left by the artist: *dony*[?]

LITERATURE: Colvin 1907, pl. 9; Bell 1914, p. 63, pl. 62; Van Marle 1923–38, vol. 12 (1931), p. 365, fig. 238; Popham 1931, p. 14, no. 45, pl. 39; Scharf 1935, p. 80, no. 175, illus.; Kurz 1937, pp. 14–15, pl. 7; Berenson 1938, vol. 2, no. 1355A; Neilson 1938, pp. 142–44, fig. 68; Matthiesen Gallery 1960, no. 44, pl. 19; Berenson 1961, vol. 2, no. 1355A; Byam Shaw 1972, no. 40, illus.; Ragghianti Collobi 1974, pp. 85–86, fig. 240; Shoemaker 1975, no. 123; Byam Shaw 1976, no. 36, pl. 41; Wohl 1986, no. 29 recto E; Bambach Cappel 1988, no. 153; Cecchi in Petrioli Tofani 1992, no. 6.8, illus.

Scharf first noted that this sheet may relate to another study of the same subject in the Morgan Library (cat. no. 95), which is reasonable despite the many disparities between them. The present drawing shows two figures with Job and clearly seems intended as a rectangular composition, whereas he has three companions in the Morgan study, which must always have been circular. Moreover, the Morgan example contains a Visitation scene not included here, and its architectural setting is more limited and less classical. There are good reasons to believe that the Christ Church study is the earlier work. The figure of Job is repeated above the group showing him with his wife and servant, this time in a pose that approximates that in the Morgan sheet; in addition, the architectural sketch at the left of the present drawing suggests a continuing process of exploration, as do the two studies of devils, one of which is heavily corrected. The Morgan drawing, by contrast, displays no visible changes and, unlike this sheet, is fully elaborated with wash.

The present drawing is extensively and closely pricked throughout the main composition and in the study of the devil at the upper right. Byam Shaw (1976) suggested that the design was intended for an embroidery. His view was rejected with good cause by Bambach Cappel, who, in turn, thought that it may have been pricked for the purpose of creating a copy. An alternate and conceivably a likelier possibility is that the pricking was carried out in the process of copying the drawing from another sheet. This theory would account for the rigid rectangularity of the composition, which would be impossible to explain if it were a study made entirely freehand. If this hypothesis is correct, Filippino or an assistant would have pricked another study to transfer its outlines to the present sheet; Filippino would then have drawn freely over the transferred elements as he developed the composition. At a considerably later point he would have executed the final version in the Morgan study. Both the present sheet and the Morgan drawing certainly date to the artist's late years, at or after the turn of the fifteenth century.

GRG

302

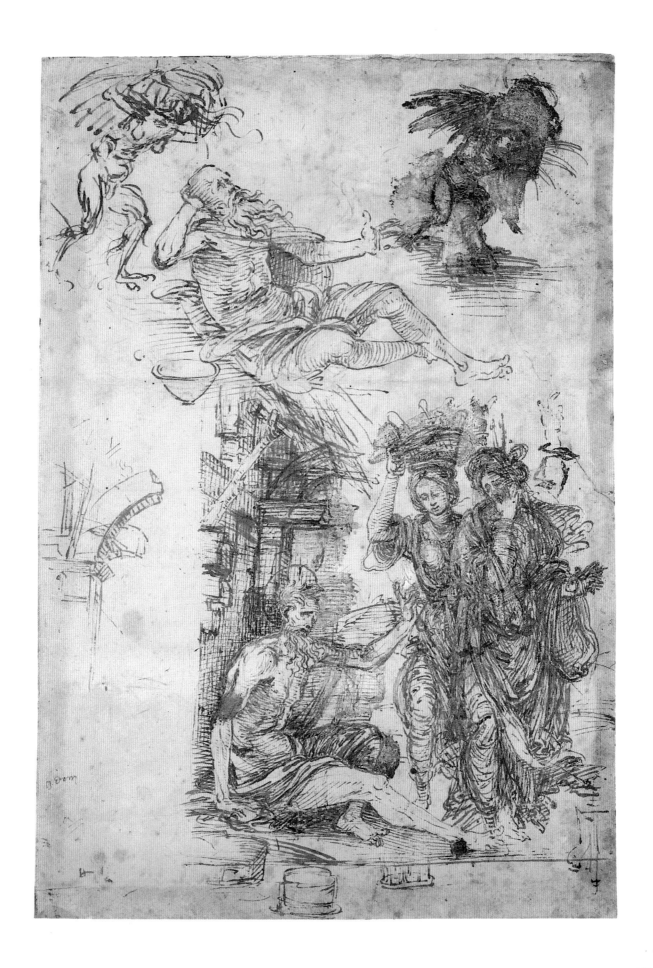

94 C *Man Fighting with a Female Centaur and Nude Man with a Slab of Stone*, upper left of recto

Pen and brown ink and brown wash, crudely silhouetted at right, 133 x 146 mm (5¼ x 5¾ in.)

LITERATURE: Popham 1931, p. 14, no. 45, pl. 39 [probably not Filippino Lippi]; Scharf 1935, p. 80, no. 175, illus.; Kurz 1937, pp. 14–15, pl. 7 [Filippino Lippi]; Berenson 1938, vol. 2, no. 1355A [Filippino Lippi]; Matthiesen Gallery 1960, no. 44 [copy after Filippino Lippi]; Berenson 1961, vol. 2, no. 1355A [Filippino Lippi]; Byam Shaw 1972, no. 40, illus.; Ragghianti Collobi 1974, pp. 85–86, fig. 240 [Filippino Lippi]; Shoemaker 1975, no. 123; Byam Shaw 1976, no. 36, pl. 41; Wohl 1986, no. 29 recto A [studio of Filippino Lippi]; Cecchi in Petrioli Tofani 1992, no. 6.8, illus.

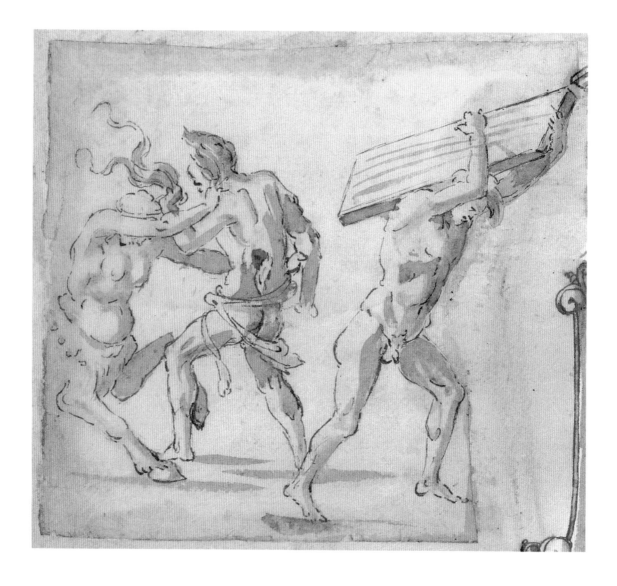

94 D *Female Centaur with a Basket on Her Head and Woman Fighting with a Centaur and a Satyr*, upper right of recto

Pen and brown ink and brown wash, 136 x 157 mm (5⅜ x 6³⁄₁₆ in.); irregularly cut

LITERATURE: Popham 1931, p. 14, no. 45, pl. 39 [probably not Filippino Lippi]; Scharf 1935, p. 80, no. 175, illus.; Kurz 1937, pp. 14–15, pl. 7 [Filippino Lippi]; Berenson 1938, vol. 2, no. 1355A [Filippino Lippi]; Matthiesen Gallery 1960, no. 44 [copy after Filippino Lippi]; Berenson 1961, vol. 2, no. 1355A [Filippino Lippi]; Byam Shaw 1972, no. 40, illus.; Ragghianti Collobi 1974, pp. 85–86, fig. 240 [Filippino Lippi]; Shoemaker 1975, no. 123; Byam Shaw 1976, no. 36, pl. 41; Wohl 1986, no. 29 recto C [studio of Filippino Lippi]; Cecchi in Petrioli Tofani 1992, no. 6.8, illus.

These lively studies after the antique are certainly by a member of Filippino's shop who emulated his master's abbreviated and dynamic pen strokes and broad application of wash. The results, however, are not up to Filippino's standard. It is possible that they were copied from lost originals by Filippino, and Shoemaker plausibly proposes that they may have been taken from his drawings after sarcophagus reliefs. If her hypothesis is correct, the originals would probably date from his Roman years.

GRG

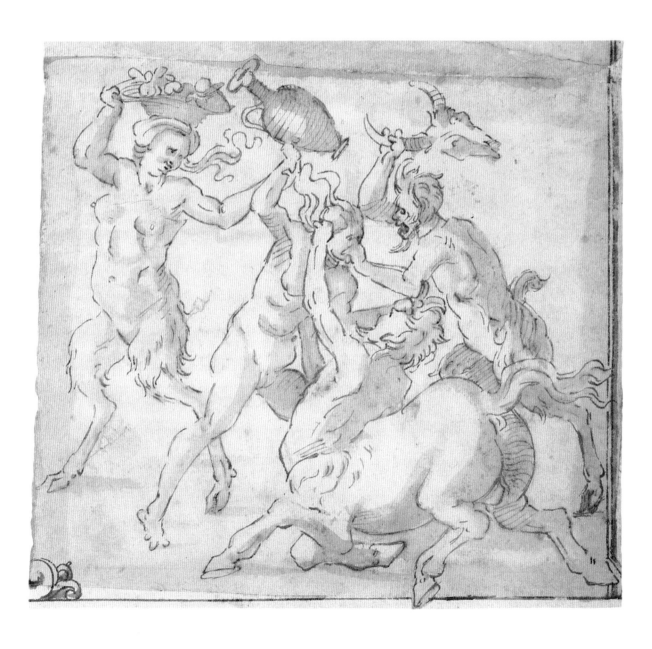

94E *Two Tritons Carrying Trophies,* top center of recto

Pen and brown ink and brown wash over black chalk, 86 x
105 mm (3⅜ x 4⅛ in.); irregularly cut; design at upper right
completed in pen and ink by Vasari

LITERATURE: Popham 1931, p. 14, no. 45, pl. 39 [probably not
Filippino Lippi]; Scharf 1935, p. 80, no. 175, illus.; Kurz 1937,
pp. 14–15, pl. 7 [Filippino Lippi]; Berenson 1938, vol. 2, no. 1355A
[Filippino Lippi]; Matthiesen Gallery 1960, no. 44 [copy after
Filippino Lippi]; Berenson 1961, vol. 2, no. 1355A [Filippino
Lippi]; Byam Shaw 1972, no. 40, illus. [possibly Filippino Lippi];
Ragghianti Collobi 1974, pp. 85–86, fig. 240 [Filippino Lippi];
Shoemaker 1975, no. 123; Byam Shaw 1976, no. 36 [possibly
Filippino Lippi]; Wohl 1986, no. 29 recto A [studio of Filippino
Lippi]; Cecchi in Petrioli Tofani 1992, no. 6.8, illus. [possibly
Filippino Lippi].

This drawing was copied from a nearly identical study
by Filippino in the Uffizi (cat. no. 62). The latter is
clearly superior in quality and shows none of the
hesitancy apparent in the draftsmanship here. Despite
Byam Shaw's judgment that it may be by Filippino,
it is much more likely a product of his workshop.

GRG

95 *Job Visited by His Three Friends with
the Visitation in the Background Landscape*

Pen and brown ink and brown wash over traces of black
chalk, traces of pen-and-brown-ink framing outlines, recto;
horizontal parallel lines (fragment of architectural design?) in
pen and brown ink, verso, d. 107 mm (4³⁄₁₆ in.)

The Pierpont Morgan Library, New York IV 3

PROVENANCE: Comte Moriz von Fries, Vienna (Lugt 2903);
Edward Habich, Boston and Kassel (Lugt 862); his sale, H. G.
Gutekunst, Stuttgart, April 27–29, 1899, lot 419; Charles
Fairfax Murray, London and Paris; John Pierpont Morgan,
New York (Lugt 1509).

LITERATURE: Habich collection n.d., pl. 16; Habich sale 1899,
p. 48, lot 419; Berenson 1903, vol. 2, no. 1272; Frizzoni 1905,
pp. 244–45, fig. 4; Fairfax Murray 1905–12, vol. 4, no. 3, pl. 3;
Scharf 1935, p. 80, no. 174, fig. 178; Berenson 1938, vol. 2, no.
1353C; Berenson 1961, vol. 2, no. 1353C; Byam Shaw 1972, with
no. 40B; Shoemaker 1975, no. 122.

A scene from the life of Saint Job is treated in this
quick, late composition sketch for a lost painting and
in the more fully rendered partial study in Christ
Church (cat. no. 94B), which most likely preceded it.
The choice of subject seems related to the fact that
Filippino joined the Confraternity of Saint Job, prob-
ably soon after its founding about 1500.[1] (The pres-
ence of a draft of a prayer to "San Giobo" in Filippino's
hand on the verso of a sketch in Berlin [cat. no. 96]
also appears to be connected with his membership
in this brotherhood.)

The iconography of Filippino's compositions is
based on the Book of Job (especially 2:11–13, 3:24–28)
and is generally comparable to that in the pages of the
so-called Florentine Picture Chronicle in the British
Museum (inv. no. 1889-5-27-19, 20, fol. 17 recto and
verso). In both the present sheet and the Christ Church
drawing a king's crown, an attribute of power, wealth,
and victory, lies before the long-suffering patriarch,
who reclines in a decrepit hut. Filippino atemporally
included a Visitation in the background here, much
as Fra Filippo Lippi had inserted scenes of the Birth
of the Virgin and the Meeting of Joachim and Anna
as backdrops for the main group in his own painted
tondo the *Madonna and Child*, 1450s–60s, in the Palazzo
Pitti, Florence. The lost composition related to this
circular sketch probably was round in format as well.

CCB

1 Nelson 1991, p. 51, nn. 49, 50.

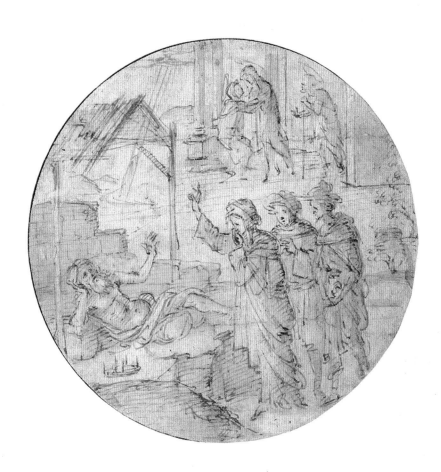

96 *Seated Woman Facing Right with Two Putti Playing Musical Instruments (Allegory of Music),* recto

Prayer Relating to the Confraternity of Saint Job, Florence, verso

Pen and brown ink and gray-brown wash over traces of black chalk, traces of pen-and-black-ink framing outlines, on paper rubbed with red chalk toward right side, recto; pen and brown ink, verso, 184 x 132 mm (7¼ x 5⁹⁄₁₆ in.), maximum; borders irregular

Text of prayer, cropped at left and right borders: "sia dell onipotente iddio e della sua madre santissima ma[donna] / [Mar]ia senpre virgine et del nostro padre havocata [*sic*] et protetto[re] / ... S⁰ Giobo benedetto Sotto dequali e fondatta e ... / santa e deuota fraternita e conpagnia e di tutti e santi ... / a celestiale corte del paradiso e quali tutti dannoi Con[fr] ... / [amo]re di charita sieno senpre preghati dinterceddia gr[at ...] / ... [cho]spetto dal nostro singniore iesu [cristo] benedetto [e ...] / a p[er] sua infinita misericordia la sua santissima gratia ... / ... e sua santi choma[n]damenti e che questa santa e deuota / sempre iretta e ghouernata nel suo santissimo nome e ... / espierentia sieno [fatte; canceled] senpre fatte tutte lopere ... / [esperientano; canceled] e a salute di tutte lanime de fratelli .ho ... / sono e che saranno di questo santo luogho ... [e deuota chasa; canceled] / ... pre esso iddio e madonna s\u1d43 maria benedetta e ... / Nostro padre Messere S⁰ Giobo Lunghamente ... / ... ghuardino e con qui et annoi lore veri e buoni / presenti e futuri ghuardino e difendino e [presti?] / [e senpre la sua; canceled] di caldare[?] senpre el mangnio iddio / ... ere e [canceled words, e ossevare?] senpre li nostri capitoli di questa / ... Conpagnia [e alla; canceled] la quale iddio lunghamente / ... e alla fine nostra meritiamo di fuere quella s\u1d43 [word canceled] / ... une della gloria dicista etterna la quale iddio / mesirecordia i[n]finita a tutti ci co[n]ceda."[1]

Kupferstichkabinett, Staatliche Museen, Berlin
KDZ 2367.327-1881

PROVENANCE: Friedrich Wilhelm IV, 1652; Giuseppe Vallardi, Milan (Lugt 1223, 1223a); Carlo Prayer, Milan (Lugt 2044); H. G. Gutekunst, Stuttgart; acquired 1881.

LITERATURE: Lippmann 1882, p. xxxii; Loeser 1902, p. 351, no. 2367; Berenson 1903, vol. 1, p. 78, vol. 2, no. 1269; Lippmann 1910, p. ix, no. 21, illus.; Halm [1931], pp. 400–401; Scharf 1935, p. 82, no. 197, fig. 188; Berenson 1938, vol. 1, p. 106, vol. 2, no. 1269, vol. 3, fig. 227; Neilson 1938, p. 140; Berenson 1961, vol. 2, no. 1269, vol. 3, fig. 241; Shoemaker 1975, no. 81; Dreyer 1979, p. 6, fig. 6; Sale 1979, pp. 351–53, fig. 136; Bober and Rubinstein 1986, nos. 38, 50; Schulze Altcappenberg 1995, pp. 166–67, 221, illus.

In style and technique this airy composition is comparable to sheets in New York, Prague, and Stockholm (cat. nos. 85, 91, 93). The woman is portrayed with the elongated proportions, small head, and dotlike features typical of Filippino's late period. Also characteristic of this phase is the execution, with staccato,

somewhat angular outlines, delicate two-tone modeling with luminous washes, and paper rubbed atmospherically with reddish chalk dust. As has often been noted, the sketch is probably a *primo pensiero* for the figural group in the *Allegory of Music* that is frescoed on the altar wall of the Strozzi Chapel (fig. 52). The connection between the sketch and Filippino's *Allegory of Music* panel in the Gemäldegalerie, Berlin (pl. 42), is much less direct.

The sketch includes both the palm tree and the vertical line at the woman's back that are present in the fresco (in which the latter element marks a fictive engaged pilaster). Moreover, the direction of the softly modulated, unifying light in the drawing corresponds to the position of the real window on the altar wall of the chapel. Filippino offered two solutions for the woman's left arm—one raised and gesturing to the palm tree, the other with her hand resting on the back of the putto blowing on a syrinx. However, he adopted neither in the fresco, where he rotated the woman's pose so she faces forward. In the drawing the putto on the right holds a lyre, and a tall lyre rests on top of the antique-style stool on the left; in the final work this putto bears a double-reed instrument

FIG. 52 Detail, fresco. Altar wall, Strozzi Chapel, pl. 24

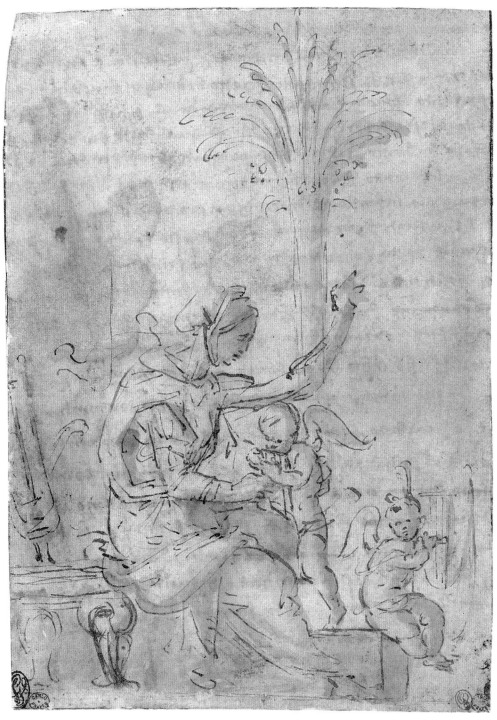

96 RECTO

...na sempre vergine et delnostro hauocato et protettore...

...re Sancto Benedetto Sotto drquali et fondata et...

...Santa et devota fraternita et conpagnia et dirutti et santi...

...a celestiale Corte delparadiso et quali tutti dannoi Co...

...ne diSanto sieno sempre pregati dinterceder a...

...al cospetto delnostro Singnore iesu xpo benedetto...

...a per sua infinita misericordia La sua santissima gratia...

...sua sancti commandamenti et ch apsta santa et devota...

...sempre retta eghovernata nel suo santissimo nome...

...reuerentia et sieno ~~fatte~~ sempre fatte tutte lopere...

...~~...~~ per la salute dituette lanime et fratelli, ho...

...o et gente paranno digesto Santo ~~...~~ luob ho...

...pr esso iddio et madonna S maria benedetta et...

...nostro padre Messere Sciobo Lunghamente...

...ghuardino et congiej et annoi ~~...~~ loro ben...

...presenti et futuri ghuardino et difendino epresti...

...~~...~~ dela loro sempre et magnio iddio...

...~~...~~ coquale sempre anno capitoli dq sti...

...con pangnia ~~...~~ laquale iddio lunghame...

...della fine nostra meritiamo difruire quella S...

...ne della gloria diuita etterna Laquale iddio...

...per cordia infinita Atutti Ciroceda...

resembling an aulos, and the Muse holds the tall lyre. The putto at the left underwent fewer changes in the development from drawing to fresco.[2]

The sketch probably dates between 1495, the time of intense work on the Strozzi Chapel frescoes, and 1501, when Filippino received the last payment for the project. On the verso there is a draft of a prayer in Filippino's hand that refers repeatedly to Job, the patron saint of the Confraternity of Saint Job, which the artist apparently joined about the turn of the fifteenth century.[3] Thus the presence of the prayer on the verso supports the dating suggested by the stylistic evidence of the recto of this sheet.

CCB

1 See also transcription in Schulze Altcappenberg 1995, p. 221.

2 The process of exploration attests to Filippino's attempt to portray the playing of antique musical instruments with archaeological correctness. A measure of his success is the fact that the tall lyre depicted in the fresco inspired a description by Vincenzo Galilei, the great astronomer's father, in his *Dialogo della musica antica e moderna*, published in Florence in 1581. For the identification of the musical instruments portrayed and a transcription of Galilei's *Dialogo*, see Winternitz 1965, pp. 270–79.

3 See further Nelson 1991, p. 51, nn. 49, 50.

97 *Standing Young Woman Seen from the Back and Holding a Kerchief*

Pen and two shades of brown ink and brown wash, heightened with white gouache, over traces of black chalk, figure silhouetted, 220 x 100 mm (8 11/16 x 3 15/16 in.), maximum of figure

Inscribed in graphite at lower right by Pasquale Nerino Ferri: *Filippino*

Gabinetto Disegni e Stampe degli Uffizi, Florence 173 F

PROVENANCE: Houses of Medici and Lorraine (manuscript inventory written by Giuseppe Pelli Bencivenni before 1793); museum stamps (Lugt 929, 930).

LITERATURE: Berenson 1903, vol. 1, p. 129, vol. 2, no. 1857A [Piero di Cosimo]; Loeser 1916, no. 17, pl. 17; Scharf 1935, no. 244; Berenson 1938, vol. 2, no. 1329B; Berenson 1961, vol. 2, no. 1329B; Shoemaker 1975, no. 115; Petrioli Tofani 1991, no. 173 F; Jaffé 1994, with no. 887C; Schulze Altcappenberg 1995, p. 173, fig. 20 [Raffaellino del Garbo].

A related drawing in Chatsworth (fig. 53) and another in Berlin (fig. 54) illustrate stages in the design of the figure on this sheet; all three, therefore, may well be autograph, although opinions about their authenticity have varied. The dazzling present study, "done with mastery and joy," according to Berenson, has been questioned least. Nearly unknown in the literature, the Chatsworth sketch was apparently attributed to Filippino in 1929 by Popham.[1] Shoemaker and Jaffé, however, rejected it.[2] The three drawings constitute a remarkably complete sequence of design that is rare, if not unique, in Filippino's known oeuvre.

The earliest of the three, the Chatsworth sheet is typical of Filippino's late sketches in its abbreviated style, its use of convex axes for the facial features, and its virtuoso pen-and-ink technique with flickering washes. In the omission of the right arm and waving kerchief it differs significantly from the others. Probably next in the sequence is the spirited Uffizi study, whose bold pen handling is comparable, except in its use of thicker outlines, to the technique in the *Dancing Putto* in the Vasari sheet in Washington, D.C., and in the Virgin and Child studies in London and New York (cat. nos. 84, 82, 85). The broad layering of luminous washes over staccato pen hatching gives the chiaroscuro of the draperies in the present sheet a monumentality usually associated with the High Renaissance style. The mass of the body is distributed along the vertical axis that is indicated for the torso, and convex axes like those in the Chatsworth example are shown in the face. The figure is silhouetted, and the right arm is drawn with an extremely fine pen in a nearly black brown ink different from the ink used for the other elements of the study. That this detail was drawn by the same artist responsible for the rest of the figure despite the variation in pen and ink is

97

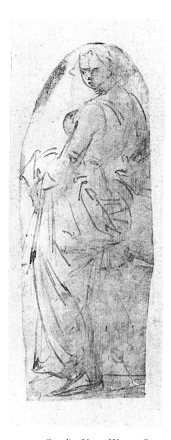

clear from the correspondence of the quick scribbles on the knot about the fingers and on the veil on the head and shoulders; its incorporation surely represents an attempt to explore further the emotive possibilities of the pose after the first draft of the figure was made.[3]

The rather abraded Berlin study displays more descriptive hatching and washes of more uniform tone executed on paper lightly tinted with reddish chalk; it is a cleaned-up draft of the Uffizi design, with more individualized facial features and details of costume. The drawing is pricked along the main outlines of the figure, but the right arm—the detail carried out in darker ink in the Uffizi study—as well as the locks of hair to the left of the face and the drapery gathered above the left arm, is unpricked. The pricked holes are not closely spaced and do not seem to have been rubbed with pouncing dust for transfer. Thus the Berlin study may well have been drawn on top of pricked outlines taken from the Uffizi study before the figure in that drawing was reworked with dark ink; those outlines were probably obtained from a translucent tracing of the Uffizi drawing that was pricked onto the Berlin study.

Evocative of the pose of the woman in all three drawings is the allegorical representation of Fides on the altar wall of the Strozzi Chapel (fig. 55), which, like the other figures in this ambitious program, probably underwent a painstaking process of preliminary design. The handling of the pen in the present study supports a dating close to that of the altar wall in the Strozzi Chapel, that is, about 1497–1500.

CCB

1 Typescript inventory of the Devonshire collection.

2 Shoemaker 1975, vol. 2, p. 458, no. R62; Jaffé 1994, p. 164, no. 137.

3 As Loeser already astutely observed in 1916; *pace* Schulze Altcappenberg 1995, pp. 170–71.

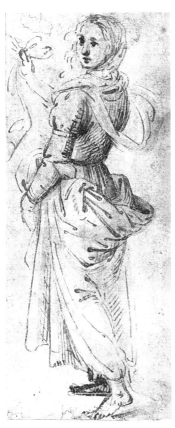

FIG.54 *Standing Young Woman Seen from the Back and Holding a Kerchief.* Pen and brown ink on paper rubbed with reddish chalk, pricked, 220 x 90 mm. Kupferstichkabinett, Staatliche Museen, Berlin 475

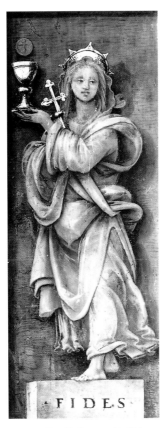

FIG.55 Detail, fresco with Fides. Altar wall, Strozzi Chapel, pl. 24

98 *Young Man Hanged by the Foot*

Pen and brown ink and gray-brown wash, pricked, figure silhouetted, framing outlines in pen and brown ink and brown wash by another hand, 289 x 166 mm (11⅜ x 6½ in.)

Inscribed in brown ink at lower center by early hand: *Ecole Lombarde*; at bottom center by early hand: *Andrea della Picchia*

Département des Arts Graphiques du Musée du Louvre, Paris 10715

PROVENANCE: Possibly Giorgio Vasari, Arezzo; possibly Filippo Baldinucci; Charles Paul Jean-Baptiste de Bourgevin Vialart de Saint-Morys, Paris and Château d'Hondainville, near Beauvais; Saint-Morys collection seized by revolutionary authorities, 1793; incorporated into Musée du Louvre, 1796–97 (Lugt 1886).

LITERATURE: Ragghianti Collobi 1974, vol. 1, p. 177, vol. 2, pl. 547; Bambach Cappel 1988, pt. 2, vol. 1, no. 363, fig. 165; Cecchi 1994a, p. 368, fig. 35; Christiansen 1994.

Ragghianti Collobi published this sheet, which was kept among the anonymous Florentine drawings in the Louvre. She believes it is from Vasari's *Libro de' disegni*, probably because of the two pen-and-ink-and-watercolor volutes that frame the figure, which are from the cinquecento and Vasarian in type.

The present writer first attributed this drawing to Filippino, based on the stylistic evidence of drawings from his mature period (see cat. nos. 84, 85, 107, 108). While the attribution seems clear, the subject is not easy to understand. The frame surrounding the gesticulating youth is misleading, for it supposes that the figure is meant to be seen with its head at the top of the page. Bambach Cappel, however, identified the figure as that of a man hanging head down and suspended by one foot in the manner of a political outlaw. In 1993 Alessandro Conti orally concurred with this finding. And Christiansen related the drawing directly to the effigies of the protagonists in Botticelli's *Conspiracy of the Pazzi*; he theorized that Filippino may have made his study after one of the figures in this painting, which was executed by July 21, 1478, above the door of the Dogana in the Palazzo del Capitano at the via de' Gondi.[1]

The link Christiansen proposed between the drawing and the painting, which was destroyed after the expulsion of the Medici and the declaration of the republic in 1494, seems highly probable. It is supported by the evolved style of the drawing, which is related to Filippino's *Christ among the Doctors* in the Uffizi (cat. no. 90) and the sheet showing a young girl looking out at the viewer in the same collection (inv. no. 173 F), both of which can be dated with assurance within the 1490s.

Once the chronology has been established, it is possible to attempt to identify the tormented young man, portrayed first by Botticelli and then by Filippino. He is likely the young Napoleone Franzesi, who, according to the Codex Magliabechiano, was the only conspirator depicted hanged by one foot in relation to the Pazzi affair because he was never captured;[2] the others, once seized and brought to justice, were hanged by the neck and shown as such.[3]

AC

1 Horne 1986–87, vol. 2, p. 478, doc. XVIII.

2 Frey 1892, p. 105.

3 Edgerton 1985, pp. 104–10.

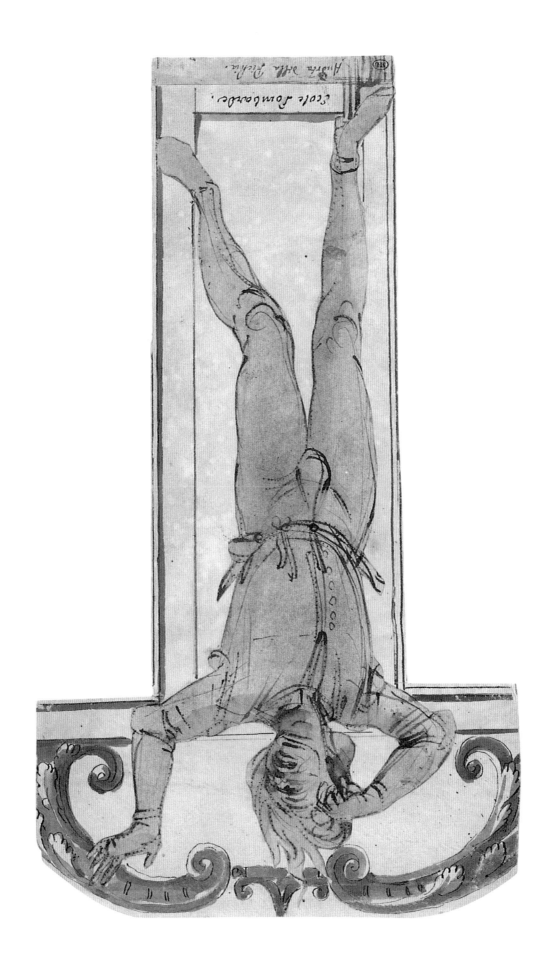

99 *Raising of Drusiana*, recto

Study of Drusiana, verso

Pen and brown ink and wash over black chalk, recto; black chalk, verso, 259 x 377 mm (10⅟₁₆ x 14¹³⁄₁₆ in.)

Gabinetto Disegni e Stampe degli Uffizi, Florence 186 E

PROVENANCE: Houses of Medici and Lorraine (manuscript inventory written by Giuseppe Pelli Bencivenni before 1793); museum stamp (Lugt 930).

LITERATURE: Ferri 1890, p. 91, no. 186; Morelli 1900, vol. 1, p. 116; Berenson 1903, vol. 2, no. 1298; Loeser 1916, no. 21, illus.; Halm [1931], p. 410, n. 1, fig. 10 (recto); Scharf 1935, pp. 61–62, 80–81, no. 192, figs. 181 (verso), 184 (recto); Berenson 1938, vol. 1, p. 105, vol. 2, no. 1298, vol. 3, fig. 225 (recto); Neilson 1938, pp. 102–4; Tolnay 1943a, p. 20, fig. 58; Scharf 1950, pp. 35–36, 45, fig. 126; Fossi [Todorow] 1955, no. 41, fig. 15; Berenson 1961, vol. 1, p. 162, vol. 2, no. 1298, vol. 3, figs. 235 (verso), 236 (recto); Ames 1962, no. 118, illus. (recto); Sandström 1963, pp. 57–60, fig. 20; Shoemaker 1975, no. 105; Sale 1979, pp. 160, 257–79, figs. 53 (recto), 91 (verso); Allegri 1986, p. 189, fig. 29; Petrioli Tofani 1986, no. 186 E; Cecchi in Petrioli Tofani 1992, no. 7.13, illus.

This important drawing for the *Raising of Drusiana* is the only surviving compositional study for the narrative frescoes in the Strozzi Chapel at Santa Maria Novella, Florence. It differs from the final work (pl. 26) in innumerable details but contains several of the most significant elements, including the poses of Saint John and Drusiana. Approximations of some of the poses of other figures appear as well: the litter bearers, for example, who are much more like those in the fresco than are their counterparts in the two following drawings (cat. nos. 100, 101). Similarly, although the architectural setting in the drawing is less centralized than that in the fresco and varies in many other respects, some of its features, such as the Tempietto-like structure, occur in somewhat related form in both works.

The style here is entirely comparable to that of several other late pen studies (cat. no. 91). The draftsmanship is much less tidy than in the grand design for the *Triumph of Saint Thomas Aquinas* (cat. no. 55), which represents a later stage in the evolution of its composition. Each figure is quickly jotted down with remarkable energy and disregard for correctness of description, and wash is applied with broad, rapid touches simply to indicate areas of shadow. The same approach holds true for the auxiliary marginal studies of several individual figures.

The study of Drusiana on the verso shows her turned in the opposite direction from the Drusiana of the recto and the fresco. Although her position is reversed, she is aligned parallel to the picture plane, unlike the Drusiana on the recto, and in this respect corresponds to the frescoed solution. One of a very small handful of chalk studies by Filippino, it is drawn in a manner that approximates his use of the pen or metalpoint.

A date of about 1500 is suggested by all of the comparative evidence.

GRG

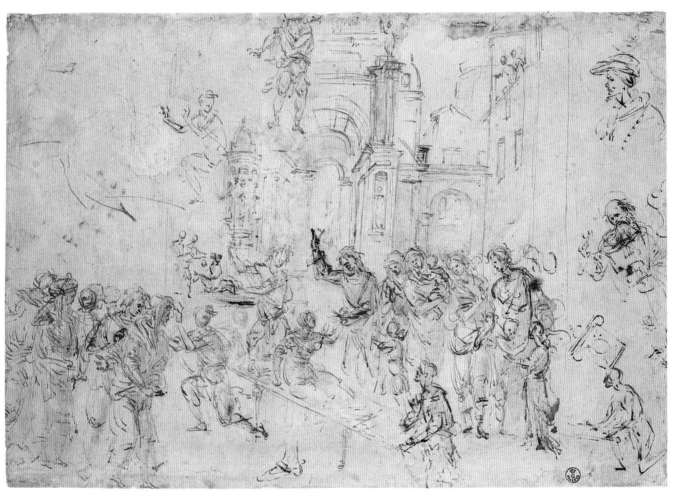

99 RECTO

99 VERSO

100 *Litter Bearer Turned to the Right*

Metalpoint, heightened with white gouache, on pink prepared paper, 175 x 122 mm (6⅞ x 4¾ in.)

Inscribed in ink at lower left: . . . *Spinello*; at lower right: *supero suo Pre [Padre]*; by John, Lord Somers: *g.20*. The Landsdowne manuscript suggests that the inscription at lower left once read: *Gasparo detto Parri di Spinello*. The inscription at lower left is written over an eradicated one that seems to include the name Filippino.

Christ Church Picture Gallery, Oxford JBS 35

LITERATURE: Berenson 1903, vol. 2, no. 1354; Bell 1914, p. 62, pl. 60; Popham 1931, no. 47 [copy after Uffizi 185 E]; Scharf 1935, p. 83, no. 237; Berenson 1938, vol. 1, p. 106, n. 2, vol. 2, no. 1354; Matthiesen Gallery 1960, no. 45, pl. 20; Berenson 1961, vol. 2, no. 1354; Walker Art Gallery 1964, no. 28; Byam Shaw 1972, no. 42, illus.; Shoemaker 1975, no. 107; Byam Shaw 1976, no. 35, pl. 37; Sale 1979, pp. 256–57, fig. 92; Ames-Lewis 1981b, pp. 43, 100, pl. 3; Ames-Lewis and Wright 1983, no. 7.

Berenson recognized this spirited drawing as a study for one of the litter bearers in Filippino's fresco the *Raising of Drusiana*, dated 1502, in the Strozzi Chapel (pl. 26). The connection to the fresco has never been questioned, although Popham mistakenly judged the study a copy after the related drawing in the Uffizi (cat. no. 101). The status of this outstanding sheet has not been doubted since, and it is by all odds among the finest of Filippino's late figure drawings. Byam Shaw correctly argues that it is freer and more spontaneous than the Uffizi study and therefore is the earlier of the two. His observation that Filippino included a second litter bearer in the Uffizi study as part of a process of elaboration should be treated with reserve, however, since it is entirely possible that the present sheet once was wider and included another figure.

In both drawings the litter bearers are shown in poses that are very different from those of the corresponding frescoed figures. This led Byam Shaw to place the sheets early in the period of fifteen years that separates the granting of the Strozzi commission in 1487 and its completion in 1502. However, in style they are far closer to several metalpoint studies that are demonstrably from Filippino's last years—the drawing for the altarpiece of 1501 in Bologna (cat. no. 105), for example—than to earlier sheets, clearly indicating a date of about 1500 for them. Not only are the litter-bearer studies and these late works similar in their free calligraphy and renunciation of fully described volumetric form, but they also share a predisposition for a pink ground and relatively sparing use of white heightening. In all these respects the sheets with litter bearers differ entirely from the much earlier studies for the Strozzi Chapel (cat. nos. 42, 44).

GRG

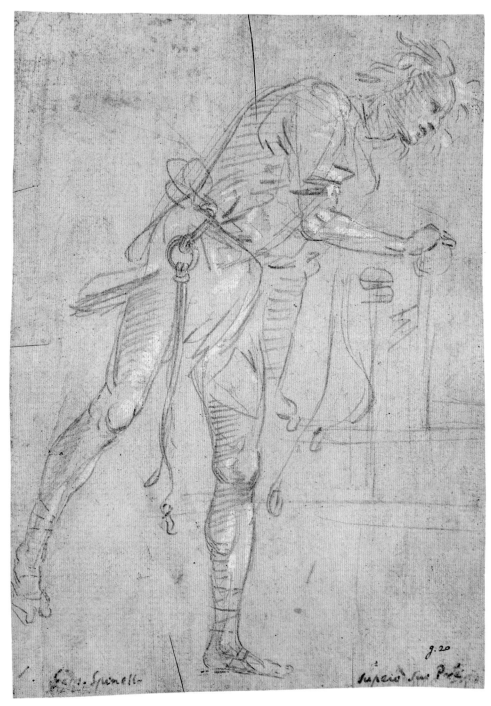

101 *Two Litter Bearers and Study of a Leg*

Metalpoint, heightened with white gouache, 196 x 242 mm
(7½ x 9½ in.)

Gabinetto Disegni e Stampe degli Uffizi, Florence 185 E

PROVENANCE: Houses of Medici and Lorraine (manuscript
inventory written by Giuseppe Pelli Bencivenni before 1793);
museum stamp (Lugt 930).

LITERATURE: Ferri 1890, p. 91, no. 185; Ulmann 1894c, p. 111,
n. 28; Berenson 1903, vol. 2, no. 1297; Loeser 1916, no. 20, illus.;
Ede 1926, p. 22, no. 38, illus.; Leporini 1928, p. 103, fig. 35;
Popham 1931, no. 47, illus.; Petit Palais 1935, no. 576; Scharf
1935, p. 83, no. 223, fig. 183; Berenson 1938, vol. 1, p. 106, vol. 2,
no. 1297, vol. 3, fig. 226; Berenson 1954, no. 20, illus.; Fossi
[Todorow] 1955, no. 40, fig. 11; Gamba 1958, p. 56, fig. 23;
Berenson 1961, vol. 2, no. 1297, vol. 3, fig. 237; Byam Shaw
1972, with no. 42; Shoemaker 1975, no. 106; Sale 1979, pp. 256–57,
fig. 93; Ames-Lewis and Wright 1983, with no. 7, fig. 7a; Petrioli
Tofani 1986, no. 185 E; Berti and Baldini 1991, p. 289, illus.;
Bartoli in Petrioli Tofani 1992, no. 2.32, illus.; Shoemaker 1994,
p. 262.

Like the preceding drawing at Christ Church (cat. no.
100), this study was made in preparation for the
litter bearers in the fresco the *Raising of Drusiana*, dated
1502, in the Strozzi Chapel (pl. 26). Both drawings
are far removed from the final work, which shows
the corresponding figures in entirely different poses
and with squatter proportions. This disparity does
not justify situating the drawings early in the chronol-
ogy of the Strozzi project, since their approach is
fully consistent with Filippino's style at the beginning
of the sixteenth century, rather than in the late 1480s—
as is more fully argued above (see cat. no. 100).

It is very probable that this is the later of the two
drawings, for the pose of the litter bearer at left is
more carefully worked out than the pose of the figure
in the Christ Church study, and a somewhat greater
effort to define details and facial expression is evident
here. Shoemaker has perceptively observed that the
care Filippino lavished on an alternative study for
the left leg of one of the litter bearers demonstrates
his continuing interest in Pollaiuolo-like anatomical
definition even in such a very free late sketch.

GRG

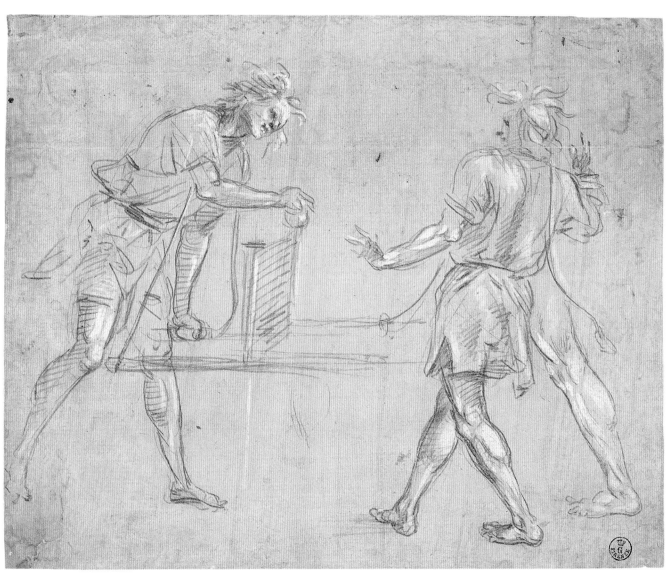

101

102 *Winged Monster with Its Paws on a Helmet and Study of a Right Paw of a Lion*

Metalpoint, heightened with white gouache, on beige prepared paper, 187 x 145 mm (7⅜ x 5¾ in.)

Inscribed in black chalk at lower left: *609*

Gabinetto Disegni e Stampe degli Uffizi, Florence 500 Orn.

PROVENANCE: Houses of Medici and Lorraine (manuscript inventory written by Giuseppe Pelli Bencivenni before 1793); museum stamp (Lugt 930).

LITERATURE: Ferri 1890, p. 93, no. 500; Fossi [Todorow] 1955, no. 61; Shoemaker 1975, no. 120; Cecchi in Petrioli Tofani 1992, no. 12.16, illus.

Ferri catalogued this drawing and the following sheet (cat. no. 103) as works by Filippino, and Berenson attributed the latter example to him.[1] Fossi, however, hesitated on the subject. More recently Shoemaker accepted the two sheets, assigning them to Filippino's late period, between the end of the quattrocento and his death in 1504.

Their vibrant strokes, set off by rapid, impressionistic highlighting in white gouache on colored paper, are typical of the period of work on the Strozzi Chapel, where the *Raising of Drusiana* (pl. 26), dated 1502, is found. Although similar monsters appear in the candelabra painted in the Carafa Chapel, the creatures with the closest morphological and stylistic affinities to the figures in these sheets are found in the decorative portions of the Strozzi Chapel. The helmets held between the leonine paws of the monsters in the drawings precisely parallel those in the lunette with the *Martyrdom of Saint John* (pl. 25); the figural type of the beasts themselves is repeated in the sphinxes that appear throughout the chapel and in particular in the stained-glass window, where they support the Strozzi coat of arms, and at the base of the throne of Mars in the fresco that shows Saint Philip exorcising the demon in the form of a dragon (pl. 28). The luminous play of white gouache against the colored paper echoes the precious effect of the delicate frieze of heads, swags, torches, and winged goats that decorates the little round temple framing the *Raising of Drusiana.*

AC

1 Berenson 1903, vol. 2, no. 1312; Berenson 1938, vol. 2, no. 1312; Berenson 1961, vol. 2, no. 1312.

103 *Winged Monster with Its Paws on a Helmet, with Part of an Oval Frame with a Winged Putto*

Metalpoint, heightened with white gouache, on gray prepared paper, 186 x 135 mm (7⅜ x 5⅜ in.)

Inscribed in black chalk at lower left: *610*; in brown ink by sixteenth-century hand: *fra filipino*; in brown ink on verso by same sixteenth-century hand: *filippino*

Gabinetto Disegni e Stampe degli Uffizi, Florence 501 Orn.

PROVENANCE: Houses of Medici and Lorraine (manuscript inventory written by Giuseppe Pelli Bencivenni before 1793); museum stamp (Lugt 930).

LITERATURE: Ferri 1890, p. 93, no. 501; Berenson 1903, vol. 2, no. 1312; Scharf 1935, no. 316; Berenson 1938, vol. 2, no. 1312; Fossi [Todorow] 1955, no. 60; Berenson 1961, vol. 2, no. 1312; Shoemaker 1975, no. 121; Cecchi in Petrioli Tofani 1992, no. 12.15, illus.

The critical history and dating of the preceding drawing (cat. no. 102) and this sheet are the same. Although the close affinities between the winged monsters date them in the same period, this example, because it is the more defined, best reveals the heights of fancy and eccentricity of Filippino's unbridled and inexhaustible imagination. The monstrous creature emerges from an assemblage of disparate parts: the wings of a cherub sprout from the body of a lion, from the collared neck of which rises a horned head, with a snout half dog, half lion, and human ears—a beast perhaps meant to recall the fierce Cerberus, which stood guard over the entrance to the underworld of classical mythology.

Filippino surely invented the monster when he was decorating the Strozzi Chapel, along with studies of "vases, buskins, trophies, banners, helmet-crests, adornments of temples, ornamental head-dresses, strange kinds of draperies, armour, scimitars, swords, togas, mantles, and such a variety of other beautiful things."[1] The result of this activity was the piling up of objects that saturate every space left free by the principal episodes of the frescoes on the walls of the Florentine chapel. There he moved beyond the antique sources of his images to translate them into a highly personal language of unequaled originality. If this aspect of his art did not set an example for figure painters, it clearly, and to a significant degree, conditioned developments in grotesque decoration in Florence during the first half of the cinquecento, in particular the grisaille and graffito work of Andrea di Cosimo Feltrini, the unquestioned expert in the genre.

AC

1 Vasari 1996, vol. 1, p. 565.

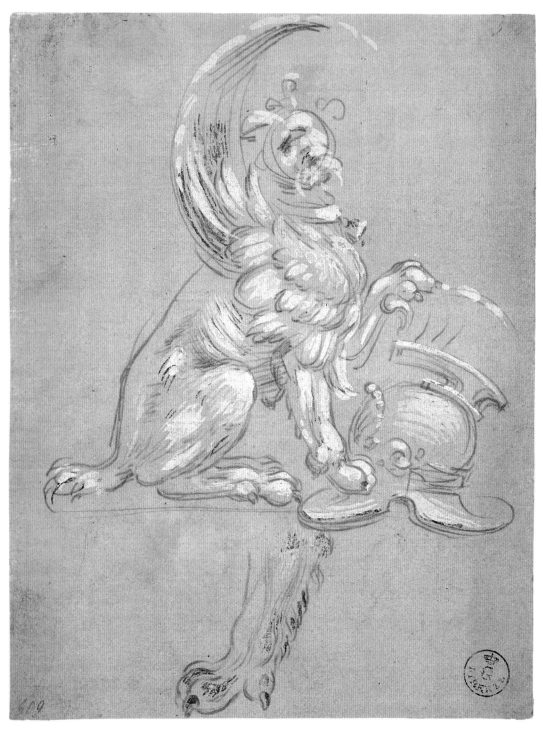

102

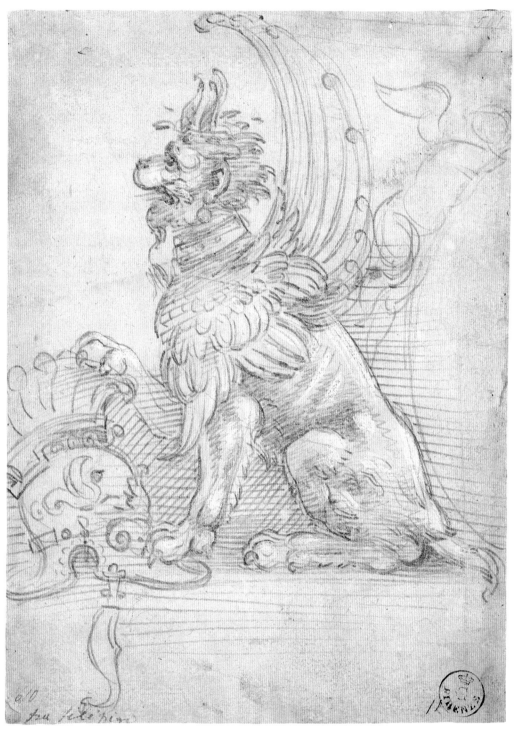

103

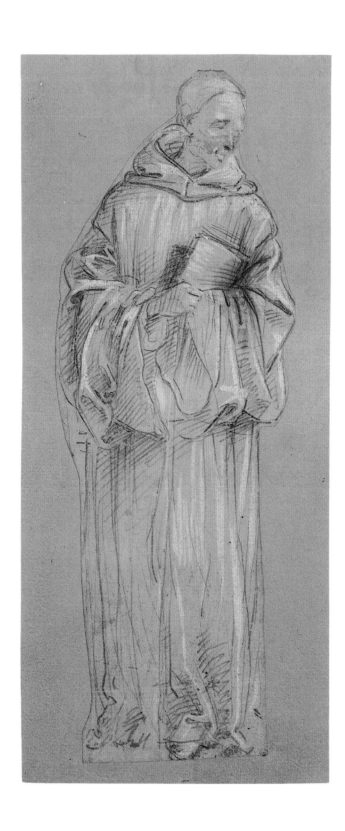

104 *Standing Monk Holding a Book*

Metalpoint, heightened with white gouache, on salmon pink prepared paper, 194 x 69 mm (7⅝ x 3¹¹⁄₁₆ in.), maximum of remains of original sheet, silhouetted

Collection Frits Lugt, Institut Néerlandais, Paris 4476

PROVENANCE: Conte Giacomo Durazzo, Genoa; his sale, H. G. Gutekunst, Stuttgart, November 19–December 3, 1872, cat. 1I, lot 4012; Professor Ernst Ehlers, Göttingen (Lugt 1391); sale, C. G. Boerner, Leipzig, May 9, 1930, lot 5, pl. III; Frits Lugt, Maartensdijk (Lugt 1028).

LITERATURE: Venturi 1934, p. 495; Berenson 1938, vol. 2, no. 1341H; Berenson 1961, vol. 2, no. 1363A; Byam Shaw 1983, no. 8, pl. 12.

Venturi attributed this drawing to Filippino, and his proposal was followed by Berenson and Byam Shaw. Strangely, it has been ignored in all the other literature on the artist.

The drawing shows great refinement in the handling of metalpoint, with varied and highly expressive strokes. The lightness of touch apparent in the interior modeling recalls Filippino's drawings from the late 1490s and after, such as the Windsor study of a shepherd (cat. no. 75). Zigzagging metalpoint lines like those used to create shadows in parts of the drapery occur in still bolder form in the study for the altarpiece in San Domenico, Bologna, in the Uffizi (cat. no. 105). The Uffizi drawing and the present sheet share as well a selective application of white heightening and grounds of similar color. These points of comparison argue for a date at the end of the fifteenth century.

GRG

105 *Turbaned Man Holding a Staff and Stepping Up*

Metalpoint, heightened with white gouache and retouched with red chalk, on pink prepared paper, 170 x 83 mm (6¾ x 3¼ in.); edges cropped, upper left corner cut, glued to paper support

Inscribed in black graphite at lower left by eighteenth-century hand: *19*; in brown graphite at lower right: *credi*

Gabinetto Disegni e Stampe degli Uffizi, Florence 1258 E

PROVENANCE: Houses of Medici and Lorraine (manuscript inventory written by Giuseppe Pelli Bencivenni before 1793); museum stamp (Lugt 930).

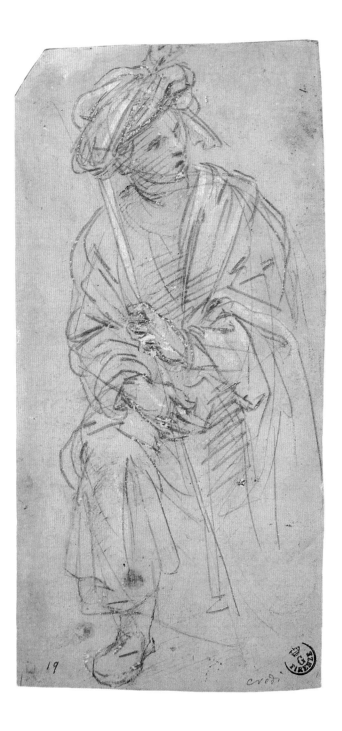

LITERATURE: Ferri 1890, p. 92, no. 1258; Ulmann 1894c, p. 111, n. 28; Berenson 1903, vol. 2, no. 1321, fig. 247; Scharf 1935, p. 83, no. 267, fig. 193; Berenson 1938, vol. 2, no. 1321, vol. 3, fig. 247; Fossi [Todorow] 1955, no. 22; Berenson 1961, vol. 2, no. 1321; Shoemaker 1975, no. 102; Petrioli Tofani 1987, no. 1258 E.

This drawing has been attributed to Filippino since Ferri's inventories of 1879–81. And indeed, the man briskly depicted here is identical in pose to the figure of Joseph in Filippino's altarpiece the *Mystic Marriage of Saint Catherine* in San Domenico, Bologna (pl. 44). The year 1501 inscribed on the altarpiece provides a secure date for the sheet.

The extraordinarily free handling of the drawing confirms its late date of about 1500 to 1501. Rapid lines of the metalpoint stylus describe bulky layers of fabric and indicate areas of shadow; a broad application of gouache, diluted almost to transparency, suggests the fall of light. Summary facial features are sketched with similar economy atop the schematic outline of the head.

The unusual pose of the figure, whose right leg is raised and left leg is omitted, is explained by reference to the altarpiece: there Joseph pauses in midstep, his left leg obscured by a pedestal. This arrested pose may symbolize Joseph's ambiguous role as Christ's foster father; significantly, he witnesses the mystic gathering of saints from the threshold, at once inside and outside the painting's sacred space.

Drawn from a life model, this figure with its sketchy handling is an early study for the San Domenico project. Yet the omission of the left leg indicates that when Filippino made his drawing he had already determined Joseph's position within the painted composition. In fact, the pose and the arrangement of the drapery in this quick sketch are virtually unchanged in the altarpiece. Filippino seems to have arrived at the final appearance of the saint with the effortless grace that Vasari called *facilità*, although the possibility remains that the artist carried out later, more detailed studies.

A drawing of a Virgin and Child in Lille (cat. no. 106) shares with the present work its sketchy manner, a pink ground, and nearly identical dimensions and may also relate to the San Domenico project. However, in its pose the Lille Virgin, unlike the Uffizi Joseph, differs from the corresponding figure in the altarpiece.

EEB

106 *Virgin and Child*

Metalpoint, heightened with white gouache, on pink prepared paper, 170 x 84 mm (6¾ x 3⅜ in.)

Inscribed in black ink at lower left: *Pl. 78*

Palais des Beaux-Arts, Lille Pl. 78

PROVENANCE: Jean-Baptiste-Joseph Wicar, Lille (Lugt 2568); acquired 1834.

LITERATURE: Benvignat 1856, no. 46 [Sandro Botticelli]; Gonse 1877, p. 397, no. 46 [Sandro Botticelli]; Pluchart 1889, no. 78 [attributed to Botticelli]; Berenson 1903, vol. 2, no. 1342; Van Marle 1923–38, vol. 11 (1929), p. 404, n. 2 [Circle of Piero del Pollaiuolo?]; Berenson 1938, vol. 2, no. 1342, vol. 3, fig. 244; Laclotte 1956, no. 141, pl. 59; Bacou 1957, p. 28; Berenson 1961, vol. 2, no. 1342; Viatte 1963, no. 56; Shoemaker 1975, no. 101; Brejon de Lavergnée 1989, p. 23, no. 3, illus.; Brejon de Lavergnée 1990, p. 39, fig. 1.

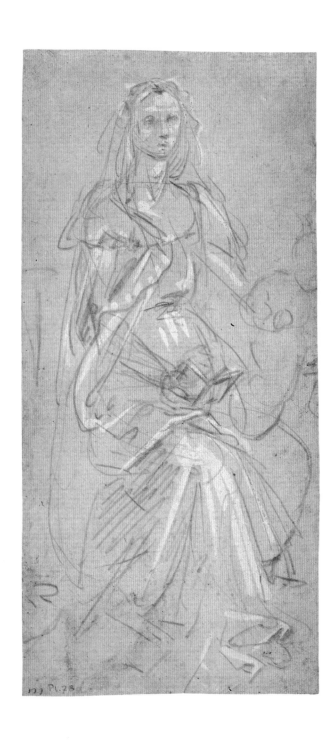

Regarded in the nineteenth century as the work of Botticelli, this drawing was first attributed to Filippino by Berenson, who suggested that it was a characteristic late work by the artist. Except for Van Marle, who idiosyncratically ascribed the sheet to Piero Pollaiuolo, no one has doubted Berenson's proposal, although Brejon de Lavergnée (1989, 1990) has suggested that it is one of Filippino's early, Botticellian efforts.

The style of the work fully confirms Berenson's view. In its bold, rapid, and diverse use of metalpoint it parallels other late drawings, such as the two surviving studies for the litter bearers in the *Raising of Drusiana* in the Strozzi Chapel (cat. nos. 100, 101) and the study of Joseph for Filippino's altarpiece of 1501 in Bologna (cat. no. 105). It also shares with these other examples a nearly identical pink ground color and economical use of white gouache heightening. Moreover, slightly indicated abstract geometric division of the face, such as that used for the Virgin, is seen in other late drawings by Filippino—although these are usually executed in pen and ink (cat. no. 85).

No firm connection can be made between this drawing and Filippino's paintings, but it would be tempting to posit a preparatory function in relation to the Virgin and Child in the Bologna altarpiece (pl. 44), given its close resemblance to the study of Joseph for that work, as Barker suggests (see entry for cat. no. 105). In the altarpiece the Virgin turns to the right and downward, whereas the figure here is almost frontal; however, a turn is suggested in the placement of the legs. In any case, the drawing surely belongs to the period just after 1500.

GRG

107 *Angel Carrying a Torch,* upper left of verso of
Page from the Libro de' disegni, see p. 99

Pen and brown ink and gray wash, pricked, figure partly
silhouetted, 206 x 130 mm (8⅛ x 5⅛ in.), maximum

National Gallery of Art, Washington, Woodner Family
Collection, Patrons' Permanent Fund 1991.190.1.f

PROVENANCE: see p. 99.

LITERATURE: Berenson 1938, vol. 2, no. 1275; Berenson 1961,
vol. 2, no. 1275; Popham 1962, no. 36; Popham 1969, no. 36;
Popham 1973, no. 36; Ragghianti Collobi 1974, p. 85, pl. 233;
Shoemaker 1975, no. 113; Bayser 1984, pp. 73–76; Miller in
Woodner collection 1986a, 1986b, 1986c, no. 24 verso B, illus;
Wohl 1986, no. 26 verso B [possibly Filippino Lippi]; Turner
in Woodner collection 1987, no. 22F, illus.; Cummings 1988
[Florentine, possibly Raffaellino del Garbo]; Miller (Turner) in
Woodner collection 1990, no. 29F, illus.; National Gallery of
Art 1992, pp. 312, 313, illus.; Gahtan and Jacks 1994, pp. 12, 41,
42, no. 52, illus.; Jaffé 1994, vol. 1, no. 36; Goldner in Woodner
collection 1995, no. 9F, illus.

108 *Two Angels Carrying Torches,* upper right of
verso of *Page from the Libro de' disegni,* see p. 99

Pen and brown ink and brown wash, pricked, figure partly
silhouetted, 175 x 126 mm (6¹¹⁄₁₆ x 4⅞ in.), maximum

National Gallery of Art, Washington, Woodner Family
Collection, Patrons' Permanent Fund 1991.190.1.g

PROVENANCE: see p. 99.

LITERATURE: Berenson 1938, vol. 2, no. 1275; Berenson 1961,
vol. 2, no. 1275; Popham 1962, no. 36; Popham 1969, no. 36;
Popham 1973, no. 36; Ragghianti Collobi 1974, p. 85, pl. 233;
Shoemaker 1975, no. 113; Bayser 1984, pp. 73–76; Miller in
Woodner collection 1986a, 1986b, 1986c, no. 24 verso C; Wohl
1986, no. 26 verso B [possibly Filippino Lippi]; Turner in
Woodner collection 1987, no. 22G, illus.; Bambach Cappel
1988, no. 155; Cummings 1988 [Florentine, possibly Raffaellino
del Garbo]; Miller (Turner) in Woodner collection 1990, no.
29G, illus.; National Gallery of Art 1992, pp. 312, 313, illus.;
Gahtan and Jacks 1994, pp. 12, 41, 42, no. 52, illus.; Jaffé 1994,
vol. 1, no. 36; Goldner in Woodner collection 1995, no. 9G, illus.

It is possible that these two fragments came from the
same sheet, although the single figure is sketchy and
exploratory in comparison with the more economi-
cally and definitively drawn pair of angels. Miller has
correctly noticed that the latter fragment, which is
pricked for transfer, is a study for figures at the top
right section of Filippino's altarpiece in San Domenico,
Bologna, dated 1501 (pl. 44). The draftsmanship here
is close to that of a study of a standing female figure
by Filippino in the Uffizi (cat. no. 97). The single angel
is more elaborately drawn, suggesting that the artist
was trying out variations on this sheet. It is stylisti-
cally comparable to the *Dancing Putto* that is also on
the Washington Vasari page (cat. no. 84), as well as
to other late pen drawings by Filippino. Turner has
related the figure to the angels at the left top of the
Bologna altarpiece, and he may well be correct, but
were it not for the historical association with the other
fragment, it might as easily be connected to several
other late projects by Filippino.

GRG

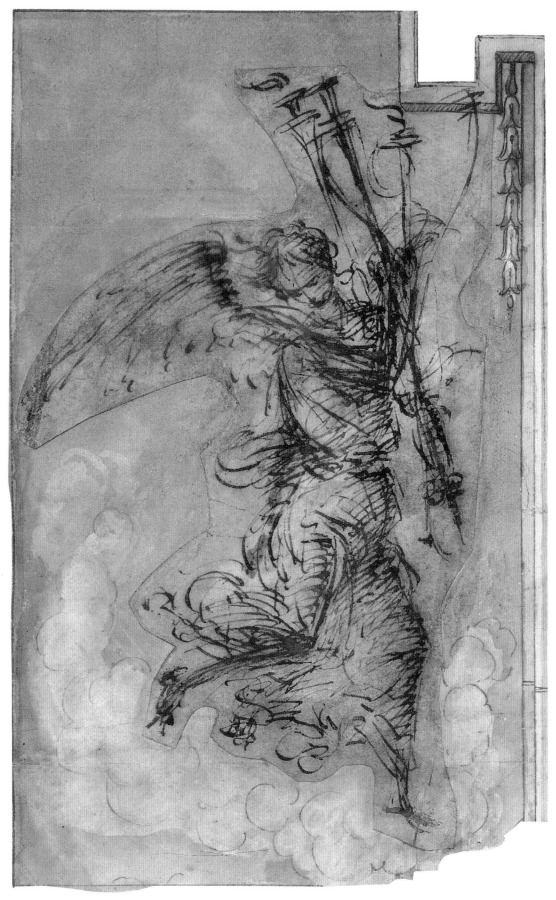

107

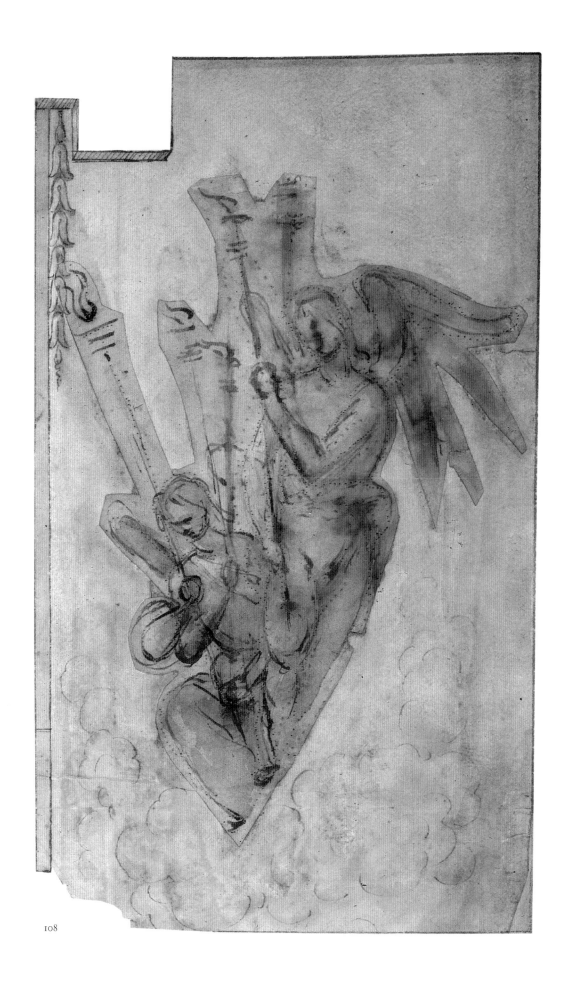

109 *Two Angels Holding the Body of the Dead Christ with Two Other Angels Bearing Instruments of the Passion*

Black chalk or charcoal, 108 x 228 mm (4¼ x 9 in.)

Inscribed in black chalk at lower left: *19*; in brown ink at lower right by sixteenth-century hand: *Filippo Lippi*

Gabinetto Disegni e Stampe degli Uffizi, Florence 148 E

PROVENANCE: Houses of Medici and Lorraine (manuscript inventory written by Giuseppe Pelli Bencivenni before 1793); museum stamp (Lugt 930).

LITERATURE: Berenson 1903, vol. 2, no. 1376 [School of Filippino Lippi]; Scharf 1935, no. 183; Berenson 1938, vol. 2, no. 1290A; Fossi [Todorow] 1955, no. 47; National Gallery of Art 1960, p. 19, no. 16, illus.; Berenson 1961, vol. 2, no. 1290A; Spencer 1966, p. 30, fig. 6; Shoemaker 1975, no. 130; Petrioli Tofani 1986, no. 148 E.

In 1903 Berenson demoted this drawing to School of Filippino, describing it as "pretty, and almost worthy of Filippino." He changed his mind in the subsequent editions of his catalogue, where he took note of the sheet's exceptional quality, with its unusual medium, nervous, agitated black-chalk strokes, and delicate sfumato effects.

The attribution to Filippino has not been debated since Berenson's reevaluation. As Berenson maintained, the sheet most likely relates to a lost panel that was at the center of a predella, for variations of its theme appear in the central panels of the predellas of the Rucellai Altarpiece for San Pancrazio, now in the National Gallery, London (pl. 20), and of the *Double Intercession* altarpiece for San Francesco in Palco in Prato, now in the Alte Pinakothek, Munich. Moreover, a small panel in the National Gallery of Art, Washington, D.C., showing Christ supported by a man who may be Nicodemus or Joseph of Arimathaea and flanked by two angels (cat. no. 111) was also once the central section of a predella.

Scholars agree that the present sheet is from Filippino's late period. A more specific date is perhaps suggested by the parallels the Christ figure and the two supporting angels share with their counterparts in the central panel of a predella,[1] known from a copy formerly in the Bellini collection, for Filippino's altarpiece for San Donato a Scopeto, which is dated 1496. Except for the incongruous presence of Saints Ubaldo and Bernardo in the panel (the result of a pastiche by the copyist), the formulation seems closely comparable in the drawing and the painting, and its

similarity is underscored by the placement at the sides of each work of two additional angels who hold the instruments of the Passion. In the drawing these instruments are the reed with the sponge and the scourge, while in the painting they are the lance and the reed with the sponge. The substitution of the lance for the scourge probably reflects a change of mind on the part of the artist after he completed the drawing.[2]

A dating of the present sheet to 1496 agrees with its advanced style. Despite the use of black chalk rather than the metalpoint or pen usually employed by Filippino, in its sfumato treatment and linear tension that style finds significant correspondences in other late drawings by the artist. Its manner is comparable as well to that of sheets from the years bridging the quattrocento and the cinquecento, such as the Uffizi drawing that shows Prometheus Stealing the Celestial Fire (cat. no. 68).

AC

1 Cecchi 1988, p. 66, fig. 14.

2 The emphasis placed on the Christ figure in the predella of the altarpiece assumes particular significance in view of two facts: the donors were the regular canons of Sant' Agostino, who depended from the congregation of the Santissimo Salvatore in Bologna, and the Day of the Holy Savior, November 9, was the day on which Florence expelled the Medici and proclaimed a republic in 1494. Ibid., p. 63.

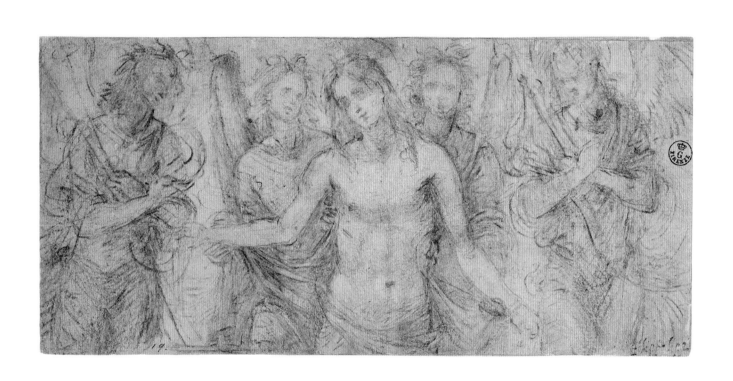

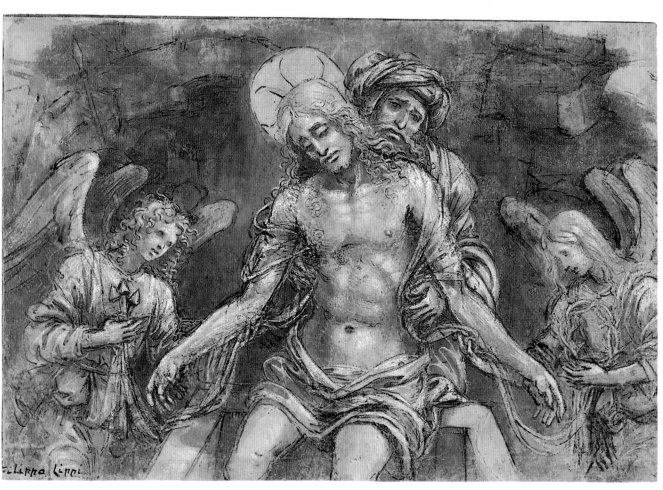

110

110 *Male Saint Holding the Body of the Dead Christ with Angels Bearing Instruments of the Passion*

Pen and brown ink and brown wash, heightened with white gouache, over black chalk, most outlines pricked, traces of pen-and-brown-ink framing outlines, on paper rubbed with black chalk pouncing dust, 181 x 265 mm (7⅛ x 10⁷⁄₁₆ in.), maximum

Inscribed in brown ink at lower left corner by seventeenth-century hand: *Filippo Lippi*

Allen Memorial Art Museum, Oberlin College, Oberlin, Ohio. R. T. Miller Jr. Fund, 1954 54.64

PROVENANCE: Earl of Pembroke, Wilton House; sale, Sotheby, Wilkinson, and Hodge, London, July 5–10, 1917, lot 324; Henry Oppenheimer, London; his sale, Christie's, London, July 10, 1936, lot 114; Agnew; Dr. Carl Robert Rudolf, London; Captain R. Langton Douglas; purchased from Mrs. Langton Douglas, R. T. Miller Jr. Fund, November 1954.

LITERATURE: Strong 1900, vol. 2, pl. 18; Berenson 1903, vol. 2, no. 1367; Auctions 1917, p. 244, fig. B; Burlington Fine Arts Club 1917, p. 26, no. 82; Scharf 1935, no. 184, fig. 62; Oppenheimer collection 1936, p. 180; Oppenheimer sale 1936, p. 58, lot 114, pl. 26; Berenson 1938, vol. 2, no. 1349A; Neilson 1938, p. 121, n. 57; Scharf 1950, p. 54, no. 61; Davis 1953, p. 992, fig. 3; Accessions 1955, p. 195; Gamba 1958, p. 102, fig. 21; Hamilton 1959, pp. 88–89, no. 61; Van Schaack 1959, pp. 13–14, no. 10, pl. 7; Berenson 1961, vol. 2, no. 1353H; London County Council 1962, p. 32, no. 43, illus.; Stechow 1964, p. 296, n. 33, fig. 7; Spencer 1966, pp. 23–24, fig. 1; Vassar College Art Gallery 1968, p. 7, no. 15; Shoemaker 1975, no. 90; Bambach Cappel 1988, pt. 2, vol. 1, pp. 202–3, no. 152, fig. 143.

111 *Male Saint Holding the Body of the Dead Christ with Angels Bearing Instruments of the Passion*

Oil or mixed media on panel, 17.5 x 33.7 cm (6⅞ x 13¼ in.); strips 6–7 mm wide added to perimeter of original painted surface

National Gallery of Art, Washington, Samuel H. Kress Collection 1952.5.86

The motif portrayed in this drawing, the body of the dead Christ displayed over the tomb, follows the iconographic tradition of images for devotional practice, which was relatively common in Florentine art.[1] Here Christ is flanked by angels holding the three nails and crown of thorns of the Passion and is held by a turbaned man, who may be Joseph of Arimathaea or Nicodemus. Filippino made a number of changes as he worked: originally he showed the wings of both angels as more open and foreshortened and included a spear as an attribute of one angel. A pentimento of the spear remains.

The drawing is related to a sheet in the Uffizi (cat. no. 109) in date and subject matter and is a cartoon for the portion of a predella panel shown here. Filippino adjusted the geometry of the composition of the drawing to achieve a greater monumentality of form in the panel. He increased the size of Christ's arms and hands and made of their poignant limp gesture a more clearly volutelike rhythm inscribed within the mortuary cloths. The rounded cave in the left background in the cartoon is centered in the painting, where its deep shadow frames and anchors the pyramidal arrangement of the figures.

Comparison of the drawing with the painting shows that the cartoon has been cropped along the left, right, and bottom borders and that the placement of elements in each work does not correspond precisely at every point; evidently the cartoon shifted slightly during the transfer of the design to the panel.[2] Infrared reflectography reveals sketchy, fairly comprehensive underdrawing in the panel but is inconclusive regarding the presence of pounce marks, although some faint dots are visible (fig. 56). While the outlines of the design that appear in the panel are finely and densely pricked in the cartoon, other elements in the painting—namely the background of rough-hewn rocks, Christ's halo, and the hair to the left of the profile of the angel at the right—were left unpricked. Betraying great speed of execution, the pricked holes are not always carefully aligned with the drawn outlines.[3]

The condition of the cartoon, particularly of the gouache used for the extensive areas of white highlight, should be taken into account in considering its date. The surface is abraded, with the serious losses in areas of the most intense and built-up highlights. Moreover, the pigment layer has become virtually transparent in a few passages of intermediate highlights, where the whites were more diluted. As a result, the tonal calibration of the highlights with respect to the ink-and-wash drawing is distorted, and many of the reinforced ink outlines beneath the whites are now more visible than intended. These factors notwithstanding, it can be said that the strong but carefully graded chiaroscuro—originally tempered

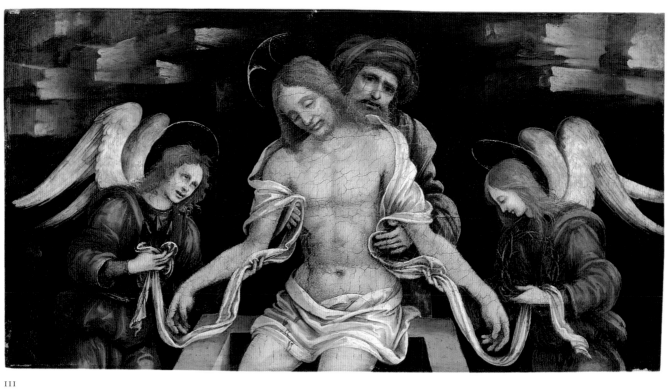

III

by more opaque layers of white—complementing fluent and flickering outlines recalls Filippino's drawings from the 1490s and later, such as the *Woman Seen Half-Length and Holding a Shield* (cat. no. 65). The handling of the ink and washes for intermediate shadows is close to that of small-scale drawings from Filippino's late years (cat. nos. 86–88, 93, 99). The related panel can probably be dated after 1500, to judge from its Leonardesque chiaroscuro and handling of media. Furthermore, the composition of the painting is more unified than that of predellas with comparable subject matter from Filippino's Rucellai Altarpiece of 1485–95 (pl. 20) and his *Double Intercession* of 1495–98 in the Alte Pinakothek, Munich.

The drawing exhibits the rich tonal depth of monumental cartoons and underpaintings that were directly influenced by Leonardo. Boldly drawn, it is, however, less precisely detailed than many small working drawings of the period that were intended for predella compositions. Like the cartoons influenced by Leonardo, it conveys with immediacy the sense of the design process unfolding.

CCB

1 For northern Italian examples, see unpublished catalogue entry of November 9, 1989, by Edward J. Olszewski in Allen Memorial Art Museum files.

2 Correspondences of design were checked by means of a tracing on translucent acetate taken from the cartoon and overlaid on the painting. About 22 millimeters along the left border, 45 millimeters along the right border, and 5 millimeters along the lower border were cropped. The misalignment of the cartoon, apparently caused by its shifting, measures about 5 by 7 millimeters at Christ's nose.

3 These include Christ's cranium, the fingers on his left hand, and the loincloth falling over his right thigh. Infrared reflectography examination by Elizabeth Walmsley, Paintings Conservator, National Gallery of Art, Washington, D.C., in August 1996.

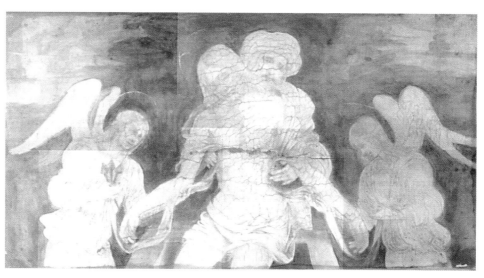

FIG. 56 Infrared reflectogram, underdrawing, *Male Saint Holding the Body of the Dead Christ with Angels Bearing Instruments of the Passion*

Raffaellino del Garbo

Raffaellino is known today as Raffaellino del Garbo, after the via del Garbo, the street in Florence near the church of the Badia where his workshop was situated. His artistic identity has been the subject of considerable debate because of ambiguous documentary evidence.[1] He was probably born to a certain Bartolomeo di Giovanni di Carlo di Cocco and is the same person who signed paintings with versions of the names Raffaello dei Carli (Karli, de Krolis), Raffaello dei Capponi (de Caponibus), and Raphael de Florentia. The first two names apparently refer to Raffaellino's foster and adoptive families in Florence—which cared for him after his father's untimely death in 1479—and the last is inscribed on an altarpiece painted for a church in Siena. Our artist is often also identified with the Raffaello whose offer of 1508 to serve as Michelangelo's assistant in the frescoing of the Sistine Ceiling was turned down.

According to Vasari, Raffaellino became an assistant of Filippino Lippi's when the murals in the Carafa Chapel (pls. 29–33) were carried out—that is, between 1488 and 1493—and "acquired Filipp[in]o's manner so well, that there were few who could distinguish the one from the other."[2] Although it was recorded by Vasari, Raffaellino's first known independent work, the vault frescoes in the small antechamber to the left of the Carafa Chapel, was discovered only in 1962. Raffaellino's frescoes probably date about 1493–95, after those of the main chapel. His figural types and use of an elaborate antique-style decorative framework suggest that in Rome Raffaellino came into contact with the work of Pietro Perugino; Pier Matteo d'Amelia, who had assisted Fra Filippo Lippi on the mural cycle at the cathedral of Spoleto; and especially Bernardino Pinturicchio, who was then frescoing the Borgia apartments in the Vatican palace. These Umbrian painters, along with Filippino, would have a lasting influence on his paintings and drawings.

After 1497–98 Raffaellino lived mainly in Florence. His most important altarpiece, the *Resurrection* (fig. 57), was commissioned by the Capponi family for the Paradise Chapel in San Bartolomeo at Monte Oliveto, near Florence. The painting is traditionally dated about 1503–4 but may be earlier, since a newly identified document from 1497 appears to refer to the gilding of its frame. The panel showing a Pietà with Saints (Alte Pinakothek, Munich), originally intended for the Nasi Chapel at Santo Spirito, Florence, is usually thought to be closely related in style and is probably contemporary. Raffaellino's land-registry declaration of 1498 mentions that he kept workshops at Borgo San Jacopo and in the neighborhood of the cathedral of

Florence. By November 15, 1499, however, when he enrolled in the Arte dei Medici e Speziali, the guild to which painters belonged, he had settled in his workshop at via del Garbo, where he stayed until at least 1517. Among his other major documented altarpieces are the *Virgin and Child with Saints and Donors*, 1500 (Uffizi, Florence), the *Mass of Saint Gregory*, 1501 (John and Mable Ringling Museum of Art, Sarasota), the *Enthroned Virgin and Child with Saints*, 1505 (Santo Spirito), and the *Coronation of the Virgin,* commissioned by the Vallombrosan monks of San Salvi in 1511 (Musée du Louvre, Paris). Among his few surviving frescoes in Florence is the *Multiplication of the Loaves and Fishes*, 1503, detached from the refectory in Santa Maria Maddalena dei Pazzi and now in the Scuola Elementare Luigi Alamanni.

Vasari's *Life* of Raffaellino renders an unduly harsh portrait of the artist, which has strongly influenced modern opinion. Yet the fact that Raffaellino was a brilliant and indefatigable draftsman throughout his career constitutes the saving grace in Vasari's moralizing tale of the painter in decline who did not live up to his youthful promise, who squandered his talents on pedestrian paintings, and who took on "any work, however mean," for a pitiful price. Among these mean works were countless designs Raffaellino labored to produce in his old age for embroiderers of ecclesiastical vestments for "the churches of Florence and throughout the Florentine territory, and also for Cardinals and Bishops in Rome." Despite their lowly function, Vasari judged these drawings often to be "most beautiful designs and fancies."[3] Attesting to Vasari's words, a vast number of pricked cartoons by Raffaellino, all carefully drawn in pen and ink with wash, have survived. The most ambitious embroideries from Raffaellino's cartoons decorate the vestments executed between 1521 and 1526 for Cardinal Silvio Passerini (Museo Diocesano, Cortona). According to Vasari, one of Raffaellino's sons, probably Bartolomeo, called il Bertucca, sold many of his father's drawings in metalpoint and pen and ink at sadly low prices, and embroiderers disposed of the artist's countless cartoons in similar fashion. It was apparently through such sources that Vasari and Vincenzo Borghini were able to obtain examples of Raffaellino's draftsmanship for their drawings collections. Raffaellino's pupils probably briefly included Andrea del Sarto and Agnolo Bronzino, two great draftsmen of the following generation.

Vasari's biography states that Raffaellino, ill and poor, died at fifty-eight years of age in 1524. This assertion has traditionally provided the basis for calculating the artist's birth and death dates, but a recently discovered document establishes that Raffaellino was still alive in April 1527.[4]

CCB

1 This discussion is based on Vasari 1906, vol. 4, pp. 233–53; Vasari 1966, vol. 4, pp. 115–20; Vasari 1996, vol. 1, pp. 687–91; Codex Magliabechiano (Frey 1892, pp. 107–8); Ulmann 1894c; Berenson 1903, 1938, and 1961 (where the work of Raffaellino is confused as that of two different artists); Scharf 1933; Neilson 1938, pp. 186–207; Shearman 1965, pp. 21–23; Carpaneto 1970; Craven 1970, p. 70; Carpaneto 1971; Luchs 1977; Padoa Rizzo 1977; Geiger 1986; Buschmann 1993; Acidini Luchinat and Capretti 1996; Nuttall 1996; and Cecchi's essay in this catalogue, "Filippino and His Circle: Designers for the Decorative Arts," pp. 37–44.

2 Vasari 1996, vol. 1, p. 688.

3 Ibid., p. 690.

4 See Cecchi, "Filippino and His Circle," p. 43, n. 12.

112 *Christ Resurrected and Studies of Two Hands*

Metalpoint, heightened with white gouache, on blue-gray prepared paper, 375 x 254 mm (14¾ x 10⅛ in.); Vasari's mount, pen and brown ink and brown wash, 479 x 336 mm (18⅞ x 13¼ in.)

Inscribed in ink on mount at upper center: *Ex Collectione olim G. Vasari nunc P.J. Mariette*; in brown ink at lower center: RAFFAELL*ino* DEL GARBO/PIT*re* FIO*to*

British Museum, London Pp. I-32

PROVENANCE: Giorgio Vasari, Arezzo; Pierre-Jean Mariette, Paris (Lugt 1852); his sale, November 15, 1775–January 30, 1776, lot 424?; sale, Thomas Philipe, London, April 24, 1801, lot 116; Richard Payne Knight, London; his bequest, 1824.

LITERATURE: Morelli 1893, p. 16, n. 1, illus.; Ulmann 1894c, p. 110; Colvin 1895, p. 11, no. 25; British Museum 1896, p. 252, no. 25; Wickhoff 1899, p. 215; Morelli 1900, p. 117, no. 3; Berenson 1903, vol. 1, p. 95, pl. LX, vol. 2, no. 764; Thieme-Becker 1907–50, vol. 13 (1920), p. 171; Van Marle 1923–38, vol. 12 (1931), p. 445; Scharf 1933, p. 162; Kurz 1937, p. 34; Berenson 1938, vol. 1, pp. 119–20, vol. 2, no. 764, vol. 3, fig. 260; Popham and Pouncey 1950, pp. 42, 209, no. 60, pl. 65; Grassi 1956, p. 65, fig. 15; Berenson 1961, vol. 2, no. 764, vol. 3, fig. 246; Louvre 1967, pp. 66–67, no. 64, illus.; Carpaneto 1970, p. 13, fig. 14; Carpaneto 1971, p. 6; Ragghianti Collobi 1974, vol. 1, p. 99, vol. 2, fig. 271; Shoemaker 1975, p. 445; Bartoli in Petrioli Tofani 1992, no. 2.33, illus.; Nelson in Agostini, Bentini, and Emiliani 1996, p. 131.

Vasari has presented Raffaellino's drawing within a frame that illusionistically suggests a marble altar, as if it were a complete composition. Wash is added throughout to enhance indications of shadow and depth. The drawing provides the touchstone for our understanding of Raffaellino as a draftsman. Unquestionably from Raffaellino's hand, it not only carries Vasari's attribution to him but also has been recognized since the nineteenth century to be a study for the central figure in the *Resurrection* he painted for the Paradise Chapel of the Capponi family in San Bartolomeo at Monte Oliveto (fig. 57).

The identification of the figure in the drawing with the painting is indisputable; however, the drawing has a clearly antique character, first noted by Van Marle and well analyzed by Popham and Pouncey,[1] that is much diminished in the final work. The wreath of vine leaves, girlish head, and nudity all indicate that the figure evolved from a Roman sculptural prototype—which Raffaellino fully transformed into the Resurrected Christ in the Monte Oliveto painting. Raffaellino clearly depicted an earthbound figure in the study, since he suggested the ground as well as the shadows cast on it. Perhaps he began by executing a variant of a study after the antique he had made in Rome, intending as he carried out his new drawing

to create a Christ Resurrected. Although he appears to have been certain about the main elements of the figure from the outset, Raffaellino adjusted the position of the feet as he drew. The resonant classicism of the figure suggests a date for the drawing in the 1490s, when the artist returned to Florence from Rome, where he had gone to join Filippino. The Capponi Chapel *Resurrection* is datable to 1497[2] or just before, which provides independent confirmation of the date proposed for the drawing.

Carpaneto (1971) has convincingly related the two hand studies to the angel at the left of Raffaellino's so-called Benson Tondo showing the Virgin and Child with Angels, sold at Christie's, London,[3] which has been situated about 1495.

This is perhaps the best documented of all drawings by Raffaellino and is certainly his most important surviving sheet. The refined and sometimes animated use of metalpoint clearly depends on the example of Filippino, whose drawing style he closely emulated. Nevertheless, even in this outstanding example his line is more labored and pedantic than Filippino's—especially in the outlines and shading of the hand studies—and his application of white highlights more particularized. The effect is more staid and less spirited than in the drawings of his master, notwithstanding the poetic beauty of the image.

GRG

1 Popham and Pouncey 1950, p. 209.
2 Craven 1970, p. 39.
3 Sale catalogue, Christie's, London, June 23, 1967; Berenson 1963, vol. 2, pl. 1158.

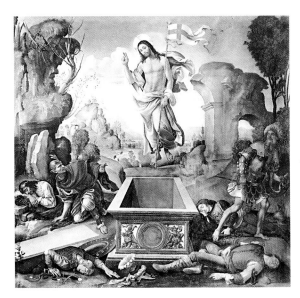

FIG. 57 Raffaellino del Garbo. *Resurrection.* Oil on panel, 174.5 x 186.5 cm. Galleria dell'Accademia, Florence 8363

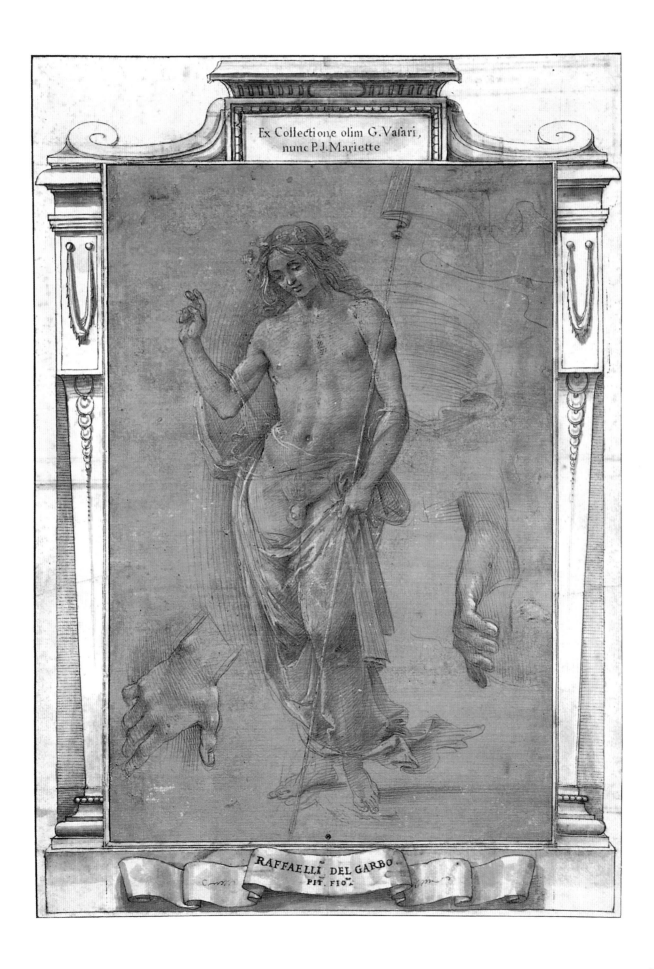

Ex Collectione olim G. Vasari,
nunc P. J. Mariette

RAFFAELLI DEL GARBO
PIT. FIO.

113 *Seven Studies of Arms and Hands and Sketch of a Head*

Metalpoint reinforced with pen and brown ink, heightened with white gouache, on three deckled pieces of gray-brown prepared paper glued together and preparation reworked to harmonize in hue, 321 x 244 mm (12⅝ x 9⁹⁄₁₆ in.)

Graphische Sammlung Albertina, Vienna 4858

PROVENANCE: Giorgio Vasari, Arezzo (suggested by remains of mount along upper center); Pierre-Jean Mariette, Paris (Lugt 1852); Herzog Albert Casimir of Saxe-Teschen, Vienna (Lugt 174).

LITERATURE: Berenson 1938, vol. 1, p. 120, vol. 2, no. 771; Berenson 1961, vol. 1, p. 178, vol. 2, no. 771, vol. 3, fig. 250; Koschatzky, Oberhuber, and Knab 1972, no. 14, illus.; Ragghianti Collobi 1974, pp. 85–86, fig. 237; Knab 1975, no. 8, illus.; Koschatzky, Knab, and Oberhuber 1975, no. 8, illus.; Ragghianti and Dalli Regoli 1975, p. 125, with no. 163; Cotté 1987, fig. 31; Birke 1991, p. 27, fig. 18; Birke and Kertész 1992–95, vol. 3, pp. 1674–75, illus.

An early owner, presumably Vasari, appears to have fashioned this single sheet by taking three pieces from separate sheets, changing the original orientation of the studies on them, and then gluing them together. He lightly wet the deckled edges of the pieces of paper to glue them as seamlessly as possible and reworked the ground preparations to harmonize the hues and surfaces; nevertheless, the greater thickness and smoother application of the ground on the two pieces at the top of the collaged sheet are still noticeable.

The studies are all clearly by the same draftsman but present telling differences in the quality of execution, even in the original portions of the same sheet. Although the artist usually built tone with a parallel, intermeshed hatching of the metalpoint, he turned to a soft sfumato technique for the hand to the right in the center row. The white highlights vary greatly not only in their cool and cream hues but also in descriptiveness, density, and manner of hatching (which is curving, straight, cross, or stippled in type). In the somewhat awkwardly drawn arm study on the upper left, the white gouache even served to correct an outline of the index finger.

Although Botticellian in their elegant proportions, the hand types are much more naturalistic than Botticelli's and are characteristic of Raffaellino—with their fleshy wrists and dimpled palms but spindly, tapering fingers and strong thumbs, highlighted around the outline of the square nails. Berenson noted the close resemblance of the three hands in the bottom row to those of the Virgin and the infant Christ in Raffaellino's painting in the Gemäldegalerie, Dresden (fig. 58). If rotated so that they are positioned as if placed on a figure's breast, the right arms and hands at the top of the sheet recall the gesture of the angel at the left in the *Enthroned Virgin and Child with Saints Bartholomew and Nicholas and Two Donors* in Santo Spirito, Florence—a much-disputed altarpiece that Berenson attributed to Raffaellino.[1] Moreover, in style and technique the present sheet is comparable to the hand studies in Raffaellino's drawing with Christ's figure in the British Museum (cat. no. 112). In addition, two sheet fragments with similarly delicate hand studies in metalpoint in the British Museum (inv. no. Pp.I-14) have been related to extant paintings by Raffaellino. The existence of close correspondences between these drawings and paintings supports the notion that Raffaellino's studies of hands such as those on the present sheet were not exempla in the earlier quattrocento tradition but rather were preparatory for specific projects.

CCB

1 Berenson 1963, vol. 2, pl. 1155. This painting is often attributed to the Master of Santo Spirito.

FIG. 58 Raffaellino del Garbo. *Virgin and Child with the Young Saint John the Baptist.* Oil on panel. Gemäldegalerie, Dresden

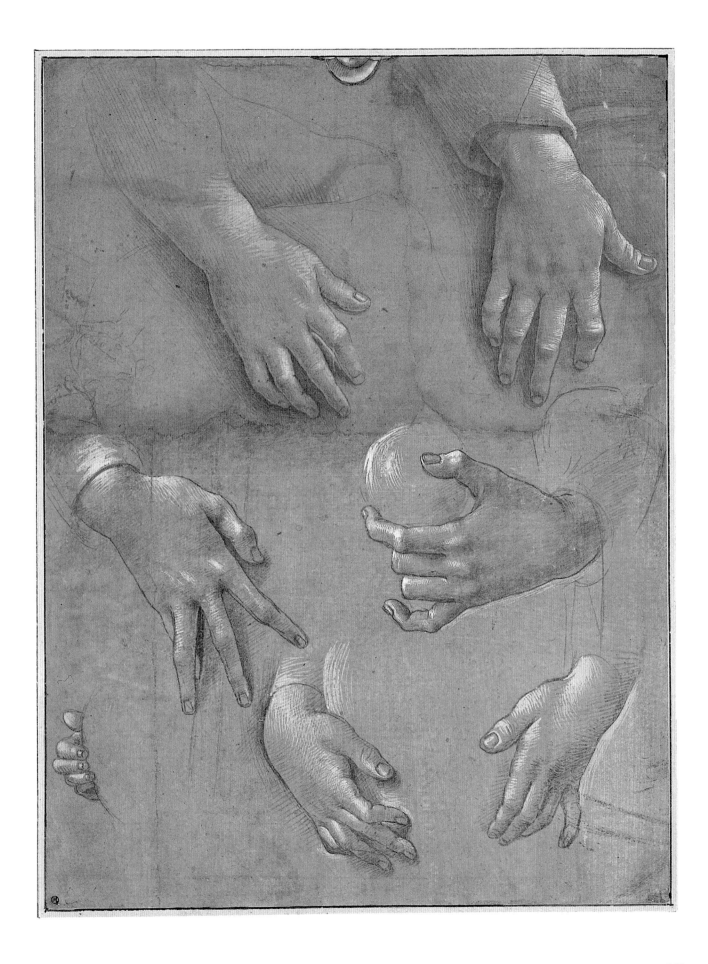

343

114 *Kneeling Angel Facing Right, Holding the Christ Child, and the Young Saint John the Baptist*

Metalpoint, pen and brown ink and brown wash, heightened with white gouache, on paper tinted with reddish chalk, 213 x 207 mm (8⅜ x 8⅛ in.)

Inscribed in brown ink at lower right by early hand, perhaps that of Filippo Baldinucci: *Sandro Botticello*

Gabinetto Disegni e Stampe degli Uffizi, Florence 207 E

PROVENANCE: Houses of Medici and Lorraine (manuscript inventory written by Giuseppe Pelli Bencivenni before 1793); museum stamp (Lugt 930).

LITERATURE: Berenson 1903, vol. 1, p. 97, vol. 2, no. 762; Ede 1926, no. 43, illus. [Filippino Lippi? (attributed to Botticelli)]; Van Marle 1923–38, vol. 12 (1931), p. 445, fig. 295; Berenson 1938, vol. 1, p. 121, vol. 2, no. 762, vol. 3, fig. 262; Berenson 1961, vol. 1, p. 179, pl. XXXV, vol. 2, no. 762; Grassi 1961, p. 193, no. 75, illus.; Petrioli Tofani 1986, no. 207 E.

This sheet was traditionally given to Botticelli, as the old writing at the lower right indicates. In 1903, however, Berenson restored its attribution to Raffaellino, writing: "although there is in the types a certain resemblance to Botticelli, I can scarcely doubt but that this drawing is by Garbo. As we have seen, the latter stood for a time in such relation to the former as to account sufficiently for any likeness. If we look closely, however, we shall not fail to note the straight profile of the angel, so characteristic of Raffaellino, his type of child with the large head and thin fluffy hair—compare his various tondi—and, most decisive of all, that close cross hatching which never occurs at all in Botticelli, but in Garbo is peculiar enough to distinguish him even from Filippino."

In fact, the sheet, which reveals pentimenti in the hand of the angel and the legs and arms of the Christ Child he holds, is closely linked to tondi painted by Raffaellino between 1495 and 1497. These include one in the Museo Nazionale di Capodimonte, Naples, in which there is a similarly joyful interaction between Christ and the young Saint John the Baptist, and the so-called Benson Tondo formerly in the W. R. Hearst collection, New York, where the Child plays with the pomegranate held by the angel, who touches the neck of the young Saint John, who, in turn, watches with amusement. Finally, the drawing seems almost to be a preparatory variant for a tondo attributed either to Raffaellino or to his school, datable to about 1505, in the Strossmayer Gallery, Zagreb: here the angel moves the young Saint John from the left toward the Virgin, who touches the Christ Child at the neck, in a sign of blessing.[1]

AC

1 Carpaneto 1971, p. 10, fig. 40; Buschmann 1993, pp. 146–48, 176, nos. 16, 17, 40.

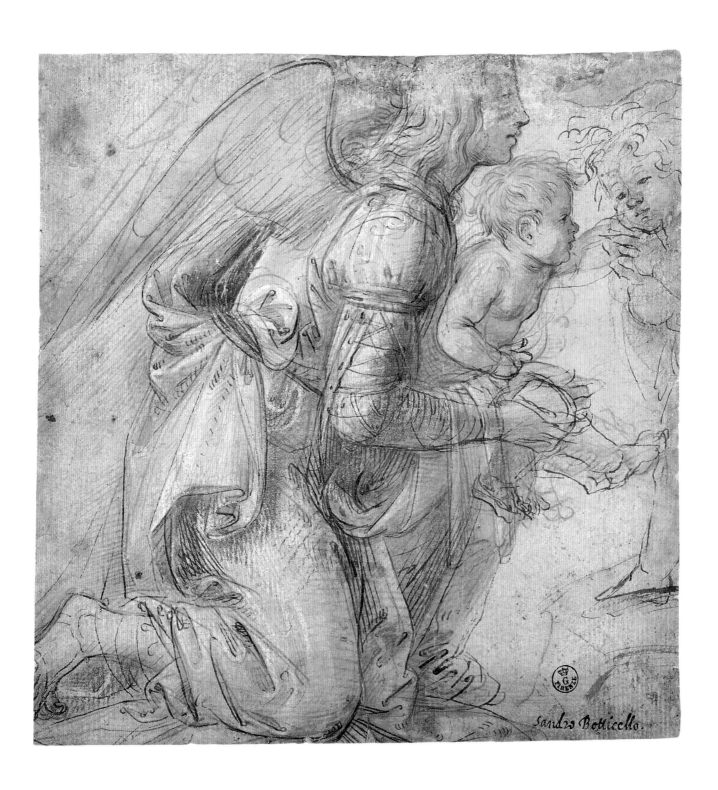

Sandro Botticello.

345

115 *Virgin and Child with Saints Catherine of Alexandria and Mary Magdalen*

Pen and brown ink, heightened with white gouache, on brown-pink tinted paper, d. 278 mm (11 in.); section lost at top

Christ Church Picture Gallery, Oxford JBS 47

PROVENANCE: General John Guise, London; his bequest, 1765.

LITERATURE: Morelli 1893, p. 16, n. 1; Ulmann 1894c, pp. 113–14, n. 31; Morelli 1900, p. 117, no. 2; Colvin 1907, pl. 11; Bell 1914, p. 45; Van Marle 1923–38, vol. 12 (1931), pp. 445–48; Scharf 1933, p. 163, n. 2, fig. 12; Berenson 1938, vol. 1, pp. 110 n. 3, 111, 120, vol. 2, no. 768, vol. 3, fig. 259; Popham and Pouncey 1950, with no. 63; Matthiesen Gallery 1960, no. 22, pl. 23; Berenson 1961, vol. 1, pp. 170, 178, vol. 2, no. 768, vol. 3, fig. 248; Byam Shaw 1967, with no. 48; Ragghianti Collobi 1974, pp. 99–100; Byam Shaw 1976, no. 47, pl. 48; De Marchi in Petrioli Tofani 1992, p. 154, no. 7.8, illus.

The attribution of this fine drawing to Raffaellino has been maintained universally since the late nineteenth century. Despite the rubbed state of extensive portions of the sheet, it is clear that this is among his most accomplished drawings. De Marchi has aptly noted its classicism, which reflects the impact of the young Fra Bartolommeo. By contrast, the spirited pen work is derived from Filippino's pen-and-ink drawings of the 1490s, although the technique is interpreted here with a degree of restraint and evenness that tames the spontaneity of Filippino's line.

It has sometimes been proposed that this drawing was made as a preparatory study for Raffaellino's painted tondo of the same subject formerly in Casa Pucci, Florence, and now in the National Gallery, London. The two works are similar in format and general disposition of the figures but very different in virtually every detail; nevertheless, the drawing may be an early study for the painting, although much superior to it in both conception and execution. A date of about 1500 for the drawing appears likely.

GRG

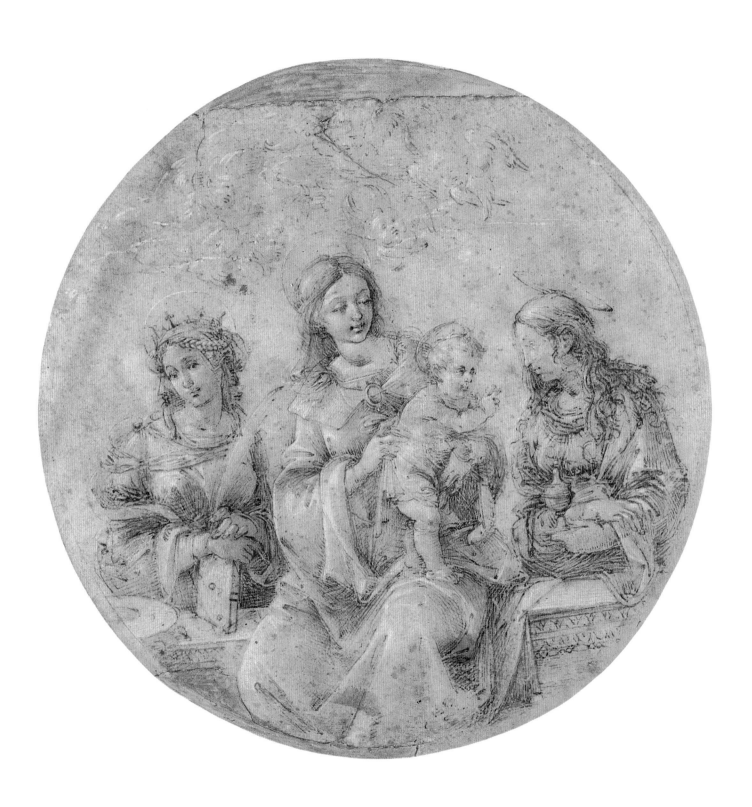

116 *Archangel of the Annunciation*

Pen and brown ink and brown wash, heightened with white gouache, over black chalk, outlines of design and framing outlines pricked, on paper washed brown with traces of rubbed black-chalk pouncing dust, d. 96 mm (3¾ in.)

The Metropolitan Museum of Art, New York; Rogers Fund, 1912 12.56.5a

PROVENANCE: Sir Charles Eastlake, London; Lady Eastlake, London; her sale, Christie's, London, June 2, 1894, part of lot 14; Jean Paul Richter, London; purchased in New York, 1912.

LITERATURE: Hellman 1916, pp. 157–61, illus.; Van Marle 1923–38, vol. 12 (1931), pp. 360–61, n. 2; Berenson 1938, vol. 2, no. 766A [close to Filippino]; Metropolitan Museum 1942, no. 12, illus.; Berenson 1961, vol. 2, no. 766E, vol. 3, fig. 250 [close to Filippino]; Bean [1964], no. 8, illus.; Bean and Stampfle 1965, no. 25, illus.; Garzelli 1973, pp. 23–24, pl. 31; Robertson 1978, p. 277, no. 7; Bean and Turčić 1982, p. 103, no. 94, illus.; Ames-Lewis and Wright 1983, p. 82, no. 11a, illus.; Bambach Cappel 1988, pt. 2, vol. 1, no. 94, fig. 123.

FIG. 59 After Raffaellino del Garbo. Detail, embroidery fragment with *Archangel of the Annunciation*. Collegiate church of San Martino, Pietrasanta

The figural type of this delicately drawn, highly finished small angel closely depends on models in Filippino's tondos of 1483–84 in the Museo Civico, San Gimignano (pls. 13, 14), and his *Adoration of Christ and the Virgin with the Annunciation* of about 1495–97 in the Alte Pinakothek, Munich—paintings that probably date more than twenty years earlier than Raffaellino's small sheet. The angel is comparable to the one in Raffaellino's altarpiece showing the Annunciation in the convent church of San Francesco, Fiesole, but seems to have been intended as a cartoon for an embroidery.

Garzelli identified a badly damaged embroidered fragment with the archangel of the Annunciation and a composition similar to that of the present drawing on a chasuble at the collegiate church of San Martino at Pietrasanta (fig. 59). Although the physical evidence confirms that this sheet was a highly functional working drawing, a number of small differences in design suggest that it was not directly used to produce the Pietrasanta embroidery. The format of the embroidery is essentially rectilinear, while the drawing is a tondo and must have been conceived as such, for even the carefully constructed circular framing outline was pricked, and in the same fine, dense manner as the figure. Moreover, in the drawing the position of the angel's right arm is higher, the left arm is much closer to a horizontal, and the wings slant farther up and outward. Although the angel wears the same type of tunic in both drawing and embroidery, not a single drapery fold is identical.

It seems probable that Raffaellino produced at least a few variations on the Annunciate-angel type, given the popularity of the Annunciation in Renaissance textiles as well as his extensive use of *spolvero*-based techniques of design reproduction in his countless extant drawings. In fact, the present drawing may offer evidence to this effect, for the artist drew two equally viable solutions for the halo here: one foreshortened in ink, wash, and white heightening, left unpricked; another in a straight-on view similar to the solution in the embroidery, as a flat circle about the angel's profile, executed with faintly drawn ink outlines. The outline of the latter was pricked from the verso of the sheet, as is corroborated by the raised paper around the tiny holes, and must derive either from a related design on that side of the sheet or from yet another intermediary sheet. After the pricking, Raffaellino reinforced some of the contours of the drawing with pen and ink of a darker brown than initially employed.

CCB

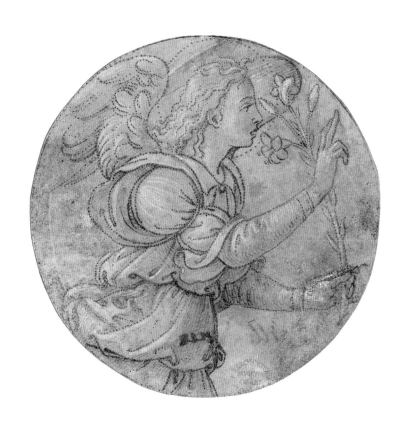

117 *Saints Anthony Abbot, Roch, and Catherine of Alexandria,* lower center of verso of *Page from the Libro de' disegni,* see p. 99

Pen and brown ink and brown wash and gouache, finished with brown-gray wash, heightened with touches of white gouache, 299 x 256 mm (11¾ x 10⅛ in.)

National Gallery of Art, Washington, Woodner Family Collection, Patrons' Permanent Fund 1991.190.1.h

PROVENANCE: see p. 99.

LITERATURE: Berenson 1903, vol. 2, no. 571 [School of Botticelli]; Van Marle 1923–38, vol. 12 (1931), p. 274 [anonymous follower of Botticelli]; Kurz 1937, p. 14 [Filippino Lippi]; Berenson 1938, vol. 2, no. 571 [probably Raffaellino del Garbo]; Berenson 1961, vol. 2, no. 571 [probably Raffaellino del Garbo]; Popham 1962, no. 36 [Raffaellino del Garbo]; Fahy 1968, p. 37, no. 9 [conceivably Botticelli]; Popham 1969, no. 36 [Raffaellino del Garbo]; Popham 1973, no. 36 [Raffaellino del Garbo]; Ragghianti Collobi 1974, p. 85, pl. 233 [Raffaellino del Garbo]; Shoemaker 1975, no. 113, fig. 113v [Raffaellino del Garbo]; Fahy 1976, pp. 20, 78, 107, no. 24 [conceivably Botticelli]; Bayser 1984, pp. 73–76 [not Filippino Lippi]; Miller in Woodner collection 1986a, 1986b, 1986c, no. 24 verso D, illus. [Botticelli?]; Wohl 1986 verso C [Raffaellino del Garbo or Botticelli]; Turner in Woodner collection 1987, no. 22H, illus. [Botticelli]; Cummings 1988 [Botticelli]; Miller (Turner) in Woodner collection 1990, no. 29H, illus. [Botticelli]; National Gallery of Art 1992, pp. 312, 313, illus. [Botticelli]; Fahy 1993b, p. 170, no. 4.3 [Botticelli]; Gahtan and Jacks 1994, pp. 12, 41, 42, no. 52, illus. [Botticelli]; Jaffé 1994, vol. 1, no. 36 [Botticelli]; Goldner in Woodner collection 1995, no. 9H, illus. [Workshop of Botticelli].

This exceptional highly finished and colored drawing is clearly linked to the altarpiece with the same saints in San Felice, Florence. However, the two works differ in many respects. In the altarpiece each saint is shown in an individual arched panel and placed farther from the foreground. There are innumerable differences in pose, gesture, and details of drapery and landscape setting. The saints in the altarpiece are more introverted and placid, and the palettes are completely unlike both in choice and sensibility. And, finally, the altarpiece is devoid of the somewhat decorative handling of such details as the clouds found in the miniature.

The nature of the relationship between the two works is difficult to ascertain, given the rarity of miniatures of this kind in the late fifteenth century. There is nothing in its draftsmanship or its format to indicate that the drawing is a preparatory *modello* for the altarpiece, from which it differs in the absence of divisions between panels and the lack of provision for the existing predella.

The authorship of both altarpiece and miniature has been much disputed, and their attributions have, understandably, followed somewhat separate paths.

The altarpiece has been ascribed to Piero di Cosimo, Cosimo Rosselli, the School of Filippino, and the School of Botticelli. Fahy (1993b) has recently concluded that it is by Botticelli himself and dates from the 1490s. There is much to recommend this view, in particular the relationship it bears to Botticelli's San Marco altarpiece of the same moment that is now in the Uffizi. At the very least, it seems surely to have been designed by Botticelli and executed in his workshop.

It is difficult to see the altarpiece and the miniature as the product of the same artist, even accounting for the obvious disparities of scale and medium. While the altarpiece is relatively simple and communicates a sense of grandeur, the miniature suggests delicacy. Furthermore, such details in the miniature as the drapery folds and hands lack the crispness and brilliant clarity apparent throughout Botticelli's work of the period, as exemplified in his drawing of Saint John the Baptist in the Uffizi (cat. no. 7). The miniature also lacks the breadth of form and execution that is visible in the three fragments of a drawing by Botticelli showing the Adoration of the Magi that is divided between the Fitzwilliam Museum, Cambridge (inv. nos. 910, 2888), and the Pierpont Morgan Library, New York (inv. no. I,5). Moreover, the use of color here is quite different from that of Botticelli not only in his paintings but also in his illustrations of the *Divine Comedy* in the Kupferstichkabinett, Berlin, and the Biblioteca Apostolica, Vatican City. Therefore, although Pouncey, Miller, Turner, and Fahy have all supported an attribution to Botticelli in recent years, it seems much more probable that the miniature is the work of a follower, made after the altarpiece, as an independent work. The possibility that Berenson's assignment of the drawing to Raffaellino may be correct should not be excluded—in which context it is worth noting that Vasari mentions that Raffaellino was skilled at executing drawings in "*aquerello*" in his youth.[1] Unfortunately, no similar work by Raffaellino is known, and comparisons with his paintings and drawings are suggestive but inconclusive.

The evidence suggests that the drawing, whether by Raffaellino or not, was based on either the altarpiece or a (now lost) preparatory drawing for it. A small hint that favors the latter possibility is offered by the decorative marbleized arch that surrounds Saint Roch. This has no perceptibly logical connection to the painting and no functional purpose but may well reflect a preparatory design in which only the central arch was summarily indicated by Botticelli.

GRG

1 Vasari 1906, vol. 3, p. 506.

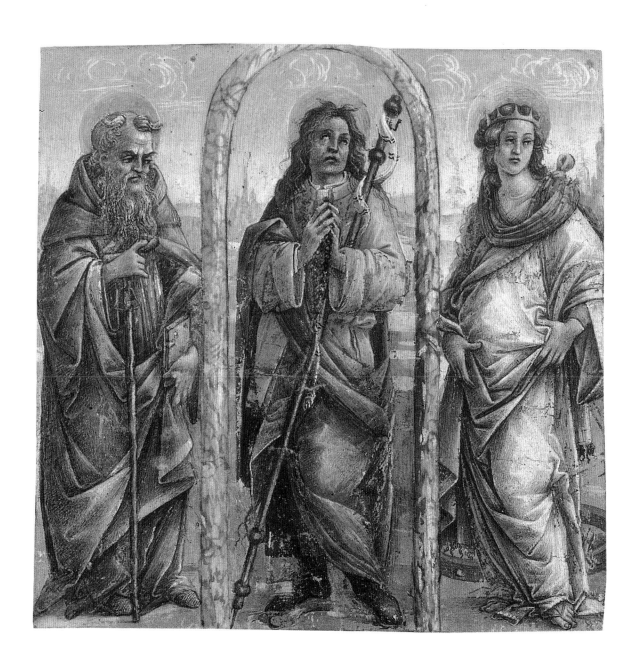

Piero di Cosimo

The paintings of Piero di Cosimo are closer in spirit to those of Filippino Lippi than to the work of any other Florentine artist of the late fifteenth century. Indeed, many of Piero's drawings have at one time or another been ascribed to his more famous contemporary. Although Piero is the subject of one of the most colorful of Vasari's *Lives*, relatively little is known for certain about his career.[1] Property tax declarations filed by his father in 1469 and 1480 indicate that he was born in 1461 or 1462 and that by the time he was eighteen he was an apprentice or unsalaried assistant in the workshop of the Florentine painter Cosimo Rosselli. Between 1503 and 1505 Piero joined the Brotherhood of Saint Luke, and in 1504 he became a member of the physicians' and apothecaries' guild, to which painters also belonged. In 1504 he served with Filippino on the committee of artists and craftsmen convened by the Florentine wool guild to determine an appropriate site for Michelangelo's recently completed statue of David. According to Vasari, Piero died in 1521 and was buried in the church of San Pier Maggiore, Florence.

Except for the apocryphally inscribed *Immaculate Conception* in San Francesco, Fiesole, none of Piero's extant pictures are signed or dated; moreover, the few known documents that refer to works by him are for the most part too ambiguous to establish the attribution, chronology, or iconography of his paintings. Vasari's attribution to Piero of sixteen paintings or cycles of paintings, one cartoon, and a book of pen drawings is therefore crucial to the reconstruction of his oeuvre. Of these works, more than half can be identified, and another forty paintings—including eight altarpieces, numerous private devotional images, and several of the mythological pictures for which Piero is particularly well known—can be attributed to him because of their stylistic connection with works described in Vasari's text.

While documents suggest that Piero's *Visitation with Saints Nicholas of Bari and Anthony Abbot* (fig. 60) and *Virgin and Child with Saints Peter, Rose of Viterbo, Catherine of Alexandria, and John the Evangelist* (Museo dello Spedale degli Innocenti, Florence) may have been executed about 1489 and 1493, respectively, most of his paintings can be dated only on the basis of internal evidence. For this reason it is virtually impossible to evaluate stylistic change within Piero's oeuvre without extensive recourse to comparisons with datable works by other artists. It is hardly surprising that his earliest identifiable paintings should owe something to the wooden style of his teacher, Rosselli; however, they betray a far greater debt to works by Filippino and Leonardo, whose combined influence is particularly evident in such (presumably) very early

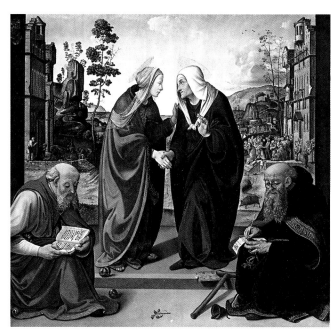

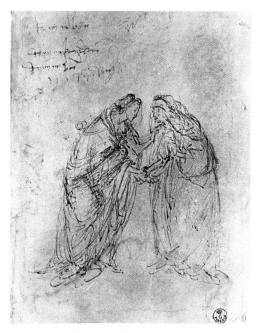

FIG.60 Piero di Cosimo. *Visitation with Saints Nicholas of Bari and Anthony Abbot*. Oil on panel, 184 x 189 cm. National Gallery of Art, Washington, D.C., Samuel H. Kress Collection

FIG.61 Piero di Cosimo. *Visitation*. Pen and brown ink with traces of black chalk on paper partially tinted yellow, 181 x 144 mm. Gabinetto Disegni e Stampe degli Uffizi, Florence 286 E recto

paintings as Piero's *Virgin and Child with Saints Lazarus and Sebastian* (Pieve dei Santi Michele e Lorenzo, Montevettolini) and a *Virgin and Child* in the royal collection at Stockholm. In the Stockholm picture, for example, the composition is derived from Filippino's Strozzi Madonna (pl. 17), while the subdued palette and the treatment of chiaroscuro may have their source in such early paintings by Leonardo as the Benois Madonna (The State Hermitage Museum, Saint Petersburg). Piero's introduction of meticulously rendered still-life elements reflects his interest in the achievements of his Netherlandish contemporaries. Nor was he indifferent to the work of Domenico Ghirlandaio and Luca Signorelli, both of whom had considerable impact upon the paintings he executed during the mid- to late 1480s and the 1490s.

In all likelihood Filippino and Piero knew each other, and although the former clearly exerted a strong influence upon the latter, it is also possible that aspects of Piero's style strongly appealed to the imagination of his older contemporary. Filippino's *Centaur in a Landscape* in Christ Church, Oxford (pl. 46), and his paintings of four saints in the Norton Simon Art Foundation, Pasadena (pls. 11, 12)—in which the head of Saint Fredianus is virtually identical to the head in Piero's posthumous "portrait" of Francesco Giamberti (Rijksmuseum, Amsterdam)—testify to the strong affinity between the works of the two artists. In paintings executed by Piero during the first decade of the sixteenth century, the influence of Filippino gradually gives way to that of Fra Bartolommeo, whose rather accessible brand of High Renaissance classicism informs the style of such late altarpieces as the *Virgin and Child with Saints John the Baptist and Thomas* (Chiesa del Crocifisso, Borgo San Lorenzo), the *Virgin and Child with Saints Dominic and Jerome* (fig. 68), and the Fiesole *Immaculate Conception*.

Only six drawings on five sheets are directly connected with paintings securely attributed to Piero di Cosimo. The earliest of these is a double-sided pen study for

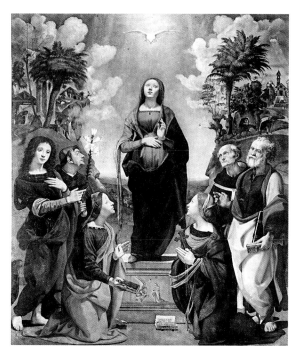

FIG.62 Piero di Cosimo. *Incarnation with Saints John the Evangelist, Filippo Benizzi, Catherine of Alexandria, Margaret, Antoninus, and Peter*. Oil on panel, 206 x 172 cm. Galleria degli Uffizi, Florence 506

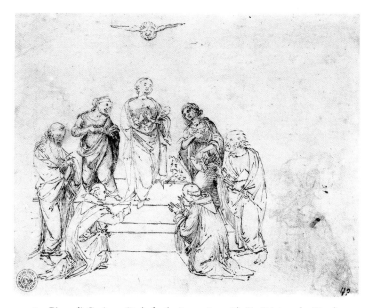

FIG.63 Piero di Cosimo. *Study for the Incarnation with Six Saints and a Standing and a Kneeling Figure*. Pen and brown ink and black chalk, 20.1 x 25.1 cm. Formerly Kunsthalle Bremen 42

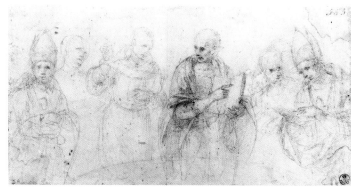

FIG.64 Piero di Cosimo. *Study for the Immaculate Conception in San Francesco a Fiesole*. Black and red chalk, 144 x 278 mm. Gabinetto Disegni e Stampe degli Uffizi, Florence 555 E

the figures of the Virgin and Saint Elizabeth (recto) (fig. 61) and for Saint Nicholas of Bari (verso) in Piero's *Visitation* painted about 1489 for a chapel in Santo Spirito, Florence, and now in Washington, D.C. A compositional sketch for the *Incarnation with Saints John the Evangelist, Filippo Benizzi, Catherine of Alexandria, Margaret, Antoninus, and Peter* (fig. 62) was formerly in the Kunsthalle Bremen (fig. 63). Both this sketch and a pen drawing in the Uffizi (inv. no. 176 E) for the *Virgin and Child with Angels* in the Galleria di Palazzo Cini, Venice, were probably executed about the middle of the first decade of the sixteenth century. Finally, there are in the Uffizi two studies in black and red chalk (inv. nos. 552 E, 555 E; fig. 64) for the upper and lower registers of the Fiesole *Immaculate Conception*, a very late work, perhaps datable to 1515–20.

On the basis of these five sheets about thirty other drawings can be attributed to Piero. These reveal that the influence of Rosselli was greater and lasted longer than Piero's paintings might suggest. Moreover, Piero's debt to Filippino is as apparent in some of his drawings as it is in his paintings. Finally, Piero's drawings reflect the complexity of his relationship with Fra Bartolommeo, for if the frate was at first influenced by the work of his older fellow-pupil in Rosselli's workshop, Piero seems eventually to have made every attempt to emulate the style of his younger contemporary.

W M G

1 For a detailed discussion of Piero's life and work, see Bacci 1966; Bacci 1976; Griswold 1988; and Fermor 1993.

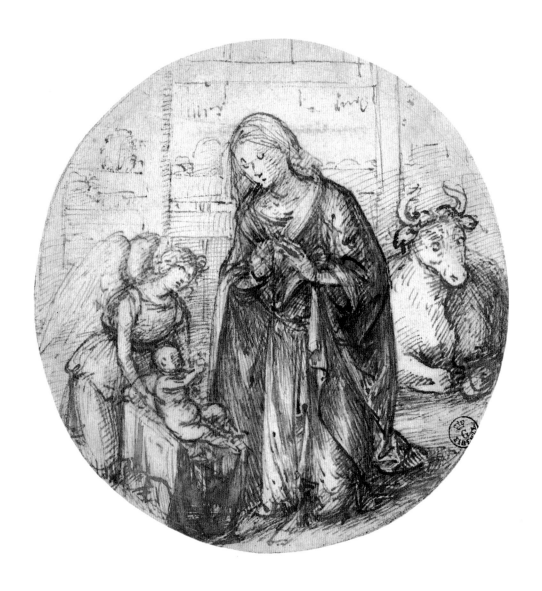

118 *Adoration of the Child*

Pen and brown ink, cut to shape of a tondo, ca. 138 x 132 mm
(5⅜ x 5¼ in.); lined, backing partially removed

Inscribed in brown ink on verso at upper center, *pietro perugino*
[canceled]; at lower center: *Pier di Cosimo*

Gabinetto Disegni e Stampe degli Uffizi, Florence 343 E

PROVENANCE: Houses of Medici and Lorraine (manuscript
inventory written by Giuseppe Pelli Bencivenni before 1793);
museum stamp (Lugt 930).

LITERATURE: Ferri 1879–81, no. 343; Ferri 1881, p. 22; Ferri
1890, p. 104; Morelli 1890, p. 156; Morelli 1891, p. 19, n. 1;
Morelli 1892–93, no. 6, col. 8, no. 211; Ferri 1895–1901, f. 31
verso; Ulmann 1896, p. 141 [workshop of Fra Bartolommeo/
Mariotto Albertinelli]; Knapp 1899, pp. 57, 58, 114, no. 12c, fig. 21;
Berenson 1903, vol. 1, p. 131, vol. 2, no. 1854; Loeser 1916, no. 2,
illus.; Giglioli 1922, p. 336; Van Marle 1923–38, vol. 13 (1931),
p. 386; Degenhart 1932, p. 103; Degenhart in Thieme-Becker
1907–50, vol. 27 (1933), p. 16; Berenson 1938, vol. 1, p. 153, vol.
2, no. 1854, vol. 3, fig. 417; Douglas 1946, p. 126 [Master of the
Borghese Nativity]; Berenson 1954, with no. 26; Fossi [Todorow]
1955, no. 83, fig. 26; Morselli 1958, p. 71; Fossi Todorow in
National Gallery of Art 1960, p. 20, no. 18; Berenson 1961, vol.
1, p. 223, vol. 2, no. 1854; Fossi Todorow in Uffizi 1961, p. 14,
no. 18, fig. 12; Bacci 1966, p. 112, illus. opposite p. 121; Dalli
Regoli 1974, pp. 74, 79, n. 77; Ragghianti Collobi 1974, p. 96;
Scholz 1976, p. xii; Griseri 1978, with no. 14; Vaccari 1981, p. 22,
no. 36b, illus.; Petrioli Tofani 1986, no. 343 E, illus. (recto and
verso); Griswold 1988, vol. 1, pp. 197–201, no. 12, vol. 2, pl. 25;
Griswold 1994, pp. 89–90, fig. 14.

Although the canceled inscription on the verso of
the sheet indicates it was formerly thought to be by
Perugino, this drawing has been attributed to Piero
di Cosimo since the seventeenth century and is the
only work correctly ascribed to him in Ferri's 1890
catalogue of drawings in the Uffizi. Morelli considered
the sheet fundamental to the reconstruction of Piero's
work as a draftsman, and both he and Berenson cited
it as evidence of the artist's formative influence upon
the young Fra Bartolommeo and Mariotto Albertinelli.

Despite Knapp's assertion that the sheet might have
been executed in connection with two tondi of iden-
tical composition in the Galleria Borghese, Rome, and
The State Hermitage Museum, Saint Petersburg, it is
not directly related to a known painting. Neverthe-
less, there can be little doubt that the drawing was
made relatively early in Piero's career. In style and
technique the *Adoration of the Child* is similar to the
Vision of Saint Bernard (British Museum, London, inv.
no. 1885-5-9-33), one of the very few sheets generally
agreed to be by Piero's teacher, Cosimo Rosselli. In
both drawings, short parallel lines and longer scribbled
strokes model the forms. In this respect and others
the sheet also invites comparison to early works by
Fra Bartolommeo. However, Piero's use of parallel

and cross-hatching differs from that of the younger
artist, who employed longer, straighter, and more con-
trolled strokes of the pen to define and articulate
the forms in his drawings. The anatomically unspecific
Virgin in the *Adoration* is more monumental than the
figures in Rosselli's drawings, and this may reflect the
influence of Luca Signorelli, which is pronounced
in Piero's early paintings but is otherwise not a major
component of his style as a draftsman.

Pentimenti in the *Adoration of the Child* suggest that
the figure of the angel was inserted after Piero had
drawn the Virgin and Child, presumably in order to
provide visual justification for the unstable half-
seated, half-reclining pose of the newborn Christ.
The pose of Christ is very similar to that in one of
two studies of a seated infant in the Istituto Nazionale
per la Grafica, Rome (inv. nos. F.C. 130473, 130481).
Executed with the point of the brush and brown
wash, heightened with white, on brick red prepared
paper, both drawings have been attributed to Piero
di Cosimo and may indeed be by him. In morphol-
ogy and pose the figures in the drawings in Rome
resemble the children in such paintings by Piero as
the altarpiece showing the Virgin and Child with
saints in the Museo dello Spedale degli Innocenti,
Florence, and the *Virgin and Child* in the Musée du
Louvre, Paris—both of which are datable to the
early to mid-1490s.

Given its similarity to Rosselli's *Vision of Saint
Bernard*, its relationship to the study of a seated infant
in Rome, and its affinity with such paintings as the
altarpiece in the Museo dello Spedale degli Innocenti
and Piero's *Virgin and Child* of the same period in
the Toledo Museum of Art, Ohio, the present sheet
can perhaps be dated to the early 1490s.

As a fairly secure work by Piero di Cosimo, the
Adoration of the Child provides support for the attri-
bution to him of many other drawings. It is close in
style to the pen sketch of an infant on the verso of
one of two drawings of Saint Jerome in the Wilderness
(Uffizi, Florence, inv. nos. 7 P, 403 P), which are gen-
erally considered to be by Piero. A sheet of studies
for an unidentified altarpiece in the Biblioteca Reale,
Turin (inv. no. 15616), also has features in common
with the present sketch.

WMG

119 *Head and Shoulders of a Young Woman Looking Down toward the Right*

Metalpoint, heightened with white gouache, on light blue prepared paper, 165 x 133 mm (6½ x 5¼ in.)

The Metropolitan Museum of Art, New York; Bequest of Walter C. Baker, 1971 1972.118.268

PROVENANCE: Colnaghi, London; Walter C. Baker, New York.

LITERATURE: Colnaghi & Co. 1951, no. 15; Parker and Byam Shaw 1953, no. 34; *Burlington Magazine* 106 (June 1964), illus. p. lxxxviii; Colnaghi & Co. 1964, no. 6, illus. (frontis.); *Emporium* 1964, pp. 88, 90, illus.; Bean and Stampfle 1965, no. 24, illus. [attributed to Piero di Cosimo]; Bacci 1966, p. 112 [not Piero di Cosimo]; Dalli Regoli 1974, pt. 1, p. 63, n. 4 [Fra Bartolommeo?]; Bean and Turčić 1982, no. 177 [Piero di Cosimo?]; Griswold 1988, vol. 1, pp. 257–58, no. 27, vol. 2, pl. 34; Griswold 1994, pp. 88–89, fig. 13; Griswold 1996, pp. 42, 46 n. 11.

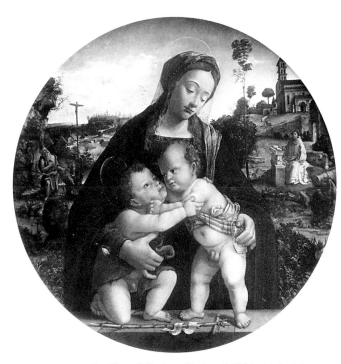

FIG. 65 Piero di Cosimo. *Virgin and Child with the Infant Saint John the Baptist*. Oil on panel, d. 93 cm. Musée des Beaux-Arts, Strasbourg

The firm contours and use of short, diagonal hatching relate this sheet to such early drawings by Piero as the *Adoration of the Child* (cat. no. 118) and the study of hands on the verso of a sheet in the Biblioteca Reale, Turin (inv. no. 15616), which was recognized as Piero's work by Bertini.[1] Moreover, the application of the highlights in short, parallel strokes is similar to that in two studies of a seated infant in the Istituto Nazionale per la Grafica, Rome (inv. nos. F.C. 130473, 130481), which, although disputed, may have been drawn by Piero during the early 1490s. There are few sketches by Piero in metalpoint, however, and the technique and color of the preparation of the paper in this example are more reminiscent of drawings by Filippino than of works by Piero's teacher, Cosimo Rosselli. The connection to Filippino is underlined by the suggestion, communicated orally to the present author by Turčić, that the sheet might have been executed by an artist from Lucca, where works by the young Filippino presumably had an influence upon local painters. Nevertheless, the emphatic plasticity of the forms and luminous touches of white that highlight the bridge of the nose and side of the neck are characteristic of Piero's work as both painter and draftsman.

The shape of the face, as well as the somewhat bulbous nose, small mouth, receding chin, shallow set of the eyes, and arrangement of the hair, recalls the paintings of Hans Memling and other fifteenth-century Netherlandish artists. Despite the overwhelming impact of Netherlandish art upon Piero's paintings, the present sheet is one of very few drawings by him in which it is possible to detect a similar influence. Among these only Piero's two studies of Saint Jerome in the Wilderness (Uffizi, Florence, inv. nos. 7 P, 403 P), possibly executed about 1495–1500, betray a comparable debt to the art of northern Europe.

Bean (1982) suggested that the "tinge of Flemish influence and the Filippinesque style of draughtsmanship would seem to point to the early phase of the activity of Piero di Cosimo." The head in the drawing has strong morphological similarities to the head of the Virgin in the tondo showing the Virgin and Child with the Infant Saint John the Baptist (fig. 65). On the basis of style, that painting can be dated to the late 1490s—to which period this sensitive study should also be assigned.

WMG

1 Bertini 1950, figs. 422 (recto), 424 (verso).

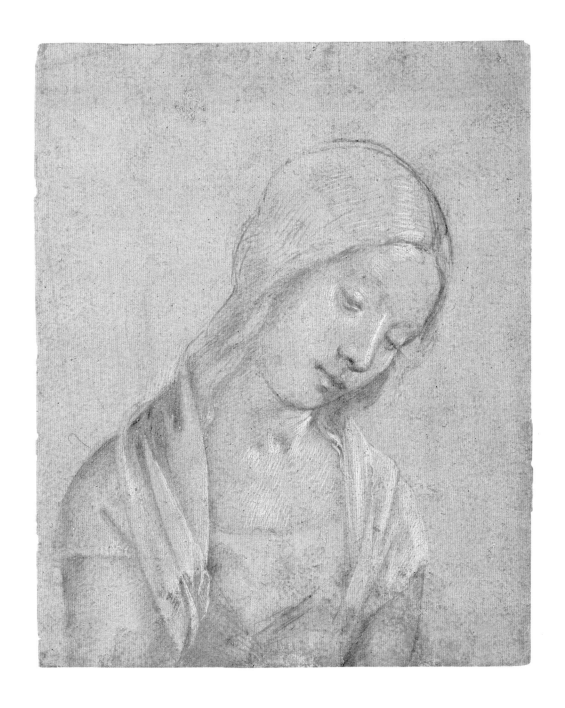

120 *Saint Francis Receiving the Stigmata*, recto

Fragmentary Study for a Virgin and Child, verso

Pen and brown ink, heightened with white gouache, over metalpoint on blue prepared paper, recto; pen and brown ink, verso, 110 x 147 mm (4⅜ x 5¾ in.); cut in half vertically (probably during eighteenth century) and the two parts reintegrated

The Pierpont Morgan Library, New York; Gift of Janos Scholz, 1980 1980.56

PROVENANCE: Jonathan Richardson Sr., London (Lugt 2183); Sir John Charles Robinson, London (Lugt 1433); Gruner; Wadsworth, Avon, New York; Janos Scholz, New York.

LITERATURE: Mills College Art Gallery 1961, no. 27; Scholz 1963, p. 18, no. 43; Scholz 1967, no. 40; Scholz 1976, p. xii, no. 11, illus. (recto); Ryskamp 1981, pp. 208–9; Griswold 1988, vol. 1, pp. 259–60, no. 28, vol. 3, pls. 3 (recto), 4 (verso); Griswold 1996, pp. 42, 46 n.12.

Ascribed to Leonardo on Richardson's mount, this spirited sketch was first attributed to Piero di Cosimo by Janos Scholz. The drawing is damaged, having been cut in half, probably when it was mounted during the eighteenth century. Although the two sections of the sheet have since been rejoined, the fragmentary pen sketch on the verso has suffered to such a degree that it is not immediately intelligible as a study for the lower part of the Virgin holding the infant Christ.

There are significant pentimenti in the figure of Brother Leo in the study on the recto, and it may have been precisely the disregard for legibility they indicate that inspired Richardson's attribution to Leonardo. The sheet is presumably a study either for part of a predella or for the background of a private devotional picture or altarpiece. The notation used to suggest the features of Saint Francis, the treatment of the hands and feet, and the animated poses of the figures are comparable to those in Piero's *Study for the Incarnation with Six Saints*, datable to the middle of the first decade of the cinquecento and formerly in the Kunsthalle Bremen (fig. 63). The present sheet is also similar in style to a sheet of studies in the Biblioteca Reale, Turin (inv. no. 15616), which was probably executed somewhat earlier in Piero's career.

Like the *Head and Shoulders of a Young Woman* in the Metropolitan Museum (cat. no. 119), the Morgan Library drawing is on blue prepared paper, and it too betrays the influence of Filippino. This is especially evident in the spare, calligraphic pen work and luminous highlights, which in drawings by Filippino, however, are generally used in a more decorative—and less descriptive—fashion.

Although the upper part of the figure of the Virgin in the pen sketch on the verso has been cut away, making it impossible to determine her exact pose, the motif appears to have been similar to that in a painting in a private collection in Hertfordshire.[1] Attributed to Piero by Berenson, the painting is more likely a copy after a lost work he produced during the first decade of the cinquecento, as Bacci has suggested. Scholz compared the style of the sketch on the verso to that of the *Adoration of the Child* in the Uffizi (cat. no. 118). There are marked similarities between the two drawings, but the extraordinary freedom of the pen work and unsystematic cross-hatching that distinguish the present sheet also recall such early works by Fra Bartolommeo as a sketch of the Adoration of the Child in the Hamburger Kunsthalle (inv. no. 21371). The drawing by Fra Bartolommeo is so close in style to sheets executed by Piero about 1500 that this writer was formerly inclined to attribute it to him.[2] The handling of both sides of the present work is consistent with a date about the turn of the fifteenth century, before the influence of Filippino and Leonardo was supplanted by that of the mature Fra Bartolommeo.

WMG

1 See Bacci 1976, no. 72, illus.

2 Griswold 1988, vol. 1, pp. 237–39, no. 21, vol. 2, figs. 41 (recto), 42 (verso).

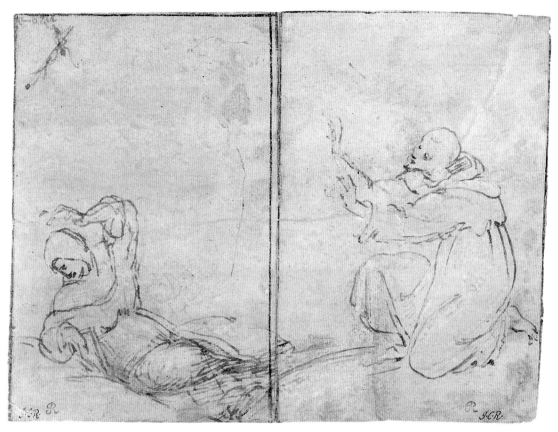

120 RECTO

120 VERSO

121 *Descent of the Holy Spirit*

Pen and brown and red-brown ink, 306 x 239 mm (12 x 9⅜ in.); upper left corner made up

Inscribed in brown ink at lower left: *P. Perugino*; on old mount: *P. Perugino*

Collection Frits Lugt, Institut Néerlandais, Paris 7263

PROVENANCE: Blaise Castle, Gloucestershire; John Scandrett Harford, acquired ca. 1815–29; by descent, Sir John Harford, second baronet; Colnaghi & Co., London; Frits Lugt, Paris, acquired by exchange, March 5, 1959 (Lugt 1028).

LITERATURE: Colnaghi & Co. 1959, no. 1 [Piero di Cosimo?]; Byam Shaw 1983, vol. 1, no. 12, vol. 3, pl. 15; Griswold 1988, vol. 1, pp. 261–63, no. 29, vol. 2, pl. 62.

Traditionally ascribed to Perugino, this impressive study was first attributed to Piero di Cosimo by Byam Shaw, who noted that it reveals "a mixture of Florentine and Umbrian elements." Although some parts of the drawing are more finished than others, the sheet appears to have been executed after the artist had established the composition in one or more comparatively rapid—and presumably somewhat smaller—sketches. The sheet is similar in style to Piero's study for the Uffizi *Incarnation with Six Saints* (fig. 63), as well as to such later drawings as the *Adoration of the Child* in the Graphische Sammlung Albertina, Vienna (inv. no. SC. R. 103). This connection is important, for it helps to justify the attribution to Piero of a number of other sheets that are stylistically related to the Vienna study but are less close in handling to the few drawings that correspond to the artist's known paintings. Among the drawings that show similarities to the *Adoration of the Child* in Vienna are no fewer than four studies for an *Expulsion of Joachim from the Temple* (Uffizi, Florence, inv. nos. 168 E, 169 E, 170 E verso; Palais des Beaux-Arts, Lille, inv. no. 269). Although Berenson's attribution of these four sheets to Piero has been challenged, there is much to recommend it; moreover, the recent assignment to the artist of a pen sketch in the Nationalmuseum, Stockholm (inv. no. 283), which has features in common with the *Expulsion of Joachim* studies and also with drawings demonstrably by Piero, further strengthens the theory that the whole group should be ascribed to him.[1]

While much of the bottom half of the present study was drawn in the rapid, jagged, and scribbled strokes typical of Piero's earliest known pen drawings, the entire upper part of the composition as well as the figures of the Virgin and the apostle on her left are rendered with a precision comparable to that of sheets by the young Fra Bartolommeo. The treatment of the drapery, the uncharacteristically wispy hair and beards of the apostles and of God the Father, and the

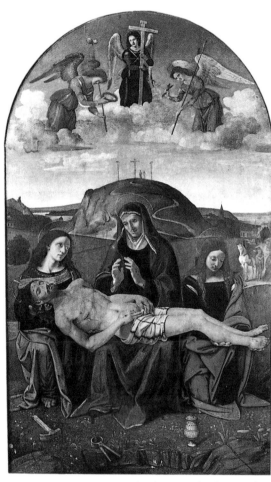

FIG. 66 Piero di Cosimo. *Pietà with Saints John the Evangelist, Mary Magdalen, and Martin.* Oil on panel, 190 x 112 cm. Galleria Nazionale dell'Umbria, Perugia 383

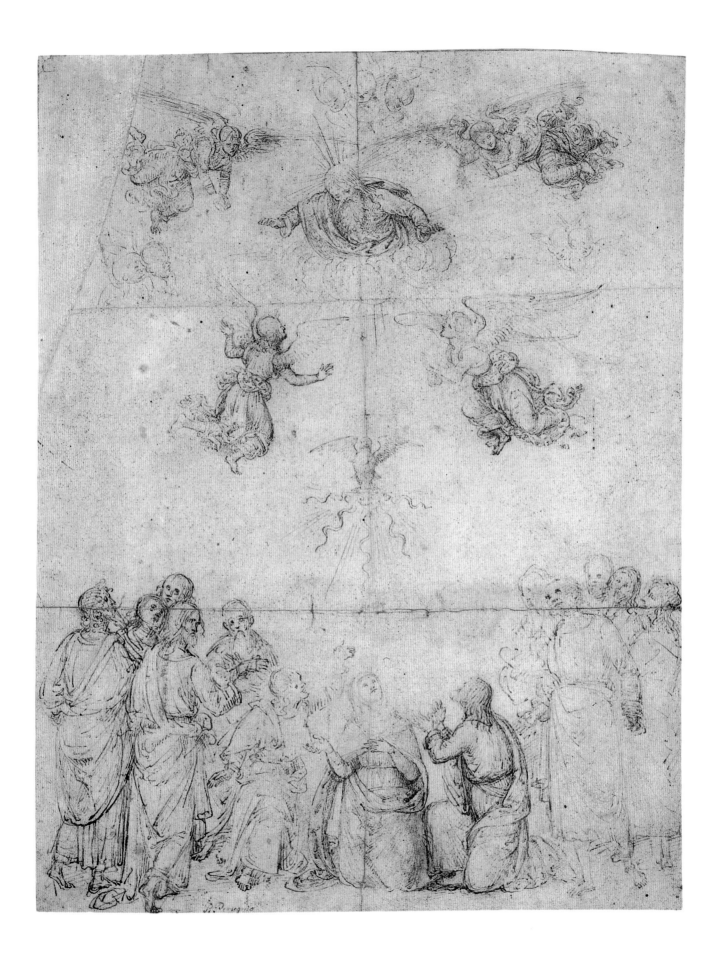

delicacy of the modeling may also reflect the influence of drawings by the younger artist.[2]

The example of Fra Bartolommeo seems to have had a major impact upon Piero's later work as a painter of religious subjects. Piero's *Incarnation with Saints*, datable to the middle of the first decade of the sixteenth century (fig. 62), for instance, owes a great deal to the style of Fra Bartolommeo's *Vision of Saint Bernard* of 1504–7 (Uffizi, Florence); its composition is also related to that of Mariotto Albertinelli's *Virgin and Child with Saints Jerome and Zenobius*, 1506 (Musée du Louvre, Paris). That Piero was familiar with Fra Bartolommeo's drawings and paintings is evidenced not only by the present work: while he never entirely abandoned the use of graphic conventions derived from the study of works by Cosimo Rosselli, Filippino, and other fifteenth-century artists, the style of his sheets datable after about 1505–10 tends to be more delicate and controlled—in the manner of Bartolommeo—than that of earlier drawings, for example, his study (fig. 61) for the *Visitation* in Washington, D.C.

While the handling of the pen in the *Descent of the Holy Spirit* recalls works by Fra Bartolommeo, the composition is closer to that of paintings by Perugino, whose altarpieces provided a model of classical restraint to many artists of Piero's generation. The comparatively slender figures and spacious, symmetrical composition are analogous to those in paintings by Piero of about 1510 such as the *Adoration of the Child* in the National Gallery of Art, Washington, D.C., and the *Pietà* in the Galleria Nazionale dell'Umbria, Perugia (fig. 66), in which the influence of Perugino is particularly evident. Although it is impossible to date most of Piero's drawings with absolute certainty, it can be said that the present work might have been made toward the end of the first decade of the sixteenth century.

WMG

1 See Griswold 1996, pp. 42–43, 46 n. 14, figs. 3 (recto), 4 (verso).

2 See, for example, Uffizi, Florence, inv. nos. 468 E, 1237 E. See also Fischer 1986a, nos. 22, 24, illus. According to Fischer, these drawings were executed during the first half of the first decade of the cinquecento.

122 *Virgin Kneeling, Embracing the Christ Child, and Two Studies of a Left Hand*

Metalpoint, pen and brown ink and touches of brown wash, heightened with white gouache, on lavender-gray prepared paper, 184 x 242 mm (7¼ x 9½ in.)

Watermark: Similar to Briquet nos. 8341–54

Gabinetto Disegni e Stampe degli Uffizi, Florence 297 E

PROVENANCE: Houses of Medici and Lorraine; blind stamp erroneously described as that of Cardinal Leopoldo de' Medici (Lugt 2712); museum stamp (Lugt 930).

LITERATURE: Ferri 1879–81, no. 297 [Domenico Ghirlandaio]; Ferri 1881, p. 19 [Domenico Ghirlandaio]; Ferri 1890, fasc. 1, p. 81 [Domenico Ghirlandaio]; Berenson 1903, vol. 2, no. 940 [Francesco Granacci]; Berenson 1938, vol. 2, no. 940, vol. 3, fig. 387 [Francesco Granacci]; Berenson 1961, vol. 2, no. 940, vol. 3, fig. 331 [Francesco Granacci]; Dalli Regoli 1968, p. 32 n. 2 [Fra Bartolommeo]; Ragghianti and Dalli Regoli 1975, pp. 122, 123, 141, fig. 70 [Fra Bartolommeo]; Petrioli Tofani 1986, no. 297 E, illus. [Francesco Granacci]; Griswold 1988, vol. 1, pp. 194–96, no. 11, vol. 2, pl. 82; Griswold 1996, pp. 44, 47–48 n. 30.

During the nineteenth century this drawing was attributed to Domenico Ghirlandaio, but in 1903 Berenson suggested that it was instead by Francesco Granacci, under whose name it is still classified in the Uffizi. Recently Dalli Regoli published the sheet as a work by the young Fra Bartolommeo. None of these attributions are satisfactory. The modeling of the forms is at once too dense and too descriptive to support an attribution to Granacci, whose pen drawings are more delicate and calligraphic.[1] Nor is the present sheet technically or stylistically compatible with drawings by Fra Bartolommeo; in even the earliest of his known pen drawings the forms are more incisively rendered and more structurally articulate than in this study.

It does, however, have many features in common with drawings more or less securely attributable to Piero di Cosimo. The use of metalpoint, pen, wash, and white heightening on prepared paper points to the work of a draftsman trained in the fifteenth century. As in the *Descent of the Holy Spirit* (cat. no. 121) and other sheets executed by Piero after about 1500, long, scratchy, vertical pen strokes model the forms, while short, swift, parallel hatching describes the troughs of the drapery folds. In the large scale of the figures and the fluency with which the artist rendered the forms of the Virgin embracing the Christ Child, it is comparable to a number of fairly late drawings by Piero, including the pair of studies in black and red chalk for the Fiesole *Immaculate Conception* (Uffizi, Florence, inv. nos. 552 E, 555 E;

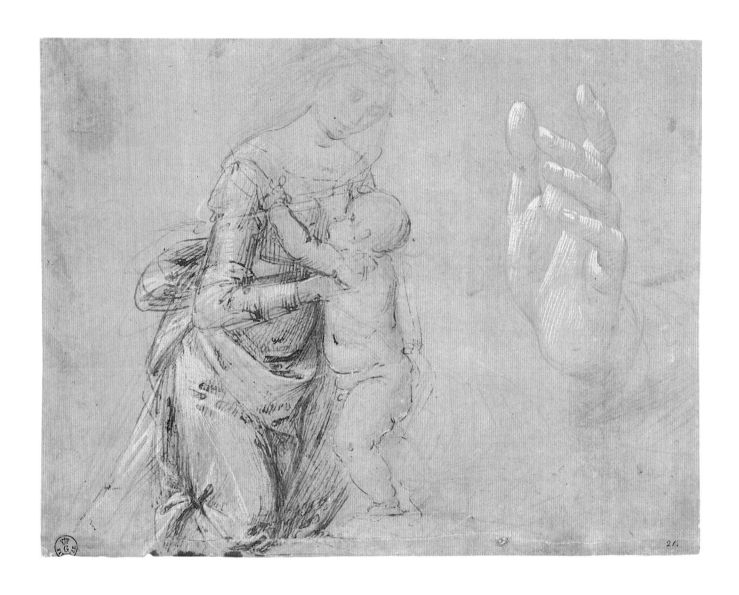

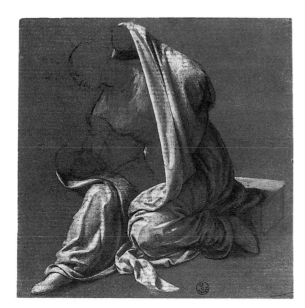

FIG.67 Piero di Cosimo. *Study of Drapery on Seated Figure.*
Point of brush and brown ink and brown wash, heightened
with white gouache, over metalpoint on olive brown prepared
paper, 182 x 187 mm. Gabinetto Disegni e Stampe degli Uffizi,
Florence 1963 F

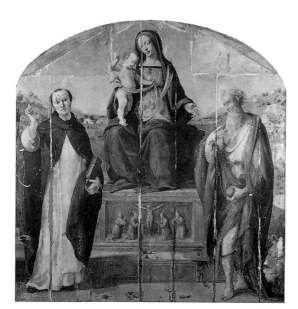

FIG.68 Piero di Cosimo. *Virgin and Child with Saints Dominic
and Jerome.* Oil on panel, 209 x 205.7 cm. Yale University Art
Gallery, New Haven, purchase from James Jackson Jarves
1871.73

fig. 64); a double-sided sheet of studies published by
Degenhart (Uffizi, Florence, inv. no. 6369 F); the
Bearded Religious in Rome (cat. no. 123); and a study
of drapery on a seated figure (fig. 67), which was
independently attributed to Piero by Petrioli Tofani
and the present writer.[2]

Piero's paintings offer numerous parallels to motifs
in the drawing. The two studies of a left hand, which
appear to have been drawn prior to the Virgin and
Child, correspond closely to the left hand of the Virgin
in the Tedaldi *Incarnation with Saints* (Uffizi, Florence).
Nevertheless, the drawing is almost certainly later
than the altarpiece, which dates to the middle of the
first decade of the sixteenth century. While the pose
of the Virgin in the drawing differs from that in any
of Piero's surviving paintings of the Nativity or the
Adoration of the Child, the figure is similar in con-
ception to that of Saint Joseph in the *Adoration of the
Shepherds,* formerly in the Kaiser Friedrich Museum,
Berlin. Neither as uncompromisingly erect as the
figures in the *Virgin and Child with Saints Dominic
and Jerome* in the Yale University Art Gallery, New
Haven (fig. 68), nor as mannered in pose as those in
the foreground of the *Liberation of Andromeda* in the
Uffizi, the Virgin is imbued with a dynamism not
unlike that in Piero's *Virgin and Child with the Infant
Saint John* in the Museu de Arte, São Paulo. It
therefore seems possible that the present drawing,
like the painting in São Paulo, was executed about
1510–15, when Piero was strongly influenced by the
example of the mature Fra Bartolommeo. The pre-
sent work and the *Bearded Religious* thus constitute a
hypothetical link between Piero's early, Filippinesque
pen drawings and such later sheets as his studies in the
Uffizi for the Fiesole *Immaculate Conception* (fig. 64).

WMG

1 See, for example, British Museum, London, inv. nos. 1895-
9-15-468 and 1936-12-12-33 (Turner 1986, nos. 59, 60,
illus.).

2 Griswold 1988, vol. 1, pp. 221–24, no. 17, vol. 2, fig. 89;
Petrioli Tofani 1992, no. 3.8, illus.

123 *Bearded Religious, Kneeling and Facing Left*, recto

Landscape with a Town on a Riverbank, verso

Pen and brown ink and brown wash, heightened with white gouache, on salmon-tinted paper, recto; pen and brown ink, verso, 201 x 173 mm (7⅞ x 6⅞ in.)

Istituto Nazionale per la Grafica, Rome F.C. 130507

PROVENANCE: Filippo Baldinucci, Florence?; Cardinal Francesco Maria de' Medici, Florence and Rome?; Neri Maria Corsini, Rome?

LITERATURE: Berenson 1903, vol. 2, no. 20 [Mariotto Albertinelli]; Gabelentz 1922, vol. 2, p. 173, no. 447 [Mariotto Albertinelli]; Berenson 1938, vol. 2, no. 20 [Mariotto Albertinelli]; Grassi 1947, p. 116, no. 16, pl. 14 [Mariotto Albertinelli]; Berenson 1961, vol. 2, no. 20 [Mariotto Albertinelli]; Beltrame Quattrocchi 1979, no. 36, illus. [Mariotto Albertinelli]; Catelli Isola et al. 1980, pp. 41, 134, no. 14, illus. [Mariotto Albertinelli]; Griswold 1988, vol. 1, pp. 272–74, no. 33, vol. 2, pls. 83 (recto), 84 (verso); Prosperi Valenti Rodinò 1993, no. 9, illus. [Mariotto Albertinelli]; Griswold 1996, pp. 43–44, 47 n. 25, figs. 7 (recto), 8 (verso).

The attribution to Mariotto Albertinelli, apparently first suggested by Berenson, is untenable. Very few pen drawings can be securely assigned to Albertinelli, and those definitely related to his paintings, including a sheet connected with the figure of Saint Dominic in an early triptych at Chartres (Uffizi, Florence, inv. no. 546 E) and two sketches for the *Trinity* in the Galleria dell'Accademia, Florence (Uffizi, Florence, inv. nos. 556 E, 19168 F), seem to be by a different hand. The forms in Albertinelli's undisputed drawings are modeled with delicate, closely spaced parallel diagonal lines and systematically crossed strokes. The impetuous handling of the present drawing also differs from the style of sheets by Fra Bartolommeo. Instead, the scratchiness of the pen work, the use of brightly tinted paper, and the reticent expression of the figure recall works by Albertinelli's former associate in Cosimo Rosselli's workshop, Piero di Cosimo.

In style the drawing is comparable to the *Virgin Kneeling* (cat. no. 122), in which similarly long, scratchy, vertical pen lines also model the forms. Moreover, the scale of the figure, the arrangement of the drapery, and the notation used to suggest the features of the face have parallels in such other presumably late drawings by Piero di Cosimo—for example, both studies for the *Immaculate Conception* in Fiesole (Uffizi, Florence, inv. nos. 552 E, 555 E; fig. 64) and a sketch of drapery on a seated figure (fig. 67), which must have been executed about the same time as the *Liberation of Andromeda* in the Uffizi and so cannot be much earlier than 1515–21. Drawn with the brush, brown ink, brown wash, and white heightening on

olive brown prepared paper, the drapery study reflects the degree to which Piero, even at the end of his career, was unwilling to abandon such late-fifteenth-century conventions as the use of prepared paper. In the same way the *Bearded Religious* demonstrates his continued adherence to established practice: the reddish tint of the support is almost identical to that of several considerably earlier works by Piero, including the *Study of a Bear and Her Cub, Two Deer, and the Head of an Ox* in the Boijmans Van Beuningen Museum, Rotterdam (inv. no. I.242), datable by comparison to paintings and other drawings to the late 1490s or the first decade of the sixteenth century.

The compact monumentality, erect posture, and overall proportions of the figure in the present sheet relate it to the flagellants in the feigned relief beneath the feet of the Virgin in the *Virgin and Child with Saints Dominic and Jerome* in the Yale University Art Gallery, New Haven (fig. 68). Moreover, the facial types of the kneeling religious in the drawing, Saint Jerome in the altarpiece in New Haven, and the saints in the lower register of the *Immaculate Conception* in Fiesole are comparable. Given the marked similarities between the *Bearded Religious* and paintings and other drawings made by Piero di Cosimo toward the end of his career, this sheet may be among the last of his extant pen studies.

The drawing on the verso of the sheet, rendered with swift, incisive, and disorderly strokes of the pen, is comparable in handling—if not in conception—to *Saint Jerome in a Rocky Wilderness* (Uffizi, Florence, inv. no. 7 P) and to a recently identified study of ruined architecture, also carried out in pen and ink on tinted paper, on the verso of a sketch of the *Adoration of the Shepherds* in the Nationalmuseum, Stockholm (inv. no. 283). It also has features in common with the many landscape drawings that Fra Bartolommeo made about the turn of the fifteenth century, but his studies of landscapes and trees are invariably more delicate and precise in handling. Although the sketch on the verso of the present work may have been executed outdoors, rather than in the studio, the town in the middle distance has not been identified; this writer's previous suggestion (1988) that it might be Prato now seems rather unlikely.

W M G

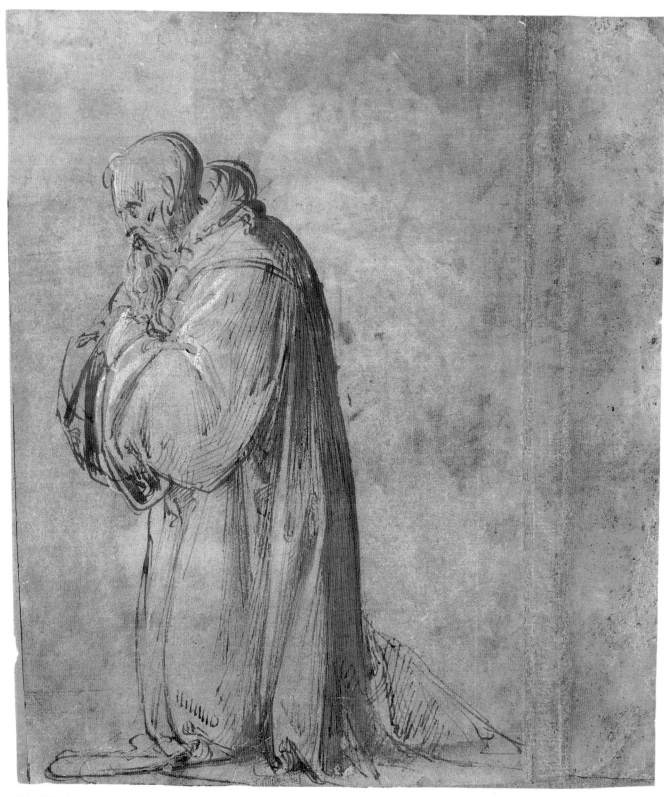

123 RECTO

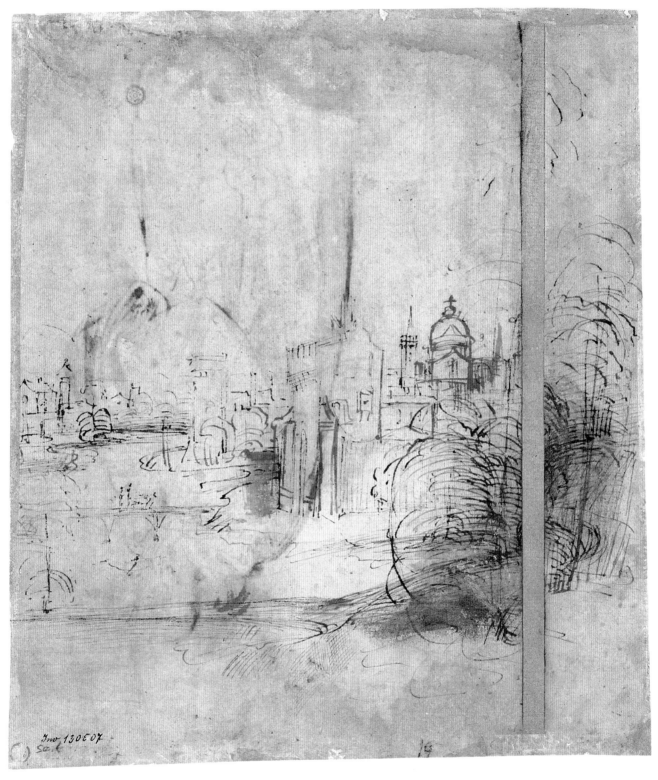

123 VERSO

124 *Head of a Woman Turned to the Left,* recto
Nude Infant Turned to the Right, verso

Black chalk and brown wash, heightened with white gouache, on red-orange tinted paper, 223 x 165 mm (8¾ x 6½ in.), maximum

Inscribed in brown ink on verso at lower left, possibly by Filippo Baldinucci: *F. Fili.o Lippi*

Gabinetto Disegni e Stampe degli Uffizi, Florence 274 E

PROVENANCE: Houses of Medici and Lorraine (manuscript inventory written by Giuseppe Pelli Bencivenni before 1793); museum stamp (Lugt 930).

LITERATURE: Pouncey 1964, p. 293, pl. 40b; Dalli Regoli 1966, p. 110, no. 26, fig. 84 [Lorenzo di Credi]; Petrioli Tofani 1986, pp. 120–21, no. 274 E, fig. 274Er [Filippino Lippi]; Chiarini, Dillon, and Petrioli Tofani 1993, pp. 5–6; Di Giampaolo 1994, pp. 293–94, fig. 15.

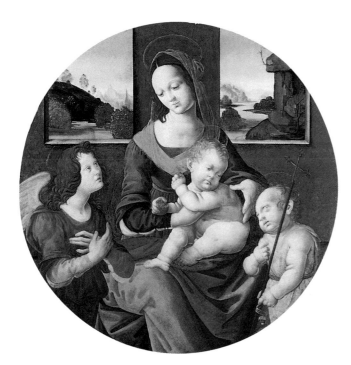

FIG. 69 Workshop of Lorenzo di Credi. *Virgin and Child with Two Angels.* Oil on panel, d. 85 cm. National Gallery of Ireland, Dublin 1140

Apparently, the traditional attribution to Filippino of this little-known sheet of studies originated as early as 1793 in Pelli Bencivenni's manuscript inventory of the Uffizi drawings. Although it has often been maintained since, the type of the woman's head on the recto is recognizable in scores of panels with the Virgin painted in the workshop of Lorenzo di Credi; among these it is closest in design to the *Virgin and Child with Two Angels* in the National Gallery of Ireland, Dublin (fig. 69). Indeed, in style and technique, this study is precisely comparable to a distinctive group of highly finished drawings that Berenson attributed to the master known as Tommaso, who is thought to be the author of the Dublin painting.[1] The present sheet was first attributed to Tommaso by Pouncey, as recorded on the mount. Like the drawing on the recto of this sheet, studies by Tommaso in the Uffizi (inv. no. 271 E) and the Nationalmuseum, Stockholm (inv. nos. 95, 97), treat the head much as if it were a detached sculpture fragment. In all these examples the forms are sharply lit from above with a flash-of-lightning effect, and the mannered chiaroscuro is refined with painterly combinations of black chalk, ink washes, and hatched white highlights, which flicker against the deep red-orange tint of the paper. Another head study in the Uffizi (inv. no. 1195 E), for a Virgin, can be given to Tommaso as well, although it is more tightly executed and introduces metalpoint to the painterly rendering with wash and white gouache on reddish tinted paper. Carried out in the same finished brush technique, the nude, puppetlike infant on the verso of the present sheet resembles figures of babies by Cosimo Rosselli, Lorenzo di Credi, Piero di Cosimo, and the young Fra Bartolommeo.

This sheet can tentatively be dated between 1510 and 1520 and seems to be the work of a young artist reliant on older, established models. Indeed, the entire corpus of drawings and paintings associated with Tommaso suggests roots in the workshop tradition of Credi and an affinity with Leonardo, Piero di Cosimo, Fra Bartolommeo, and Raffaellino del Garbo. At least for the definition of Tommaso as a draftsman, his link with the style and technique of Raffaellino del Garbo's small-scale, late drawings (for example, cat. nos. 112, 114, 116) should be emphasized, especially in terms of the choice of deep reddish tinted papers, highlights that set up strong contrasts, and loose brush and chalk treatment.

The creation of Tommaso is owed to Morelli, who invented him in his studies of 1890 and 1891 and identified him with Tommaso di Stefano Lunetti (ca. 1495–1564),[2] an artist listed by Vasari as the son of a manuscript illuminator and one of Credi's principal pupils. The firmest touchstone for reconstructing

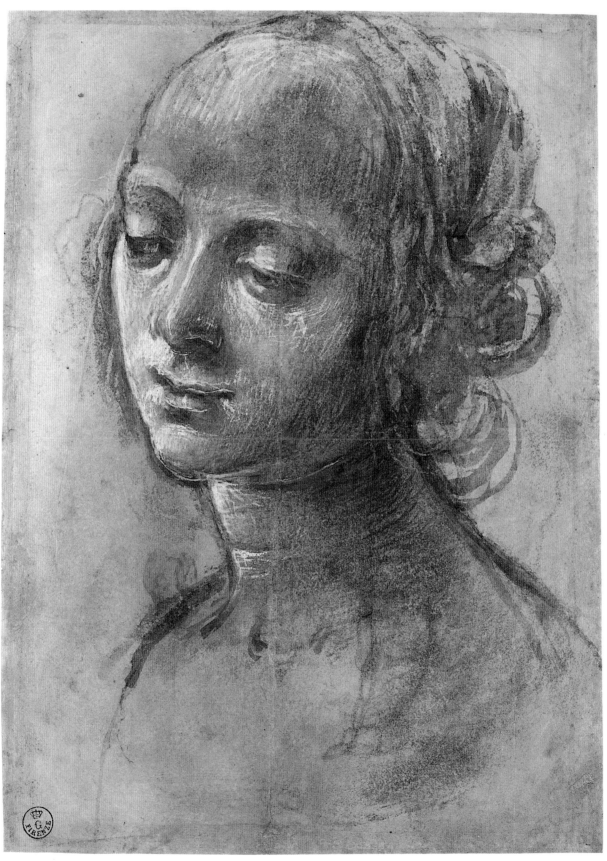

124 RECTO

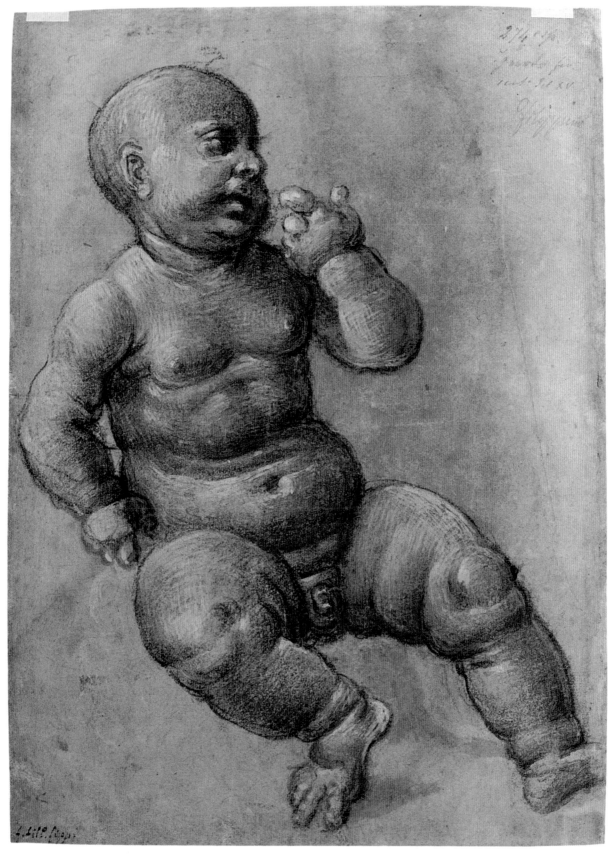

124 VERSO

Lunetti's painted oeuvre is the *Portrait of a Man* in The Metropolitan Museum of Art (inv. no. 17.190.8), signed Tommaso Fiorentino and dated 1521. But it is the other point of reference for Lunetti's work, his altarpiece the *Adoration of the Shepherds* for the chapel of Villa Capponi at Arcetri, near Florence,[3] that offers relevant parallels for this drawing: the woman's head and the nude Child echo the types of Credi, and the mannered treatment of the chiaroscuro is close to that of Leonardo and Credi after 1500. The painting, however, may well prove to be a decade later in date than the drawing.

Tommaso and Tommaso di Stefano Lunetti are now correctly considered to be two different artists, but Morelli's interpretation was accurate in focusing on the inextricably close similarities of style shared by the pupils who worked under Credi in the last three decades of his life. Berenson's identification in 1903 of Tommaso with Giovanni di Benedetto Cianfanini (1462–1542) was not a radical departure from Morelli's view, since Cianfanini, like Lunetti, seems to have been a follower of Credi's. In his *Life* of Credi, Vasari mentions only Tommaso di Stefano and Giovanni Antonio Sogliani as pupils of the artist, but in his biography of Fra Bartolommeo he does include a Benedetto Cianfanini as a follower of the frate's.[4] Notwithstanding his early assertion that Tommaso was Cianfanini, Berenson (1903, 1938) stated with growing conviction that he was closely related to Piero di Cosimo and that he might be Piero himself, in an unrecognized late phase of his career. The identity of Tommaso is today considered synonymous with that of the Master of the Tondi, the Master of the Czartoryski Tondo, and the Master of the *Conversazione* of Santo Spirito. Despite the nearly insurmountable difficulty of documenting Tommaso as a historical personality, the corpus of work attributed to him by Morelli, Berenson, and Fahy is strikingly coherent.

CCB

1 Everett Fahy has generously made available his reconstruction of Tommaso's oeuvre (unpublished manuscript).

2 Morelli 1890, pp. 114–15; Morelli 1891, p. 131. See also Stechow 1928; Gamba 1928–29, pp. 466–71; Berenson 1932a; Degenhart 1932, pp. 129–37; and Berenson 1933b, pp. 251–55.

3 Vasari 1906, vol. 4, p. 570.

4 Ibid., pp. 200, 569–70. Giovanni di Benedetto Cianfanini ("*pictoris*") was named as a witness in Lorenzo di Credi's will on April 3, 1531, along with Credi's pupils Stefano di Tommaso ("*miniatoris*") and Giovanni Antonio di Francesco Sogliani ("*pictoris*").

125 *Noah Reading*, recto

Jacob Reading, verso

Pen and brown ink over traces of black chalk, 140 x 204 mm (5½ x 8 in.)

Inscribed in ink on recto at left: *NOE*; at right: *PRIARCHA*; on verso at left: *JA/COB*; on scroll: *HEC EST DOMV DELET PORT*; at right: *PRIA/RCHA*; all presumably by the artist; in black chalk on recto and verso at lower center by later hand: *Rafaolo*; in ink on recto at upper right by later hand: *26799*

Département des Arts Graphiques du Musée du Louvre, Paris 3848

PROVENANCE: Pierre-Jean Mariette, Paris (Lugt 1852); Charles Paul Jean-Baptiste de Bourgevin Vialart de Saint-Morys, Paris and Château d'Hondainville, near Beauvais; Saint-Morys collection, seized by revolutionary authorities, 1793; incorporated into Musée du Louvre, 1796–97 (Lugt 1886).

LITERATURE: Passavant 1860, vol. 2, p. 475 [manner of Raphael]; Ruland 1876, p. 121, d/vii, nos. 1, 2 [attributed to Raphael]; Fischel 1913–41, vol. 15 (1924), pp. 229, 233, with no. 215 [School of Raphael]; Monbeig Goguel in Grand Palais 1983, nos. 64, 65; Oberhuber and Ferino-Pagden 1983a, nos. 276, 277 [Raphael? or perhaps a copy]; Oberhuber and Ferino-Pagden 1983b, nos. 276, 277; Arquié-Bruley, Labbé, and Bicart-Sée 1987, vol. 2, p. 93; Joannides 1990, pp. 270–71, n. 6; Académie de France à Rome 1992, p. 120, no. 40, illus.; Cordellier and Py 1992, p. 94, no. 83, illus.; Goldner 1994, p. 158, figs. 4, 5.

The attribution of this double-sided sheet to Raphael was reintroduced in modern times by Oberhuber and Ferino-Pagden in the Italian edition of the catalogue raisonné. It has since achieved general acceptance and surely is correct. Recto and verso copy Filippino's vault frescoes of Noah and Jacob in the Strozzi Chapel, Santa Maria Novella, Florence (pl. 23), the decoration of which had been completed shortly before Raphael's move to Florence.

As Monbeig Goguel and Cordellier and Py have noted, Raphael's interest in Filippino began early in his career and is evidenced in an ornamental study in the Ashmolean Museum, Oxford (inv. no. P II 502). Raphael moved to Florence in 1504 and remained there, except for trips to Urbino and Perugia, until 1508. The present sheet was drawn during this period, perhaps toward its end. The draftsmanship is varied and highly animated—especially notable for a copy—showing great self-assurance. Raphael made a few modifications of the configurations in the frescoes, such as the alteration in the turn of Jacob's head, but these are relatively inconsequential and must result from the desire to abbreviate.

GRG

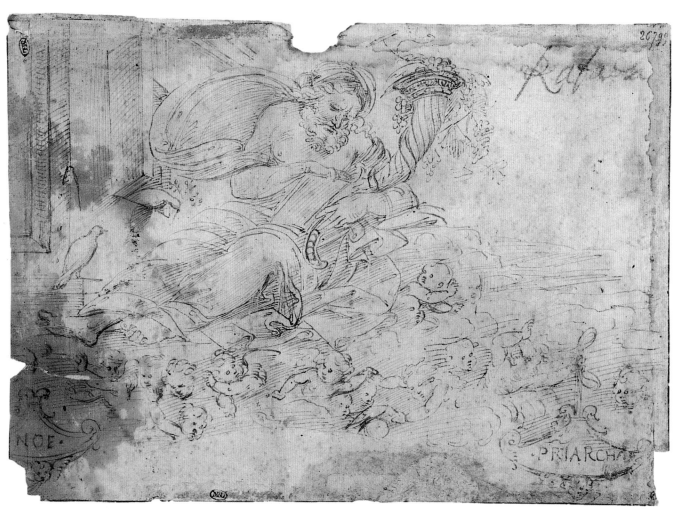

125 RECTO

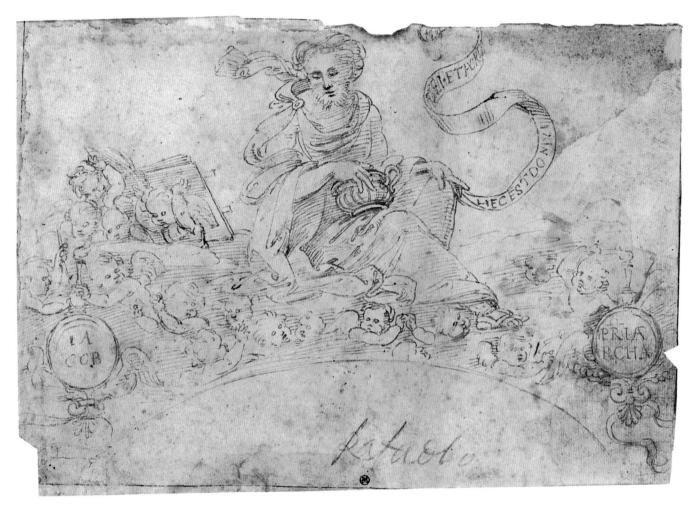

125 VERSO

126 *Standing Woman Turned to the Left and Holding a Tibia, Ornamental Studies*, recto

Ornamental Studies, verso

Pen and brown ink over black chalk underdrawing, 305 x 189 mm (12 x 7⁷⁄₁₆ in.)

Inscribed in brown ink on verso: *Lippi (fra filippo) Carmalitano da firenze 1381–1438*; *Fra filippo Lippi*; illegible inscriptions [canceled]

WATERMARK: Similar to Briquet no. 7375

Collection of The J. Paul Getty Museum, Malibu, California 88.GA.90

PROVENANCE: Private collection, France; sale, Hôtel Drouot, Paris, June 19, 1986, lot 214; art market, Boston; purchased 1988.

LITERATURE: Goldner and Hendrix 1992, no. 40; Goldner 1993, no. 68, pl. 4; Goldner 1994, pp. 157–58, figs. 1, 2.

Several years ago the present author suggested that this sheet and one in the Uffizi showing the same figure (inv. no. 199 E recto) were both based upon a lost work by Filippino.[1] The tall, somewhat mannered proportions and the pose, as well as the appearance of obscure musical instruments, clearly point in this direction. As the Getty and Uffizi drawings—the latter by a minor artist of the first quarter of the sixteenth century—differ from each other in many details, there is every likelihood that one is not based on the other but rather that they follow a common model.

Recently a third representation of the same female figure has been noted on the verso of a sheet attributed to Filippino in the Louvre (figs. 70, 71). Freely drawn in pen and ink, this fragmentary sketch portrays the lower half of the figure in the Getty and Uffizi versions, but with many variations in details. Moreover, it is an original working drawing rather than a copy. The style is close to some of Filippino's pen drawings from his Roman years onward. Similarly, the fine head on the recto is imbued with Filippinesque qualities. The study is surely autograph, adding weight to the argument that the present sheet is based on a lost painted figure by Filippino. The attribution of the Getty drawing to Raphael rests on a graphic similarity to the Louvre sheet showing Noah and Jacob that is indisputably from his hand (cat. no. 125) and on the rather Peruginesque interpretation given to the figure. In addition, there is a clear morphological parallel between the small ornamental figure at the left of the Getty drawing and the angels throughout the sheet with Noah and Jacob. Finally, the classical profile and selective emphasis and hatching of the leg are characteristic aspects of Raphael's draftsmanship. Given these comparisons

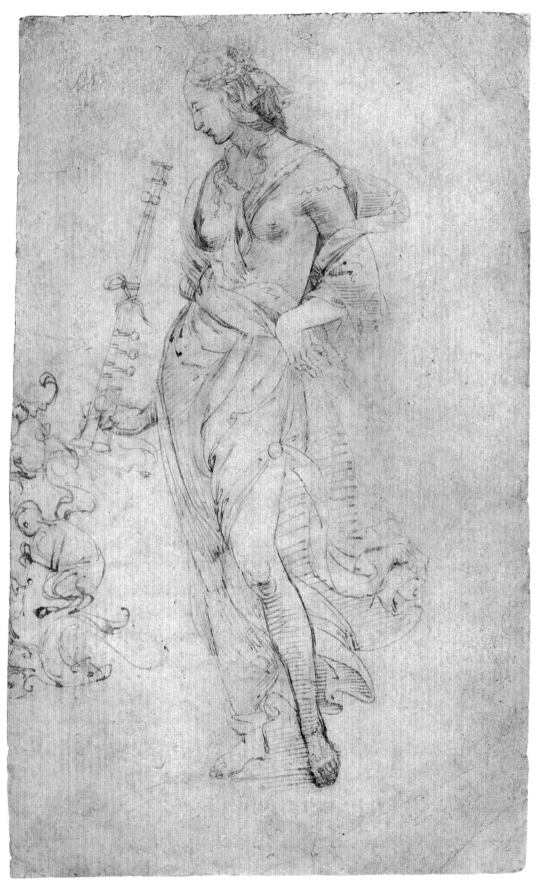

126 RECTO

126 VERSO

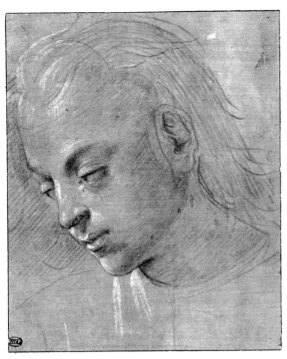

FIG.70 *Head of a Boy*. Metalpoint, heightened with white gouache, on yellow prepared paper, 119 x 99 mm. Département des Arts Graphiques du Musée du Louvre, Paris 2265 recto

and Raphael's documented interest in copying the works of Filippino, an attribution of the present sheet to Raphael is very likely correct. The still-Peruginesque quality argues for a date relatively early in his Florentine years, the period 1504 to 1508.

GRG

1 The Getty drawing has suffered considerably. It has a large repaired hole to the right of the figure, below the left arm. In addition, the recto has been restored twice in the last fifteen years and has lost some of its graphic resonance. The sheet's watermark would be suitable for a drawing of the early sixteenth century.

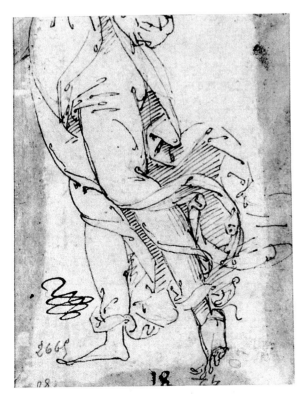

FIG.71 *Lower Half of a Figure in Billowing Draperies*. Pen and brown ink, 119 x 99 mm. Département des Arts Graphiques du Musée du Louvre, Paris 2265 verso

Bibliography

Index

Photograph Credits

Bibliography

Académie de France à Rome

1992 *Raphaël: Autour des dessins du Louvre.* Exh. cat. Rome: Villa Medici. Also published in Italian as *Raffaello e i suoi: Disegni di Raffaello e della sua cerchia.*

Accessions

1955 "Accessions of American and Canadian Museums, October–December 1954." *Art Quarterly* 18 (Summer), pp. 194–206.

Acidini Luchinat, Cristina

1986 *Il restauro della parete d'altare nella cappella di Filippo Strozzi in Santa Maria Novella.* Florence.

Acidini Luchinat, Cristina, and Elena Capretti

1996 *La Chiesa e il Convento di Santo Spirito a Firenze.* Florence.

Acquisitions

1985 "La chronique des arts: Principales acquisitions des musées en 1984." *Gazette des Beaux-Arts,* ser. 6, 105 (March), supplement.

Adams, Frederick B.

1952 *Third Annual Report to the Fellows of the Pierpont Morgan Library.* New York.

Agostini, Grazia, Jadranka Bentini, and Andrea Emiliani, eds.

1996 *La leggenda del collezionismo: Le quadrerie storiche ferraresi.* Exh. cat. Ferrara: Pinacoteca Nazionale.

Allegri, Ettore

1986 "Committenza pubblica e religiosa nel quattrocento." In *La Rinascenza a Firenze: Il quattrocento,* vol. 1. Florence: Istituto della Enciclopedia Italiana.

Ames, Winslow

1962 *Great Drawings of All Time.* Vol. 1, *Italian Thirteenth through Nineteenth Century.* Edited by Ira Moskowitz. New York.

1963 *Italian Drawings: From the 15th to the 19th Century.* Drawings of the Masters. New York.

Ames, Winslow, et al.

1959 *Great Master Drawings of Seven Centuries.* Exh. cat. New York: M. Knoedler & Co.

Ames-Lewis, Francis

1981a "Drapery 'Pattern'—Drawings in Ghirlandaio's Workshop and Ghirlandaio's Early Apprenticeship." *Art Bulletin* 63, pp. 49–62.

1981b *Drawing in Early Renaissance Italy.* New Haven.

1987 "Modelbook Drawings and the Florentine Quattrocento Artist." *Art History* 10 (March), pp. 1–11.

1992 "The Renaissance Draughtsman and His Models." In *Drawing, Masters and Methods: Raphael to Redon,* edited by Diana Dethloff, pp. 1–6. Papers presented to the Ian Woodner Master Drawings Symposium at the Royal Academy of Arts. London.

1995 "Drawing for Secular Subjects in Late Quattrocento Florence." *Apollo* 142, no. 405 (November), pp. 51–56.

Ames-Lewis, Francis, and Joanne Wright

1983 *Drawing in the Italian Renaissance Workshop.* Exh. cat. London: Victoria and Albert Museum.

Anglo, Sydney

1989 "The Man Who Taught Leonardo Darts: Pietro Monte and His 'Lost' Fencing Book." *Antiquaries Journal* 69, pp. 261–78.

Arnolds, Günter

1949 *Italienische Zeichnungen.* Berlin.

Arquié–Bruley, Françoise, Jacqueline Labbé, and Lise Bicart-Sée

1987 *La collection Saint-Morys au Cabinet des Dessins du Musée du Louvre.* 2 vols. Paris.

Ashmolean Museum

1951 *Ashmolean Museum Report of the Visitors 1951,* by D. B. Harden and K. T. Parker. Oxford.

Auctions

1917 "Auctions." *Burlington Magazine* 30 (June), p. 244.

Bacci, Mina

1966 *Piero di Cosimo.* Milan.

1976 *L'opera completa di Piero di Cosimo.* Milan.

Bacou, Roseline

1952 *Dessins florentins du trecento et du quattrocento.* Exh. cat. Paris: Cabinet des Dessins, Musée du Louvre.

1957 "Ils existent: Le saviez-vous?" *L'Oeil*, no. 28 (April), pp. 22–29, 62.

Bacou, Roseline, and Jacob Bean

1958 *Dessins florentins de la collection de Filippo Baldinucci (1625–1696)*. Exh. cat. Paris: Cabinet des Dessins, Musée du Louvre.

1959 *Disegni fiorentini del Museo del Louvre dalla collezione di Filippo Baldinucci*. Exh. cat. Rome: Gabinetto Nazionale delle Stampe.

Bacou, Roseline, and Marie-Rose Séguy

1977 *Collections de Louis XIV: Dessins, albums, manuscrits*. Exh. cat. Paris: Musée de l'Orangerie.

Bacou, Roseline, and Françoise Viatte

1968 *Dessins du Louvre: École italienne*. Paris.

Baldinucci, Filippo

1673 *Listra [sic] de' Nomi de' Pittori, di mano de' quali si hanno Disegni, e il primo numero denota quello de' Disegni, e l'altro denota quello, nel quale, ò fiorirono, ò morirono i medesimi Pittori, e tutto fino al presente giorno 8 Settembre 1673. . . .* Florence.

Balogh, Jolán

1975 *Die Anfänge der Renaissance in Ungarn: Matthias Corvinus und die Kunst*. Translated from Hungarian by Hildegard Baranyi. Graz.

Bambach Cappel, Carmen C.

1988 "The Tradition of Pouncing Drawings in the Italian Renaissance Workshop: Innovation and Derivation." 2 vols. Ph.D. dissertation, Yale University, New Haven.

Bandello, Matteo

1928 *Le novelle*. Edited by Gioachino Brognoligo. 2 vols. Bari.

Baracchini, Clara, and Severina Russo

1995 *Arte sacra nella Versilia medicea: Il culto e gli arredi*. Exh. cat. Seravezza: Palazzo Mediceo.

Barocchi, Paola, ed.

1992 *Giardino di San Marco: Maestri e compagni del giovane Michelangelo*. Exh. cat. Florence: Casa Buonarroti.

Bauereisen, Hildegard, and Margret Stuffmann

1994 *Von Kunst und Kennerschaft: Die Graphische Sammlung im Städelschen Kunstinstitut unter Johann David Passavant, 1840 bis 1861*. Exh. cat. Frankfurt am Main: Städelsches Kunstinstitut und Städtische Galerie, Graphische Sammlung.

Bayser, Bruno de

1984 "Rêves de collectionneur." *Connaissance des arts*, no. 394 (December), pp. 72–79.

Bean, Jacob

[1964] *100 European Drawings in The Metropolitan Museum of Art*. New York, n.d.

1969 "Reports of the Departments: Drawings." *Metropolitan Museum of Art Bulletin*, n.s., 28 (October), pp. 65–67.

Bean, Jacob, and Felice Stampfle

1965 *Drawings from New York Collections I: The Italian Renaissance*. Exh. cat. New York: The Metropolitan Museum of Art and Pierpont Morgan Library.

Bean, Jacob, with the assistance of Lawrence Turčić

1982 *15th and 16th Century Italian Drawings in The Metropolitan Museum of Art*. New York.

Beckerath, Adolf von

1904 "Notes on Some Florentine Drawings in the Print Room, Berlin." *Burlington Magazine* 6 (December), pp. 234–40.

1905 "Über einige Zeichnungen florentinischer Maler im Königl. Kupferstichkabinett in Berlin." *Repertorium für Kunstwissenschaft* 28, pp. 104–26.

Bell, Charles Francis

1914 *Drawings by the Old Masters in the Library of Christ Church Oxford*. Oxford.

Below, Irene

1971 "Leonardo da Vinci und Filippino Lippi." Ph.D. dissertation, Freie Universität, Berlin.

Beltrame Quattrocchi, Enrichetta

1979 *Disegni toscani e umbri del primo rinascimento dalle collezioni del Gabinetto Nazionale delle Stampe*. Exh. cat. Rome: Villa alla Farnesina.

Benvignat, C. C.

1856 *Musée Wicar: Catalogue des dessins et objets d'art*. Lille.

Berenson, Bernard

1903 *The Drawings of the Florentine Painters: Classified, Criticised, and Studied as Documents in the History and Appreciation of Tuscan Art, with a Copious Catalogue Raisonné*. 2 vols. New York.

1932a "Disegni inediti di 'Tommaso.'" *Rivista d'arte* 14 (July–September), pp. 249–62.

1932b "Three Drawings by Fra Filippo Lippi." *Old Master Drawings* 7 (September), pp. 16–18.

1933a "Filippino's Design for a Death of Meleager." *Old Master Drawings* 8 (December), pp. 32–33.

1933b "Verrocchio e Leonardo, Leonardo e Credi." *Bollettino d'arte* 27, ser. 3, pp. 193–214, 241–64.

1938 *The Drawings of the Florentine Painters*. 2d ed., revised and enlarged. 3 vols. Chicago.

1954 *Disegni di maestri fiorentini del rinascimento in Firenze: Cinquantatrè riproduzioni in facsimile di opere esistente nella Galleria degli Uffizi e nella Casa Buonarroti*. Turin.

1961 *I disegni dei pittori fiorentini*. 3d ed., revised and enlarged. Translated by Luisa Vertova Nicolson. 3 vols. Milan.

1963 *Italian Pictures of the Renaissance. A List of the Principal Artists and Their Works, with an Index of Places: Florentine School*. 2 vols. London.

Bergot, François

1972 *Dessins de la collection Robien*. Exh. cat. Rennes: Musée des Beaux-Arts.

Bernacchioni, Annamaria

1992 "Le botteghe di pittura: Luoghi, struttura, e attività." In Gregori, Paolucci, and Acidini Luchinat 1992, pp. 23–33.

Bertelli, Carlo

1963 "Filippino Lippi riscoperto." *Il veltro* 1, pp. 55–65.

1965a "Appunti sugli affreschi nella Cappella Carafa alla Minerva." *Archivum Fratrum Praedicatorum* 35, pp. 115–30.

1965b "Il restauro della Cappella Carafa in S. Maria sopra Minerva a Roma." *Bollettino dell'Istituto Centrale del Restauro*, 1965, pp. 145–95.

Berti, Luciano, and Umberto Baldini

1957 *Filippino Lippi*. Florence.

1991 *Filippino Lippi*. New ed. Florence.

Bertini, Aldo

1950 "Disegni inediti nella Biblioteca Reale di Torino." *Critica d'arte*, no. 32 (March), pp. 501–5.

1953 *Botticelli*. I grandi maestri del disegno. Milan.

1968 *Drawings by Botticelli*. Translation of Bertini 1953 by Florence H. Phillips. New York.

Billi, Antonio

1892 *Il libro di Antonio Billi esistente in due copie nella Biblioteca Nazionale di Firenze*. Edited by Carl Frey. Berlin.

Birke, Veronika

1991 *Die italienischen Zeichnungen der Albertina: Zur Geschichte der Zeichnung in Italien*. Munich.

Birke, Veronika, and Janine Kertész

1992–95 *Die italienischen Zeichnungen der Albertina*. 3 vols. Vienna.

Bjurström, Per

1969 *Drawings from Stockholm: A Loan Exhibition from the Nationalmuseum*. Exh. cat. New York: Pierpont Morgan Library.

1970 *Dessins du Nationalmuseum de Stockholm*. Exh. cat. Paris: Cabinet des Dessins, Musée du Louvre.

Bober, Phyllis Pray, and Ruth Rubinstein

1986 *Renaissance Artists and Antique Sculpture: A Handbook of Sources*. New York.

Bodmer, Heinrich

1932 "Der Spätstil des Filippino Lippi." *Pantheon* 9 (January–June), pp. 126–31.

Borghini, Raffaello

1584 *Il Riposo di Raffaello Borghini in cui della pittura, e della scultura si favella. . . .* Florence.

Borgo, Ludovico

1966 "Fra Bartolommeo, Albertinelli, and the *Pietà* for the Certosa of Pavia." *Burlington Magazine* 108 (September), pp. 463–69.

Borsook, Eve

1961 "Decor in Florence for the Entry of Charles VIII of France." *Mitteilungen des Kunsthistorischen Institutes in Florenz* 10, pp. 106–22.

1970 "Documenti relativi alle Cappelle di Lecceto e delle Selve di Filippo Strozzi." *Antichità viva* 9, no. 3, pp. 3–20.

1970a "Documents for Filippo Strozzi's Chapel in Santa Maria Novella and Other Related Papers," parts 1, 2. *Burlington Magazine* 112 (November), pp. 737–45; (December), pp. 800–804.

1975 "Fra Filippo Lippi and the Murals for Prato Cathedral." *Mitteilungen des Kunsthistorischen Institutes in Florenz* 19, pp. 1–148.

1980 *The Mural Painters of Tuscany: From Cimabue to Andrea del Sarto*. 2d ed., revised and enlarged. Oxford.

Bradshaw, Marilyn

1996 "Lippi, Filippino." In *The Dictionary of Art*, edited by Jane Turner, vol. 19, pp. 445–52. London.

Brandi, Cesare

1935 "The First Version of Filippino Lippi's *Assumption*." *Burlington Magazine* 67 (July–December), pp. 30–35.

Brejon de Lavergnée, Barbara

1989 *Renaissance et Baroque: Dessins italiens du Musée de Lille*. With contributions by Dominique Cordellier, Catherine Monbeig Goguel, and Frédérique Lemerle. Exh. cat. Lille: Musée des Beaux-Arts.

1990 "Renaissance et Baroque: Dessins italiens du Musée de Lille." *Connaissance des arts*, no. 455 (January), pp. 38–47.

Brejon de Lavergnée, Barbara, Dominique Cordellier, Frédérique Lemerle, and Uwe Westfehling

1990 *Raffael und die Zeichenkunst der italienischen Renaissance: Meisterzeichnungen aus dem Musée des Beaux-Arts in Lille und aus eigenem Bestand*. Exh. cat. Cologne: Wallraf-Richartz-Museum, Graphische Sammlung.

Bridgeman, Jane

1988 "Filippino Lippi's Nerli Altar-piece — a New Date." *Burlington Magazine* 130 (September), pp. 668–71.

Briganti, Giuliano

1988 *La pittura in Italia: Il cinquecento*. 2 vols. Milan.

British Museum

1896 *A Guide to the Exhibition Galleries of the British Museum*. Exh. cat. London: British Museum.

Brogi, F., comp.

1897 *Inventario generale degli oggetti d'arte della provincia di Siena*. Siena.

Brown, Alison

1979 "Pierfrancesco de' Medici, 1430–1476: A Radical Alternative to Elder Medicean Supremacy?" *Journal of the Warburg and Courtauld Institutes* 42, pp. 81–103.

Buckingham Palace

1972 *Drawings by Michelangelo, Raphael, and Leonardo and Their Contemporaries*. Exh. cat. London: Queen's Gallery, Buckingham Palace.

Buffalo

1935 *Master Drawings Selected from the Museums and Private Collections of America*. Exh. cat. Buffalo: Buffalo Fine Arts Academy, Albright Art Gallery.

Burlington Fine Arts Club

1917 *Catalogue of a Collection of Drawings by Deceased Masters with some Decorative Furniture and Other Objects of Art*. Exh. cat. Buffalo: Burlington Fine Arts Club.

Buschmann, H.

1993 "Raffaellino del Garbo: Werkmonographie und Katalog." Inaugural dissertation, Albert-Ludwigs Universität, Freiburg im Breisgau.

Byam Shaw, James

1967 *Paintings by Old Masters at Christ Church Oxford.* London.

1969 *Old Master Drawings from Chatsworth: A Loan Exhibition from the Devonshire Collection.* Exh. cat. Washington, D.C.: International Exhibitions Foundation.

1972 *Old Master Drawings from Christ Church Oxford.* Exh. cat. Washington, D.C.: International Exhibitions Foundation.

1976 *Drawings by Old Masters at Christ Church Oxford.* 2 vols. Oxford.

1983 *The Italian Drawings of the Frits Lugt Collection.* 3 vols. Paris.

1984 Review of *15th and 16th Century Italian Drawings in The Metropolitan Museum of Art,* by Jacob Bean, with the assistance of Lawrence Turčić. *Master Drawings* 21, no. 4 (Winter 1983), pp. 410–12.

1987 "The Royal Academy Exhibition: Drawings from the Collection of Ian Woodner." *Apollo* 126 (October), pp. 236–41.

Cadogan, Jean K.

1983 "Reconsidering Some Aspects of Ghirlandaio's Drawings." *Art Bulletin* 65, no. 2 (June), pp. 274–90.

1984 "Observations on Ghirlandaio's Method of Composition." *Master Drawings* 22 (Summer), pp. 159–72.

1994 "Domenico Ghirlandaio in Santa Maria Novella: Invention and Execution." In *Florentine Drawing at the Time of Lorenzo the Magnificent,* edited by Elizabeth Cropper, pp. 63–72. Papers from a colloquium held at the Villa Spelman, Florence, 1992. Bologna.

Cagnola, Guido

1906 "Intorno a due dipinti di Filippino Lippi." *Rassegna d'arte* 6, pp. 41–42.

Carl, Doris

1987 "Das Inventar der Werkstatt von Filippino Lippi aus dem Jahre 1504." *Mitteilungen des Kunsthistorischen Institutes in Florenz* 31, pp. 373–91.

Caroselli, Susan L.

1994 *Italian Panel Painting of the Early Renaissance in the Collection of the Los Angeles County Museum of Art.* Exh. cat. Los Angeles: Los Angeles County Museum of Art.

Carpaneto, Maria Grazia

1970 "Raffaellino del Garbo: I. Parte." *Antichità viva* 9, no. 4, pp. 3–23.

1971 "Raffaellino del Garbo: II. Parte." *Antichità viva* 10, no. 1, pp. 3–19.

Casazza, Ornella

1988 "Al di là dell'immagine." In *I pittori della Brancacci agli Uffizi,* pp. 92–101. Gli Uffizi—Studi e ricerche 5. Florence.

Catelli Isola, Maria, Simonetta Prosperi Valenti Rodinò, Enrichetta Beltrame Quattrocchi, and Giulia Fusconi

1980 *I grandi disegni italiani dal Gabinetto Nazionale delle Stampe di Roma.* Milan.

Cecchi, Alessandro

1986 "La committenza delle grandi famiglie nella Firenze del quattrocento." In *La Rinascenza a Firenze: Il quattrocento,* vol. 1. Florence: Istituto della Enciclopedia Italiana, Fondata da G. Treccani.

1988 "Una predella e altri contributi per l'Adorazione dei Magi di Filippino." In *I pittori della Brancacci agli Uffizi,* pp. 59–72. Gli Uffizi—Studi e ricerche 5. Florence.

1994a "Filippino disegnatore per le arti applicate." In *Florentine Drawing at the Time of Lorenzo the Magnificent,* edited by Elizabeth Cropper, pp. 55–61. Papers from a colloquium held at the Villa Spelman, Florence, 1992. Bologna.

1994b "Giuliano e Benedetto da Maiano ai servigi della Signoria fiorentina." In *Giuliano e la bottega dei da Maiano: Atti del Convegno Internazionale di Studi, Fiesole 13–15 giugno 1991,* edited by Daniela Lamberini, Marcello Lotti, and Roberto Lunardi, pp. 148–57. Florence.

1994c "A New Drawing by Filippino Lippi in the Louvre." *Burlington Magazine* 136 (June), pp. 368–69.

1996 Review of *The Palazzo Vecchio, 1298–1532: Government, Architecture and Imagery in the Civic Palace of the Florentine Republic,* by Nicolai Rubinstein. *Burlington Magazine* 138 (May), pp. 330–31.

Cecchi, Alessandro, and Antonio Natali, eds.

1996 *L'officina della "Maniera": Varietà e fierezza nell'arte fiorentina del cinquecento fra le due repubbliche, 1494–1530.* Exh. cat. Florence: Galleria degli Uffizi.

Cellini, Benvenuto

1910 *The Life of Benvenuto Cellini.* Edited and translated by Robert H. B. Cust. 2 vols. London.

1969 *The Autobiography of Benvenuto Cellini.* Edited by Alfred Tamarin; abridged and adapted from the translation by John A. Symonds. London.

Cennini, Cennino

1933 *The Craftsman's Handbook.* Translated by Daniel V. Thompson Jr. New York.

1991 *Libro dell'arte.* Edited and annotated by Mario Serchi. Florence.

Chastel, André

1950 *Florentine Drawings, XIV–XVII Centuries.* Translated by Rosamund Frost. New York.

1954 *Marsile Ficin et l'art.* Geneva.

Châtelet, Albert

1970 *Disegni di Raffaello e di altri italiani del Museo di Lille.* Exh. cat. Florence: Gabinetto Disegni e Stampe degli Uffizi.

Châtelet, Albert, and R. W. Scheller

1968 *Dessins italiens du Musée de Lille.* Exh. cat. Lille: Palais des Beaux-Arts.

Chiarini, Marco, Gianvittorio Dillon, and Annamaria Petrioli Tofani

1993 *Philip Pouncey per gli Uffizi.* Exh. cat. Florence: Gabinetto Disegni e Stampe degli Uffizi.

Christiansen, Keith

1990 "La Chapelle Brancacci Restaurée: Masaccio nuovo." *Connaissance des arts,* no. 466 (December), pp. 92–103.

1991 "Some Observations on the Brancacci Chapel Frescoes after Their Cleaning." *Burlington Magazine* 133 (January), pp. 4–20.

1994 "Letter: A Hanged Man by Filippino." *Burlington Magazine* 136 (October), p. 706.

Christie, Manson and Woods

1968 *Catalogue of Important Drawings by Old Masters.* Sale catalogue, London, June 25.

Clayton, Martin

1993 *Seven Florentine Heads: Fifteenth-Century Drawings from the Collection of Her Majesty the Queen.* Exh. cat. Toronto: Art Gallery of Ontario.

Colasanti, Arduino

1903 "Nuovi dipinti di Filippo e di Filippino Lippi." *L'arte* 6, pp. 299–304.

Collareta, Marco, and D. Devoti, eds.

1987 *Arte Aurea Aretina: Tesori dalle chiese di Cortona.* Exh. cat. Cortona.

Colnaghi, Dominic Ellis, Sir

1986 *Colnaghi's Dictionary of Florentine Painters, from the 13th to the 17th Centuries.* Reprint ed., with essays by Harold Acton, Mina Gregori, Piero Marchi, and Carlo Malvani. Florence. First published London, 1928.

Colnaghi & Co.

1951 *Exhibition of Old Master Drawings.* Exh. cat. London: P. and D. Colnaghi & Co., Ltd.

1959 *Exhibition of Old Master Drawings.* Exh. cat. London: P. and D. Colnaghi & Co., Ltd.

1964 *Exhibition of Old Master Drawings.* Exh. cat. London: P. and D. Colnaghi & Co., Ltd.

1969 *Exhibition of Old Master and English Drawings.* Exh. cat. London: P. and D. Colnaghi & Co., Ltd.

Colvin, Sidney

1895 *British Museum: Guide to an Exhibition of Drawings and Engravings by the Old Masters, Principally from the Malcolm Collection, in the Print and Drawing Gallery.* 2d ed. London.

1907 *Drawings of the Old Masters in the University Galleries and in the Library of Christ Church, Oxford.* Vol. 1, *Schools of Florence and Lombardy.* Oxford.

Cordellier, Dominique, and Bernadette Py

1992 *Raphaël: Son atelier, ses copistes.* Vol. 5 of *Musée du Louvre, Inventaire général des dessins italiens.* Paris.

Cotté, Sabine

1987 *Dessins italiens de la Renaissance.* Zurich.

Covi, Dario A.

1963 "Lettering in Fifteenth Century Florentine Painting." *Art Bulletin* 45, pp. 1–17.

Craven, Stephanie Jane

1970 "Aspects of Patronage in Florence, 1494–1512." Ph.D. dissertation, Courtauld Institute, University of London.

Crozat sale

1741 *Description sommaire des desseins des grands maîtres . . . du Cabinet de feu M. Crozat,* by P. J. Mariette. Sale cat., Paris, April 10–May 13.

Crum, Roger J., and David G. Wilkins

1990 "In the Defense of Florentine Republicanism: *Saint Anne and Florentine Art, 1343–1575.*" In *Interpreting Cultural Symbols: Saint Anne in Late Medieval Society,* edited by Kathleen Ashley and Pamela Sheingorn. Athens, Ga.

Cummings, Paul

1988 "Ian Woodner Talks with Paul Cummings." *Drawing* 9, no. 5, p. 109.

Czeczowiczka sale

1930 *Eine Wiener Sammlung.* Part 1, *Alte Handzeichnungen.* Sale cat., C. G. Boerner, Leipzig; Paul Graupe, Berlin, May 12.

Dacos, Nicole

1969 *La découverte de la Domus Aurea et la formation des grotesques à la Renaissance.* Studies of the Warburg Institute, edited by E. H. Gombrich, vol. 31. London.

Dalli Regoli, Gigetta,

1960 "Un disegno giovanile di Filippo Lippi." *Critica d'arte* 7, no. 39, pp. 199–205.

1966 *Lorenzo di Credi.* Pisa.

1968 "Verifica di un'ipotesi (Credi, Granacci, Fra Bartolomeo)." *Critica d'arte,* n.s., 15, no. 96 (June), pp. 19–34.

1974 "Piero di Cosimo, disegni noti e ignoti," parts 1, 2. *Critica d'arte* 39 (n.s. 20), no. 133 (January/February), pp. 49–65; no. 134 (March–April), pp. 62–80.

1992 "Il disegno nella bottega." In Gregori, Paolucci, and Acidini Luchinat 1992.

1994 "Postille ai disegni dal modello: I temi e le forme della sperimentazione." In *Florentine Drawing at the Time of Lorenzo the Magnificent,* edited by Elizabeth Cropper, pp. 73–79. Papers from a colloquium held at the Villa Spelman, Florence, 1992. Bologna.

1994a "'Iam securis ad radicem arborum posita est': La scure di San Giovannino, un attributo e un indizio." *Artista,* pp. 66–73.

Davies, Martin

1951 *The Earlier Italian Schools.* London: National Gallery.

Davis, Charles

1995 "I bassorilievi fiorentini di Giovan Francesco Rustici: Esercizi di lettura." *Mitteilungen des Kunsthistorischen Institutes in Florenz* 39, pp. 92–133.

Davis, Frank

1953 "A Page for Collectors: Drawings by the Great and the Near-Great." *Illustrated London News,* June 13, p. 992.

Degenhart, Bernhard

1932 "Die Schüler des Lorenzo di Credi." *Münchner Jahrbuch der bildenden Kunst,* n.F., 9, pp. 95–161.

1934 "Eine Gruppe von Gewandstudien des jungen Fra Bartolommeo." *Münchner Jahrbuch der bildenden Kunst,* n.F., 11, pp. 222–31.

1937 "Zur Graphologie der Handzeichnung: Die Strichbildung als stetige Erscheinung innerhalb der italienischen Kunstkreise." *Kunstgeschichtliches Jahrbuch der Bibliotheca Hertziana* 1, pp. 223–343.

1955 "Dante, Leonardo, und Sangallo: Dante-Illustrationen Giuliano da Sangallos in ihrem Verhältnis zu Leonardo da Vinci und zu den Figurenzeichnungen der Sangallo." *Römisches Jahrbuch für Kunstgeschichte* 7, pp. 101–292.

Degenhart, Bernhard, and Annegrit Schmitt

1968 *Corpus der italienischen Zeichnungen, 1300–1450.* Part 1, *Süd- und Mittelitalien.* 4 vols. Berlin.

Del Serra, Alfio

1985 "A Conversation on Painting Techniques." *Burlington Magazine* 127 (January), pp. 4–16.

Dethloff, Diana, ed.

1992 *Drawing: Masters and Methods, Raphael to Redon.* Papers presented to the Ian Woodner Master Drawings Symposium at the Royal Academy of Arts. London.

Di Giampaolo, Mario, ed.

1994 *Philip Pouncey: Raccolta di scritti (1937–1985).* Rimini.

D'Otrange-Mastai, M. L.

1955 "Drawings of the Morgan Collection at the Pierpont Morgan Library, New York." *Connoisseur* 135, no. 544 (April), pp. 136–42.

Douglas, Robert Langton

1946 *Piero di Cosimo.* Chicago.

Dreyer, Peter

1979 *I grandi disegni italiani del Kupferstichkabinett di Berlino.* Milan.

1988 "Raggio Sensale, Giuliano da Sangallo, und Sandro Botticelli—Der Höllentrichter." *Jahrbuch der Berliner Museen* 29–30 (1987–88), pp. 179–96.

Dunbar, Burton L., and Edward J. Olszewski, eds.

1996 *Drawings in Midwestern Collections: A Corpus.* Vol. 1, *Early Works.* Compiled by the Midwest Art History Society. Columbia, Mo.

Dunkerton, Jill, and Ashok Roy

1996 "The Materials of a Group of Late Fifteenth Century Florentine Panel Paintings." *National Gallery Technical Bulletin* 27, pp. 21–32.

École des Beaux-Arts

1879 *Catalogue descriptif des dessins de maîtres anciens.* Exh. cat. Paris: École Nationale Supérieure des Beaux-Arts.

1953 *L'art graphique au Moyen-Âge: Exposition de dessins, manuscrits enluminés, gravures, et incunables conservés dans les collections de l'École et tirés en majeure partie de la Donation J. Masson.* Exh. cat. Paris: École Nationale Supérieure des Beaux-Arts.

Ede, Harold Stanley

1926 *Florentine Drawings of the Quattrocento.* London.

Edgerton, Samuel Y.

1985 *Pictures and Punishment: Art and Criminal Prosecution during the Florentine Renaissance.* Ithaca.

Egger, Hermann

1906 *Codex Escurialensis: Ein Skizzenbuch aus der Werkstatt Domenico Ghirlandaios.* 2 vols. Vienna.

Emporium

1964 "Londra: Mostre di maestri antichi—mercato antiquario," by H. A. *Emporium* 140 (August), pp. 87–91.

Ergmann, Raoul

1986 "L'état-verbe et l'état-fisc." *Connaissance des arts*, no. 407 (January), pp. 66–73.

Ettlinger, Leopold D.

1972 "Hercules Florentinus." *Mitteilungen des Kunsthistorischen Institutes in Florenz* 16, pp. 119–42.

1978 *Antonio and Piero Pollaiuolo: Complete Edition with a Critical Catalogue.* Oxford and New York.

Fabjan, Barbara, ed.

1986 *Perugino, Lippi, e la bottega di San Marco alla Certosa di Pavia, 1495–1511.* Exh. cat. Milan: Pinacoteca di Brera.

Fahy, Everett

1965 "A Lucchese Follower of Filippino Lippi." *Paragone* 16 (July), pp. 9–20.

1968 "The 'Master of Apollo and Daphne.'" In *Museum Studies* 3, edited by John Maxon, Harold Joachim, and Frederick A. Sweet, pp. 21–41. Chicago.

1976 *Some Followers of Domenico Ghirlandajo.* Outstanding Dissertations in the Fine Arts. New York. Originally the author's Ph.D. dissertation, Harvard University, Cambridge, Mass., 1968.

1993a "Morelli and Botticelli." In *Giovanni Morelli e la cultura dei conoscitori: Atti del convegno internazionale, Bergamo, 4–7 giugno 1987*, edited by Giacomo Agosti, vol. 2, pp. 351–58. Bergamo.

1993b "Florence, Palazzo Strozzi: Late Fifteenth-Century Florentine Painting." *Burlington Magazine* 135 (February), pp. 169–71.

Faietti, Marzia, and Arnold Nesselrath

1995 "'Bizar più che reverso di medaglia': Un codex avec grotesques, monstres, et ornaments du jeune Amico Aspertini." *Revue de l'art* 107, pp. 44–88.

Fairfax Murray, Charles

1905–12 *A Selection from the Collection of Drawings by the Old Masters Formed by C. Fairfax Murray.* 4 vols. London.

n.d. List of Drawings Supplementing the Fairfax Murray catalogue. Typescript, Pierpont Morgan Library, New York.

Falb, Rodolfo

1899 *Il taccuino senese di Giuliano da Sangallo.* Siena.

Fermor, Sharon

1993 *Piero di Cosimo: Fiction, Invention, and Fantasìa.* London.

Ferri, Pasquale Nerino

1879–81 "Catalogo descrittivo dei disegni della R. Galleria degli Uffizi esposti al pubblico. Compilato da P. N. Ferri dal 1879 al 1881." Ms., Gabinetto Disegni e Stampe degli Uffizi, Florence.

1881 *Catalogo dei disegni esposti al pubblico nel corridoio del Ponte Vecchio nella R. Galleria degli Uffizi con l'indice alfabetico dei nomi degli Artefici.* Florence.

1890 *Catalogo Riassuntivo della Raccolta di disegni antichi e moderni posseduta dalla R. Galleria degli Uffizi di Firenze, compilato ora per la prima volta dal conservatore Pasquale Nerino Ferri.* Rome.

1895– "Catalogo dei disegni, cartoni e bozzetti esposti al
1901 pubblico nella R. Galleria degli Uffizi ed in altri Musei di Firenze compilato da Pasquale Nerino Ferri, ispettore preposto al Gabinetto dei disegni e delle stampe nella detta Galleria. Firenze, MDCCCXCV–MCMI." Ms., Gabinetto Disegni e Stampe degli Uffizi, Florence.

Fischel, Oskar

1913–41 *Raffaels Zeichnungen.* 8 vols. Berlin.

Fischer, Chris

1986a *Disegni di Fra Bartolommeo e della sua scuola.* Translated by Stefano Baldi Lanfranchi. Exh. cat. Florence: Gabinetto Disegni e Stampe degli Uffizi.

1986b "Filippino Lippi, Mariotto Albertinelli, Fra Bartolommeo, e l'Ancona per l'altar maggiore della Certosa di Pavia." In *Perugino, Lippi, e la bottega di San Marco alla Certosa di Pavia, 1495–1511,* edited by Barbara Fabjan, pp. 59–66. Exh. cat. Milan: Pinacoteca di Brera.

1990 *Fra Bartolommeo: Master Draughtsman of the High Renaissance: A Selection from the Rotterdam Albums and Landscape Drawings from Various Collections.* Rotterdam.

1994 *Fra Bartolommeo et son atelier: Dessins et peintures des collections françaises.* Exh. cat. Paris: Musée du Louvre.

Fleres, Ugo

1896 "Gabinetto Nazionale delle Stampe in Roma." In *Gallerie nazionale italiane: Notizie e documenti,* 2. Rome.

Fogg Art Museum

1948 *Seventy Master Drawings: A Loan Exhibition Arranged in Honor of Professor Paul J. Sachs on the Occasion of His Seventieth Birthday.* Exh. cat. Cambridge, Mass.: Fogg Art Museum, Harvard University.

Fossi [Todorow], Maria

1955 *Mostra di disegni di Filippino Lippi e Piero di Cosimo,* by Maria Fossi. Exh. cat. Florence: Gabinetto Disegni e Stampe degli Uffizi.

Foster, Philip

1981 "Lorenzo de' Medici and the Florence Cathedral Façade." *Art Bulletin* 63, pp. 495–500.

Francis, Henry S.

1948 "A Fifteenth-Century Drawing." *Bulletin of the Cleveland Museum of Art* 35, no. 2, pt. 1 (February), pp. 15–18.

Freedberg, Sidney J.

1961 *Painting of the High Renaissance in Rome and Florence.* Cambridge, Mass.

Frey, Carl, ed.

1892 *Il codice Magliabechiano cl.XVII. 17 contenente notizie sopra l'arte degli antichi e quella de' Fiorentini da Cimabue a Michelangelo Buonarroti scritte da Anonimo fiorentino.* Berlin.

Friedman, David

1970 "The Burial Chapel of Filippo Strozzi in Santa Maria Novella in Florence." *L'arte,* no. 9, pp. 109–31.

Frizzoni, Gustavo

1905 "Disegni di antichi maestri a proposito della terza parte dell'opera intorno alle collezioni di Oxford." *L'arte* 8, pp. 241–53.

Fusco, Laurie

1982 "The Use of Sculptural Models by Painters in Fifteenth-Century Italy." *Art Bulletin* 64, pp. 175–94.

Gabelentz, Hans von der

1922 *Fra Bartolommeo und die Florentiner Renaissance.* 2 vols. Leipzig.

Gahtan, Maia W., and Philip J. Jacks

1994 *Vasari's Florence: Artists and Literati at the Medicean Court,* edited by Lesley K. Baier. Exh. cat. New Haven: Yale University Art Gallery.

Galassi, Maria Clelia

1988–89 "Il disegno sottostante nella pittura italiana del quattrocento: Teoria e prassi in alcuni artisti di area centro-settentrionale." Doctoral thesis, Università degli studi, Milan.

1997 "Filippino Lippi's Underdrawing: The Contribution of Infrared Reflectography." In *Dessins sous-jacent et technologie de la peinture: Perspectives,* edited by Hélène Verougstraete and Roger van Schoute. Proceedings of Colloque XI, September 14–16, 1995. Louvain-la-Neuve. In press.

Gamba, Carlo

1909 "A proposito di alcuni disegni del Louvre." *Rassegna d'arte* 9 (March), pp. 37–40.

1928–29 "Ridolfo e Michele di Ridolfo del Ghirlandaio," parts 1, 2. *Dedalo* 9, pp. 463–90, 544–61.

Gamba, Fiammetta

1958 *Filippino Lippi nella storia della critica.* Florence.

Garzelli, Annarosa

1973 *Il ricamo nella attività artistica di Pollaiolo, Botticelli, Bartolomeo di Giovanni.* Florence.

Gasparri, Carlo

1990 "Antichità nei 'disegni esposti' agli Uffizi." *Prospettiva,* nos. 53–56 (April 1988–January 1989), pp. 338–43.

Gaye, Giovanni

1839 *Carteggio inedito d'artisti dei secoli XIV, XV, XVI.* Vol. 1. Florence.

Geiger, Gail L.

1981 "Filippino Lippi's Carafa 'Annunciation': Theology, Artistic Conventions, and Patronage." *Art Bulletin* 63, pp. 62–75.

1984 "Filippino Lippis *Wunder des heiligen Thomas von Aquin* im Rom des späten Quattrocento." *Zeitschrift für Kunstgeschichte* 47, no. 2, pp. 247–60.

1986 *Filippino Lippi's Carafa Chapel: Renaissance Art in Rome.* Kirksville, Mo.

Giglioli, Odoardo H.

1922 "I disegni della R. Galleria degli Uffizi." *La Bibliofilia* 23, nos. 11–12 (February–March), pp. 313–51.

1926–27 "Disegni sconosciuti di Filippino Lippi e del Pontormo." *Dedalo* 7, pp. 777–91.

Glasser, Hannelore

1977 *Artists' Contracts of the Early Renaissance.* Outstanding Dissertations in the Fine Arts. New York. Originally the author's Ph.D. dissertation, Columbia University, New York, 1965.

Goldner, George R.

1993 *Drawings from the J. Paul Getty Museum, Checklist.* Exh. cat. New York: The Metropolitan Museum of Art.

1994 "A New Raphael Drawing after Filippino." In *Florentine Drawing at the Time of Lorenzo the Magnificent*, edited by Elizabeth Cropper, pp. 157–58. Papers from a colloquium held at the Villa Spelman, Florence, 1992. Bologna.

Goldner, George R., and Lee Hendrix

1992 *European Drawings, 2: Catalogue of the Collections.* Malibu: J. Paul Getty Museum.

Golzio, Vincenzo, and Giuseppe Zander

1968 *L'arte in Roma nel secolo XV.* Bologna.

Gonse, Louis

1877 "Musée de Lille: Le Musée Wicar." *Gazette des Beaux-Arts*, ser. 2, 16, pp. 393–409.

Grand Palais

1983 *Raphaël dans les collections françaises.* Exh. cat. Paris: Galeries Nationales du Grand Palais.

Grassi, Luigi

1947 *Storia del disegno: Svolgimento del pensiero critico e un catalogo.* Rome.

1956 *Il disegno italiano dal trecento al seicento.* Rome.

1961 *I disegni italiani del trecento e quattrocento: Scuole fiorentina, senese, marchigiana, umbra.* Venice.

Gregori, Mina, Antonio Paolucci, and Cristina Acidini Luchinat, eds.

1992 *Maestri e botteghe: Pittura a Firenze alla fine del quattrocento.* Exh. cat. Florence: Palazzo Strozzi.

Griseri, Andreina

1978 *I grandi disegni della Biblioteca Reale di Torino.* Turin.

Griswold, William M.

1988 "The Drawings of Piero di Cosimo." Ph.D. dissertation, The Courtauld Institute of Art, London.

1994 "Cosimo Rosselli as Draughtsman." In *Florentine Drawing at the Time of Lorenzo the Magnificent*, edited by Elizabeth Cropper, pp. 83–90. Papers from a colloquium held at the Villa Spelman, Florence, 1992. Bologna.

1996 "Three New Attributions to Piero di Cosimo." In *Hommage au dessin: Mélanges offerts à Roseline Bacou.* Rimini.

Gruner, Ludwig

1862 *Verzeichniss der im Königlichen Museum zu Dresden aufgestellten Original-Zeichnungen alter und neuer Meister.* Dresden.

Habich collection

n.d. *Ausgewählte Handzeichnungen älterer Meister aus der Sammlung Edward Habich zu Cassel.* Edited by Oscar Eisenmann. 2d ed. Leipzig.

Habich sale

1899 *Katalog der Rühmlichst Bekannten Sammlung von Handzeichnungen alter Meister des XV–XVIII Jahrhunderts aus dem Besitze des Herrn Edw. Habich in Kassel.* Sale cat., H. G. Gutekunst Kunst-Auktion, Stuttgart, April 27–29.

Hadley, Rollin van N., ed.

1968 *Drawings: Isabella Stewart Gardner Museum.* Boston.

Hall, Edwin, and Horst Uhr

1985 "*Aureola super Auream*: Crowns and Related Symbols of Special Distinction for Saints in Late Gothic and Renaissance Iconography." *Art Bulletin* 67 (December), pp. 567–603.

Halm, Peter

[1931] "Das unvollendente Fresko des Filippino Lippi in Poggio a Caiano." *Mitteilungen des Kunsthistorischen Institutes in Florenz* 3 (Winter 1919–January 1932), pp. 393–427.

Hamilton, Chloe

1959 "Catalogue [of Miller Fund Acquisitions]: Drawings." *Allen Memorial Art Museum Bulletin* 16, no. 2 (Winter), pp. 85–93.

Haraszti-Takács, Marianne

1989 "Fifteenth-Century Painted Furniture with Scenes from the Esther Story." *Jewish Art* 15, pp. 14–25.

Haskell, Francis, and Nicholas Penny

1981 *Taste and the Antique: The Lure of Classical Sculpture, 1500–1900.* New Haven.

Hegarty, Melinda

1996 "Laurentian Patronage in the Palazzo Vecchio: The Frescoes of the Sala dei Gigli." *Art Bulletin* 78 (June), pp. 264–85.

Hellman, George S.

1916 "Drawings by Italian Artists in the Metropolitan Museum of Art." *Print Collector's Quarterly* 6 (April) pp. 157–84.

Hendy, Philip

1931 *Catalogue of the Exhibited Paintings and Drawings.* Exh. cat. Boston: Isabella Stewart Gardner Museum.

Heseltine, John Postle

1913 *Original Drawings by Old Masters of the Italian School Forming Part of the Collection of J. P. H.* London.

Holme, Bryan, ed.

1943 *Master Drawings.* New ed. New York.

Horne, Herbert P.

1980 *Botticelli, Painter of Florence.* Reprint ed. Princeton. Originally published as *Alessandro Filipepi, Commonly Called Sandro Botticelli, Painter of Florence.* London, 1908.

1986–87 *Alessandro Filipepi, Commonly Called Sandro Botticelli, Painter of Florence.* 3 vols. Reprint ed. Florence.

Jacobsen, Emil

1904 "Studien zu einem Gemälde aus der Ghirlandajo-Werkstatt in der Berliner Galerie." *Jahrbuch der Königlich preuszischen Kunstsammlungen* 25, pp. 185–95.

Jaffé, Michael

1994 *The Devonshire Collection of Italian Drawings.* Vol. 1, *Tuscan and Umbrian Schools.* London.

Joannides, Paul

1990 "A Raphaelesque Moment in the Veneto." *Arte Cristiana* 78, no. 739 (July–August), pp. 267–71.

Johnston, Catherine

1988 "Paintings from the Liechtenstein Collection." *Apollo* 127 (May), pp. 319–27.

Kennedy, Ruth Wedgwood

1938 *Alesso Baldovinetti: A Critical and Historical Study*. New Haven.

Knab, Eckhart

1975 *Italienische Zeichnungen der Renaissance zum 500. Geburtsjahr Michelangelos*. Exh. cat. Vienna: Graphische Sammlung Albertina.

Knab, Eckhart, Erwin Mitsch, Konrad Oberhuber, and Sylvia Ferino-Pagden

1983a *Raphael: Die Zeichnungen*. Stuttgart.

1983b *Raffaello: I disegni*. Revised, Italian ed. Florence.

Knapp, Fritz

1899 *Piero di Cosimo: Ein Übergangsmeister vom Florentiner Quattrocento zum Cinquecento*. Halle, Ger.

Koenigs collection

1995 *Five Centuries of European Drawings: The Former Collection of Franz Koenigs*. Exh. cat. Moscow: Pushkin State Museum of Fine Arts.

Koschatzky, Walter, Eckhart Knab, and Konrad Oberhuber, with Françoise Viatte

1975 *Dessins italiens de l'Albertina de Vienne*. Exh. cat. Paris: Musée du Louvre.

Koschatzky, Walter, Konrad Oberhuber, and Eckhart Knab

1972 *I grandi disegni italiani dell'Albertina di Vienna*. Milan.

Krohn, Deborah L.

1994 "The Framing of Two Tondi in San Gimignano Attributed to Filippino Lippi." *Burlington Magazine* 136 (March), pp. 160–63.

Kunstgeschichtliche Gesellschaft

1898 *Ausstellung von Kunstwerken des Mittelalters und der Renaissance aus Berliner Privatbesitz veranstaltet von der Kunstgeschichtlichen Gesellschaft*. Exh. cat. Berlin: Kunstgeschichtliche Gesellschaft.

Kurz, Otto

1937 "Giorgio Vasari's 'Libro de' Disegni,'" parts 1, 2. *Old Master Drawings* 12 (June), pp. 1–15; (December), pp. 32–44.

1947 "Filippino Lippi's *Worship of the Apis*." *Burlington Magazine* 89 (June), pp. 145–47.

Laclotte, Michel

1956 *De Giotto à Bellini: Les primitifs italiens dans les musées de France*. Exh. cat. Paris: Orangerie des Tuileries.

Lagrange, Léon

1862 "Catalogue des dessins de maîtres exposés dans la Galerie des Uffizii [*sic*], à Florence," parts 1–3. *Gazette des Beaux-Arts* 12, pp. 535–54; 13, pp. 276–84, 446–62.

Lavallée, Pierre

1917 "La collection de dessins de l'École des Beaux-Arts," part 1. *Gazette des Beaux-Arts*, ser. 4, 13, pp. 265–83.

1935 *Art italien des XV^me & XVI^me siècles*. Exh. cat. Paris: École des Beaux-Arts.

Lavin, Marilyn Aronberg

1955 "Giovanni Battista: A Study in Renaissance Religious Symbolism." *Art Bulletin* 37, pp. 85–101.

1961 "Giovannino Battista: A Supplement." *Art Bulletin* 43, pp. 319–26.

Legrand, Jos

1983 "Filippino Lippi: Tod des Laokoon." *Zeitschrift für Kunstgeschichte* 46, no. 2, pp. 203–14.

Leporini, Heinrich

1928 *Die Künstlerzeichnung: Ein Handbuch für Liebhaber und Sammler*. Berlin.

Levenson, Jay A., Konrad Oberhuber, and Jacquelyn L. Sheehan

1973 *Early Italian Engravings from the National Gallery of Art*. Published in conjunction with the exhibition *Prints of the Italian Renaissance*. Washington, D.C.: National Gallery of Art.

Levine, Saul

1974 "The Location of Michelangelo's *David*: The Meeting of January 25, 1504." *Art Bulletin* 56, pp. 31–49.

Lightbown, Ronald

1978 *Sandro Botticelli*. 2 vols. London.

Lippmann, Friedrich

1882 "Königliche Museen in Berlin, E.: Kupferstichkabinet." *Jahrbuch der Königlich preussischen Kunstsammlungen* 3, cols. xxx–xxxiv.

1910 *Zeichnungen alter Meister im Kupferstichkabinett der Königl. Museen zu Berlin*. Vol. 1, *Italien—Frankreich—Spanien*. Berlin.

Lippold, Georg

1936 *Die Skulpturen des Vatikanischen Museums*, by Walther Amelung. Vol. 3, part 1, *Sala delle muse; sala rotonda; sala a croce greca*. Berlin.

Loeser, Charles

1897 "I disegni italiani della raccolta Malcolm." *Archivio storico dell'arte*, 2d ser., 3, pp. 341–59.

1902 "Über einige italienische Handzeichnungen des Berliner Kupferstichkabinett." *Repertorium für Kunstwissenschaft* 25, pp. 348–59.

1916 *Disegni di Piero di Cosimo e Filippino Lippi*. Ser. 4, vol. 1 of *I disegni della R. Galleria degli Uffizi*. Florence.

London County Council

1962 *An American University Collection: Works of Art from the Allen Memorial Art Museum, Oberlin, Ohio*. Exh. cat. London: London County Council.

Longhi, Roberto

1956 *Officina Ferrarese*. Rev. ed. Florence.

Louvre

1952 See Bacou 1952.

1967 *Le cabinet d'un grand amateur P.-J. Mariette, 1694–1774: Dessins du XV^e siècle au XVIII^e siècle*. Exh. cat. Paris: Musée du Louvre, Galerie Mollien.

Luchs, Alison

1977 *Cestello: A Cistercian Church of the Florentine Renaissance*. Outstanding Dissertations in the Fine Arts. New York. Originally the author's Ph.D. dissertation, Johns Hopkins University, Baltimore, 1975.

Lugt, Frits

1921 *Les marques de collections de dessins et d'estampes. . . .* Amsterdam.

1956 *Les marques de collections de dessins et d'estampes. . . . Supplément.* The Hague.

Lunardi, Roberto

1982 "Il patrimonio artistico del Comune." In *La città degli Uffizi*, edited by Franco Sottani, pp. 43–60. Exh. cat. Florence: Palazzo Vecchio and Museo Mediceo.

Mackowsky, Hans

1898 *Ausstellung von Kunstwerken des Mittelalters und der Renaissance aus Berliner Privatbesitz veranstaltet von der Kunstgeschichtlichen Gesellschaft.* Exh. cat. Berlin.

1930 "Lorenzo di Credi." *Old Master Drawings* 5 (September), p. 32.

Malke, Lutz S.

1980 *Italienische Zeichnungen des 15. und 16. Jahrhunderts aus eigenen Beständen.* Exh. cat. Frankfurt am Main: Städelsches Kunstinstitut und Städtische Galerie.

Marani, Pietro C.

1989 *Leonardo: Catalogo completo.* Florence.

Marchini, Giuseppe

1975 *Filippo Lippi.* Milan.

Marcucci, Luisa

1951 *Mostra di disegni d'arte decorativa.* Exh. cat. Florence: Gabinetto Disegni e Stampe degli Uffizi.

van Marle, Raimond

1923–38 *The Development of the Italian Schools of Painting.* 19 vols. The Hague. Reprint ed., New York, 1970.

Martineau, Jane, and Charles Hope, eds.

1983 *The Genius of Venice, 1500–1600.* Exh. cat. London: Royal Academy of Arts.

Mascalchi, Sylvia

1984 "Giovan Carlo de' Medici: An Outstanding but Neglected Collector in Seventeenth Century Florence." *Apollo* 120 (October), pp. 268–72.

Matthiesen Gallery

1960 *Paintings and Drawings from Christ Church, Oxford.* Exh. cat. London: Matthiesen Gallery.

Mazzini, Franco

1969 *Turin, the Sabauda Gallery.* Turin.

McMahon, A. Philip, trans. and ann.

1956 *Treatise on Painting [Codex Urbinas Latinus 1270] by Leonardo da Vinci.* 2 vols. Princeton.

Meder, Joseph

1919 *Die Handzeichnung: Ihre Technik und Entwicklung.* Vienna.

1923 *Handzeichnungen aus der Albertina*, vol 2: *Italienische Meister des XIV bis XVI Jahrhunderts.* Vienna.

Meder, Joseph, and Winslow Ames

1978 *The Mastery of Drawing*, by Joseph Meder; translated and revised by Winslow Ames. 2 vols. New York.

Meiss, Millard

1973 "A New Monumental Painting by Filippino Lippi." *Art Bulletin* 55, pp. 479–93.

Melikian, Souren

1987 "A Master Collector, Ian Woodner: An Eye for the Future." *Art and Auction* 10 (November), pp. 80–87.

Metropolitan Museum

1942 *European Drawings from the Collections of The Metropolitan Museum of Art.* Vol. 1, *Italian Drawings.* New York.

1943 "Some Italian Drawings in the Metropolitan Museum, from a New York Correspondent." *Connoisseur* 110, no. 486 (January), pp. 148–52.

1952 *Art Treasures of the Metropolitan: A Selection from the European and Asiatic Collections of The Metropolitan Museum of Art.* Exh. cat. New York: The Metropolitan Museum of Art.

1968 *The Great Age of Fresco: Giotto to Pontormo.* Exh. cat. New York: The Metropolitan Museum of Art.

1975 *Notable Acquisitions, 1965–1975.* New York: The Metropolitan Museum of Art.

1992 *Masterworks from the Musée des Beaux-Arts, Lille.* Exh. cat. New York: The Metropolitan Museum of Art.

Middeldorf, Ulrich

1928 "Del Tasso, Domenico di Francesco." In Thieme-Becker 1907–50, vol. 32, p. 460.

Mills College Art Gallery

1961 *Drawings from Tuscany and Umbria, 1350–1700.* Exh. cat. Oakland: Mills College Art Gallery; Berkeley: University of California Art Gallery.

Monbeig Goguel, Catherine

1994 "A propos des dessins du 'Maître de la femme violée assise du Louvre': Réflexion méthodologique en faveur du 'Maître de Santo Spirito' (Agnolo et/ou Donnino di Domenico del Mazziere?)." In *Florentine Drawing at the Time of Lorenzo the Magnificent*, edited by Elizabeth Cropper, pp. 111–29. Papers from a colloquium held at the Villa Spelman, Florence, 1992. Bologna.

Mongan, Agnes

1933 "The Loeser Collection of Drawings." *Bulletin of the Fogg Art Museum* 2, no. 2 (March), pp. 22–24.

1949 *One Hundred Master Drawings.* Exh. cat. Cambridge, Mass.: Fogg Museum of Art, Harvard University.

Mongan, Agnes, and Paul J. Sachs

1940 *Drawings in the Fogg Museum of Art.* Cambridge, Mass.

Morelli, Giovanni [Ivan Lermolieff]

1880 *Die Werke italienischer Meister in den Galerien von München, Dresden, und Berlin.* Leipzig. 2d ed., Leipzig, 1881.

1890 *Kunstkritische Studien über italienische Malerei.* Vol. 1, *Die Galerien Borghese und Doria Panfili in Rom.* Leipzig.

1891 *Kunstkritische Studien über italienische Malerei.* Vol. 2, *Die Galerien zu München und Dresden.* Leipzig.

1892 "Handzeichnungen italienischer Meister in photographischen Aufnahmen von Braun & Co. in Dornach, kritisch gesichtet von Giovanni Morelli (Lermolieff); mitgeteilt von E. Habich." *Kunstchronik,* n.F. 3, no. 17 (March 3), cols. 289–94; no. 22 (April 21), cols. 373–78; no. 26 (May 26), cols. 441–45; no. 28 (June 16), cols. 487–90; no. 29 (June 23), cols. 505–8; no. 30 (June 30), cols. 524–28; no. 31 (July 21), cols. 543–47; no. 32 (August 18), cols. 571–74; no. 33 (September 15), cols. 590–93.

1892–93 "Handzeichnungen italienischer Meister in photographischen Aufnahmen von Braun & Co. in Dornach, kritisch gesichtet von Giovanni Morelli (Lermolieff); mitgeteilt von E. Habich." *Kunstchronik,* n.F. 4, no. 4 (November 3), cols. 53–56; no. 6 (November 24), cols. 84–90; no. 10 (December 29), cols. 156–62; no. 13 (January 26), cols. 207–10; no. 15 (February 16), cols. 237–40.

1893 *Kunstkritische Studien über italienische Malerei.* Vol. 3, *Die Galerie zu Berlin.* Leipzig.

1900 *Italian Painters: Critical Studies of Their Works.* Vol. 1. Translated by C. J. Ffoulkes. Introduced by A. H. Layard. London.

Moretti, Italo

1973 *La chiesa di San Niccolò Oltrarno.* Florence.

Morselli, Paola

1958 "Piero di Cosimo, saggio di un catalogo delle opere." *L'arte* 57, no. 23, pp. 67–92.

Müntz, Eugène

1889 *La Renaissance: Italie; les Primitifs.* Vol. 1. Paris.

1890 "Le Musée de l'École des Beaux-Arts, III: Le musée de peinture." *Gazette des Beaux-Arts,* ser. 3, 4, pp. 282–95.

Murat, Laure

1992 "Les lauriers de Laurent." *Connaissance des arts,* nos. 485–86 (July–August), pp. 54–61.

Natali, Antonio

1995 "Filologia e ghiribizzi: Pittori eccentrici, piste impraticate." In *La piscina di Betsaida: Movimenti dell' arte fiorentina del cinquecento,* pp. 138–82. Florence.

National Gallery of Art

1960 *Italian Drawings: Masterpieces of Five Centuries.* Exh. cat. Washington, D.C.: National Gallery of Art. Organized by the Gabinetto Disegni e Stampe degli Uffizi; circulated by the Smithsonian Institution.

1992 *National Gallery of Art.* New York.

Neilson, Katharine B.

1934 "A Pair of Angels by Filippino Lippi." *Art in America* 22 (June), pp. 96–98.

1938 *Filippino Lippi: A Critical Study.* Cambridge, Mass.

Nelson, Jonathan

1991 "Aggiunte alla cronologia di Filippino Lippi." *Rivista d'arte* 43 (4th ser., vol. 7), pp. 33–57.

1992a "Antonio da Sangallo il Vecchio, Studio per due figure della *Morte di Meleagro* (da Filippino Lippi)." In *Giardino di San Marco: Maestri e compagni del giovane Michelangelo,* edited by Paola Barocchi. Exh. cat. Florence: Casa Buonarroti.

1992b "The Later Works of Filippino Lippi: From His Roman Sojourn until His Death." Ph.D. dissertation, New York University.

1994 "Filippino Lippi at the Medici Villa of Poggio a Caiano." In *Florentine Drawing at the Time of Lorenzo the Magnificent,* edited by Elizabeth Cropper, pp. 159–74. Papers from a colloquium held at the Villa Spelman, Florence, 1992. Bologna.

1995 "The Place of Women in Filippino Lippi's Nerli Altarpiece." *Studies in Italian History and Culture,* no. 1, pp. 65–80.

1996 "Filippino Lippi's *Allegory of Discord*: A Warning about Families and Politics." *Gazette des Beaux-Arts,* ser. 6, 128 (December), pp. 237–52.

1997 "The High Altar-piece of SS. Annunziata in Florence: History, Form, and Function." *Burlington Magazine* 139 (February), pp. 84–94.

Nesselrath, Arnold

1996 "Il *Codice Escurialense.*" In *Domenico Ghirlandaio, 1449–1494: Atti del Convegno Internazionale, Firenze, 16–18 ottobre 1994,* edited by Max Seidel and Wolfram Prinz, pp. 175–98. Florence.

Norman, Diana

1986 "The Succorpo in the Cathedral of Naples: 'Empress of All Chapels.'" *Zeitschrift für Kunstgeschichte* 49, pp. 323–55.

1987 "Case Studies in Interpretation. A Dominican Chapel and a Franciscan Church: *Filippino Lippi's Carafa Chapel,* by G. L. Geiger; *Piety and Patronage in Renaissance Venice,* by R. Goffen." *Art History* 10, no. 4 (December), pp. 532–41.

Nota de' libri

n.d. "Nota de' libri de' disegni tanto grandi, che mezzani, con la distinzione di quanti ne sono attaccati per libro, avvertendo, che oltre a quelli che rimasero dopo la morte del Ser.mo Principe Card.le Leopoldo di Gloriosa Memoria, vi si comprendono quelli hauti di camera del Ser.mo Padrone per mano del Sig.r Falconieri in num.o di 193, e detta nota comincia secondo il nume.o che son notati, e che stanno nell'armadio." Ms., Florence, Archivio di Stato, Guardaroba 779, *Affari diversi,* inserto 9. Transcribed in Petrioli Tofani 1986, vol. 2, appendix 1.

Nuttall, Paula

1996 "Raffaellino del Garbo." In *The Dictionary of Art,* edited by Jane Turner, vol. 25, pp. 847–49. London.

Oberhuber, Konrad, ed.

1979 *Old Master Drawings: Selections from the Charles A. Loeser Bequest.* Cambridge, Mass.

Oberhuber, Konrad, and Sylvia Ferino-Pagden

1983a "Katalog der Zeichnungen." In Knab, Mitsch, and Oberhuber 1983a.

1983b "Catalogo dei disegni." In Knab, Mitsch, and Oberhuber 1983b.

Oertel, Robert

1942 *Fra Filippo Lippi.* Vienna.

Oppenheimer collection

1936 "In the Auctions Rooms: The Oppenheimer Collections." *Connoisseur* 98 (July–December), p. 180.

Oppenheimer sale

1936 *Catalogue of the Famous Collection of Old Master Drawings Formed by the Late Henry Oppenheimer, Esq., F.S.A. of 9 Kensington Palace Gardens, W.8.* Sale cat., Christie, Manson, and Woods, London, July 10, 13, 14.

Padoa Rizzo, Anna

1977 "Carli, Raffaello dei, detto Raffaellino del Garbo." In *Dizionario biografico degli Italiani*, vol. 20, pp. 173–75. Rome.

1989 "L'altare della Compagnia dei Tessitori in San Marco a Firenze: Dalla cerchia di Cosimo Rosselli al Cigoli." *Antichità viva* 28, no. 4, pp. 19–20.

Palazzo Pitti

1986 *Andrea del Sarto, 1486–1530: Dipinti e disegni a Firenze.* Exh. cat. Florence: Palazzo Pitti.

Parker, Karl T.

1956 *Catalogue of the Collection of Drawings in the Ashmolean Museum: Italian Schools.* Vol. 2. Oxford.

Parker, Karl T., and James Byam Shaw

1953 *Drawings by Old Masters.* Exh. cat. London: Royal Academy of Arts.

Parks, N. Randolph

1975 "The Placement of Michelangelo's *David*: A Review of the Documents." *Art Bulletin* 57, pp. 560–70.

Passavant, Johann David

1860 *Raphaël d'Urbin et son père Giovanni Santi.* 2 vols. Paris.

Pedretti, Carlo

1977 *The Literary Works of Leonardo da Vinci.* Compiled and edited by Jean Paul Richter; commentary by Carlo Pedretti. 2 vols. Berkeley and Los Angeles.

Pelli Bencivenni, Giuseppe

1784 "Inventario Generale della Real Galleria di Firenze compilato nel 1784. Essendo Direttore della Medesima Giuseppe Bencivenni già Pelli N. P. F. colla presenza, ed assistenza del Sig.re Pietro Mancini Ministro dell'Ufficio delle Revisioni e Sindacati." 2 vols. Ms., Florence, Biblioteca della Soprintendenza per i Beni Artistici e Storici, Inv. no. 113.

n.d. "Inventario dei disegni." Ms., Florence, Gabinetto Disegni e Stampe degli Uffizi.

Petit Palais

1935 *Exposition de l'art italien de Cimabue à Tiepolo.* Exh. cat. Paris: Petit Palais.

Petrioli Tofani, Annamaria, ed.

1986 *Inventario 1: Disegni esposti.* Florence.

1987 *Inventario 2: Disegni esposti.* Florence.

1991 *Inventario disegni di figura, 1.* Florence.

1992 *Il disegno fiorentino del tempo di Lorenzo il Magnifico.* Exh. cat. Florence: Gabinetto Disegni e Stampe degli Uffizi.

Petrioli Tofani, Annamaria, et al.

1991 *Il disegno: Forme, tecniche, significativo.* Cinisello Balsamo.

Petrucci Nardelli, Franca

1996 "Il legatore: Un mestiere fra organizzazione e sfruttamento." In *Documenti 3: Conservazione dei materiali librari archivistici e grafici*, edited by Marina Regni and Piera Giovanna Tordella, pp. 329–32. Turin.

Philadelphia Museum of Art

1950 *Masterpieces of Drawing, Diamond Jubilee Exhibition.* Exh. cat. Philadelphia: Philadelphia Museum of Art.

Pierpont Morgan Library

1939 *Illustrated Catalogue of an Exhibition Held on the Occasion of the New York World's Fair, 1939, New York, May through October.* Exh. cat. New York: Pierpont Morgan Library.

1957 *Treasures from the Pierpont Morgan Library: Fiftieth Anniversary Exhibition.* Exh. cat. New York: Pierpont Morgan Library.

Pillsbury, Edmund P.

1971 *Florence and the Arts: Five Centuries of Patronage.* Florentine Art in Cleveland Collections. Cleveland.

Pittaluga, Mary

1949 *Filippo Lippi.* Florence.

Plomp, Michiel C.

1997 "Jan Pietersz. Zomer's Inscriptions on Drawings." *Delineavit et Sculpsit*, no. 17 (March), pp. 13–27.

Pluchart, Henry

1889 *Ville de Lille, Musée de Lille, Musée Wicar. Notice des dessins, cartons, pastels, miniatures, et grisailles exposés, précédé d'une introduction et du résumé de l'inventaire général.* Lille.

Pons, Nicoletta

1992 "L'unità delle arti in bottega." In Gregori, Paolucci, and Acidini Luchinat 1992, pp. 251–60.

1994 *I Pollaiolo.* Florence.

1996 "Importanti opere perdute di pittori fiorentini a Pistoia e una aggiunta al Maestro di Apollo e Dafne." In *Fra Paolino e la pittura a Pistoia nel primo '500*, edited by Chiara D'Afflitto, Franca Falletti, and Andrea Muzzi, pp. 50–53. Exh. cat. Pistoia: Palazzo Comunale.

Popham, Arthur E.

1931 *Italian Drawings Exhibited at the Royal Academy, Burlington House, London, 1930.* Exh. cat. London.

1935 *Catalogue of Drawings in the Collection Formed by Sir Thomas Phillipps, Bart., F.R.S., Now in Possession of His Grandson T. Fitzroy Phillips Fenwick of Thirlestaine House Cheltenham.* London.

1937a "Acquisitions at the Oppenheimer Sale." *British Museum Quarterly* 11, pp. 127–32.

1937b "The Drawings at the Burlington Fine Arts Club." *Burlington Magazine* 70 (January–June), pp. 87–88.

1946 *The Drawings of Leonardo da Vinci.* London.

1949 *Old Master Drawings from Chatsworth.* Exh. cat. London: Arts Council of Great Britain.

1962 *Old Master Drawings from Chatsworth: A Loan Exhibition from the Devonshire Collection.* Exh. cat. Washington, D.C.: National Gallery of Art.

1969 *Old Master Drawings from Chatsworth: A Loan Exhibition from the Devonshire Collection.* Exh. cat. London: Royal Academy. Catalogue reprinted from Popham 1962, minus five drawings.

1973 *Old Master Drawings from Chatsworth: A Loan Exhibition from the Devonshire Collection.* Exh. cat. London: Victoria and Albert Museum.

Popham, Arthur E., and Philip Pouncey

1950 *Italian Drawings in the Department of Prints and Drawings in the British Museum.* Vol. 1, *The Fourteenth and Fifteenth Centuries.* London.

Popham, Arthur E., and Johannes Wilde

1949 *The Italian Drawings of the XV and XVI Centuries in the Collection of Her Majesty the Queen at Windsor Castle.* With an Appendix to the Catalogue by Rosalind Wood. [London.] Reprint ed., New York and London, 1984.

Pouncey, Philip

1964 Review of *I disegni dei pittori fiorentini,* by Bernard Berenson. In *Master Drawings* 2, no. 3, pp. 278–93. Reprinted in Di Giampaolo 1994, pp. 269–306.

Prosperi Valenti Rodinò, Simonetta

1993 *The Golden Age of Florentine Drawing: Two Centuries of Disegno from Leonardo to Volterrano.* Exh. cat. Fort Worth: Kimbell Art Museum.

Ragghianti, Carlo L.

1939 "Un 'corpus photographicum' di disegni." In "Notizie e letture," *Critica d'arte* 3, no. 16–18 (August–December 1938), pp. XXV–XXX.

1954 "Inizio di Leonardo," parts 1–3. *Critica d'arte* 1, pp. 1–18, 102–18, 302–29.

1960 "Filippino Lippi a Lucca: L'Altare Magrini, nuovi problemi e nuove soluzioni." *Critica d'arte* 7, no. 37, pp. 1–56.

Ragghianti, Carlo L., and Gigetta Dalli Regoli

1975 *Firenze, 1470–1480: Disegni dal modello, Pollaiolo/ Leonardo/Botticelli.* Pisa.

Ragghianti Collobi, Licia

1971 "Il 'Libro de' disegni' di Giorgio Vasari." *Critica d'arte,* n.s., 18, no. 116 (March–April), pp. 13–40.

1974 *Il Libro de' disegni del Vasari.* 2 vols. Florence.

Ramade, Patrick

1988 "Dessins de la Renaissance italienne." In *L'Estampille* 211 (February), pp. 38–45.

1990 *Disegno: Les dessins italiens du Musée de Rennes.* Exh. cat. Rennes: Musée des Beaux-Arts; Modena: Galleria Estense.

Reiset, Frédéric

1866 *Notice des dessins, cartons, pastels, miniatures, et émaux.* Paris: Musée du Louvre.

Reuterswärd, Patrick

1966 "Den unge Johannes Döparen i Öken." In *Konsthistoriska studier tillägnade Sten Karling.* Stockholm.

Richa, Giovanni

1754–62 *Notizie istoriche delle chiese fiorentine.* 10 vols. Florence.

Richter, Jean Paul, comp. and ed.

1970 *The Literary Works of Leonardo da Vinci.* 3d ed. 2 vols. London. 2d ed., London, 1939.

Robert, Carl

1969 *Die antiken Sarkophagreliefs.* Vol. 3, *Einzelmythen.* 3 parts. Reprint ed. Rome. First published Rome, 1897–1919.

Robertson, David

1978 *Sir Charles Eastlake and the Victorian Art World.* Princeton.

Robinson, J. C.

1869 *Descriptive Catalogue of the Drawings by the Old Masters, Forming the Collection of John Malcolm of Poltalloch, Esq.* London.

Rolfi, Gianfranco, Ludovica Sebregondi, Paolo Viti

1992 *La chiesa e la città a Firenze nel XV secolo.* Exh. cat. Florence: Sotterranei di San Lorenzo.

Rosenauer, Artur

1972 "Ein nicht zur Ausführung gelangter Entwurf Domenico Ghirlandaios für die Cappella Sassetti." *Wiener Jahrbuch für Kunstgeschichte* 25, pp. 187–96.

Rouchès, Gabriel

1931 *Exposition de dessins italiens XIVe, XVe, XVIe siècles.* Exh. cat. Paris: Musée de l'Orangerie.

Royal Academy

1960 *Italian Art and Britain.* Exh. cat. London: Royal Academy of Arts.

Ruda, Jeffrey

1982 *Filippo Lippi Studies: Naturalism, Style and Iconography in Early Renaissance Art.* Outstanding Dissertations in the Fine Arts. New York. Originally the author's Ph.D. dissertation, Harvard University, Cambridge, Mass., 1979.

1993 *Fra Filippo Lippi: Life and Work, with a Complete Catalogue.* New York.

Ruland, Carl

1876 *The Works of Raphael Santi da Urbino as Represented in the Raphael Collection in the Royal Library at Windsor Castle, Formed by H. R. H. the Prince Consort, 1853–1861, and Completed by Her Majesty Queen Victoria.* [London]: Privately printed.

Rusconi, Art John

1907 "Arte retrospettiva: I disegni di antichi maestri nella Galleria Corsini." *Emporium* 25 (April), pp. 262–75.

Ryskamp, Charles, ed.

1981 *Nineteenth Report to the Fellows of the Pierpont Morgan Library, 1978–1980.* New York.

Sale, John Russell

1979 *Filippino Lippi's Strozzi Chapel in Santa Maria Novella.* Outstanding Dissertations in the Fine Arts. New York. Originally the author's Ph.D. dissertation, University of Pennsylvania, Philadelphia, 1976.

Salvini, Roberto

1958 *Tutta la pittura del Botticelli.* 2 vols. Milan.

Sandström, Sven

1963 *Levels of Unreality: Studies in Structure and Construction in Italian Mural Painting During the Renaissance.* Stockholm.

San Niccolò Oltrarno

1982 *San Niccolò Oltrarno: La chiesa; una famiglia di antiquari nel quartiere di San Niccolò.* Vol. 1. Florence.

Scharf, Alfred

1931 "Studien zu einigen spätwerken des Filippino Lippi." *Jahrbuch der preuszischen Kunstsammlungen* 52, pp. 201–22.

1933 "Die frühen Gemälde des Raffaellino del Garbo." *Jahrbuch der preuszischen Kunstsammlungen* 54, pp. 151–66.

1935 *Filippino Lippi.* Vienna.

1950 *Filippino Lippi.* 2d ed., revised. Vienna.

Scheller, Robert W.

1963 *A Survey of Medieval Modelbooks.* Haarlem.

1995 *Exemplum: Model-Book Drawings and the Practice of Artistic Transmission in the Middle Ages (ca. 900– ca. 1470).* Translated by Michael Hoyle. Amsterdam.

Schmidt, Werner, et al.

1978 *Die Albertina und das Dresdner Kupferstich-Kabinett: Meisterzeichnungen aus zwei alten Sammlungen.* Exh. cat. Vienna: Graphische Sammlung Albertina.

Schmitt, Annegritt

1970 "Römische Antikensammlungen im Spiegel eines Musterbuchs der Renaissance." *Münchner Jahrbuch der Bildenden Kunst* 21, pp. 99–128.

Scholz, Janos

1963 *Italienische Meisterzeichnungen vom 14. bis zum 18. Jahrhundert aus amerikanischem Besitz: Die Sammlung Janos Scholz, New York.* Exh. cat. Hamburg: Hamburger Kunsthalle.

1967 *Tuscan and Venetian Drawings of the Quattrocento from the Collection of Janos Scholz.* Exh. cat. Los Angeles: Los Angeles County Museum of Art; Seattle: Seattle Art Museum.

1976 *Italian Master Drawings, 1350–1800, from the Janos Scholz Collection.* New York.

Schönbrunner, Josef, and Josef Meder, eds.

1896– *Handzeichnungen alter Meister aus der Albertina und*
1908 *anderen Sammlungen.* 12 vols. Vienna.

Schulze Altcappenberg, Hein-Th.

1995 *Die italienische Zeichnungen des 14. und 15. Jahrhunderts im Berliner Kupferstichkabinett: Kritischer Katalog.* Exh. cat. Berlin: Staatliche Museen zu Berlin.

Seymour, Charles, Jr.

1971 *The Sculpture of Verrocchio.* Greenwich, Conn.

Shapley, Fern Rusk

1966 *Paintings from the Samuel H. Kress Collection: Italian Schools, XIII–XV Century.* London.

1979 *Catalogue of the Italian Paintings.* Washington, D.C.: National Gallery of Art.

Shearman, John

1965 *Andrea del Sarto.* 2 vols. Oxford.

1983 *The Early Italian Pictures in the Collection of Her Majesty the Queen.* Cambridge.

Shoemaker, Innis Howe

1975 "Filippino Lippi as a Draughtsman." Ph.D. dissertation, Columbia University, New York.

1978 "Drawings after the Antique by Filippino Lippi." *Master Drawings* 16, no. 1 (Spring), pp. 35–43.

1994 "Some Observations on the Development of Filippino Lippi's Figure Drawings." In *Florentine Drawing at the Time of Lorenzo the Magnificent,* edited by Elizabeth Cropper, pp. 255–63. Papers from a colloquium held at the Villa Spelman, Florence, 1992. Bologna.

Sinibaldi, Giulia

1954 *Mostra di disegni dei primi Manieristi italiani.* Exh. cat. Florence: Gabinetto Disegni e Stampe degli Uffizi.

Sirén, Osvald

1902 *Dessins et tableaux de la Renaissance italienne dans les collections de Suède.* Stockholm.

1916 *A Descriptive Catalogue of the Pictures in the Jarves Collection Belonging to Yale University.* New Haven.

1917 *Italienska handteckningar från 1400- och 1500-talen i Nationalmuseum: Catalogue raisonné.* Stockholm.

1933 *Italienska tavlor och teckningar i Nationalmuseum.* Stockholm.

Spencer, John R.

1966 "The *Lament at the Tomb* by Filippino Lippi." *Allen Memorial Art Museum Bulletin* 24, no. 1 (Fall), pp. 23–34.

Stechow, Wolfgang

1928 "Tommaso di Stefano." *Pinacotheca* 1, no. 3 (November–December), pp. 132–36.

1964 "Joseph of Arimathea or Nicodemus?" In *Studien zur toskanischen Kunst: Festschrift für Ludwig Heinrich Heydenreich zum 23 März 1963,* edited by Wolfgang Lotz and Lisa Lotte Möller. Munich.

Straelen, Hildegard Conrad van

1938 *Studien zur Florentiner Glasmalerei des Trecento und Quattrocento.* Lebensräume der Kunst, vol. 5. Wattenscheid.

Strong, Sanford Arthur

1900 *Reproductions in Facsimile of Drawings by the Old Masters in the Collection of the Earl of Pembroke and Montgomery at Wilton House.* 6 parts in 1 vol. London.

1902 *Reproductions of Drawings by Old Masters in the Collection of the Duke of Devonshire at Chatsworth.* London.

Sutton, Denys

1985a "XIV.: From Ottley to Eastlake." In "Aspects of British Collecting, Part IV," *Apollo* 123 (August), pp. 84–95.

1985b "XV.: The Age of Robert Browning." In "Aspects of British Collecting, Part IV," *Apollo* 123 (August), pp. 96–110.

1985c Ed. "Letters from Herbert Horne to Roger Fry." Part 2 of "Herbert Horne and Roger Fry." *Apollo* 123 (August), pp. 136–56.

Thieme, Ulrich, and Felix Becker, eds.

1907–50 *Allgemeines Lexikon der bildenden Künstler von der Antike bis zur Gegenwart.* 37 vols. Leipzig.

Thompson, Francis

1929 "The Collection of Drawings Belonging to the Duke of Devonshire, Chatsworth, Devonshire." Typescript catalogue, Study Room, Devonshire Collections, Chatsworth.

Tietze, Hans

1947 *European Master Drawings in the United States.* New York.

Tolnay, Charles de

1943a *History and Technique of Old Master Drawings.* New York.

1943b *The Youth of Michelangelo.* Princeton.

Tordella, Piera Giovanna

1996 "La matita rossa nella pratica del disegno: Considerazioni sulle sperimentazioni preliminari del medium attraverso le fonti antichi." In *Documenti 3: Conservazione dei materiali librari archivistici e grafici,* edited by Marina Regni and Piera Giovanna Tordella, pp. 187–207. Turin.

Turner, Nicholas

1986 *Florentine Drawings of the Sixteenth Century.* Exh. cat. London: British Museum.

Uffizi

1961 *Mostra del disegno italiano di cinque secoli.* Exh. cat. Florence: Gabinetto Disegni e Stampe degli Uffizi.

Ulmann, Hermann

[1893] *Sandro Botticelli.* Munich.

1894a "Die Ausstellung der Malcolm-Sammlung im British Museum." *Repertorium für Kunstwissenschaft* 17, pp. 322–26.

1894b "Bilder und Zeichnungen der Brüder Pollajuoli." *Jahrbuch der Königlich preussischen Kunstsammlungen* 15, pp. 230–47.

1894c "Raffaellino del Garbo." *Repertorium für Kunstwissenschaft* 17, pp. 90–115.

1896 "Piero di Cosimo," parts 1, 2. *Jahrbuch der Königlich preussischen Kunstsammlungen* 17, pp. 42–64, 120–42.

Vaccari, Maria Grazia

1981 *Maestri toscani del quattrocento: Cosimo Rosselli, Botticelli, Botticini, Filippino Lippi, David Ghirlandaio, Raffaellino del Garbo, Tommaso, Piero di Cosimo.* Biblioteca di disegni, vol. 18. Florence.

Valentiner, W. R.

1930 "Leonardo as Verrocchio's Coworker." *Art Bulletin* 12, pp. 43–89.

Van Cleave, Claire

1994 "Tradition and Innovation in the Early History of Black Chalk Drawing." In *Florentine Drawing at the Time of Lorenzo the Magnificent,* edited by Elizabeth Cropper, pp. 231–43. Papers from a colloquium held at the Villa Spelman, Florence, 1992. Bologna.

Van Schaack, Eric

1959 "Filippino Lippi—*Imago Pietatis.*" In *Great Master Drawings of Seven Centuries,* by Winslow Ames et al. Exh. cat. New York: M. Knoedler & Co.

Vasari, Giorgio

1906 *Le vite de' più eccellenti pittori scultori ed architettori,* edited by Gaetano Milanese. 9 vols. Florence. Reprint of 1878–85 ed.; based on the 2d ed. of 1568.

1966– *Le vite de' più eccellenti pittori scultori ed architettori nelle redazioni del 1550 e 1568,* edited by Rossana Bettarini and annotated by Paola Barocchi. 6 vols. to date. Florence.

1996 *Lives of the Painters, Sculptors, and Architects.* Translated by Gaston du C. de Vere; with an introduction and notes by David Ekserdjian. New York. Translation, based on the 2d ed. of 1568, first published in 1912.

Vasari Society

1920–35 *The Vasari Society for the Reproduction of Drawings by Old Masters.* Oxford.

Vassar College Art Gallery

1968 *The Italian Renaissance: Prints—Drawings—Miniatures—Books.* Exh. cat. Poughkeepsie: Vassar College Art Gallery.

Venturi, Lionello

1934 "Nell'esposizione d'arte italiana ad Amsterdam." *L'arte* 37, n.s. 5, no. 6 (November), pp. 494–99.

[Vertova, Luisa]

1968 "Zibaldone delle arti: Aste, Christie's, e Sotheby's alla riscossa." *Antichità viva* 7, no. 3, pp. 60–62.

Viatte, Françoise

1963 "Catalogue raisonné des dessins florentins des XVe et XVIe siècles au Musée de Lille." Thesis, Section Supérieure de l'École du Louvre, Paris.

Voss, Hermann

1913 "Handzeichnungen alter Meister im Leipziger Museum." *Zeitschrift für bildende Kunst,* n.F., 24, pp. 221–36.

Wackernagel, Martin

1938 *Der Lebensraum des Künstlers in der florentinischen Renaissance: Aufgaben und Auftraggeber, Werkstatt und Kunstmarkt.* Leipzig.

1981 *The World of the Florentine Renaissance Artist: Projects and Patrons, Workshop and Art Market.* Translated by Alison Luchs. Princeton.

Walker, John, III

1933 "Cristofano Robetta and Filippino Lippi." *Bulletin of the Fogg Art Museum, Harvard University* 2 (March), pp. 23–36.

Walker Art Gallery

1964 *Masterpieces from Christ Church: The Drawings.* Exh. pamphlet. Liverpool: Walker Art Gallery.

Warburg, Aby

1905 "Dürer und die italienische Antike." In *Verhandlungen der achtundvierzigsten Versammlung deutscher Philologen und Schulmänner in Hamburg vom 3. bis 6. Oktober 1905*. Leipzig. Reprinted in *A. Warburg: Gesammelte Schriften. Die Erneuerung der heidnischen Antike*, vol. 2, pp. 443–49. Leipzig, 1932.

Wehle, Harry B.

1937 "Four Drawings." In *Bulletin of the Metropolitan Museum of Art* 32, no. 1 (January) pp. 6–9.

Wehrhahn-Stauch, Liselotte

1968 "Bär." In *Lexikon der Christlichen Ikonographie*, edited by Engelbert Kirschbaum et al., cols. 242–44. Freiburg im Breisgau.

Weinberger, Martin

1967 *Michelangelo the Sculptor*. 2 vols. London and New York.

White, John

1957 *The Birth and Rebirth of Pictorial Space*. London.

1987 *The Birth and Rebirth of Pictorial Space*. 3d ed. Cambridge, Mass.

Wickhoff, Franz

1899 "Über einige italienische Zeichnungen im British Museum." *Jahrbuch der Königlich preussischen Kunstsammlungen* 20, pp. 202–15.

Wiemers, Michael

1996 *Bildform und Werkgenese: Studien zur zeichnerischen Bildvorbereitung in der italienische Malerei zwischen 1450 und 1490*. Munich.

Wilde, Johannes

1944 "The Hall of the Great Council of Florence." *Journal of the Warburg and Courtauld Institutes* 7, pp. 65–81.

Wildenstein & Co.

1961 *Loan Exhibition of Paintings and Drawings. Masterpieces: A Memorial Exhibition for Adele R. Levy*. Exh. cat. New York: Wildenstein & Co.

1970 *Italian Drawings from the Ashmolean Museum, Oxford*. Exh. cat. New York: Wildenstein & Co.

Winternitz, Emanuel

1965 "Muses and Music in a Burial Chapel: An Interpretation of Filippino Lippi's Window Wall in the Cappella Strozzi." *Mitteilungen des Kunsthistorischen Institutes in Florenz* 11, pp. 263–86.

Woermann, Karl

1896–98 *Handzeichnungen alter Meister im Königlichen Kupferstichkabinett zu Dresden*. 10 vols. Munich.

Wohl, Hellmut

1986 "The Eye of Vasari." *Mitteilungen des Kunsthistorischen Institutes in Florenz* 30, pp. 537–68.

Woodner collection

1983 *Master Drawings from the Woodner Collection*, by George R. Goldner. Exh. cat. Malibu: J. Paul Getty Museum.

1986a *Dibujos de los siglos XIV al XX: Colección Woodner*. Exh. cat. Madrid: Museo del Prado.

1986b *Meisterzeichnungen aus Sechs Jahrhunderten: Die Sammlung Ian Woodner*. Exh. cat. Munich: Haus der Kunst München.

1986c *Die Sammlung Ian Woodner*. Exh. cat. Vienna: Graphische Sammlung Albertina.

1987 *Master Drawings: The Woodner Collection*, compiled by Christopher Lloyd, Mary Anne Stevens, and Nicholas Turner; edited by Jane Shoaf Turner. Exh. cat. London: Royal Academy of Arts.

1990 *Woodner Collection Master Drawings*. Exh. cat. New York: The Metropolitan Museum of Art.

1995 *The Touch of the Artist: Master Drawings from the Woodner Collections*. Edited by Margaret Morgan Grasselli. Exh. cat. Washington, D.C.: National Gallery of Art.

Zambrano, Patrizia

1990 "Il 'Compianto' del Sodoma in Sant'Anna in Camprena e le sue fonti." In "Antologia di artisti," *Paragone*, n.s., 41, no. 487 (September), pp. 52–58.

1995 "L'eredità di Filippo: Qualche indicazione sui primi passi di Filippino Lippi nella bottega paterna." In *La Natività di Filippo Lippi: Restauro, saggi, e ricerche*, edited by Maria Pia Mannini, pp. 40–47. Exh. cat. Prato: Museo Civico di Prato.

1996 "The 'Dead Christ' in Cherbourg: A New Attribution to the Young Filippino Lippi." *Burlington Magazine* 138 (May), pp. 321–24.

Zeri, Federico, with the assistance of Elizabeth E. Gardner

1971 *Italian Paintings: A Catalogue of the Collection of The Metropolitan Museum of Art*. Vol. 1, *Florentine School*. New York.

Zeri, Federico, Mauro Natale, and Alessandra Mottola Molfino, eds.

1984 *Dipinti toscani e oggetti d'arte dalla collezione Vittorio Cini*. Vicenza.

Zlatohlávek, Martin

1991 "A Late-Fifteenth-Century Italian Drawing in the National Gallery." *Bulletin of the National Gallery in Prague/Bulletin Národní Galerie v Praze*, 1991, pp. 121–24.

Index of Works of Art

Index of Names

Photograph Credits